WINNER OF THE PUL...

A Finalist for the
PEN/JACQUELINE BOGRAD WELD AWARD
and the
LAMBDA LITERARY AWARD

NAMED ONE OF THE BEST BOOKS OF THE YEAR
by *O, The Oprah Magazine*, the *Milwaukee Journal Sentinel*, and the *Seattle Times*, one of the Best and Biggest Books of the Fall by *New York*, and one of *USA Today*'s Five Books Not to Miss

"Utterly riveting and consistently insightful. . . . Fascinating."
—LESLIE JAMISON, *The New Republic*

"The first major reintroduction of an incomparable literary heavyweight to the public since her death." —*New York Times*

"This is it: the last word on Susan Sontag. I can't imagine the necessity of another book about her life." —SIGRID NUNEZ, National Book Award–winning author of *The Friend*

"If it's already difficult to imagine American culture without Susan Sontag's contributions to it, it may soon become difficult to imagine her life without Benjamin Moser's account of it." —MICHAEL CUNNINGHAM, Pulitzer Prize–winning author of *The Hours*

"Moser's biography is a stunningly generous gift—to readers, obviously, but also to his subject." —TERRY CASTLE, *ArtForum*

"Moser's epic portrait of the iconic writer and critic winds through American history, entwining its subject to pivotal points in our culture and reshaping her legacy in the process." —*Entertainment Weekly*

Praise for *Sontag*

"A landmark biography, the first major reintroduction of an incomparable literary heavyweight to the public since her death." —*New York Times*

"This is it: the last word on Susan Sontag. I can't imagine the necessity of another book about her life." —Sigrid Nunez, author of *The Friend*

"Utterly riveting and consistently insightful. . . . The book takes this larger-than-life intellectual powerhouse—formidable, intimidating, often stubbornly impersonal in her work—and makes her life-size again. . . . Fascinating." —Leslie Jamison, *The New Republic*

"If it's already difficult to imagine American culture without Susan Sontag's contributions to it, it may soon become difficult to imagine her life without Benjamin Moser's account of it. A significant life like Sontag's demands a significant biography. That demand has now been incisively, extravagantly met."
 —Michael Cunningham, Pulitzer Prize–winning author of *The Hours*

"Beautifully written and moving. . . . [A] monumental achievement. . . . This brilliant book matches Sontag's own brilliance and finally gives her the biography she deserves." —*BookPage*

"Fascinating. . . . Moser's biography of Sontag is an education in Sontag, but also in what Sontag wanted and why, as well as an education in the worlds that inspired her and fought her." —*Los Angeles Times*

"A skilled, lively, prodigiously researched book that, in the main, neither whitewashes nor rebukes its subject: it works hard to make the reader see Sontag as the severely complex person she was. . . . [Moser] writes vividly of a woman of parts determined to leave a mark on her time; and makes us feel viscerally how large those parts were—the arrogance, the anxiety, the reach! No mean achievement."
 —Vivian Gornick, *The New York Times Book Review*

"Succeeds as it does—magnificently, humanely—by displaying the same intellectual purchase, curiosity, and moral capaciousness to which [Sontag] laid so inspiring and noble a claim over a lifetime. . . . Graceful, tactful, scrupulous, unerringly insightful. . . . Moser's biography is a stunningly generous gift—to readers, obviously, but also to his subject." —Terry Castle, *ArtForum*

"Moser's epic portrait of the iconic writer and critic winds through American history, entwining its subject to pivotal points in our culture and reshaping her legacy in the process." —*Entertainment Weekly*

"Persuasive and illuminating . . . does what a biography ought to do: it enriches our understanding of its subject." —*The Los Angeles Review of Books*

"A towering figure like Susan Sontag deserves a towering tome, and Moser's seven-hundred-plus-page biography of the iconic cultural critic delivers. . . . This blockbuster à la Stacy Schiff's *Cleopatra* is both granular and grand— an opus fit for the writer-philosopher who 'created the mold, and then she broke it.'" —*O, The Oprah Magazine*

"Moser has managed the near-impossible feat of capturing Sontag in all of her dark brilliance and pointed contradictions." —*Interview*

"Glorious. . . . An epiphany of research and storytelling, the definitive life of a writer both more and less than the myth she fastidiously crafted. . . . [A] luminous achievement." —*Minneapolis Star Tribune*

"Monumental and stylish." —*The Atlantic*

"Enlightening and finely tuned. . . . Because Moser's tone is so reserved, so disinterested in passing judgement, none of what he writes about comes off as dishy or inappropriate. More to the point, his critical distance from his subject makes him an echo of Sontag herself." —Mark Athitakis, *On the Seawall*

"There can be no doubting the brilliance—the sheer explanatory vigor—of Moser's biography. . . . A triumph of the virtues of seriousness and truth-telling that Susan Sontag espoused again and again but was conspicuously and often quite consciously unable to force herself to live by." —*The New Statesman*

"Moser is a tenacious biographer, keeping a tight hold on his narrative and reaching firm conclusions. He is very tough-minded, as Sontag herself was at her best, and his mind is like Sontag's in that he can make very sharp turns and land decisive blows." —*Nylon*

"Engrossing. . . . [Sontag] was avid, ardent, driven, generous, narcissistic, Olympian, obtuse, maddening, sometimes loveable but not very likeable. Moser has had the confidence and erudition to bring all these contradictory aspects together in a biography fully commensurate with the scale of his subject. He is also a gifted, compassionate writer." —Elaine Showalter, *The Times Literary Supplement*

"Brilliant. . . . We need [Sontag] now, more than ever, and this biography keeps her defiantly alive: argumentative, willful, often right, always interesting, encouraging us to up our game as we watch her at the top of hers."
—*The Guardian*

"If Moser's *Why This World: A Biography of Clarice Lispector* was indispensable in greatly expanding the Brazilian writer's profile and readership, especially in the U.S., then *Sontag* accomplishes something just as valuable: it deepens our understanding of a world-renowned eminence."　　　　—*Bookforum*

"A landmark achievement—astonishing in its scope, brilliant in its perceptiveness, and a joy to read."　　　　　　　　　—Jewish Book Council

"A comprehensive, intimate—and surely definitive—biography of writer, provocateur, and celebrity intellectual Susan Sontag. . . . Sympathetic and sharply astute. . . . A nuanced, authoritative portrait of a legendary artist."
—*Kirkus Reviews* (starred review)

"Moser ably chronicles Sontag's childhood, her youthful brilliance and glamour, her shaping of the public conversation—with essays and books like 'Notes on "Camp"' and *Regarding the Pain of Others*—and her heroic efforts on behalf of the people of Sarajevo during the Bosnian war."
—*Seattle Times*

"Through it all, Moser tends to strike an effective balance between the kind of immersive detail Sontag specialists will eagerly expect and the kind of broader narrative momentum that ordinary readers will appreciate (and that might turn a few of them into Sontag specialists, always a pleasant side effect)."　　　　　　　　　　　—*Christian Science Monitor*

"Engagingly written. . . . With its personal details and gossip about New York literary parties, Moser's biography both entertains and scandalizes."
—*Mosaic*

"Remarkably perceptive and penetrating."　　　　—*National Review*

"Don't be fooled by the length. This book, at more than eight hundred pages, is compulsive reading: moving, maddening, ridiculous, and beautiful scenes from the life of Susan Sontag and the epochs she traversed. Moser has a true and deep love for his subject, a love unafraid to be truthful, and it shows."　　　　　—Rachel Kushner, author of *The Flamethrowers*

"Benjamin Moser's accomplishment here is breathtaking: it includes an extraordinary knowledge of the subject—her milieu, her writings, her ideas, and her friends and family—beautiful prose, extraordinary insights, and a capacity to understand her driven emotional life and her stellar intellectual life. It will be called unsparing because some of its truths about this complex figure are harsh, but it is generous to the subject as well as to readers who want to understand this woman who stood so tall and cast such a long shadow across twentieth-century intellectual life."
—Rebecca Solnit, author of *Call Them by Their True Names* and *Men Explain Things to Me*

"In this penetrating and timely new biography, Benjamin Moser casts new eyes on the life and works of Susan Sontag and pens a volume that captures the essence of this iconic genius. Through his compelling and beautifully balanced prose style, the author propels us through Sontag's eventful life in meticulous detail, drawing a sensitive portrait of the artist against the backdrop of over a half century of American letters, arts, politics, and rapid cultural change. For both Sontag scholars and those new to the subject, Moser has written an illuminating and important volume."
—Henry Louis Gates Jr., Alphonse Fletcher University Professor, Harvard University

"Susan Sontag made and broke the mold of the American twentieth-century public intellectual. In this long-awaited, brilliant biography, Benjamin Moser shows us how to read Sontag—and, by extension, her times—and reveals the extents and limits of her genius. His psychologically nuanced critical study is written with sangfroid and compassion."
—Chris Kraus, author of *After Kathy Acker* and *I Love Dick*

"Moser brings his iconic subject to life in this gripping, insightful, and supremely stylish biography. He makes a modern epic out of Sontag's remarkable story—from her tortured relationship with her alcoholic mother to her unflinching visits to besieged Sarajevo—revealing at every turn the vital, complicated, imperfect human being behind the formidable public intellectual." —Edmund Gordon, author of *The Invention of Angela Carter*

"Who better than distinguished critic Moser, National Book Critics Circle finalist for *Why This World: A Biography of Clarice Lispector*, to write a biography of Susan Sontag?" —*Library Journal* (starred review)

SONTAG

ALSO BY BENJAMIN MOSER

Why This World:
A Biography of Clarice Lispector

SONTAG

Her Life and Work

BENJAMIN MOSER

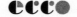

An Imprint of HarperCollinsPublishers

HarperCollins books may be purchased for educational, business, or sales promotional use. For information, please e-mail the Special Markets Department at SPsales@harpercollins.com.

Ecco® and HarperCollins® are trademarks of HarperCollins Publishers.

A hardcover edition of this book was published in 2019 by Ecco, an imprint of HarperCollins Publishers.

FIRST ECCO PAPERBACK EDITION PUBLISHED 2020

Designed by Suet Yee Chong

Library of Congress Cataloging-in-Publication Data

Names: Moser, Benjamin, author.
Title: Sontag / Benjamin Moser.
Description: First edition. | New York : Ecco, [2019] | Includes bibliographical references and index.
Identifiers: LCCN 2018044760 (print) | LCCN 2018050255 (ebook) | ISBN 9780062896414 (ebook) | ISBN 9780062896391 | ISBN 9780062896407
Subjects: LCSH: Sontag, Susan, 1933–2004. | Authors, American—20th century—Biography. | Women authors, American—20th century—Biography.
Classification: LCC PS3569.O6547 (ebook) | LCC PS3569.O6547 Z767 2019 (print) | DDC 818/.5409 [B]—dc23
LC record available at https://lccn.loc.gov/2018044760

20 21 22 23 24 LSC 10 9 8 7 6 5 4 3 2 1

For

ARTHUR JAPIN

To the memory of

MICHELLE CORMIER

Q: Do you succeed always?

A: Yes, I succeed thirty percent of the time.

Q: Then you don't succeed always.

A: Yes I do. To succeed 30% of the time is always.

—FROM THE JOURNALS OF SUSAN SONTAG,
NOVEMBER 1, 1964

CONTENTS

SONTAG

Auction of Souls

I n January 1919, in a dry riverbed north of Los Angeles, a cast of thousands gathered to re-create a contemporary horror. Based on a book published a year before by a teenage survivor of the Armenian massacres, *Auction of Souls*, alternatively known as *Ravished Armenia*, was one of the earliest Hollywood spectaculars, a new genre that married special effects and extravagant expense to overwhelm its audience. This one would be all the more immediate, all the more powerful, because it incorporated another new genre, the newsreel, popularized in the Great War that had ended only two months before. This film was, as they say, "based on a true story." The Armenian massacres, begun in 1915, were still going on.

The dry sand bed of the San Fernando River near Newhall, California, turned out to be the "ideal" location, one trade paper said, to film "the ferocious Turks and Kurds" driving "the ragged army of Armenians with their bundles, and some of them

dragging small children, over the stony roads and byways of the desert."[1] Thousands of Armenians participated in the filming, including survivors who had reached the United States.

For some of these extras, the filming, which included depictions of mob rapes, mass drownings, people forced to dig their own graves, and a sweeping panorama of women being crucified, proved too much. "Several women whose relatives had perished under the sword of the Turk," the chronicler continued, "were overcome by the mimic spectacles of torture and infamy."

The producer, he went on to note, "furnished a picnic luncheon."

———

One image from that day shows a young woman in flowery garb with a large carpetbag on her arm. Amid makeshift refugee tents, and with an afflicted expression on her face, she stands comforting a girl. Neither dares look at the sinister shadows approaching, invisible men with upraised arms, aiming something at them. Perhaps the women are about to be shot. Perhaps, given the panoply of available tortures, death by gunshot is the least painful option.

Gazing at this devastated corner of Anatolia, we are relieved to recall that it is, in fact, a film location in Southern California, and that the long shadows belong not to marauding Turks but to photographers. Despite press releases to the contrary, the Armenians being filmed were not all Armenians: this pair, for example, turns out to be a Jewish woman named Sarah Leah Jacobson and her thirteen-year-old daughter, Mildred.

If knowing that the picture is staged makes it less poignant, another fact, which neither subjects nor photographers could have known, does not. Though they returned home to downtown Los Angeles after playing their part in the "mimic spectacles of torture and infamy," Sarah Leah would be dead a little more than a

year later, aged thirty-three. This picture of bereavement would be the last surviving image of her with her daughter.

Mildred would never forgive her mother for abandoning her. But abandonment was not Sarah Leah's only legacy. In her short life, she traveled from Białystok, in eastern Poland, where she was born, to Hollywood, where she died. Mildred, too, would be adventurous. She married a man born in New York who reached China by nineteen, where he traveled into the Gobi Desert and bought furs from Mongolian nomads. Like Sarah Leah's, his precocious start was cut short; he, too, died at thirty-three.

Their daughter, named Susan Lee in an Americanized echo of Sarah Leah, was five when her father died. She only knew him, she later wrote, as "a set of photographs."[2]

———

"Photographs," Mildred's daughter Susan wrote, "state the innocence, the vulnerability of lives heading toward their own destruction."[3] That most people standing before the lens are not thinking about their impending destruction makes pictures more, rather than less, affecting: Sarah Leah and Mildred, acting out a tragedy, did not see that their own was so swiftly approaching.

Neither could they have known how much *Auction of Souls,* meant to commemorate the past, looked to the future. It is spookily appropriate that the last photograph of Susan Sontag's mother and grandmother should be connected to an artistic reenactment of genocide. Troubled all her life by questions of cruelty and war, Sontag would redefine the ways people look at images of suffering and ask what, if anything, they do with the images they see.

The problem, for her, was not a philosophical abstraction. As Mildred's life was shattered by the death of Sarah Leah, Susan's, by her own account, was also split in two. The breach occurred in a Santa Monica bookstore, where she first glimpsed photographs

of the Holocaust. "Nothing I have seen—in photographs or in real life—ever cut me as sharply, deeply, instantaneously," she wrote.[4]

She was twelve. The shock was so great that for the rest of her life she would ask, in one book after the next, how pain could be portrayed, and how it could be endured. Books, and the vision of a better world they offered, saved her from an unhappy childhood, and whenever she was faced with sadness and depression, her first instinct was to hide in a book, head to the movies or the opera. Art might not have made up for life's disappointments, but it was an indispensable palliative; and toward the end of her life, during another "genocide"—the word invented to describe the Armenian calamity—Susan Sontag knew exactly what the Bosnians needed. She went to Sarajevo, and she put on a play.

———

Susan Sontag was America's last great literary star, a flashback to a time when writers could be, more than simply respected or well regarded, *famous*. But never before had a writer who bemoaned the shortcomings in Georg Lukács's literary criticism and Nathalie Sarraute's theory of the *nouveau roman* become as prominent, as quickly, as Sontag did. Her success was literally spectacular: played out in full public view.

Tall, olive-skinned, "with strongly traced Picasso eyelids and serene lips less curled than Mona Lisa's," Sontag attracted the cameras of the greatest photographers of her age.[5] She was Athena, not Aphrodite: a warrior, a "dark prince." With the mind of a European philosopher and the looks of a musketeer, she combined qualities that had been combined in men. What was new was that they were combined in a woman—and for generations of artistic and intellectual women, that combination provided a model more potent than any they knew.

Her fame fascinated them in part because it was so unprecedented. At the beginning of her career, she was incongruous: a

beautiful young woman who was intimidatingly learned; a writer from the hieratic fastness of the New York intellectual world who engaged with the contemporary "low" culture the older generation claimed to abhor. She had no real lineage. And though many would fashion themselves in her image, her role would never be convincingly filled again. She created the mold, and then she broke it.

Sontag was only thirty-two when she was spotted at a table of six at a posh Manhattan restaurant: "Miss Librarian"—her name for her bookish private self—holding her own alongside Leonard Bernstein, Richard Avedon, William Styron, Sybil Burton, and Jacqueline Kennedy.[6] It was the White House and Fifth Avenue, Hollywood and *Vogue,* the New York Philharmonic and the Pulitzer Prize: as glitzy a circle as existed in the United States, and indeed the world. It was one Sontag would inhabit for the rest of her life.

Yet the camera-ready version of Susan Sontag would always remain at odds with Miss Librarian. Never, perhaps, had a great beauty worked less hard at being beautiful. She often expressed her astonishment at encountering the glamorous woman in the photographs. At the end of her life, seeing a picture of her younger self, she gasped. "I was so good-looking!" she said. "And I had no idea."[7]

———

In a lifetime that coincided with a revolution in how fame was acquired and perceived, Susan Sontag, alone among American writers, followed all its permutations. She chronicled them, too. In the nineteenth century, she wrote, a celebrity was "someone who gets photographed."[8] In the age of Warhol—not coincidentally, one of the first to recognize Sontag's star power—getting photographed was no longer enough. In a time when *everyone* got photographed, fame meant an "image," a doppelgänger, a collection of received ideas, often but not exclusively visual, standing

in for whoever it was—eventually it no longer mattered who it was—crouching behind them.

Raised in the shadow of Hollywood, Sontag sought recognition and cultivated her image. But she was acidly disappointed by the price her double—"The Dark Lady of American Letters," "The Sibyl of Manhattan"—exacted. She confessed that she'd hoped "being famous would be more fun,"[9] and constantly denounced the dangers of subsuming the individual into the representation of the individual, of preferring the image to the person it showed, and warned of everything that images distort and omit. She saw the difference between the person, on the one hand, and the person's appearance, on the other: the self-as-image, as photograph, as metaphor.

In *On Photography*, she noted how easy it was, given "the choice between the photograph and a life, to choose the photograph." In "Notes on 'Camp,'" the essay that made her notorious, the word "camp" stood for the same phenomenon: "Camp sees everything in quotation marks. It's not a lamp, but a 'lamp'; not a woman, but a 'woman.'" What better illustration of camp than the gap between Susan Sontag and "Susan Sontag"?

Her personal experience of the camera made Sontag keenly aware of the difference between voluntarily posing and exposing oneself, without consent, to the eye of the voyeur. "There is aggression implicit in every use of the camera," she wrote.[10] (The resemblance to Turkish vigilantes or the men pointing their cameras at Sarah Leah and Mildred is not accidental.) "A camera is sold as a predatory weapon."[11]

Beyond the personal consequences of being looked at too often, Sontag insistently posed the question of what a picture says about the object it purports to show. "A suitable photograph of the subject is available," her secret FBI file noted.[12] But what is "a suitable photograph of the subject," and for whom? What can we really learn—about a celebrity, about a dead parent—from "a

set of photographs"? Early in her career, Sontag asked these questions with a skepticism that often sounded dismissive. An image perverts the truth, she insisted, offering a fake intimacy. What, after all, do we know about Susan Sontag when we see the camp icon "Susan Sontag"?

The gulf between a thing and a thing *perceived* was accentuated in Sontag's time. But that such a gulf existed had been remarked as early as Plato. The search for an image that would describe without altering, for a language that would define without distorting, absorbed the lives of philosophers: the medieval Jews, for example, believed that the dissociation of subject from object, of language from meaning, caused all the ills of the world. Balzac regarded cameras superstitiously almost as soon as they were invented, believing that they stripped their subjects down, Sontag wrote, "used up layers of the body."[13] His vehemence suggests that the interest of this problem was not primarily intellectual.

Like Balzac's, Sontag's reactions to photographs, to metaphors, would be highly emotional. To read her examinations of these themes is to wonder why questions about metaphor—the relationship between a thing and its symbol—were so viscerally important to her, to wonder why metaphor bothered her so much. How had the apparently abstract relation of epistemology to ontology eventually become, for her, a matter of life and death?

———

"Je rêve donc je suis."

This paraphrase of Descartes ("I dream therefore I am") is the first line of Sontag's first novel.[14] As the opening sentence, and the only one in a foreign language, it stands out, a strange opening to a strange book. *The Benefactor*'s protagonist, Hippolyte, has renounced every normal ambition—family and friendship, sex and love, money and career—in order to devote himself to his dreams.

His dreams alone are real, but his dreams are not interesting for the usual reasons, "in order to understand myself better, in order to know my true feelings," he insists. "I am interested in my dreams as—acts."[15]

Thus defined—all style, no substance—Hippolyte's dreams are the essence of camp. And Sontag's rejection of "mere psychology" is a refusal of the questions of the connection of substance to style, and, by analogy, of the connection of body to mind—thing to image—reality to dream—that she would later so profitably explore. Instead, at the very beginning of her career, she claims that the dream itself is the only reality. We *are*, as she says in her very first sentence, our dreams: our imaginings, our minds, our metaphors.

The definition is almost perversely calculated to thwart the aims of the traditional novel. If there is nothing to be learned about these people from excursions into their subconscious, why embark on these excursions at all? Hippolyte acknowledges the problem, but assures us that there is another attraction. His mistress, whom he sells into slavery, "must have been aware of my lack of romantic interest in her," he writes. "But I wished she had been aware of how deeply, though impersonally, I felt her as the embodiment of my passionate relationship to my dreams."[16] Her protagonist is interested in another person, in other words, to the complete exclusion of reality, and only to the extent that she embodies a figment of his imagination. It is a way of seeing that remits to Sontag's own definition of camp: "seeing the world as an aesthetic phenomenon."[17]

But the world is not an aesthetic phenomenon. There is a reality beyond the dream. At the beginning of her career Sontag described her own ambiguous feelings about Hippolyte's worldview. "I am strongly drawn to Camp," she said, "and almost as strongly offended by it." Much of her later life was devoted to insisting that there is a real object beyond the word that describes it, a real body

beyond the dreaming mind, a real person beyond the photograph. As she would write decades after, one use of literature is to make us aware "that other people, people different from us, really do exist."[18]

———

Other people really do exist.

It is an astonishing conclusion to reach, an astonishing conclusion to *need* to reach. For Sontag, reality—the actual thing shorn of metaphor—was never quite acceptable. From the time she was very young, she knew that reality was disappointing, cruel, something to be avoided. As a child, she hoped her mother would stir from her alcoholic stupor; she hoped to dwell, instead of in a humdrum suburban street, upon a mythic Parnassus. With all the power of her mind, she wished away pain, including the most painful reality of all, death: first her father's, when she was five—and then, with hideous consequences, her own.

In a notebook from the 1970s, she maps the "obsessive theme of fake death" in her novels, films, and stories. "I suppose it all stems from my reaction to Daddy's death," she notes. "It seemed so unreal, I had no proof he was dead, for years I dreamed he turned up one day at the front door."[19] Then, having noted this, she exhorts herself, condescendingly: "Let's get away from this theme." But childhood habits, no matter how accurately diagnosed, are hard to break.

As a child, facing an awful reality, she fled into the safety of her mind. Forever after, she tried to creep back out. The friction between body and mind, common enough in many lives, became for her a seismic conflict. "Head separate from body," a schema from her diaries announces. She noted that, if her body were unable to dance or make love, she could at least perform the mental function of talking; and divided her self-presentation between "I'm no good" and "I'm great"—with nothing in between. On the

one hand "helpless (Who the hell am I . . .) (help me . . .) (be patient with me . . .) feeling of being a fake." On the other, "cocky (intellectual contempt for others—impatience)."

With characteristic industry, she strove to overcome this division. There is something Olympian about her sex life, for example, her effort to emerge from her head into her body. How many American women of her generation had lovers, male and female, as numerous, beautiful, and prominent? But reading her diaries, speaking to her lovers, one leaves with the impression that her sexuality was fraught, overdetermined, the body either unreal or a locus of pain. "I have always liked to pretend my body isn't there," she wrote in her journals, "and that I do all these things (riding, sex, etc.) without it."[20]

Pretending that her body wasn't there also allowed Sontag to deny another inescapable reality: the sexuality of which she was ashamed. Despite occasional male lovers, Sontag's eroticism centered almost exclusively on women, and her lifelong frustration with her inability to think her way out of that unwanted reality led to an inability to be honest about it—either in public, long after homosexuality ceased to be a matter of scandal, or in private, with many of those closest to her. It is not a coincidence that the preeminent theme in her writing about love and sex—as well as in her own personal relationships—was sadomasochism.

To deny the reality of the body is also to deny death with a doggedness that made Sontag's own end unnecessarily ghastly. She believed—literally believed—that an applied mind could, eventually, triumph over death. She lamented, her son wrote, "that chemical immortality" that "we were both, though probably just barely, going to miss."[21] As she got older and managed, time and again, to beat the odds, she started to hope that, in her case, the body's rules could be waived.

To "pretend my body isn't there" betrays a shadowy sense of self, and to remind oneself that "Other people really do exist" is

to reveal a more paralyzing fear: that she herself did not, that her self was a tenuous possession that could be misplaced, snatched away, at any moment. "It is," she wrote in despair, "as if no mirror which I looked into returned the image of my body."[22]

––––

"The aim of all commentary on art now," Sontag insisted in an essay contemporaneous with *The Benefactor*, "should be to make works of art—and, by analogy, our own experience—more, rather than less, real to us."

That famous essay, "Against Interpretation," denounced the accretions of metaphor that interfered with our experience of art. Weary of the mind ("interpretation"), Sontag had grown equally skeptical of the body—"content"—that the mind's hyperaction blurs. "It's very tiny—very tiny, content," the essay begins, quoting Willem de Kooning; and by the end of the essay, the notion of content comes to seem preposterous. As in Hippolyte's dreams, one is left with no there there: the nihilism that, in Sontag's definition, is the essence of camp.

"Against Interpretation" betrays Sontag's fear that art, "and, by analogy, our own experience," is not quite real; or that art, like our selves, requires some outside assistance in order to become real. "What is important now," she insists, "is to recover our senses. We must learn to *see* more, to *hear* more, to *feel* more." Assuming a numbed body desperate for stimulation, Sontag suspects that art might be the means of providing it; but what, without "content," is art? What should it make us see, hear, or feel? Perhaps, she says, nothing more than its form—though she adds, a bit disconsolately, that the distinction between form and content is "ultimately, an illusion."

Sontag devoted so much of her life to "interpretation" that it is hard to know how much of this she believed. Is all the world a stage, and life but a dream? Is there no distinction between form

and content, body and mind, a person and a photograph of a person, illness and its metaphors?

A weakness for rhetorical pizzazz led Sontag to make statements whose phrasing could trivialize profound questions about "the unreality and remoteness of the real."[23] But the tension between these purported opposites gave her the great subject of her life. "Camp, which blocks out content," was an idea she could only ever half endorse.[24] "I am strongly drawn to Camp," she wrote, "and just as strongly offended by it." For four decades after the publication of *The Benefactor* and "Against Interpretation," she vacillated between the extremes of an always-divided vision, journeying from the dreamworld toward whatever it was—her opinions varied wildly—that she could call reality.

———

One of Susan Sontag's strengths was that anything that could be said about her by others was said, first and best, by Susan Sontag. Her journals betray an uncanny understanding of her character, a self-awareness—though it slipped as she aged—that anchored a chaotic life. Her "head and body don't seem connected," a friend observed in the sixties. Sontag answered: "That's the story of my life."[25] She set about to improve herself: "I'm only interested in people engaged in a project of self-transformation."[26]

Though she found the effort exhausting, she vigorously set to work to escape the dreamworld. She would banish anything that fogged her perception of reality. If metaphors and language interfered, then she, like Plato expelling poets from his utopia, would cast them out. In book after book, from *On Photography* to *Illness as Metaphor* to *AIDS and Its Metaphors* to *Regarding the Pain of Others,* she moved away from her earlier, "camp" writings. Instead of insisting that the dream was all that was real, she asked how to look at even the grimmest realities, those of sickness, war, and death.

Her thirst for reality led to dangerous extremes. When, in the 1990s, the need to *"see* more, to *hear* more, to *feel* more" brought her to besieged Sarajevo, she was bewildered that more writers were not volunteering for a trip she described as "a bit like what it must have been to visit the Warsaw Ghetto in late 1942."[27] The trapped Bosnians were grateful, but wondered why anyone would want to participate in their suffering. "What was her reason?" an actor wondered, two decades later, amid another horror. "How would I, now, go to Syria? What do you have to have inside of you to go to Syria now and share their pain?"[28]

But Sontag was no longer forcing herself to look reality in the face. She was not simply denouncing the racism that had horrified her since she saw the pictures of the Nazi camps. She came to Sarajevo to prove her lifelong conviction that culture was worth dying for. This belief propelled her through a miserable childhood, when books, movies, and music offered her an idea of a richer existence, and brought her through a difficult life. And because she had committed her life to that idea, she became famous as a one-woman dam, standing fast against relentless tides of aesthetic and moral pollution.

Like all metaphors, this one was imperfect. Many who encountered the actual woman were disappointed to discover a reality far short of the glorious myth. Disappointment with her, indeed, is a prominent theme in memoirs of Sontag, not to mention in her own private writings. But the myth, perhaps Sontag's most enduring creation, inspired people on every continent who felt that the principles she insisted upon so passionately were precisely those that elevated life above its dullest or most bitter realities. *"Je rêve donc je suis"* was not, by the time she got to Sarajevo, a decadent catchphrase. It was an acknowledgment that the truth of images and symbols—the truth of dreams—is the truth of art. That art is not separate from life but its highest form; that metaphor, like the dramatization of the Armenian genocide in

which her mother participated, could make reality visible to those who could not see it for themselves.

And so, in her final years, Sontag brought metaphors to Sarajevo. She brought the character of Susan Sontag, symbol of art and civilization. And she brought the characters of Samuel Beckett, waiting, like the Bosnians, for a salvation that never quite came. If the people of Sarajevo needed food, heating, and a friendly air force, they also needed what Susan Sontag gave them. Many foreigners opined that it was frivolous to direct a play in a war zone. To that, a Bosnian friend, one of the many who loved her, answers that she is remembered exactly because her contribution was so oblique. "There was nothing direct about people's emotions. We needed it," she said of Sontag's production of *Waiting for Godot*. "It was full of metaphors."[29]

PART I

The Queen of Denial

Until she died, Susan Sontag kept two home movies that were made with such ancient technology that she never was able to view them. She cherished these talismans because they contained the only moving images of her parents together: when they were young, embarking on adventurous lives.[1]

The shaky footage shows Peking, as the Chinese capital was then known: pagodas and shops, rickshaws and camels, bicycles and trams. It briefly shows a group of Westerners standing on the opposite side of a barbed-wire fence from a gathering of curious Chinese. And then, for a couple of seconds, Mildred Rosenblatt appears, looking so much like her daughter that it is no surprise that they were later mistaken for sisters. Her handsome husband, Jack, turns up for a couple of seconds, so badly lit that it is hard to see more of him than to note the contrast he forms—tall, white, in foreign clothes—with the Chinese onlookers.

The film was made around 1926, when Mildred was twenty. The second was made around five years later. It begins on a train

in Europe, and then moves to the upper deck of a ship. There, a group of passengers—Jack and Mildred and another couple—is tossing a ring over a net, laughing. Mildred is wearing a summery white dress and a beret, smiling broadly and talking to whoever is behind the camera. A game of shuffleboard begins, and about halfway through the film, thin, gangly Jack appears in a three-piece suit and a beret of his own. He and the other man vigorously compete, and then their friends start making faces and horsing around as Mildred leans on a doorway, nearly breathless from laughter. Together, the films are less than six minutes long.

———

Mildred Jacobson was born in Newark on March 25, 1906. Though her parents, Sarah Leah and Charles Jacobson, were born in Russian-occupied Poland, both reached the United States as children: Sarah Leah in 1894, at seven, and Charles the year before, at nine. Unusually for Jews in that age of mass immigration, Mildred's parents both spoke unaccented English. And— ironically for the most Europeanized American writer of her generation—their granddaughter was perhaps the only major Jewish writer of that generation with no personal connection to Europe, no experience of the immigrant background that defined so many of her fellow writers.

Though born in New Jersey, Mildred grew up on the other side of the continent, in California. When the Jacobsons moved to Boyle Heights, a Jewish neighborhood east of downtown, Los Angeles was a town on the cusp of becoming a big city. The first Hollywood film was made in 1911, around the time the Jacobsons arrived. Eight years later, when Mildred and Sarah Leah appeared in *Auction of Souls,* the city was already home to a large-scale industry. The nascent film colony attracted sleaze: Mildred loved to tell people that she had gone to school with the notorious gangster Mickey Cohen, one of the early kingpins of Prohibition-

era Las Vegas.[2] And it attracted, and exuded, glamour: Mildred would always strike people as beautiful, vain, and sophisticated in a Hollywood way. Susan once likened her to Joan Crawford; others would compare Susan to the same diva.[3]

"She was always made up," said Paul Brown, who knew Mildred in Honolulu. In that city of hippies and surfers, where she spent the last part of her life, she stood out. "Her hair was always done. Always. Like a New York Jewish princess who wears Chanel suits and was too thin." She retained her Hollywood mannerisms all her life. She answered the phone with a throaty "Yeeeees?" and forbade her daughters to cross the living room rug until expressly summoned by a manicured hand.[4] Mildred "had this better-than-thou attitude, like royals," said Paul Brown, who saw her difficulty in dealing with the real world. "Like somebody who didn't know how to find the light switch."[5]

———

When she sailed off to China, beautiful Mildred seemed headed for a dazzling destiny. Her shipboard companion was Jack Rosenblatt, whom she had met while working as a nanny at Grossinger's. This was one of the giant summer resorts of the Catskills, the "Jewish Alps." For a middle-class girl like Mildred, Grossinger's was a summer job. For someone like Jack, Grossinger's was a step up.

Like thousands of poor immigrants, Jack's parents, Samuel and Gussie, had squeezed into the Lower East Side of Manhattan, then perhaps the most notorious slum in America. Born in Krzywcza, in Galicia, a part of Poland under Austrian rule, the Rosenblatts were markedly more plebeian than the "middle-class and suburban" Jacobsons, who were "nothing at all like first-generation Jews," Susan once told an interviewer.[6] In private, she said that her father's family was "horribly vulgar."[7]

Perhaps Samuel and Gussie's disregard for learning made their

granddaughter look down on them. Born in New York on February 1, 1905, Jack had a fourth-grade education. He dropped out of school at ten, and headed to work as a delivery boy in the fur district, on the West Side of Manhattan, where his energy and intelligence were soon noted. He had a flawless photographic memory: his daughter's memory would likewise be exceptional.[8] Elevating him from the mailroom, his superiors shipped him off to China when he was just sixteen. There, he braved the Gobi Desert on camelback, bought furs from Mongolian nomads,[9] and eventually set up his own business, the Kung Chen Fur Corporation, with offices in New York and Tientsin. It was the beginning of a busy life: in the eight years they were married, Jack and Mildred built a prosperous international business, went to China several times, traveled to Bermuda, Cuba, Hawaii, and Europe, moved house at least three times, and paused to have two children.

When Susan Lee Rosenblatt came into the world on January 16, 1933, the couple was living in a smart new building on West Eighty-Sixth Street, in Manhattan. That summer, the family moved to Huntington, Long Island; and around the time Judith was born, in 1936, they were installed in a suburban idyll in Great Neck. This was the town immortalized as West Egg in *The Great Gatsby,* and Jack Rosenblatt's arrival there was a testament to the success of a slum dropout. In class terms, Great Neck was as far from the sweatshops and the tenements of the Lower East Side as it was from China. It was the kind of ascension that might have cost a lifetime of hard work. Jack Rosenblatt achieved it by the time he was twenty-five.

A rise that rapid could only have been accomplished by a driven man; and Jack knew he had to hurry. When he was eighteen, two years after his first journey to China, he had his first attack of

tuberculosis. In literary terms, as Susan later wrote, this was "a disease apt to strike the hypersensitive, the talented, the passionate."[10] In nonliterary terms, it would fill his lungs with fluid and drown him.

To all appearances, the man Mildred met at Grossinger's was vigorous and athletic, rich and about to get richer. But the spots on his lungs gave her pause; his mother had brought him to Grossinger's, in fact, in the hopes that the country air might bring relief.[11] Mildred realized that their life together might not be long. Perhaps she reasoned that his infection might not blossom into full-fledged tuberculosis: the bacillus could linger harmlessly for years. But there was, as yet, no treatment. (Penicillin, discovered in 1928, would not be widely available until after World War II.) But Mildred was passionately in love with Jack. In 1930, they married and headed to China, setting up shop in Tientsin.

The major port closest to Beijing, Tientsin, now usually written Tianjin, was one of the "treaty ports" forced upon China after its defeat in the Opium Wars. There, foreign traders could operate outside of the constraints of Chinese law; for them, Susan wrote, this meant "villas, hotels, country clubs, polo grounds, churches, hospitals, and protecting military garrison." For the Chinese, it meant "a closed space, bounded by barbed wire; all who live there must show a pass to enter and leave, and the only Chinese are domestic servants."[12]

These servants were always chief among Mildred's memories of China. As the land was being devoured by Japanese invasion and civil war, the newlywed Rosenblatts were enjoying a golden age. "She loved the lifestyle," her friend Paul Brown remembered. "The servants. Having someone cook and serve. Just living like that in the beautiful clothes and the beautiful things, the embassy parties."[13] For the rest of her life, Mildred would distribute Chinese knickknacks to favored friends. "She had some things

that were just amazing," Brown said. "Beautiful Chinese stuff made with little Chinese hands." But her romantic memories were not to everyone's taste: "Even as a child," her daughter Judith wrote, "I was disgusted at her stories of all the people who waited on her for this and that in China."[14]

It is unclear how long the Rosenblatts were actually in China. They could not have lived there full-time. Tientsin is so far from New York that when Jack came back in 1924, the crossing from Shanghai to Seattle took sixteen days; the entire trip, nearly a month. Customs records find them entering New York nearly every year of their marriage, sometimes from beach destinations where they were presumably on vacation.[15] It would have been difficult to travel to China even once a year. It was an exhausting trip, even for people in good health: hard on Jack, with his weak lungs; hard on Mildred, who purportedly made it twice while pregnant.

But it was China that forever occupied Mildred's imagination. The house in Great Neck, where Susan spent her earliest infancy, was stuffed with Chinese memorabilia. "In China the colonialists came to prefer Chinese culture to their own," she wrote. "Their houses became little museums of Chinese art."[16] This interior decoration became another ambiguous heritage. "China was always everywhere in the house," Judith wrote. "Mother's way of putting down the present, reminders of her 'glorious' past."[17]

———

Jack's energy manifested itself in another area as well. Susan remembered a mistress,[18] and Judith described him as "a playboy."[19] Perhaps this, too, reflected his tortured awareness that his time was short: determined, as his daughter Susan would be, to make the most of it. Did Mildred know? It is hard to imagine the girls could have learned from any other source. Did she mind? Sex, as her later career demonstrated, was not among her interests.

Like many people who lose their parents in childhood, Mildred wanted to be taken care of; it is not a coincidence that the servants were what she remembered most fondly from China. And Jack Rosenblatt took good care of her.

She was less interested in—or less capable of—taking care of others. Along with her elegant furniture, she imported from China parenting precepts that reinforced her natural inclination. to keep children out of sight. "In China, children don't break things," she would say, approvingly. "In China, children don't talk."[20] Chinese or not, these ideas reflected the mind-set of a woman who was by no account maternal, one who was not eager to exchange her adventurous life with her husband for the drudgery of child-rearing. "Our mother," Judith said, "never really knew how to be a mother."[21]

When parenting became a chore, Mildred could simply sail away. "Somehow the myth has gotten out that it was relatives" who took care of the girls, Judith said, when Jack and Mildred were abroad. But "the relatives all had their own troubles." And so, from a very young age, the girls were dumped on Long Island with their nanny Rose McNulty, a "freckled elephant" of Irish German extraction, and a black cook named Nellie. These women mothered Susan and Judith. But a child wants her mother, and though she rarely spoke of her publicly, Sontag's journals reveal a fascination with Mildred.

As a child, Susan saw her as a romantic heroine. "I copied things from *Little Lord Fauntleroy*," she wrote, "which I read when I was 8 or 9, like calling her 'Darling.'"[22] Her letters read more like those of a concerned parent, or a passionate spouse, than those of a young daughter. "Darling," she breathed when she was twenty-three, "pardon if I make this short because it's late (3 am) + my eyes are watering a little. Be well + be careful + be everything. I'm mad about you + miss you."[23]

"She was clearly in love with her mother," said Susan's first

girlfriend, Harriet Sohmers, who met Mildred around this time. "She was always criticizing her about how cruel she was, how self-ish she was, how vain she was, but it was like a lover talking about a person that they were in love with."[24]

———

Mildred's vanity, her attention to hair and makeup and clothes, had a psychological counterpart, too: she prettified ugly realities so in-sistently that her daughter Judith described her as "the queen of denial."[25] Susan was often frustrated by her mother's determination to skirt unpleasant topics, and one year, after calling her mother to congratulate her on her birthday, noted the following conversation:

> M: (re her recent colon biopsy—negative)—
> I: "Why didn't you tell me about it?"
> M: "You know—I don't like details."[26]

She only told her daughters she was going to remarry after the ceremony. She didn't tell Susan when her grandfather died, say-ing only: "I don't think he enjoyed the idea of becoming a great-grandfather."[27] (Susan was pregnant.) She didn't tell Susan when her father died—and when she did, she lied about both the cause of his death and the site of his burial. (Decades later, when she tried to find his grave, she was thwarted by this misinformation.)

Another example of not getting bogged down in details comes in a memoir Susan wrote as a young woman—the only dusting of fiction the slightly changed names.

> One evening when Ruth was three years old, her guests par-ticularly enjoying themselves, and her husband much more pleasant than usual, Mrs. Nathanson felt the first labor pains for the birth of her second child. She had another drink. An hour later she walked into the kitchen where Mary, who was

helping to serve, was working, and asked her to undo the hooks on the expensive maternity dress she was wearing. Laughter and the sound of breaking glass could be heard from the living room as Mrs. Nathanson fell to her knees and moaned.

Don't disturb anybody.

Joan was born 2 hours later.

Rather than seeing this as lying, Mildred saw omitting details as courtesy, tact: a consideration she extended to others and expected them to extend to her. "Lie to me, I'm weak," Susan imagined her saying. She was, she insisted, too fragile for the truth, and believed that "honesty equaled cruelty." Once, when Susan attacked Judith for speaking honestly to her mother, Mildred seconded the reproach: "Exactly," she said.[28]

"Susan spent a huge amount of her life trying to figure Mother out," Judith believed.[29] Susan saw how Mildred's superficiality shaped her own personality: "Born to, growing up with M.—her absorption in the surface—I dived straight into the inner life."[30] But she did not see how Mildred's superficiality had itself been shaped: how and why she had become "the queen of denial."

A quick glance at Mildred's early life reveals a series of reversals that would have shaken a much stronger personality. She was just fourteen when Sarah Leah died of ptomaine poisoning. For the rest of her life, Mildred "very rarely" spoke of Sarah Leah, but her daughters suspected that the wound was deep. Judith remembered going with Mildred to see the "beautiful little cottage" in Boyle Heights where she lived before her mother's death: Mildred sobbed upon finding it, and the neighborhood, ruined.

Susan recalled a journey Mildred made from China across the Soviet Union, then under the reign of Stalin. She wanted to get off the train when it reached her mother's birthplace. But in the 1930s the doors of the coaches reserved for foreigners were sealed.

—The train stayed for several hours in the station.

—Old women rapped on the icy windowpane, hoping to sell them tepid kvass and oranges.

—M. wept.

—She wanted to feel the ground of her mother's faraway birthplace under her feet. Just once.

—She wasn't allowed to. (She would be arrested, she was warned, if she asked once more to step off the train for a minute.)

—She wept.

—She didn't tell me that she wept, but I know she did. I see her.[31]

———

She had another reason to weep on that train. On October 19, 1938, at the German American Hospital in Tientsin, Jack Rosenblatt had succumbed to the disease that had stalked him for nearly half his life. Like Sarah Leah, he was thirty-three.

Rather than sailing straight across the Pacific, Mildred concocted an almost perversely complex itinerary. Bundling a houseful of Chinese furniture onto a train, she plunged straight into Manchuria, the puppet state from which the Japanese were invading China, and crossed the Soviet Union and all of Europe before boarding a ship for New York. It was on this journey that she paid her only visit to her mother's birthplace in eastern Poland.

"She brought all this shit back with her," said Judith. That luggage included the remains of Jack Rosenblatt, who was buried in Queens upon her return. In New York, Mildred seemed at an utter loss. "I tried to conceal my feelings when I came back from China," she confessed under Susan's questioning. "It was the way my father brought me up. Aunt Ann's death—didn't tell me."[32] Susan and Judith were not allowed to attend the funeral; it was months before Mildred got around to telling them that their

father was dead. After she finally told Susan, she sent the first-grader out to play.[33]

In *Illness as Metaphor*, Susan's examination of the lies surrounding sickness, she quotes Kafka: "In discussing tuberculosis . . . everybody drops into a shy, evasive, glassy-eyed manner of speech."[34] The disease was, like cancer and later AIDS, a shameful one, and Mildred told Susan that her father had died of pneumonia.[35] As Susan grew older, Mildred hardly rushed to fill in the "details," and went to lengths to erase her husband's memory. As a result, Susan knew almost nothing about Jack Rosenblatt: "I don't know what his handwriting was like," she wrote thirty years later. "Not even his signature."[36] In the 1970s, preparing to visit China for the first time, Susan jotted down some notes on her father. In them, a woman devoted to facts got his birthday wrong by more than a year.[37]

———

Mildred was thirty-two when Jack died. She was widowed, and returned to the life of the middle-class American housewife she had seemed determined to avoid. But she would never complain. Instead, for the next half century, she would present a lovely face to the world, stepping out of the room when things got awkward, medicating her sadness in secret, with vodka and pills. It is no wonder that China, where she had lived the great adventure of her life, would haunt her forever after.

It haunted her daughter, too. Far more than France, with whose culture she would later be identified, China was the site of Susan's earliest and most powerful geographic fantasies. China was a "landscape of jade, teak, bamboo, fried dog."[38] It was also the possibility of another origin, another life: "Is going to China like being born again?"[39] China exercised a powerful fascination over Susan and Judith, who, though born in Manhattan, lied to impress their classmates: "I knew I was lying when I said at school

that I was born there," Susan wrote, "but being only a small por-
tion of a lie so much bigger and more inclusive, mine was quite
forgivable. Told in the service of the bigger lie, my lie became a
kind of truth."[40]

She does not say what the bigger lie was. But her stories about
China were her first fiction, one to which she returned again and
again. In the early 1970s, during her abortive career as a film-
maker, she sketched a screenplay featuring a prosperous couple in
the British Concession in Tientsin. The tubercular father "loves
the game of making money," though his "slum background" gives
him a "sense of social inferiority." The couple are fawned on by
servants, and protected by barbed wire from a distasteful China
where people pee in the streets. "Wife: crazy," Susan writes of
the mother. On the next page she asks: "What about Mildred
(poor Mildred) nutty as a fruitcake?"[41]

———

What remained of that time, and of Jack Rosenblatt, was a cou-
ple of unwatchable film reels and the "set of photographs" that
showed Susan's father alive. But she had nothing to help her
imagine him dead. Without facts—a date, a cause of death, a fu-
neral, a grave, or any visible sentiment—Susan "didn't really be-
lieve" he was gone.[42] "It seemed so unreal. I had no proof he was
dead, for years I dreamed he turned up one day at the front door."
This fantasy evolved into the "theme of fake death" she discovered
in her own work, a recurrence of miracles and the "Jack-in-the-
box haunting of one person by another."[43]

Can the word "Jack" be coincidental? This "unfinished pain"[44]
haunted her forever after, figuring repeatedly, her son wrote, "in
the inwardly directed talk of her final days."[45]

The Master Lie

In 1949, shortly after Susan entered the University of Chicago, she was chatting with a group of fellow freshmen in the dining hall. One, Martha Edelheit, mentioned that summer camp had saved her from "total insanity" while growing up. "Camp," Susan replied, "was the worst thing that ever happened to me." Martie went on to describe the progressive institution she attended in the Poconos, Camp Arrowhead: "That's the camp I was sent to!" Susan exclaimed. "I ran away."

Martie was amazed to realize who was sitting across from her: the girl who ran away from Camp Arrowhead had been a myth of Martie's childhood. At the time, Martie was seven and Susan six. "The whole camp was awakened in the middle of the night because this child was missing," Martie recalled. State troopers were summoned. "It was terrifying." Now, all those years later, that legendary girl had unexpectedly resurfaced. "She hated it," Martie remembered. "She absolutely hated it. She didn't want to be there. Nobody would listen to her."

This escape was a response to a pair of unbearable traumas: her father's death—by the summer of 1939, had Mildred even told her?—and her longing for her absent mother. "I always tried to get her attention," she said of her mother, "always did something to get her attention, to get her love."[1] Yet "her mother dumped her in this camp so that she could do whatever she needed to do," Martie said.[2]

For a recently widowed woman who had just crossed half the planet, the need for a break was understandable. But Mildred had been dumping Susan almost from the time she was born. The fear of abandonment—and its corollary, the urge to abandon those she feared were about to abandon her—became a hallmark of Susan's personality.

———

Mildred had to adapt to sharply different circumstances. She had money. The Kung Chen Fur Corporation still threw off a monthly allowance of no less than five hundred dollars, the equivalent of over eight thousand dollars in 2018. But the business suffered in the hands of Jack's younger brother Aaron, who had a reputation in the family for incompetence. The war, too, took its toll. After a few years, this income began to dry up.[3]

Mildred was not destitute, but her husband's death meant fewer possibilities for escape. She seemed constantly to be trying to find a new life, and was incessantly on the move. She sold the house in Great Neck and moved to Verona, New Jersey, where she briefly lived near her father, in Montclair—perhaps too near, since before long she decamped to Miami Beach, where she and her daughters spent the year of 1939–40. Not long after, she returned north, to Woodmere, Long Island. A year later, in 1941, she moved to Forest Hills, Queens, where she remained until heading across the continent, in 1943, to the desert resort of Tuc-

son. She would stay in the West, where she had grown up, for the rest of her life.

This itinerancy—which marked her daughter's life, too—had a devastating chemical counterpart. While mourning her husband and trying to find a new life for herself, Mildred had succumbed to alcoholism. She never mentioned the problem to Susan or, it seems, to anyone else; careful as ever to maintain appearances, she would sip a tall glass of vodka over ice and ask visitors: "Would you like some water?"[4] Unable to deal with the world, she spent much of her time supine in her bedroom, leaving household concerns, including her children, to Nellie and Rosie.

"My profoundest experience is of indifference," Susan wrote years later, "rather than contempt."[5] Indolent Mildred seems only to have sprung to life when there was a man around: "We had a lot of uncles," Judith remembered.[6] "We didn't always know their names. . . . One was called 'Unk.'"[7] But when there was no man, one of Susan's friends recalled, "the mother would literally take to her bed and say to Susan, 'Oh my God, my precious, I couldn't live through the day without you.'"[8]

When an "uncle" was around, or when Mildred couldn't be bothered, she shut off. "M. didn't answer when I was a child," Susan wrote in her journals. "The worst punishment—and the ultimate frustration. She was always 'off'—even when she wasn't angry. (The drinking a symptom of this.) But I kept trying."[9]

———

Mildred may not have known how to be a mother. But with her beauty and her devotion to appearances, she knew how to draw the eyes of men, and enlisted her daughters in the cause. She was delighted when people mistook her and Susan for sisters—welcoming Susan and Judith when they made her look younger, banishing them when they "dated" her.[10]

While still very young, the precocious girl discovered how to make Mildred see her. "One of the things I felt pleased my mother was an erotic admiration," Susan wrote. "She played at flirting with me, turning me on; I played at being turned on (and was turned on by her, too)."[11] Whenever there was no "uncle" around, Susan played the role. "Don't leave me," Mildred would implore her. "You must hold my hand. I'm afraid of the dark. I need you here. My darling, my precious."[12] Her mother's mother, she also became Mildred's husband, forced to compete with the suitors swarming around the beautiful young widow. By flirting, she wrote, "I somehow triumphed over the boyfriends in the background, who claimed her time, if not her deep feeling (as she repeatedly told me). She was 'feminine' with me; I played the shy adoring boy with her. I was delicate; the boyfriends were gross. I was in love with her; I also played at being in love with her."[13] Whenever things went wrong with men, Mildred always had Susan.

Her mother ascribed "magical powers" to her, Susan wrote, "with the understanding that if I withdrew them, she'd die."[14] She burdened the child with this terrible responsibility; but in another foreshadowing of Susan's subsequent relationships, Mildred also wielded the threat of abandonment, shoving Susan aside when somebody more important came along. Susan lived "in constant terror that she would withdraw suddenly and arbitrarily."[15] From Mildred, Susan learned to kindle erotic admiration by periodically removing her attention.

This was Susan's "profoundest experience," she said. It created a sadomasochistic dynamic that recurred throughout Susan's life. In the house she grew up in, love was not given unconditionally. Instead, it was extended temporarily, only to be dropped at will: a winnerless game whose rules the girl learned far too well. Mildred's "need" for Susan forced her daughter to protect herself. As much as she wanted her mother to need her, she also despised

the "misery and weakness" Mildred showed, and when her be-
havior became unbearably pathetic, Susan had no choice but
to step back.[16] "When she needed me without my having tried to
elicit anything from her," Susan wrote, "I felt oppressed, tried to
edge away, pretending I didn't notice her appeal."[17]

———

In later life, and for a variety of reasons, Susan denounced "la-
bels." She declined invitations to be included in anthologies of
women writers. She told Darryl Pinckney not to dwell on black-
ness and Edmund White not to dwell on gayness: she believed
that a writer should strive to be so individual as to become univer-
sal. But though few were as forcefully individual as Susan Sontag,
she remained, almost to the point of caricature, the adult child
of an alcoholic, with all of their weaknesses—as well as their
strengths.

Cancer, Susan would later insist, strikes people regardless of
their sterling character, or their degree of sexual repression, or the
elaborate euphemisms they employ to deny it. Cancer is simply a
disease. And there is a common saying that alcoholism, too, is
a disease—because it has symptoms. As in any other pathology,
these follow predictable patterns.

Predictable, too, are the ways it affects the children of
alcoholics—but these were not fully understood until Susan was
much older. "I wasn't ever really a child!" Susan wrote in her late
twenties.[18] This single exclamation sums up the core of the prob-
lem. "When is a child not a child?" asked an early specialist in
this syndrome, Janet Woititz. "When the child lives with alco-
holism."[19]

Susan was given to understand that she held her mother's
life in her hands, and children like her typically try frantically to
be perfect—Susan was "exceptionally well behaved," her mother
said[20]—terrified that they cannot live up to those responsibilities.

Aware of her failings, the child of the alcoholic is plagued by low self-esteem, always feeling, no matter how loudly she is acclaimed, that she is falling short. Unable to take love for granted, she becomes an adult dependent on affirmation from others—only to reject that affirmation when it is given.[21]

Indeed, many of the apparently rebarbative aspects of Sontag's personality are clarified in light of the alcoholic family system, as it was later understood. Her enemies, for example, accused her of taking herself too seriously, of being rigid and humorless, of possessing a baffling inability to relinquish control of even the most trivial matters. But "the young child of the alcoholic was not in control," Woititz explained. "He needed to begin taking charge of his environment."[22] Such children are often liars: aware that they cannot tell others how things really are at home, they construct elaborate masks, then take refuge in these same fantasies. Parents to their parents, forbidden the carelessness of normal children, they assume an air of premature seriousness. But often, in adulthood, the "exceptionally well behaved" mask slips, and reveals an out-of-season child.

———

Mildred, "the queen of denial," would flee reality, and so would Susan. But her flight was more productive. The "resident alien" at home,[23] she wanted nothing more than to escape. Among her earliest memories was the desire to flee. "Whose voice is the voice of the person who wants to go to China?" she asked. "A child's voice. Less than six years old."[24] She imagined "a teeming world of oppressed coolies and concubines. Of cruel landlords. Of arrogant mandarins, arms crossed, long fingernails sheathed inside the wide sleeves of their robes."[25]

Part of this was longing for her father. But the novelistic phrasings of these imaginings were thanks to her mother. Mil-

dred made Susan want to escape, and gave her the means to do so. In a rare but essential example of maternal solicitude, Mildred taught her daughter to read. "She would put her name on a chalkboard," Paul Brown remembered. "She would say 'Susan,' and point to her. She would sound it. Then she'd put another word on. Then when she got that other word she'd put another word on and then another word. Then she started verbalizing. Susan was reading when she was two or three."[26]

Reading gave Susan a way to recast reality, to aestheticize it—as when *Little Lord Fauntleroy* inspired her to call her otherwise unfathomable mother "darling." When she needed to escape, books let her close the door: "When you didn't like something," Mildred wrote, "you'd just go into your room and read."[27] A happier child might never have become such an accomplished reader. Mildred encouraged her to take up residence in a fairytale world.

———

"Absolutely intimidated" by Susan's precocious intellectualism,[28] her mother, like so many after her, feared Susan's judgment. When, for example, she was ambushed reading *Redbook,* a magazine for middle-class housewives, Mildred would shamefacedly shove it beneath the bedcovers.[29] Loath to embarrass her, Susan wordlessly agreed not to see. "I," Susan wrote, "obligingly, do my best not to look, not to record in consciousness or ever consciously use against her what I see."[30]

"I grew up trying both to see and not to see," she wrote.[31] Pretending not to see her mother, she eventually became *actually* unable to see her, veering between "slavish thralldom"[32] and its opposite. "My mother was a horrible person," she told a friend after Mildred's death.[33] "I had no mother," she told another, with whom she discussed alcoholism at great length. "What I had

was this ice-cold—it was just depressing. I always tried to get her attention, to get her love. I had no mother."[34]

This was as much of a caricature as Susan's childish notion of her as a romantic heroine. "She was never able to know what goes on in another person," one of her lovers said. "I mean the sensitivity that we exercise in everyday life all the time. Like 'What are you thinking, what are you feeling, where are you in this?' Susan was not sensitive."[35] Unable to see the disappointments that led her mother to seek reprieve from real life, she seems not to have made the connection between "the master-lie about how and what [her mother] is"[36] and what she herself was. She denounced the feeling of "fraudulence" the lie gave her. But though she tried to distance herself ("I hate anything in me—especially physical things—that's like her"), the connection, even disowned, remained.[37] Another lover told Susan she was "ruled by a family image of myself: being my mother's daughter."[38]

CHAPTER 3

From Another Planet

Among the fragments of memories Susan conserved from the period after her father's death was a question that gives a recognizable glimpse, in the five-year-old Sue Rosenblatt, of the future Susan Sontag: "Do you know the difference between the trachea and the esophagus?"[1]

Other fragments also suggest Sue's state of mind. She remembered her uncle Sonny's taking her far out into the water, leaving her a mild but enduring phobia; she recalled a spider in a backyard tent and the stink of urine in the basement of an insane asylum.[2] Her anxieties may also have manifested as the asthma that appeared at this time. This disease is often triggered by emotional turmoil, and the experience of suffocation, terrifying enough for an adult, can only be more so for a child: the first disease in a life that would be full of them.

To "the asthmatic's recurrent nightmare of being interred alive"[3] she added another, her mother's inability to face difficult situations. In an unpublished memoir fictionalized only by

changing the names, she wrote that during her asthmatic attacks
Mildred "was always most inadequate, not being able to bear
watching her daughter push off the sheets that covered her, and
kneel on top of the bed, stretching toward the ceiling in the effort
to find breath."[4]

Mildred could not stay in the room. But she was not indif-
ferent to Susan's illness. In 1939, for the third time in little more
than a year, she uprooted herself and her family, including Nellie
and Rosie, and bundled them into a train to Florida. Of Susan's
few memories of this time was a question she asked along the
way: "Mother, how do you spell pneumonia?"[5]

She was trying to put her mind around the incomprehensible
disease that, Mildred had told her, had killed her father: tuber-
culosis was as yet unpronounceable. But as she was gasping for
breath, the knowledge that her disease—like his—was seated in
the lungs must have been scary. And though she wrote almost
nothing about her time there, in Miami Beach she would have
occasion to grow better acquainted with lung diseases and with
an institution, the sanatorium, that would resonate throughout
her life.

Of Florida she remembered "coconut palms and white houses
decorated with imitation-Moorish stucco"[6] and a visit from her
grandma Rosenblatt, who told her that there was no Santa Claus.[7]

———

Miami's humidity was bad for asthma, and the family stayed less
than a year. Mildred dragged them back to New York in 1940,
and they alighted, temporarily, in Woodmere, Long Island. Just
past Idlewild Golf Course—today John F. Kennedy International
Airport—Woodmere does not seem to have left an impression on
Susan. But in Forest Hills, where Mildred moved the family in
1941, Susan herself left an impression.

Walter Flegenheimer, an older classmate at PS 144, where Susan spent fifth and sixth grades, was accosted on the playground by a younger girl who demanded to know whether he and a friend were enrolled in the "Intellectually Gifted Children" program. She had arrived too late in the school year to join and breathed a sigh of relief when she heard they were. "Can I talk to you?" she asked. "Because the kids in my class are so dumb I can't talk to them."

Sue was funny, and her wit attracted the older boys. They became pals, Flegenheimer said, and were surprised to discover she was two years younger. "She was certainly our equal intellectually—and we were smart." They hung out on the playground and visited the Rosenblatts' apartment, where they got a glimpse of "a very glamorous lady," Mildred, "strikingly more sophisticated than the other mothers I was familiar with."

"I don't recall her being particularly interested in or talking about literature or writing," Flegenheimer said. What he did recall was her overwhelming charisma. Sue was "always on"— sometimes "trying a little too hard" but with a "star quality" that made it obvious that she was destined for greatness.

> When I was in my twenties and thirties I used to look for the name Sue Rosenblatt in some context, because I knew she'd become famous. And then after I didn't find Sue Rosenblatt, I went: "Oh, I guess she didn't become famous."[8]

On the playground of PS 144, Sue was not yet talking about books. But as her opening salvo to Walt reveals, she was already aware of herself as a misfit. Bored at school, unhappy at home, in fragile health, she aspired to better things. But the woman who

would inspire bookish girls everywhere had few models when she herself was a bookish girl.

The feminist critic Carolyn Heilbrun has written that, until very recently, the only women deemed worthy of biography were "royal women or women celebrated as events in the lives of famous men." Women whose importance resided in their own achievement were invisible. "Only the female life of prime devotion to male destiny had been told before; for the young girl who wanted more from a female biography, there were, before 1970, few or no exemplars."[9] Even a writer of such apparently unquestionable eminence as Virginia Woolf was, in the 1960s, dismissed by one of the deans of American criticism, Lionel Trilling.[10] His own wife bitterly joked that no matter how substantial her own accomplishments, her obituary would inevitably read: "Diana Trilling Dies at 150. Widow of Distinguished Professor and Literary Critic Lionel Trilling."[11]

In the memoirs of women intellectuals of Sontag's generation, one great exception was mentioned time and again. In 1937, Eve Curie published *Madame Curie,* which Susan read soon after, when she was seven or eight. "That made me want to be a biochemist and win the Nobel Prize," she said. (Her failure to do so was less poignant than Eve's, whose mother, father, husband, sister, and brother-in-law all won Nobel Prizes—her mother, twice.) "I didn't know it was supposed to be difficult for women,"[12] Susan later said.

This "supreme heroine of my earliest childhood"[13] held a lifelong fascination. In her last decade, she considered writing a novel about her.[14] The lofty and intimidating Madame Curie made Sue wonder whether she had the kind of intelligence rewarded with Nobel Prizes. But she realized early on that her own brand of intelligence—"trying a little too hard"—was a great strength. "I did think that I could do whatever I set my mind to (I was going to be a chemist, like Madame Curie), that steadfastness and car-

ing more than the others about what was important would take me wherever I wanted to go."[15]

———

From reading, Sue was also deriving an idea of social duty as socialist heroism. In Forest Hills, she read a comic book about the Canadian doctor Norman Bethune, a Communist who served in the Spanish Civil War before traveling to China, where he died, an exemplary martyr of socialist internationalism, in the service of Mao.[16] And she read two books about desperate prison escapes, Lewis Lawes's *20,000 Years in Sing Sing* and Victor Hugo's great drama of injustice and redemption, *Les Misérables*. At nine, she told an interviewer, she "lived for months of grief and suspense" in her five-volume edition of *Les Misérables*. "It was the chapter in which Fantine is obliged to sell her hair that had made a conscious socialist out of me."[17]

There was another reason for her identification with the oppressed. During the family's years in Forest Hills, a hitherto unimaginable catastrophe was sweeping the Jews of Europe; and if the full extent of the Nazi horror would not be understood until after the war, the Jewish community certainly knew its outline. The city was swelled with thousands of refugees, including Sue's friend Walter Flegenheimer, born in Germany.

During her life, her attitude toward her background would prove as unsettled as her attitude to other aspects of her identity. She told the Israeli novelist Yoram Kaniuk that she was "first a Jew, second a writer, and third an American."[18] This "shocked" Kaniuk, because "there had been nothing about her that he associated with Jews." Others agreed. "Susan didn't come on Jewish," the film scholar Don Eric Levine said—allowing that "insofar as she was trying to come on Jewish, she was trying to come on as Hannah Arendt."[19] Jarosław Anders, a Polish writer who traveled through Poland with a group of American writers,

remembered John Ashbery's crying at Auschwitz. "She did not. And she talked about it, about this manipulation of history, and this hiding of certain aspects of Jewish suffering, but it was an intellectual challenge for her, and an issue, but not a personal one."

Sometimes, as with the Israeli Kaniuk, she emphasized her Jewish background. At other times she downplayed it. She told an Italian friend that the first shul she ever set foot in was the suitably opulent Great Synagogue of Florence—though her stepfather founded a synagogue in the far less glamorous San Fernando Valley.[20] She told the writer Jonathan Safran Foer, "I've no Jewish background, and have never celebrated Pesach"[21]—though the family held seders every year, her sister remembers, and celebrated the other Jewish holidays as well. Her grandmother ate only in kosher restaurants; Mildred taught Hebrew school on their porch; Susan gave blood for Israel.[22]

None of this suggests a household aflame with religious fervor. (Mildred, in fact, allowed the girls a Christmas tree, and let them accompany Rosie to church.) It suggests, instead, a perfectly normal Jewish childhood in middle-class America, and raises the question of why she would deny it.

———

For a child born two weeks before Hitler came to power, another aspect of a normal Jewish childhood was fear. No matter how remote she felt from her origins, she knew they endangered her. Even if she was only nominally Jewish, "nominally," she realized, "was enough for Nazis." During the war, she "was beset by a recurrent nightmare in which Nazi soldiers had escaped from the prison and had made their way downstate to the bungalow on the outskirts of the town where I lived with my mother and sister and were about to kill me."[23]

The danger was not limited to dreams. One day, on her way home from school in Forest Hills, she was called a dirty Jew and hit on the head with a rock. Her injuries required stitches, and left other scars as well. "I think, I know," said Judith, referring to this attack, "that Susan hated labels."[24] It was natural for her to despise and avoid them: labels, particularly the unsolicited kind referring to ethnicity, gender, or sexuality, were dangerous.

Yet a fear of being labeled does not necessarily mean that Jewish suffering was merely "an issue, but not a personal one." Throughout her life, the more personal the issue, the more energetically she strove to recast it intellectually. Disguised or abstracted, these emotional undercurrents lent her examinations of apparently dry questions an unexpected urgency. In her book on cancer, *Illness as Metaphor,* she never once mentions her own cancer. And many of her intellectual interests relate directly to the experience of Jewish suffering, like the Holocaust photographs that, she wrote, split her life in two.

Just after the war—perhaps just after seeing those photographs—she wrote a poem summing up many of her later questions about how to remember: how, in her later phrase, to regard the pain of others.

Ashes of those who were burnt in the camps,
bodies starved, shot, beaten, maimed in the camps,
resume to me what befell you, O allow me to remember
 you . . .

I do not think your ashes will nourish and fructify
 anything, I do not think your deaths had any meaning,
 or that any good will be seen served from them:
Forgive me for not having the power—had I the right—to
 transmute them.

Aware of the obscenity of looking at these maimed bodies, she is, at age twelve or thirteen, determined to look anyway. But she is also determined not to demean the victims by tacking a happy ending onto their suffering, and struggles with the question of how to remember. "If there is any tact possible in such painful imaginings I will search for it," she promised.[25] For the rest of her life she did. But she would not do so by embracing the blunt identities that, she feared, had created the catastrophe. Instead, she wrote, "I try abstractly."[26]

———

In New York, Sue's asthma worsened. In search of better treatment, Mildred turned to Tucson, whose desert climate had attracted sanatoria and hospitals since the 1920s. By then, to dispel concerns about extreme temperatures, Arizona's boosters had already hit on their favorite cliché. It wasn't the heat, the advertisements for the Desert Sanatorium insisted, it was the humidity. "With midsummer comes intense heat," they allowed, "yet because of the extreme dryness of the air, sunstroke and heat prostration are unknown, and the 'high temperatures here are decidedly less oppressive than much lower temperatures in a humid atmosphere.'"[27]

Perhaps nowhere in the United States is the atmosphere less like New York than in Tucson. Its empty streets, its wild temperatures, its native populations, its distant location, its exotic flora and fauna, all left an enduring impression on Sue. "No landscape," she had one of her characters say of the southwestern desert, "not even the swampy jungle of the Isthmus of Panama, had struck any of them as this awesomely strange."[28] Her first encounter with this landscape proved unforgettable. After the three-day train journey, Sue darted off the train and hugged the first saguaro she saw. "She had never seen a cactus before," Judith remembered. "She was covered with spines."[29]

The Rosenblatts settled into a bungalow at 2409 East Drach-man Street. Today near the center of a sprawling city, in 1943 the street was a dirt road so far from civilization that on her way to the Arizona Inn, only a couple of blocks away, Susan often encountered rattlesnakes.[30] The house itself was four tiny rooms poised atop a recently poured concrete slab, contrasting so unfavorably with Mildred's previous addresses in Tientsin and Long Island that it seems difficult to imagine she intended to stay long. She, Rosie, Judith, Susan, and their dog Lassie squeezed into the house. For the girls, the house's size was not important: the heat drove them outdoors and even underground, into a hole—eventually the word would be capitalized—they dug in the yard, and that formed one of the enduring memories of Susan's and Judith's childhoods.

As her embrace of the cactus indicates, Susan did not take easily to Tucson. She was ten; East Drachman was her eighth address in four states. She had been uprooted so often that now, plunked down in the middle of the desert, she had trouble fitting in. Many of her memories of Tucson suggest loneliness. Her first school, Catalina Junior High, was a "catastrophe." When a girl was nice to her, she realized she simply "didn't know how to be nice back."[31] She left for another school, the Arizona Sunshine School. The next year, when she was eleven, she entered yet another, Mansfeld Junior High.

After Mildred died and Susan began to study her ailment, she jotted a brief phrase in her journal. "Children of alcoholics—feeling of being a visitor from another planet."[32] Lacking reliable models of human interaction, she had to look to others and imitate them. When she entered Mansfeld she made what she called her "great decision—the conscious decision I took when I was 11." Her vow: "I will be popular." Even then, she wrote, "I understood the difference between the outside and the inside."[33] Her acute perception of this difference could only have come from a person on the outside.

In his memoir of his mother, Susan's son, David Rieff, described her greatest anxiety—after her fear of death—as a "profound, and in the end inconsolable, sense of being always the outsider, always out of place."[34] At first blush, it is a surprising comment. In the cultural world, Susan Sontag was not only an insider: she symbolized insiderness. It was to her insiderness that admirers paid homage when noting that no one could draw attention to art and artists as powerfully as she; it was her insiderness detractors acknowledged when denouncing her failing to draw attention to causes—more often than not themselves—that they hoped to advance. Like no other writer of her generation, she embodied the cultural prestige emanating from New York, and seemed to bear the very keys to Manhattan.

Yet in Tucson she already was what she always remained in her mind: an alien, a misfit. Her most sustained memoir of Arizona came in her second novel, *Death Kit*, in which the protagonist dreams of a feral child "in Sabino Canyon, which lies in the foothills of the Catalina Mountains just outside Tucson."

> The Wolf-Boy doesn't want to be an animal. Envies the superior suffering of human beings . . . Doesn't want to be an animal, but has no choice.[35]

This feeling of being trapped in the wrong life saturates Susan's memories of the "long prison sentence" of her childhood.[36] She tried to shape her younger sister into a companion, but Judith had other interests: "No point in trying to teach 6-year-olds that the collarbone was called the clavicle," Susan later conceded, "or Judith the 48 capitals of the 48 states."[37] Susan nonetheless drilled

her sister. "Ten sixty-six," Judith recited seventy years later. "The Battle of Hastings."

In the bunk beds they shared in Tucson, Judith said, Susan inevitably was on top. "Because," she explained, "if the bed fell apart she would be okay."[38] Noting this indifference to her demise, Judith "tortured her" with occult powers.

> I'd be lying in my bed and she'd be up there reading or something with her head practically hitting the ceiling. There was a bureau at the foot of the bed and a mirror above the bureau. I would say, "I am magic. I know what you're doing. You raised your arm."

Spooked by these paranormal insights, Susan never noticed the mirror in front of her face. "She was so dumb about some really strange things," Judith said. In fact, Susan did not learn the truth until shortly before her death when, in the hospital, the sisters sat apologizing for the wrongs they had done each other. When Judith finally confessed, Susan "loved it. She just loved it. She never figured it out."

———

Like her attempts to make Mildred into a Hollywood heroine, her attempts to lift Judith to her intellectual level were thwarted not just by a gap in age and ambition, but by an inability to see who Judith really was. In those deathbed conversations, Susan told her she had always regretted that Judith had never pursued a professional career, insisting that she ought to have become a lawyer. "But Susan, I'm the least argumentative person in the world," Judith objected. "I would have lost the case before I stepped into the courtroom."

But her failure to shape her sister meant that Susan had no

one to talk to about the many things she was not dumb about. Unhappy at home, an oddball at school, dislocated geographically, she retreated inward, to reading—and, increasingly, to writing. Her journals, which eventually spanned more than a hundred volumes, began with a notebook purchased at the corner of Speedway and Country Club in Tucson, and her very first concern expressed the hope of finding a sympathetic reader. "Someday, I'll show these to the person I will learn to love:—this is the way I was—this is my loneliness."[39]

Her loneliness was assuaged by supportive teachers. "She was not just a good student," said a friend. "She was a champion student."[40] But though she was devouring books in ever-increasing volume, no one had oriented her reading until a Mr. Starkie ("I don't think I ever knew his first name"[41]) appeared at the Arizona Sunshine School. Mr. Starkie, who had fought with Pershing in Mexico, loaned her his copies of *The Sorrows of Young Werther* and Theodor Storm's *Immensee,* giving her a taste for German literature that stayed with her all her life. If this was an odd taste for a Jewish girl to acquire during World War II, it cannot be a coincidence that both novels concern doomed loves: "This is my loneliness" might be the motto of both.

The actual desert in which she lived offered a ready metaphor for the intellectual aridity of her surroundings. Despite exceptions like Mr. Starkie, Tucson, she wrote, was a "cultural desert." She discovered the Modern Library at the back of a stationery store and began reading through all the volumes in the series. In literature, she found an escape from "the prison of national vanity, of philistinism, of compulsory provincialism, of inane schooling, of imperfect destinies and bad luck."[42] And she discovered that mental escape might lead to physical escape.

Like many adventurous kids of her generation, she loved the sexy swashbuckler Richard Halliburton, one of the country's bestselling authors, who was little more than a boy when he fig-

ured out how to trade Tennessee for Angkor Wat: how to take, as the dreamy title of one of his books put it, *The Royal Road to Romance*. His attitude to his Middle American origins surely appealed to Sue as much as the world into which he swam and climbed and flew. "Let those who wish have their respectability," he declared. "I wanted freedom, freedom to indulge in whatever caprice struck my fancy, freedom to search in the farthermost corners of the earth for the beautiful, the joyous and the romantic."[43]

The phrase could be Susan Sontag's epitaph. She described his books as "among the most important of my life," and collected them as an adult.[44] Halliburton's terrible end would have had spooky echoes, too, for the girl who dreamed of China. In 1939, the same year Sue learned of her father's death in Tientsin, Halliburton and his crew departed Hong Kong in a junk bound for San Francisco. The ship was never heard from again. Halliburton was thirty-nine, only slightly older than her father. But he left his mark on a girl destined to become a great traveler, and gave her an aspiration to orient her life. He was "my first vision of what I thought had to be the most privileged of lives, that of a writer: a life of endless curiosity and energy and countless enthusiasms. To be a traveler, to be a writer—in my child mind they started off as the same thing."[45] To write would be to escape.

———

Isolated in its desert, East Drachman Street was nonetheless no stranger to world events. "Didn't we play War a great deal?" Judith later asked her.[46] The street had its own reporter, twelve-year-old Sue Rosenblatt. In the *Cactus Press,* she analyzed world affairs, announcing a "Shakeup in the Jap Navy" and piously reminding her readership that "the executed Fascist leaders were our enemies. But the Italian people are not."[47] In the mimeographed purple ink of the paper, sold for a nickel, one can see how closely

Sue followed the war's events. In this, she was no different from millions of other children; but what is most remarkable is how perfectly she aped the hokey language of American war reporting. This attention to language would characterize her later writings about one of her great subjects: not simply the facts of war, violence, and pain, but the words in which they were described.

The war brought an important change in their lives. On November 10, 1945, Mildred slipped across the Mexican border and married Nathan Stuart Sontag in Nogales. The event came as a shock to Judy and Sue, who were hurt not to learn of it until after it had happened. In a story Susan wrote as a young woman, she remembered the moment she found out about the impending nuptials:

> You know what I want to tell you, darling.
> I think I do, mother. (WHAT IS IT?)
> You do want a father, don't you, Ruth? What do you think of him, darling?
> (GOD, WHO IS IT?) I think he's swell, mother. Anyway, what you want to do is most important.[48]

Sue's confusion was understandable. Surrounded by "uncles," flirty Mildred may have seemed like a promiscuous merry widow. But her choice of Nat Sontag proves that nothing could have been further from the truth.

Five days after D-Day, Captain Sontag was shot down over France. Wounded, he was sent for treatment to the giant Davis-Monthan Army Air Field outside Tucson. While in town, he met the enchanting Mildred. Her choice from among her many other suitors struck some as odd. "I never found him to have what she had," said Paul Brown. "She longed for the pretentious high-end lifestyle, and Nat could never provide that for her. He was kind

of a bourgeois, middle-class guy. They were like buddies, though, really tight friends." In contrast to Mildred, Nat "didn't have star quality at all, period. She did."

The marriage would have seemed even more odd if their friends had known what Judith was shocked to discover many years later. This concerned the nature of his wartime injuries, which were never specified to the girls and which Susan seems never to have learned. Mildred told her daughter later that his injuries had left Nat sexually incapacitated. "I don't think she was much into sex," Judith said wryly.

But Nat "doted on her," Brown said. He was handsome enough to satisfy Mildred's need for a presentable surface—"somebody on her arm."[49] And he met another need that went far deeper than sensuality. Loving her but not her lover, Nat provided motherless Mildred with a parent. "With my stepfather she was baby," Judith remembered. "Nat Sontag called my mother 'Baby.'" The endearment is common enough, but Nat's role in the relationship was maternal, and he cooked and cleaned for her like the Chinese servants she remembered.

The relationship seemed strange to many who knew them. Himself bisexual, Paul Brown was struck, many years later, that Nat would try to hook him up with men. Once, Mildred urged him to marry a black female employee at his salon, giving him a book about a gay man and a lesbian who pursued private interests while publicly in a heterosexual marriage. "The black thing was just becoming fancy," Brown said. Mildred, with an eye for publicity, realized the same thing, telling him that the alliance would get "huge press." Brown knew she was right. But he was not interested in a dishonest relationship, and the black woman was straight. Mildred imperiously brushed aside his objections, and made Brown wonder if a similar dynamic might be at work in the Sontag marriage.

Perhaps, with Mildred's remarriage, Susan was happy to be relieved of the duty of parenting her parent. But with a mother who encouraged repression and dissimilation to this degree, Susan, too, would always have trouble knowing what to reveal and what to keep private. And with a dead father and a mother who was herself a child, she, too, would turn lovers into parents.

———

Nat Sontag's most enduring contribution was his name, which transformed the gawky syllables of Sue Rosenblatt into the sleek trochees of Susan Sontag. He never adopted the girls, but the decision to take his name was partly inspired by anti-Semitism. "The incident of being hit in the head and called a dirty Jew left an imprint," Judith said. At Mansfeld Junior High in Tucson, Susan remembered being called a kike.[50]

When she herself married, Susan, in one of the rare documents signed "Susan Rieff," wrote about changing names. Rosenblatt, she said, sounded too Jewish. "I've no loyalty to his name," she wrote. "I gave it up when my mother re-married, and not because she or my step-father asked me to. I wanted to. I always wished my mother would remarry. I wanted a new name, the name I had was ugly and foreign."[51]

"Sontag" was Jewish, too, but it did, in fact, ring less "foreign." It made Sue less easy to label. Her change of name is of a piece with her resolution to be popular, taken around the same time. These were decisions to shed her outsider status, the first recorded instances, in a life that would be full of them, of a canny reinvention. They also betrayed an ambition—never subsequently manifested—to blend into Middle America. The change was not merely cosmetic, she wrote in her final novel, *In America:* "Impossible to feel sincere while having one's photograph taken. And impossible to feel like the same person after changing one's name."[52]

Susan Sontag did not want to feel like asthmatic, helpless, unpopular Sue Rosenblatt. Soon she would leave behind the scene of that girl's humiliation. When, as an adult, she was visiting nearby Phoenix, her friend Larry McMurtry invited her to Tucson, where he lived. She refused. Once she left, she never returned.[53]

Lower Slobbovia

The family left Arizona in the summer of 1946, a few months after Nat and Mildred's marriage. Their destination was Los Angeles, where Nat found a job selling clocks with advertising slogans printed on them.[1] It was the city where Mildred grew up, the city where her mother was buried. And as Mildred had passed from adolescence to middle age in the intervening twenty-five years, the city, too, had changed beyond recognition. Only the perfect weather remained the same.

When she left, Los Angeles was a provincial place, isolated by its mountains and deserts. When she returned, it had become one of the preeminent symbols of a triumphant America. It was a symbol of American industrial power and American military power and, especially, of American cultural power. In the days of *Auction of Souls*, Hollywood meant a modest suburb of a distant city. By the end of the war, it was one of the most recognizable words in the world. The glamour of Hollywood and the apparently endless wealth of Southern California made Los Angeles an

American dream even for Americans themselves. "America has its America," Sontag wrote in her final novel, "its better destination where everyone dreams of going."[2]

Many headed for Los Angeles's own paradise, the San Fernando Valley, separated by mountains from the Los Angeles Basin. Through television shows like *The Brady Bunch* and *Leave It to Beaver*, the Valley eventually became a metonym for prosperous Middle America. With its neat bungalows and freshly clipped lawns, its blue skies and swaying palms, the great latifundium of Southern California was being divvied up to people like Nat Sontag: middle-class home buyers, often veterans, who bought houses on streets that, in Mildred's youth, had been orange and lemon groves.

The Valley meant everything clean and new about America. It also meant everything white, conformist, and nationalistic about "the deep America she came from and which she both feared and despised," Susan's son, David, wrote.[3] Her contempt seeps through in the essay "Pilgrimage," published in 1987. In it, she recalled scenes of postwar suburbia: "sirloins and butter-brushed corn tightly wrapped in tinfoil on the patio barbecue"; "the weekly comedy shows festooned with canned laughter, the treacly Hit Parade, the hysterical narratings of baseball games and prize fights." She felt obliged to "ward off the drivel," the materialist airheadedness later symbolized by the Valley Girl.[4]

Sontag's memories of Los Angeles were not all negative. Late in life, she complained to an assistant, himself from Los Angeles, about someone who had just come back to New York. "I'm just so sick of hearing their cliché complaints," she said, reeling them off: "There's no center. You need a car to get everywhere. There's no culture."[5] Los Angeles in 1946 was nothing like the international metropolis it is today, but it was a vast improvement over a dirt road in Arizona. For a girl who had been reduced to reading the Modern Library in the back of a stationery store, it had more

than enough of what Sue needed to take the next steps in her self-creation.

————

The Sontag family moved to 4540 Longridge Avenue in Sherman Oaks, at the base of the Santa Monica Mountains. From the studios just down the road, Sherman Oaks would soon popularize fast food and television and car culture, Frank Sinatra and Bing Crosby, all over the world. It was pretty in the mildly anesthetized manner of Southern California, and seedy in the same way. Susan remembered "wrinkled condoms" scattered on the lawn of her high school,[6] and a neighbor on Longridge Avenue remembered that, when he moved there, Sherman Oaks had the reputation of being "the wife-swapping capital of Los Angeles."[7]

At first blush, this did not seem to be a place with much to offer a bookish teenager. The house on Longridge Avenue had one important advantage, though: for the first time, she had a room of her own. "Now I could read for hours by flashlight after being sent to bed and told to turn off the light, not inside a tent of bedclothes but outside the covers."[8] That door let her escape; and around the time of the move, she read a book she remembered all her life, one that gave a taste of the arduous profession she was beginning to imagine for herself. It was *Martin Eden*, by Jack London, a Californian who had become one of the most successful writers in the world. Like Richard Halliburton, he was an adventurer; like Halliburton, he died young. *Martin Eden* is about the hardships of the writing life: a California rube who dreams of literature, Martin struggles valiantly against philistinism and incomprehension, and sees his efforts briefly rewarded—though his life, perhaps inevitably for such a romantic hero, ends in suicide. His isolation and dreaminess mirrored Sue's own, and when she received her first rejection letter the experience was just as Jack London predicted. She was "not greatly disappointed," she

wrote. "Rather thrilled to have the note and the rejection slip, for I understood—thinking, always, of *Martin Eden!*—that these were (my first) emblems of being, becoming a writer."[9]

She was nagged by suspicions that *Martin Eden* was not the high art to which she aspired. Perhaps Jack London's bestseller-dom bothered her: Jack London was the kind of author people read in Sherman Oaks. Three years after she first read *Martin Eden,* she noted it was "insignificant as art" and referred to London's "vulgar panoramic flash-back device." Nonetheless, the novel also meant her "real awakening to life," she wrote.

> There is not an idea in *Martin Eden* about which I do not have a strong conviction, and many of my conceptions were formed under the direct stimulus of this novel—my atheism + the value I place on physical energy + its expression, creativity, sleep and death, and the possibility of happiness!

The possibility of happiness, according to London, was that there was none. "For me, the 'awakening' book preached despair + defeat, and I have grown up literally never daring to expect happiness."[10]

———

Skepticism about happiness was common enough in Sontag's generation. Her friend Florence Malraux, two months younger than Susan, was the daughter of the French writer André Malraux and his Jewish wife, Clara. Florence's childhood was overshadowed by the Nazi occupation of her country, circumstances in which "personal happiness was not an aspiration," she said. "Everything was subordinated to the great causes."[11]

Susan's own experience made her respond to authors who denounced injustice. The war had shocked her; Victor Hugo made a conscious socialist out of her; Jack London pushed her further.

But it was her family that provided the emotional underpinning for that intellectual commitment: the feeling that led to her identification with Fantine or Martin Eden. Her missing father, her miserable mother, her feeling of being misunderstood, of "slumming, in my own life,"[12] made it difficult for her even to conceive of happiness, because she simply had no experience of it. Her son wrote that "not having known how to be happier in the present" was one of the "great, besetting regrets of her life."[13]

To make matters worse, Susan's personal situation could not have contrasted more strikingly with sunny Southern California. In the San Fernando Valley, where everything spoke the language of progress, unhappiness amounted to something like a moral failure. Susan's misery at home and boredom at school placed her, willingly or not, in an adversarial position to her entire culture.

She was not the first to feel this. The contrast between personal failure and the promise of the golden land is the great theme of California's literature. It appears in the works of Jack London; it appears in Frank Norris's *The Octopus* of 1901, about the clash between the railroads and the farmers they destroy; it appears in John Steinbeck's *The Grapes of Wrath*, about the disappointments of Dust Bowl emigrants. It is the theme of the "hard-boiled" detective writers like Raymond Chandler and Dashiell Hammett, whose novels are populated by recognizable California failures: washed-up actresses, strung-out lounge lizards.

Darkness in the golden land: the theme also runs through science fiction. "The Imagination of Disaster," Susan's essay of 1965, results from her intense interest in a genre often dismissed as kitsch. She watched hundreds of these films, set "in some ultra-normal middle class surroundings" like the California suburbs where many were filmed—boring places where a membrane of normality violently ruptures: "Suddenly, someone starts behaving strangely; or some innocent form of vegetation becomes monstrously enlarged and ambulatory."[14]

As in her earliest writings from Tucson, she pays careful at-
tention to the language in which this horror is expressed.

Lines like "Come quickly, there's a monster in my bathtub,"
"We must do something about this," "Wait, Professor. There's
someone on the telephone," "But that's incredible," and the
old American stand-by, "I hope it works!" are hilarious in
the context of picturesque and deafening holocaust. Yet the
films also contain something that is painful and in deadly
earnest.[15]

That earnest concerns the fear, in the Atomic Age, of the
"continual threat of two equally fearful, but seemingly opposed,
destinies: unremitting banality and inconceivable terror."[16] And
another fear appears in this essay, one that explains some of her
apparently incongruous interest in this form of popular culture.
That is of the depiction of people like herself as freaks. "Being a
clearly labeled species of intellectual, scientists in science fiction
films are always liable to crack up or go off the deep end," she
writes. "Disinterested intellectual curiosity rarely appears in any
form other than caricature, as a maniacal dementia that cuts one
off from normal human relations."[17]

———

In Los Angeles, she was finding normal human relations. In
Tucson, she had not known how to react when another girl was
friendly. Now, her passionate interests, which previously had
only made her something of a freak, brought her friendship.
Throughout her life, she often felt out of place and unhappy, but
throughout her life she also found that delight in art brought
friends. "The flip side of my discontent . . . was rapture. Rapture
I couldn't share" in her earliest years. It would be fed by her new

city's bookstores, record stores, and movie theaters: "Soon I was sipping at a thousand straws."[18]

From her friends, she was learning more than she was at school. The city's musical life had produced high school students with "tastes elevated and made eccentrically rigorous by the distinct bias of high musical culture in Los Angeles in the nineteen-forties—there was chamber music, and then there was everything else."[19] It was an attitude that Susan, who always felt separate from those around her, instantly adopted: despite her love for science fiction and comic books, her embrace of the arcane was a mark of much of her work. "We knew we were supposed to appreciate ugly music," she later wrote, dutifully.[20] Astonishingly, considering how little she must have seen, and how fanatical she later became, this duty made her despise opera: "She disdained opera," her friend Merrill Rodin said. "It was like Tchaikovsky, romantic. It was more important to be moved by Bach or Beethoven or Stravinsky."[21]

This was insecurity expressed as snobbery, of course. But it was also, like the Modern Library lists, an attempt to gain bearings in the culture she aspired to understand. Nothing in her family or education had given her any orientation in that world, and such musical hierarchies were a toehold. Like her interest in literature, her interest in music was never merely intellectual. "One thing that was striking to me about her," Merrill said, "was that she had the capacity to be tremendously moved."

She also had a tremendous capacity for work. In her notes on *Martin Eden,* she mentioned that she derived from that book her ideas on "sleep and death." Like the autodidact Martin Eden, she slept as little as possible:

> The days were too short. There was so much he wanted to study. He cut his sleep down to five hours and found that

he could get along upon it. He tried four hours and a half, and regretfully came back to five. He could joyfully have spent all his waking hours upon any one of his pursuits. It was with regret that he ceased from writing to study, that he ceased from study to go to the library, that he tore himself away from that chart-room of knowledge or from the magazines in the reading-room that were filled with the secrets of writers who succeeded in selling their wares.[22]

Her equation of sleep with death would never change. Associating sleep with sloth, she tried to avoid it, and was often ashamed to reveal that she slept at all. Writing for the North Hollywood High paper, *The Arcade,* of which she was "Third Page Editor," she declared that "Many hours of my life (mostly between 2 and 4 AM) have been spent just trying to think of a different way of starting the day than opening my eyes."[23]

Most high school students know the feeling. But what is remarkable is the *time* ("between 2 and 4 AM") she is trying to nudge herself into consciousness: as if, without those extra hours, she could never possibly catch up.

———

The air of premature seriousness was already notable in high school. "She was so focused—even austere, if you can call a fifteen-year-old austere," a classmate recalled. "Susan—no one ever called her Susie—was never frivolous. She had no time for small talk."[24]

Part of this was shyness. "She seemed like the kind of person who watched and observed—I am a camera—rather than engaged and participated," said her friend Merrill Rodin. She was both taller and younger than her fellow students, making her seem "gangly and self-conscious and awkward to me, maybe sort of a social misfit," Rodin said.[25]

She later characterized her years at North Hollywood High

as bleak and intellectually starved. Even during those years, she compared her surroundings, in a satirical article in *The Arcade*, to a fictional republic borrowed from the comic strip *Li'l Abner:* "There is a remarkable similarity between our citizens and the citizens of Lower Slobbovia," she opined.[26] In 1977, she summed up her education with a story that showed just how hard it was to "ward off the drivel":

> In 11th grade English class we were given the *Reader's Digest* and told to read it and be quiet. The teacher sat in front of the class and knitted. And I was reading European fiction and philosophy and hiding it behind my *Reader's Digest*. I remember that once I was reading Kant's *Critique of Pure Reason*—I don't know how I could have understood it at that age, but I was trying to understand it—and I got caught. So the teacher made me put the book away and go back to *Reader's Digest*.[27]

Her writings from the time remember many inspiring teachers (including English teachers) who engaged her in debates on music, literature, religion, and politics, at school and in their homes. Still, her journals reveal an adolescent so precocious that it is hard to imagine what school or teacher could have been good enough. "Basically, I believe Schopenhauer to be wrong," she intoned at age fourteen. "In making this statement I am considering only the most elemental portion of his philosophy: the inevitable barrenness of existence."[28] She quoted Nietzsche—"Convictions are more dangerous enemies of truth than lies"—only to cock a skeptical eyebrow: "It sounds good, anyway."[29] At fifteen, she bemoaned "the tragically literal Kollwitz." And in a class paper from her senior year, she embraced Freud ("too well known to require comment") with a loftiness that few high school seniors, then or now, could muster: "I can have no possible disagreement with this

first chapter" of *Civilization and Its Discontents*, she writes. "In the succeeding seven, particularly in the last few, of this book, there are many points where I cannot follow Freud's logic. However, I have found these first two chapters which deal with religion a most lucid setting-forth of a basic idea to which I most emphatically adhere."[30]

———

Southern California was not Lower Slobbovia. Nonetheless, it seems clear that the sources for this style ("a most lucid setting-forth of a basic idea to which I most emphatically adhere") must be sought somewhere outside North Hollywood High. Much of what she read with the flashlight in the room on Longridge Avenue had been found in the bookshops she discovered in Los Angeles, including the newsstand she remembered on the corner of Hollywood and Las Palmas, "with the porno in the front and the lit mags in the rear."[31]

Among these was *Partisan Review*, the organ of the highest reaches of the New York intelligentsia. Between its covers was a voice far removed from those one imagines at the barbecue on the patio. It was a voice that Susan, at first, did not grasp. She took an issue home and found the language "completely incomprehensible," she told a friend. "But somehow she had the impression that the things these people were talking about were enormously significant for her, and she made up her mind to crack the code."[32]

The magazine symbolized everything to which she aspired. "My greatest dream," she later said, "was to grow up and come to New York and write for *Partisan Review* and be read by 5,000 people."[33] Like her, it was culturally but not religiously Jewish; and like Jack London, politically socialist, despite the Communist origins its name betrayed. "A New York intellectual," it was later said, "was one who wrote for, edited, or read *Partisan Re-*

view."[34] In that world—where intellectuals were not exotic, not freaks—she might find a place.

"Sue," her stepfather told her, "if you read so much you'll never find a husband." Books, and magazines like *Partisan Review,* proved him wrong. "This idiot doesn't know there are intelligent men out in the world. He thinks they're all like him," Sue remembered thinking. "Because isolated as I was, it never occurred to me that there weren't lots of people like me out there, somewhere."[35]

The Color of Shame

O ut there, somewhere, in faraway Manhattan, a continent away from Sherman Oaks, was a world to which Susan might belong. But much closer by, in the hills rising just beyond Ventura Boulevard, was a constellation of other stars, if that is the word: some of the greatest cultural figures of the European diaspora, who had sought refuge from Hitler in the land of "lemon trees and beach boys and neo-Bauhaus architecture and fantasy hamburgers." Here, under the bright blue skies of Southern California, lived Igor Stravinsky and Arnold Schoenberg, Fritz Lang and Billy Wilder, Christopher Isherwood and Aldous Huxley, Bertolt Brecht and Thomas Mann.[1]

Susan encountered that world on December 28, 1949, when she and two friends "interrogated God"—that is, Thomas Mann—"this evening at six."

We sat, immobilized with awe, outside his house (1550 San Remo Drive) from 5:30 to 5:55, rehearsing. His wife,

slight, grey face and hair, opened the door. He at the far
end of the large living room on the couch, holding a large
black dog by the collar, which we'd heard barking as we had
approached. Beige suit, maroon tie, white shoes—feet to-
gether, knees apart—(Bashan!)—Very controlled, undistin-
guished face, exactly like his photographs. He led us into his
study (walls lined with book-cases, of course)—his speech is
slow and precise, and his accent is much less prominent than
I expected—"But—O tell us what the oracle said"—

On *The Magic Mountain*:

Was begun before 1914, and finished, after many interrup-
tions, in 1934—
 "a pedagogical experiment"
 "allegorical"
 "like all German novels, it is an education novel"
 "I tried to make a summa of all the problems facing Eu-
rope before World War I"
 "It's to ask questions, not to give solutions—that would be
too presumptuous"[2]

She was disappointed. "The author's comments betray his
book with their banality." So did his diaries. On Monday, De-
cember 26, he wrote: "Clear weather." On Tuesday, he complained
of ear discharge and noted: "Weather still clear and mild." On
Thursday, he wrote: "Afternoon interview with three Chicago
students about the *Magic Mountain*." He then added: "Lots of
mail, books, manuscripts."[3]
 The encounter was so momentous for Susan that she im-
mediately started to try to write about it. The effort would not
culminate for nearly forty years, when, in 1987, she published
"Pilgrimage," a story about her adolescent encounter with the el-

derly "god in exile," winner of the Nobel Prize, preeminent symbol of the dignity of German culture. "Pilgrimage" has come to stand for the whole precocious childhood of Susan Sontag, the girl from the provinces who, by dint of her admirations for her illustrious predecessors, eventually catapulted herself into their ranks. It is one of the few memoirs she wrote. Because it reveals an insecurity few suspected lurked behind the figure of Susan Sontag—by 1987, hardly less intimidating than Thomas Mann himself—it became one of her best-known pieces of writing.

The story tells of her friendship with Merrill Rodin, not only "cool and chunky and blond" but as smart as she was. He was a boy who, like her, enjoyed memorizing the 626 "Köchel numbers" that cataloged Mozart's compositions chronologically. He was a boy who loved Stravinsky enough to play a game with her: "How many more years of life for Stravinsky would justify our dying now, on the spot?" Twenty years was easy. Three years was too little to exchange their "paltry California-high-school-students' lives." Four, then? "Yes," she writes. "To give Stravinsky four more years either one of us was prepared right then and there to die."[4]

Above all, Merrill was someone with whom she could share her enthusiasm for literature. When she discovered *The Magic Mountain* at the Pickwick Bookstore in Hollywood and "all of Europe fell into my head," the person she wanted to share it with was Merrill. He devoured it, too, and then came up with a shockingly bold idea: they should try to meet Thomas Mann, who lived a short drive away, in Pacific Palisades. Susan was aghast; but right there, in the telephone book, was Thomas Mann, at 1550 San Remo Drive. Merrill calls, while Susan, mortified, cringes in another room. To their amazement, the woman who answers the phone is polite, and invites them to visit the great man.

"I'd never met anyone who didn't affect being relaxed," Susan wrote. As the two squirming high school students sit there, the great eminence discusses difficult-sounding things: "the fate of

Germany," "the demonic," "the abyss," "the Faustian bargain with the Devil." Susan tries desperately not to say anything stupid: "I had the impression (and this is the part of my recollection that is most touching to me) that Thomas Mann could be injured by Merrill's stupidity or mine . . . that stupidity was always injuring, and that as I revered Mann it was my duty to protect him from this injury." At last, without any horrible gaffes, the awkward encounter ends. "I doubt we spoke of it again."

———

The story is symbolically rich, full of resonant contrasts: between Europe and America, age and youth, past and future, rigid masculinity and bubbling femininity. We meet "Ella and Nella, the dwarf sisters, who led the Bible Club boycott that resulted in the withdrawal of our biology textbook." And Thomas Mann illustrates one of her great themes: the distance between the shadow-world of images and the wartier reality of life. "I would learn to be more tolerant of the gap between the person and the work," she wrote. And: "This was the first time I'd met someone whose appearance I had already formed a strong idea of through photographs."

But to compare "Pilgrimage" to other accounts of the meeting is to see a different meaning in the story. It is true that Susan and Merrill met Thomas Mann at his home in Pacific Palisades, but beyond that, the story has been so extensively doctored—far beyond the usual elisions that occur when memory becomes memoir—that it can only be called a memoir in the baggiest sense of the word. This is all the more striking because of the energy with which it advertises its faithfulness to detail:

"Yeah, another woman's voice—they both had accents— saying, 'This is Miss Mann, what do you want?'"
"Is that what she said? It sounds as if she was angry."

"No, no, she didn't sound angry. Maybe she said, 'Miss Mann speaking.' I don't remember, but, honest, she didn't sound angry. Then she said, 'What do you want?' No, wait, it was 'What is it that you want?'"

"Then what?"

"And then I said . . . you know, that we were two high-school students . . .'"

As both Mann's and Sontag's diaries record, they were, in fact, not two but three students. They were not high school but college students, and the date Sontag places at the very beginning of the story—"December, 1947"—is equally wrong. The meeting took place in December 1949, a very different time in her life, when she had been definitively freed from the drivel of the Valley and inhabited a milieu—the University of Chicago—as rarefied as even she could have wished. Perhaps she thought that the correct date would undermine the contrast between her dull suburban life and "the world in which I aspired to live, even as the humblest citizen."

Even in Los Angeles, high German culture was not as distant as she portrayed it. The third person in the story, the unmentioned Gene Marum, was Merrill's best friend. He was born in Germany to a prosperous family, not Jewish. In California, where he arrived as a child, his family stayed in touch with the other members of the German colony. He dated Nuria Schoenberg, the composer's daughter. And as it happened, his aunt Olga, as a student in Munich, had lived with a Jewish girl named Katia Pringsheim: the very same Mrs. Thomas Mann who picked up the phone on San Remo Drive. It was Gene who called, not Merrill. He spoke, of course, in German ("they both had accents") and made an appointment to visit Mann.

For the purposes of fiction, it is easy enough to understand why Susan would omit this crucial entrée to the god in exile. It is

funnier to imagine Thomas Mann in the telephone book between "Rose Mann, Ocean Park, and Wilbur Mann, North Holly-wood,"[5] which emphasizes the gulf between her lowliness and the exalted winner of the Nobel Prize. Whether she knew someone who knew someone who knew Katia Mann—whether she was fourteen (in the story) or sixteen (in reality)—there is no question that such a gulf existed.

But the story is also filled with other retouches that, because they serve no dramatic purpose and are so apparently insig-nificant, suggest the presence of some hidden truth. Her initial journal entry from December 28, 1949, brief though it is, reveals several discrepancies. In "Pilgrimage" they meet at four, for ex-ample, whereas in the journals they "interrogated God this eve-ning at six." In the journals Mann sits on a couch; in the story, on a chair. In the journals they talk in the living room; in the story they meet in "Thomas Mann's study."

In the story, they also discuss his forthcoming *Doctor Faus-tus*. The novel is filled with the German dialect of the sixteenth century, Mann explains, and he fears it will not readily be under-stood by an American public. And in fact they did talk about the book, but not in this way, since the book appeared in English in 1948. By setting the meeting in 1947, though, Susan can antici-pate a discussion of this work. "Ten months, later, within days of the appearance" of the book, she and Merrill were at the Pick-wick Bookstore: "I bought mine and Merrill his."

Another stray diary entry, in a long list of childhood memo-ries, tells another story.

"Being caught at the Pickwick Bookstore for stealing *Doctor Faustus*."[6]

———

In the journals of Susan's years in Los Angeles, a fear emerges, time and again, that she is a liar, a fake, a fraud. In June 1948,

she doodled a tombstone in her notebook and wrote upon it the words

Here Lies
(as she did throughout life)
Susan Sontag
1933—195?[7]

Some of this resulted from her "great decision," taken in Tucson, to be popular, which she managed to pull off "more capably" at North Hollywood High. She reproached herself for not standing up for her beliefs—

The kids were saying the most abysmally stupid and preju-dicial things, particularly in relation to Negroes—I said a few things in my homey, slangey, let's-be-friends–I'm-a-right-guy manner and returned to my seat completely frustrated and longing desperately to tell them all to go to hell.

—including when she sought confirmation of her popularity by running for student council. "If only I could say honestly that I wish I had not won the election!" she wrote. "And then, the girl who came up to me and said that she was happy I won be-cause she didn't want any Jews—I hate them so—I'm being eaten up inside—Oh, to be beautifully, chastely, cleanly, perfectly sincere!—with myself, with all the world!"[8]

The frustration was manifested toward the end of her life, when she offered advice to a graduating class at Vassar: "Don't take shit. Tell the bastards off."[9] For her as for anyone, this was easier said than done. But beyond a wish to tell off racists, a feel-ing of inauthenticity haunts the journals of these years. She notes "a mad frustrated longing for absolute honesty"[10] and wonders,

rereading her earlier journals in 1947, "when and if a person ever tells the truth."

> —So far I have written only what upholds the ideal of what I would wish to be—calm, patient, understanding,—a stoic (I must always be suffering!!!) and, last but not least, a genius. That person who has been watching me as long as I can remember is looking now—it would be swell if "it" kept me from doing the wrong things but instead I don't do the right things.[11]

A feeling of posing, of straining to come across as something she was not, pervades these writings. There is a gap not only between the person she is and the person others perceive, but also, more acutely, between herself and some higher power watching over her. Striking a pose: it is not a coincidence that Susan Sontag was one of the most photogenic public figures of her generation, nor that in her finest novel, *The Volcano Lover*, the protagonist is a specialist in "attitudes." Renowned for her masterful talent for mimicry, Lady Hamilton can summon, with a gesture or a tone, a whole host of figures from mythology and history.

Sontag often spoke of her capacity for admiration, and this was one of her most appealing characteristics. But her fascination with figures like Thomas Mann was, in part, an attempt to force herself to be that better self of whose standards she was always falling short. Mann was a "god" in the sense of a great and admirable figure. He was also a god in the sense of a judgmental father who, if he only could see through her, would surely dash her asunder. "All that I say is with the feeling that it is being recorded," she wrote in 1948. "All that I do is being watched."[12]

Mildred Sontag demanded that she be shielded from reality, and early on enlisted Susan to help her. Susan noted that she had inherited from her mother the idea that honesty equaled cruelty;

and she also must have learned from Mildred the art of presenting one face in public and another in private, a skill Mildred had perfected and that only the people closest to her could see through. "Everyone was charmed by Mother," Susan's sister, Judith, said. "I don't know how she managed it, because she did not charm her daughters."[13]

Mildred's second marriage, her encouragement to other people to lie, including about their sexuality, reflects her own loss, her mother's death, and a strange association that she had always retained from it. When Susan was around fourteen, a drunk propositioned her on the street, prompting a scandalized Mildred to declare she felt "positively unclean." Susan, in her journal, replied: "Your horror is ugly and unclean—You and the memory of your mother's buckle-like contraception lying on the table—your mother dying on a clean hospital bed—dying, in your mind, of Sex."

This was Susan's heritage. "Everything that reminds her of the sex act is unclean—and I have been permeated with that disease."[14]

————

Her mother encouraged her to lie, especially about sex. And from the time she was quite young, she realized she had something to lie about. "Just as I was once terrifiedly and neurotically religious and thought I should one day become a Catholic," she wrote almost a year to the day before her visit to Mann, "so now I feel that I have lesbian tendencies (how reluctantly I write this)—"[15] A few months later, she mentions "the incipient guilt I have always felt about my lesbianism—making me ugly to myself."[16]

Even without her mother's encouragement, she would have needed to lie at a time when homosexuals were commonly seen as perverts and criminals: laws against homosexual behavior were not overturned in all the United States until 2003. She would

never quite lose the reluctance she expressed about those "les-
bian tendencies," but her sexuality was the key to the single-
mindedness with which she pursued her vocation. "My desire to
write is connected with my homosexuality," she wrote. "I need
the identity as a weapon, to match the weapon that society has
against me. It doesn't justify my homosexuality. But it would give
me—I feel—a license. . . . Being queer makes me feel more vul-
nerable. It increases my wish to hide, to be invisible—which I've
always felt anyway."[17]

———

A decade later, in 1959, Susan wrote that "the only kind of writer
I could be is the kind who exposes himself."[18] The masculine pro-
noun stands in instructive contradiction to the rest of the sen-
tence. Indeed, a frequent criticism of Susan Sontag would be that
she placed the intellectual above the physical or the emotional
and thereby distanced herself from her subjects. That is what she
did in "Pilgrimage," in which all sorts of curious edits betray the
historical accuracy the label of memoir demands.

The hidden drama in "Pilgrimage" has nothing to do with
the question of who placed the phone call to the Mann house,
or whether Susan went with one or two friends, or whether they
turned up at four or six. It has to do with her sexuality—which,
she implies throughout the piece, is heterosexuality. She mentions
her friend Peter Haidu: "A boyfriend had to be not just a best
friend but taller, and only Peter qualified." She describes how at-
tractive Merrill was and declares that she "wanted to merge with
him or for him to merge with me," but Merrill was disqualified:
"he was several inches shorter than I was. The other barriers were
harder to think about."

She does not talk about these other barriers. The real bar-
rier was that Merrill was every bit as gay as she was—as, of
course, was Thomas Mann. And that is the genuine theme of the

story, which she originally titled "Aria About Embarrassment":[19] "Everything that surrounds my meeting with him has the color of shame," it begins. Similar words recur so frequently that there can be no mistaking their importance. She speaks of the "faintly shameful disease" of which her father had died. She writes that when Merrill suggested the visit "my joy turned to shame." She describes the phone call as "mortifying" and herself as a "coward." She was "awash in shame and dread" and refers to "further embarrassment" and "more embarrassment" and "how embarrassing" the situation was and feeling "ashamed, depressed" and "illicit, improper" and recalls the visit as "the memory of embarrassment" and "something shameful."

What, though, was she so ashamed of? The words seem a bit melodramatic to describe an ancient moment of teenage awkwardness. So often in Sontag's writings the great artists appear not simply as models to emulate but as admonishing superegos before whom she must humbly abase herself: people who might see through her and discover her unworthiness, her ugliness, her lies. Thomas Mann was the first in this genealogy of gods, and that her shame in his presence was sexual emerges from a metaphor she uses at the end of the story. She and Merrill scurry away from San Remo Drive "like two teen-age boys driving away after their first visit to a brothel."

And this, despite the elaborate lies, is why "Pilgrimage" rings true. The facts were fake. But the shame was real.

CHAPTER 6

The Bi's Progress

I 'm only interested in people engaged in a project of self-transformation," Susan wrote in 1971.[1] If the desire for transformation can derive from a lack of positive self-satisfaction, it is also the enemy of self-satisfaction in the negative sense, of smugness and complacency. In "Pilgrimage," she mentions her "model of condescending to present time in favor of the better future." As her mother, forever pining for her Chinese servants, looked to the past, Susan looked to the future. "I want to write—I want to live in an intellectual atmosphere—I want to live in a cultural center where I can hear a great deal of music."[2] She was fourteen when the principal of North Hollywood High told Nat and Mildred that Susan had read more books than her English teacher.[3] And she soon learned where she could find the intellectual atmosphere she sought.

In an article in *Collier's* magazine, she read about the University of Chicago, "which didn't have a football team, where all people did was study, and where they talked about Plato and

Aristotle and Aquinas day and night. I thought, that's for me."[4]
Mildred, however, was not having it. On a cross-country trip in
the summer of 1948, Susan's first visit to New York since depart-
ing for Tucson five years before, the family stopped in Chicago:
"It looks as if the Plaisance hotel, across from the University, is as
close as I'll ever get to said educational institution!" she groaned
in June. "Hell and damnation—just an immovable wall that I
cannot beat down with any argument."[5]

 This was not the story Mildred put about in later years. "I
thought that anyone who was bright should do as she damn
pleased," she told a reporter.[6] "She had a lilt in her voice," a neigh-
bor said, "when she told me Susan defied Nat"—who in this tell-
ing forbade Susan to leave—"and went on to the University of
Chicago."[7] But Mildred and Nat were on the rocks: Susan men-
tions that "the strong possibility of a divorce includes the chance
of Mother moving back to NY." One of the subjects they dis-
agreed on was allowing Susan to go away for college.[8] Mildred
and Nat patched things up. By September, with Nat's help, Su-
san had broken down the immovable wall: "A tearful discussion
with Mildred (damn it!). She said, 'You should be very happy I
married Nat. You would never be going to Chicago, rest assured
of that! I can't tell you how unhappy I am about it.'"[9]

———

Susan waited until a year after Mildred's death, in 1986, to pub-
lish "Pilgrimage." In it, Susan portrayed her "bony, morose"
mother without affection, emphasizing only how desperate she
was to leave home. As when Mildred told the story, that was
only part of the truth, because as much as she felt oppressed by
her mother, as much as she longed to find her way in the world,
Susan was also aware of the "magical powers" her mother had
granted her, the powers without which—she had been given to
understand—Mildred would die. It was not easy for either to cut

the tie. "I know that I must get away from home," she wrote in May, "although I like LA and would not mind living here under other circumstances—the promise of a car is tempting, but hardly enough for me to continue this prostitution."[10]

She was only fifteen; all year, she hesitated. It was a momentous decision for one so young, and Susan was strongly tempted by familiarity. "How I long to surrender! How easy it would be to convince myself of the plausibility of my parents' life! If I saw only them and their friends for a year, would I resign myself—surrender? . . . For I can feel myself slipping, wavering—at certain times, even accepting the idea of staying home for college."

Her reluctance was bound with her passionate entanglement with her mother. Susan—not Nat—could help her, Mildred let her know. Susan alone could comfort her. Susan always believed it.

> All I can think of is Mother, how pretty she is, what smooth skin she has, how she loves me. How she shook when she cried the other night—she didn't want Dad, in the other room, to hear her, and the noise of each choked wave of tears was like a giant hiccup.[11]

At the end of 1948, she graduated from North Hollywood High. By then, she had given up on Chicago and elected, after all, UCLA, just over the hills from Sherman Oaks. But then a compromise candidate emerged: Berkeley, the flagship of the University of California. It was close—but not too close—to home. "UCLA vs. Cal," she wrote a few months later. "Cal meant a complete uprooting of myself—new city, new environment, new people—an immediate opportunity to leave home. Emotionally, I wanted to stay. Intellectually, I wanted to leave. As always, I seemed to enjoy punishing myself."[12]

The masochism that would characterize most of her important relationships had first been established with Mildred. In a

lightly fictionalized memoir, she recalled being "obsessed with longing to grow up" and longing, too, "for more affection from her silent dark handsome mother." That affection only came gushing forth when her mother was about to lose her, rebounding "with a suddenly awakened flow of maternal love and dependence." This, in turn, prompted Susan to flee.[13]

But she did not do so without guilt, including toward her sister, whom she offered to Mildred in atonement. More than a decade later, she apologized. "Do you know I have never ceased to feel guilty about 'leaving home,'" she wrote her sister in a confessional letter. "At my age! And after so many years! But Judith, I reasoned—mainly unconsciously—Judith is there, Judith is holding the fort. So I sacrificed you—any thought about what might have been good for you—to my feeling of guilt toward her. . . . You have every reason not to trust me at all, or to like me very much."[14]

Thirty-seven years after she left home, shortly after Mildred's death, Susan still blamed herself for the failed relationship. "I've always felt guilty for leaving home/M. So she had a right to treat me so coldly, so ungenerously."[15]

———

This guilt hung over her first weeks in Berkeley. "Well, I'm here," she sighed to her notebook. "It's no different at all; it seems it never was a matter of finding more felicitous surroundings, but of finding myself—finding self-esteem and personal integrity. I'm no happier now than I was at home."[16] The challenge—"finding self-esteem and personal integrity"—was the same. A university might have seemed to invite the same solutions she found in high school, immersion in literature and music. But Berkeley had another experience in store for her, and her academic life soon took a back seat.

During her first months, she read as intensely as ever, con-

fessing her initial disappointment with Thomas Mann's *Doctor Faustus,* castigating herself for being snobbish about Robert Browning, declaiming passages from Christopher Marlowe, feeling disappointed with Hermann Hesse's "childishness of conception," and making summer plans "to concentrate on Aristotle, Yeats, Hardy, and Henry James."[17] She was also brooding about an unrequited crush on a girl named Irene Lyons, and dabbling in sex with men in order to "prove, at least, that I am bisexual," only to confess that she felt "nothing but humiliation and degradation at the thought of physical relations with a man."[18]

In April, she read Djuna Barnes's *Nightwood.* Published in 1936, this was one of the few contemporary works of literary merit that openly discussed gay lives. (For men, there were the journals of André Gide, which Susan and Merrill read, and *Death in Venice,* which might explain some of her attachment to Thomas Mann.) *Nightwood* came with a preface by T. S. Eliot that praised its "brilliance of wit and characterization, and a quality of horror and doom very nearly related to that of Elizabethan tragedy." For many who read it, the novel was a turn-on, sexual and artistic: "not just a read, an enchantment."[19]

There are fake barons; people with names like Frau Mann, Duchess of Broadback; and sentences of a rococo gayness that has rarely been surpassed: "Like a painting by the *douanier* Rousseau, she seemed to lie like a jungle trapped in a drawing room."[20] As *Partisan Review* introduced her to an intellectual language that Susan longed to master, *Nightwood* brought her a language for her erotic aspirations. Its self-conscious style is often incomprehensible—"Ho, nocturnal hag whimpering on the thorn, rot in the grist, mildew in the corn"[21]—a language that flaunts its impenetrability. The entire book reflects a concept, derived from Wilde, Huysmans, and their nineteenth-century decadents, of homosexuality as aristocracy. Barnes employs the traditional settings of this world (the Left Bank) along with the

sexual frankness ("in the old days I was possibly a girl in Mar-
seilles thumping the dock with a sailor") that express contempt
for bourgeois proprieties. At its core, this is the concept that con-
ventional life is not available to homosexuals—and neither do
homosexuals want it to be. "One's life is peculiarly one's own,"
Barnes wrote in a sentence that must have thrilled Susan, "when
one has invented it."[22]

Yet there is also, in *Nightwood*, a vision of homosexuals as
sick, deranged, maddened by indecent lust: "Look for the girls
[i.e. gay men] also in the toilets at night, and you will find them
kneeling in that great secret confessional crying between tongues,
the terrible excommunication."[23] Lesbian life is no more edifying,
Barnes suggests with a brutal metaphor: "Like the poor beasts
that get their antlers mixed and are found dead that way, their
heads fattened with a knowledge of each other they never wanted,
having had to contemplate, head-on and eye to eye, until death."[24]

———

"Have you read *Nightwood*?" Harriet Sohmers asked a "gor-
geous," "truly beautiful" sixteen-year-old Susan Sontag, who was
browsing in the Berkeley bookstore. It was nearly the end of the
semester, and Harriet, a junior from New York, stood chatting
with another employee, a gay man who saw Harriet checking the
girl out: "the prettiest thing," she remembered, "adorable."

"Go get her," he commanded.[25]

Five years older than Susan, Harriet was a New Yorker al-
ready sophisticated in the ways to which Susan aspired: she had
spent two years at NYU and a summer at the experimental Black
Mountain College in North Carolina, where she met important
avant-garde artists, including John Cage and Merce Cunning-
ham. There, she also met Peggy Tolk-Watkins, later famed as
"queen of the dykes" in San Francisco, where she owned a legend-

ary lesbian bar on the Embarcadero called the Tin Angel. Peggy was Harriet's first gay relationship, and introduced her to the San Francisco underground. To this world Harriet now introduced Susan.

Their affair would last, on and off, for most of a decade. Its first three weeks would be essential to Susan's future life—and she immediately knew it. On May 23, 1949, she wrote that those weeks were, "perhaps, the most important space of time—(important to whatever I will be as a whole person)—I've known." On the cover page of the diary, she wrote: "I AM REBORN IN THE TIME RETOLD IN THIS NOTEBOOK."[26] Reborn in the sense of discovering love and sex with the full force of a passionate adolescent; reborn because, in that discovery, she glimpsed a solution to the division she had already diagnosed as the great challenge of her life: "my greatest unhappiness, the agonized dichotomy between the body and the mind."[27] In Harriet, she saw a way to overcome that dichotomy. Rather than a depressing reality to be avoided by flight into the mind, the body itself could be the source of the self-esteem she hoped to find when she left home.

A sense of fun, of relief and release, permeates her account of the last weeks of the semester. The world she was discovering in the bars of San Francisco thrilled her, and she recorded it carefully in her diaries. "The singer was a very tall and beautiful blonde in a strapless evening gown," she wrote, "and even though I wondered about her remarkably powerful voice, Harriet—smilingly—had to *tell* me she was a man." On another occasion, "C bought a gun and threatened to shoot them both . . . The other two women were a couple named Florence and Roma . . . Harriet had had an affair with Florence . . . At one point C began to laugh and asked us if we realized what a parody of *Nightwood* this all was."

As so often in her life, this fun had to do with the discovery of a new language. Martin Eden kept vocabulary lists, and so,

throughout her life, did Susan. Her notes show how much she had to learn:

> Homosexual = gay
> Heterosexual = jam (West Coast), straight (East)[28]

Her diary carried many other terms, sexual and otherwise, from the subculture of gay San Francisco:

> "86," "he 86'd me," "I was 86'd" (throw out)
> act "swishy," "I'm swish tonight" (effeminate)
> "I'm fruit for—" (I'm crazy about—)
> the "head," the "john" (toilet)
> T.S. (tough shit)
> "he's gay trade," "take it out in trade" (one-night stands)
> "go commercial," "I'm going commercial" (for money)
> "get a (have a) head on" (have an erection)
> "a chippie" (a one-night-stand woman—just for sex—no money)
> "fall off the roof" (menstrual period)[29]

These lists were the beginning of another list, the fifty-eight theses of "Notes on 'Camp,'" that she published nearly fifteen years later. That list described, with a nearly anthropological meticulousness, a mode of homosexual sensibility that Susan started observing at Berkeley and that she, more than any other writer, first brought to the awareness of a heterosexual public. She confessed that it was a sensibility that alternately attracted and repelled her, but at Berkeley she clearly sensed its liberating potential. If longing for a woman nearly ruined her, "congealing the incipient guilt I have always felt about my lesbianism—making me ugly to myself—I know the truth now—I know how good and right it is to love."[30]

It was an erotic revelation in the broadest sense of the term. Just before she met Harriet, she went on a date with a man, during which the topics under examination seemed almost parodically Sontagian—"We discussed everything from Bach cantatas to Mann's *Faustus* to pragmatism to hyperbolic functions to the Cal Labor School to Einstein's theory of curved space"—and during which she realized "I had rejected more than I had ever had: the totality of wandering and laziness and sun and sex and food and sleep and music." Now, an embrace of her sexuality gave her the possibility of integrating that voracious mind with an equally hungry body. "I'll begin right by going out and grabbing at experience, not waiting for it to come to me—I can do that now because the Great Barrier is down—*the feeling of sanctity about my body*—I have always been full of lust."[31] Berkeley meant "accepting my self, aye, rejoicing in my self—The really important thing is not to reject anything—When I think how I wavered about actually coming up to Cal! That I actually considered not accepting this new experience!"[32]

As she wrote this, however, she was getting ready to leave. She had not given up her dream of the University of Chicago, and on May 28 she learned that she had been accepted, with a scholarship of $765.

Her Berkeley idyll was over. She left feeling reborn, but Harriet returned to New York unsure of the totality of Susan's transformation. "Sexually it was a dud," she said. "She was beautiful, but she was not sexual. There's a big difference." Indeed, in a pattern she would often repeat with her lovers, Susan looked up to Harriet as a teacher, learning from her everything she could. "I always thought it was because she was too intellectual," Harriet said of the problems in their relationship. "If we went to a movie, she would wait to hear if I liked it. If I didn't like it, she didn't like it."

Susan was still plagued by the insecurity she had come to

Berkeley to combat. "She was such a weakling," Harriet said of Susan in the first weeks of their relationship. "She was so impressionable and easy to intimidate, and unsure of herself. Everything that came later is sort of a killing of that child that she was, because she was really very unsure of who she was." Nonetheless, Harriet knew Susan was extraordinary. "I remember being with her in the train that went from San Francisco to Sausalito and saying to her: 'You have a great destiny.'"[33]

———

Shortly after the sexual revolution of Berkeley, Susan's mind reasserted itself over her body. She returned to Los Angeles for the summer, where she got a job as a file clerk at Republic Indemnity Company of America, and where she met up with Merrill Rodin. At her urging, he, three years older, had gone to the University of Chicago the year before. "That was the greatest intellectual experience of my life," he said, "and a kind of awakening for me."

Back in California, they took up their old friendship. "Hesitatingly at first," she told him "about these experiences she had at Berkeley that she would never be able to tell her parents," who "would be shocked and horrified if they ever knew."[34] They spent the whole summer "exploring the gay life, the underground, very underground gay life in Los Angeles. And we were fascinated by it." In the world they came from, the only gay people were those displayed as tourist attractions, like circus dwarves. Merrill's mother once told him that she and his father "went to the Flamingo Club and saw the fairies," he said. "And that was the first time I heard of fairies."

That club, on La Brea, was closed to tourists on Sunday afternoons, when real gay people, including Susan and Merrill, turned up. In all of enormous Los Angeles, there were "fewer than five" places where homosexuals gathered: besides the Flamingo Club, Merrill remembered Tropic Village in Ocean Park and a place on

the beach in Santa Monica, "a whole different world—parallel but underneath the real world."

Significantly for Susan's intellectual development, that parallel underworld included avant-garde culture. In the Coronet Theater on La Cienega Boulevard, they saw the films of Maya Deren, who had been making experimental movies in Los Angeles since 1943. At the Coronet, they also saw the homoerotic short *Fireworks* by Kenneth Anger. (It showed a young man dreaming about dreaming, a theme that would recur in Sontag's later work.) Only a few years older than Susan and Merrill, Anger had been greatly influenced by Deren; his film, a mere fourteen minutes long, led to his arrest on obscenity charges. The case was appealed all the way to the Supreme Court of California, which finally ruled that the film could be exhibited; but the scandal indicated the climate in which gay artists had to work, even in great urban centers such as Los Angeles.

Like the characters in *Nightwood*, the inhabitants of this parallel homosexual world formed a cultural elite, as people like Susan were proudly aware. But they were also aware that that world meant constant danger: to young people exposed to "shocked and horrified" families; to artists like Kenneth Anger, the objects of public scandal; to anyone who frequented the places Susan and Merrill frequented. "They were raided all the time," he said. "They were illegal. They were risky."

Even without a mother who encouraged her to think of sex as dangerous and dirty, it would not have been surprising if Susan, after the rush of liberation she felt at Berkeley, had started to feel misgivings. With Harriet gone, she fretted about accepting permanent membership in this society. In Tucson, she had "understood the difference between the outside and the inside"—and gayness was practically the definition of the outside. As she had succeeded in becoming popular at North Hollywood High, she now tried to rejoin the mainstream.

Merrill's best friend, Gene Marum, who would phone Thomas Mann at the end of the year, spent much of the summer with Merrill and Susan. Gene was straight, though he shared their interest in the gay world, stealing André Gide's journals for Susan; but he also offered Susan some practical advice. "If you don't want to be gay," he explained to her, "this is what you have to do. You have to force yourself to go out with men; you have to suck their penises, and it's going to be hard, but it's the only way to overcome being a lesbian."[35]

This advice was perfectly calibrated for an insecure girl whose faith in self-transformation was all that had brought her through an unhappy childhood. It is at this time that Susan, who only a few months earlier had confessed she felt "nothing but humiliation and degradation at the thought of physical relations with a man," began to describe herself, privately, as bisexual, and to apply herself, with the studious dedication that made her so outstanding academically, to taking Gene's advice.

An astonishing document survives from this time. Entitled "The Bi's Progress," it is a single page listing her sexual encounters, from "Xmas Eve 1947 (age 14) to 8/28/50 (age 17)."[36] The list is noteworthy for several reasons. The first is the sheer quantity of people she had managed to sleep with by her second year in college: thirty-six. The second is the number of one-night stands, people with single names, from Yvonne to "Phil" to the alarming "Grandma." But the most remarkable aspect of this list is the pedagogical mind-set its title reveals. "The Bi's Progress" shows that Susan had taken Gene's advice and was trying to train herself into heterosexuality by increasing the proportion of heterosexual encounters. Perhaps she could master heterosexuality as she mastered vocabulary words: by dint of practice.

These efforts were not crowned with success. Susan, Gene,

and Merrill decided to prove that they "were so uninhibited about sex that we could have our own private orgy." They rented a room at the Normandie Village motel on the Sunset Strip, drank a beer, and stripped. They saw each other's naked bodies, then didn't quite know what to do with them. Merrill was circumcised; Gene was not. Susan was intrigued by the difference, which made the proceedings "scientific, and not at all erotic," for Merrill. For Gene, it was simply "disgusting."

But sexiness was not the point. "It was adult and sophisticated, and it was defying conventions," Merrill said. "That's what we were all about, discovering the conventions and discovering the hypocrisy of the adult world, or of the normal, everyday world, and discovering the secret world underneath."

The "orgy" was a far cry from the physical rebirth Susan had experienced at Berkeley, and its quality of a scientific expedition a rebuke of a line from Keats scrawled in her notebook at the beginning of the summer: "O for a life of sensations rather than of thoughts."[37] Now her head was separate from her body once again. She told herself to "force yourself to have sex with men," Merrill said. "And that was one of her main projects when she went to the University of Chicago."

The Benevolent Dictatorship

I n those years, Susan said, the University of Chicago was "a
benevolent dictatorship." Its dictator was Robert Maynard
Hutchins, a messianic figure who seems unimaginable in
higher education today. He was just as remarkable then, both
for his youth—thirty when named president of the University of
Chicago—as for the ideas that attracted many of the leading cul-
tural figures of a generation, both as teachers and students.

Tall and attractive, the son of a Presbyterian clergyman,
Hutchins, like the Puritan founders of Harvard and Yale, saw
rigorous education as a means of transforming the nation. His
school was the opposite of the frivolous America of "the treacly
Hit Parade, the hysterical narratings of baseball games." And
he had a flair for gestures that spread the school's reputation
for seriousness to precisely the kinds of students who, like Susan
and Merrill, felt alienated from that culture. In the capital of the
American Midwest, he even banned the football team—a deci-
sion of which Susan, like so many others attracted to Chicago,

fondly approved. In 1942, beneath the stands of the abandoned football stadium, Enrico Fermi had built the world's first nuclear reactor.

Founded in 1890 by John D. Rockefeller, the university had been devoted to meritocracy from the beginning. If the eastern universities admitted students, explicitly or otherwise, on the basis of race, sex, class, and religion, Chicago admitted them through a uniform test. This excluded the possibility of "legacy" admissions, which perpetuated caste privilege. Chicago was the first major university to admit women on an equal basis with men,[1] and by 1940, it had granted forty-five Ph.D.s to African Americans, more than any other university in the country.[2] In an age where prestigious schools strictly limited Jewish admissions, the school was heavily Jewish, perhaps as much as half.[3]

Hutchins's University of Chicago, western, young, and democratic, was not meant, like those older universities, to serve an elite. It was meant to create one. Once inside, the students found that the curriculum, based on the classics of philosophy and literature, was the same for everyone, and all classes were required, except those from which the student had placed out.

His instrument was a general education, known as the Common Core, based on the great books. There were no grades. Instead, said Robert Silvers, founder of *The New York Review of Books,* who graduated in 1947, "The University of Chicago was a series of readings. It started with Aristotle's *Physics* and everyone in the college had read Aristotle's *Physics* in one or two different courses. You read Aristotle's *On Aesthetics.* You read Plato's *Republic.* You read Augustine"—and so forth, through the whole history of Western philosophy, ending roughly with Marx and Freud. Science was an essential part of this education: "Everyone had to know some physiology. Everyone had to know some physics," said Silvers. "Everyone was supposed to have some idea what the quantum theory was."[4]

THE BENEVOLENT DICTATORSHIP

The Chicago curriculum—essentially for Susan—was a list. "I am absolutely a defender of the mandatory curriculum, shaped by philosophical inquiry," she later said, "and beginning with, yes, Plato and Aristotle and the Greek dramatists and Herodotus and Thucydides." Like the lists of classics at the back of the Modern Library she found in Tucson, Chicago promised its graduates a solid foundation in culture. The difference between Chicago and the older universities, she said, was that Harvard had "a big menu and no 'right way.'"[5]

"The purpose of the university is nothing less than to procure a moral, intellectual, and spiritual revolution throughout the world," Hutchins said.[6] This ambition was the opposite of the narrow academic concerns Susan had recorded with a shiver a few months earlier at Berkeley. There, in the wake of the sensual revelations she was experiencing, she became "frightened to realize how close I came to letting myself slide into the academic life"—a slide that would have culminated, at sixty, when she was "ugly and respected and a full professor."

> I was looking through the English Dept. publications in the library today—long (hundreds of pages) monographs on such subjects as: The Use of "Tu" and "Vous" in Voltaire; The Social Criticism of Fenimore Cooper; A Bibliography of the Writings of Bret Harte in the Magazines + Newspapers of California (1859–1891). Jesus Christ! What did I almost submit to?!?[7]

———

Many classmates never forgot their first glimpse of Susan Sontag. "A Chicago woman wasn't supposed to call attention to her physical attractiveness," a professor said, "but there was nothing Sontag could do not to."[8] A friend remembered the opening reception. "People were standing around and she walked into the

room, all of the men . . . Whoa!"[9] On campus, "scruffy 17-year-old girls in blue jeans were the norm," wrote another, when Susan Sontag turned up in silk stockings, high heels, silky dresses, and a California suntan. "It was assumed she was somehow associated with the term 'Movie Star.'"[10]

The high heels and the silky dresses seem not to have lasted much longer than it took her to hustle Mildred back off to Los Angeles: jeans were her norm, too. But her kind of beauty found fervent admirers at Chicago. She stood out on campus. "It attracted the brightest kids from the littlest ponds," said the painter Martie Edelheit, who attended the camp from which Susan had absconded as a girl. Some graduates from those years—Philip Roth, Philip Glass, Robert Silvers, Carl Sagan, Mike Nichols, Susan Sontag—would be noticed in far bigger ponds. But the pressure was such, Edelheit said, that suicides were frequent:

> You get a thirteen-, fourteen-year-old kid who's been the brightest kid in their town and they're dumped into a setting like the University of Chicago. We had a dorm mother who was a twenty-two-year-old kid, who didn't know her ass from her elbow and didn't have a clue as to what she was supposed to be doing. There was nobody to talk to, and there was no real supervision.[11]

If they were left to their own devices socially and emotionally, the students found that the "benevolent dictatorship" gave them a clear road map. In Hutchins, at Chicago, Susan found relentless standards to match her own. "Hutchins despised holidays, despised breaks," wrote George Steiner, another illustrious alumnus. "He was a workaholic, and no one was ashamed of trying to be one after him. He hated sloppiness, mediocrity, cowardice; he made no secret of his standards."[12] These standards were so Himalayan that no one who adopted them could ever

measure up, one scholar, James Miller, said with reference to Sontag.

> The question of whether she can measure up to the true teacher, and the true teacher is Socrates. . . . [Chicago students] want to measure up to this classic ideal of moral perfection. And they also want to be encyclopedic. They want to master the whole great books. So exemplary is on the one hand knowing a bunch of stuff. And on the other hand it's being a perfect kind of soul. And people who don't share this ambition, because they're crass, money-grubbing schlubs and capitalists, because Hutchins had contempt for such people, are like the vermin of the earth. . . . It is an absolutely rigorously punishing ideal. And if you take it seriously, which I think Susan Sontag did, it means you have no choice but to have contempt for yourself.[13]

Among all these overachievers, Susan Sontag stood out. She looked like a movie star and had a weight of learning behind her that awed even students accustomed to being the smartest kids in every class. Martie Edelheit recalled Susan's dorm room: "I had gone to music and art high school, I had been a music student, I had read a fair amount, I thought," she said, "and then I walked into her room and she had a wall of bookshelves in her room. Here was this sixteen-year-old kid who'd already had a year at Berkeley and who had this wall of books, and I was bowled over."

Like so many others, Joyce Farber never forgot her first glimpse of Susan. "I remember the first time I came down for breakfast," she said, the image still clear almost seventy years later. "There she is sitting at the head of the table. She's almost sixteen and everybody was hanging on every word. They don't know anything about her. I can still see her there."[14]

She awed her professors, too. Robert Boyers, a friend later in

Sontag's life, recalled "two enormously different people" from that time, Philip Rieff, whom Sontag would marry, and David Riesman, author of *The Lonely Crowd*. "And both attest to the fact that she was, at age seventeen, *the most brilliant student they had ever met*. Precociously, obviously, unmistakably brilliant. And she had read more than any other seventeen-year-old they had ever met."[15]

––––––

"Now, what do you see as the central point? What do you think? How would this apply to some problem?" Robert Silvers recalled the questions in a typical Chicago seminar.[16] "We weren't expected to turn in papers," Susan said, "any more than Socrates's students were expected to turn in papers."[17]

Yet some of Sontag's papers from this time survive, including one she wrote for Kenneth Burke. One of the great eminences of Chicago, Burke was hardly well known outside it. When, at the beginning of one class, he wrote his name—"Mr. Burke"—on the blackboard, he had no reason to suspect that any undergraduate would know him. Then, after class, a girl asked his first name. The surprised professor wondered why she wanted to know.

> "Because I wondered if you might be Kenneth Burke."
> He said, "How do you know who I am?"
> And I said, well, I've read *Permanence and Change* and *Philosophy of Literary Form* and *A Grammar of Motives*, and I've read . . .
> He said, "You have?"[18]

Like everyone else at Chicago, Kenneth Burke was a scholar of great reputation. Unlike everyone else at Chicago, he had a direct connection to two legends of the literary bohemia of Greenwich Village. There, he had once shared an apartment with Hart

Crane, the poet who killed himself in despair that he could never "correct" his homosexuality, and Djuna Barnes, author of *Nightwood*. For Susan, Burke was a direct connection to the world to which she aspired. For him, she was "the best student I ever had."[19]

For him, she wrote a paper on *Nightwood*. It shows her boldness in challenging even the most august opinions. If T. S. Eliot discovered in the book a quality "very nearly related to that of Elizabethan tragedy," Sontag writes, correctly, that the fin de siècle decadents are the work's true antecedents: "*Nightwood*'s wit and passion have no affinity to the 'wholesomeness' of an Elizabethan tragic plot," she objects. "It is Pater's style, rather than Marlowe's or Webster's, that Miss Barnes's hyper-conscious refinement of perception resembles." She further relates this refinement to a more literal decadence, referring to Barnes's "apprehension of decay in the form of an initiation into the mysteries of disintegration, grotesquely equivalent to the successive steps in a mystic's development toward absolute communion."

The disintegration that Barnes's characters undergo has a philosophical purpose, too. A mystic must move away from the life of the "world" in order to find some greater truth beyond it: the positive meaning of disintegration. But this disintegration is only "grotesquely" equivalent because the world of *Nightwood* is not a spiritual world. It is more closely linked, at the one extreme, to the Sade of *La philosophie dans le boudoir*, and at the other to the basically Buddhist notions that absorbed so many of Sontag's contemporaries, such as John Cage or Jasper Johns.

Written and published as conspiratorial anti-Semitism was reaching its hysterical climax, Djuna Barnes's book also makes much of Jews as frauds, sexually limp and fundamentally incapable of authenticity. It is a combination that would make the book, written by almost any other author, seem racist. But in Sontag's writing about it, her affinity with this theme reinforces

her—always unspoken—identification with the lesbian themes throughout: "Ultimately, the Jew as persecuted, outcast, reinforces the theme of the 'questionable,' as the sexual abnormalities previously noted represent unsanctioned behavior generally, i.e. the life of the socially estranged."[20] Homosexuality and Judaism are intertwined with theatricality and aristocracy in a dreamworld in which nothing is what it seems, Sontag writes:

> These masquerades are so integral a part of this world that Frau Mann, who calls herself the Duchess of Broadback, is astonished when, in the company of Matthew O'Conner, Felix asks her if Count Altamonte is really a Count. 'Herr Gott!' says the Duchess. 'Am I what I say? Are you? Is the doctor?' The reader wonders if Herr Gott is, either!

———

At Chicago, she was engaged in her own masquerade, widening the gulf between the real Susan and the Susan others saw. In high school she already thought of herself as a liar, and in Chicago she pursued her campaign to reinvent her origins. "She let one know that she came from a glamorous background," said one classmate, "wealth, big convertibles, Hollywood suntan, important people."[21] This background was further embroidered by stories about Mildred—who, she told one friend, was half Irish—and Nat, who was so consumed with jealousy that he tried to kill Susan by running her over with a car.[22]

These fictions reveal deeper truths. There is the wish for a different, happier origin. There is the recurrence of "the master-lie" about her mother. The notion that Mildred was Irish was a rather literal rendering of Susan's desire not to see her as she really was, a desire that appears in their letters from this time. Susan is still the concerned parent—"I hope nothing that I said in our phone conversation disturbed you," she told Mildred in October

1950—keeping up her campaign to educate the by-all-accounts-indifferent Mildred: "I began and finished *Washington Square*," she wrote, "which is really marvelous—you must read it—did you finish the Thackeray?"[23] A mother who read Henry James and Thackeray may have been Susan's ideal parent; but that was not the parent she had. Finally, and most painfully: if Nat was jealous of her to the point of wanting to murder her, that meant that Susan—not he—was the one Mildred really loved. At Berkeley, Harriet saw that Susan "was clearly in love with her mother." At Chicago, a girl said "she never saw anybody who adored anybody as much as Susan adored her mother."[24]

But her taste for invented truths lost her the friendship of Merrill Rodin, who had started at Chicago a year before. After her first semester in Chicago, they returned to Los Angeles, where they visited Thomas Mann. At some point, Merrill told her about a professor named Joseph Schwab. Schwab, who taught nearly every course in the Chicago curriculum, embodied its universalizing ideals; Susan later called him "the most important teacher I ever had."[25] In the coming months, Merrill said, "she kind of took over with him in a way that made me competitive or jealous." The final straw came when Susan, in a display of her own scrupulousness, confessed to Mrs. Schwab, who worked in the bookstore, that she and Merrill had stolen books.

"I got the feeling that she wanted to emerge as repentant and purged," Merrill said—"absolved, but make me incriminated somehow. Making an intellectual issue out of something that was emotional and personal for her, and throwing me under the bus without caring about me or my feelings."

———

The real conundrum, which she skirts even in her paper on *Nightwood*, is sexuality. At Chicago, many of the teachers, like many of the students, were young, and experimentation was in the air:

"We invented all that stuff that later on was called the sexual revolution," said another friend from this time.[26] Indeed, to read about Chicago in these years is to see many ideas taking shape nearly a generation before "The Sixties." Some were not new—the avant-garde of every American generation tried, and failed, to reject consumerism—but some were, particularly the emphasis on sexual liberation that became one of the great movements of the postwar period. At Chicago, full of adolescents in a rush to grow up, sex was as much a part of education as Socrates, and incoming students rushed to shed their unwanted virginity. For the girls, there was even a "professional cherry picker," a good-looking guy named Dick Lynn. (After this promising start, he pursued a career in insurance.)[27]

At Chicago, Susan had several affairs, including with women—and with Dick Lynn. But she was increasingly rejecting the "rebirth" she had experienced in Berkeley. In November 1950, shortly after writing her *Nightwood* paper for Burke, she reread *Martin Eden* and acknowledged the disillusion it brought her: this was when she noted that she had "grown up literally never daring to expect happiness." The happiness she experienced with Harriet had faded and she found herself debating "the dichotomy of sex and affection," feeling "neurotic anxiety about death," and writing that "sex has been a secret, silent, dark admission of affectional need, which must be forgotten when vertical."[28]

And she wrote of a confession that sounds like the kind of confession she made to Mrs. Schwab: "My need to 'confess' to Mother was not commendable at all—it does not show me to be upright and honest but 1) weak, seeking to strength[en] the only affectional relationship I have, + 2) sadistic—since my illicit activities are an expression of rebellion; they are not efficacious unless known!"[29]

In November, at the end of a newsy letter, Susan wrote her mother: "I sound very busy, but don't forget for a minute that I'm

just as miserable as I've always been."[30] Lonely and insecure, Susan would soon rush into one of the most fraught relationships of her life. Merrill urged her to sit in on a sociology lecture taught by a young instructor named Philip Rieff. She had placed out of the class but went anyway—and when, at the end, Rieff asked if anyone wanted to help with some research, Joyce Farber said, "up went her hand, and that's how she met him."

CHAPTER 8

Mr. Casaubon

P hilip Rieff joked grimly that his epitaph ought to read: "Book smart, life stupid."[1] It was an acknowledgment of failure. Unlike the shattered figures in the pages of Dickens and Balzac, Rieff never quite failed; he died, in fact, bedecked with a grand title—Benjamin Franklin Professor of Sociology and University Professor Emeritus at the University of Pennsylvania—in a grand Philadelphia house. That house, where he lived with his second wife, the lawyer Alison Douglas Knox, had an important collection of British art, and Rieff had a devoted coterie of faithful admirers among his former students.[2]

Yet the journey from his origins was so arduous that Rieff was never entirely reconciled to it. Having left the world he came from, he found the world to which he had aspired every bit as unsatisfactory. Susan, "only interested in people engaged in a project of self-transformation," found a paragon of that ideal in Philip Rieff. Philip started life as a boy from the slums. By car or by tram, Rogers Park to Hyde Park—the north side of Chicago

to the south, where the university was located—is a short journey down Lake Shore Drive. In terms of class—the terms that came to matter to Philip—it was as dramatic as the leap Jack Rosenblatt had made, in the same amount of time, from the griminess of the Lower East Side to the leafiness of Great Neck.

In later life, an Ivy League grandee, Philip would become known for a mannered donnishness. His model was the British gentleman in a bespoke suit, with a bowler hat, a gold watch fob, and a walking stick. He spoke in an accent of his own invention that was somewhere to the east of the mid-Atlantic English of American patricians. On a radicalized American campus, the apparel branded him as a reactionary, a label he embraced: he once remarked that walls should be erected around the entire perimeter of the University of Pennsylvania in order to bar entrance to those not, like himself, properly attired.[3] Susan Sontag was accused of being a popularizer, but no such accusation would ever be leveled at Philip Rieff: "He once claimed that only seventeen people in the world could really read him," a reviewer said, "and he wrote at times as if he were trying to whittle that number down."[4]

This reviewer, astonishingly enough, was an admirer. Those who did not admire Rieff found his interest in status, in class—in what he eventually called "order"—as obnoxious as his clothes. But such a rigorous insistence on order, which he later assigned the dignity of a sociological principle, could only have come from one profoundly unsure of his own place. And as it happened, this sense of order was precisely what proved irresistible to the young Susan Sontag.

———

"The accent I grew up with is ugly," his son imagined his father saying, to explain his affected speech. As for the clothes: well, where he grew up, "the clothes people wore were not very nice."[5] On both accounts, he was surely right. Like so many of the Jewish

writers of Sontag's generation, Philip Rieff was the child of *folks-yidn,* "regular Jews" hounded from Europe into the proletarian neighborhoods of American cities. These people stayed connected to each other and to their homelands by their language, Yiddish, and by their associations, from burial societies to synagogues, that even in America were organized according to their origins in the tiny villages of Ukraine and Poland and Romania. In a famous book, Irving Howe called this the "World of Our Fathers." But for Susan, that world was far more remote—the world, at best, of her grandfathers. In terms of assimilation into America, Philip was two generations behind her.

Susan's grandparents immigrated as small children; Philip was nearly not even born in America at all. His parents came from a village in Lithuania and reached America in November 1921. People who left Eastern Europe in the years of catastrophe following the First World War and the Russian Civil War were more refugees than immigrants; Philip was born in Chicago on December 15, 1922, and his brother Martin followed two years later. His mother was named Ida Horwitz; his father was named Gabriel—at least until he arrived at Ellis Island. There, petty officials, "being in a hurry, wrote him down as a Joseph," Rieff said at the end of his life. "So, at an American stroke, he found himself with an American name that meant nothing to him. His own search for meaning in his life in America, his appearance as a man, was harmed by this stroke of American fate."

The new country robbed his father of his identity, literally, and emasculated him in the process. The immigrant, in every country, does become someone else. For some the experience is traumatic; for others liberating. For his father, Rieff said, the change of name rendered him "a profoundly uncomfortable man. I have certainly transferred some of that self-discomfort to myself."[6]

The Rieffs were packed into an apartment so tiny that one person always had to sleep in the bathtub.[7] Gabriel/Joseph was

a butcher, a lowly profession; the family was not much interested in learning. "They were synagogue-attending people," Rieff's son said, "so I suppose they could read something, but they didn't read, there were no books in the house." Philip's ambition was exceptional. His brother Martin, following the family tradition, spent his life working in the meat department at Safeway, a local supermarket. Philip, on the other hand, pursued his academic interests at the University of Chicago.

———

For an uprooted person plagued by "self-discomfort," that university gave him, as it gave Susan, a right way. Susan would later say that she "had the good fortune" to have been elevated by "the most successful authoritarian program of education ever devised in this country."[8] The school, however, only reinforced a streak of authoritarianism already conspicuous in Rieff's personality. But in the first flush of their acquaintance, he appeared to Susan as a guide to an author who had absorbed her at least since high school. The subject was Freud; he was teaching *Moses and Monotheism* and *Civilization and Its Discontents*.

On November 25, 1950, she wrote her fourteen-year-old sister to advise her to watch *All About Eve* ("an excellent movie") and to study classical mythology ("Certainly, this is a subject any educated person must know very well") and then mentioned her new project:

> I'm a research assistant to a professor of economics named Philip Rieff who is writing a book. . . . Naturally this is a great honor for me + it would be an education in itself. Besides the work I will do on this book (research + writing) I will take over most of the book-reviewing that Rieff does for various popular + scholarly journals: I'll read the book + make a précis of it + write the review. Then I'll give him the

précis + the review, which saves him the trouble of reading the book + he corrects what I have written + submits it under his own name. In other words, I'm a ghost writer![9]

Only a few days later, she wrote her mother that

I am seeing a great deal of Philip Rieff, + suddenly I am aware that this is really something—a relationship entirely different from any I've ever known—Don't laugh! he's not handsome—he's tall + thin with a skeletal face + a receding hairline—he's frightfully unbohemian + respectable— BUT he's amazingly brilliant + very kind + a whole lot of things that seem beautiful to me—Can you believe that your icy-hearted offspring is actually feeling these hackneyed emotions??[10]

Later that very day, Philip "proposed to Susan . . . in the name of our children."[11]

She was seventeen. He was twenty-eight. They had known each other slightly more than a week.

———

During the Christmas break, Philip followed her to Los Angeles. On January 3, 1951, they were married by a justice of the peace in Burbank. "Susan and I giggled a little in the middle of it," Judith said. "We were trying to behave as best we could, but we caught each other's eyes and we giggled." Mildred expressed no opinion about the match, and the nuptials were celebrated with a visit to the Big Boy in Glendale, a hamburger joint symbolized by its big-eyed, rosy-cheeked trademark. In her diary, Susan wrote: "I marry Philip with full consciousness + fear of my will toward self-destructiveness."

"That was big gossip on campus," said her friend Minda Rae

Amiran, when word reached Chicago. "Marrying your professor
was kind of a dream for an academically minded young woman."[12]
For a few weeks, they lived a great passion, physical as well as in-
tellectual. In an unpublished memoir written in the third person,
Susan wrote of these early days: "They stayed in bed most of the
first months of their marriage, making love four or five times a
day and in between talking, talking endlessly about art and poli-
tics and religion and morals. She anatomized her family and he
his; he showed her how worthless her friends were, and confessed
that he had none of his own."[13]

But early on, Susan started having doubts. "2 days after
marriage—he makes a mess of opening soft-boiled egg in cup,
shatters (instead of shears) shell—she is repelled."[14] In a diary en-
try a few years later, she remembered him as "a completely inept
unworldly man, whom I had to tutor—to show how to stay in
hotels, to call for Room Service, to have a checking account."[15] If
it is easy to imagine her contempt for someone who did not know
how to perform such basic middle-class operations, it is also easy
to imagine his shame when his slum background was revealed to
his worldly and beautiful young wife.

Philip, however, had his own clear notions of propriety—
and enforced them, already at this young age. His rigor alien-
ated Susan's friends. Joyce Farber testifies that Philip's sartorial
intransigence was already apparent in his twenties. The three were
driving around Chicago, on their way to see *The Red Shoes*. But
Philip refused to go until the ladies changed from blue jeans into
skirts. "It was just crazy," said Joyce. "We never went to see the
movie. It stayed in my mind all these years."

———

Susan's diaries fall uncharacteristically silent during the first years
of her marriage. But its first months were significant. She gradu-
ated from Chicago at the end of the semester, having spent just

two years there. In the summer, she and Philip sailed for Europe. Perhaps already loath to be left alone with him, she invited Joyce along on their honeymoon: Joyce considered going, until her mother put a stop to the plan.

They visited London and Paris. It is unfortunate that almost nothing remains of Susan's first impressions of the city with whose high culture she would come to be identified, the city where she would be buried. She does not mention the trip at all in her short memoir of this time. She spoke her first words of French at the Gare Saint-Lazare—*"La Sorbonne, s'il vous plaît!"* she told a cabdriver—and stayed in the Hôtel des Étrangers in the rue Racine, on the corner of the Boulevard Saint-Michel, in the heart of the student quarter. It was the hotel where Rimbaud and Verlaine first met, and there Philip and Susan spent their "mute summer,"[16] intimidated by the foreign language, inhibited by Philip's fastidiousness. His social awkwardness made it difficult for him to make friends, as Susan frequently noted: she, throughout her life, was always surrounded by people. Paris was the center of the avant-garde and stood for everything progressive and cosmopolitan, the opposite of conventional Middle America or the red scare then sweeping the country. It was where an American who was not understood at home could become a writer. When the *Statendam* arrived back in New York, Philip had Henry Miller's famously scandalous and famously banned *Tropic of Cancer* in his luggage, the words "Not to Be Imported into Great Britain or U.S.A." printed prominently on its cover. Because he was a professor, he was not searched at customs.[17]

"The first of the blows that was to destroy" their marriage came soon after their return. To her horror, Susan realized she was pregnant. "She wept that her life would be over and she must have an abortion," she wrote in her memoir. "After ugly quarrels and tears and humiliating inquiries among rude and unhelpful acquaintances, an address was found on North State St."

Abortion would not be legal throughout the United States until 1973, and women frequently died of botched procedures. "The era was barbaric," Joyce Farber said. Susan told her friend that instead of anesthesia the abortionist "turned up the radio loudly" so the neighbors wouldn't hear her scream.

The volume on the radio was another reminder of Susan's association of sex with pain, of the disease of her mother's that had "permeated" her. The episode reminded Mildred of her own childhood traumas, and she was among the "unhelpful acquaintances." When a panicked Susan called to ask for financial help for the abortion, "my mother went hysterical," said Judith. Instead of offering her daughter aid or comfort, she handed the phone to fifteen-year-old Judith. Then, as so often in her life, the queen of denial stepped out of the room.

"That really changed their relationship forever," said Judith, "that refusal of help."[18] From then on, Susan would occasionally try to reconnect, but the days of helpless attachment were over, and by the end no vestige of affection remained.

Even before her pregnancy, she was already struggling to reestablish the primacy of mind over body, which, at Berkeley, she had begun to equalize: "I reject weak, manipulative, despairing lust. I am not a beast, I will not be a futilitarian."[19] After the abortion, she writes, "they ceased to make love as often, he much more than she haunted by the fear of another pregnancy."[20]

———

Upon their return from Europe, they did not go back to Chicago. Instead, they headed north, to Madison, where Philip was working at the University of Wisconsin with the prominent German sociologist Hans Gerth. Like many of the professors at Chicago, Gerth was a Hitler exile, and his connections to one of the founders of sociology, Max Weber, fascinated Susan and Philip both.

"I don't know what would have become of me if I had not known him," she said, many years later, upon hearing of his death.[21]

He gave her mimeographed translations of Theodor Adorno and Walter Benjamin, a full decade before critical theory made them household names in humanities departments everywhere.[22] Adorno was not old—in his late forties—and though he spent the war in Pacific Palisades, he did not belong to the constellation of Los Angeles exiles—Mann, Stravinsky, Schoenberg—who had great reputations before the war, and whose proximity enthralled the young Susan. The year she went to Wisconsin, he published *Minima Moralia,* which showed the essayistic potential of the aphoristic style that already characterized her notebooks.

Philip and Susan had a tiny apartment in Madison and ate every night in a diner by the railroad, where they could get a steak for less than a dollar.[23] In Madison she had her abortion; in Madison they started working on Freud: first on Philip's dissertation, "Freud's Contribution to Political Philosophy," and then on a book, *Freud: The Mind of the Moralist.* This interlude of reading and working was short, since Susan almost immediately became pregnant again. She wanted to go back to the abortionist, but Philip, afraid the operation would kill her, refused. "Then followed a terrible scene in which she banged her head on the floor and begged [Philip] to get out."[24]

———

They left Madison in June and spent the summer at the senior Rieffs' apartment in Rogers Park. Susan never wrote about this summer, but for Philip it must have been awkward to be thrown back into the gritty milieu of his childhood, particularly in the company of his pregnant wife. One anecdote survives to give a flavor of the surroundings: one day, when Susan came in, everyone was yelling at Philip's mother, who, despite her heart condition,

was tottering on a ladder as she vigorously scrubbed the ceiling. The reason she gave for this burst of activity was that a house cleaner was coming. "I couldn't let her think I had a dirty house," Ida Rieff explained.[25]

In later years, Philip suggested that the standard bourgeois family was what he had in mind when he married Susan. "I was a traditional man," he said. "I thought marriage was for having children, a traditional family. I just couldn't adjust to the kind of family life she wanted. You see, there are families and anti-families. Ours was the latter, I suppose."[26]

For all its poverty and lack of polish, the Rieff household was the kind of traditional family—parents and children under one roof—that Susan had never known. The idea of being trapped in that structure terrified her. Though she rarely published the stories she wrote about her own life, she did write them, often in many versions. And she wrote about her marriage most of all, keenly aware, even then, that this precarious time would determine the shape of her life. Once she was married, her will seemed to waver, and the momentum that sped her through her early life began to sputter and ebb. And the loss of control—the loss of self—she experienced in these years was a conundrum all the more intractable because it was one she herself had sought.

So often, in her early years, she had expressed the desire for precisely the kind of relationship, the submissive wifely role, that she found with Philip. "I seem to enjoy punishing myself," she wrote before leaving home; and, around the same time: "How I long to surrender!" She expressed her feeling toward a high school friend by writing, "My feeling for her is too much of awe, of fear, of being 'not good enough.'"[27] Philip appealed to the side of her that always felt "not good enough."

One benefit of the authoritarian education Hutchins designed, with its "absolutely rigorously punishing ideal," was its promise—to students smart enough, to those willing to put in the

hours—to equip them to contend with the entire range of civilized thought. Leo Strauss, another émigré who deeply impressed Susan and Philip both, was typical of its great teachers, "such a forceful personality," said Susan's friend Stephen Koch, "and so erudite and so polymathically informed that you felt like getting the key to Leo Strauss, you got the key to culture."[28]

This was a model for the intellectual she herself would come to represent. Philip held out the same promise, and that was why he enthralled minds that longed to be led—minds like Susan's. "I could make you somebody," one of his students imagined his saying. "Right now you're dirt, but I can make you into an important human being. So if you are insecure, this very powerful, seemingly totally brilliant mind will lift you out of the gutter."[29] Throughout his life, he maintained this pontifical pose. "I never saw him accept somebody else, in any interaction, as an equal," said a colleague at Penn. "But then I never saw him with, say, Isaiah Berlin."[30]

———

At first, Susan was grateful for this superior influence. For someone who had no father and who "wasn't ever really a child," the temptation was irresistible. "It was as if they had utterly misconceived the nature of marriage—as if they had both understood it as a surrender of self," she wrote in one memoir.[31] The question of how much to surrender plagued her. Part of her wanted to hand over a self that had always been hard to bear; another part wanted to cling to a hard-won identity. In "Decisions," one of the rare documents signed "Susan Rieff," she reproduces a basic debate about the person she was to become.

Philip, in this instance, allows her to decide whether to change her name: "That she should raise this problem, after taking his name in that embarrassing, impersonal filling-out-of-forms a week ago, now that she should want to reclaim her own name,

there was something too distasteful and ambiguous about it," she wrote. But problems loomed wherever she turned. "It occurs to me that if I keep my step-father's name," she tells Philip, "it's only a sign of my subjection to him. That's true for my real father's name, too." At last, she realizes that the decision is hers, that "he could not help her, no more than he could help her not to bear the child that she did not want."[32]

The arrival of that child would institutionalize a series of submissions. First was to the heterosexuality to which she had been such an ambivalent convert. Second was to the academic career she had so recently mocked but which now seemed the only outlet for her intellectual ambitions. "All her energies," she wrote, "concentrated in an attempt to evade the role into which she felt herself to be locked—that of a wife and mother—without ceasing to be that. Only bourgeois solutions seemed possible."[33]

One of these bourgeois solutions was Philip himself. In an anecdote she often repeated, Susan described reading *Middlemarch* and realizing "not only that *I* was Dorothea but that, a few months earlier, I had married Mr. Casaubon."[34] That symbol of finicky pedantry, however, disguises the real attractions Philip held for her. After a childhood starved of attention, of interest, she had found an intellectual partner at last. "We talked for seven years," she wrote. They talked when one of them had to go to the bathroom; they talked all night in the car when, losing track of time, they forgot to go back up to their apartment.[35]

Life with Philip did not mean a surrender of academic ambitions. Indeed, to some degree, he and his modest but respectable income would make them possible. He found a position at Brandeis University in Waltham, Massachusetts. This was an institution founded four years before, in 1948, in part to address anti-Semitism in older universities. Brandeis was one of the flagships of postwar American Judaism, in which commitment to a secular Jewish identity went hand in hand with a commitment to

a patriotic Americanism. It was a bid for integration and accep-
tance that attracted figures no less prominent than Albert Ein-
stein and Eleanor Roosevelt, along with a faculty that was, from
the very beginning, of the first rank: not a dismal prospect for
Susan or Philip. And in and around Boston was a range of intel-
lectual life far more exciting than in Madison or even Chicago.

They moved to Arlington, near Cambridge, in September.
Susan was in her last month of pregnancy, but a woman who later
insisted that patients must demand as much information as pos-
sible from their doctors did not know what she was facing. She
was, her son later wrote, "medically somewhat incurious."[36] This
seems to be an understatement. Bizarrely, she never once con-
sulted a doctor during her pregnancy, nor betrayed the slightest
curiosity about what childbirth entailed.

One night, "she was asleep in bed and woke up and said: Oh,
I wet the bed," she told a friend. "And then stood up out of the
bed and there was this horrible pain. . . . She said, I just thought I
had a stomachache and then I just kept peeing myself." She woke
Philip. When he explained that her water had broken, she had no
idea what the phrase meant. When she reached the hospital and
went into labor, "she couldn't understand why it was so painful
and that they wouldn't help her out."[37]

Without a wealth of other evidence that, in her own words, "I
have always liked to pretend my body isn't there," the notion that
Susan Sontag did not know that childbirth was painful would
seem too outlandish to be true. But the story is hers.

———

David Rosenblatt Rieff was born on September 28, 1952. His first
name honored Michelangelo's sculpture, an homage to beauty
and perfectibility. It was also an imposition, on the infant, of the
exacting standards to which his mother held herself. His middle
name honored Susan's dead father, but—reflecting his mother's

anguished debates about her own identity—he came to be known as David Sontag Rieff.

In their first photographs together, his mother looks utterly dazed, herself a child. She was nineteen and looked younger. For the first year of David's life, Susan stayed home with him and Rosie McNulty, who looked after David as she had looked after Susan and Judith. "That's one of the reasons David and I resemble each other so much," Susan said years later. "We had the same mother."[38]

Eighteen months after his birth, Mildred Sontag finally bestirred herself to meet her grandson. "Oh, he's charming," she said. "And you know I don't like children, Susan."[39]

The Moralist

It is hard to imagine, today, a single figure who could exercise the enduring, magnetic attraction that Sigmund Freud held for at least three generations of intellectuals, artists, and scientists. His terrifying vision, laid out in volume after volume of seductive prose, offered a totalizing theory of personality and history that had not been attempted since Marx and Hegel, one that was embraced and resisted, debated and refined, in a way that made his the mind with which any thinker worthy of the name was forced to contend. He was the writer who, more than any other, reshaped the grammar of the world, rearranging the relation of subject to object.

The subject and the object were the mind and the body. A medical doctor, a product of the positivist science that made so many sensational discoveries in the nineteenth century, Freud spent years seeking material explanations for the apparently inexplicable psychological symptoms with which he—a specialist in nervous disorders—was daily confronted. In his generation, he

wrote in 1925, physicians and scientists were "brought up to re-
spect only anatomical, physical and chemical factors." And early
on, he, too, believed that "the mental is based on the organic"—
that the body was the seat of the mind. Accordingly, the physi-
cian "addressed himself only to the disease"—the physical—"as
an alien which had somehow insinuated itself into the body of the
patient." The patient was a mere vessel, a "feudal lady," "a specta-
tor at the tournament for which he had engaged the physician as
his champion."[1]

The Freudian revolution overturned the physiological ap-
proach to mental illness, eventually extending to most aspects of
sickness—including, in one of Freud's most polemical utterances,
to death itself. "In the Freudian conception," wrote one author,
"as it gradually emerged through these early years of uncertainty,
the body exists as a symptom of mental demands."

———

The identity of that author is one of the enduring mysteries in the
life of Susan Sontag. The book that contains it, *Freud: The Mind
of the Moralist,* was published in 1959 under the name of Philip
Rieff. But ever after, the wife from whom he was by that point
separated would claim to be its real author. The book is so excel-
lent in so many ways, so complete a working-out of the themes
that marked Susan Sontag's life, that it is hard to imagine it could
be the product of a mind that later produced such meager fruits.

In 1966, Rieff published a further book on Freud, *The Tri-
umph of the Therapeutic: Uses of Faith after Freud,* but his later writ-
ings were few. After a short essay called *Fellow Teachers* appeared
in 1973, more than three decades would pass before he wrote an-
other book. His late writings did not enhance his early reputation.
They return, in ponderous prose, to the same gloomy themes of
civilizational *Untergang* that marked his work from the begin-

ning. In his department at Penn, colleagues and students who saw
past the presumptuous veneer that overlay his interactions with
them came away with the impression that there was something
unearned about his eminence. The slum kid who dressed like a
British grandee had something of the scam artist about him. The
"profoundly uncomfortable man" surely knew this himself.

Yet the question about *The Mind of the Moralist* is not whether
Philip Rieff was capable of producing it, or whether he contributed
to it: the book seems to be based, at least to some degree, on his
research and notes. But Susan's very first account of their relation-
ship was the letter to Judith in which she described her excite-
ment at meeting him and the work she was doing ghostwriting
his reviews, saving him "the trouble of reading the book." Perhaps
this procedure seemed normal in 1950; but even viewed in the most
liberal light, it begs the question of why a twenty-seven-year-old
not-yet-professor was hiring an undergraduate to review books he
himself had not read.[2]

There are contemporary witnesses to Susan's authorship of
The Mind of the Moralist. It began as Philip's project. "He had
a gazillion notes," her friend Minda Rae Amiran said, "and he
strove to put it together into a book." Susan tried to help orga-
nize it, but "when it was completed, she saw that it was still a
mess." During their years in Cambridge, Amiran said, "Susan
was spending every afternoon rewriting the whole thing from
scratch."[3] Even more than every afternoon: in 1956, she wrote her
mother that she was "in third gear now on the book—working
about 10 hours a day on it at least."[4] In 1958, when he was trying
to get her a job at *Commentary,* her friend Jacob Taubes warned
her not to relinquish her authorship. "I told [the editor] you are
an excellent ghostwriter. I wish I would not be bound by your
confidence to what degree! Did you, by the way, relinquish all
rights on the Freud? It would be a crime."

("I see you in Cambridge typing on the bed." He adds, with a wink: "What a waste of time and waste of the bed.")[5]

She later said that she worked in the bedroom so that their friends would not see her writing; in any case, she wrote Taubes, she had indeed relinquished her rights.[6] "I am without consolation," he answered. "You cannot give your intellectual contribution to another person. . . . It could be the ruin of Philip if he dared to come out shamelessly without your signature."[7]

Susan always regretted signing it over to him: "It was almost like a blood sacrifice," said Taubes's son Ethan. "That she was willing to give up the book to get rid of him." Four decades later—long after the question ceased to matter to either of their careers—the doorbell rang at Susan's apartment in New York. A package was delivered. She opened it to find a copy of *The Mind of the Moralist*. It was inscribed to "Susan, Love of my life, mother of my son, co-author of this book: forgive me. Please. Philip."[8]

———

When, in 1966, Susan Sontag published the essays collected as *Against Interpretation,* many reviewers expressed amazement that an obscure young person, just thirty-three, had produced a work of such breadth and maturity. The book dazzles with an erudition that was impressive then and is impressive now, and that begs the question of how and where it was acquired.

Their Francophile biases led many to assume that these essays had been produced in a café somewhere on the Left Bank. But the Parisian patina overlaid a far more substantial foundation that was the product of nearly a decade of monastic seclusion. From the time she moved to Wisconsin in 1951, when Joyce Farber saw her working on the book, to the time she reached Paris in 1958, where a friend saw her correcting the proofs,[9] she worked on Freud. For the rest of her life, she would never work as long

or as intensely on any subject. *The Mind of the Moralist* bears the marks of this concentration and this engagement, mapping out the terrain she would later explore in *Against Interpretation* and in her first novel, *The Benefactor.*

Yet her subsequent writings rarely so much as breathe the name of Freud. Throughout her life, she would often write most revealingly about herself when she was writing about others, and the odd direct mentions of what she called "psychology" would usually be dismissive. The very title of *Against Interpretation* might well read *Against Freud,* since it is against his hermeneutic principles that she inveighs. To read *Against Interpretation* in the light of *The Mind of the Moralist* recalls the film she recommended to Judith, *All About Eve,* in which a younger upstart attaches herself to, and then destroys, an older master.

Or, in the Freudian terms of the Oedipus complex: the child, in love with the mother, obsessed with the father, aspires to kill and replace him. For the fatherless Sontag, Freud proved as formidable a model of the father-philosopher as she would encounter in her life.

———

Respect for this great figure blinks from every page of *The Mind of the Moralist.* But as in the college paper in which Sontag challenged T. S. Eliot, respect does not equal unquestioning acceptance. In the areas of disagreement as well as of agreement, we see the young Sontag honing her philosophical skills, probing the work of an illustrious predecessor in order to discover an intellectual path of her own. The book was intended to "show the mind of Freud, not the man or the movement he founded, as it derives lessons on the right conduct of life from the misery of living it."[10] And it resists many of the ideas being derived from Freud in postwar America, including the idea that Freud was a figure of

liberation. The book does acknowledge the liberating potential in his work, but emphasizes that—rather than resisting morality—Freud urged people to submit to it.

Any writer as rich as Freud offers a thousand possible approaches, and the ones Sontag chose (surely, at least initially, in collaboration with Philip) give a foretaste of the questions she would pursue ever after. They emerged from her own difficult life, and at their heart was a pessimistic vision of personality and, by extension, of history: an intimation that illness and pain, psychic and physical, could be comprehended, but never entirely relieved.

The book begins with an examination of the relation of physical to mental sickness. This is the subject with which she would contend far more aggressively in her writings on disease, whose power derives from the dreadful physical and emotional travails, never mentioned, that underlie their author's highly intellectual approach. Many of those writings were a reaction against what she defines here as "Freud's general thesis—sickness conceived of as historical."[11] But when she was young, this notion was especially attractive to someone who had already suffered a great deal of psychic pain.

"*Our hysterical patients suffer from reminiscences*," Freud wrote. The italics are his; they could have been hers.[12] With or without Freud, her first approach to problems had always been through the mind, though Freud's concept of memory extends far beyond the recollection of painful events in the history of the individual. He eventually expanded his view of "reminiscences" to traumas impressed upon mankind's collective unconscious mind as far back as prehistory.

The self is not simply "the body's restive tenant," she writes.

For Freud the mind is not so much that which dwells inside the body, speaking metaphorically, as that which forms a sheath for the body. It is mind—by means of its basic unit,

the "wish"—which first defines the body's needs. The un-conscious, or "primary system," as Freud sometimes calls it, "is unable to do anything but wish."[13]

Freud's reluctantly formed idea that the body is a precipi-tate of the mind led him away from the positivist science of the nineteenth century. This revolutionary notion would not triumph permanently. The pendulum later swung back toward the very an-atomical and chemical factors he had downplayed: today, diseases of the body are most commonly seen as they were in the nine-teenth century, as chemical problems best treated with chemicals. This became Sontag's own public standpoint—though it is a tes-tament to her enduring Freudianism that, when she became sick herself, she would confess that she could never quite believe it.

In Freud's system, body and mind manifest themselves through language. The language of the body is disease; the lan-guage of the mind is language. Since almost all minds are dis-eased, language is symptomatic, too, pathological, betraying origins, history, and intentions through texts that reveal far more than the speaker consciously intends. The task of the psychoana-lyst was to divine truth from "the rubbish-heap . . . of our obser-vations."[14] The rubbish heap was made up of slips of the tongue, jokes, forgettings, and mistakes. But the most important evidence was the dream, which bore messages from the unconscious that were strange, but—Freud discovered—eminently decipherable.

The dream was not only real. As an emissary from the uncon-scious, it was far more real than the visible "reality" of personal-ity. Dreams are not in conflict with reality. They are facts uttered by the unconscious; and the analyst, in order to understand this more profound reality, had to see through the symbols in which that truth was cloaked. Nothing was what it seemed; everything was a symbol of something else; and the interpretation of dreams became the cornerstone of the Freudian method, whose literature

necessarily had a highly metaphorical cast. "The task of the Freud-ian science remains a kind of literary criticism," Sontag wrote.[15]

Like so many readers, she took delight in Freud's case studies. His interpretations are as exciting as those of his contemporary Ar-thur Conan Doyle. Sherlock Holmes scoured the rubbish heap to discover clues that seem, in retrospect, to have been hiding in plain sight; and to read Freud on Michelangelo—"What are the fingers of Moses' right hand doing in the 'mighty beard' with which they are in contact?"[16]—is to await, as in detective stories, a startling denouement. It is also to discover new possibilities for criticism that, Sontag emphasizes, elevate the interpretation to a position superior to the original work. As the meaning of the dream es-capes the dreamer, the meaning of a work of art will as necessarily escape its creator. "In radical opposition to constitutional psychol-ogy, Freud puts language before body," she writes, which method "raises the art of interpretation to the highest relevance."[17]

It is a vision of the critic masked as the artist. And it is all the more meaningful in this highly masked work: Sontag writ-ing under another name; Sontag subsuming personal concerns into a portrait of another intellectual. It is a procedure to which she would often resort. In the 1950s, her personal writings—her diaries—all but disappear. But that does not mean she had stopped writing about herself. In contrast to Montaigne, creator of the autobiographical essay, or to Freud, who unflinchingly in-terpreted his own dreams, Sontag's most personal works are pre-cisely those in which she most determinedly elides the "I." But as the unconscious reveals itself in dreams and in speech, the self unconsciously leaks into her writings.

———

Her criticisms of Freud's method of interpretation developed a polemical force in the next decade that is absent here. She does

aim some aphorisms at him: "All direction is erection," she writes, for example, summarizing his tendency to see sexual imagery in unlikely places.[18] Her most searching criticisms are, in fact, reserved for Freud's writings on sexuality, the heart of the psychoanalytic theory. She dwells on his idea of the erotic as a conflict between the longing for freedom and the repression both individual and society require in order to function. This notion relates to other tensions Freud identified: between reason and spontaneity, following the German Romantics; between the scientific and the artistic imaginations, following Kant. These were questions to which Sontag would return again and again.

Freud believed that these more visible tensions overlay the fundamentally "sexual" tension looming beneath the surface of every life. It was the threat of chaos, the skull grinning in on the banquet, a "humiliation of the highest possessions of civilization,"[19] to which repression, both political and personal, was an appropriate, indeed indispensable, response. But repression also lent sexuality its sadomasochistic character. "Freud traced love back to the parental fact of domination," Sontag wrote. "Power is the father of love, and in love one follows the paternal example of power, in a relation that must include a superior and a subordinate."[20]

Somewhat mystifyingly, given Freud's vision of ideal love as a relation between equals, this vision did not include a vision of women as equals to men. "Freud shows condescension toward his female patients," Sontag notes. She was hardly the first to attack this misogynist bias, but she does so along interesting lines. She mentions such notions as penis envy and the Oedipus complex, inherently problematic from the female perspective, but invests most of her energy in addressing the idea that women, and particularly educated women, are divided between their minds and their bodies. "Freud faced the great problem created by the

emancipation of women," she writes. "'Intellectual training' may cause them 'to depreciate the feminine role for which [they are] intended.'"

The mind is only developed at the expense of the task biology has assigned them:

> In thus charging that [the] sexual and intellectual are incompatible in women, Freud exhibits again his belief that the two qualities are basically opposed. This opposition between sex and intellect remained an unquestioned part of Freud's doctrine of human nature.[21]

This opposition makes women particularly susceptible to sexual frustration, Freud wrote. But he offers little consolation. "He contrasts the job of psychoanalysis with male patients—to *develop* their capacities, sexual and otherwise—with the more limited aim, in the case of women patients, of *resigning* them to their sexuality."[22] This attitude shaped a culture in which sexual and intellectual life were, for women, far more fraught than for men, as Sontag was quick to note: "That the great critical figures in modern philosophy, literature, psychology—Nietzsche, Lawrence, Freud—were misogynists is a fact the significance of which has not yet been properly assessed."[23]

But another side of Freud did offer Sontag consolation, and that was his attitude toward homosexuality. If, viewed today, his writings hardly make him seem progressive, he was, in many ways, by the standards of his day. His arguments offered scientific fortification to early movements for gay rights. "By discovering a universal disposition to bisexuality," Sontag wrote, "Freud assaulted prevailing prejudices by showing 'normality' in its accepted meaning to be another name for the conventional." The implication, she writes, "is greater tolerance for those who aim perversely."[24]

Susan claimed she wrote "every single word" of *The Mind of the Moralist*. Philip belatedly allowed that she was its "co-author."[25] And it is in certain passages, on women and homosexuality, that Susan's voice can be most clearly distinguished. Perhaps their divorce darkened Philip's view of women, particularly of gay women. But even as a young man, as when he forbade Susan and Joyce Farber to go to the movies in jeans, his notions of female propriety had raised eyebrows.

Susan seems to have had less influence over his thesis, "Freud's Contribution to Political Philosophy," accepted at Chicago in 1954. There, the "traditional man" approvingly ascribed to Freud the belief that "there is an inevitable inequality in even the happiest marriages," in which love becomes "a relation of obedience to authority."[26] The interest in domination and authority, certainly present in Freud's thought, is also present in *The Mind of the Moralist*. But there it is subjected to a strong feminist reading absent from Philip's thesis.

In his later career, he was notorious for refusing to direct the dissertations of women students.[27] As for homosexuals—to whom he referred as "homosexualists"[28]—they were "disgusting."[29] Love, for them, was impossible:

> Bisexuality is as powerful a perversion and rebellion against reality and its commanding truths of resistance as is homosexuality. For love in the sexual mode must be across the sexes in order to be true.[30]

Rieff's late works are so eccentric—this one warns that the hip-hop group 2 Live Crew was "a matter of world conquest" and includes condescending remarks about Abraham Lincoln—that it

is hard to take them seriously, no matter how seriously they take themselves. Perhaps it is enough to note the distance between Philip Rieff's opinion on bisexuality and the call for tolerance voiced in *The Mind of the Moralist*.

———

The book from which the above quote was taken, *My Life Among the Deathworks*, was published in 2006, the year Philip Rieff died. It includes an understated, tender dedication: "Susan Sontag in remembrance."

This was a marked change of tone from the acknowledgments included in *The Mind of the Moralist*. When it was published in 1959, he thanked "my wife, Susan Rieff, who devoted herself unstintingly to this book." Even this grudging nod would be removed from subsequent editions, but it raised eyebrows when it appeared. "Boy, he hates her," Joyce Farber thought when she saw the book. "She never in her whole life used that name, ever."[31] It was an attempt to colonize her identity, to shove his wife back into the traditional role: to reassert his authority, to get back on top.

As in her later writings about illness, in which the vigor of Sontag's polemics swept aside the doubts she herself harbored, her assertions of a woman's need for an independent identity masked an equally eager need to submit. Freud, and Philip, were not alone in believing that every relationship "must include a superior and a subordinate." Whether this statement applies to all love relationships is dubious, but it would prove sadly germane to Susan Sontag's. Her inability to abandon what Freud calls "the sadistic conception of coitus" doomed one relationship after another; and his proffered solution, "an ideal love purged of parental influences, an exchange of equals,"[32] proved impossible for her to achieve. Her parental influences—what she called her "profoundest experience"—were of affection given and withdrawn.

The result was "conceiving all relationships as between a master and a slave," she wrote a few years after her marriage ended. "In each case, which was I to be? I found more gratification as a slave; I was more nourished. But—Master or slave, one is equally unfree."[33]

The Harvard Gnostics

Susan seems to have been contemplating escape from thralldom to the traditional family almost from the moment she reached Massachusetts. David was born in September 1952. The following June, they moved from Arlington to 29 Chauncy Street, in Cambridge, only a few blocks from Harvard. At the end of the summer, she began graduate school in English at the University of Connecticut at Storrs.

Unlike the private University of Chicago or the public University of California, the University of Connecticut was a modest institution. It began as the Storrs Agricultural School in 1881 and had only assumed its more imposing current name fourteen years before Susan arrived. Storrs was a town that was "a crossroads . . . in the middle of a cornfield," said a classmate, Hardy Frank. The town lacked so much as a drugstore, and the university lacked much permanent architecture: "Our offices and our classes were in Quonset huts," Frank said.

But the state was investing in building a real university from

a school whose previous ambitions were "just enough to teach the farmhands to read." The recruits "were very bright, interesting men who were making their way up the ladder," Frank said.[1] As part of this effort, the school sought recent graduates to teach freshman composition. That is how Susan Sontag, still only twenty years old, became "the youngest college instructor in the United States."[2]

She rarely mentioned her time in Storrs. She was not keeping a journal, and the only description of her reasons for going there are in a letter to her mother. "Since I knew how competitive a thing it was to get into Harvard-Radcliffe, and since I knew my Chicago degree (not that it isn't the best school, but it isn't a B.A. that takes 4 full years) counted heavily against me in the competition, I felt my only chance was to apply to the English Dept., where I could add as evidence my year of part-time teaching to the abbreviated work I had done as an undergraduate."[3]

David was not yet a year old when Susan started her graduate work at Storrs, and she had arranged to spend Monday through Friday in the women's dormitory. She only returned home on weekends. All her life she had longed for more attention from her part-time mother. "I hardly saw her as a child," Susan said after Mildred's death. "She was always away."[4] But she would often be away for her own child. "Susan was using it as an escape," said Frank. "To get away from getting trapped looking after the baby."

In 1954, she was accepted into the Harvard English Department. This, though English "never seemed to me an entirely legitimate academic study," she wrote Mildred. Instead, it was "a field which attracts a great many unserious students; it is notoriously easy, as compared with math or anthropology or physics or history."[5] She

was, in fact, unhappy in English. "I loathed last year's studies," she told her mother in 1955. "They were shallow, boring, and ridiculously easy." At Harvard, moreover, she faced a hurdle she had not mentioned in her previous universities: a deep-rooted misogyny that made the English Department "extremely unwelcoming to women," said Minda Rae Amiran. "It was hard to meet any other women there. They weren't admitted."[6]

Amiran was one of the rare women who made it past this barrier. She remembered Susan from Chicago and was happy to meet her again at Harvard. They became close, together suffering the indignities meted out to women. The sexism went beyond the presumption that the wives would pass around the canapés at receptions, a task that Professor Rieff's wife, Amiran recalled, dutifully performed. A prominent professor, Harry Levin, told Susan that he did not "believe" in female graduate students, making her decision to leave a field she already held in low regard all that much easier.[7] In 1955, at the beginning of the fall semester, she attended two days of classes in English, was "bored and disgusted," rushed to the Philosophy Department, "practical considerations be damned," and threw herself on the mercy of the far more sympathetic chairman, Morton White, who immediately saw her "great intelligence and a prodigious amount of learning for one her age."[8] The department was far better suited to her.

Once she had made the change, she wrote her mother: "I am completely happy and for the first time find graduate school not a chore."

———

In one of the unpublished memoirs she wrote of these years, she observed that she and Philip "had great difficulty making friends. They tended to criticize them out of acceptability."[9] This was the impression she conveyed to Hardy Frank in Connecticut: "You

had the sense that she was perpetually judging and perpetually judging unfavorably."[10] She was not the only one. Memoirs of her Harvard circle are replete with sexism, snobbery, fraudulence, and one-upmanship. The word that most frequently recurs may be "condescension." The contrast with the Chicago of Hutchins, which many alumni remembered as a great moment in their lives, could not be more striking. Philip and Susan were not the only members of this circle who were as talented as they were insecure. The result of constant competition was an atmosphere redolent of the Versailles of Saint-Simon, a court whose inhabitants were constantly menaced by a crash into *le ridicule*. One, Jacob Taubes, struck his colleagues as too self-important, and so they invented a "medieval scholastic, whose thinking constituted an interesting hybrid of the Thomistic and Scotistic schools."

Taubes took the bait.

After the first exchange of views, during which Taubes had listened without commenting, as if he were thoroughly acquainted with the subject, he spoke brilliantly about Bertram of Hildesheim's psychology and astonished those present with his profound and comprehensive knowledge—until he was informed that no such person existed; he'd been invented for the purposes of this discussion. That put an end to Taubes's hopes of a career at Harvard.[11]

"He was an awful, gnomish little man," said Amiran of the victim. Many were repelled by the squat, chinless Taubes—but not everyone. Some of the most interesting women of the day succumbed. His admirers, besides Susan Sontag, included the Austrian poet Ingeborg Bachmann; the scholar Margherita von Brentano, scion of an illustrious German family; and his first wife, Susan Taubes. She and her husband formed a couple of the first importance in Sontag's life.

Born in Vienna in 1923, Jacob Taubes survived the Nazis thanks to his father's providential appointment, when Jacob was thirteen, as Grand Rabbi of Zürich. He was himself ordained as a rabbi and published *Abendländische Eschatologie (Western Eschatology)*, his dissertation and only published book, in 1947. In that year, for any European Jew, an interest in the end of the world was natural. Natural, too, was an awareness, for anyone who straddled the worlds of secular and religious learning, that the old observant Judaism had been rendered absurd by the Holocaust. The philosophically minded had to discover a new way to live.

Soon after, he left Switzerland for New York, where he taught at the Jewish Theological Seminary and, in 1949, married the twenty-one-year-old Susan Feldmann. Her given name, Judit Zsuzsánna, combined Susan and Judith Sontag's names. "Susan: same name as me, *ma sosie* [my double], also unassimilable,"[12] she wrote many years later. "Unassimilable" was the word she reserved for people, including her father and Antonin Artaud, who were impossible to know or understand.

Like her husband, Susan Taubes was of distinguished Jewish lineage. Her grandfather was the Grand Rabbi of Budapest; her father, Sándor Feldmann, swapped Judaism for Freudianism and became one of the leading Hungarian disseminators of psychoanalysis, close to Sándor Ferenczi and the fabled circle around Freud. For Sontag, such proximity to the fountainhead was glamorous in the extreme. For Susan Taubes, raised according to psychoanalytical principles, it was something less. In her autobiographical novel, the father "explained to her the Electra complex: she was really in love with him and wanted to marry him and there was no point in denying it; that was part of her Electra complex to deny it."[13]

She and her father fled ahead of the Nazis and reached the
United States in 1939, when she was eleven; her mother joined
them later. They lived in the Pittsburgh slums for three years,
while her father, whose foreign degree was invalid in the United
States, studied to pass the American medical boards. She fin-
ished high school in Rochester, New York. In her yearbook, the
answer to "What People Usually Say to Her" was "Smile, Susan,
SMILE!"[14] It was a sharp contrast to Sontag's worry that she
came across as too perky and Californian. Unlike Sontag, she
would never have to exhort herself "to smile less, talk less."[15]

Torn from Europe but estranged from America, alienated
from the Judaism of her grandparents but unconvinced by the
Freudianism of her father, she found a similarly uprooted figure
in Jacob Taubes, who called her Susan Anima, Susan Soul. Their
distaste for convention was not, as for someone from middle-class
America like Susan Sontag, an aesthetic choice. It was an ines-
capable destiny imposed by history. They entered marriage on un-
conventional terms, in which sexuality would be unrestricted:

> If Ezra's [i.e., Jacob's] practices did not appeal to her that was
> a matter of personal taste; to judge him by society's rules,
> as a principle she refused. She hadn't asked for a bourgeois
> marriage; and if ever the depressing thought took hold of
> her that she was trapped in a bourgeois marriage, [Jacob's]
> behavior assured her that she was not.[16]

Their unorthodox sexual arrangements proved disastrous for
all involved. But the very unconventionality of the marriage gave
Susan Taubes an anchor, an identity, a relationship whose nature
expressed the radical thought to which she was necessarily at-
tracted. She had "a special interest in the topic of estrangement,"
said Christina Pareigis, a scholar of her life, "feeling estranged
from any kind of belonging. Belonging to a nation, belonging

even to a language. Belonging to other people, to a group, to a religion."[17]

———

Years later, Susan Sontag remembered their first meeting: "You're still the twenty-three-year-old who started an absurdly pedantic conversation with me on the steps of Widener Library."[18] Unlike the pedantry that suffused many conversations at Harvard, Susan Taubes's conversation was fertile. Many topics that appear in Sontag's later work originated in conversations with the Taubeses.

Susan Taubes's dissertation, "The Absent God: On the Religious Use of Tyranny," was a study of Simone Weil, who offered another answer to the demonic twentieth century. By rejecting Judaism in favor of mystical Christianity; by starving herself to death, aged thirty-four, as an act of compassion, Weil was a Romantic heroine who offered both Susans an exemplar of female courage, a woman who had given her suffering a meaning that transcended the merely personal.

Susan Taubes's dissertation on Weil was advised by Paul Tillich, the German exile theologian whose studies of Christian symbolism sought to discover a role for religious thought in the wake of catastrophe. Tillich approached the question from the Protestant perspective, but his questions were not substantially different from those that Jewish thinkers posed in a world in ruins. Indeed, the notion of philosophy among the ruins (of a culture, of a life) would become central to Sontag's writing. Illustrated by Walter Benjamin, Elias Canetti, E. M. Cioran, and others, "the sense of standing in the ruins of thought and on the verge of the ruins of history and man himself" was, Susan wrote in her later essay on Cioran, the theme par excellence of the twentieth century.[19]

In this shattered world, there was new interest in heterodoxies. In Susan's circle of exiles, the ancient heresy of gnosticism

offered a compelling alternative. A few months after the end of the Second World War, near the town of Nag Hammadi in Upper Egypt, a farmer happened upon a series of papyrus manuscripts. Wary of jinns, his mother burned a few. But when Coptologists examined them, this fourth-century library came to rank with the Dead Sea Scrolls—discovered in Palestine the next year—as among the most valuable archaeological finds in history. Texts whose outlines were known only through the negative arguments of Christian polemicists revealed astounding evidence of the gnostic heresies.

The timing was providential. The gnostics were the product of a time analogous to the postwar period. The Hellenistic world became the first cosmopolitan society known to history. Peoples mixed freely—and so, at least around the edges of society, did their gods. Gnosticism compounded "oriental mythologies, astrological doctrines, Iranian theology, elements of Jewish tradition, whether Biblical, rabbinical, or occult, Christian salvation-eschatology, Platonic terms and concepts."[20] This shaded into an antinomianism, disdain for all convention, including sexual: a theoretical source of the libertinism the Taubeses practiced.

———

"The Creator of the World is evil and the World is bad," one ancient polemic put it.[21] Gnosticism, a religion that lost, was also a religion of losers, of exiles who transfigured suffering into faith. The modern gnostics were exiles, too, and their experience explained a dualism opposing "God and the world, spirit and matter, soul and body, light and darkness, good and evil, life and death—and consequently an extreme polarization of existence affecting not only man but reality as a whole."[22]

The world was divided; so was the mind. The greatest modern exponent of gnosticism, Antonin Artaud, proposed "a theater

that Savonarola or Cromwell might well have approved of," an impossible idea of the theater that was more ambitious even than Wagner's. Sontag was fascinated enough by Artaud to spend eight years collecting his work in an almost seven-hundred-page anthology. He posited "an exact and delicate concordance between the mind's 'animal' impulses and the highest operation of the intellect," Sontag wrote, "a swift, wholly unified consciousness."[23] This was the concordance that Freud had despaired of bringing about, especially for educated women; but Artaud's theater would do nothing less than "to heal the split between language and flesh."[24]

Artaud thought "about the unthinkable—about how body is mind and how mind is also a body."[25] This thinking came

> from metaphysical anxiety and acute psychological distress—the sense of being abandoned, of being an alien, of being possessed by demonic powers which prey on the human spirit in a cosmos vacated by the divine. The cosmos itself is a battlefield, and each human life exhibits the conflict between the repressive, persecuting forces from without and the feverish afflicted individual spirit seeking redemption. . . . Founded on an exacerbation of dualisms (body-mind, matter-spirit, evil-good, dark-light), Gnosticism promises the abolition of all dualisms.[26]

In the sixties, a syncretism arose as radical as the one gnosticism created. Freudianism and Marxism and Christianity and Buddhism and existentialism were thrown together, often by Jewish writers. It was sometimes hard to distinguish between syncretism and pastiche, sometimes easy to ridicule that intermixture's more demotic manifestations. But there was more than faddishness in the attempt to braid such diverse strands together. Modern art

did not create "the shock of the new." It tried, imperfectly, to reflect it.

One such attempt happened in Philip and Susan's own house, where one of the most renowned of the Hitler exiles, Herbert Marcuse, took refuge after his first wife died. Marcuse was teaching at Harvard and working on books that, like those of Adorno and Benjamin, would become central to the critical debates of the sixties. Marcuse stayed for a year in a household where intellectual debate mixed with the life of a young family. "I guess David heard us talking about Hegel," Susan remembered, "because when he came down for breakfast he just sort of marched around the table saying, 'Hegel, bagel. Hegel, bagel.'" He was three.[27]

The book Marcuse was finishing, *Eros and Civilization*, published in 1955, was a typically syncretistic product of the age. It combined Freud and Marx with a brand of optimism suited to postwar America. In a dehumanizing and repressive industrial civilization, Marcuse wrote, Eros was a potentially liberating force that opened "the possibility of an erotic civilization—that is, one which does not live on the repression of the sexual in the Eros." The phrase is Jacob Taubes's, who had derived a similar possibility from the gnostics. The context was a class at Columbia University, six years after the publication of Marcuse's book, that Sontag and Taubes taught together.

"Freud never conceived of the possibility of an unrepressed society," she said, according to a record of the class.

> Miss Sontag then pointed out that there is no hope seen for real happiness or contentment in Freud's doctrine (except in work and science). Rather, Freud seems to be trying to help us minimize the agony of life. Happiness is possible in intellectual endeavors, but it could be argued that this too is merely sublimated happiness. There is no real sexual

happiness, because the motivation of our sexual life is in-
cestuous. Thus, sex is never contented, being never directly
gratified.[28]

Sontag gets Freud wrong in a way so revealing that it might
be called a Freudian slip. As she surely knew—it is a famous pre-
cept of Freud's—he had not said "work and science" but "work"
and "*love*," in that order. Why would she forget love—or locate it
within sex, and then doom it to incestuous discontent?

The notion that happiness is possible in intellectual but not
sexual endeavors reveals Sontag's experience as surely as hopes for
an antirepressive society mirror Taubes's and Marcuse's. Popular-
ized, their ideas, more than hers, would shape the sexual revolu-
tions known as "the sixties."

Marcuse's thought, as well as Sontag's, would evolve in differ-
ent, radical directions, and nowhere more than in views of sex and
revolution. In the fifties, when many "sixties" ideas were still the
embryonic property of elite intellectual circles, Marcuse himself
was already taking a skeptical view of Susan's preference for the
abstract over the concrete. "She can make a theory out of a potato
peel," he later told a friend.[29]

———

In so many ways, Susan's decision to flee her marriage seems a
foregone conclusion. Her writings on marriage are notably bleak.
The thing itself was bad, she wrote in 1956,

> an institution *committed* to the dulling of the feelings. The
> whole point of marriage is repetition. The best it aims for is
> the creation of strong, mutual dependencies. Quarrels even-
> tually become pointless, unless one is always prepared to act
> on them—that is, to end the marriage. So, after the first
> year, one stops "making up" after quarrels—one just relapses

into angry silence, which passes into ordinary silence, and then one resumes again.[30]

Marriage to Philip—"an emotional totalitarian"[31]—was destroying and suffocating her:

> The sense of not being free has never left me these six years. The dream of a few weeks ago: a horse came up behind me as I was going down a short flight of stairs—into a swimming pool, it seemed—and placed its two front legs on me, one over each shoulder. I screamed and tried to free myself from the weight, then awoke. An objective correlative for my darker moods.[32]

But the marriage's doom is inevitable only in retrospect. Plenty of people stay in unsatisfying marriages, particularly when children, money, and careers are involved. Susan would display a talent, in later years, for sticking it out in relationships long after anyone watching from the outside would have fled. She was unhappy, but the contemptuous tone she adopted toward Philip only appeared after he subjected her to public humiliation. It is revealing that when the break came, it was not on her initiative but on his. He did not realize the consequences of his decision until long after taking it.

"He doesn't know," a friend said at the time, "he's cutting his own throat."[33]

———

She would write about this decision over and over in her memoirs. Friends recalled that for the rest of her life it was a favorite topic of conversation. The pretext was academic. With Paul Tillich's support, she applied to the American Association of University

Women to study "the metaphysical presuppositions of ethics" at St. Anne's, one of the women's colleges at Oxford.[34] It was a logical next step in her education—logical, too, in ways of which she was not quite aware.

In one version of her unpublished memoirs, she wrote: "The plan was, as usual, joint. [Philip] was to come, too, but at the last moment he had a better offer for the year"—from Stanford. In another version, the idea was hers. She wanted to "travel—really travel—in Europe."

> "But sweetheart, we've talked about this before. Next year, when the book is finished, we'll both apply for teaching positions abroad. It's all settled."
>
> "But I can't wait!" she cried. "It's always next year, and next year, and nothing ever happens. And we sit in this rat hole on our asses growing eminent and middle-aged and paunchy—"
>
> She stopped, aware that it was no "we" she meant, and that this attack was entirely unprovoked.
>
> She had been a feverish and gentle and weepy girl when she married Martin; now she was a shrewish, weak, tearless woman, full of premature bitterness. . . .[35]

The decision to leave America was not a decision to leave Philip, at least not immediately. In June 1958, after she had been in Europe for a year, she wrote Morton White at Harvard to discuss her thesis; in July, she proposed to the American Association of University Women that she "continue working on the manuscript during the summer, and to return to the Harvard Dept. of Philosophy this coming year."[36] Part of her still wanted to come back to her husband, or thought she ought to: she had a five-year-old child, after all. And even if the original idea had not been

Philip's, she could not have gone away for a year without his tacit encouragement.

In one of her unsparing memoirs of this time, she noted her "fastidiousness in personal relationships that was not always clear of cowardice" and constant movement "from entanglement to escape and back to involvement again." She described "a bearable life" as "a balancing act—in which one didn't lose the benefits of being entangled or get lost in the loneliness of escape."[37]

She surely did not intend to reproduce her mother's pattern. (Few people ever do.) And she did not do so out of a lack of love: David was the most important and enduring relationship of her life. "She always adored David," said Minda Rae Amiran. "She was constantly rushing home to see him. He was in no way a neglected child, even though she was spending every afternoon reworking this manuscript, and doing her own schoolwork and so forth. He continued to be the center of her life."[38]

She tried to give him the childhood she wished she had had, and when he was a toddler she was already leading him through a University of Chicago–like great-books curriculum. One of his first books was *Candide,* and she read *Gulliver's Travels* with him, "but nothing specifically engineered for children," a friend said. "She had no tolerance for it."[39] In early 1957, her diaries record the following scenes:

> Yesterday David announced, as he was being prepared for bed, "You know what I see when I shut my eyes? Whenever I shut my eyes I see Jesus on the cross." It's time for Homer, I think. The best way to divert these morbid individualized religious fancies is to overwhelm them by the impersonal Homeric bloodbath. Paganize his tender spirit. . . .
>
> Today, David is Ajax the Lesser + I am Ajax the Greater. Together we're "invincible," a new word he's learned. His last words as I kissed him goodnight + left the room tonight:

"See you later, Ajax the Greater." Then, peals of laughter. . . .

"My son, aged four, on first reading Homer."[40]

———

When Susan departed, David, along with Rosie and Philip, left for Berkeley. She recorded her last day in Cambridge, September 3, 1957, with nearly minute-by-minute detail, unique in her journals. This care suggests that she knew how weighty the moment was:

It was now 1:00. I shut the padlock on the kitchen closet, shut my suitcases, used the toilet, then called a Harvard cab which came in three minutes with a pleasant old man driving it. It was now 1:15. I directed him down Mass. Ave. (1) to stop in front of the Widener entrance so I could return a book ([John] Gay's *Plays*—Abbey edition, with the music); then (2) to the post office, where I mailed the rest of the packages, including one of old clothes to Chicago; then (3) to the Bradley offices on Brattle St., where I left a copy of the lease + the keys to the house with perspiring, disorganized Mr. Elliot; then (4) to Back Bay Station. It was just 2:00 when the cab got there, + the train was due in 5 minutes, + there were no porters anywhere in sight. The driver offered to carry my bags (this is against the rules) when I became slightly frantic—carried them into the station, where there were still no porters, + then down the stairs to the train which was just pulling in. For all this and the cab fare ($2.15) I gave him $4.00—he tipped his hat + wished me a good trip, the conductor put the bags aboard the train, + I was off.

Often, in her life, motivations that seemed obvious to others remained veiled to her; and she seems not to have admitted, even

to herself, that she was leaving her marriage. "You don't have to be Sigmund Freud," David said, "to say if you leave that kind of marriage and a very young kid it's because somewhere you want to escape. But I would bet dollars against dimes she didn't know she was doing that consciously at the time."[41]

She sailed from New York on September 5. Jacob Taubes had been waiting for her at the boat for an hour. "I was really touched," she wrote, "for who can afford *not* to be moved by the *gestures* of affection. I kissed him + boarded—he continued to wave until the boat was out of sight."[42]

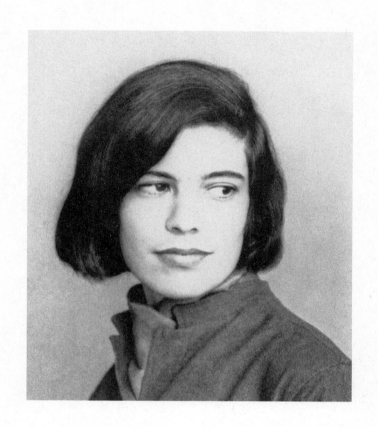

PART II

What Do You Mean by Mean?

S he felt a savage desire to come to Europe," Susan wrote in one of her unpublished autobiographical stories, "and all the myths of Europe echoed in her mind. Corrupt Europe, tired Europe, amoral Europe."[1] This was the Europe that had beguiled her when she first read Thomas Mann; the counterpart, intellectual and amorous, to her monastic life with Philip.

"Romantic by temperament," she had dreamed of "vagabond-age in Europe and love-affairs and fame." Marriage forced her to lower her sights, to be practical, and to compromise by choosing "a career of her own but which was in the same world" as Philip's.[2] This was not simply a safe choice: in the 1950s, an academic woman was still a pioneer. Still, it seemed that the university, at least intellectually, was as congenial a milieu as someone of her interests was likely to find. But her romantic temperament resisted. Lacking alternatives, she hesitated to leave the only society she had known since she went to Berkeley at fifteen. She would remain inside it even when she went abroad.

Everything about Oxford—its medieval architecture, its venerable name, its intellectual romance—spoke to Susan's aspirations. But Oxford was chilly and dank.[3] Ancient Britain, which Americans had always seen as superior, was threadbare, still recovering from the war; and Susan was disappointed. "It's hard to explain in retrospect," said an acquaintance, Judith Spink, "how Americans came from a wealthier, happier, luckier world." She had "wanted to get away from America," said a friend from that time, Bernard Donoughue, but now she "was really rather hankering for California." Most of the conversation was about "how cold she was and why didn't the English central heating systems work."[4] Spink said she complained about the cold a lot: "I remember that because she wore pajamas under her clothes."

Her disappointment was as palpable as her superiority. "Her presence among those of us who met her at Oxford was unmistakably one of contained force," said Spink. "Partly this had to do with her physical image: the dark prince. And *prince* because of the dominance." Years later, once Susan's diaries were published, Spink was astonished at the self-doubt they revealed. "We didn't see the weaknesses," she said. "In every way she held the advantage. We guessed that she knew much more than she cared to say." The dark prince dressed entirely in black, and the first time Spink saw her stride across the ancient quadrangles in cowboy boots, she wondered where she could possibly be from: "South America? The Hindu Kush?"[5]

The look was not entirely artless. "I never mentioned the cowboy boots," said Bernard Donoughue, "and after a while she drew my attention to them. She got a bit impatient that I was not impressed."

———

In painting as in architecture, in literature as in theology, twentieth-century artists and thinkers attempted to discover some

core of ultimate meaning, if such a core existed: to find the most basic forms with which to rebuild a ruined world. But if Sontag was attracted to these ideas in other realms, including dance and painting, she was not excited by a philosophy that sought to discover formulas in language along the mathematical model.

"I can remember asking my philosophy teacher what something meant," Donoughue said, "and he said, 'What do you mean by mean?'" Jonathan Miller, the actor and director who would become a friend of Susan's, satirized this thinking in a sketch, "Oxbridge Philosophy," with John Cleese:

> CLEESE: Yes, yes.
> MILLER: Tell me—are you using yes, here, in the affirmative sense?
> CLEESE: *(carefully, after a thoughtful pause)* Nooooo.[6]

"Her interest in philosophy was bigger than that," Donoughue said. She had written an important book on Freud; she had known ambitious thinkers, from Strauss to Gerth to Taubes to Marcuse. "Analytical philosophy was too cramped and academic a mode for her," Spink said. At a time when she was trying to regain the vigor that propelled her this far, this reeked of Mr. Casaubon and of the men she found wimpy and sexless. "There is a type—the male virgin—lots of them in England," she wrote in her diary.[7] Sexism was pervasive but not palpable—"Nothing was palpable at Oxford," said Donoughue—and the men, she found, managed to be "both anti-woman and not real men."

This explained her attraction to Donoughue. Though later created Baron Donoughue of Ashton for his service to three Labour prime ministers, he was that rare Oxford student from a working-class family. ("I was told there were four," he said, carefully pointing out that the number was not an exaggeration.) At a lunch party, he spotted another talented outsider. "I was aware

that she looked disengaged. We vaguely sort of came together and chatted. She was obviously a bit bored," he said.

> I was immediately attracted to her. She was in some ways stunning looking. Wonderful structure in the face, lovely dark eyes, lovely hair. She was a bit tall and gangly, a bit elbow-y and so forth. Not the kind of lady I normally like. I like slim, small, cuddly ladies, and she wasn't that.

At Susan's initiative, they began a relationship, which, if occasionally sexual, was primarily philosophical. They both considered themselves radicals, but the differences in their leftist views were instructive. Donoughue's were those of the practical politician in the real world: "I was interested in boring things like getting homes for people, pensions for people, these kind of tedious things."

He had visited America:

> I went down to Kentucky to get involved in a coal strike where people got shot and I investigated the trial lawyer, who I found was a totally corrupt person. She wasn't interested in any of that. She had these great left-wing intellectual ideas. It meant exploring your sexuality and your whole life and questioning all establishments and disliking all regimes and so forth.

For Susan, radicalism meant possibilities for personal freedom and self-creation. But when she hinted at her attraction to women, she only did so obliquely. "She would talk about how you've got to grow out of this society where it assumes you're all one thing," he said. "Where it assumes a woman has to marry a man, has to be stuck in a marriage with a man. She wanted to explore other things. She was telling me what she wanted to do."[8]

———

At first, she wrote Philip aerograms every evening. "During the day I'd be composing my letter to him in my head," she wrote. "I was always talking to him in my head. I was, you see, so *used* to him. I felt safe. I didn't feel like a separate person."[9] But she spoke dismissively of him to Bernard, whose masculinity contrasted dramatically with Philip's. A notorious hypochondriac[10] ("neurasthenic"[11] was Susan's word), Philip had promised to come to Oxford, but changed his mind because the journey made him nervous. This looked pathetic to someone engaged in a brave self-creation.

But—as with her politics—positive self-creation could sometimes shade into solipsism. She had left her son behind, and "talked as if she missed him," Bernard said. "She clearly felt she was paying the price. I felt she wasn't adequately aware of any price the son might perhaps be paying." To Judy Spink, her involvement with her son also seemed odd, particularly when Susan made a pass at her: "She showed me this photograph of David Rieff as a little tiny boy and I could not square that with her making sexual advances to a woman. The moment I saw that photograph, it was: No! You don't do that."

Perhaps, absent such intense focus on the self, she could not have made the heavy decisions that faced her. Donoughue noted she was humorless and excessively earnest. But she was being forced, as she had not been since the painful decision to go to Berkeley, to decide what she was going to do with her life. Chicago gave her a "right way." So did marriage, graduate school, and motherhood. Now she was being granted her freedom—at the price of all the obscurity and uncertainty of an independent life.

She would later call the 1950s a lost decade. But the strength her Oxford friends found so overwhelming was the product of a decade's evolution, from the "weakling" at Berkeley to the dark

prince her fellow students met at Oxford. Her apprenticeship
was over, and she was ready to be an adult. The legal philosopher
H. L. A. Hart described her interactions with another Oxford
eminence, Sir Isaiah Berlin:

> Among his most formidable critics is Miss Susan Sontag.
> She is right in thinking that he is a bit careless of the detail,
> but she is wrong if she thinks there were not shafts of great
> insight and illumination. She has, I think, enjoyed her term
> here though she professes to think very little of everybody
> except [the philosopher J. L.] Austin, whose sense data lec-
> tures have sent her into raptures.[12]

To Bernard, she talked about "boring Oxford, the failings
of intellectuals. I felt, from my dealings with some of them, she
wasn't wrong." Still, like Hart, he thought that was only part of
the story. "I loved Oxford. Though she was right, in every way,
about its failings, she didn't see its good side." At another, earlier
point, she would have. But it was not the right place for her now.
She needed something radical. She needed something warm. In
December, at the end of Michaelmas term, she left for France,
and did not return.

———

In 1957—with New York still shaking off the vestiges of pro-
vincialism and London the bedraggled capital of a disintegrating
empire—Paris reigned as the most sophisticated city in the world.
The prestige of its language was then equal, probably indeed supe-
rior, to that of English; and for ambitious people from the tens of
thousands of Tucsons scattered across the globe, its name meant
art and architecture, science and philosophy, fashion and fame,
sex and perfume, in a way no modern city has rivaled. Susan went
to Paris to find those things, but especially to find a previous ver-

sion of herself, the potentially happy woman reborn in Berkeley and then quickly shoehorned into an impossible marriage.

Susan went specifically to find Harriet Sohmers, the personification of that early liberation. She had not seen her in almost a decade; Harriet had been living in Paris since early 1950. They had kept up sporadically, and even when writing to tell Harriet of her marriage, she said that she loved her ("It is a transcendent fact").[13] In July 1951, during her first trip to Europe, she wrote: "I am in Paris. Meet me at Notre Dame." She added, detective-novel style: "I cannot see you with my husband's knowledge," which led Harriet to suppose that Philip knew about their past relationship.[14] In 1954, Harriet returned to New York, where her mother had been stricken by cancer. Just before her mother died, in December,

> she opened her tormented eyes to me, and, wanting to comfort her, I said, "Mom, you know the Israeli guy I told you about? I might marry him." "No, you won't," she whispered. "Why not, Mom?" I asked, surprised. "Because, because," she struggled to bring it out, "because you like women better," and her eyes closed on a deep, strangled sigh.[15]

This dramatic deathbed utterance turned out to be untrue: Harriet was predominantly heterosexual. But a year before her mother died, she had met a Cuban American named María Irene Fornés, one of the most consequential figures in her life, and—soon enough—in Susan's. Their stormy liaison ("I love you, Irene. How well you fill my need for pain!"[16]) lurched and sputtered, on and off, for years, as Harriet simultaneously juggled a relationship, also tempestuous, also on-and-off, with a Swedish painter named Sven Blomberg.

Just when Harriet had broken up with both Irene and Sven, Susan, looking for a new life, stepped into the combustible mix.

She was desperate for love: desperate for a woman's love. In January, when a "dumpy, over-dressed blonde" hit on her, she was thrilled, she confessed: "I wasn't attracted to her, but it was so good to be home, as it were—to have women, instead of men, interested in me."[17] Harriet had been her first great love, and it was to Harriet she looked for help in making a new life.

But the love was not reciprocal. "I'm not sure that I want to see her," Harriet confessed in her journal even before Susan arrived. And once she got there, Harriet wrote: "What a beauty she is! But I dislike so much about her . . . the way she sings, girlish and off key, the way she dances, rhythmless and fake sexy . . . Poor kid! I don't really think I'm attracted to her at all, but then, she says she loves me, and I need to hear that right now!"[18]

Disappointed by others, each sought something their new lover could not offer. Susan wanted the passion of a decade earlier; Harriet wanted Irene. "Susan's vulnerability and insecurity displease me," Harriet wrote. "She seems so naïve. Is she honest? I can't really believe she means what she says." As if to prove she was not, in fact, honest, Susan read Harriet's journals, "that curt, unfair, uncharitable assessment of me which concludes by her saying that she really doesn't like me but my passion for her is acceptable and opportune. God knows it hurts, and I feel indignant and humiliated."[19]

Susan wondered whether she was supposed to be peeping at Harriet's diary. "Do I feel guilty about reading what was not intended for my eyes?" Her firm answer: "No. One of the main (social) functions of a journal or diary is precisely to be read furtively by other people."

This reasoning was typical of Susan's resort to intellectual excuses to justify the emotional reactions of which she was ashamed. But if she sinned against Harriet, Harriet sinned against her, too, finding her own excuses for allowing the affair to sputter on long after she ought to have broken it off. The relation-

ship, she knew long before Susan realized it, was doomed; and the main feeling that results from reading both Harriet's and Susan's journals from this time is dread.

———

Susan's personal turmoil was so intense that she wrote very little about France. She hardly spoke French; she had left Philip and David; she had left Harvard and Oxford. It was clear within days that Harriet was no replacement for Philip, and that she was leaving the career into which she had invested nearly a decade without any viable alternative. Letting go of marriage and career might offer a quick liberation, but it could also mean poverty and failure. Only days after arriving, she mentioned

> the ratés, the failed intellectuals (writers, artists, would-be Ph.D.'s). People like Sam Wolfenstein, with his limp, his briefcase, his empty days, his addiction to the films, his penny-pinching and scavengering, his arid family nest from which he flees—terrify me.[20]

The city was filled with such *ratés*. They clustered on the Left Bank, between the Sorbonne and the cafés of Saint-Germain-des-Prés. Many of the people Susan met during her few months there would become profoundly important in her life; others would turn into precisely the kind of failures she most feared becoming.

Among these new friends was Annette Michelson, a decade older than Susan. In 1958, Michelson had been living in Paris for several years and working as the art critic of the *International Herald Tribune*. She frequented the most advanced artistic circles in France. Her partner, Bernard Frechtman, was the American translator of Jean Genet, and Michelson knew Jean-Paul Sartre and Simone de Beauvoir, whose *Must We Burn de Sade?* she had

translated in 1953. This crowd gathered at the Café de Flore and offered a combination of worldly glamour and intellectual rigor that stood in sharp contrast with the musty chilliness of Oxford. It, and they, would serve Susan as a template for her own life: "I realize," she wrote a few years later, "how important Sartre has been to me. He is the model—that abundance, that lucidity, that knowingness. And the bad taste."[21]

In February, through Annette, she met Sartre at the home of the philosopher Jean Wahl in the rue Le Peletier. She described every detail of the apartment—the North African furniture, his ten-thousand-book library, and Wahl's beautiful Tunisian wife, thirty years younger than he.[22] This world was so far removed from anything either Susan or Annette had grown up with that to be accepted within it demanded certain adaptations—though Annette, most agreed, went too far. (In the mouth of a Jewish girl from Brooklyn, a flawless British accent seemed a bit much.) But those who knew her in Paris agreed that she was unquestionably brilliant, and Susan found her fascinating. "Susan was, at first, very much the enthusiastic admirer," said Stephen Koch, who later became close to both. "Susan was as impressed with Annette as Annette was with her."[23]

Annette's interests came as a revelation to Susan, with her highly traditional education, part of which, in America, meant a decided national prejudice. If Germany had collapsed, the prestige of Germanic culture had not. Places like the University of Chicago and Harvard were still in the thrall of the lineage running from Freud and Marx through to contemporary thinkers including Mann and Adorno and Marcuse and Strauss. They were "wholly uninterested in postwar continental culture," Koch said, which basically meant the culture of France.

But the culture of France was not so easily dismissed. Economically, France was far less ruined than Britain. Its writers were far less interested in Casaubon hairsplitting than in the

urgent human questions derived from the Nazi occupation and from France's own Enlightenment heritage. France was where many of the greatest modernist books—by Henry Miller, James Joyce, Samuel Beckett, Vladimir Nabokov—were published—in English—when banned in the English-speaking countries. French philosophers and writers, including Genet, Beauvoir, Sartre, and Camus, were among the most influential in the world, and Susan would write about them all; French filmmakers, including Godard, Resnais, and Bresson, furnished another rich subject. None were taken fully seriously in Anglo-American academe.

Annette Michelson took them seriously. "Annette had a great deal of admiration for Susan," said the filmmaker Noël Burch, who was carrying on a clandestine affair with Michelson even as she was officially connected to Frechtman. "Susan had even more admiration for Annette."[24] Annette also had something Susan lacked, and knew she lacked. Annette had an eye. "She was much more sensitive to art in general than Susan," said Stephen Koch. "She had a genuine critical eye. I was very impressed, as I never was impressed with Susan, by her sensitivity to the arts, which was really remarkable. I began to see what it means to take a hypersensitivity to art and turn it into language."

The suggestion that Susan was insensitive to art, surprising as it may seem, was widely echoed.[25] In Los Angeles, Merrill Rodin had noted her great capacity to be moved by music. But—perhaps as a result of her equally great insecurity—she had developed a tendency to bury emotional reactions under a blizzard of pedantry. "Susan drives me mad," Harriet wrote in April 1958, "with her long scholarly explanations of things one only needs the eyes and ears of someone like Irene [Fornés] to see. At the Prado, she discoursed at length on Bosch and just now, explained that women are the backbone of the Church. I find these textbook dissertations of hers unbearable!"[26]

Susan had grown up "trying both to see and not to see," and seeing, for her, would always be an effort. Something in her even seemed to resist looking at all. "She would forbid David to look out of the window from buses or trains when they were traveling," said one of David's later girlfriends, Joanna Robertson. "She used to say that he needed to hear all about a place in terms of facts and history in order to understand it, but that looking out of the window would tell him nothing. She never looked out of the window on journeys like that—I remember her, always talking about the places we were in or were headed towards, but never curious to simply look out to see them." David told Joanna about an early visit to London, when he was a boy. He was staring out the window, trying to take in this completely new country; Susan ordered him not to look. Toward the end of Susan's life, when the three were in a train together, they saw her staring resolutely ahead. "I remember David and I winking at each other—an inside joke about her utter refusal to just look out there and take in what she saw. The world as is, in the raw, happening now. No connection."[27] But precisely because seeing did not come naturally, she was forced to reflect on it as someone to whom it came without effort did not. The effort is palpable in her often-belabored early prose, which took those reactions and tried to put them into words. And Sontag, not Michelson, became the great critic of her generation. "Name a book that Annette Michelson has written," Stephen Koch said. "There are none."

———

"Annette is a scary person," said Noël Burch. "All her life she's frightened people away." One of these, eventually, was Susan, and her intelligence became destructive. As for her failure to live up to her early promise: "It was sadomasochism that did it," said Stephen Koch. Burch himself was a confessed "viragophile," interested in women who practiced martial arts: "What he wants is

girls in black leather to come out and rip his velvet suit off him and kick him in the balls."[28]

The interest in sadomasochism was widespread in Susan's new circle. She was not the only one who thought of love as between a master and a slave. Another new friend, Elliott Stein, was a gay sadomasochist, "famous for his whip collection."[29] Harriet Sohmers had translated the Marquis de Sade's *Misfortunes of Virtue* in 1953 for the avant-garde publisher and occasional pornographer Maurice Girodias. He also published many of Sade's descendants in twentieth-century French literature, including writers like Georges Bataille and Anne Desclos, who, as "Pauline Réage," wrote *The Story of O.* Sontag would examine their work at length in "The Pornographic Imagination."

The connection between sex and pain was so natural for her—"All relationships are essentially masochistic," she told Burch[30]—that she could never imagine the loving partnership of equals that Freud had posited. Her "profoundest experience," of her mother's giving and then withdrawing her love, was perpetually renewed. Harriet dribbled out her affection by the scant thimbleful, which Susan gratefully slurped down: "I suppose, with my sore heart + unused body, it doesn't take much to make me happy."[31] A couple of weeks later, she described the "total collapse" of their relationship and "blindly walking through a forest of pain."[32] But like "the poor beasts that get their antlers mixed" in *Nightwood,* the relationship dragged on. In April, they spent two weeks in Spain and Morocco. In June, Susan noted that "living with Harriet means to live through an all-out assault on my personality—my sensibility, my intelligence, everything but my looks which instead of being criticized are resented."[33]

Harriet hardly disagreed. "My jealousy reflex is being activated big time," she wrote in January, "with everyone wanting her, men and women. Although I don't really care for her, I envy her success."[34] Her jealousy even led to violence, when she punched

Susan in the face at a party. Allen Ginsberg—whose *Howl,* one
of the monuments of the Beat Generation, had been published in
1956—asked Harriet why she treated Susan so badly, since Susan,
after all, was younger and better looking. Harriet answered that
that was exactly the reason.[35]

Harriet also admitted that she was relying on Susan finan-
cially. Susan was hardly rich, but she had her scholarship, and
an unwitting Philip was sending money, too. In addition to their
trip to Spain and Morocco, they also traveled to Greece and Ger-
many. Susan's shyness and insecurity, her willingness to be the
submissive partner, are obvious in her diaries: "It's true—what
Harriet charges—I'm not very sharp about other people, about
what they are thinking and feeling, though I'm sure I have it in
me to be empathetic and intuitive," she wrote in June.

Like an "eye," empathy and intuition are hard to learn, as she
would show when the tables were turned. Susan could be cruel.
She wrote Bernard Donoughue that spring that she was in Paris,
and when he was next over, he looked her up. "We chatted a bit,"
he remembered. "I think she gave me some coffee or some-
thing. And then I realized there was somebody in the bed, a very
attractive, live young lady. I felt she was probably hoping to shock
me a bit."

It was not her interest in women, which he already suspected,
that shocked him. It was the brutality with which he was dis-
patched. He found it "an unnecessarily aggressive statement that
she was rejecting me"—and never saw or heard from her again.

The contrast would recur between her imperious treatment
of men—who loved or admired her, but in whom she was never
especially interested sexually—and her groveling treatment of
women. "She could have done it more graciously and subtly,"
Lord Donoughue said. "A French lady would have."[36]

———

In Germany, she and Harriet hitched a ride to Dachau. "What feelings I had seeing 'Dachau, 7 km' as we sped along the Autobahn toward Munich in the Dutch anti-Semite's car!" she wrote.[37] This was her first physical encounter with the Nazi camps whose existence she had discovered as a girl in Santa Monica, the shock that led to her reflections in *On Photography*. She alludes to the feelings, but never wrote about the visit.

Her time in Paris coincided with one of the turning points of French history: in May, as a result of the ongoing disaster in Algeria, civil war loomed. The American embassy considered evacuating its citizens as France fell under martial law: Corsica was conquered by dissident elements from the French Algerian army, and only an emergency government under General de Gaulle prevented a coup d'état.[38] Yet there is not a word about this in Susan's journals. "I came to Paris in 1957 and I saw nothing," she said ten years later. "I stayed closed off in a milieu that was in itself a milieu of foreigners. But I felt the city."[39]

She was so weighed down by heavy choices that she could spare little attention for even the most dramatic events; later, when she became a public figure called upon to pronounce on world affairs, her difficulty in seeing political matters became clear. Now, she was trying to determine the shape of her life. She had already rejected many possibilities, even if she still clung to them, as to her marriage or her academic career. Surrounded by brilliant *ratés,* she saw that becoming a writer—a real writer, a successful writer, no longer a promising young person but one with the stamina and focus to create an enduring career—was a matter of urgency. "Why is writing important?" she asked a few weeks after she arrived.

> Mainly, out of egotism, I suppose. Because I want to be that persona, a writer, and not because there is something I must say. Yet why not that too? With a little ego-building—

such as the fait accompli this journal provides—I shall win through to the confidence that I (I) have something to say, that should be said.

My "I" is puny, cautious, too sane. Good writers are roaring egotists, even to the point of fatuity.[40]

In later life, Sontag exuded such bulletproof certainty that few sensed the weakness behind the pose. Read with that invulnerable image in mind, the above passage lends itself to misunderstandings: her beauty, and her sex, encouraged the idea that her reputation was a triumph of image-making over substance. But Harriet called her a "weakling," and she called herself "puny." Unprotected by family, money, or profession, subject to abuse from those she tried to love, she took shelter behind an alternative self. Through writing, she said, "I create myself."[41] And it was to this other self that she appealed now: "Give me strength, tall lonely walker of my journals!"[42]

"To have two selves is the definition of a pathetic fate," she later wrote.[43] But the success of the performance would be such that, when extracts from those journals were published, even longtime friends were shocked by the lacerating insecurities they exposed. In an amphitheater in the southern Peloponnesus, with Harriet, she saw a performance of *Medea* that stayed with her ever after, her son wrote.

The experience moved her profoundly because as Medea is about to kill her children, a number of people in the audience started yelling, "No, don't do it, Medea!" "These people had no sense of seeing a work of art," she told me many times. "It was all real."[44]

The Price of Salt

In 1986, Susan published a story called "The Letter Scene."
Among other such scenes described in the story—Tatyana
writing Eugene Onegin; a Japanese man writing his wife
from a doomed airplane—she included one of her own: her ar-
rival at San Francisco airport, where she handed a letter to Philip.

She seems to have stayed in Europe through the summer
of 1958 precisely to avoid this confrontation. From Athens, she
mysteriously told her mother that there was a "personal reason
for extending my stay—that it's not just the desire to see another
beautiful country." Perhaps she was, yet again, trying to patch
things up with Harriet, since she had already told Mildred what
she intended to do. "When I arrive in California—around Sept.
1st, I assume still!—I want to talk to Philip immediately. By im-
mediately I mean that—the day I see him. But then what? It
seems absurd, exposing David and myself to too much rage and
hysteria, for me to live in the same house with him while I try to
divorce him."[1]

Though he later claimed to have been utterly unprepared for the letter scene, Philip suspected that something was going on. By July, when he was already living in California—he had taken an assistant professorship at Berkeley—he was writing "letters filled with hate and despair and self-righteousness. He speaks of my crime, my folly, my stupidity, my self-indulgence."[2] David said: "If he—and I do not know whether he did or he didn't—imagined that when she came back to California, that it would all be okay, he was indulging himself in very wishful thinking."[3] Yet that was the story Philip put out in a letter to Susan's Chicago friend Joyce Farber: "What a tough, ruthless character Susan turned out to be, harboring her little secret for half a year in Europe, then springing it on the happy, wonderful day of her return to adoring husband and son."[4]

The letter she gave him on that day is, however, exceptionally kind. She describes the dissatisfactions of marriage in general terms that assign no blame to him. She describes, instead, "germinating under the old dead tissue," a "new self—creative and alive—but that self needs a new life to be born."

> I don't want to be married, at least not on the terms I (and you) have understood marriage. I hate the exclusiveness, the possessiveness of marriage—each couple stewing in its own privacy, guarding its interests against the world . . . Perhaps if I (I mean, we) had understood marriage differently from the start . . . Perhaps if I (we) weren't so romantic, so in love with the idea of love. Adultery, civilized arrangements, marriages of convenience or of comradeship—these happen, and work, all the time. But they're not for you and me, are they? Timid, easily bruised, sentimental as we are . . .

She returns again and again to the idea of a self struggling to be born. "I feel a vocation flowering within me," she writes;

"I want to be free. I'm prepared to pay the price—in terms of my own unhappiness—for being free. Alas, I must make you suffer, too."[5]

———

It was the sort of letter that invited a civilized arrangement. Susan noted "the beauty and temptation of the house in Berkeley" where Philip was living with David and Rosie. She was still attached to the warmth of California. Her family, for better and worse, was nearby. There was David to consider. In a wildly optimistic miscalculation, and in spite of what she had written to her mother, she had decided to stay with Philip in Berkeley while the separation was being worked out. But relations soon devolved into Woody Allen–like scenes of feuding Jewish intellectuals: at one point, fisticuffs ensued over who would keep the back issues of Partisan Review.[6]

The last straw came one evening when Rosie prepared her "signature" dish, fried chicken. Philip accused Rosie of trying to poison him, becoming "absolutely hysterical" and "making wild threats," David remembered. Susan called the cops, who escorted her, Rosie, and David across the bay to San Mateo, where Nat and Mildred were now living. In later years, when Susan told the story, she would always note that she remembered to take the poisoned chicken at the last minute. They ate it in the back of the police car: "I mean, we hadn't had a chance to eat," Susan would say when people laughed, "and David was hungry. So of course I thought to bring it."[7]

By his own later admission, Philip was out of his mind. "He had a really, really rough time," David said. "He was, as they would say in the nineteenth century, maddened by it." Looking back at his father's life, David said that, despite Philip's long subsequent marriage, "he was a wolf, a mate-for-life kind of person. I think he truly loved her."[8] For Susan, it was a return to the

family she had left a decade before. She took a little apartment near San Mateo and spent time with relatives she had not seen for almost a decade. She got reacquainted with Judith, who had recently graduated from Berkeley and was now working in the Bay Area. "She was so miserable, and I wanted to relax her," Judith said. "I taught her how to smoke. That's the worst thing I ever did."[9]

Unaware of Susan's interest in women, Judith loaned her a famous lesbian novel, Patricia Highsmith's *The Price of Salt*. In 1958, this was one of the rare works of gay fiction that did not demand some dreadful catastrophe as the price for homosexuality. For many lesbians, the novel's sympathetic portrayal was a welcome revelation. But it also portrayed an aspect of their lives that caused Susan to note that she had read it "at very much the wrong, vulnerable, moment."[10] One of the women, Carol, is involved in a custody dispute with her husband, who hires a private investigator to discover evidence of her homosexuality. In an age when such evidence was often used in court to take gay people's children away, this was scary, and *The Price of Salt* can only be considered to have a "happy ending" in comparison to other contemporary writings about homosexuals.

Though Carol and her girlfriend stay together, she loses the custody battle; Susan could not have read without a shiver how her daughter is taken from her.[11] Her relationship to David, who was only six, was already frayed by her long absence. He had to adjust to his mother; she had to be a mother to a child she had not seen in a year.

In Paris, she had written that

I hardly ever dream of David, and don't think of him much. He has made few inroads on my fantasy life. When I am with him, I adore him completely and without ambivalence. When I go away, as long as I know he's well taken-care-of,

he dwindles very quickly. Of all the people I have loved, he's least of all a mental object of love, most intensely real.[12]

This statement has often been translated into an expression of maternal indifference. (As one friend put it, "When Susan was there, she was there.")[13] But for a person who tended to love images—"mental objects"—rather than "intensely real" things, to speak of David's physical reality was an overwhelming statement of his importance to her.

But Philip was not about to let him go. "You know that Philip will not settle in peace," Jacob Taubes wrote in November, as he was urging her not to abandon all rights to *Freud: The Mind of the Moralist,* which was about to be published. "Calvin must see those who oppose him as enemies of the light and truth."

Beware! Even in Rieff vs. Rieff there are degrees of perse-cution. And you must be ready for the worst. Do you have good i.e. ruthless legal advice? And you, do not play "gentle" in a life and death struggle. It is meaningful to be gentle and forbearing when the other lives in the same universe of experience.

You did not ask for this way. It is humiliating and degrad-ing, but Philip is at your neck. I am bound by confidence, but you must be on guard. Every generous gesture will be twisted around.[14]

In just such a "gentle and forbearing" way, Susan did not fight him over the book, which she regretted ever after; and though she accepted child support she proudly refused alimony. Mean-while, Philip terrorized Susan—though David emphasized that "he SAID violent things and made violent threats but DID noth-ing violent"[15]—to the point that Nat, who had grown fiercely pro-tective of Susan, poured sugar into Philip's gas tank. The tactic,

straight out of a detective novel, was intended to disable his engine and prevent him from harassing Susan and David.[16] The bickering would drag on for years. But Susan was safe for now. "Yeah, your husband's crazy," the family court judge said. "You get the kid."[17]

———

On the day Fidel Castro arrived in Havana, January 1, 1959, Susan arrived in New York. She moved to 350 West End Avenue, between Seventy-Sixth and Seventy-Seventh Streets, less than ten blocks from the building on Eighty-Sixth Street where she spent her first months of life. It was a floor-through, fifth-floor walk-up; David got the only real bedroom, overlooking the avenue, and the living room doubled as Susan's bedroom.

By the time she reached New York, her origins in the city were a vague memory. She had lived in seven other states, besides her stints in England and France: "I'm not even a New Yorker," she later said, emphasizing her connection to the American provinces that people were often astounded to discover had produced her.[18] In one sense she was right; in another, of course, her desire to escape her origins and remake herself was the most New York thing about her. It was a city of refugees, and this "great athlete of ambition" found herself in a place where she had plenty of company.[19]

When Sontag arrived, the city was struggling against decline. In 1950, the city's population began to decrease as many headed for the greener, and whiter, acres of suburbia. Through the musical *West Side Story,* which premiered in 1957, the Upper West Side became known for its ethnic tensions and its slums—though West End Avenue was always populated by professionals: psychoanalysts, for example, and professors at Columbia.

Thanks to Jacob Taubes, she found a job at *Commentary* magazine. "That you are a woman is a difficulty but not an insurmountable difficulty," he had told her in October.[20] Elliot Co-

hen, the editor of *Commentary* who would die only a few months later, said that "the difference between us and *Partisan Review* is that we admit we're Jewish."[21] It was published by the American Jewish Committee, and according to Cohen's successor, Norman Podhoretz, it was "one of the two magazines that you"—young people who aspired to join the intelligentsia—"wanted to write for, the other one being *Partisan Review*."[22] Like Podhoretz and Sontag themselves, both magazines would soon find themselves at the center of the cultural and political battles of the sixties.

————

Susan's introduction to publishing and journalism was important, but another introduction marked her first months in the city. As Harriet had jealously foretold in Paris, Susan began an affair with Irene Fornés, Harriet's ex. Irene was fast becoming a legend of Greenwich Village bohemia, "the queen of downtown," and though she never became widely known outside theatrical circles, a whole generation of New York artists recalled her artistic brilliance, her ardent temper, and her sheer irrepressible sexiness.[23] "A Latin firecracker," said Robert Silvers, who would soon begin *The New York Review of Books*.[24] Harriet spelled it out with characteristic explicitness: "Irene could make a *rock* come."[25]

Born in Cuba in 1930, she lived there until her father died. Then, because her mother, like Mildred, was obsessed with Hollywood—and obsessed, too, with the vision of America she saw in the movies—she, her sister, and her mother moved north in 1945. They first went to New Orleans, where they had relatives, and then headed to New York.

Naturally I found life as a young girl in New York was much more exciting than it was in Cuba because in Cuba girls are not supposed to do this and they're not supposed to do that and they were constantly being watched. And in the

United States there was so much more freedom for young
people. And I loved working. My first job was in a factory
and I loved it! I just loved being a worker and I loved getting
my salary at the end of the week. It was like magic when I
cashed that check. When I went to the bank and I would
cash that check into dollars I would hold it in my pocket
and almost caress it! So from then on I think I immediately
became an American.[26]

New York was a new city for Susan. But the staff of *Commen-
tary* was no different, in terms of interests or background, from
the people she had known at Berkeley, Chicago, Cambridge, Ox-
ford, or Paris. Irene, in contrast, was "absolutely uneducated,"
said Stephen Koch. "But, in Susan's opinion, a genius. She'd never
had this experience before, of people whose intelligence was tre-
mendously powerful, without education. Susan was overwhelmed
by her intelligence."[27]

Irene was dyslexic and had a sixth-grade education. She
started working in a textile factory and then began designing tex-
tiles herself, which led her to painting. After she met Harriet, at
the end of 1953, she followed her back to Paris. There, she began
to paint, and back in New York became involved in a ménage
à trois with Norman Mailer and Adele Morales, the second of
Mailer's six wives. Adele was renowned for ordering her linge-
rie from Frederick's of Hollywood and for being stabbed by her
husband—and almost killed—in a brawl.[28]

Bob Silvers remembered Irene as "a woman of almost electric
intensity. You couldn't visualize any calm thing with her." She
would say: "You know, Susan, sometimes the only way to deal
with someone is a good beating." This was her "advice, Latino
advice,"[29] and it did not remain in the realm of advice. She was
"very vivacious and pretty in a zaftig, cuddly kind of way," an ac-

quaintance said of her. But that cuddliness was deceiving. "Some guy made a pass at her or something," the man said, and the next thing he knew, the guy was "screaming and holding up a bloody hand tattooed with teethmarks"—Irene's.

She had never read anything—except the newspaper, *Little Women,* and *Hedda Gabler.*[30] Susan, constantly "trying a little too hard," was enthralled by Irene's natural, unforced, effortless genius. "Irene was the real thing," Koch said. "She was a real artist. Not a pretend one, and not a critic, and not a discussant, and not a graduate student making notes."

Susan was given to hectoring discourses, "long scholarly explanations of things one only needs the eyes and ears of someone like Irene to see." But one thing that Susan could always see was talent, and she saw Irene's. That talent had still not found its form, and not until she met Susan would she discover it. In turn, Irene's eyes and ears would help Susan discover her own.

Susan's first couple of months in New York were gloomy. She was not much interested in her job—

> Having a daily job, going to the office—to permit one to feel at ease, at home, in the world. For most people, to be (to exist) is to be somewhere. The job gives them permission to exist, it gives them a private life (by forcing them to give over most days to the public one). Only by fracturing their lives, by amputating most of their time, can they have a life at all.
>
> The job, like marriage, a crude solution which works. Most people would be lost without it. But there are people on a certain level of sensibility for whom Job, like Marriage, can't work at all—people who wither when their lives are fractured, put in splints.[31]

—and she was still mourning the almost-end of her relationship
with Harriet, which, as so often over the previous year, had not
yet quite ended. When Harriet returned to the United States af-
ter almost a decade abroad, she moved in with Susan on West
End Avenue.

"How I looked toward her coming to New York, just to seeing
her, to seeing her smile, to going to bed with her once and waking
beside her," Susan wrote with a lovingness that would not be recip-
rocated.[32] She threw a welcome-home party, at which Harriet got
"insanely drunk," slipped while dancing, fell on her face, broke her
nose, and ended the evening in the emergency room at St. Luke's.[33]

It was an inauspicious beginning, and at that party Susan met
Irene. It is hard not to see this as karmic comeuppance for Har-
riet's treatment.

> Her vision of me makes me despise myself. And I'm terrified
> that it is partly because she finds me uninteresting, depress-
> ing, naive, sexually dull that I continue to be in love with
> her. No one has ever regarded me in this way, no one whom
> I've liked and responded to—but I love her + somehow lov-
> ing her, respecting her has dragged out of me a numb assent
> to her opinion of me.[34]

Harriet headed to Miami at the end of February, and Susan
began seeing Irene—at first, it seems, to talk over their common
ex. "Astonishing that my account of H. + me should make her
say, I could be saying that. She loved H., + H. killed it by need-
ing to be jealous, to be in doubt as to Irene's love; and loved her
most when Irene stopped loving her."

Also astonishing: "Irene not fictional."[35]

The next week, Susan went to bed with Jacob Taubes ("un-
expectedly good + sensitive sexually"), feeling no apparent guilt

about sleeping with her best friend's husband but sounding almost relieved that the experience gave her the "feeling of being totally queer."[36]

And then her friendship with Irene became something else. If Harriet made her feel her "sexual dullness," Irene introduced her to the orgasm, a revolution in her life that opened the possibility for the new, better self she hoped to discover when she resolved to get a divorce:

> It is two months now since that September night, when I was preparing the Euthyphro for Friday's nine o'clock class. The repercussions, the shock waves are only now beginning to fan out, to radiate through my whole character and conception of myself.
>
> I feel for the first time the living possibility of being a writer. The coming of the orgasm is not the salvation but, more, the birth of my ego. For me to write I must find my ego. The only kind of writer I could be is one who exposes himself. (That is why the Freud book doesn't count.) To write is to spend oneself, to gamble oneself. But up to now I have not even liked the sound of my own name. To write, I must love the sound of my own name. The writer is in love with himself, he fucks himself, and makes his books out of that meeting and that violence. It must be a rape, a violation, a spending and yielding and using up. Up to now, I have not had even the courage to understand myself, much less because I dared . . . I knew that if I tore anything off, used anything up, it could not be replenished; and, stripped from the maimed, incomplete, pre-orgiastic self, this limb of me would be as dead as the trunk from which it was carved.
>
> I was hoarding myself. But I was not a self yet, I had no signature. I was only the hope of a self.[37]

After endless demoralization at the hands of Philip and Harriet, Irene was a radically new experience. Susan was reborn as she had been at Berkeley, and emerged less puny, less of a weakling, readier for her new life; and by the time Harriet got back from Florida, passion had fermented into contempt.

Susan would go out at night, supposedly spending all night in Times Square, "watching a million movies," Harriet said, "but she'd come back reeking of Mitsouko, which was a Guerlain perfume that I loved and I had always given Irene. I never picked up on it."

Finally, Irene called.

"Susan wants you to leave," she said. "Pack up."

Harriet left, and never slept with another woman.[38]

———

Susan understood how essential her alliance with Irene Fornés would prove. She had outgrown the academic world. The teenager who jittered in the presence of Thomas Mann had become a woman who could take note of Jean-Paul Sartre's bad taste and tell Sir Isaiah Berlin he was a bit careless of the detail. She was still a champion student, but she had indeed been hoarding herself. "I have always been violently, naively ambitious," she wrote in the journal entry cited on the previous page. Such ambition could not have been satisfied by an academic career. And the radical novelty that Susan Sontag came to represent could not have emerged from academia. Her work displayed a scholar with perfect classical training turning to an avant-garde culture too fresh to have attracted much serious criticism. Irene Fornés catalyzed the persona soon to be known as Susan Sontag.

Through Irene, she became a part of New York's artistic bohemia: a world that she would not have encountered with Philip. The sense of discovery that permeated her early essays offered

her readers the same excitements. She would dedicate one book to Irene; she would dedicate two to another essential figure, the painter Paul Thek. Like Irene, he was completely without education; like her, he was dazzlingly attractive: "He literally lit up a room when he walked in," said Stephen Koch. "Very blond. Very good looking. Intensely sexual. She was thrilled by the idea of someone who was both gay and as hot as Paul was."

But more than that, Koch said, she was thrilled "to meet these people who didn't need Leo Strauss to validate their thinking, who would never have heard of Leo Strauss, who would have had no concept at all of why we were even discussing him: that was really overwhelming to her." A phrase Thek cast off in conversation would, through Susan, become a motto of the emerging culture—a motto, too, for the new self she hoped to create.

Many had complained that her cerebral way of talking about art was a bore; and one day, when she was holding forth, Paul ran out of patience: "Susan, stop, stop. I'm against interpretation. We don't look at art when we interpret it. That's not the way to look at art." The first book she dedicated to Thek was *Against Interpretation*. "That's one of the things that Paul Thek and Irene brought to her," said Koch. "That you could be a dazzling artist and know practically nothing."[39]

———

"Mad people = people who stand alone + burn," she wrote a few years later. "I'm attracted to them because they give me permission to do the same."[40]

Despite the thrill of her sexual and intellectual discoveries, Susan could not stand alone. She was a mother. David was stuck in an undesirable position, or rather two: between his mother and her new life on the one hand, and between his parents on the other. He spent the summer in California with his father, who

was far from resigned to the divorce. David wrote him "the sweet-est and most insightful letters out of his troubled soul," Philip said decades later, "pleading to be left out of the middle of the conflict."[41] Susan had to remind herself, in a list compiled around the time of David's seventh birthday, to keep him out of it.

1. Be consistent.
2. Don't speak about him to others (e.g., tell funny things) in his presence. (Don't make him self-conscious.)
3. Don't praise him for something I wouldn't always accept as good.
4. Don't reprimand him harshly for something he's been allowed to do.
5. Daily routine: eating, homework, bath, teeth, room, story, bed.
6. Don't allow him to monopolize me when I am with other people.
7. Always speak well of his pop. (No faces, sighs, impatience, etc.)
8. Do not discourage childish fantasies.
9. Make him aware that there is a grown-up world that's none of his business.
10. Don't assume that what I don't like to do (bath, hairwash) he won't like either.[42]

Philip later admitted that Susan "never denounced me as I denounced her to him, and that was my blunder—and a short-coming of character. He found my hostility to Susan, which was a form of bitterness, very hard to take."[43]

Life as a single mother was hard. Just before she met Irene, she mentioned "the unspeakable loneliness of this new life with David."[44] Yet loneliness did not equal lovelessness. Once Harriet left for Miami, she noted that "I began to grow more detached

when I saw that she disliked David (predictably). I don't doubt his worth + charm as a person as I do my own."[45]

For David, these were difficult years. Susan once wrote that "I wasn't ever really a child!" David could make the same complaint. Once Irene entered the picture and introduced Susan to the downtown scene, David was either brought along or left at home. "It was because she couldn't afford a sitter," David remembered.

People will tell these stories about David sleeping on the pile of coats. Listen, I don't think it was the greatest thing she ever did, to be honest. If I had my childhood to live all over again and I could tell her what not to do, that would probably be very high on my list, dragging me along to all that stuff. But when I think back, she didn't have any money, and she wasn't willing not to go, and obviously, until I was a certain age, she could never leave me, so she chose the option she chose.[46]

Susan's boundless energy, which David called "her single most distinguishing characteristic," kept her whirling from party to gallery to reading to dinner to film to play. After she put David to bed, she would go out with friends, attending movies and performances and coming back around dawn, before David woke up.

He began to strike Susan's friends as isolated, and to display a vivid interest in weapons. His only fond memory of Nat Sontag was that he allowed him to hold his gun,[47] and the only positive memory he allowed of his father to an interviewer was of "outings to target ranges."[48] In 1960, the poet Sam Menashe proposed marriage to Susan, and David was relieved when she declined because Menashe had once suggested David should throw all his toy guns into the Hudson, Susan wrote Mildred. "Ever since, David

has been very cold to poor Sam!"[49] A couple of years later, when David was about ten, a new friend, Don Eric Levine, came to the West End apartment for the first time. David was playing with metal soldiers; Susan handed Levine the manuscript of a piece she was working on, "Notes on 'Camp.'"[50]

The Comedy of Roles

Susan met Irene only a few months before the emergence of an art form that would become typical of the new decade. In October 1959, the first "happening," Allan Kaprow's *Eighteen Happenings in Six Parts,* took place in New York. Partly a protest against "the museum conception of art," happenings were ephemeral and thus noncommercial. ("One cannot buy a Happening," Susan wrote.) They were a quick, disorienting series of "radical juxtapositions" designed "to tease and abuse the audience." They were not quite theater and not quite painting but used elements of both to create a new immersive experience: held in cheap spaces, employing found objects, including the castoff debris of urban life, they were a downtown, downmarket Gesamtkunstwerk.

They were also the kind of events that fascinated Irene Fornés. With the death of Jackson Pollock in 1956, abstract expressionism, which had defined his generation of American artists, seemed to have run its course. Happenings were created by

artists Susan's age—Kaprow was only six years older. They were the expression of an emerging avant-garde, Sontag wrote in 1962, and "one logical development of the New York school of the fifties."

> The gigantic size of many of the canvases painted in New York in the last decade, designed to overwhelm and envelop the spectator, plus the increasing use of materials other than paint to adhere to, and later expand from, the canvas, indicated the latent intention of this type of painting to project itself into a three-dimensional form.

These events drew inspiration from abstract expressionism, as well as from surrealism and the theatrical writings of Artaud. But the notion of an art that would envelop the spectator and create an alternative reality had a source even better known to Sontag: Sigmund Freud. "The Freudian technique of interpretation," she wrote in her essay on happenings, "shows itself to be based on the same logic of coherence behind contradiction to which we are accustomed in modern art." And what was modern art? "The meaning of modern art is its discovery beneath the logic of everyday life of the alogic of dreams."[1]

———

The refusal of reality—setting the dream on a pedestal to lord over the waking world—would become as much a hallmark of the new decade as it would of Sontag's work. "The world *is*, ultimately, an aesthetic phenomenon," she would write in one of her most complex essays, "On Style." This idea had a complicated genealogy. In the sixties, it would find expressions ranging from the erudite to the vernacular, as with the vogues for LSD (first championed by literary and scientific figures, including the English writer Aldous Huxley and the Harvard professor Timothy

Leary) and for the hyperstylized not-quite-art favored in certain homosexual circles.

"The meaning of modern art" that she identified derived from Freud, who placed dreams at the center of many psychoanalytic theories. But the tension between reality and dream, between object and metaphor, had been a favorite of philosophical discourse since Plato; and if it appealed to Sontag intellectually, its interest to her was above all emotional.

There was the private self: the self when nobody else was around. There was the sexual self. There was the social self: self as representation, metaphor, mask. And there was yet another self: an alter ego who had haunted her all her life, the person she thought she ought to be. "That person who has been watching me as long as I can remember is looking now," she wrote at just fourteen.[2]

The tension between the reality of her life and the ways in which she represented it to others appeared in her attitude toward her sexuality. Her rediscovery of sexual happiness with Irene, the abandonment of the "maimed, incomplete, pre-orgiastic self," had, she said, turned her from the hope of a self into a real self.

Yet that postorgiastic sexual self was strictly cordoned off. In her warm letters to Judith, for example, she transformed Irene into Carlos:

I'm doing nothing much, except going to work, making love, going to the movies, and playing chess. I don't know how long this affair will continue—perhaps for years, it's that sort of thing. I have absolutely ruled out any thought of marriage, and Carlos accepts that. But he may get fed up with our arrangement when David comes back. . . . I fear very much that then he will raise the question of marriage, and I am completely and unambivalently against it. If it comes to that, or breaking off with him, I will break off with him.

I suppose this only shows that I am less in love with him
than he is with me, which is true. But I am very much in
love, and he is everything I need in a person now . . .[3]

As the letter indicates, David was in California, where Judith
lived, and Susan still had to worry about Philip. Perhaps Su-
san feared that an indiscreet word could unleash a custody suit.
(Philip would, indeed, soon sue her over David.) Susan kept up
the pretense with her sister, whom she rarely saw, for years, de-
cades after custody of David was no longer an issue: Judith only
found out that Susan loved women shortly before her death.
"How stupid can you be," she said in self-reproach—adding, in
her own defense, that Susan always "talked my ear off" about her
affairs with men.[4]

She hid her sexuality from Judith and, mysteriously, hid Ju-
dith from even close friends. "For the first six years that I knew
Susan," said Don Eric Levine, who met her in the early sixties,
"and, of those, three when I was living in the same house with
her, I didn't know she had a sister. She was simply never men-
tioned." This, though they discussed their childhoods at length.
"I have lots of stories, lots of internal movies in my head of Susan
with her overbearing mother on her bed, and all of this, and I
would have asked: 'Where was this sister?'" Minda Rae Amiran,
one of her closest friends from her years in Cambridge, "never
knew she had a sister until much later"—though, she emphasized,
"we talked about everything in the world."

This is not a gnostic vision of a divided world, or a Platonic re-
flection on the distance between object and metaphor, or a Freud-
ian dream-interpretation: it is the compartmentalization Susan
learned from Mildred. On the one hand, the vulnerable self.
On the other, a performance of personality—a mask intended,
as she wrote in 1959, to shield that vulnerability. ("My desire to

write is connected with my homosexuality. I need the identity as a weapon, to match the weapon that society has against me.") But the uneasiness she felt about that division, and the emotional expense it demanded, is reflected in the meticulously honest journals she preserved. She hoped, she wrote in 1968, "that someday someone I love who loves me will read my journals—+ feel even closer to me."[5]

She always believed, as Harriet told her, that she would have a great destiny. Even when she was fourteen, she rued her tendency to primp for future biographers: "If I could just stop writing for posterity for a minute and make sense!!!"[6] In an essay from 1962, Sontag asked why writers' journals are interesting, and part of her answer was that in the journal "we read the writer in the first person; we encounter the ego behind the masks of ego." She must have known how extreme an example her own journals would furnish of the distance between the ego and its masks. But: "Is that what is always wanted, truth?" she asked in 1963. "The need for truth is not constant; no more than is the need for repose."[7] She would hide in public—revealing herself, in private, to that unknown reader.

———

At the beginning of the 1960s, Sontag was working on a novel, *The Benefactor*. Dissatisfied with the contemporary novel, she was intrigued by the new kinds of prose emerging from France under the name *nouveau roman:* an attempt to free the novel from traditional devices such as plot and character and capture the fragmented nature of modern experience. These novels would reflect "life among the ruins."

"It is time that the novel became what it is not, in England and America with rare and unrelated exceptions," she wrote in 1963: "a form of art which people with serious and sophisticated

taste in the other arts can take seriously." In the age of Freud, the form was too solipsistic: "Some of us," she confessed, "wish we were endowed with a good deal less of the excruciating psychological self-consciousness that is the burden of educated people in our time."[8]

This burden was the novel's, too. She envisioned a new approach, one freed from the morbid introspection she called "psychology" while at the same time preserving the other heritage of Freud: the decipherment of dreams. *The Benefactor* would attempt to square the Freudian circle: all dream, no psychology. It is the story of Hippolyte, a young man from the provinces who arrives in the capital of an unnamed country (France). In the first few pages, Sontag sweeps aside a host of the psychological motives that drove earlier novels. Hippolyte is not interested in money; he is not interested in love; he is not interested in sex; he is not interested in politics; he is not interested in art. After publishing a philosophical article—the only thing he will write until, thirty years later, he begins composing this memoir—he is introduced to a circle of "virtuoso talkers" at the home of a rich foreign *salonnière* named Frau Anders.[9] The name is a wink at Hannah Arendt, who had been married to the German philosopher Günther Anders. For Susan, Arendt, who wrote a blurb for the book, was an illustrious example of the kind of writer she wanted to be: a woman, but a writer first of all.

Hippolyte has a homosexual friend, Jean-Jacques, a thief, prostitute, and writer based on Jean Genet.[10] "I have staged my life to incorporate the energy that is usually diverted in dreaming," Jean-Jacques says.

> My writing forces from me the dream-substance, prolongs it, plays with it. Then I replenish the substance in the show of the café, in the extravagances of the opera, in the comedy of roles which is the homosexual encounter.[11]

Following this conversation, Hippolyte, who does not have a method, like writing, of wringing the dream-substance from himself, starts to dream increasingly elaborate dreams. They read like scripts for films by Buñuel, filled with images that seem plucked from the canvases of Dalí or Magritte.

> She said, "I don't like your face. Give it to me. I'll use it as a shoe."
> I wasn't alarmed by this, because she did not get up from her chair. I only said, "You can't put a foot in a face."
> "Why not?" she answered. "A shoe has eyeholes."
> "And a tongue," I added.
> "And a sole," she said, standing up.

Like many well-heeled analysands with too much time to devote to therapy, Hippolyte becomes obsessed with his dreams, which is to say: with himself. "Dreams are the onanism of the spirit," he declares.[12] He, however, disavows any such narcissistic motive. Indeed, he thinks only of others, and particularly of Frau Anders, whom he sells to an Arab. He is surprised "that a young Arab would desire an expensive middle-aged European woman, no matter how earnestly his dark flesh yearned to triumph over white." The gesture, which he calls "perhaps, my only altruistic act," makes him the benefactor of the title.[13]

He engages occasionally with women, including Frau Anders, who returns from sexual slavery in the Levant to enter, temporarily, a nunnery; and whom Hippolyte, as ever for her own good, decides to murder by burning down her house with her inside. Alas, he fails. (This is an instance of what Sontag later called her "obsessive theme of fake death.") "My dear," she tut-tuts, "you're no better as a murderer than as a white-slaver."[14] To avenge himself, he enters a sexless marriage with a meek and respectable woman.

The book has plenty of comic moments, particularly in its exotic dreamscapes. Lautréamont, in a line Sontag quoted in her essay on happenings, said that beauty was "the fortuitous encounter of a sewing machine and an umbrella on a dissecting table."[15] That is the beauty, and also the comedy, that marbles the dreams of Hippolyte.

Like all Sontag's work, *The Benefactor* is rich with one-liners, dense with aperçus. Its wit includes fairy-tale absurdities (the Levantine slave trader, for example) that remind one of *Candide*. So, too, can its "questing" plot, a common device of philosophical novels. Though by the end of the story Hippolyte professes to be "cleansed and purged of my dreams," his quest—in sharp contrast to Candide's—leads nowhere. It simply plays itself out.[16] Whatever story the book may have, Sontag rigorously insists, is not the story. Anything we think we know we probably don't. Hippolyte may be insane. He may as well not be insane. Sontag's determination to create an unreliable narrator is so reliable that it becomes tedious: there is, after all, nothing here we relied on to begin with.

Albert Camus—to whom Sontag would soon devote an essay—wrote a book of which, in some ways, *The Benefactor* is an echo. The narrator of *The Stranger*, Meursault, resembles Hippolyte. He fails to weep at his mother's funeral. He is indifferent to a woman who loves him; he murders a man without remorse. But though that book is also a kind of fable, it is nonetheless so grounded in the real world, including in the political world, that its lack of emotional engagement is an effective illustration of the dehumanizing systems it seeks to indict. In the real world, Hippolyte, like Meursault, would be a sociopath. But because, in *The Benefactor*, the dreamworld is the only reality, we read the parables as unrelated to any actual situation. Sontag has so studiously re-

versed the normal order—in which waking experiences are held to be more important than those undergone in dreams—that the "real" world hardly matters at all. With the anchor of reality removed, we read the parables and are often amused by them. But we cannot, as in Camus's work, participate in them. As Conrad wrote, "We live as we dream—alone."

The Freudian origins of Sontag's reversal of dream and reality are obvious. It was he who placed the dream at the center of his view of the world—he who asserted its reality—he who offered a key to its interpretation. In *The Benefactor*, Sontag wrestles with the question of to what extent one might be "against interpretation." If the Freudian view could lead to easily ridiculed exaggerations, his ideas about mind and body, language and object, dream and reality, disclosed truths far too disturbing to be waved away. Several ideas in *The Mind of the Moralist* announce the theoretical underpinnings of *The Benefactor*. "The Freudian interpreter tends to view plot with suspicion," she wrote then. And: "Fantasy became psychologically real and therefore as legitimate an invitation to analytic exertion as any actual event." She recalled "the likeness of dreamer to artist, as Freud suggested in *The Interpretation of Dreams*, where the dream work is analogized to the craft of the poet." She noted that "art becomes, in [Freud's] view, a public dream."[17]

Yet—more pronouncedly than in *The Mind of the Moralist*—Sontag is resisting Freud. Early in the book, Hippolyte organizes his dreams into neat, explicit categories: "I'm having a religious dream," he announces, or: "I have had a sexual dream."[18] He is obsessed by interpretation, by the need to understand the hidden meaning of things, a need that risks driving him mad. "I did not wish to deny an obvious erotic sense to all the dreams," he writes, carefully respectful of Freud, "abstract longings for union and penetration."[19] At the same time, he knows that this tendency is a bore—which is, not coincidentally, the way the reader experiences it. In the film he participates in, which gives rise to

many interesting observations on the nature of photography, he
grows frustrated and explodes at the director.

> Don't exonerate him, I urged Larsen. Respect his choice and
> don't try to turn evil into good. Let nothing be interpreted.
> No part of the modern sensibility is more tiresome than
> its eagerness to excuse and to have one thing always mean
> something else![20]

At the end of the quest, Hippolyte and Frau Anders both
manage to leave their heads. "I've learned to love myself, Hip-
polyte," she tells him. "I love my powdery smooth wrinkled
flesh, my sagging breasts, my veined feet, the smell of my arm-
pits."[21] Purged of his dreams, he, too, focuses exclusively on the
physical, taking care of the dying poor. "The patients in this hos-
pital, being destitute, really enjoy being ill," he claims,[22] and tak-
ing care of these rotting bodies gives him pleasure.

This is the book's happy ending: his dreams vanquished, he
can return, undivided, to the warts of the real world.

———

Yet the refusal of the real world lends *The Benefactor* an ominous
undertone even in a book that mainly takes place in the dreams of
a man of questionable sanity. The book reveals the inability to see
other people as real that Sontag struggled with throughout her
life. As much as this question is intellectualized and abstracted
in *The Benefactor*—and Sontag always abstracted and intellectual-
ized precisely the things she cared about most—it had concrete
manifestations. As she was writing it, she began to note certain
characteristics in her journals.

> Alfred [Chester] says I'm extraordinarily tactless.—But it's
> not that I'm unkind, or need to hurt people. In fact, I find

it very hard to be unkind—to give hurt. (X) Rather, it's that I'm dumb, insensitive. Harriet said it, Judith said it, now Alfred. Irene doesn't say it because she doesn't know how dumb I am; she thinks I know what I'm doing, but that I'm cruel.[23]

This tactlessness included behavior that most people, it is safe to assume, would have understood was inappropriate. "She just did what she did when she wanted to do it," said Don Levine. "Certainly in things that we might have second thoughts about—is it a good idea to sleep with your best friend's husband [as she had with Jacob Taubes]. Those just weren't issues with her. It was not, somehow, an issue."[24]

But she did notice her own insensitivity, at least around this time, and worried about it. In her diaries, she acknowledged a "cowardice, unknowingness in the face of my own feelings," which caused her to "betray those I love verbally, to others when I refuse to express my feelings for them."[25] These betrayals were often related to sex:

How many times have I told people that Pearl Kazin was a major girlfriend of Dylan Thomas? That Norman Mailer has orgies? That [F. O.] Matthiessen was queer? All public knowledge, to be sure, but who the hell am I to go advertising other people's sexual habits? How many times have I reviled myself for that, which is only a little less offensive than my habit of name-dropping (how many times did I talk about Allen Ginsberg last year, while I was on *Commentary*?). And my habit of criticizing people if other people invite it. E.g., criticizing Jacob to Martin Greenberg, to Helen Lynd (more temperately, but because she set the tone), to Morton White years ago, etc.

I have always betrayed people to each other. No wonder

I've been so high-minded and scrupulous about how I use the word "friend"![26]

———

At this time, Susan produced an astonishing document concerning "X, The Scourge." As the single letter suggests, this scourge does not have a name. "Many things in the world have not been named," she wrote in her essay on camp.

One of these things was the idea of adult children of alcoholics. Susan did not connect X with the consequences of parental alcoholism, partly because the idea that such people had similar pathologies would not be popularized in psychotherapy for another twenty years. By then, in her journals, Sontag had identified almost every one of these characteristics. "I grew up trying both to see and not to see," Sontag wrote elsewhere. "X, The Scourge" offers a magnificent example of her ability to see things and situations with uncanny accuracy—and of her inability to use this intellectual knowledge in a practical, emotional way.

> "X" is when you feel yourself an object, not a subject. When you want to please and impress people, either by saying what they want to hear, or by shocking them, or by boasting + namedropping, or by being very cool. . . .
>
> The tendency to be indiscreet—either about oneself or about others (the two often go together, as in me)—is a classic symptom of X. . . .
>
> X is why I am a habitual liar. My lies are what I think the other person wants to hear. . . .
>
> People who have pride don't awaken the X in us. They don't beg. We can't worry about hurting them. They rule themselves out of our little game from the beginning.
>
> *Pride,* the secret weapon against X. Pride, the X-cide.

. . . Apart from analysis, mockery, etc., how do I really cure myself of X?

I. says analysis is good. Since it was my mind that got me into this hole, I have to dig myself out by way of the mind.

But the real result is a change of feeling. More precisely, a new relation between feelings and the mind.

The *source* of X is: I don't *know* my own feelings.

I don't know what my real feelings are, so I look to other people (the other person) to tell me. Then the other person tells me what he or she would like my feelings to be. This is ok with me, since I don't know what my feelings are anyway, I like being agreeable, etc. . . .

Isn't the problem that I don't know any of the degrees between a total enslavement to a responsibility and ostrich-like irresponsibility? All or nothing, what I've been so proud of in my love life!

All the things that I despise in myself are X: being a moral coward, being a liar, being indiscreet about myself + others, being a phony, being passive.[27]

This shakily possessed sense of existence—insecurity in her own judgment, inability to assess her own feelings—explains her need to cling to those feelings so ferociously: to construct, urgently, some solid self.

———

The Benefactor reveals an additional form of being a phony: being queer. Despite the dreamscapes, despite the novelistic dressing, the book's disdain for homosexuals takes a peculiar shape that reveals its author's own opinions. If one can dismiss the stereotypes sprinkled throughout the book as products of another time, or as resulting from Sontag's long-standing interest in gay

subculture, that does not make them any less troublesome, or conspicuous.

Gay people, the author insists, are fake, not real people but caricatures playing roles: "the homosexual parody." Gay sex is not real but "the comedy of roles that is the homosexual encounter." Homosexuality is phoniness, theater, a means of attracting attention: "It was true that he was frivolous, vain, disloyal, and homosexual," she writes, for example, "principally out of loyalty to the style of exaggeration."[28]

Many of Sontag's descriptions of homosexuals allude to this campy "style of exaggeration." We see Jean-Jacques "chatting gaily about old furniture or the opera," and "the waiting, gossiping sisterhood of men, the peroxided and beringed friends."[29] The effeminate, bitchy queen was not only a cliché. Similar descriptions had a long history in books by gay writers: some of these phrases could have been taken straight from *Nightwood*. Yet their cumulative effect emphasizes, once again, that homosexuality is not a lived experience or a bodily reality but a matter of aesthetics. And no matter how much she would have wished it to be otherwise, Sontag knew this was untrue.

At the same time, these references are above all literary, no worse than the allusions to Jean Genet in her references to homosexual criminals. But another reference raises darker questions. "Homosexuality, you see, is a kind of playfulness with masks," she has Jean-Jacques explain.[30] This, and the passage that contains it, is an allusion to Yukio Mishima's *Confessions of a Mask*, translated in 1958. It is the story of how a young gay protagonist creates a false personality—a mask—in order to defend himself in the world.

But the book is not only a description of a situation with which Sontag could identify personally. Politically speaking, allusion to Mishima was a different matter than allusion to Genet, who had been involved in the French Resistance and supported

left-wing causes all his life. Mishima was a fanatic reactionary whose worship of violence would end, in 1970, in an act of hara-kiri committed in full public view. Like the writings of Céline and Heidegger—like the films of Leni Riefenstahl—his books belong to that group of works whose artistic value is impossible to untangle from their creators' sympathies for fascism.

Yet it is this connection that Sontag chooses to emphasize in *The Benefactor*. Not only does she allude to Mishima through Jean-Jacques. She also—in case the allusion had been missed—makes Jean-Jacques, her spokesman for homosexuality, into a willing collaborator of the Nazis and the lover of an SS colonel. This may be a reference to Genet's novel *Notre-Dame-des-Fleurs*, involving the French lover of a German soldier who is killed by the Resistance, and whose flesh is eaten by him in homage. But perhaps even more than the constantly recurring violence against women, the implied equation of homosexuality with fascism is the most disturbing aspect of *The Benefactor*—and one that will recur.

———

Yet this is not the reason that *The Benefactor* has often been summoned to the stand as a hostile witness against its author. The charge—that Sontag was an excellent essayist but a bad writer of fiction—eventually became a platitude. But the frequency with which the accusation is heard, as well as the obvious delight with which it is uttered, reflects a need to cut Sontag down to size: to humble a person who seemed so intimidating. It is, moreover, twice wrong. Sontag wrote some excellent fiction, and she wrote some awful essays. Her successes were inextricable from her failures, both products of a mind in constant flux.

It is worthwhile to read *The Benefactor* in the context of its time and of its author's evolving thought. This is not to say that *The Benefactor* is easy reading; its author has deliberately declined to be entertaining, and it is rare to hear positive impressions of

it today. But when it was published, in 1963, people as different as Joseph Cornell, Hannah Arendt, and Jacques Derrida admired it. And in the artistic context of the sixties, as well as in the context of Susan's own experiences as she entered her thirties, it shows a whole stratigraphy of emerging ideas. It is part response to Sigmund Freud; part response to María Irene Fornés, to whom it is dedicated; part Kaprowian happening; part surrealist film; part gnostic allegory. The difficulties readers encounter reflect real shortcomings. But they also reflect the radically different cultural context in which it was produced. In an age when Freud himself is hardly read, and few nonspecialists know much about Allan Kaprow or have ever sat through *Last Year at Marienbad*, *The Benefactor* is a relic of an age in which the novel, a later critic, Mark Greif, wrote, was "a vault of cultural knowledge, a tool for culturing people, and a work of art rather than an entertainment."[31]

All Joy or All Rage

Much of Sontag's interest in modern art was in the way it placed at its center the hidden world of dreams. Her definition of camp was "seeing the world as an aesthetic phenomenon." This—at least partially, at least early on—describes her own way of seeing the world: "The world *is*, ultimately, an aesthetic phenomenon," as she wrote in "On Style."

To see the world as an aesthetic phenomenon is to exclude the impact of politics, ideology, human action—and human evil—upon it. And Sontag's indifference to politics, as a young writer, is particularly striking in relation to her immersion in it later. For Sontag at Oxford, as Bernard Donoughue observed, politics was a matter of personal liberation. In France, she never mentioned that the country nearly plunged into civil war over the Algeria question. In America, not even the most violent upheavals—the assassination of President Kennedy, for example—were mentioned in her journals. When she and Irene spent the summer of 1960 in Cuba, she noted

Cuban bad taste in women's clothes, modern furniture, etc.

Clean tile floor even in bohíos [shacks]. No one uses a rug or carpet in Cuba

Cubans don't drink, not even the bums or clochards who sleep on the streets. Never see a drunk.

the total absence of servility or consciousness of race in Cuban Negroes

the walk of Cuban women, breasts forward, buttocks thrust back (to hide their cunts)

Cubans don't read—children only starting to read comics

piropos [catcalling] on the street—hardly any now since Fidel criticized them in a TV speech—said not everyone is a poet[1]

One wonders how she knew Afro-Cubans had no consciousness of race; but what is most remarkable is that her experience was exclusively aesthetic. Amid one of the most consequential revolutions of the twentieth century, she notices the lack of carpets, and only mentions Fidel Castro in connection with his views on poetry.

———

Among the esoteric influences on *The Benefactor*, the most important, Sontag said, was Jacob Taubes and the history of gnosticism.[2] Taubes appears as Professor Bulgaraux, a scholar of a gnostic sect of which he is also—rumor has it—an adherent. Though separated, the Taubeses remained important in Sontag's life. Jacob ended up at Columbia, where, after a year spent teaching at Sarah Lawrence and City College, Susan Sontag joined him as instructor in religion. They taught together, and the minutes of their classes survive: "Prof. Taubes showed that Marcuse joins the critique of modernity opened up by Rousseau and Nietzsche," read the notes from March 7, 1961.[3]

Marcuse [Taubes said] feels that Freud, by insisting on the sexual in Eros, went beyond the Platonic-Christian premise of Western civilization, and therefore opened up the possibility of an erotic civilization—that is, one which does not live on the repression of the sexual in the Eros.

Miss Sontag began by asking if Marcuse and [Norman O.] Brown aren't using Freud for their own purposes while claiming to interpret his insights? Miss Sontag believed that they seem to be saying something quite different from what Freud said. . . . Freud never conceived of the possibility of an unrepressed society, a possibility which is at the core of Marcuse's thought. Also Marcuse and Brown say that Freud misconceives sexuality itself. He had, they feel, a repressive view of sexuality—seeing it as man's animal inheritance and a source of psychic weakness and vulnerability.

Taubes suggests the liberating possibilities of the end of repression, a popularization of Freud that would make Marcuse a prophet of the sixties. Sontag is far more skeptical, a skepticism that may have less to do with Freud than with her own experience. Intellectual happiness is a real possibility. Sexual happiness is not.

———

From these years, Susan would retain a few close friends. One was Don Eric Levine, born in Manhattan of Russian émigré parents. He had trained as a classical pianist before enrolling at Columbia, where he took the courses Susan and Jacob taught in mysticism and religion, and worked as Susan Taubes's assistant as curator of the Columbia Religion Collection. Eventually, he became a professor of English and film studies at the University of Massachusetts, dividing his time between Amherst and Susan's various addresses in New York. He would live with her on and off

for eight years, helping her edit her second novel, *Death Kit*, the essays that became *On Photography*, and the landmark anthology of Antonin Artaud that she published in 1976.

Another was Frederic Tuten, a young writer who met Susan the week she published *The Benefactor*. He had just read a review of the book and was invited by the photographer Peter Hujar and Hujar's boyfriend, Paul Thek, to lunch with her; a week later, they went together to see a new Godard film, *Le mépris*, and then to a downtown dance hall. "It was the time of the twist, and I didn't dance. I felt awkward about it and watching everyone dance and then Susan, she gets up and starts dancing the twist." They would remain friends for the rest of their lives, and Susan would often help him. He remembered her "absolute generosity" toward those she believed in: "I don't know anyone today in New York, any writer, painter, poet, anyone who comes near—forget equal—near her generosity to other writers and artists and poets and painters."[4]

Another was Stephen Koch, who had entered the University of Minnesota in the same class as Bob Dylan and then, dreaming of becoming a writer, came to New York. After completing his undergraduate degree at City College, he reluctantly enrolled in grad school at Columbia and began writing essays. One was on two recent literary novels, Thomas Pynchon's *V.* and Susan Sontag's *The Benefactor*. He preferred *V.*, but found *The Benefactor* congenial, and said so in the pages of the *Antioch Review:* the first thing he had ever published. He had the "bright idea" to send his essay to the authors. The one he sent to Pynchon was returned by his agent unopened: "Mr. Pynchon does not receive mail." The one he sent to Sontag, however, received a warm answer from the author, saying that it was more interesting than most reviews of her novel, and ending with the sentence: "We should meet."

He had seen her around Columbia: "radiantly beautiful and charismatic, walking across the campus surrounded by an all-

male pack of graduate students and junior faculty. I eavesdropped; I seem to recall her saying to her assembled worshippers, 'I wrote the book as a catharsis.'" They finally met at the New Moon Inn, a Chinese restaurant on Broadway, where Stephen tried to impress her by ordering something esoteric.

> She spoke about Roland Barthes, of whom I had never before heard. (In any case, the first time I went to her apartment on Washington Place, she pressed into my hands Barthes's *Essais critiques* and told me that it was essential that I read the book.) And we agreed to meet again, after she had read my essays. We did that, and she was impressed. I do not remember any real discussion of their content, but she announced that I should meet some literary editors and that she was going to take me around to meet them. . . . And so I was launched, Susan's protégé.[5]

The year Sontag began teaching at Columbia was the first year Jews were admitted without quotas. Because of the backlash, it was also the last. In a city with the largest, richest, and most influential Jewish community in the world, bastions of gentile privilege survived. Many law firms and banks, fancy clubs and elegant apartment buildings, were either entirely off-limits or admitted Jews only as tokens. This was true, too, at the city's most prestigious university, where even Jewish scholars of international reputation were placed in decidedly secondary positions. When Lionel Trilling became the first Jew appointed to a professorship in English, his appointment was controversial, since he could not possibly understand English literature as well as a "rooted" Anglo-Saxon.[6]

The class of 1964, whose college years coincide exactly with Sontag's at Columbia, was admitted on the basis of merit and

grades alone. "Suddenly there was this freshman class that was like sixty-five percent Jewish from New York," said the writer Phillip Lopate, who, like Levine, Koch, and Tuten, met Sontag at this time. "It was a scandal." For this meritocratic indiscretion, the director of admissions, David A. Dudley, was fired. After all, as the *Columbia Spectator* candidly explained, "it is no secret that many [alumni] have expressed dissatisfaction with the geographical and religious content of the Class of 1964."

The class would be known as "Dudley's Folly."[7] The Jews Dudley admitted were far more like Lopate, or Philip Rieff, than Sontag. She came from sunny suburbs; they, from immigrant ghettos. She was at home in elite institutions; for them Columbia was exotic. "I remember the first time I ever even fathomed that there were Jews with money," said Lopate.[8] Edward Field, a poet who, like Lopate, hailed from working-class Brooklyn, met Sontag around this time and was astonished by her middle-class "sense of entitlement." She would take taxis, something inconceivable in his world. "The lower-class people like me, you automatically think of the subway."[9] Admitted to Columbia a few years earlier, under a much lower quota, Norman Podhoretz, also from poor immigrant Brooklyn, never "anticipated how chic the idea of Jewishness was soon to become in America."[10]

These kids were dazzled by their first contact with high Anglo-Saxon New York. For those who aspired to traditional professions—law and medicine, engineering and science—their education allowed them access to the national elite. But if they aspired to the world of culture, they were also seeking entrance to a Jewish power structure in some ways more intimidating: the group known as the New York Intellectuals. These were the writers who had created what the young Randall Jarrell called the "Age of Criticism."

"Physical sciences apart," Podhoretz wrote, "literary criticism was probably the most vital intellectual activity in America, and

the most vital branch of literature itself."[11] In *Making It*, his 1967 succès de scandale, he popularized the nickname the Family. They, "by virtue of their tastes, ideas, and general concerns found themselves stuck with one another against the rest of the world whether they liked it or not (and most did not), preoccupied with one another to the point of obsession, and intense in their attachments and hostilities as only a family is capable of being."[12]

Their house organ was *Partisan Review*, the same magazine Susan discovered stashed behind the porn on Hollywood Boulevard. In that publication, aesthetic and political considerations were intertwined. Never seamlessly—but whether they liked it or not.

———

As the name suggested, the magazine's origins were political. It was founded in 1934 by the John Reed Clubs, the youth movement named for the American Communist author of *Ten Days That Shook the World*. In that first year, its editors congratulated a woman departing for maternity leave on producing "a future citizen of Soviet America."[13] In 1937, Philip Rahv and William Phillips freed the magazine of this tutelage, swapping Stalin for Trotsky while keeping its leftist orientation.

Rahv was born Fevel Greenberg in Ukraine; Phillips, born in East Harlem, was known until 1935 as Wallace Phelps, a name that was already a far cry from his family's original name, Litvinsky, which his father had discarded. The new magazine allied with young writers, including non-Jews like Dwight Macdonald and Mary McCarthy, who had reasons of their own for disaffection from the American mainstream.

The Family was predominantly Jewish, yet even in the late 1930s, one of the hotly debated editorial issues was whether America should fight Hitler. Many believed that the best hope for revolutionary socialism was for the capitalist powers, including

the United States, to perish in a final inferno. Phillips and Rahv supported the war. But in the Family there was a wide sense that if other countries were bad, so was America. Even after the war, when the Holocaust became common knowledge, many American leftists correctly pointed out that if Germany was responsible for the Holocaust, America had vaporized two entire cities with atomic bombs.

Because of their marginal immigrant background, many of these Jewish writers felt estranged from America. And they found allies among other groups who felt similarly. These included southerners like Faulkner, who still felt an allegiance to a decaying, premodern society; as well as northern WASPs like Macdonald and Edmund Wilson, who sensed that the moneygrubbing new world had no room for them and their older values.

Whatever their origins, the Family, above all, was "highbrow." The term was created by an older member, Van Wyck Brooks, an Anglo-Dutch patrician who took the view that refinement of mind meant allegiance to certain transcendent values. In a country whose business was business, these were the opposite of the financial values they considered vulgar. They were the values that could not be bought: beauty and freedom, learning and art. What separated highbrow from lowbrow was not class or education or religion or race but a belief in certain permanent spiritual and political values, which the highbrow reflected and the lowbrow rejected.

Culturally, the Family's roots were traditional, exemplified by Hutchins's University of Chicago: a great-books fustiness that made coexistence with modernism difficult, as it was even for Sontag. Politically, it was radical. Its rejection of the "middlebrow" or "philistine"—mindless patriotism, popular television, sleazy advertising—also meant a rejection of half-baked politics, which they understood to be the tepid meliorism of Franklin Roosevelt and his successors. For many Family members, the

word "liberalism" conveyed trashy bestsellers, foot-stomping Broadway musicals, *Time* and the *Reader's Digest*. With her portrait of a Los Angeles drowning in elevator music, this is the note Sontag sounded in "Pilgrimage." This culture offered escapism, anesthesia, to a world that had so recently produced Hiroshima and Auschwitz.

In 1947, twenty-seven-year-old Irving Howe—younger than Rahv or Phillips, older than Podhoretz or Sontag—traced the positions of the Family in a rough chronology:

> Their attraction to radical politics in the early thirties; their subsequent break from Stalinism and turn to Trotskyism; their retreat from Marxism in the late thirties; and finally their flight from politics in general . . . [in] turns to religion, absolute moralism, psychoanalysis and existential philosophy as *substitutes* for politics.[14]

After the war, political activism, though certainly present in the pages of *Partisan Review,* was mostly channeled into aesthetic debates that made criticism the most elevated intellectual endeavor of the day. That urgency kept *Partisan Review*'s standards so high that when Mark Greif, a critic young enough to be Sontag's grandson, read through the first decades of the magazine, he was stunned that it was "impossibly good. It was better than I expected or could have imagined, maybe the best American journal of the century, or ever."[15]

———

By the time Sontag reached New York, many of these debates, particularly those around communism, had played themselves out. Like the debates around psychoanalysis and existentialism, they would linger, explicitly and implicitly, for decades; but like Rahv and Phillips and Trilling and Arendt and McCarthy and

Macdonald, they were aging. In the Family genealogy Podhoretz traced in 1967, another generation—Howe's, Philip Roth's, Norman Mailer's—had already risen, and a third was making its appearance in the form of two prodigies. The firstborn son, at least according to Podhoretz, was Podhoretz himself. The firstborn daughter, he wrote, was Susan Sontag.

But though she was Jewish, Sontag did not share the older Family members' fraught relationship to America. She expressed little love for the heartland—but talented people who flee boring provinces for capitals rarely do. She was not the only New Yorker, Jewish or otherwise, who took a dim view of the philistinism they believed to reign in those provinces, nor the only American who ranked highbrow Europe above lowbrow America. When she occasionally expressed her disdain for America, she did so in the same terms that Americans always had; and when those terms changed during the Vietnam War, she, like so many other Americans, would change with them.

Nor was her relationship to Jewishness particularly troubled. After her first visit to Israel, she said: "I couldn't live there. But I'm glad it exists, so I could have somewhere to be buried."[16] Of Judaism, the religion, she took little notice, though in her early years she wrote quite a lot about Jewish identity: "Are the Jews played out?" she wondered in 1957. "I am proud of being Jewish. Of *what*?"[17] The Nazi horrors marked her as they did every other Jew. But being Jewish was, as much as anything, a way of belonging: she noted that "in New York (Greenwich Village) there's a shared comedy of being Jewish."[18] Podhoretz wrote that the second generation of the Family, including Saul Bellow, marked itself off from the first by its desire

to lay a serious claim to their identity as Americans and to their right to play a more than marginal role in the literary culture of the country. Both the claim and the right were a

decade later to be taken so entirely for granted that one is in
danger of forgetting how tenuous they seemed to all con-
cerned even as late as the year 1953—how widespread, still,
and not least among Jews, was the association of Jewishness
with vulgarity and lack of cultivation.[19]

The worldly, sophisticated Sontag would become the preemi-
nent symbol of the third generation. She would not need to lay
claim to anything—except, as Americans from Thomas Jeffer-
son to Henry James to T. S. Eliot always had, to Europe. She
would share with the Jews an ideal of seriousness, "haunted," in
Podhoretz's words, "by what was perhaps the most ferociously
tyrannical tradition of scholarship the world has ever seen"—the
Talmudic—and by a suffocating feeling that "they must either be
Marx or Freud or not be anything at all between the covers of a
book."[20] And she shared the earlier generation's profound sense
of alienation. Like Paul, who hoped Christ would abolish the
distinction between Greek and Jew, master and slave, male and
female, she, too, would despise categories, seeking a universal cul-
ture that would abolish them—but not because she was Jewish.
Because she was gay.

———

In 1962, four years after her divorce, Sontag's gayness endangered
her again. When she and Philip separated, they agreed that
David would spend summers with his father. By then, Philip had
moved to Philadelphia to take a position in the Sociology De-
partment at the University of Pennsylvania. But when David re-
turned to New York on September 15, 1961, he was, his mother
claimed, "a mass of neuroses," including those induced by "en-
forced attendance with his father at graduate meetings and sociol-
ogy classes."[21]

She spoke these words in response to a custody suit. The suit

demonstrated that Philip's bitterness had not relented, as Jacob
Taubes predicted in 1958. At the end of 1959, she wrote in her
journal: "I have an enemy—Philip."[22] In 1961, he admitted to
stalking her in New York. In a piece in the *Daily News* entitled
"Prof: Gotta Be Sneak to See My Son," he said he had only ob-
tained "fleeting glances" of his son by "lying in wait outside the
school the boy attends, or near the apartment house at 350 West
End Ave. where Mrs. Rieff lives."[23]

The name "Mrs. Rieff" is a clue to who was behind the ap-
pearance of these articles. Absent a concerted campaign to elicit
sympathy, it is hard to imagine why the press would have taken
an interest in a routine squabble between two unknown academ-
ics. But Philip was eager to play the martyr. Described as the "au-
thor of several solemn tomes" (at this point, only one, *The Mind
of the Moralist,* had appeared), and emphasizing his "international
reputation in the highest levels of academic ivy," one article casts
Philip as the true victim, even going so far as to insinuate that
Susan's real problem was godlessness. "This woman teaches reli-
gion at Columbia University," his lawyer intoned, "but not to the
boy."

Claiming to be acting in the interest of a child, Philip stalked
and sued that child's mother. He dragged her through the news-
papers, which published at least one picture of David, with Susan
standing beside him, composed and elegant. But she was dev-
astated by the proceedings, which dragged on for months. Philip
came close to succeeding, particularly after Susan refused to
send David to him for Christmas,[24] and particularly when Philip
brought the heaviest charge against her, one not reported in the
paper: that her relationship with Irene Fornés made her an un-
fit mother. Homosexuality, as in *The Price of Salt,* was enough to
cost many parents custody. But when the case came to trial on
February 14, 1962—Valentine's Day—Philip's harassment worked

against him, as it had in the original divorce in California. Not only did he not get custody: his visitation rights were cut back.

Susan and Philip never spoke again. The poet Richard Howard remembered how often she spoke of the divorce and custody battle, and particularly of the traumatizing smear campaign in the press. Thirty years later, when David was going to lunch with his father, Susan asked where they would be eating and asked David to arrange a table by the window. She walked by and stole a glimpse of Philip; she was shocked at how he had aged. When she sold her archive to UCLA, she wrote her agent to request that some materials be withheld. "There are a few items—such as my correspondence with my ex-husband—which to protect his reputation, if that's the right word, I don't want anyone to look at as long as he is alive. (I don't know why I feel obliged to be protective of the bastard, but I do.)"[25]

Though he remarried, Philip always loved Susan. On a trip to Boston in the company of a Philadelphia rabbi, Philip "insisted that he drive round and round and round where their home used to be, when he and Sontag were married."[26]

———

In 1962, Susan met a man who, though a Jew and a New Yorker, was as far from the Family—immigrants or their children, socialists or their offshoots—as could be conceived. Roger Straus's family belonged to "Our Crowd," the great capitalist magnates of Jewish New York. If Lopate and Podhoretz were impressed that Sontag took taxis, one can imagine how intimidating they must have found Straus, scion of two of the richest families in the United States. His mother, Gladys Guggenheim, belonged to the mining dynasty; his father's family had owned Macy's department store; his wife, Dorothea Liebmann, was the heiress to a brewing fortune.

The marriage of old Jewish money to avant-garde art was consummated in the construction of the Guggenheim Museum, Frank Lloyd Wright's upside-down ziggurat on Fifth Avenue. Founded by Roger's great-uncle Solomon, it opened only three years before Susan met Roger, its radical architecture offering an impudent contrast to the staid pile of the Metropolitan Museum down the street. From the Europeanizing Met to the American Guggenheim, a momentous historical shift was given plastic form; but the Guggenheim was not merely an American assertion of independence from European tutelage. (With varying degrees of conviction, Americans had been asserting that for centuries.) It did not assert equality or distance but superiority and authority—a shift that, not coincidentally, assigned the city of New York a new status as the cultural capital of the world.

The Guggenheims and the Strauses had been in America since before the Civil War, two generations before the pogroms in Russia in 1881 that marked the beginning of mass Jewish immigration. Straus's grandfather had been United States minister to the Sublime Porte, as well as the first Jewish cabinet secretary. His caste, which included families like the Morgenthaus, Warburgs, Sachses, and Lehmans, were akin to the court Jews of Europe, and their money largely insulated them from the indignities of anti-Semitism with which poorer, more recent Jewish arrivals had to contend.

They identified strongly with the country that made their affluence possible, an identification that Straus's career reflected: in World War II, he worked in public relations for the navy; and once he started the firm that became Farrar, Straus and Giroux, he allowed the CIA to use his literary scouts in Europe to sniff out Communists: a black phone in his office reportedly provided a direct line to Washington. (Once wartime patriotism gave way to Cold War jingoism, the phone was repurposed for calls to his mistresses.)[27]

Such a telephone would not have appeared on a desk at *Partisan Review*. But the Family would never have created an institution like FSG. If the Guggenheim Museum was proudly American, that did not mean its galleries housed a chauvinistic national collection. Alongside its American works were Modiglianis and Picassos and Kirchners and Klees, gathered in pursuit of the cosmopolitan ideal whose monuments, from the Statue of Liberty to the new United Nations, filled New York. It was a city that saw itself as the Mother of Exiles, an American ideal of diversity that later became commonplace. But particularly during World War II, with most of Europe under Nazi occupation, it was not shared by everyone, inside or outside the United States. It was an ideal that Farrar, Straus—and Susan Sontag—would embody.

Of the twenty-three Nobel Prize winners the house has published, none were born and died as Americans. (T. S. Eliot renounced his citizenship; Joseph Brodsky and Isaac Bashevis Singer were naturalized.) Eventually, FSG published an impressive range of international writers: Europeans like Hermann Hesse and Aleksandr Solzhenitsyn, Eugenio Montale and Elias Canetti; Latin Americans including Pablo Neruda and Mario Vargas Llosa; Africans including Wole Soyinka and Nadine Gordimer. Together with the Americans FSG published, the house embodied the ambition of the postwar republic of letters.

Through FSG, many great international writers reached America. From it, the great Americans irradiated. None embraced the pluralistic model as enthusiastically as Susan Sontag, who would become the most important of Straus's scouts. "Susan is the real editor in chief of FSG," Robert Giroux was heard to grumble.[28] She helped dozens of writers, often with little fanfare, make their way into English. Roger's loyalty to her was unquestioned, as was hers to him. "You're the only person in the world," she told Straus, "who can call me 'baby' and get away with it."[29]

It was the same word Nat Sontag used to address Susan's mother-less mother. As Nat proved to be an ideal parent to Mildred, Roger became the same for fatherless Susan. Though he was sixteen years older than Susan, they died within months of each other in 2004. Those who knew them felt the timing was a blessing. "That was a mitzvah that he died before her," said Peggy Miller, Roger's longtime secretary.[30]

Roger made Susan's career possible. He published every one of her books. He kept her alive, professionally, financially, and sometimes physically. She was fully aware that she would not have had the life she had if he had not taken her under his protection when he did. In the literary world, their relationship was a source of fascination: of envy for writers who longed for a protector as powerful and loyal; of gossip for everyone who speculated about what the relationship entailed. It was, briefly, sexual: "They used to go out for 'margarita lunches,'" an assistant said. "That was her word. It must have reminded her of California or something. They had sex on several occasions, in hotels. She had no problems telling me that."[31] But this short-lived tryst in no way explains their lifelong bond.

In May 1962, Susan signed a contract with Farrar, Straus for *The Benefactor*. It stipulated payment of five hundred dollars, one hundred paid in advance. It wasn't much, but money was not the point. Roger, for the rest of her life, would be more than a publisher. He would be a friend who would deliver the stability, the confidence in her work, that she required to write.

When Roger's Mercedes pulled up to the office each morning, Tom Wolfe wrote, the drug deals and assaults on Union Square came to "a momentary but deferential halt."[32] In those days, Union

Square was nasty, and so were FSG's offices. They were appropriate to a publishing house that was never, or only rarely, profitable: "He loved walking on the thin edge of nothing," Dorothea Straus said of her husband.[33] But if the offices were shabby, the Strauses' Upper East Side town house was decidedly not. Its Our-Crowd glamour gave FSG an air of solidity that Roger used to bolster his business's reputation, and parties at their house struck many guests, particularly new arrivals, as from another, Proustian, age. "We will dress" or "We will not dress," Dorothea would say when she called to issue an invitation. This dazzled many younger people, like Susan's friend Fred Tuten: "I was just a kid from the Bronx," he said. "I had no idea what it meant—none."

("Dressing" meant ball gowns and jewels and tuxedos; "not dressing," suits and skirts.)

At the house, a guest would be greeted by the eccentrically outfitted Dorothea, whose dresses were made by a Russian émigrée couturière who styled herself "Countess Jora." (Her son said: "I think my mother saw an Aubrey Beardsley drawing when she was young and never recovered from the experience."[34]) Roger, who rarely remembered people's names, would offer a drink— "Whaddaya like, pal?"—and then bring newcomers around to meet the other guests. "Edmund Wilson was there, and Susan Sontag was there, and Malamud was there, and Lillian Hellman was there," Tuten remembered. "It was the most interesting level of literary culture."

Their son, Roger III, called them Fred Astaire and Ginger Rogers, masterful performers—"Roger was an external person, not an internal person," said Jonathan Galassi, his successor as publisher of FSG—and after the performance, the set was struck. The house without a party was like "an airport runway waiting for the plane to come in," their son said. "The main function wasn't being performed; the landing field was there but it was waiting for the plane."[35]

Straus exuded the kind of politician's warmth that made everyone feel welcome and important—but only up to a point, especially with men. "He was incredibly effective, but he was not someone that you would sit and have a heart-to-heart with," said Galassi.[36] For Straus as for his publishing house, the point was to bring people together; and his parties brought Susan into contact with people she had idolized since childhood. She was not, however, daunted by her new surroundings, and cast aside rules that did not suit her, including the postprandial separating of the sexes. One evening, Susan, hearing the suggestion that she go upstairs and join the ladies, simply kept talking. "And that was that," said Dorothea Straus. "Susan broke the tradition, and we never split up after dinner again."[37]

————

It was there that she met William Phillips, coeditor of *Partisan Review,* and asked him how one wrote for his magazine.

"You ask," he said.

"I'm asking," she answered.[38]

And in the summer of 1962, only a few weeks after she signed her contract with Farrar, Straus, her first piece appeared, a review of Isaac Bashevis Singer's *The Slave.* It focused on familiar preoccupations: the dream ("the purest form of the post-classical novel is the nightmare"); the gulf between body and mind ("the novel has been preempted by the agony of disembodied emotional and intellectual struggles"); and an interesting but unexplained definition of the principal subject of modern fiction: "the failure of appetite and passionate feeling."[39] What is new about the essay, never reprinted, is its context. It marked the arrival of Susan Sontag into the Family flagship, and announced her membership in the Farrar, Straus circle: *The Slave* had been published by Roger, and its cotranslator, Cecil Hemley, had been an enthusiastic reader of *The Benefactor,* and would be Sontag's first editor.

In February 1963, another institution, *The New York Review of Books,* was born. A printers' union strike had forced a stop to the publication of the *New York Times* and the city's other newspapers. Inspired by an essay Elizabeth Hardwick had published in *Harper's* in 1959, "The Decline of Book Reviewing," a small group, including Hardwick herself, took advantage of the work stoppage to begin a review of their own. The group included Robert Silvers, another product of Hutchins's University of Chicago who had edited Hardwick's essay at *Harper's.* Silvers and Hardwick were joined by a young married couple of prominent editors, Jason and Barbara Epstein. The inaugural issue included Gore Vidal, Norman Mailer, William Styron, Adrienne Rich, Alfred Kazin, Robert Penn Warren, W. H. Auden, Robert Lowell, and—with a short essay on Simone Weil—Susan Sontag.

The New York Review of Books, a club often mocked as *The New York Review of Each Other's Books,* would become the preeminent institution of the third—and last—generation of the Family. Last, because people would never joke, as they did of the aging *Partisan Review,* that it had special typewriters with words like "alienation" stamped on individual keys.[40] Like the Guggenheim Museum and Farrar, Straus, *The New York Review* was firmly integrated into an American culture whose cruelty and vulgarity it criticized, and whose ambitions and prestige it symbolized. Together with Farrar, Straus, the *Review* would become the foundation upon which Susan Sontag built her career.

———

When *The Benefactor* was published in October 1963, it bore a dedication to María Irene Fornés. Already in Cuba, in 1960, and indeed before, their relationship had adopted the pattern that marked her relationships with Philip and Harriet; the pattern would remain remarkably similar throughout her life. Within months, passion dissolved into sniping and jealousy.

Susan's attraction to Irene was physical. But it was also a tro-
pism to someone unlike herself. "Till now," she wrote in 1959, "I
have felt that the only persons I could know in depth, or really
love, were duplicates or versions of my own wretched self. (My in-
tellectual and sexual feelings have always been incestuous.) Now
I know and love someone who is not like me—e.g., not a Jew, not
a New York-type intellectual—without any failure of intimacy. I
am always conscious of I.'s foreignness, of the absence of a shared
background—and I experience this as a great release."[41]

She expressed this to Irene, who resented the "Latin fire-
cracker" stereotype. She summed up how Susan saw her as
"Latin, foreign, good taste, sexual experience, uneducated intel-
ligence." In her diary, Susan tweaked her: "(—this is not correct,
since according to the dictionary, education is development of
character and mental powers as well as systematic instruction)."[42]
The resort to the dictionary was a perfect illustration of their dif-
ferences, a gap that grew with their increasingly wild fights. Their
neighbor Sam Menashe, the poet who proposed marriage to Su-
san, was shocked by the screeching from the apartment.

Irene pinpointed the sources of Susan's insecurity. "I. says I am
ruled by a family image of myself: being my mother's daughter,"[43]
Susan wrote. She noted a passive-aggressive mechanism in herself,
and knew that she had, indeed, turned Irene into Mildred:

> My "masochism"—caricatured in the exchange of letters
> with Irene this summer—reflects not the desire to suffer, but
> the hope of appeasing anger and making a dent in indif-
> ference that I suffer (and am "good," i.e. harmless.) . . . If
> Mommy sees she's really hurt me, she'll stop hitting me. But
> Irene isn't my mommy.[44]

At the same time, Irene was "the great turning point." She
reflected Susan's anxieties. She also offered a chance to escape

them. "She introduced me to an idea deeply foreign to me—how incredible it seems now!—that of seeing myself. I thought my mind was only to see outside myself! Because I didn't exist in the sense that others and everything else did."[45]

She despaired when she read Irene's diaries, as she had Harriet's. Her despair came not from invading Irene's privacy but from what the act revealed about her own wretchedness. It was "the glimpse of myself reading the notes that disturbed me, perennially looking for my bearings in the opinions of others."[46]

———

As Susan struggled with "X," Irene had been sexually abused by a relative, a trauma that left inevitable psychic consequences. She was, a cousin said, "all joy or all rage." The relationship was bound to explode,[47] but the partnership—between Susan's willed intellect and Irene's natural genius—was a breakthrough for both. Irene had flitted around Europe, pretending to be a painter, living first in Paris and then in a Spanish village: "I thought I was Gauguin," she said. "The people of the village thought I was crazy."[48]

Not until she met Susan did she discover her true vocation, and helped Susan discover hers. The breakthrough came in the spring of 1961, when they were sitting at a restaurant. Susan was teaching at Columbia and fretting about her inability to write. "How silly," Irene said. "If you want to write, why not just sit down and write?" As they were talking, a friend appeared and invited them to a party. Susan accepted; Irene ordered her home to write. When they got there, Irene said she would write something, too, "just to show you how easy it is."

She had never written a word, but opened a cookbook and wrote a story by using the first word of every sentence. It was a technique she would later refine, and the creativity it unleashed would make her "the queen of Off-Broadway," who won more

Obie Awards than any other playwright.[49] At first, said the great friend of her last years, Michelle Memran, she was "experimental, because she had no idea what she was doing." This spontaneity would be conveyed to her students, whom she taught to unblock their imaginations with the same techniques she herself had begun with.

> "Close your eyes," Fornés instructs. "Visualize two people in conflict." After a minute's silence, she picks up a paperback she'd found in the street that morning, skims through several pages, finds a sentence at random. "Use this sentence," she says: "'It's all just as you left it.'" Everyone begins to write, including Fornés—she's written almost every word of her last half-dozen plays in the workshop. After half an hour, she speaks again. "Now it's a week later," she says, and reads another random sentence from the paperback: "I haven't the faintest idea what you want me to do."[50]

Susan Taubes joined Sontag and Fornés every Saturday. As Irene was writing *Tango Palace* and Susan Sontag was writing *The Benefactor,* Susan Taubes was writing a novel about a woman separating from a charismatic, sexually insatiable man who bore more than a passing resemblance to her husband. If *The Benefactor* errs by presenting its characters as too ethereal, *Divorcing*—which is far more absorbing—is almost too wrenchingly grounded in the world of real people, real emotions, and real history. This is ironic, because *Divorcing* is the story of a refugee who, torn from one world, can never find another.

Susan Taubes did, indeed, seem lost. Whenever Don Levine went to her apartment, he would first clean out a refrigerator full of rotting food. Literally unable to cross the street, she was eventually diagnosed with an eye condition that explained a bit of her strangeness. But fragility was only part of the story. She was "more

than a bit of a *monstre sacré*," Don said. When he reproached her for her treatment of her children, she shrugged: "My childhood was awful. Why should theirs be any better?"[51] Like Irene, like Harriet, she defied convention, and gave Sontag permission to do things she might not otherwise have dared to.

———

By the time *The Benefactor* came out, with its dedication to Irene, she and Susan were no longer a couple. But Irene would remember Susan even when she remembered almost nothing else. At the end of her life, when her mind had been destroyed by Alzheimer's disease, she suddenly told Michelle Memran, who was making a documentary about her life, about a "bookworm, which ordinarily is, like, not very attractive, but she was very attractive, and the idea that this very beautiful woman was a *bookworm* where Sartre—Sartre—would come to a café and be looking for where Susan was to sit at her table. Sartre!"

In her still-heavy Spanish accent, Irene asked:

If I said because she was the love of my life, would you get any more information? She was the person I loved the most profound. Right now my eyes begin to tear. And this is now a hundred and fifty-five years later. So do you want to still ask why sooner or later I start talking about Susan? And why is someone the love of your life? That is a mystery. That's magic cannot be explained. And it's as real as this table, and you cannot say it's because of this, you cannot analyze it. Because it is. . . . When you fall in love with a person it is not logical. What I think if I'm actually being, if I have a lot of freedom or trust in the person, I would say I think it has to do with something in a person's system that is almost like chemical, that has a need, like you go to the doctor, you feel weak, and the doctor takes a blood test, they analyze it,

and so they figure out that you need vitamin C or vitamin
B, and also drink as much milk as you can, and it has to
do with a balance of certain chemicals in the system, and
certain, because people would say, why were you so com-
pletely, through the years, even after we broke up, in love
with her? And I would say, you know why was I in love with
her? Because I was![52]

Funsville

The Benefactor was published in the fall of 1963. Reviews were respectful, though several expressed surprise that the novel was the work of an American author. "If I did not know that the book was written by a native New Yorker and issued by a publisher in that city, I would assume without question that its author came from somewhere—anywhere—between Calais and Warsaw," wrote the critic for *The New Republic*.[1] *Time*'s critic agreed: the book was "written in what would be identifiable as English prose if it did not sound so much like a blurred translation from some other language."[2] Hannah Arendt, herself born between Calais and Warsaw, wrote Roger Straus who had sent it to her for a blurb: "It is extraordinarily good. My sincere congratulations: you may have discovered there a major writer."[3]

Only a few weeks later, President Kennedy was assassinated in Dallas. The decade had started hopefully, with the transfer of authority from the oldest president in history, Dwight Eisenhower,

to the youngest, John Kennedy. Many Americans imagined that the new decade Kennedy's election inaugurated would allow the nation to savor the fruits of victory amid unparalleled power and prosperity—and that the world, under benevolent American leadership, would bask in a *Pax Americana*. Things did not work out that way, to say the least; and the rise of the new generation was marked by traumas. Kennedy's murder was one. Kennedy's creation, Vietnam, was another. The decade would be remembered for a series of revolts: at home, for a previously unthinkable wave of assassinations; for the assertiveness of blacks, women, and homosexuals; for the determination of young people to remake a society that, at the height of its wealth and influence, they rejected as greedy, bigoted, and repressive. Abroad, revolts were under way in nations determined to overcome imperialism, American, Soviet, and otherwise; but in *The Benefactor*, Hippolyte identifies a more profound change, the change that underlay all the others.

> I believe that the revolutions of my time have been changes
> not of government or of the personnel of public institutions,
> but revolutions of feelings and seeing.[4]

To study the cultural revolutions of the sixties is to realize to what extent its "revolutions of feelings and seeing" had to do with fear of miscegenation. The racist term was "mongrelization." It expressed the fear that sexual intercourse between blacks and whites—widespread in private, taboo in public—would create a degenerate mulatto race. This was not a fringe opinion. Blacks and whites would not be allowed to marry in all fifty states until 1967.

And in fact all the sixties revolts strove to break down boundaries. Some of these—between women and men, blacks and

whites, Jews and gentiles, straights and gays—had such a long history that they seem to require little explanation, though this is deceptive: in the last half century, the connotations of all those terms have changed, often beyond recognition. And American society was riven by other taboos that, though almost entirely forgotten now, make it hard to understand how a person as intimidatingly erudite, as polymathically allusive, as Susan Sontag could have been attacked as a mongrelizer, a leveling popularizer whose prominence was a sign of decadence.

T. S. Eliot had called criticism, the policing of cultural boundaries, "the correction of taste." This task was so central to the second generation of the Family, writers like Edmund Wilson, Lionel Trilling, and Randall Jarrell, that their writing shaped something called the "Age of Criticism." Many of the greatest American writers—the most influential, most learned, most admired writers—were critics, and saw themselves as forming a prophylactic shield against the pollution tainting everything they held dear. The culture they defended was the culture that despised and rejected anything too easy, too popular, too in thrall to money and image and success.

For the *Partisan Review* crowd in the 1950s, the quintessence of middlebrowism was the Book of the Month Club and *Life* magazine. For serious painters, the enemy was commercial art, with its reek of advertising. For serious theater and music, the enemy was Broadway. For the avant-garde cinema, it was everything the word "Hollywood" connoted. Cinema itself was dubious: debates about whether film could be considered an art mirrored a similar debate about photography. The idea that someone could write on science fiction films, or happenings, or a homosexual style known as "camp," and still wish to be taken seriously as an intellectual, was unsettling. The elders saw their carefully drawn distinctions being carted off to the rubbish heap.

In 1964, Susan Sontag got in a rickety elevator on East Forty-Seventh Street and emerged into a fourth-floor loft, rented for one hundred dollars a year. Decorated in silver foil and known as the Factory, it was a guerrilla outpost, and its presiding genius was Andy Warhol.

In 1957, Warhol won the Art Directors Club Medal, "the citation noting particularly his shoe advertisements."[5] A few years later, he was the most notorious artist in America. This confirmed the worst fears of the critical gatekeepers. He was their opposite in every way. They were mostly Jewish; he, and most of his entourage, were Catholic. They liked to talk; he was famously silent. They sought depth; he lingered on the surface. They worshipped learning; he dandyishly held aloof. (One of the best-read visual artists of his generation kept his reading a "closely held secret.") They professed to loathe commercial values and culture, while he had nothing against money, and reveled in tabloid celebrity. "All is pretty," he blandly affirmed, soaring on amphetamines, chewing on his endless sticks of gum.[6]

He was, in a phrase, against interpretation. And though this inevitably made him one of the most interpreted artists of modern times, his dedication to surfaces was not an affectation. It was a strategy for survival, and one Susan instinctively would have understood. She warned against having two selves, but she also realized that through writing she could create a new self, a metaphorical self, that could protect the "weakling" within. Warhol had reached a similar insight. If Andrew Warhola was introverted, pallid, stammering, exceedingly phobic, and—not coincidentally—homosexual, Andy Warhol was a famous person: a persona.

His presence turned a party into a scene. His gaze turned a soup can into a masterpiece, and a street hustler or a strung-out

heiress into an icon. The names of his Warhol Superstars—Penny Arcade, Candy Darling, Ultra Violet, Rotten Rita—testify to Warhol's view of self-transformation as drag, people and objects transformed "into the image, par excellence, of a subterranean world of beautiful people and geniuses and poseurs, the obsessed and the bored, come at last into their glamorous own."[7]

He had made himself into one of his own objects, Stephen Koch wrote: "tawdry and brilliant, unmistakable, instantly grasped, but with a resonance that kept flickering at the edges of attention, his image seeming to build meanings that then fell away like static in fantasy that seems to come and go at once." He did the same for others. He made "Screen Tests" of hundreds of people, famous but mostly not, who got off the freight elevator and entered the silver hall. "That was Warhol's gift," Koch wrote. "He made everybody in his world watched. And what is being watched has a meaning, even if it's only the meaning of being watched."[8]

———

By the time she turned up at the Factory, "Warhol already had it on good authority that Sontag didn't care much for his paintings and distrusted his sincerity." Warhol had no interest in her critical opinions, and would never have let on if he did. He was interested in a "good look—shoulder-length, straight dark hair and big eyes, and she wore very tailored things."[9] As Warhol spoke encouraging banalities in his fey voice, she did seven four-minute Screen Tests.

"Oh, wow," he said, as Susan slouched, legs spread wide, in a chair.

Hidden behind sunglasses, she struck a butch pose.

"Smile," he said. "Say cheese."

The longer she was watched, the more restless she grew. She shifts in the chair; the playful joking peters out. As the camera

whizzes away, we see this woman, with all her boldness and beauty and affectation, being turned into a superstar, which is to say: a commodity, devoid of life. This objectification was Warhol's way of aestheticizing death, with which he was obsessed, and from this obsession he drew a shocking conclusion. By objectifying its imagery (Mrs. Kennedy in her widow's veil) and its creepiest modern instruments (the electric chair), he could aestheticize even the most immitigable human fears.

This was the attraction of stardom. He wanted to transform his own jittery self into the figure of the modern celebrity, "to remove himself from the dangerous, anxiety-ridden world of human action and interaction, to wrap himself in the serene fullness of the functionless aesthetic sphere," wrote Koch, a prominent critic of Warhol.

> Desiring the glamorous peace of existing only in the eye of the beholder, he tries to become a celebrity, a star, making no bones at all about his preference for objecthood over being human. "Machines have less problems," he once told an interviewer. "I'd like to be a machine, wouldn't you?"[10]

———

A year before her visit to the Factory, Susan had not been a celebrity. She had been a young writer making a name for herself. She published her novel. She published her essays. But *The Benefactor* and reviews of Simone Weil were not the stuff of which celebrities were made. In the summer of 1964, she made her third visit to Europe. In Paris, she wrote "Notes on 'Camp,'" published in the fall 1964 issue of *Partisan Review.*

Even before it appeared, it was divisive. William Phillips, one of the two editors of *PR,* loved it. The other, Philip Rahv, "had no use for her"[11] and no use for the essay. As soon as it hit

the newsstands, it unleashed a parallel reaction in society. Susan found herself in *Time* magazine, and *The New York Times Magazine* noted that "immediately both the intellectual and the not so intellectual world was suddenly abuzz about Camp." To that, a *Times* reader, Mrs. Roberta Copeland of Philadelphia, sternly riposted that "if the concept of Camp is to be allowed to enter the mainstream of our cultural life, with the blessing, no less, of the *New York Times,* then I think our society is headed for a moral collapse unlike anything we've ever seen."[12]

The *Times* article described camp as "anything that might be described as 'mad,' 'crazy,' or '*funsville*.'" What was so bad about funsville? Hilton Kramer, an art critic who knew Susan from *Commentary,* explained that she was making "the very idea of moral discrimination seem stale and distinctly un-chic," collapsing fundamental distinctions. James Atlas wrote: "Works that were popular but serious, that occupied the middle ground . . . posed a threat to the sanctity of high culture."[13] This was Philip Rahv's objection: "He saw her as an enemy of the high culture," said Norman Podhoretz.

Sontag rarely bothered to contend with these objections, or to address the many misunderstandings her essay spawned. "Camp taste . . . still presupposes the older, higher standards of discrimination," she pointed out later, in a rare reference to the essay. And it was these standards that stood "in contrast to the taste incarnated by, say, Andy Warhol, the franchiser and mass marketer of the dandyism of leveling."[14] To read *Against Interpretation,* Sontag's first book of essays, where "Notes on 'Camp'" was published in book form in 1966, is to ask: If this woman is an enemy of high culture, who could possibly be its friend? But Mrs. Roberta Copeland, one suspects, was not worried about the mass marketing of the dandyism of leveling.

Though short—sixteen pages, a little more than six thousand

words—"Notes on 'Camp'" is the product of years of reflection. A draft surfaces six years before its publication in *Partisan Review*, during her trip to Greece in 1958. Its title announced the theme that, as Mrs. Copeland surely suspected, was behind the one Sontag ultimately chose: "Notes on Homosexuality."

> Homosexuality and narcissism. Concern with clothes, with ageing, with beauty. Ricardo making H. and me go with him to the department store at Sevres Babylon [*sic*] to buy wrinkle-cream for his eyes. [He + H. speaking together in Spanish—she pretending to be the buyer, had to ask him, "Do you like this?" "Would you rather have that?"—thinking the salesgirl didn't understand.] The faggot on Astir Beach who continually runs his hands through his grey-rinsed hair. Bruno's blue silk cravat, his rings, his shame at balding.
>
> Homosexuals are extraordinarily vain. Concern with being beautiful. Obsessed by idea of getting old. If you are ugly or old, you have no pay, no one wants you. (Ricardo said.) No one finds an old queen attractive. Not like lesbians who look for "character" more than "looks."
>
> Homosexuals and chic—faggots always to be found in the chic part of the bar, e.g. Zonar's. Or in chic resorts, e.g. the Mediterranean islands (Capri, Ischia, Mykonos + Ydra + Poros).
>
> Homosexuality has a more developed world than lesbianism. Phenomenon of "camp" taste. (Kitsch = sentimental, cheap). The super-snobbery of liking what is vulgar—more than "liking" it, being mad about it. Elliott Stein: digs opera, horror movies, artless pornography, odd newspaper stories and montages of newspaper headlines, holidaying in Lourdes—
>
> Faggot taste in interior decoration (bars, Sandy + Mary's apartment): stripes—black, white, red; painted plates, In-

dian rugs, modern furniture, blue + pink Picasso-type paint-
ings (acrobats, sad youths), coasters for the glasses. . . .

The attractiveness of homosexuality for me—the element
of parody, of masquerade, the melange of wit and bathos.

Members of a secret society, with succursales—bars—in
most cities. The game of recognition. Is he one or isn't he?
(H. and I call it bird-watching.) Main clues are visual ges-
tures and dress. The unmistakable ass-wiggling, soft-footed
walk of the faggot. . . .

Two forerunners—extreme types of female emancipa-
tion: the courtesan and the lesbian.

Serious possibility of improvising and breaking away from
set conventions of the erotic relationship—male and female,
dominator and dominated—if both people are of the same
sex. This possibility exists, promisingly. But most homosex-
ual couples only parody the heterosexual coupling. . . .

Homosexuality a criticism of society—a form of internal
expatriation. Protest against bourgeois expectations. . . .

Homosexual speech: (1) high-pitched, heavily accented
voice, flapping hands and other between-the-wars manner-
isms of English upper class women. "Dahling, whenever did
you get back from Istanbul." . . .

Colonel Veloutis—in his sixties, silver hair, pink skin,
plump, soft mouth, faggoty army shirt with phallus cuff-
links. Talks of ancient Greece.[15]

Behind the stereotyping, there is admiration for lives con-
structed outside the "bourgeois expectations" against which she
herself was in revolt. This was homosexuality as resistance to the
conventional relationship Susan was ready to escape, a few weeks
before she returned to California to tell Philip their marriage was
over. It was the sexiness of a secret society like the one she had
frequented in Los Angeles, whose denizens were as thrilled by

avant-garde films as by illicit hookups. And, as the "faggots . . . in the chic part of the bar" suggested, it was homosexuality as—to use a Warholian word—*glamour.*

This glamour depended on codes only known to its initiates. And it was those codes that Susan Sontag, with her keen understanding of "the difference between the outside and the inside," revealed in "Notes on 'Camp.'" She was well aware this was treason. "To talk about Camp," she wrote, "is therefore to betray it."

————

"Notes on 'Camp'" was effective at the time, and remains effective now, for the feeling it gives: of insiderness. Like so many of Sontag's best writings, it is a list, a guided tour. She patiently explains why Cocteau is camp but not Gide; Strauss but not Wagner. Caravaggio and "much of Mozart" are grouped, in her ranking, with Jayne Mansfield and Bette Davis. John Ruskin effortlessly sidles up alongside Mae West. Sontag's ability to make apparent previously invisible connections is what makes this essay—along with its prankishness, its mischief, and its humor—a work of critical genius.

It is a calculated blurring of boundaries, typified by camp's fondness for the epicene: "What is most beautiful in virile men is something feminine," Sontag declares. "What is most beautiful in feminine women is something masculine." The camp sensibility undermined hierarchies. She attributes to Oscar Wilde, to whom the essay is dedicated, "an important element of the Camp sensibility—the equivalence of all objects." This meant an attack on critical authority: in their own house organ, an attack on the Family. Hilton Kramer felt this did nothing less than open the floodgates to the "spiritual bankruptcy of the post-modern era." He thundered that Sontag "severed the link between high culture and high seriousness that had been a fundamental tenet of the

modernist ethos. It released high culture from its obligation to be entirely serious, to insist on difficult standards, to sustain an attitude of unassailable rectitude. . . ."[16]

He never forgave her.

But hidden in "Notes on 'Camp'"—not, it must be said, well hidden—is a still more aggressive contention. Camp, as Sontag posited it, was not about leveling: *au contraire*. It meant the establishment of a new hierarchy. The true "aristocrats of taste," she proclaimed, were homosexuals. Their "aestheticism and irony," alongside "Jewish moral seriousness," made up the avant-garde of the modern sensibility. More than a coded assertion of equality, this was a bald statement of homosexual superiority.

The idea that gay people were inferior to straight people was as generally unquestioned as the idea that women were inferior to men, or blacks to whites. And it was this that made "Notes on 'Camp'" as threatening as black nationalism was to white supremacy or the birth control pill—approved in 1960—to male supremacy. To see gay people taking charge of aesthetics meant they would be in charge of the ways they would be seen, another of the "revolutions of feelings and seeing."

If Warhol and Sontag triumphed, the old hierarchies would crumble. To study the subsequent history of the culture wars is to see how fiercely, and for how long, those hierarchies would be defended.

————

When "Notes on 'Camp'" appeared, gay people were assumed to be sick, deranged, and perverted. On May 19, 1964, only months before "Notes on 'Camp,'" the *New York Times* ran a piece entitled "Homosexuals Proud of Deviancy," in which phrases like "sexual deviants" and "sex inverts" were used as interchangeable synonyms for "homosexuals." (The deviants, the report announced, were increasingly militant, and "seem to have taken to writing

autobiographies.")[17] In 1969, Donn Teal—writing, as he then had to, under a pseudonym—published a pioneering bit of criticism entitled "Why Can't 'We' Live Happily Ever After, Too?"

> Much like the American Negro of 20 to 30 years ago who saw himself on stage and screen—and read about himself in novels—as Ole Black Joe or Prissy or Shoe Shine Boy, the American homosexual has a complaint: He does not believe his life must end in tragedy and would like to see a change in his image.[18]

This change was coming. The feminist critic Carolyn Heilbrun remembered her shock at learning that Gertrude Stein was a lesbian.[19] "Even Allen Ginsberg's sexuality was not discussed," said Stephen Koch, who himself was bisexual. "And not known by most people who knew anything about Allen Ginsberg. Even though he wrote about it."[20]

To see that sexuality, so obvious in retrospect, required a "revolution of seeing." That revolution was coming, thanks in large part to the inverts the *Times* piece cited. "There was a new element of freedom," said Koch. "There was a new level of permission in the air for which the crowning achievement was 'Notes on "Camp."'"

———

That permission had not quite won the day. On April 13, 1964, in *The Nation*, Susan published a short review of a new experimental film called *Flaming Creatures*. Despite its duration (forty-three minutes) and budget (three hundred dollars), the film, by a gay artist named Jack Smith, excited the censors. The racist South Carolina senator Strom Thurmond weighed in, and so did a Catholic antipornography outfit called Citizens for Decent Lit-

erature. But the climate was no longer quite as deferential, and Smith, only a couple of months older than Susan, was the kind of downtown personality now emerging into broader awareness.

Her review opened with an impatient brushing-off of the more tiresome objections:

> The only thing to be regretted about the close-ups of limp penises and bouncing breasts, the shots of masturbation and oral sexuality, in Jack Smith's *Flaming Creatures* is that they make it hard simply to talk about this remarkable film; one has to *defend* it.[21]

She did defend it, and not only with appeals to the "poetry of transvestism" or the "poetic cinema of shock." In June, she was summoned to court to defend Jonas Mekas, the critic who had been accused on charges of "showing an obscene film." The film was *Flaming Creatures,* which Mekas had shown at the New Bowery Theater in New York. Sontag was the only expert witness allowed to testify at any length, the *Village Voice* reported, because the lawyers on both sides were intrigued by her definitions of pornography. "That which aroused sexual interest," she offered, uncontroversially, stressing intent and context. Then, pressed to give examples, she answered in a way that hearkened back to her discovery, as an adolescent, of the pictures of the Nazi camps, and that looked forward to so much of her later work: "She referred to posters outside Times Square movie theaters that advertise war movies with sadistic atrocity pictures." This definition appeared to clash with her previous description of pornography as something that aroused sexual interest, but her definitions had no impact. Mekas was convicted, along with the projectionist and a woman taking donations. (A fourth defendant, the ticket-taker, was let off.)[22]

In her essay, Susan wrote that "there are some elements of life—above all, sexual pleasure—about which it isn't necessary to have a position." That was not quite true. Certain sexual pleasures, above all those she would suggest with the word "camp," inspired certain people to call the cops. Sontag herself harbored doubts about homosexuality, both attracted to and repulsed by the "camp" view. In her essay, she had praised *Flaming Creatures* as "a triumphant example of an aesthetic vision of the world." The aesthetic vision—world as representation, world as metaphor, world as camp—was one about which she had decidedly mixed feelings.

———

In later years, this ambivalence would be extended to "Notes on 'Camp'" itself. The writer Terry Castle recalled an incident at a dinner at Stanford in 1995, when another guest remarked that he admired "Notes on 'Camp.'"

> Nostrils flaring, Sontag instantly fixes him with a basilisk stare. How can he say such a dumb thing? She has no interest in discussing that essay and never will. He should never have brought it up. He is behind the times, intellectually dead. Hasn't he ever read any of her other works? Doesn't he keep up? As she slips down a dark tunnel of rage—one to become all-too-familiar to us over the next two weeks—the rest of us watch, horrified and transfixed. Now the offending interlocutor is a person of no little eminence himself—the inventor, in fact, of the birth-control pill. He is clearly not used to having women tell him to shut up and be ashamed of himself.[23]

It was a reaction that many ham-handed individuals would receive over the years, and its melodrama, redolent of Joan Craw-

ford, would eventually thrust Sontag herself into the first rank of camp divas. But like the overwrought reaction that greeted the original publication of the essay, Sontag's histrionics suggested a more profound conflict.

In the second paragraph, she had written: "I am strongly drawn to Camp, and almost as strongly frustrated by it."[24] In the version published in *Against Interpretation,* as if to increase her distance, she made this more emphatic: "I am strongly drawn to Camp, and almost as strongly offended by it." If "Camp" is substituted with "homosexuality," as in the title of the piece, the conflict becomes obvious. "Too obvious," in Castle's words, "about her own erotic orientation: the gay 'coding' and the in-jokes too blatant for comfort." She was conflicted about the piece because it was about homosexuality: because it was about her.

Still, as long as it remained an in-joke—read by the Family and a handful of culturally ambitious hinterlanders—it was harmless. Once it wandered off the reservation, it became dangerous for another reason. If Sontag could be said to have a life project, it was to escape the feeling of fakeness she had identified in herself as a teenager. She wanted to become an authentic person, more physical, less cerebral. She wanted "to *see* more, to *hear* more, to *feel* more." And camp was "to understand Being-as-Playing-a-Role." It was "the farthest extension, in its sensibility, of the metaphor of life as theater." This was the metaphor that Andy Warhol pushed to its logical conclusion. Fearing the human, he embraced dehumanization.

"I want to be plastic," he said.[25]

And: "I'd like to be a machine."

Susan did not.

A decade later, in *On Photography,* Sontag would describe how people become images, how the individual is subsumed into the representation of the individual, and how the image and the representation—the metaphor—come to be preferred over the

thing or the person they represent. She wrote of "how plausible it has become, in situations where the photographer has the choice between the photograph and a life, to choose the photograph." It was this process that "Notes on 'Camp,'" for all its playful tone, examined, finding a modern name for a phenomenon Plato had described. "Camp sees everything in quotation marks. It's not a lamp, but a 'lamp'; not a woman, but a 'woman.'" What better illustration of camp than the gap between Susan Sontag and "Susan Sontag"?

In February 1965, only months after "Notes on 'Camp,'" Susan was spotted at Elaine's. This was a celebrity hangout on the Upper East Side, famous for its mediocre food, insulting prices, and ineffable glamour, whose proprietress, Elaine Kaufman, seated patrons according to her own ideas of their cultural importance. The few tourists or gawkers who made it past the maître d' were banished to a back room known as Siberia; the round tables near the door were reserved for initiates. This was the evening that she was seen dining with Leonard Bernstein, Richard Avedon, William Styron, Sybil Burton, and Jacqueline Kennedy.

Through a Chicago friend, Mike Nichols, the comedian and director, Susan had gotten to know the murdered president's beautiful young widow. Bookish, Francophile, and less than four years older than Susan, Jacqueline Kennedy—herself a favorite Warhol subject—would invite Nichols and Susan to her apartment and weep over her lost husband.[26] Susan was awed by Mrs. Kennedy's palatial surroundings. (She had thirteen living rooms, Susan told a friend: "You better not forget your cigarettes.") She was fascinated by the glimpses of the person behind the famous face and thought it was hilarious, she told another friend, that "Jackie kept saying 'fuck' all the time."[27]

It took Susan a while to learn the ways of this new world.

One evening, not long after she published "Notes on 'Camp,'" she was invited to the New York apartment of Marella Agnelli, a Neapolitan princess whose husband was the chairman of Fiat. The doorman directed them to the fifteenth floor. But as they were walking to the elevator, Susan realized he had forgotten the apartment number. She turned back to the doorman and said: "Excuse me, fifteen what?" Her companions burst out laughing, and one asked: "You think the Fiat heiress lives in 15G?"

Another evening, a limo brought her and her socialite friends to a famous nightclub. There was a crowd waiting to get in, but after one of her friends whispered to the bouncer, the group was immediately whisked inside.

Susan, impressed, asked: "What did you say?"

He answered: "I said we're with Susan Sontag."[28]

———

Susan was thirty-one when "Notes on 'Camp'" was published. "Suddenly one day, Susan Sontag, highbrow critic, little-magazine essayist, philosophical novelist and college professor, became a midcult commodity," Nora Ephron wrote in 1967.

The piece had been preceded by the essays she was publishing in the most prestigious magazines in New York, and by a novel that seemed to have been composed by some learned European. That the author of these complex works was a gorgeous young woman with a California accent was a source of constant comment; and when "Notes on 'Camp'" appeared, with its risky whiff of verboten sex, the popular media began to pay attention, too.

"Blame it on *Time Magazine*," Ephron wrote. "It spotted her 'Notes on Camp' when it was snug and safe in the *Partisan Review*, distilled and oversimplified the essay, and wrote about Camp and Miss Sontag as if the two were somehow symbiotic."[29] In early 1965, *The New York Times Magazine* devoted a long, heavily illustrated essay to "The Sir Isaac Newton of Camp." As soon

as "Notes on 'Camp'" appeared, "both the intellectual and the not so intellectual world was suddenly abuzz about Camp," and "the favorite parlor game of New York's intellectual set this winter has been to label those things that are Camp and those that are not Camp."[30] The article quoted grave warnings about its connection to homosexuality.

> "Basically, Camp is a form of regression, a rather sentimental and adolescent way of flying in the face of authority," an anti-Camp New York psychiatrist told a friend recently. "In short, Camp is a way of running from life and its real responsibilities. Thus, in a sense, it's not only extremely childish but also potentially dangerous to society—it's sick and decadent."

For Susan's career, this publicity was valuable, up to a certain point. She became someone who could be filmed by Andy Warhol and go to dinner with Jackie Kennedy. She herself became a symbol of New York; and like the first sight of the Statue of Liberty in the immigrant memoir, the first glimpse of Sontag became a set piece in twentieth-century American literary life. Already in 1968, Larry McMurtry imagined the highest peak a provincial writer could attain: "If he ever gets to New York," he wrote, "he may even meet Susan Sontag."[31] In 1968, Susan Sontag was only thirty-five.

In January 1966, when *Against Interpretation* was published, the *Times* reviewer Eliot Fremont-Smith could already call her "easily the most controversial critic writing in America today." She had not, he said, "crept modestly and hesitantly onto the intellectual scene." Rather, "she burst from nowhere amid something like a ticker tape parade—the ticker tape being her own very certain essays and reviews, and a quasi-surrealist philosophical novel called *The Benefactor*—and the ticker tape-throwers

being her publisher (Roger Straus) and the somewhat brassy, assertive and valuable junior members of the *Partisan Review-New York Review of Books* cultural coterie. Suddenly, around 1963, Susan Sontag was there—instead of being announced, she had been proclaimed."[32]

To Noël Burch, she said: "I have done everything I have to do to become famous."[33] She never spelled out what exactly that was; Stephen Koch, for one, was "haunted" by the question of why and how Susan became as famous as she did, and how she sustained that fame for decades, even through her most reader-unfriendly phases. At the beginning of her career, she was incongruous: a young woman who was intimidatingly learned; a writer from the hieratic fastness of *Partisan Review* who also engaged with the contemporary "low" culture the older generation abhorred, or claimed to. Yet her fame fascinated her friends because it was so unprecedented. She had no real lineage. And though many would fashion themselves in her image, her role would never be convincingly filled again: she created the mold, and then broke it.

But friends saw her ambiguous relationship to fame. It gave her the recognition that she had always craved, but it was dangerous for someone who was "perennially looking for [her] bearings in the opinions of others." Some of her early brushes with fame were comic. Soon after she began getting recognized in public, she and Don Levine were in a grocery store in the Village, and a besotted fan rushed up to say that Susan was one of her two favorite novelists. Susan was flattered; Don cringed, hoping she would not ask the question he knew was on the tip of her tongue. "Really? Who's the other?" The woman eagerly answered: "Ayn Rand."[34]

Stephen often asked her about how she had done it. "It's very simple," she told him. "You find some limb, and you go out on it." Yet friends found that Susan was not immediately changed. "She didn't mind looking ugly," said Don. "She had this natural appeal

that was unworked at, no makeup, no expensive clothes." Neither did she seem to savor attention. "I hate these things," she told Stephen at one glitzy party. "I just park myself near the food table and wonder when I should leave." She tried to protect the private self from the swirl of new obligations that came along with the increasingly powerful public self. A little sign by her phone reminded her: "NO."[35]

Surely—as when she grew annoyed that Bernard Donoughue had not noticed her cowboy boots—she worked at seeming unworked at more than she admitted. Yet so many people strive to make an impression, and those who knew her agreed that she had that mysterious inborn property that did not depend on how many parties she went to, or what she looked like, or how she dressed. "She had star quality," said David, "and she knew it." But she did not go as far as she could have. "She could have been more famous if she wanted to be. There were lots of publicity-seeking offers, in that first period when she burst on the scene: television things, and she never tried to write a Hollywood script, a whole bunch of things she could have done at that moment."[36]

———

She seized many of the opportunities her new position opened. She was magnificently, dazzlingly productive. She had always pushed her limits. "She would be studying and reading and she would read twenty-four hours nonstop," said Martie Edelheit, her friend from Chicago. "She'd be walking around absolutely blurry-eyed."[37] Ever since her teens, when she read *Martin Eden* and started trying to wake up at two in the morning, she endeavored to sleep less in order to achieve more. Now, as she was basking in the success that had eluded Martin Eden, she discovered amphetamines—speed—which seemed to eliminate the need for sleep entirely. The drug was the Factory favorite, its zenith coming in late 1965 and early 1966, precisely as Susan herself was

becoming prominent. Ondine, one of the Warhol Superstars, described the time.

> Oh, it was splendid. Everything was gold, everything. Every color was gold. It was just fabulous, it was complete freedom. Any time I went to the Factory it was the right time. Any time I went home, it was right. Everybody was together, it was the end of an era. That was the end of the amphetamine scene, it was the last time amphetamine really was good. And we used it. We really played it.[38]

Susan's drug dealers included W. H. Auden. She would go to his house on St. Marks Place and marvel at his ugly feet: "Often he was barefoot," she told an assistant, laughing, "and he had these horrible feet with corns and just . . . really gross feet."[39] But Sontag's amphetamine use was not stylish. "The one thing speed never was for us was cool," Don Levine said. "It was a work thing." For hours on end and for days on end, she and Don would work. "The only thing Susan would get up for was to pee or to empty the ashtray, or get her next coffee."[40]

Speed let Susan do what she had always done, but far more: "Susan liked to do as many things in one day as she possibly could," said her friend Gary Indiana, who, though a speed user himself, nonetheless marveled at her energy. "If she could go to Chinatown for lunch and then go to Bleecker Street Cinema to see a matinee and then go to Public Theater in Chelsea and then go to Times Square to see a double feature of kung fu movies, she would do it."[41]

"Writing is very hard," said the writer Sigrid Nunez, who lived with David and Susan for a while in the seventies. "And particularly that kind of writing. And it makes it so much easier to take the speed. She would take it, and then, in a much less painful way, she would get there. The only reason she did it was

because it made it easier, that's all." She later told Camille Paglia
that to finish her essays she simply stayed awake for two weeks.[42]

Weeks without sleep; cartons of Marlboros; bottles of Dex-
edrine, washed down by rivers of coffee: this may have seemed
normal for a person who liked to "pretend my body isn't there."
But as surely as a real person hides behind the image of a person,
the physical body, however firmly denied, asserts itself eventually.

Where You Leave Off and the Camera Begins

When, after her death, extracts from Sontag's diaries were published, many who knew her were surprised by the often-remorseless self-awareness they revealed. "I've always identified with the Lady Bitch Who Destroys Herself," she wrote, for example, in 1960.[1] "I'm not a good person," she emphasized in 1961. "Say this 20 times a day. Sorry, that's the way it is." A few days later, she added: "Better yet. Say, 'Who the hell are you?'"[2] She did not think she was bad, she wrote in 1965. Rather, she was "incomplete. It's not what I am that's wrong, it's that I'm not *more* (responsive, alive, generous, considerate, original, sensitive, brave, etc.)."[3] She noted other people's criticisms of her, but, citing "X," protested that she was not deliberately unkind: "Rather, it's that I'm dumb, insensitive."

For a person who suffered from "X," this was the real danger of fame. She needed other people to see herself, and without

them reverted to the self Irene identified: Mildred's daughter. "I hate to be alone because when alone I feel about ten years old," she wrote in 1963, shortly before "Notes on 'Camp.'" "When I'm with another person, I borrow adult status + self-confidence." After twenty-four hours alone on a trip to Puerto Rico, she was confronted with "the 'real me,' the lifeless one. The one I flee, partly, in being with other people. The slug. The one that sleeps and when awake is continually hungry. The one that doesn't like to bathe or swim and can't dance. The one that goes to the movies. The one that bites her nails."

This was not Sontag.

This was not even Susan.

"Call her Sue," she concludes.[4]

"It's hard to tell where you leave off and the camera begins." She would quote this line, from a 1976 Minolta ad, in *On Photography*. "When you are the camera and the camera is you." It was a distinction that was hard to draw: "real me" vs. self-for-others, the others whose eyes lent life to "the lifeless one." But fame seemed to offer a solution to her besetting loneliness. A constant influx of people kept "the slug" at bay. Amphetamines warded off "the one that sleeps."

———

The sheer numbers of new people that entered her life at this time kept her occupied. They included students from her days at Columbia, where she taught until 1964, people like Koch and Levine. They included the literary circles around Farrar, Straus, *Partisan Review*, and *The New York Review*. And they included older artists attracted to her charisma: Warhol, briefly, but also Joseph Cornell, whose relation to fame offered a poignant counterpoint to Warhol's.

Cornell sent her a range of paraphernalia in the last years of his life, little objects that seem to have crept out of his dreamlike

world. There is a card printed with a quote from John Donne, Victorian photographs, a yellow feather, a sheet reading "Dear Susan" that incorporated a leaf into her first initial, old letters in an elegant Greek hand, and a book he published in 1933: *Monsieur Phot,* short for *photographie.* There are kind notes with playful names, "Suzanne Dimanche" and "Miss Henriette Sontag" and "David Sontag." Sometimes he signed them "Jackie Derequeleine"; sometimes, even, "Hippolyte."

It was *The Benefactor* that brought him into Susan's life. She suggested that he would have identified with her protagonist, who "lives entirely in his head and in his dreams." But Cornell was captivated by the picture of the author more than by the text. "He was fascinated by photography," she said, "but what was important in photography was people. He was fascinated by stars, he was fascinated by the romance of the performer." He noticed "that my last name is the same as the last name of a very famous 19th century performing artist, a soprano, who was one of the great divas of the first half of the 19th century along with Maria Malibran and Pauline Viardot, and her name was Henriette Sontag. . . . She was a great diva and there are some wonderful images of her, and so he made a connection between me and this famous soprano."[5]

Warhol shared these fascinations; his library was full of books about divas. But the contrast is otherwise complete. Warhol's art refused depth, aggressively affirming the surface, "tawdry and brilliant, unmistakable, instantly grasped."[6] Cornell's was all suggestion. His characteristic form was a quiet little box; his characteristic surface a glass, transparent but nevertheless blocking entry to the objects arranged behind it. Behind the glass were compositions as oblique as baroque still-lifes: "against interpretation" not because, as in Warhol's art, there was nothing one *needed* to understand, but because, in Cornell's, there was nothing one *could*.

Warhol collected celebrities; Cornell, their images. These

bore only the vaguest relation to the people themselves: photographs were hieratic objects, showing people impossible to know or possess. He was, Susan said, a "classic example of the reclusive bachelor artist." He had

> the artist's temperament to an exquisite degree but he also has the temperament of the collector which is often not the same as the artist's temperament, in fact very often the collector is precisely someone who can't—who's fascinated by the beautiful but cannot create it, must collect it, but whose creative possibilities either don't exist or remain latent.

Susan later wrote that Thomas Mann was the first person she had met "whose appearance I had already formed a strong idea of through photographs." This is how Cornell's relationship with her began. "The images of people that fascinated him most of course were images of women, famous women, glamorous women," Susan said. "Some of the imagery comes from advertising and comes from popular magazines." This was exactly the case with Warhol, but Cornell's approach to these mythic women was very different. The picture of Susan on the back of *The Benefactor* became a collage, entitled "The Ellipsian." He had it delivered to her house, and others followed. "I did not answer his first communications," she said. "I just received them I think in the spirit in which they were written, that they were part of his relationship to the world and they didn't really require an answer." As they piled up, she grew alarmed by the value of the gifts.

At last, she wrote to say that she considered them loans, to be returned whenever he might need them; and in the ensuing correspondence he repeatedly invited her to visit. Unsure of his intentions, she hesitated, and when she eventually accepted, she brought David as protection from unwelcome advances. She need not have worried. "He was extremely beautiful," she remembered.

"A sort of transparent face and wonderful bones and incredible eyes. . . . You didn't feel his sexuality, you felt his delicacy and his refinement and the sweetness and he was magical." They sat in the kitchen; he put on a Jacques Brel record: "He said well tell me what the words mean, and I said oh I'm sure you know French, he said no no but it doesn't matter, I get the feeling. I know what it is."

He continued to send her letters and gifts, but they never met again.

———

Ratified by Warhol, rarified by Cornell—and photographed by a long list of the leading photographers of the day—Susan was also starting to be portrayed in fiction. The first recorded instance of Sontag-as-character came in an unfinished novel by Alfred Chester, *The Foot*. There, she appeared as "Mary Monday," and there were two Mary Mondays, Chester presciently observed: "the person and her image of herself."[7]

Chester's rise and fall made him a character out of a nineteenth-century French novel. Five years older than Susan, born in Brooklyn to Jewish immigrants, he was strikingly ugly: a childhood illness had left him entirely hairless, and the wig he wore to disguise his deformity succeeded only in calling attention to this condition. It was a totem, his British editor Diana Athill wrote, for his freakishness, his shattered life. "When the wig was first put on his head, he wrote, it was as though his skull had been split with an axe."[8]

But he was, as Gore Vidal said of him, "Genet with a brain." Despite his appearance, that brain made him indelibly attractive.[9] "What he wrote was too strange to attract a large readership," Athill wrote. "But he remains the most remarkable person I met through publishing."[10] After several years in Europe, Chester returned to New York. There, for a few years, he enjoyed a

Balzacian rise; there, through Irene, he met Susan, and became one of her closest friends. He encouraged her and shared his contacts when she first arrived in New York, and she, in turn, defended him when his book of stories, *Behold Goliath*, was trashed in *The New York Times Book Review*.

The reviewer, Saul Maloff, attacked Chester for mixing dream and nightmare in his fiction—a favorite mode of Sontag's—and also attacked Chester for the way he wrote about homosexuality. "What vagueness! What banality! What impudence!" Sontag thundered in a letter to the editor—adding, for good measure, that the reviewer was "pathetic" and "beneath contempt."[11]

In a great moment of self-reinvention, Chester had burnt his wig, and "talks about having a small cock + no pubic hair," she wrote. "He has always felt hideous, + now he talks about it, wants to talk of nothing else."[12] In the summer of 1965, she visited him in Tangier, where he was living among the druggy gay expatriates in the circle around Paul and Jane Bowles. She was repulsed. "And I thought it was all a joke," the author of "Notes on 'Camp,'" still alternatively attracted and repelled, wrote in her diary. "That obsessiveness, that heartlessness, that cruelty. The international homosexual style—God, how mad + humanly ugly + unhappy it is."[13]

Things went wrong almost as soon as Susan set foot in Morocco. Chester became convinced that Susan was trying to steal his boyfriend, although he also proposed marriage to her. Susan confided to one of Chester's friends that she had grown afraid of him physically.[14] Chester wrote a friend in New York that Susan's visit was, in a word, "catastrophic."[15] He became one of Susan's harshest critics. "How dare you say 'your friend S. Sontag?'" he wrote another friend. "You rat, she is my enemy. She is everybody's enemy. She is The Enemy."[16] Elsewhere, he wondered "if Susan is really a rat" before adding, murderously: "I think she is just very much at home in the world."[17]

But Susan began to suspect that Chester's attitude had nothing to do with distrust of her professional ambition, or her designs on his boyfriend. She noted the symptoms:

> "I feel the whole world is listening to everything I say"
> "Susan, what's happening? There's something very strange going on."
> "You're hiding something from me."
> "I think I have syphilis. Or cancer."
> "Susan, you look so sad. I've never seen you look so sad."[18]

He was, in fact, insane. Hearing voices, unable to write, chased out of Morocco, he died in Jerusalem six years later, aged forty-one, the neighbors alerted to his corpse by the baying of his dogs.

———

Eventually, after her trip to Morocco, Susan broke with Chester. But her journals from this time show that much of what attracted her to him was precisely his disdain for her.

> I always fell for the bullies—thinking, if they don't find me so hot they must be great. Their rejection of me showed their superior qualities, their good taste. (Harriet, Alfred, Irene.) I didn't respect myself. . . . I feel unlovable. But I respect that unlovable soldier—struggling to survive, struggling to be honest, just, honorable. I respect myself. I'll never fall for the bullies again.[19]

Many of the bullies, including Alfred, envied her. The timid, questioning soldier of her journals only appeared rarely to others, whom she struck as self-confident to the point of arrogance. But even as she was dependent on outside perceptions, they made only

a glancing impression on her perception of herself. She was, she wrote, "eternally surprised at the malice . . . of people I haven't harmed," among whom she classed Alfred Chester.

> I was (felt) profoundly neglected, ignored, unperceived as a child—perhaps always, until or with the exception of Irene—Even persecution, hostility, envy seem to me, 'au fond,' more *attention* than I feel myself likely to receive.[20]

Despite her successes, a sense of failure descended upon her; throughout her life, success would always unsettle her more than the failure her diaries reveal she thought she deserved. She was trapped, without past, present, or future. "She was not a woman with a past," said her German publisher, Michael Krüger. This might explain her interest in modern art, he speculated: "The beginning of her career was modernism, which had wanted to break entirely with the past."[21] The Israeli novelist Yoram Kaniuk made a similar remark. Susan was "without history," he said. "Susan rejected her history."[22] Of course, she had as much history as anyone else. But it is true that she had rejected her past, had difficulty being happy in the present, and was now finding it almost impossible to visualize, or to believe in, the future. When she left Europe, she was consumed with worry about the weighty steps she had to take upon her return to America. Now, her lacerating romantic impasses convinced her that her life was over.

> Have I done all the living I'm going to do? A spectator now, calming down. Going to bed with the *New York Times*. Yet I thank God for this relative peace—resignation. Meanwhile the terror underneath grows, consolidates itself. How does anyone love? . . . But I must not think of the past. I must go on, destroying my memory. If only I felt some real energy in

the present (something more than stoicism, good soldierliness), some hope for the future.[23]

———

In September 1965, Susan returned to New York from Paris, unsure what to do with herself. She had a girlfriend, Eva Kollisch, whom she had met through another friend from the downtown scene, Joseph Chaikin, who had founded the Open Theater in 1963 and became one of the most attractive young figures in the experimental culture that galvanized Irene, Alfred, and Susan Taubes. Eva was a refugee, born and raised in Vienna. She had been a Trotskyist, was married, and had a son roughly David's age.

"I admired her energy and passion," she said of Susan, "how much she could do. I found her very interesting, sort of wonderful and awful." Soon after they got together in 1962, Eva struggled, like so many of Susan's lovers, to escape. Susan seems never to have been entirely in love with her, Eva freely admitted. "I was never the important lover," Kollisch pointed out. "I was never the high-up-intellectual-circles friend. I was a college teacher."[24]

Eva saw the struggle between Susan, the woman, and Sontag, Athenian paragon. This was the struggle "to be honest, just, honorable" that she described when she was fourteen, when she asked "when and if a person ever tells the truth." Eva allowed herself to be enlisted in Susan's dishonesty. As late as May 1966, though she was already one of the best-known young writers in the country, Susan was basically unemployed and considered finishing her Ph.D. She wrote to the head of the Philosophy Department at Harvard to ask permission to reenroll.[25] She had to prove competence in two languages, and though she passed in French she got Eva to take the German exam in her place.[26]

But the dishonesty she feared had less to do with cheating on the German test than with some fundamental fraudulence

that was a source of constant suffering for those around her. Eva said,

> I've seen Susan in so many situations in which she could be really unkind to a person sitting right there and at the same time spouting very lofty ideals. I've never understood Susan's self-image. Who is she? She was addressing herself all the time, "Am I living up to this? Will I?" But who was she trying to live up to?[27]

As a teenager, Susan noted the damning presence of "that person who has been watching me as long as I can remember." It was that admonishing shadow, that better self, of whose rigid exigencies she was always falling short. For a person whose education had taught her that any life short of the Socratic was a failure, and whose upbringing had instilled in her a tyrannical ideal of moral perfection, the desire for purity was an inspiration, but it was also a terrible oppression. "There was very little freedom in Susan," Eva said. "It took away some of the joy to be with someone if you're always thinking of your epitaph."

———

"Susan was very interested in being morally pure," Eva said, "but at the same time she was one of the most immoral people I ever knew. Pathologically so. Treacherous." Without a Ph.D., Eva's career could not progress. She had a child and made little money, so she decided to write a dissertation. "I'm going to get you a scholarship from the American Association of University Women," Susan told her. This was the group that financed her year in England and France. "All I have to do is write them." She never did. Recounting this betrayal half a century later, Eva was still hurt. "It really pains me," she said. "There was something very wrong with Susan."

Susan's strengths and charms depended almost entirely on her determination to vanquish her shortcomings. Her profound desire to escape the flaws she meticulously cataloged created a productive psychological tension. Without a keen need to improve, she would have ended up, like so many other *ratés,* nursing her bitterness in obscurity. "What's wrong with projects of self-reformation?" she asked in her journals.[28]

Sometimes her attempts at self-reformation struck others as forced. Susan's indignation about Eva's dislike of seafood stayed in Eva's mind for the rest of her life, in part because it was such an odd thing to be incensed by. But Susan made a point of eating outrageous foods. During her first meeting with Stephen Koch, when he tried to impress her with his own esoteric selections, she wolfed down "hundred-year eggs," a sulfurous Chinese delicacy. In Marrakech, with her girlfriend Nicole Stéphane, she appalled the elegant Frenchwoman by eating snails covered with flies, straight from a market vendor.[29] She savored organs; she and Joseph Brodsky enjoyed chicken feet so much that when the dim-sum waitress failed to stop at their table to offer them more, they would chase after her cart.[30] One acquaintance described watching her eat as "scary." "I *like* excremental food," she told Koch.

In her journals, she listed intolerance of other people's tastes as a fault of her own. She noted with disapproval "my indignation at Susan [Taubes's] and Eva's physical squeamishness." She refers to her "ostentatious appetite—real need—to eat exotic and 'disgusting' foods = a need to state my denial of squeamishness. A counter-statement."[31] It was a way of separating herself from her fastidious mother: "Testing myself to see if I flinch? (reacting against my mother's squeamishness, as with food)."[32] Anything in Eva that reminded Susan of Mildred was attacked: "My mother had something beautiful (the Chinese furniture) but she didn't care enough to keep it. Eva didn't care enough about Kleist to buy his 'Collected Works.'"[33]

———

Yet in some ways—including one very devastating way—Susan strongly resembled her mother. After her death, when her diaries were published, Don Levine was stunned to come across a phrase from 1962: "I wasn't my mother's child—I was her subject, companion, friend, consort."[34] He was astonished because the description so closely resembled the one Susan herself had used when, not long afterward, he tried to broach a delicate topic. "Susan, do you really think it's such a good idea that you treat David the way you do?" he asked. "You don't understand," she answered. "David is my brother, my lover, my father, my son." Don realized there was nothing he could say. He simply thought: "That's going to be a disaster for him."[35]

Susan was young herself—in her early thirties—as David was entering adolescence. But her approach to raising him had long alarmed her friends. "Irene was jealous of David because that was the one part of my life she couldn't completely take over," she wrote in August 1965. "One thing I know: if I hadn't had David, I would have killed myself last year."[36] The phrase echoes Mildred's telling Susan that without her she would die. But Irene's real desire to "take over" her relationship with David was similar to Don's. She thought that Susan gave him a bad combination of too much latitude and too little attention, and told her so.

That was exactly Eva's opinion. "He was a very precious child and he had to adapt himself to whatever space she would give him," she said. "I think she shortchanged him of a lot of love and affection." The boy who was given the name of an image of Renaissance perfection was put in "a space with no baby. He had to be there at the ready to keep up an intellectual discussion with her. She was not there for him, and then she made demands on him pedagogically." She forbade him children's literature, insisting on Voltaire and Homer instead. "Always more, more. He had

to improve his intellectual stature so he could be a companion to her."

That was the pattern she had first created when drilling tiny Judith on state capitals; or insisting that dyslexic Irene read more; or, later, berating Annie Leibovitz for her ignorance of Balzac. David was her child, entirely dependent on her, and the pressure was intense. Others saw what she intended as praise and stimulus as a crushing burden. Everyone agreed that David was intelligent. But was he, as his mother liked to proclaim, "the second-greatest mind of his generation"?[37] "I thought it was awful," Eva said of her treatment of David. "She thought she was the world's greatest mother."

The strains began to show. At eleven, reading *War and Peace*, David despaired that "he would never write so well."[38] At thirteen, he was "an avid reader of books on the Boxer Rebellion and the Albigensian Crusade."[39] When Fred Tuten once came to visit Susan, David opened the door while she was getting dressed. "What are you doing these days?" Tuten asked, making small talk while Susan was getting ready. "I'm writing a novel about the Spanish Civil War," David replied. Tuten wanted to laugh, but instead asked whether David had read Hugh Thomas's book on the subject. "Of course," said David.[40] But if his interests were natural for a precocious boy, their display in the press reflected Susan's need to present her son as a great intellectual—an extension of herself. In contrast to his mother, David was not ostentatious, particularly in high school: "His intelligence was never something that he wanted to be the first thing that you would see," said a friend.[41]

When he was little, David longed for attention from his itinerant mother. "She devised this phone, paper cups and string," said Ethan Taubes, Jacob and Susan Taubes's son. "She would say: Pull the string from my room to your room, you'll know that I'm there. You won't feel night terrors."[42] But she was not always

there, even when not abroad or amorously intertwined. Once she
told Don Levine that she had gone to pick him up from a visit
to a schoolmate, and he was gobsmacked by this hitherto unre-
marked interest in parenting.

> This is not Susan. Why is she going to pick up her son? I
> didn't say anything. When she came back she put David to
> bed and then she said, "Guess what? I knocked on the door.
> It was the Dakota." I thought maybe that's why. She wanted
> to be inside the Dakota. She knocked on the door, and who
> opened the door? . . . Of course she knew who was opening
> the door. Lauren Bacall.[43]

Eva "loved David. I thought he was a very tender-hearted
person." (She added: "He would not recognize himself in that de-
scription.") What Don found revealing about Susan's oft-repeated
comment about his growing up sleeping on a pile of coats at par-
ties was not that she did it, "but that she made it a part of her told
life, found it quite enchanting, exploited it."

Susan thought she was giving him the cultural advantages
of which she had dreamed during her desert childhood. But the
emotional landscape was the same. She had not had a father, and
neither did David. Mildred left her daughters to travel; Susan
did the same. Even when she was home, Mildred was often too
involved in her own dramas to pay much heed to her daughters:
Susan was the same, and it is remarkable how rarely David is
mentioned in the roughly hundred volumes of her journals.

Only when Susan seemed bound to leave did Mildred show
how important she was to her. Susan, using her middle name, de-
scribed this dynamic in an early piece of autobiographical fiction:

> When Lee was fourteen, her mother began to turn to her
> with a suddenly awakened flow of maternal love and depen-

dence, and Lee fled home in guilt and anguish the next year
to go away to college.[44]

Once he grew old enough to leave her, Susan did the same to
David. "Susan was not obsessed with me as a child," he said. "She
became much more involved with me in her head when I was
a teenager."[45] Her hands-off parenting gave him enviable advan-
tages. She left him all but by himself during her many long visits
to Europe; he stayed with neighbors or friends.[46] In ninth grade,
indulging his interest in archaeology, she did not bat an eye at
allowing him to travel unchaperoned through Peru with only a
friend his age and "names of people to look up in Lima."[47] In high
school, she let him travel with friends through Pakistan, Afghan-
istan, and Iran. But in return for all Susan Sontag could offer her
son—far more than "poor Mildred" could ever offer Susan—she
determined to keep him by any means necessary.

"She needed somebody," Stephen Koch said. "And that need
extended to David to a sinister degree. She set out to see to it that
he couldn't escape her." When he tried to get away, she said, "I'll
outflank him."[48]

In early 1965, Susan began a relationship with Jasper Johns. Like
many of the men she had affairs with, Johns was mostly gay;
and as with most of the men Susan was involved with, the rela-
tionship was brief. And—as with all the men she was involved
with—Johns was supremely talented: "My intellectual and sexual
feelings have always been incestuous," she said.[49]

Johns's philosophical preoccupations harmonized perfectly
with her own—and, at least at first glance, with Warhol's. Johns
and Warhol were born to obscure provincial families within two
years of each other. Both "arrived" on the New York art scene
in the 1950s, and both stood firmly in the tradition of Marcel

Duchamp, who had plucked objects from the rubbish and placed them in the museum. Warhol painted tins of Campbell's soup and bottles of Coca-Cola; Johns, Savarin coffee and Ballantine ale.

But where Warhol refused interpretation—for him, a picture of Elizabeth Taylor was exactly that—Johns masked the "real" meanings of his paintings, which refused interpretation not because, as with Warhol, they had no hidden meanings, but because their creator refused to reveal them. "I tried to hide my personality, my psychological state, my emotions,"[50] he said of his early work. "Playfulness with masks" was the key to Susan's own work, too.

Painted in 1954, *Flag* came to him in a dream. "I have not dreamed of any other paintings. I must be grateful for such a dream!" he exclaimed in an explanation redolent of Hippolyte. "The unconscious thought was accepted by my consciousness gratefully."[51] Seen up close, the apparently straightforward image dissolves, and all one can see behind the paint are newspaper clippings. The attentive viewer will try, and fail, to piece them together, as one might try to connect the mysterious objects in a Joseph Cornell box. The only entirely comprehensible symbol is the flag itself, one whose clichéd familiarity let Johns focus exclusively on painting it, forcing the viewer to try—and fail—to discover some other meaning beyond the obvious symbol. "It remained the most interesting point about Johns," the critic Leo Steinberg wrote, "that he managed somehow to discover uninteresting subjects."[52] For Susan, this uninterestingness was a virtue, implying a refusal of the easy accessibility she associated with commercial entertainment.

Most of the interesting art of our time *is* boring. Jasper Johns is boring. Beckett is boring, Robbe-Grillet is boring. Etc. Etc. Maybe art *has* to be boring, now. (Which obviously

doesn't mean that boring art is necessarily good—obviously.)
We should not expect art to entertain or divert any more.
At least, not high art.[53]

Flag's uninterestingness and illegibility made it irresistible to
critics, who plastered it with the very interpretations it deliber-
ately thwarted. They posed a classic question—a classical ques-
tion, indeed: derived from Plato—that animated much of the art
of the day: Was *Flag* a flag, or was it simply the image of a flag?
Johns answered that it was both. With that, he addressed a ques-
tion that had preoccupied philosophers for centuries: Could a
thing be both itself and a symbol of itself?

In later years, he would paint objects whose contents were de-
liberately obscured—books that could not be opened, newspapers
that could not be read, canvases with their backs turned toward
the viewer—all hinting at some unknowable meaning. In lieu
of that content, viewers projected their own interpretations onto
them, which could be neither confirmed nor denied. In this case
as in so many others, the questions (Can language and metaphor
be transcended?) were far richer than the answers (So *that's* what's
on the second page of that newspaper!).

But the answers meant a possibility of making art that might
overcome the divisions postulated by the gnostics. Such art, as
in the performance Susan witnessed of *Medea,* could dissolve the
boundary between art and life, mind and body, image of self and
self.

———

In the 1950s, when he was producing these works, Johns's lover
was Robert Rauschenberg, who made his name with vast "empty"
paintings. One was all black, another all white. John Cage, who,
with his partner, Merce Cunningham, completed this circle of

young artists, responded to them with his famous piece of 1952, *4'33"*—four minutes and thirty-three seconds of silence. He described Rauschenberg's monochromes as "'landing strips' for dust motes, light and shadow."[54] But dust motes, light and shadow, were not the only things that could land on such tabulae rasae. Interpretations, too, could be cast upon their apparently closed surfaces. And Johns appreciated Susan's.

"I don't think I could have easily connected my feelings about my work to the Supremes," Johns said. "Her ability to make such connections was very attractive."[55] In her journal, she wrote that the "Feeling (sensation) of a Jasper Johns painting or object might be like that of The Supremes."[56] A version of this line appeared in her essay "One Culture and the New Sensibility":

> If art is understood as a form of discipline of the feelings and a programming of sensations, then the feeling (or sensation) given off by a Rauschenberg painting might be like that of a song by the Supremes. The brio and elegance of Budd Boetticher's *The Rise and Fall of Legs Diamond* or the singing style of Dionne Warwick can be appreciated as a complex and pleasurable event. They are experienced without condescension.[57]

This dry passage set off disproportional reactions. "The lady swings," Benjamin DeMott exclaimed, with mingled admiration and mockery, in *The New York Times Book Review*. "She digs the Supremes and is savvy about Camp. She catches the major Happenings and the best of the kinky flicks. . . ."[58] The mention of the Supremes would be wielded against her for decades, as an illustration of her enmity toward high culture ("The Supremes, for Christ's sake?" gasped Norman Podhoretz) and as an illustration of a supposed hipness she later abandoned. Twenty-seven years later, her friend Larry McMurtry defended her against an attack:

She occasionally says that she likes rock music, and it's also true that in "One Culture and the New Sensibility," an essay published in 1965, she speaks appreciatively of Dionne Warwick and the Supremes, but does this constitute an "interest" that she can be said to have "dropped," if indeed she's dropped it? Perhaps she still likes the Supremes.[59]

If Johns was attracted to Susan's ability to make these connections, they rubbed many people the wrong way. What later became known as Cultural Studies was then in its infancy, and examinations of the difficult relationship between commercial art and high art were often seen as "leveling." But between the Warhol idea of no interpretation and the Johns idea of no *possible* interpretation, Susan Sontag would soon come up with an even more attractive idea: of being against interpretation.

———

In Johns, Susan found the same characteristic that she often appreciated in men: he was a master—a teacher, like Hutchins at Chicago, who could give her the "right way." Stephen Koch said that

> Jasper is as dominating, as egotistic, as ready to assume that anyone around him is going to take a secondary position, as the most besotted heterosexual alpha male who ever lived. So it's not like she found in Jasper the sensitive man that would let her flourish as the dominating personality. That wasn't it at all. She was very aware that Jasper *never* conceded anything but first place. That turned her on.[60]

Susan's desire to submit to superior influences was surely more important than whatever erotic dynamic bound them. Because Johns was a man, Susan could be in his thrall intellectually and

artistically while remaining emotionally insulated. Her journals
record none of the hand-wringing that makes it so agonizing to
read about her relationships with women. When Jasper dumped
her, he did so in a way that would have devastated almost anyone.
He invited her to a New Year's Eve party and then left, without
a word, with another woman. The incident goes unmentioned in
her journals.[61]

The brief relationship had a practical legacy. He left her the
lease on his penthouse at 340 Riverside Drive, on the corner of
106th Street. All bright sunlight, wide terraces, and broad views,
it would have been entirely unaffordable for a later generation
of writers with Sontag's income; but in the scruffy city of those
years, the rent was reasonable, and when Johns moved out, Susan
moved in. There was just one drawback. Johns had created elabo-
rate preliminary sketches for his paintings directly on the walls.
The apartment was littered with these drawings, and the new
tenant had to decide what to do with them. Choosing the sim-
plest option, she had them painted over.[62]

God Bless America

Three emblematic figures of the sixties—Joseph Cornell, Andy Warhol, Jasper Johns—offered Susan new ways of looking, and of understanding what she saw. But *Against Interpretation,* published in January 1966, her own reflection on what we do with what we see, was dedicated to a fourth artist, Paul Thek, whom she called, after his death, "the most important person in my life."[1]

Today, the works of Cornell, Warhol, and Johns sell for tens of millions. Thek's do not. His sculptures of raw meat and severed body parts, reeking of chthonic sacrifice, destined him to minority status. But if connoisseurs like Sontag admired him fanatically, this was precisely because, like Artaud, he was never assimilable. Indeed, many of his most remarkable works no longer exist: they were temporary constructions that, like dances, survive only in photographs. To describe them, he coined the word "installation."

Many sixties artists—including Sontag—were determined to undermine the consumerist society they loathed. Thek was one of

the few principal artists of the period who succeeded. "Now high modern art is establishment art," Sontag lamented in 1980. "It turned out that high modernist art, far from being subversive, was perfectly compatible with the consumer society."[2] Thek, by contrast, approached painting and sculpture directly, in the body, like music or dance, and enthralled Susan, anxious to escape her head. He joined the long list of gay men she went to bed with, though their friendship was far from harmonious: Thek once accused her of "reeking of garlic and data."[3]

Nevertheless, Thek was the only man besides Philip with whom she discussed having a child. And it is easy to imagine a child that inherited equally from mother and father as a perfect union: of Susan's intellectualism and Paul's sensuality. Each possessed—in extreme proportions—what the other lacked.

———

"Instead of a hermeneutics we need an erotics of art," Susan wrote at the end of her essay "Against Interpretation." The words were hers. But the title, and the idea, was Paul Thek's. In an intellectual culture so heavily saturated with Freud and Marx, who offered vast and complicated keys to personality and society, the emphasis on immediate experience was welcome, exciting, and of a piece with the decade's other liberations. There were political liberations (black liberation, women's liberation, gay liberation) at home, and of colonized peoples abroad. In philosophy and sociology, there was a plea for the kind of "erotic civilization" that Marcuse proposed. This had its counterparts in music, from the Beatles to Bob Dylan, and in every area of cultural life: Vidal Sassoon banished teased hair set on rollers; Yves Saint-Laurent introduced a new informality even to Parisian couture.

In popular culture, this movement was symbolized by the hippies and the flower children, who had dropped out of the hierarchy symbolized by the culture of Sherman Oaks. The hip-

pies were even younger than Susan. She was thirty-one in an age whose rallying cry, issued in 1964, the year of "Notes on 'Camp,'" was "Never trust anyone over thirty."

Into this atmosphere of cultural revolution came a collection of essays, *Against Interpretation*. Its chapters had appeared elsewhere, where they had been read, praised, and—just as often—condemned. Here was "Notes on 'Camp,'" and the title piece, "Against Interpretation." Here were the writings on avant-garde and popular culture, including on *Flaming Creatures,* science fiction films, and happenings; and on the French culture that had interested her since the fifties: writers including Simone Weil, Camus, Sartre, Genet, and Artaud; filmmakers including Bresson, Resnais, and Godard.

Given how broad and serious the book was, it is remarkable that so much of the reaction focused on its author's supposed determination to destroy culture. In 1969, Irving Howe wrote: "Susan Sontag has proposed a cheerfully eclectic view. . . . Now everyone is to do 'his thing,' high, middle, or low; the old puritan habit of interpretation and judgment, so inimical to sensuousness, gives way to a programmed receptivity; and we are enlightened by lengthy studies of the Beatles."[4] And in a review that must have stung, Peter Brooks acknowledged Sontag's role in bringing new work to public attention: "American critical discourse has, on the whole, either neglected or failed to talk intelligently about Michel Butor, Jean-Luc Godard, Roland Barthes or Claude Lévi-Strauss—a few of the heroes on Miss Sontag's roster," he wrote in *Partisan Review*. "This neglect and failure point to Miss Sontag's importance: with a fine sense of timing and drama she has made herself the authoritative propagandist for much that is vital in contemporary artistic consciousness." This compliment, however, soon gives way to mentions of her "failures of logic, language, and historical understanding."[5] The criticism was often sexualized: Brooks called the book "a richly festive orgy," and

Pauline Kael, *The New Yorker*'s film critic, said: "I think in treating indiscriminateness as a *value,* she has become a real swinger."[6]

———

The book closed with an essay, "One Culture and the New Sensibility," that gave a name to many of the shifts that characterized the age. Sontag's opponents understood the "New Sensibility" to mean an equation of high culture with low: a broader collapse of values, including sexual values, leading to promiscuity both intellectual and sexual. In an article about the media theorist Marshall McLuhan, for example, a journalist attacked McLuhan's "function as prophet of the hippies and the flower children and Susan Sontag's new sensibility, and all the other forms and formulas of disengagement, of withdrawal, of repudiation of the dominant culture."[7] Yet the essay made obvious that Sontag's idea of "one culture" was not to abolish distinctions between high and low but to propose a new alliance between the literary culture and the scientific culture to which it had traditionally been opposed.

This meant dethroning literature as the greatest bulwark against mechanized dehumanization, an idea derived most prominently from Matthew Arnold. Sontag sensed that a new notion of art and science was necessary now that, as Buckminster Fuller said, "all major advances since World War I have been in the infra and the ultrasensorial frequencies of the electromagnetic spectrum."[8] Science had absorbed many of the great creative energies that, in another age, might have been diverted into art, and so Sontag created an alternative canon of thinkers from fields other than fiction.

> The primary feature of the new sensibility is that its model product is not the literary work, above all, the novel. . . . Some of the basic texts for this new cultural alignment are to be found in the writings of Nietzsche, Wittgenstein,

Antonin Artaud, C. S. Sherrington, Buckminster Fuller, Marshall McLuhan, John Cage, André Breton, Roland Barthes, Claude Lévi-Strauss, Sigfried Giedion, Norman O. Brown, and Gyorgy Kepes.[9]

To understand a world shaped by a mysterious and often deleterious science, philosophers, playwrights, architects, musicians, anthropologists, psychoanalysts, and painters would take the scientific model as their basis: "Today's art, with its insistence on coolness, its refusal of what it considers to be sentimentality, its spirit of exactness, its sense of 'research' and 'problems,' is closer to the spirit of science than of art in the old-fashioned sense," she wrote.[10] Like science, it would demand rigorous application:

> The music of Milton Babbitt and Morton Feldman, the painting of Mark Rothko and Frank Stella, the dance of Merce Cunningham and James Waring demand an education of sensibility whose difficulties and length of apprenticeship are at least comparable to the difficulties of mastering physics or engineering. (Only the novel, among the arts, at least in America, fails to provide similar examples.)[11]

Ruskin had criticized the art of the Renaissance for its coldness, its inaccessibility to the common man; but Sontag thought that complexity offered a defense against a high culture constantly at risk of collapse under pressure from empowered philistinism. This was why modern culture so often seemed serious, humorless, earnest; and why its products, far from being popularizing, were the opposite. The thinkers Sontag admired were not the Warhols. They were the ones attempting to decipher the "infra and the ultrasensorial frequencies" that made art "a new kind of instrument, an instrument for modifying consciousness and organizing new modes of sensibility."[12]

Here is the essay's hidden plea. Once again, in this new guise, Sontag is depicting the relation between "rational" science and the romantic mind of the artist. This was a favorite topic, one also found in Freud, who had reflected on the tensions between freedom and repression, spontaneity and reason, and the artistic and scientific imaginations. All had once been seen as antagonists. In this new conception, they no longer would be. By adopting a scientific approach, the artist would usurp the role of guardian of meanings, traditionally reserved to scientists, scholars, and theologians. He would provide his audiences interpretations of a new and often unfathomable world, joining the previously separate roles of god and priest, creator and interpreter. This, in other words, was a vision of criticism as art; and Susan Sontag's "new sensibility" was a vision of critic as artist.

———

Despite her stern warnings about its impenetrability, Sontag was thrilled by modern art. It helped her, and others, "to *see* more, to *hear* more, to *feel* more." In "One Culture," she expressed the hope that it would help resist the "massive sensory anesthesia" resulting from an increasingly mechanized life. Some new art took a dim view of pleasure. But she did not, and it was that pleasure she recalled when she looked back in an essay called "Thirty Years Later," written in 1996.

Like the best travel writing, the essay makes you want to be there. "The dedication and daring and absence of venality of the artists whose work mattered to me seemed, well, the way it was supposed to be," she wrote. "I thought it normal that there be new masterpieces every month." She mentions "the conviction thirty years ago that we were on the threshold of a great positive transformation of culture and society."[13] Marginal views were entering the mainstream, or at least the mainstream of progressive thought, with a consequence she did not then anticipate.

What I didn't understand (I was surely not the right person to understand this) was that seriousness itself was in the early stages of losing credibility in the culture at large, and that some of the more transgressive art I was enjoying would reinforce frivolous, merely consumerist transgressions. Thirty years later, the undermining of standards of seriousness is almost complete, with the ascendancy of a culture whose most intelligible, persuasive values are drawn from the entertainment industries. Now, the very idea of the serious (and the honorable) seems quaint, "unrealistic," to most people.

This confession places the accusations that she was a "leveler" in relief. She did indeed want to reverse arbitrary distinctions: "The hierarchies (high/low) and polarities (form/content, intellect/feeling) I was challenging were those that inhibited the proper understanding of the new work I admired."[14] These hierarchies, like others being challenged (black/white, man/woman, straight/gay, art/science) often deserved to be overturned. But that did not mean that all hierarchies were bad. The cultural conservatives were right, though not in the way they thought they were. If they wished to preserve those hierarchies, they were hardly more successful than people like Susan Sontag and Jasper Johns and John Cage, who tried to expand or redefine them. Consumerism, Sontag ruefully noted, swamped them all.

————

Against Interpretation is a work of the first half of the sixties, when things seemed to be changing for the better. "There was so little nostalgia," Sontag wrote. "In that sense, it was indeed a utopian moment." The triumph over Hitler, the civil rights movement, the rise of Kennedy, gave Sontag's generation a progressive view: not because they were unaware of injustices, but because they had seen them overcome.

But darkness, the gnostics preached, would always follow light. For Susan's generation, that darkness could be resumed in one word: Vietnam. During the Kennedy administration, heavily staffed with the same kinds of people Susan found in the cinemas and galleries of Manhattan, American "advisers" began arriving in Saigon. They did so in the same spirit of idealism that brought Kennedy to power, wrote the novelist Philip Caputo.

> We went overseas full of illusions, for which the intoxicating atmosphere of those years was as much to blame as our youth. War is attractive to young men who have known nothing about it, but we had also been seduced into uniform by Kennedy's challenge to ask what you can do for your country and by the missionary idealism he had awakened in us.[15]

Before the full consequences of this idealism became clear, Susan had been absent from politics. This was fairly typical. In the fifties, many writers had retreated into the private dream: the individual drama was at the center of their literature, including the writings of the Beats. Questions of politics and society, so urgent a generation before, had retreated. Whenever politics appears in Susan's journals, it is—as in Cuba—in relation to aesthetics. In America—as with *Flaming Creatures*—her political interventions were limited to artistic matters.

In the fifties, after all, the main goal of American foreign policy, the containment of communism, was fairly uncontroversial. Liberals quarreled about how best to do it, but mostly agreed that containment was desirable; even *Partisan Review* supported the Cold War and American backing of free regimes. The problem was the meaning of the word "free," which was nowhere more dubiously applied than to the shambolic dictatorship of South Vietnam.

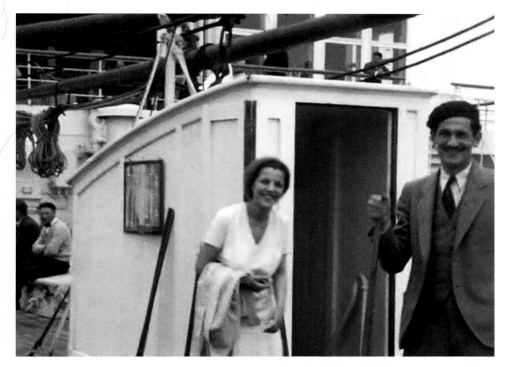

In two talismanic films that Susan kept all her life but never was able to view, her parents, Mildred and Jack Rosenblatt, frolic shipboard on their way home from Europe. For Mildred, her short time with Jack was a carefree golden age of adventurous travel and obsequious servants; for Susan, his early death in China was an unassimilable loss. She would only know him as "a set of photographs," including these.

Susan and her beautiful mother, Mildred Jacobson. All her life, Susan would be fascinated by this unattainable figure, who grew up in the shadow of Hollywood and whom Susan alternately worshipped and loathed. To treat Susan's asthma, Mildred moved Susan (*bottom, right*) and her sister, Judith (*bottom, left*), to Arizona, where she met her second husband, the wounded flying ace Nat Sontag.

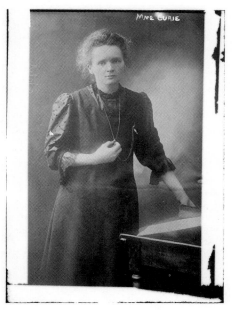

Marie Curie gave generations of brainy girls one of their only role models and instilled in Susan the desire to win the Nobel Prize. Richard Halliburton's thrilling tales of true-life adventure inspired her to see the world *(bottom);* and through Thomas Mann *(top),* whom she met during his California exile, "all of Europe fell into my head."

Backstage At Th'Club Flamingo

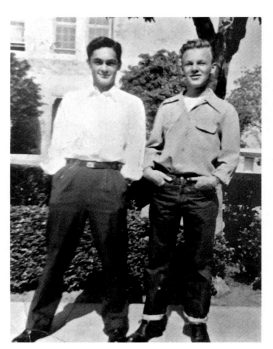

With Gene Marum (*bottom, left*) and Merrill Rodin (*bottom, right*), Susan visited Thomas Mann in Pacific Palisades and began to explore the gay subculture of Los Angeles, including venues like Club Flamingo, where tourists went to see the "fairies." They were in constant danger of raids by cops in search of undesirables. Club Flamingo was closed in 1951.

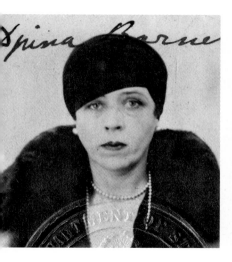

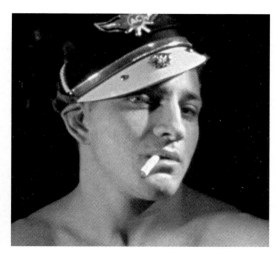

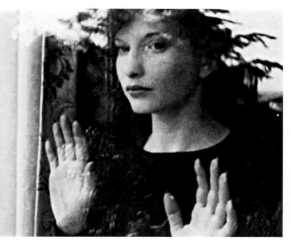

The underground gay world was intertwined with the avant-garde works of artists like Djuna Barnes, Kenneth Anger, and Maya Deren (*clockwise from top left*), who gave Susan an alternative to the suburban world of baseball and barbecue in which she had been brought up. And in Robert Hutchins (*bottom*), just thirty when made president of the University of Chicago, she found a notion of learning as a tool to remake self and society.

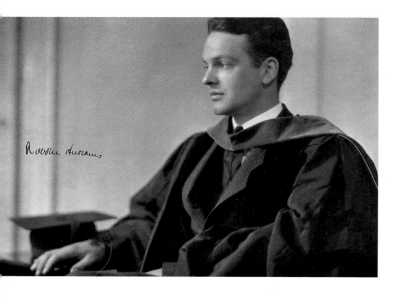

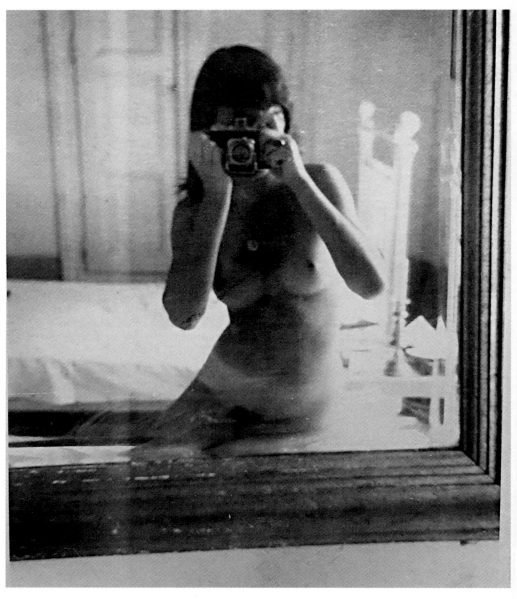

Susan met her first great love, Harriet Sohmers, at Berkeley. For a while their affair banished "the incipient guilt I have always felt about my lesbianism—making me ugly to myself—I know the truth now—I know how good and right it is to love."

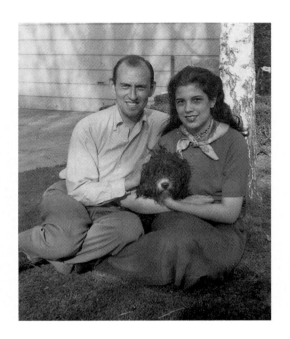

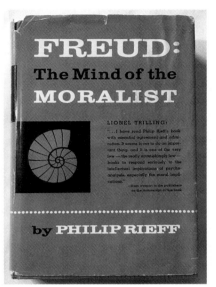

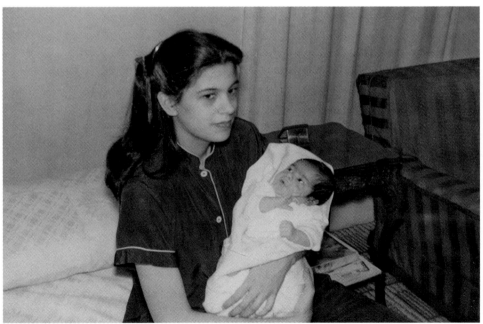

At Chicago, Susan, age seventeen, got engaged to a professor named Philip Rieff after knowing him for little more than a week; the marriage was celebrated at the Big Boy in Glendale, California. At nineteen, she had her only child, David, and began writing a landmark book about Freud that Philip would publish under his own name.

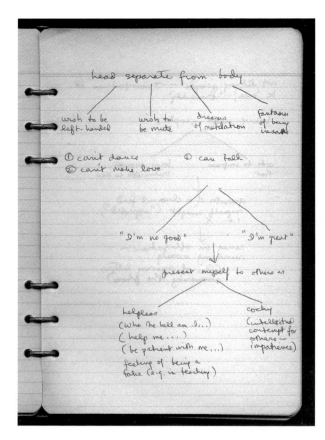

head separate from body

wish to be
left-handed

wish to
be mute

dreams
of mutilation

fantasies
of being
insane

① can't dance
② can't make love

① can fall

"I'm no good" "I'm great"

present myself to others as

helpless
(who the hell am I...)
(help me...)
(be patient with me...)
feeling of being a
fake (e.g. in teaching)

cocky
(intellectual
contempt for
others—
impatience)

Susan sketched a problem that would beset her all her life: "Head separate from body." Both body and head fit awkwardly into the traditional heterosexual family Philip expected; and when, eighteen months after David's birth, Mildred (*bottom, left*) finally met him, she exclaimed: "Oh, he's charming. And you know I don't like children, Susan."

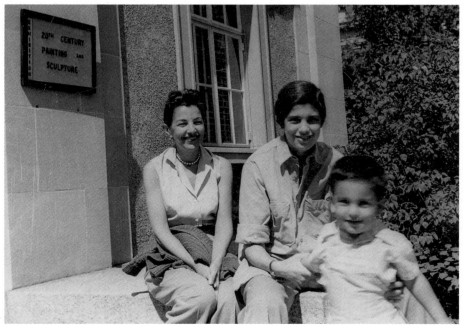

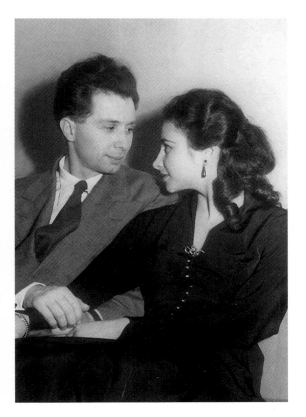

In Jacob and Susan Taubes *(top)*, a charismatic guru and his doomed wife, Sontag discovered new ways of thinking about living "among the ruins," including about marriage in the shadow of war and Holocaust. In 1957, Susan *(bottom right, in Spain)* left her husband and young child and sailed to Europe. There, during a year of intellectual and sexual exploration, she reencountered Harriet *(bottom left, in Greece)* and girded herself to leave her husband.

Prof: Gotta Be Sneak to See My Son

By ALFRED ALBELLI

An author and sociology prof with an international reputation in the highest levels of academic ivy, complained in Supreme Court yesterday that he had to lie in wait, like a thief, just to steal glimpses of his 9-year-old son.

The plaint was voiced by Philip Rieff, now on the faculty of the University of Pennsylvania, to Justice Louis Capozzoli in an action brought by Rieff to gain custody of his boy, David, from his ex-wife, Susan Sontag Rieff.

Rieff, formerly of Harvard and once a Fulbright scholar at the University of Munich, is the author of several solemn tomes, including "Freud: The Mind of a Moralist."

But he has had no luck, he admitted, in convincing his former spouse of his competence as a father. She has not let him see the boy "in a companionable way" since David was returned to her Sept. 15 from a summer stay with the father.

"Only Fleeting Glances"

In fact, Rieff complained, he had obtained only "fleeting glances" at his son on three occasions since then, and each time by lying in wait outside the school the boy attends, or near the apartment house at 350 West End Ave. where Mrs. Rieff lives.

The Rieffs were married in California in 1951 and divorced there in 1958, with the mother getting custody of David. The father maintained he was entitled to visitation rights, which he says, his ex-wife now denies him.

"The mother has threatened to take the child to Paris," added

(NEWS foto by Bill Meurer)
Susan Sontag Rieff in court corridor with son, David.

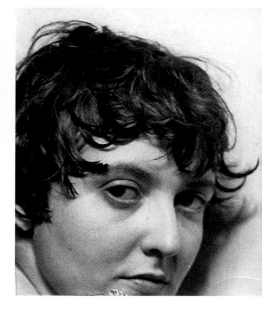

Back home, Susan filed for divorce, and a "maddened" Philip stalked her, dragging her and her young son into the tabloids. The experience left deep wounds on Susan, who soon entered a relationship with Harriet's ex, María Irene Fornés. Irene had never read anything but "the newspaper, *Little Women,* and *Hedda Gabler*" but was, in Susan's opinion, a genius, and sexually volcanic: "She could make a rock come," Harriet said. Susan caricatured her own neediness in a cartoon in her journals.

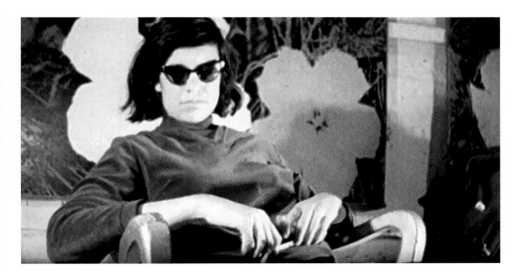

Freshly arrived in New York, Susan was fascinated by the emerging new art scene. She was filmed by Andy Warhol for a "Screen Test," spurring reflections on how the camera reduces a person to an image of a person. And she wrote an essay about "happenings," a new non-commercial form pioneered by Allan Kaprow (*bottom, second from left*), part of a movement that rejected a society too in thrall to money, trashy celebrity, and glib fame: the commodification Warhol celebrated.

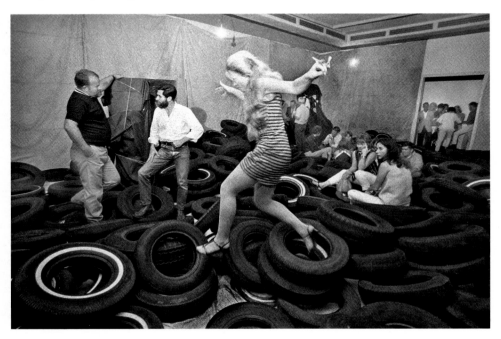

SPECIAL ISSUE

PARTISAN REVIEW

ROBERT LOWELL
 My Kinsman, Major Molineux (a play)
SUSAN SONTAG
 Notes on "Camp"
R.H.S. CROSSMAN
 Radicals on the Right
MURIEL SPARK
 Four Poems
MAX KOZLOFF
 The New York Avant-Garde
GEORGE LICHTHEIM
 On David Riesman

Reviews by Marshall Berman, Reuben A. Brower,
Paul de Man, Stephen Donadio, Mason W. Gross,
Philip P. Hallie, and John Simon

SOME COMMENTS ON GOLDWATER FALL
Daniel Bell, Martin B. Duberman, George P. Elliott, 1964
Richard Hofstadter, John Hollander, Jack Ludwig,
Hans J. Morgenthau, William Phillips, Richard
Poirier, Philip Rahv, Richard Schlatter, and William $1.50
Taylor 9/—

Brilliant, unlucky Alfred Chester (*shown here with his Moroccan boyfriend*) was the first to include a portrait of Sontag, whom he called "Mary Monday," in fiction. In the fall of 1963, she published her first novel, *The Benefactor*, at Farrar, Straus, whose publisher, Roger Straus, would become her own most enduring benefactor; his favorite author was Susan Sontag. A year later, she became notorious when "Notes on 'Camp'" appeared in *Partisan Review*, the house organ of the New York intellectuals.

The New York Review

OF BOOKS

Special Issue

Twenty-five Cents

Lionel Abel	Jules Feiffer	Robert Jay Lifton	Richard Poirier
James Ackerman	R. W. Flint	Robert Lowell	Philip Rahv
W. H. Auden	Edgar Z. Friedenberg	Dwight Macdonald	Adrienne Rich
David Bazelon	Oscar Gass	John Maddocks	Barbara Probst Solomon
John Berryman	Nathan Glazer	Norman Mailer	Susan Sontag
Marius Bewley	Paul Goodman	Steven Marcus	Edward Sorel
Nicolo Chiaromonte	Elizabeth Hardwick	Mary McCarthy	William Styron
Lewis Coser	John Hollander	William Meredith	John Thompson
Midge Decter	Irving Howe	Jonathan Miller	Gore Vidal
F. W. Dupee	Alfred Kazin	James R. Newman	Robert Penn Warren
Jason Epstein		William Phillips	Dennis Wrong

In 1963, Robert Silvers and Barbara Epstein started *The New York Review of Books*, with which Sontag would be associated for the rest of her life. Soon after, she began a brief relationship with Jasper Johns, who said, "I don't think I could have easily connected my feelings about my work to the Supremes. Her ability to make such connections was very attractive."

The artist Joseph Cornell, who loved divas, discovered one in Sontag, and sent her little gifts: a feather, a quotation from John Donne, a nineteenth-century letter in a calligraphic Greek hand. They only met once, in his house on Utopia Parkway in Queens. "He was fascinated by photography," she said. "He was fascinated by stars, he was fascinated by the romance of the performer."

Many artists replied to the bombast and cruelty of the world in works united by what Sontag called "the aesthetics of silence": the nearly empty canvases of Mark Rothko; the silent musical compositions of John Cage; or the cinema of Ingmar Bergman, in whose *Persona* one character went mute in response to the atrocities of the modern world—Auschwitz and Vietnam.

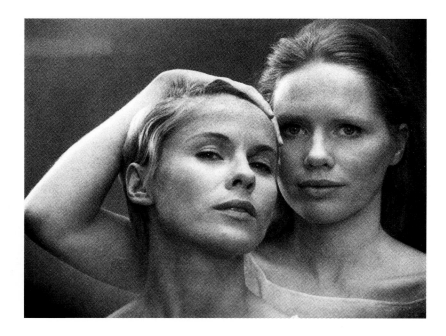

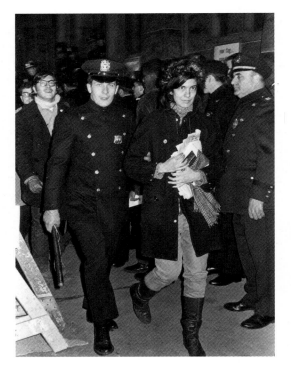

The excitement of the early sixties soon gave way to a generation's nightmare, the Vietnam War, which laid bare the brutality of the American empire. Susan was arrested protesting the draft in New York and traveled to Sweden to make a film about American deserters from Vietnam. She ended up making two Bergmanesque films that sought to avoid the mystifications of narrative but only succeeded in mystifying viewers, and even the actors who played in them: "We kept asking each other, out of the corner of our mouth: 'What is this about?'"

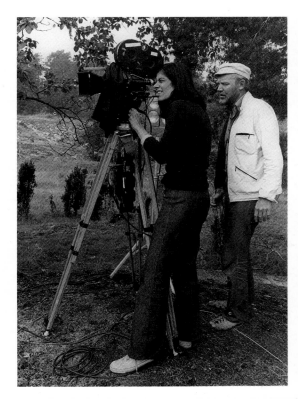

Even before the Vietnam War emerged as the most violently divisive issue in the country, a new radicalism had been afoot. Vietnam played almost no role in the early years of the "New Left," which had emerged by 1962.[16] It incorporated many of Marcuse's ideas about how a quest for personal liberation might inform a broader politics, and condemned America as doomed by capitalism, imperialism, and racism. The Vietnam War seemed perfectly conceived to illustrate these ideas.

It split the Left. The New Left mocked the liberals who retained a sentimental belief in American goodness. By 1965, when bombing of North Vietnam began, the radicals were painting the liberals as naïve and credulous, and Susan's circles gravitated toward the radical position. *The New York Review of Books*, with which she had been involved from the beginning, became known as "The New York Review of Vietnam." By 1967, when it published a how-to diagram of a Molotov cocktail on its cover, it was the most radical publication in the country.

Despair at the mounting carnage led her, for the first time in her life, into active protest. On February 21, 1966, a month after the publication of *Against Interpretation*, she joined other writers, including Norman Mailer, Lillian Hellman, William Styron, Bernard Malamud, and Robert Lowell, for a "Read-In" at Town Hall, near Times Square. The gathering was interrupted by an off-duty policeman who walked onstage and sang "God Bless America" in front of a "stark, bamboo-framed backdrop of photographs showing bombs and dead soldiers and maimed Asian children."[17] The audience, needless to say, did not accept the detective's invitation to join in his song.

In December 1967, "suggesting for a second as she walked toward the van a Joan of Arc in slacks and boots," Susan was arrested for blocking the entrance to a draft center in Manhattan.[18] "Writers should be in the vanguard of the dissenting minority," she wrote in March 1966, "those who are afraid, those who are

ashamed, those who say No, those who say 'We are bleeding,' those who cry Stop."[19]

———

Soon thereafter, Susan would pen an indictment of America that would long stand as an indictment of Susan Sontag. Her detractors never forgave or forgot "What's Happening in America."[20] The piece was most remembered for a single phrase: "The white race *is* the cancer of human history." The phrasing may have been unfortunate—so much so that she, who never apologized, would later apologize for it, though more for the metaphor than for the underlying sentiment. She was, after all, hardly the only one maddened by Vietnam.

Much that she wrote in the piece was true. The country *was* founded, at least to a significant degree, on the genocide of Native Americans and the enslavement of Africans. Many Americans *were* both extremely violent and extremely moralistic. Much American material civilization *was*, in fact, trashy; many American politicians *were*, of course, sleazy. And in the full context of the piece, there does emerge a kind of hope for the country, mainly in the rising generation, in whose interests she saw a

profound concordance between the sexual revolution, redefined, and the political revolution, redefined. That being a socialist and taking certain drugs (in a fully serious spirit: as a technique for exploring one's consciousness, not as an anodyne or a crutch) are not incompatible, that there is no incompatibility between the exploration of inner space and the rectification of social space.

A consciousness expanded through sex and drugs might rectify all of society, though she does not specify how; in the decade since Bernard Donoughue described her notion of politics as

"exploring your sexuality and your whole life and questioning all establishments and disliking all regimes," she retained the Marcusian hope that this questioning might be expanded into politics.

But practical politics are missing from "What's Happening in America." It was true, for example, that American racism seemed to defy solution. It was also true that less than a year before Sontag wrote this piece, the same president she derided for "[scratching] his balls in public" signed the Voting Rights Act, a triumphant sequel to his equally monumental Civil Rights Act of 1964. In the century since Lincoln, no leader had achieved anything comparable. But Sontag, who so keenly perceived the intermixture of darkness and light in herself, could not bring such a nuanced reading to her own country.

The primary repository of virtue in America was the one she herself inhabited. "Cross the Hudson," she instructed her readers. "You find out that not just *some* Americans but virtually all Americans" feel that "there are still more hordes of redskins to be mowed down before virtue triumphs." This was a grotesque caricature; in any case, most of the architects of Vietnam hailed, like Kennedy himself, from the eastern establishment.

But to read this essay is to see that it is not really about "what's happening" in a huge and complicated country. It is the portrait of an America with a long pedigree in magazines like *Partisan Review*, where the piece appeared: the Moloch of Allen Ginsberg's *Howl*.

> Moloch whose mind is pure machinery! Moloch whose blood is running money! Moloch whose fingers are ten armies! Moloch whose breast is a cannibal dynamo! Moloch whose ear is a smoking tomb![21]

Sontag's America was a literary trope, and her political observations were still, as in Cuba, primarily aesthetic. America was

"filled up by new generations of the poor and built up according to the tawdry fantasy of the good life that culturally deprived, uprooted people might have at the beginning of the industrial era," she wrote. One could grant every single one of her observations—and fully share her outrage at Vietnam—while still knowing that this was not the whole story, that hers was not the "real" America. It was America as camp, as aesthetic phenomenon: America as metaphor.

But what is the right way to watch one's country go to hell? For the former editor of the *Cactus Press,* who grew up with the fierce patriotism of a generation who had seen America and its armies as the last, best hope of civilization, it was no easy thing to look on, year after year, as those armies rained death on a distant country that had never threatened the United States. What is the right way to express one's horror, one's heartbreak, one's sense of betrayal?

———

There is no mastery without apprenticeship, no success without failure; and in literature, artists who arrive fully formed are so rare as to be practically nonexistent. Their lives would not, in any case, make for illuminating biographies: it is the mind's progression that gives a narrative to the writer's life. Failures do not diminish subsequent achievements but, by illustrating the difficulty of attaining them, magnify them instead.

One of Sontag's failures is universally reckoned to be *Death Kit,* her second novel, published in August 1967. It became even less loved than *The Benefactor,* if such a thing is possible: perhaps because a debut is viewed with an indulgence a sequel is rarely granted. Yet its interest lies not in novelistic satisfactions but in the glimpse it offers of Sontag's thinking about the themes—What is real? How to see?—that run through all her writing. By constantly questioning the reality of her characters and their ex-

periences, she places them at an emotional remove that frustrates a reading on the level of plot and character. But as a witness to her unfolding thought it is unusually rewarding—and the emotional strands, related to the theme announced in the title, are just under the surface—though heavily disguised, in some cases even to the author herself.

One involved a visit Peter Hujar, Paul Thek's boyfriend, made to Sicily. Hujar was a photographer who—like Paul and Irene— was a great unschooled talent. Born in New Jersey to a semiliterate peasant family of Ukrainian origin, he was abandoned by his father when his mother, a brutish alcoholic waitress who later married a bookie, was pregnant with him. "The way to get on Peter's A-list, always, was to have been an abused child," said Stephen Koch. Hujar evolved into a forbidding individual. The first day Koch met him, "he sat there in this Mission rocker Susan had. He sat there. It never rocked."

> He had spent the day in the studio photographing Jayne Mansfield as she was changing from fashion to fashion, nude. Listening to him describing it was like listening to a wonderful novelist. For example, he'd describe her relation to her breasts, how she connected to them, how her nipples were the color of crushed raspberries.[22]

In 1963, he went to Sicily, and the pictures he brought back bore witness to this novelistic bent, and to this intensity. In 1976, he published them, with a preface by Susan, as *Portraits in Life and Death*. The portraits in life include Susan and many important figures in the art world, including William Burroughs, Paul Thek, Fran Lebowitz, Robert Wilson, and John Waters. The portraits in death show the macabre assemblage of the bodies of fully dressed citizens, religious and secular, preserved in the Capuchin crypt of Palermo.

They had a "tremendous influence" on Susan, said Koch, and determined much of Paul Thek's later work: the pieces of meat, the body parts. Thek remembered their first visit:

> Their initial effect is so stunning you fall back for a moment and then it's exhilarating. There are 8,000 corpses—not skeletons, corpses—decorating the walls, and the corridors are filled with windowed coffins. I opened one and picked up what I thought was a piece of paper; it was a piece of dried thigh. I felt strangely relieved and free. It delighted me that bodies could be used to decorate a room, like flowers. We accept our thing-ness intellectually but the emotional acceptance of it can be a joy.[23]

In the final scene of *Death Kit,* the protagonist wanders through this necropolis. It is a book about a man living—if indeed he is living: we can never be entirely sure—in the kingdom of the dead. "He completely forgets where he is," she writes on the penultimate page. "Where and in what state is his body."[24]

His strange name, Diddy, bears witness to another drama, one Susan herself did not grasp until 1972, when she noted in her diary her astonishment at discovering its meaning.

> Diddy, Diddy only. Those five letters. Why? I've never understood. Today I saw.
>
> Diddy.
>
> Daddy.
>
> That's the source of the meditation on death I've carried in my heart all my life.
>
> Diddy is 33 years old. So was Daddy when he died.
>
> Did-he? Did he die? The theme of false death, la mort equivoque, la resurrection inattendu [*sic*] in all my work—[25]

———

Heading from New York to Buffalo, Diddy's train is delayed in a tunnel. The wait stretches on, and Diddy leaves the train and finds a workman, Angelo Incardona, whom he murders with a crowbar. Back in the compartment, none of the other five passengers has noticed his absence. His eye falls on a blind girl, Hester, and he confesses to her, but she assures him, as in the dreamworld of *The Benefactor,* that he has only fantasized this crime: "You never left the train," she tells him. "You were never out of the compartment. Believe me."

Has she, who cannot see, seen something that he, who can, cannot? In Buffalo, Diddy learns that a workman had in fact been killed, but not by a crowbar: he was struck by the train, which never stopped. Diddy could not, therefore, have left the train, could not have entered the tunnel, could not have killed him; but "Diddy knows the world is built on lies," and all the passengers "can testify that the train stopped for about forty minutes"—or they could if we are to believe Diddy.

A corpse that may or may not be there is a rather explicit symbol of Susan's sense of the unreality of the body, a refusal of the "thing-ness" that Thek's work embraced. Diddy believes firmly in a crime the reader has every reason to believe he has not committed. Perhaps, as Freud postulated, that reality is less important than the reality of his conscience, whose guilt echoes another old fear of Susan's: that she was fraudulent, inauthentic, unreal. To expiate this guilt, Diddy repeatedly tries, and fails, to be held to account, going so far as to visit Mrs. Incardona, who, in a druggy, nightmarish scene, makes a pass at him. But like Hippolyte, whose attempts at crime are continually thwarted, Diddy cannot convince anyone of his guilt. He wanders the city as Hester undergoes a doomed operation to restore her sight.

As in almost all of Sontag's work, vision provides the domi-
nant metaphor. Hester is blind; Diddy works for a manufacturer
of microscopes. But seeing, for him, is the act of a depressive.
"If you only knew how I suffer from my kind of seeing," he says.
"How it hurts to see everything . . . almost everything as ugly."[26]
Hence his obsession with beauty, which he suspects might be
a distraction from the true apprehension of things, and which
partly explains his interest in Hester. Her way of seeing is so dif-
ferent from his that it almost becomes an ideal. Because he must
see, he is tormented by the betrayals and uncertainties of vision.

In a dream, he appears at the hospital where Hester is being
operated on and begins, "very carefully," to photograph the opera-
tion.

> She must be in pain. See how she's turning restlessly on the
> table. The doctors continue. Diddy would like to do some-
> thing, but he's too far away. So he goes on photographing,
> his camera clicking. . . . Hester is the specimen beneath
> Diddy's eye. Turning the knobs very slowly, he moves the
> tube up and down gradually, seeking the most accurate
> focus.[27]

This way of regarding the pain of others is also a way of using
a device—a microscope, a camera—to distance that pain: to use
technology to protect one's eyes from unmediated seeing. Para-
doxically, the camera could make such seeing even more painful,
as Sontag observed in *On Photography:*

> In a hospital in Shanghai in 1973, watching a factory worker
> with advanced ulcers have nine-tenths of his stomach re-
> moved under acupuncture anesthesia, I managed to follow
> the three-hour procedure (the first operation I'd ever ob-
> served) without queasiness, never once feeling the need to

look away. In a movie theater in Paris a year later, the less gory operation in Antonioni's China documentary *Chung Kuo* made me flinch at the first cut of the scalpel and avert my eyes several times during the sequence.[28]

What is the correct—the honest—way to see? Dispensing with the artificial device does not guarantee greater proximity to reality, as Sontag learned in Shanghai, and as Diddy learns in the book. He banishes images, sight—and then, when that fails to get him nearer to whatever truth he is seeking—language:

> Determined that nothing between him and Hester must be allowed to get mechanical and flat, Diddy seeks a means for reducing conversation without losing contact with the girl. Already lacking images, words cannot be sacrificed altogether. Only replaced.[29]

The replacement that they find is in the "thing-ness of the body." There is the physical language that Hester has mastered, identifying things not by images or by language but by shape and feel. And there is their eyeless sex, "more and more, the unifying theme of their relationship."[30] But—as eyes reveal one truth only to occlude another—Diddy discovers good and bad blindness. The good way of not-seeing likewise thrusts them back into their alienated bodies:

> Noble blindness. As in the Greek statues. Because they're eyeless, these figures seem that much more alive, more centered in their bodies, more present. Making us, when we contemplate them, feel more present in ourselves.
>
> Ignoble blindness: the blindness of impacted rage and despair. Something passive. As in the negative statuary of death. When someone drowns, the eyes are the first element

of the body to disintegrate or rot; it's through the vacant eye sockets of a freshly drowned corpse that eels swim.

It is appropriate that the first edition of *Death Kit* boasted a black cover. Oppression, darkness, blindness—being trapped in the tunnel—are the feelings the book conveys. If Sontag's readers are exhausted by the time the book huffs and wheezes toward its unsatisfying end, that may be the point. Little in the novel turns out to be "real." But that dark feeling surely is. It was exactly the feeling that descended on much of the world, and certainly on Susan, in the years of the Vietnam War.

Continent of Neurosis

I f Susan's commitment to activism identified her with the opponents of the war, her private life gave her access to the people waging it. Through Jackie Kennedy, she met Robert Kennedy, attorney general in his brother's administration and, for a time, the second most powerful man in the United States. More boyish—more bad-boyish—than his brother, he kept alive the hope that the light of the early sixties might be recaptured in a darkening age. In August 1964, after the president's murder, he received an unprecedented twenty-two-minute ovation at the Democratic Convention in Atlantic City. The reception made it seem that he, too, was destined for the White House. Though Vietnam was in part his brother's creation, and though he himself was a principal author of the blockade against Cuba, he became a left-wing icon; and though he fathered eleven children, his lovers, on at least one occasion, included Susan Sontag.[1]

In November of that year, his hated rival, President Johnson, was elected in the largest landslide in American history. Never

a favorite of liberals, Johnson had allied himself with the cause dearest to the left by passing the Civil Rights Act in July. For a moment, his actions made him a hero to surpass even Roosevelt, whose New Deal Johnson emulated. His far-reaching social programs included Medicare, which provided health care to elderly Americans, and Medicaid, which offered the same to the poor. Other programs—in education, transportation, housing—would shape America into something like a social democracy, and were collectively known as the "Great Society."

The phrase belonged to a young staffer named Richard Goodwin, who had also been close to President Kennedy. "The ugliest person I've slept with was the best in bed," Susan told Don Levine. In stark contrast to Kennedy or Johns, the pockmarked, chubby Goodwin was not attractive, but—like so many of Susan's male lovers—he was a man of consequence, and one who offered a close-up view of the power she was ever more energetically opposing. "Come to the Statue of Liberty," he would say. "There's going to be a dedication ceremony. I'll introduce you to the president."[2] Such invitations were hard to resist.

And though Goodwin was married, this was not what created an unexpected complication. Before Irene, Susan had never had an orgasm at all; before Dick Goodwin, she had never had an orgasm with a man. "It's not that he did anything any different from what other men do," she told Koch. "It's just that he was taught how to do it by a French prostitute." She felt liberated by the possibilities in her body that Irene helped her discover. But she was flustered when they happened with Dick, and collapsed back on the pillow. "Oh, shit," she remembered thinking. "Now I'm just like everybody else."[3]

———

In 1967, she began an affair with Warren Beatty. He was thirty, and had just scored a great success with *Bonnie and Clyde,* which

broke Hollywood taboos surrounding the depiction of sex and vi-
olence and became an emblematic film of the sixties. Susan liked
to tell friends that she sometimes had to wait forty minutes for him
to get ready: she would flip through magazines, bored stiff, as he
primped in the bathroom.[4] After one date, she told Don Levine
that it was "very strange. All he could talk about was his sister. I
haven't the vaguest idea who his sister is." Shirley MacLaine had
been a major star for at least a decade.[5]

But a man whose air of languor and decadence made him fas-
cinatingly attractive to a whole generation was not especially at-
tractive to Susan Sontag. Perhaps partly for this reason, he was
fascinated by her, "obsessed in a way that I had never seen before,"
said Stephen Koch. "I would be sitting there with Susan and the
phone would start to ring. In those days there were no answering
machines. And it would ring *five hundred times*. She would lock
the phone in a closet and say, well, let's just go on. And it would
then ring for the next two or three hours." Their affair was brief:
she told her sister—to whom she never mentioned her relation-
ships with women—that it lasted a month.[6]

"Never for a moment," said Levine, "did I get the feeling that
she had any real interest in Dick Goodwin." The same could be
said for Beatty and the other men she dated in the years follow-
ing her breakup with Irene. Exciting as it may have seemed to be
courted by men like Kennedy, Goodwin, or Beatty, these men
are rarely so much as mentioned in her journals. "The affairs were
amusing to her," said her son, "but I don't think any of them en-
gaged her in a deep way." "Amusing" was surely the right word
for her relationship to the world of celebrity: a fun but superficial
escape from her intense work life. "She knew all these people,"
David said, "Jackie whatever she was, Onassis Kennedy Bouvier,
whatever: she would see them, and then it was back to the mo-
nastic cell."[7]

Increasingly "at home in the world," as Alfred Chester had

said, she came to idealize the monastic cell. She loved the access fame brought—to Hollywood, to the White House—but fame meant sharpening the split between the simulacrum, the metaphor, the mask, the persona, and the self found in silence. And so it was toward the cell that she gravitated. Austerity, seriousness, purity—values that had always attracted her—were the backbone of *Styles of Radical Will,* her second book of essays.

Published in 1969, it was mainly written in 1967 and included her two pieces about Vietnam, "What's Happening in America" and "Trip to Hanoi." The title is, in a way, misleading. If, in those years, "radical will" meant a positive means of forcing change, it is, in her use, quite something else. It was negative, a weapon against will, or, as in her essay on E. M. Cioran, "thinking against oneself." The title meant not changing the world but overcoming it.

Her heroic will had brought her far. But she had always been radically skeptical of it, writing in her journal in 1960:

> The idea of will has often come in to close the gap between what I say (I say what I don't mean—or w/o thinking my feelings through) and what I feel.
> Thus, I willed my marriage.
> I willed custody of David.
> I willed Irene.
> Project: to destroy the will.[8]

In these years of superficial fame and loveless affairs, she feared she was losing what little remained of a self she had never steadfastly possessed. When she said that being with Dick Goodwin made her "just like everybody else," she meant that she was becoming less herself. The loss of self that heterosexuality implied was, like immersion in celebrity culture, another form of untruthfulness, of fraudulence. The idea terrified her, since she knew that

holding on to herself—whatever that meant—was a matter of life and death.

> With D.G. a whole new continent of neurosis sailed into view. (Atlantis.) Who I am. I won't let "them" take it away from me. I won't be annihilated.[9]

———

"To exist is a habit I do not despair of acquiring."[10] The words are quoted in Sontag's essay "'Thinking Against Oneself': Reflections on Cioran." Included in *Styles of Radical Will,* it is one of her best essays, precisely because the questions Cioran raises are so close to her own, and because her attitude toward his ideas, though never uncritical, revealed a way of thinking about her personal conundrum in the context of a greater crisis. Some called that crisis "history"; others, "modernity." It was the problem that arose in a culture so highly developed that it seemed to have nowhere else to go, in which the arts and sciences had made such dramatic progress that they now provided answers to almost any question a person might pose. "The best of the intellectual and creative speculation carried on in the West over the past hundred and fifty years seems incontestably the most energetic, dense, subtle, sheerly interesting, and *true* in the entire lifetime of man," Sontag wrote.[11] This was the "one culture" that she had helped define as a new sensibility.

Alas, this was not, or not necessarily, a consolation. Amid that artistic and intellectual splendor, the individual problem remained. "By now," Susan wrote, "both the brightest and the gloomiest, the most foolish and the wisest, have been set down. But the need for individual spiritual counsel has never seemed more acute."[12] To live in this late phase, to possess this richness of knowledge, was to be trapped, to be aware that the old systems—she mentions Comte, Marx, and Freud—could not

possibly account for the complexities this advanced culture had brought to light. (The older systems, including the religions, were hardly mentioned.) Increasing knowledge meant the progressive destruction of the consolations that once held out hope. There was no system, no overarching meaning, she wrote: "After Hegel's effort, this quest for the eternal—once so glamorous and inevitable a gesture of consciousness—now stood exposed, as the root of philosophical thinking, in all its pathos and childishness."[13]

And so the figure of Cioran became emblematic of this unconsoled consciousness. He had created "a new kind of philosophizing: personal (even autobiographical), aphoristic, lyrical, anti-systematic. Its foremost exemplars: Kierkegaard, Nietzsche, Wittgenstein. Cioran is the most distinguished figure in this tradition writing today."[14] It is not a coincidence that Susan Sontag would be the next figure in this lineage: she had always revered, and modeled herself after, her great predecessors, and in Cioran's experience saw a mirror of her own. She noted in his writing a "strange dialectic" that was not so strange for her:

> On the one hand, the traditional Romantic and vitalist contempt for "intellectuality" and for the hypertrophy of the mind at the expense of the body and the feelings and of the capacity for action. On the other hand, an exaltation of the life of the mind at the expense of the body, feelings, and the capacity for action that could not be more radical and imperious.[15]

Amid these paradoxes and impasses—and though he spent his life in something like the "monastic cell"—Cioran does not prescribe a renunciation of the life of the mind. It is this point that Sontag both admires and disputes. She alludes to "On the Puppet Theater," an essay of Kleist's that she often mentioned.

However much we may long to repair the disorders in the natural harmony of man created by consciousness, this is not to be accomplished by a surrender of consciousness. There is no return, no going back to innocence. We have no choice but to go to the end of thought, there (perhaps), in total self-consciousness, to recover grace and innocence.[16]

———

Kleist's position was congenial to Cioran's. But its insistence that there was no escape from rational thought brooked no revolutionary foolishness. Susan acknowledged this with reluctance. "Politically, Cioran must be regarded as a conservative," she wrote. "He regards the hope of radical revolution as something to be outgrown by the mature mind." It is not clear how much Susan knew about Cioran's development, since he suppressed his first books, written in Romanian before his establishment in France in 1937. They would not be revived until the fall of communism, but they reveal a youthful infatuation with radicalism that paralleled hers.

Cioran had begun his political life as an extremist of the Right: a fascist. But the underlying process was the same, as one of his biographers has written, and had been common among twentieth-century intellectuals. It was not so different from the trajectory among Americans that Irving Howe had traced. The cycle "begins with intellectuals' critique of modern society, coupled with utopian, totalitarian solutions. It ends with their revulsion at the excesses of revolution, war, and totalitarianism, and a retreat into the de-politicized realm of art and ideas."[17] A generation younger, Susan would become disillusioned along similar lines. Like her, Cioran was a great believer in self-transformation. And if he had any ideological beliefs, they were in the permanence of the high culture embodied by his rigorously classical French.

As in their politics, so in their styles. Both desired to escape

marginal origins with an appeal to universality. Both became aphorists who aspired to an eighteenth-century ideal of esprit. Both, when young, were manically ambitious. Both were insomniacs; and both produced works that were all the more profoundly autobiographical for being so highly masked. "All my books are more or less veiled confessions," Cioran said, in a phrase that might have been Sontag's. And, in an admission that describes perfectly her essays' relevance to the biographer: "The only sincere confession is the one we make indirectly—speaking of others."[18]

Both, in their youth, would embrace radical politics. Coming from "a nation of nobodies," Cioran dreamed of "a reformed nation that would suit his sense of himself."[19] Revolution, for him, was a dream of personal happiness; its failure, a failure of the same. After the Second World War, Cioran accepted the verdict of history, and the far more modest role it brought for him. "It may seem outrageous for Cioran to advocate, as he often does, resisting the vulgar temptation to be happy and of the 'impasse of happiness,'" Susan wrote. But one who grew up "literally never daring to expect happiness" knew exactly what he meant.[20]

———

For one besieged by consciousness, there was another solution. If Susan bore many similarities to Cioran, she suggested at the end of the essay that her true ideal was John Cage. She calls Cioran's work "a manual of spiritual good taste" that might help "to keep one's life from being turned into an object, a thing." Despite the condescension in the first phrase, the goal was hers: the opposite of Warhol's goal to become a machine. But even this seemed inferior to Cage's, whose thought she called "no less radical and spiritually ambitious than Cioran's," including because it "refuses to admit these themes."[21]

Cage was as indifferent to distinctions between good taste and bad as he was to the aphoristic style of eighteenth-century France.

What he offered was an escape from the shipwreck of introspection, "a world in which it's never preferable to do other than we are doing or be elsewhere than we are."[22] This idea, derived from Zen, involved no heroic renunciation, no lifelong project of self-conquest. "It is not irritating to be where one is," he said. "It is only irritating to think one would like to be somewhere else."[23] That meant a possibility of a happiness that, for people like her or Cioran, was foreclosed. But the implication—self-acceptance—was not something Susan could envision. Instead, as for Cioran or Freud before him, knowledge would have to be its own end. "Relief, of course, is scarcely Cioran's intention," she wrote. "His aim is diagnosis." Behind that comfortless "of course": her old assumption of unhappiness.

Her fascination with the possibility of returning to an authentic self through art is the theme of the first essay in *Styles of Radical Will*, "The Aesthetics of Silence." The essay shows all the strengths, and also the weaknesses, of the aphoristic style. She aimed to put a new idea in every sentence, she later said. The result is a dazzling range of ideas, far too many for a reader to absorb: here and elsewhere in the book, the density daunts in a way *Against Interpretation* did not. Perhaps it could not have been otherwise. The difficulty of the ideas she contended with in the essay mirrored the difficulty of the ideas she was contending with in her own life, including in her creative life.

These were the difficulties of making art in her time. The peculiarity of modern art—literature, painting, dance, music—was that it had become a "site on which to stage the formal dramas besetting consciousness." This Sontag calls "art"—as opposed to art. And "art," as in Cioran's notion of "thinking against oneself," is a way of surpassing the self. "Art becomes the enemy of the artist, for it denies him the realization—the transcendence—he desires," she writes. "Therefore, art comes to be considered something to be overthrown."[24]

Many elected silence. Rimbaud headed for Abyssinia; Wittgenstein became a schoolteacher; Duchamp devoted himself to chess. This "art," mastered only to be subsequently discarded, was a redirection of older renunciations, mystical in origin: art as a journey to the monastic cell. "Through it, the artist becomes purified—of himself and, eventually, of his art. The artist (if not art itself) is still engaged in a progress toward 'the good.'"[25]

That could be accomplished by getting rid of "the bad": metaphor. "Language," she insisted, "is the most impure, the most contaminated, the most exhausted of all the materials out of which art is made." In a late historical period like the one Cioran described and Sontag inhabited, meanings, like plaque in the arteries, clotted up words. Language was experienced "not merely as something shared but as something corrupted, weighed down by historical accumulation." Yet this accumulation had still not offered enough words for a world in the shadow of Hiroshima and Auschwitz. "We lack words, and we have too many of them," she wrote.

The way out of this conundrum was the simple refusal of language that Sontag identified as a hallmark of modern art. "The art of our time is noisy with appeals for silence." The empty canvases of Rauschenberg and Rothko, the silent music of John Cage, were attempts to incorporate into art values that had previously been the province of religion.[26] But a refusal of language was impossible for a writer. Like Kleist and Cioran, Sontag was not a mystic. She understood the world through the tool many modern artists had renounced: the exhausted and impure vessel of language.

———

What the aesthetics of silence might look like—*sound* like—was the theme of another great work from the age of Vietnam. Released in 1966, Ingmar Bergman's *Persona* captured perhaps better than any other film the suffocating dilemmas of modern consciousness. It shows two women, Elisabet, an actress, and

Alma, her nurse. Elisabet has fallen completely mute, but her doctors cannot say why. She first stirs to life when the television shows a Vietnamese monk burning himself alive; later, she will carefully study the famous picture of a terrified boy arrested in the Warsaw Ghetto.

What words could be appropriate in the face of these images of modern cruelty? Silence is a legitimate response. But Bergman reveals Elisabet's as another form of cruelty. Her refusal of language is a refusal of the connections that might have made her plight—whatever that plight actually is—less punishing. She punishes Alma; she punishes her husband and child. And Bergman, through her, punishes his viewers. The silence of *Persona* is not the prankish silence of Andy Warhol's films. Almost nobody watched all of *Empire*—his single shot, eight hours long, of the Empire State Building—and it is hard to imagine that Warhol thought anyone would. In contrast, Bergman's silence is an ordeal. The film "bears an almost defiling charge of personal agony," Sontag wrote in *Styles of Radical Will.*[27]

"Bergman withholds the kind of clear signals for sorting out fantasies from reality," she wrote. "The insufficiency of the clues Bergman has planted must be taken to indicate that he intends the film to remain partly encoded." The parallels with her novels, particularly *Death Kit,* speak for themselves. The film is likewise filled with metaphors of blindness, as when Elisabet's blind husband makes love to Alma instead of to his own wife. But Bergman constantly frustrates the most basic "interpretation": we can be no more sure whether he is really blind than we are that Elisabet is really mute.

But one thing is sure, Sontag writes, and that is that Elisabet has refused life as a metaphor. Alma

has grasped that Elizabeth wants to be sincere, not to play a role, not to lie; to make the inner and the outer come

together. And that, having rejected suicide as a solution, she has decided to be mute.[28]

Persona is the Latin for a theatrical mask. Etymologically, the mask is the condition of personhood, and to strip the mask is to depersonalize, literally. Removing the mask of language and speech is a "solution" almost spookier than suicide; an elected silence forces all expression into the eyes and reveals their oddity and creepiness. Eyes make *Persona* potent: Alma's and Elisabet's, but especially the eyes of Bergman, which force the viewer's eyes, bereft of other clues, to probe his characters' faces so invasively.

"In the aesthetic of traditional films," Sontag wrote, "the camera tried to remain unperceived." No longer: the camera is everywhere, an uncomfortable, obstinate presence. But it comes no closer to "reality" than equally imperfect speech. *"Persona,"* Sontag wrote, "demonstrates the lack of an appropriate language, a language that is genuinely full. All that remains is a language of lacunae."[29]

———

Another form of surpassing consciousness appears in *Styles of Radical Will,* and that is pornography. Rather, "pornography": though her essay on the subject fortified Susan's reputation for what would soon become known as radical chic, few would recognize the works she describes in the essay as pornographic.

At the outset, she acknowledged this confusion with terms similar to those she employed at the Jonas Mekas trial: "Pornography is a malady to be diagnosed and an occasion for judgment," she wrote. "It's something one is for or against."[30] She was not talking about its more vernacular forms, she emphasized, but "a body of work belonging to literature considered as an art."[31] The careful framing is now dated, as if she were embarrassed to be wading into these waters. Indeed, this carefulness reflected a

change typical of the sixties. A serious intellectual could not write about anything she wanted to, and a subject like pornography had to put on its Sunday best: made as respectably bloodless as possible.

Susan had long been interested in pornography as most people understand the term. When she was fifteen, she recognized the appeal of smutty passages of D. H. Lawrence's *Sons and Lovers*.

> I detect in myself a tendency toward the pornographic, a kind of muted pleasure when I read about sexual relations. It is practically negligible when concerned with heterosexual love, but I experience a very sharp feeling when I come across passages such as the part describing Winifred and Ursula. Nothing will ever equal the intensity of my shock when I read the "Well of Loneliness" and I have since re-read parts of the book simply for the guilty and yet shameless stimulation I receive from such thoughts.
>
> This is not very pretty—in fact, it's rather disgusting—but I feel obliged to record it.[32]

This was not exactly a "tendency toward the pornographic." It was a teenager turned on by writing for grown-ups. In any event, no heavy breathing would ruffle the pages of "The Pornographic Imagination"; the pornography she discussed was no more about sex than science fiction was about astronomy.

> The ahistorical dream landscape where action is situated, the peculiarly congealed time in which acts are performed— these occur almost as often in science fiction as they do in pornography. There is nothing conclusive in the well-known fact that most men and women fall short of the sexual prowess that people in pornography are represented as enjoying; that the size of organs, number and duration

of orgasms, variety and feasibility of sexual powers, and amount of sexual energy all seem grossly exaggerated. Yes, and the spaceships and the teeming planets depicted in science fiction don't exist either.[33]

This was pornography as a literary discourse. As such—like so much of the art that interested her—it was an aestheticization of "real life": an attempt to speak the ineffable, to express the radical will. Her case studies were French novels such as Georges Bataille's *Story of the Eye* and Anne Desclos's *Story of O*, whose roots were in the eighteenth-century writings of Sade but whose interest was fundamentally modern: Sade was "one of the patron saints of the Surrealist movement."[34]

Neither book was about sex. They were about domination and submission, about purification through degradation and libertinage. And they were about the *representation* of sex, metaphors of sex. Because there were as many representations of sex as there were of everything else, the ones Susan chose were instructive, stories of a surrender of will so abject that it became a species of religious discipline or monasticism. This placed these works in a different context: "The use of sexual obsessions as a literary subject whose validity far fewer people would contest: religious obsessions."[35]

Not my will but thine be done: "Religion is probably, after sex, the second oldest resource which human beings have available to them for blowing their minds," Susan noted. "Yet among the multitudes of the pious, the number who have ventured very far into that state of consciousness must be fairly small, too."[36] Bataille and Desclos did, and as such become paradigmatic modern figures: "One of the tasks art has assumed is making forays into and taking up positions on the frontiers of consciousness (often very dangerous to the artist as a person) and reporting back what's there."[37] Bataille's and Desclos's characters do not return,

nor do they want to: "O does not simply become identical with her sexual availability, but wants to reach the perfection of becoming an object."[38]

This desire connects the sexual pilgrim to a strain in modern art. If some artists strove "to keep one's life from being turned into an object, a thing," many others shared Warhol's goal of becoming a machine: both motivations, however apparently opposed, essentially mystical. The desire to escape self, and even its "personas," through some extreme negation can lead to physical annihilation, making many of the characters described in these works akin to Simone Weils or Antonin Artauds of sexuality. As in Sade, they go very far indeed: Bataille's book climaxes, if that is the word, with a gouged-out eyeball being shoved into a vagina.

Sontag's readings go to extremes of their own, toward general statements about sexuality that are much more convincing as statements about *her* sexuality. What she sees in sexuality is the master-slave dynamic, and in this kind of pornography a reflection of her "Project: to destroy the will."

> Human sexuality is, quite apart from Christian repressions, a highly questionable phenomenon and belongs, at least potentially, among the extreme rather than the ordinary experiences of humanity. Tamed as it may be, sexuality remains one of the demonic forces in human consciousness . . . making love surely resembles having an epileptic fit at least as much, if not more, than it does eating a meal or conversing with someone.[39]

One can agree without finding *The Story of O* representative of sexuality as it occurs in most lives, even in those in which it is unambiguously demonic. What Sontag admires in Desclos—who wrote under the pseudonym of Pauline Réage, and would not reveal her authorship until 1994—is that she "entirely presumes

this dark and complex vision of sexuality so far removed from the hopeful view sponsored by American Freudianism and liberal culture."[40]

Sontag's own vision emerges from her skepticism toward metaphor and images. "What pornography is really about, ultimately, isn't sex but death," she writes. This seems questionable: pornography, at least for most people, really is about sex. But etymology relates pornography to the broader themes in Sontag's work. In Greek, *pornografia* means a "depiction of prostitutes." And it is not prostitutes but the depiction of them that relates pornography to death. Depictions—images—show lives bound toward their undoing. "Photographs," Susan wrote, "state the innocence, the vulnerability of lives heading toward their own destruction."[41] This is the pathos of the image. There may be escapes from consciousness. But there is no escape from time.

Xu-Dan Xôn-Tăc

In 1968, a new phrase entered the American lexicon: "credibility gap." It referred to the distance Plato had described between language and reality, and showed that that distance, rather than a mere intellectual abstraction, was a matter of life and death.

In practical terms, "the credibility gap" meant the gap between the Johnson administration's rosy rhetoric and a bloody quagmire. "We are not about to send American boys nine or ten thousand miles away from home to do what Asian boys ought to be doing for themselves," Johnson had said in the 1964 campaign.[1] The gap grew once fifty thousand troops became 549,000, especially because photographs revealed something no amount of propaganda could prettify: monks setting themselves on fire; a naked girl running in terror from her napalmed village; a civilian shot in the head in the middle of the street; American soldiers with their limbs blown off.

The extent of the deception reached such proportions that it

came very close to upending the nation's social contract. Great though Johnson's initial achievements were, they almost immediately ran aground on the distrust of a corrupt authority that he came to symbolize. He signed the Voting Rights Act on August 6, 1965. On August 11, as a reaction to police brutality, riots broke out in the Watts district of Los Angeles. Those six days of mayhem were followed, in coming years, by mass rioting in one city after the next—Newark, Chicago, Detroit, New York, Baltimore. In Washington, in 1968, for the first time in memory, troops bristling with machine guns perched on the steps of the Capitol.

They had been called out on April 5. Six days before, President Johnson stunned the nation with his announcement that he would not seek reelection. On April 4, Martin Luther King was assassinated in Memphis, and more than a hundred cities burned. On June 5, the day after he won the California primary, Robert Kennedy was shot in Los Angeles.

———

The early 1960s, with their hopes of generational renewal, personal reinvention, and escape from outmoded social conventions, were over, and darkness was pouring in. In "Trip to Hanoi," the record of Susan's journey to North Vietnam, those hopes are not quite dead, and the essay illustrates an attempt, common enough at the time, to salvage some of the idealism that was propelling revolts all over the world, from Mexico to Prague to the Paris barricades. Susan visited in May 1968, halfway between the assassinations of King and Kennedy. The chaos of those weeks haunts every page of the essay, and makes it a sinister mirror of the times.

Her activism had earned her an invitation from the North Vietnamese government. She traveled to Laos, then entered a country that had suffered years of bombardment, where life had been reduced to the barest necessities. She was immediately con-

fronted with the problem of how to see a place that she had only known through words and images. "Like anyone who cared about Vietnam in the last years, I already knew a great deal," she wrote. But she soon realized that she knew nothing, and the first days were "profoundly discouraging."[2]

Again and again, she confessed to her bafflement. She realized how inadequate words and photographs were, understood how hard it was to see Vietnam independent from the ideology that had grown up around it. She tried to reconcile the country in her mind with the one in front of her eyes: "The problem was that Vietnam had become so much of my consciousness as an American that I was having enormous difficulty getting it out of my head."[3] It was, she later said, "the first time I ever wrote about myself at *all*." This was not a natural voice; she had always written about herself when hidden behind a persona. "I can't hope to have the kind of influence that Norman Mailer and Paul Goodman have because I can't imagine writing personally the way they do. I'm just not temperamentally capable of using the kind of direct, immediate, first-person experience that Mailer uses in his essays, but that's precisely what makes him so effective," she said the year she went to Vietnam.[4] She had to step out from behind the mask. "I don't want to write about myself," she thought. "I just want to write about *them*. But when I realized that the best way that *I* could write about them *was* to include myself, then it was like a sacrifice."[5]

Hippolyte had confessed his interest in revolutions, his conviction that revolutions were "changes not of government or of the personnel of public institutions, but revolutions of feelings and seeing." Vietnam was both. It was, first of all, the bloody revolt Che Guevara envisioned when exhorting radicals to create "two, three, many Vietnams." And it was an individual commitment to radical consciousness. "It would be good if we each made a Vietnam inside ourselves," Jean-Luc Godard said. Susan cited the

phrase approvingly.[6] But in Hanoi, she found that reconciling these different Vietnams—the real country and the image that trickled through language and photographs—was harder than she expected.

Over and over, in her first days, she emphasized how much she could not see, how much she could not understand. "I try to discover the differences between each of them, but can't," she said of her hosts, "and I worry that they don't see what's different or special about me." She did her best to go along with being "reduced to the status of a child: scheduled, led about, explained to, fussed over, pampered, kept under benign surveillance." This was a form of surrender of consciousness, like those she had discussed in her essays on pornography, *Persona,* and the aesthetics of silence, but it was not easy to accept: "The heaviness of it all comes from the fact that the script is written entirely by them; and they're directing the play, too. Though this is how it has to be."[7]

As usual, language was no help. "What makes it especially hard to see people as individuals is that everybody here seems to talk in the same style and to have the same things to say," she wrote.[8] The Vietnamese spoke in language that she felt reduced her to the status of a child: indeed, to being Sue Rosenblatt, cub reporter at Tucson's *Cactus Press.* "The executed Fascist leaders were our enemies," she wrote when she was twelve. "But the Italian people are not." In Vietnam, she heard clichés she had long outgrown: "We know that the American people are our friends," she was told. "Only the present American government is our enemy."[9]

One could smile at that childish language. Sontag did, uncomfortably: "The root of my bad faith: that I long for the three-dimensional, textured, 'adult' world in which I live in America . . . [even] in this two-dimensional world of the ethical fairy tale where I am paying a visit."[10] But a writer who loved complexity found that some things were quite simple: "For once, I think, the

political and moral reality is as simple as the Communist rhetoric would have it. The French *were* 'the French colonialists'; the Americans *are* 'imperialist aggressors'; the Thieu-Ky regime *is* a 'puppet government.'"[11] Here, at last, the credibility gap was bridged.

The simple language consoled her. But she also knew that the surrender of intelligence and personality it required was not a way out of her own consciousness. Adopting the Vietnamese view would mean losing "what's different or special about me." It meant the loss of self she had always feared. ("I won't let 'them' take it away from me. I won't be annihilated.") Still, she tried to imagine a positive side to such a loss.

> Of course, I *could* live in Vietnam, or an ethical society like this one—but not without the loss of a big part of myself. Though I believe incorporation into such a society will greatly improve the lives of most people in the world (and therefore support the advent of such societies), I imagine it will in many ways impoverish mine.[12]

This was why Cioran rejected musings about a return to a less complex consciousness as neither desirable nor possible. There was no going back, no rewriting history; and Susan's desire to square this circle, to remain herself while also embracing some alternative she thought might be simpler, gave her an experience of being trapped in history—the social, economic, and political structures that produced her—and trapped in herself.

"It is a very complex self that an American brings to Hanoi."[13] No matter how much she admired the Vietnamese peasant revolutionaries, Susan Sontag could never become a Vietnamese peasant revolutionary. Did this make her a phony? "My impulse is to follow the old, severe rule: if you can't put your life where your head (heart) is, then what you think (feel) is a fraud."[14] This

paradoxical desire—to be authentic by being something other than she was—would lead her to greater fraudulence: in terms of Vietnamese culture, in terms of her own.

————

The first part of "Trip to Hanoi" is filled with admissions, candid and concise, of blindness: "I want their victory. But I don't understand their revolution."[15] The language, the starkness, the tight control ("which leaves me unable to believe I'm seeing a genuine sample of what this country is about"[16]), turned Vietnam into the kind of "ahistorical dream landscape" in which she had situated pornography. Vietnam was "the target of what's most ugly in America: the principle of 'will,' the self-righteous taste for violence."[17] But the same principle of will—the desire to be different—led her, suddenly, to submit to her American fantasy of Vietnamese ethics and heroism.

By making up her mind to believe everything she was told, she could make the credibility gap disappear. By substituting her hosts' eyes for her own, her skeptical language could be replaced by what sounds like a transcription of a government brochure: "The country is pitifully lacking in . . . basic tools like lathes and pneumatic drills and welding machines," she pronounces.[18] "The Vietnamese think a great deal about their future," she writes. They "genuinely believe that life is simple. They also believe, incredible as it may seem considering their present situation, that life is full of joy." Furthermore, they "genuinely love and admire their leaders; and, even more inconceivable to us, the government loves the people."[19]

Perhaps this is all true. But these assertions are supported by little more than the word "genuinely." No facts are mustered; no Vietnamese voices are heard. The statements are supported only by the reader's belief in the authenticity of Sontag's experience.

But the brilliant author of *Against Interpretation*—the perceptive critic who wrote the first pages of the essay—has stepped out of the room, passing the microphone to a person willing to overlook even the most well-documented facts about Vietnam: the treatment of American prisoners, for example. Sontag visits the lovingly tended grave of an American serviceman and writes that "the North Vietnamese genuinely care about the welfare of the hundreds of captured American pilots."

This was not too far out of the Left mainstream. In the age of the "credibility gap," when the American government repeatedly insisted on alternative facts, many disbelieved these reports. But her hotel, a grand French pile known as Thống Nhất ("Reunification"), was five blocks from a more famous hostelry, Hỏa Lò Prison, known as the "Hanoi Hilton." There, captured Americans, many of whom were luckless draftees, were starved and beaten, shackled to cement slabs and hung from meat hooks. Susan ignored the possibility of their existence, refusing to view even the most outlandish claims of another government with the skepticism she brought to her own.

She had noted in her journals that Harriet accused her of not being "very sharp about other people, about what they are thinking and feeling, though I'm sure I have it in me to be empathetic and intuitive." More than a decade later, in "Trip to Hanoi," she mentioned "my empathic talents." Back in New York, she wore an aluminum ring made from the fuselage of a downed American plane.

———

After "Trip to Hanoi" was published, "the American female writer Xu-Dan Xôn-Tăc" was written about in the North Vietnamese press. "Living by the Vietnamese way of life, according to Americans, would be a great loss of the soul!" one journalist exclaimed.

Of course in our perspective, the things that Sontag worries might be "lost" are not to be regretted or things that make the soul feel fulfilled. She is not yet able to understand what enriches our soul. Yet we are able to understand and evaluate American culture.[20]

This is surely untrue: it is common enough for non-Americans to think that familiarity with America's more exportable products adds up to an understanding of American culture. But Susan herself had trouble creating a more nuanced view of her own country. At the end of the piece, she called for a new idea of American patriotism to replace the cruelty and chauvinism that generally went by that name. In London, in 1967, she said that

> living in the United States hurts so much. It's like having an ulcer all the time. The present administration is a world disaster, and it is mainly because there are so few thinking people in the administration. I feel embarrassed to be an American. . . . The pity is that there is a minority generation at the universities which is the most gifted, most human America has ever known. They are left with no choice but to opt out. When I come abroad, it is my way of opting out. But I am American, and when I am in America, I am automatically involved with protest—whatever good it can do.[21]

This is a reasonable reflection of the feeling many Americans experienced as Vietnam dragged on and on. But her outrage led her to an increasingly extreme anti-Americanism. She was amazed that the Vietnamese could fight America so self-sacrificingly while reading Whitman and Poe. In "What's Happening in America," she seemed to will destruction upon the entire nation: "Americans know their backs are against the wall:

'they' want to take all that away from 'us.' And, I think, America deserves to have it taken away."[22]

To embrace communism—at least its Vietnamese variety—was to embrace a romantic politics unavailable at home. "It was a willful blindness," said Robert Silvers. "Susan being carried away, Susan wanting to believe."[23] Later, she was embarrassed by the piece.[24] "Even she, in retrospect, would have winced at some of the things she said during her visits to Hanoi under U.S. bombardment," according to David. But "the horrors of war that made her go off to an extreme were anything but figments of her imagination. She may have been unwise, but the war was still the unspeakable monstrosity she thought it was at the time."[25]

———

Before and after her trip to Hanoi, her dual role as emerging young writer and activist took her to a more peaceable kingdom. In April 1968, a cultural attaché from the Swedish embassy invited her to Stockholm to make a film.

The surprise invitation was a testimony to her burgeoning reputation. It awed her friends, who saw her go from triumph to triumph. But the impression of blessedness other people saw was not one she shared. Privately, she was still the "unloveable soldier" who was "struggling to survive, struggling to be honest, just, honorable," and who still worried, as always at moments of apparent success, that she was falling short. In all of her work from the late sixties, a depression would be palpable that was something more than the terror that fell on so many in the age of Vietnam.

Still, the surface was dazzling. She stopped in Sweden on her way to Hanoi, and returned to spend three months in the capital of a country that had lingered for most of history in poverty and obscurity. Now, like Vietnam, it was famous: "Some countries are more famous than others," Susan wrote. "And similar laws of

celebrity—the false optics of fashion; the cruel swings of admiration, envy, and excoriation—apply to countries as to people."[26]

Sweden's fame came from one of the boldest political experiments in the world. Its social-democratic system was a non-Communist socialism meant to counter communism by removing the grievances upon which revolution thrived. To show that capitalist societies could be as friendly to workers as Communist ones, Sweden's Social Democrats created programs that became legendary for their generosity. Through a combination of high taxes and lavish welfare outlays, Sweden became a role model, perhaps the role model, for the democratic Left all over the world.

Its political model made Sweden determined to play a role in culture, too. Bergman showed that this once-marginal country could produce artistically advanced cinema, though Swedish film was more widely known for something else. In 1951, in *One Summer of Happiness,* the actress Ulla Jacobsson's breasts appeared. This was a first in a mainstream film, and caused an international frisson; Sweden's relaxed attitude to nudity eventually gave rise to a lucrative pornography industry.

As part of its cultural diplomacy, Sweden strove to internationalize its cinema, paying for several of Godard's films and inviting foreign directors, including Agnès Varda and Peter Watkins, to make films there. Susan Sontag seemed like a good choice: *Against Interpretation* had appeared in Swedish in 1967, and her essay on Bergman was influential even in his homeland.

And so she landed in room 404 of the Hotel Diplomat, on the elegant waterfront avenue called Strandvägen. There, she wrote "Trip to Hanoi" and a screenplay, *Duet for Cannibals.* "We all thought it was an adventure," said Agneta Ekmanner, a young actress who would appear in *Duet for Cannibals.* Agneta and her friends looked forward to "a very thrilling adventure to work

with Susan Sontag, whom we had already read about. Everyone was young and stupid—but very intelligent."[27]

"We were used to working with very strange directors, auteurs," said Bo Jonsson, deputy head of production at Sandrews, the production company. "So we had a very liberal attitude when she came here." They were aware it was a risk: "France had a hundred first directors," Jonsson said, but only three enjoyed a full career. And Sweden had no professional scriptwriters: "Almost all directors wrote the script themselves." Susan got a generous budget. "They liked Sweden because they were absolutely free to do whatever they wanted. As a producer, we never said: you have to do like this. That kind of dialogue didn't exist."[28]

———

Social Democratic Sweden was what people meant when they said "liberal," as opposed to "radical." But, like so many bastions of liberalism, Sweden had radicalized. Swedish opposition to Vietnam, including its willingness to welcome deserters from the United States armed forces, drove relations with the Johnson administration to such a low that the American ambassador was recalled in March 1968. This was an exceedingly rare step toward a friendly Western European country; and for almost two years, until the Nixon administration, no ambassador would return.

"Vietnam was the biggest Swedish question," said Peter Hald, who worked with Susan. Part of the reason for Swedish interest in her was her interest in Vietnam. "Sweden was all over interested in Vietnam."[29] And so if summery Stockholm, with its ancient spires and flowery isles, seemed far removed from the napalmed villages of Vietnam, it was not. The city was filled with Americans fleeing the draft: for them, Sweden was the most popular destination after Canada.

They had "nowhere to go, to live," said Gösta Ekman, who

had been Ingmar Bergman's assistant at Dramaten, Sweden's most prestigious theater. "So we said: you're welcome. And Susan heard about this, the deserters living in our house, and the intention when she came to Sweden was to make a film about the deserters."[30]

In a surviving treatment, we read: "Concerns the situation of an American deserter, Tom Moss, who has come to Stockholm." Her film would include documentary footage. Then, after thirty minutes, "his life becomes more dream-like." Some of these scenes might have been outtakes from *The Benefactor* or *Death Kit:* "a party at which Tom, Lars, and Ingrid are all present: Tom eventually becomes so upset that he ends by bandaging much of his body, including his face."[31]

This marriage of real politics to a weird dreamworld attempted to illustrate the meaning of modern art that Susan had earlier defined: "its discovery beneath the logic of everyday life of the alogic of dreams." But she discovered that another film about deserters was being made; and so she produced a different script, one that baffled everyone involved. "I said, I don't understand. What's it about?" said Ekman. "And we were all like that." But Göran Lindgren, the head of Sandrews, the production company, said: "She's very famous. I trust her."[32]

———

"I have never, never heard so many interesting things about film," said Agneta Ekmanner. Susan's cinephilia, inherited from Mildred—"my mother, movie fan-fatale"[33]—was also a characteristic of the sixties. "In a funny way, that was what was driving the culture at that moment, film love," said Phillip Lopate, speaking of the years he knew Sontag at Columbia.[34] It was, as Susan wrote near the end of her life, "the age of feverish moviegoing, with the full-time cinephile always hoping to find a seat as close as possible to the big screen, ideally the third row center." This was moviegoing as education, as weltanschauung:

Cinema had apostles (it was like religion). Cinema was a crusade. Cinema was a world view. Lovers of poetry or opera or dance don't think there is *only* poetry or opera or dance.

It was from a weekly visit to the cinema that you learned (or tried to learn) how to strut, to smoke, to kiss, to fight, to grieve. Movies gave you tips about how to be attractive, such as . . . it looks good to wear a raincoat even when it isn't raining.

The movies also offered a flight from consciousness: "You wanted to be kidnapped by the movie," she wrote. "To be kidnapped, you have to be in a movie theater, seated in the dark among anonymous strangers." And if this setup had a sexual component, Sontag was not one to deny it: "No amount of mourning will revive the vanished rituals—erotic, ruminative—of the darkened theater."[35]

In the late sixties, perhaps the most admired creator in avant-garde film was Jean-Luc Godard, to whom Sontag dedicated an essay in *Against Interpretation* and then, in February 1968, another. Only three years older than Susan, Godard was a phenomenon, "turning out a film every few months": by the end of 1968, when he was thirty-eight, he had already made eighteen movies. Despite her longing to destroy the will, she also admired such Nietzschean creators: "The great culture heroes of our time have shared two qualities," she wrote. "They have all been ascetics in some exemplary way, and also great destroyers."[36] The "monastic cell," the aesthetics of silence, could coexist with this kind of heroism.

There was something else that interested her in Godard, and made him a model for the work she was trying to do. "I'm still as much of a critic as I ever was during the time of *Cahiers du Cinéma*," she quoted him. "The only difference is that instead of writing criticism, I now film it."[37] He had located "a new vein of

lyricism and pathos for cinema: in bookishness, in genuine cultural passion, in intellectual callowness, in the misery of someone strangling in his own thoughts."[38] And he showed how a critic might become an artist:

> Godard has elaborated a largely anti-poetic cinema, one of whose chief literary models is the prose essay. Godard has even said: "I consider myself an essay writer. I write essays in the form of novels, or novels in the form of essays."[39]

———

Though many tried, Godard's mystifying films, with their interpretive, critical sensibility, were difficult to emulate. Sontag was steeped in film and film criticism. She had been on the jury at the Venice Film Festival in 1967, and on the selection committee of the New York Film Festival. Her cinephilic knowledge was second to none, but when it came to making *Duet for Cannibals* she seemed to succeed only at mystification.

Ekman plays Tomas, secretary to a loopy but charismatic revolutionary, Bauer, in Swedish exile. Agneta Ekmanner plays Ingrid, his wife, who watches nervously as Tomas comes increasingly under Bauer's spell. Bauer—based on Jacob Taubes, like Professor Bulgaraux in *The Benefactor*—is married to an Italian named Francesca. This character is another iteration of Frau Anders, the woman-without-a-will: "She doesn't like to be touched," her husband says. "It's best to pay no attention to her."[40] Bauer is suffering from some disease, which adds to the atmosphere of mistrust, espionage, and things going bump in the night.

"Not plot, but incident": Warhol's instructions to his collaborator Ronald Tavel offer a motto for this film, too.[41] Incidents happen. Francesca locks herself in the car, for example, then sprays the inside of the windshield with shaving cream. She wraps Tomas's head in gauze. There are surrealist gestures, as when Tomas

is listening to a recording of Bauer's voice and the voice suddenly starts speaking directly to him. Ingrid turns up at chez Bauer, falls under his charm, fucks him on the sofa, and then becomes, like Francesca, a spineless servant, another will-less woman. Francesca feeds Ingrid off her own plate; Ingrid and Francesca flirt; Francesca dies; Bauer commits suicide; neither is really dead. As the bandaged Tomas is another example of her obsessive theme of vision and blindness, Bauer's return is another example of Susan's "obsessive theme of fake death."

The film is far more interesting to interpret or analyze than it is to watch. The viewer can only sympathize with the befuddlement of the actors. "We kept asking each other, out of the corner of our mouth: 'What is this about?'" said Gösta Ekman.[42] At first, said Agneta, "We felt that this was very exciting. That this film could be something very new. But we couldn't judge. Because the script didn't say so much." Susan had trouble explaining what she meant. "I don't think she had real feeling for the actors," said Jonsson. After trying and failing to elicit explanations from her, they shrugged their shoulders and got on with their work. "What it was all about . . . I don't think any of us really grasped that," said Peter Hald.

Susan was isolated. The actors knew each other and had worked together. She, on the other hand, had no experience with directing or acting, and no knowledge of the language in which she was directing. As in Vietnam, where she was aware that her ignorance of Vietnamese made her dependent on the interpretations of others, in Sweden she found herself in the odd situation of directing in a language she did not understand.

———

Susan's difficulties in approaching the real world of politics—as opposed to the theoretical or aestheticized world of ideology—come through in "A Letter from Sweden," published in *Ramparts*

in 1969. Alongside *Death Kit*, "Trip to Hanoi," and *Duet for Can-
nibals*, it betokens the frustration lurking beneath a frenetic sur-
face. Susan was trying to find the passion that made *Against
Interpretation* ring with the excitement of discovery. Even the best
essays in *Styles of Radical Will* feel belabored, opaque: difficult
rather than challenging, daunting both to reader and, one senses,
to writer. In her fiction, reportage, and films—forms that were
not her native languages—the difficulties become even more ap-
parent.

"Letter from Sweden" reveals the source of Susan's confu-
sion, and of her difficulties. It is hard to locate exactly her objec-
tions to Sweden. To read between the lines is to find a model of
a humane society, and Susan is not blind to its positive quali-
ties. She praises its extraordinary generosity to artists, including
to her. She notes that it has the highest per-capita income in the
world. She describes its egalitarianism: "The country is, for ex-
ample, virtually servantless."[43] She admires its lack of corruption.
"The standard of honesty among people in work situations could
scarcely be higher," she writes.[44] As for the status of women: "I
can't tell you how relieving, liberating it is to be in a city where
an unaccompanied woman can walk around at any hour, day or
night, and hardly even be looked at, much less accosted or fol-
lowed by men."[45] The Swedes were furthermore "spectacularly
good-looking" and in "exceptional physical health"—though she
criticized "a discrepancy between beauty of face and unliberated
body."[46] They were not hung up about sex: there was "no stigma
attached to being a bastard." And "if you want a dildo, you can
buy one at your nearest sex store."[47]

But this is interspersed with complaints that seem almost
touristy. Swedes, like every northern people, drink. Sweden is
cold. The winters are long, and the darkness depressing. "The
Swedes simply do find it hard to accept generosity and to extend

it," she writes, forgetting the $180,000 she has just received to make a film. And "being with people feels like work for them." Perhaps all this is true, but these assertions are offered as just that, assertions, without much evidence. As in her essay on North Vietnam, we never learn what the Swedes themselves think. Would they have been surprised to hear that they have "a relatively weak drive toward differentiation as individuals," for example?[48] What did they think of her statement that "the ruling class of this country is genuinely benevolent and filled with good intentions"?[49] We never learn—any more than we hear whether "the Swedes want to be raped."[50]

But "Letter from Sweden" is less about its purported subject than it is about its author, and the last few sentences suggest a solution to her dilemma.

> Sweden has enjoyed a great reform, not a radical change. Humane and ingenious as these reforms are, they don't strike at the root of the situation of the Swedes as human beings. They have not awakened the Swedes from their centuries' old chronic state of depression, they have not liberated new energy, they have not—and cannot—create a New Man. To do that Sweden needs a revolution.[51]

This is the disappointed hope behind the slogans. The reforms she described were less important than the hopes Sweden created inside herself. Her journey to Sweden, in this context, seems like travel as escape-from-consciousness: a fresh start, somewhere else. In the terminology of alcoholism, this is known as a "geographical cure," an attempt to escape addiction by seeking a fresh start, a change of scenery. An outraged American could go abroad. A blocked writer could become a filmmaker. A depressed woman could become a "New Man." It was this elusive creature that she

had glimpsed in Hanoi: "Through these ordeals, 'a new man' is being formed."[52]

She was not done trying to find him: to find romance. The piece concludes with the ultimate sixties slogan: *"¡Hasta la victoria siempre!"*[53]

CHAPTER 20

Four Hundred Lesbians

There were four hundred lesbians in Europe, Susan used to joke.[1] For this group—heiresses and socialites, writers and academics, actresses and designers—lesbianism amounted to an aristocracy within an aristocracy. This was the sapphic equivalent of what, in England, Isaiah Berlin called the Homintern, and what was known in France as *l'homo-people*. In Paris and London, Cannes and Capri, these women holidayed, fell in love, and broke hearts in the same exclusive circles.

For them, homosexuality in no way meant a renunciation of class privilege, as it often had in works like *Nightwood*. "They lived in a lovely palace," one member said of another. "But you certainly couldn't call them rich."[2] This was the family of Anna Carlotta del Pezzo, Duchess of Caianello. When they met in 1969, Susan was desperate for romance, and Carlotta was romantic in the older sense of the word: straight out of a novel. Susan had not been in love since she met Irene a decade before. "I don't

think Susan ever loved anyone the way she loved Carlotta," David would later say.[3]

They were opposites in every way. Susan was a middle-class American consumed with becoming. Carlotta was a Neapolitan aristocrat whose only concern was being. "It's almost offensive to ask those people: What do you think, what are you going to do," said the poet Patrizia Cavalli. Carlotta was notably indolent even by the standards of her milieu. "Her friends, women her age, women she went to school with: they all did *something*," said the painter Marilù Eustachio. "She was the only one who did absolutely nothing."

"Carlotta might not even get out of bed," Cavalli explained. "It was impossible to make any plans with her."[4] In 1970, their friend Giovannella Zannoni explained this to Susan: "She gets at times very vague about time and its meaning and seems totally uncapable of understanding that other people may take dates and appointments as something precise."[5] Cavalli added: "I don't think she ever read a book in her life." And she only ever made two things in her life, said Don Levine: "her fat dark brown paper joints, which she rolled every morning, and her very spicy pasta sauce for breakfast."[6]

Carlotta was the opposite of "radical will"—the opposite of Susan—but her refusal of activity created problems of its own. Once, when Eustachio reproached her for her languor, Carlotta bristled: "So you think it's easy, doing nothing?"

———

Carlotta's early life was half feudal, half jet set, lived in a world, David Rieff said, "one would now call Eurotrash." Tall and lean, partial to belted fur coats with shoulder pads, or to minks thrown over the T-shirts she wore without a bra, she modeled, hung out with Visconti, was an extra for Pasolini: inhabited a world, Levine said, "of people who don't think: 'Instead of being at this party on Capri, I should be writing a play.'"[7]

She and Susan would seem to have been almost comically *mésalliées*—and they were. But Carlotta was beautiful, and Susan was susceptible to beauty. "To experience a thing as beautiful means: to experience it necessarily wrong," Nietzsche said. It was a phrase Susan liked to quote,[8] but if Susan experienced Carlotta wrong, she was not the only one. "When I met her," said Eustachio, "it was difficult not to sense the fascination of Carlotta." Cavalli agreed: "Fascination incarnated." Many fell for her charm. She was androgynous—"like a boy," said Cavalli—and had lovers of both sexes. Once, in New York, Levine took her to see a movie starring Kirk Douglas. "He was very good in bed," she confided in a low voice. Her female lovers included many of the four hundred lesbians: Colette de Jouvenel, daughter of the great Colette; the Italian movie star Mariella Lotti.

She was also a toxicomaniac. The gorgeous lesbian duchess with a taste for smack was a legend. Her charm, and the impression she gave of not being on first-name terms with reality, let her get away with things others would not have dared attempt. But her drug use eventually brought legal problems. Sometimes she wiggled out of it ("My next phone call will be to the Minister of Justice"), but sometimes her connections proved less helpful. Once, she spent a month in an Italian jail, and Susan wrote every day. Carlotta got along famously with the hookers with whom she shared a cell, but the court ordered her to rehab, and she headed to a clinic in Switzerland.[9]

———

Beautiful, stoned, and unavailable, Carlotta resembled Mildred—and Susan knew it. In 1975, she described her "taste for custodial relationships. Propensity first developed in relation to my mother. (Weak, unhappy, confused, charming women.) Another argument against resuming any sort of connection with C."[10]

In 1958, during her breakup with Harriet, Susan noted a

lesson. "Not to surrender one's heart where it's not wanted."[11]
Carlotta made her forget that lesson, and her surrender was hu-
miliating. "Carlotta was cruel—very cruel—to Susan," said Ca-
valli, bringing out Susan's "endless masochism." Stephen Koch
agreed. "She was masochistic to an unbearable degree. She would
crawl on the floor, almost literally." Florence Malraux said: "Su-
san was at Carlotta's feet." And Don Levine said: "Susan literally
sat at the feet of only two people. If she came into a room and
saw either of these two people she'd sit right here on the floor:
Hannah Arendt and Carlotta."

"I'm looking for my dignity. Don't laugh," Susan wrote in
1971. "I'm very intolerant and very indulgent (of others). Toward
myself, the intolerance predominates. I like myself, but I don't
love myself. I'm indulgent—to an extreme—of those I love."[12]
The lengths to which she was prepared to go shocked her friends.
Carlotta was stingy; Susan was generous. Carlotta was demand-
ing; Susan kowtowed. Levine once asked what she would do if
Carlotta insisted she cut off contact with David. "She didn't say
what an absurd question or out of the question or anything like
that. She said, I would wait until she was getting her hair done
and I would call him from a phone."

They had met in the summer of 1969, through Giovannella
Zannoni, a Neapolitan producer; but by the fall of 1970, a lit-
tle more than a year after it began, the relationship ended. Like
many of Susan's disappointed loves, including with her mother,
this one would linger in other guises, but when it was over, Susan
fled to Amherst, where Levine taught. She was more depressed
than he had ever seen her, and he tried to distract her with walks,
conversation, and music. Nothing worked.

I say let's go into town. It's autumn, and at one point we
walk under this tree, the fabulous maple trees, this tree is
just in flames, and we're under it so it's all around us, like

an umbrella. She's talking about Carlotta, and I say, "Susan, stop!" She stops, and I said: "Look at the leaves." And Susan was not someone who cursed, and she says: "Fuck the leaves."

———

Carlotta was named for her Swedish grandmother, the feminist writer Anne Charlotte Leffler. And Carlotta's effect on Susan recalled other Swedish women whose very blankness offered an ideal screen for other people's projections. Blankness was what gave Elisabet power in Bergman's *Persona;* blankness was Greta Garbo's secret, too.

Susan had long been fascinated by Garbo, whose lesbianism—an open secret—was a source of pride for many gay women. In 1958, she listed learning "to subscribe to the Garbo cult" as an important part of her sexual and worldly education.[13] And in 1965, when she saw a play called *The Private Potato Patch of Greta Garbo,* she gave an idea of her power:

> I wanted to *be* Garbo. (I studied her; I wanted to assimilate her, learn her gestures, feel as she felt)—then, toward the end, I started to want her, to think of her sexually, to want to possess her. Longing succeeded admiration—as the end of my seeing her drew near. The sequence of my homosexuality?[14]

In "Notes on 'Camp,'" she referred to her twice, both times in terms of her blankness: to "the haunting androgynous vacancy behind the perfect beauty of Greta Garbo," and then claimed that "Garbo's incompetence (at least, lack of depth) as an *actress* enhances her beauty. She's always herself."[15] This—"always herself"—was Carlotta's greatest attraction for Susan. Whatever her failings, Carlotta never aspired to be other than she was.

"Make your face a mask," a director once told Garbo. "Think and feel nothing."[16] Like Garbo, Carlotta was a Warholian ideal, all surface, no depth. Susan was a house divided; Carlotta was all body, no brain: "She was only an image, you understand?" said Eustachio. "She was absolutely not interested in substance." For Susan, Carlotta became a way of surrendering the will.

————

Another possibility for escaping consciousness appeared on the afternoon of November 6, 1969, when a woman took a train from Manhattan to East Hampton and got in a cab headed for the beach. "There's nobody here," the driver said when they reached their destination. "I realize that," the woman answered. A couple of hours later, a body washed ashore at the end of Ocean Avenue.[17]

The woman was Susan Taubes. Four days earlier, her novel *Divorcing* had been savaged in the *Times*. Hugh Kenner, the critic, allowed that the book contained "mild rewards once you fight down the rising gorge that's coupled to your Sontag-detector." But it was otherwise no more than the annoying work of a "lady novelist": "a quick-change artist with the clothes of other writers" who began "her performance with a stylish vertigo à la 'Death Kit.'"[18]

Sontag and Stephen Koch went to Suffolk County to identify the body. They were met by a doctor, who led them into a sterile room with a large viewing window, entirely covered by a brown plastic curtain. A man pushed a button, and the curtain slowly rose.

Beyond the glass, Susan Taubes's body lay on a gurney, with her very long hair spread expansively around her head. There was no bloating or disfigurement of her face. Apart from her head, the rest of her body was covered with a large paper covering, stamped in large letters, SUFFOLK COUNTY NEW YORK.

"Is this your friend Susan Taubes?"

"Yes," Susan said. "Yes, it certainly is."

The man lowered the curtain. There was a table in the same room, where there were legal documents laid out for Susan to sign. Her hand was trembling so much she could not manage the pen. Then she recovered herself and signed. We were led out.

Walking back to the car, Susan said, "So, she finally did it—that stupid woman."[19]

———

The Taubeses had long been separated, though they only divorced in 1967. Jacob returned to Europe, where he would remain for the rest of his life. As recounted in *Divorcing*, the marriage had been a high-concept disaster, an attempt to reformulate relations in ways that ranged from the monstrous—Jacob made his wife crawl up to their roof on the Upper West Side and howl at the full moon—to the philosophical.

"In the sexual revolution of the sixties," said their son Ethan, "where there was a lot of sleeping around, there wasn't a whole philosophy behind it, which he did have: to liberate people, like redemption through sin." Jacob helped Marcuse publish *Eros and Civilization,* but in real life—in his own life—liberating erotic energy proved far more difficult. He was bipolar: "He couldn't control himself," his son said. "He was constantly flying off the handle. Every little thing was a catastrophe. Crumbs on the floor, catastrophe. Bad manners, catastrophe."[20]

Susan Taubes spent time in Europe, too, sending their children, Tania and Ethan, to various boarding schools, and occasionally working at Columbia. For her, sexual antinomianism, however necessary historically or justifiable intellectually, was a different matter emotionally. "I think my mother was a heartbroken romantic," said Ethan. "This is the love of her life, and

this guy is basically sleeping with everybody." She had other lov-
ers after separating from Jacob, and shortly before her death, she
spent three months in Budapest, where she had an ill-fated affair
with the novelist György Konrád.

Sontag blamed Konrád for the suicide, which Ethan found "a
little over the top." Others blamed the scathing *Times* review. But
already in high school people had exhorted her to smile. She had
long been despondent and had attempted suicide before. Like
Susan Sontag, she was often unable to see: literally, because she
was nearly blind and could hardly cross the street without help;
and metaphorically, because she was unable to see the effects of
her actions on others—on the children she left behind, and on her
parents. "It was just grim," said Ethan Taubes. "The parents were
both alive, so it was really sad to see two people in their seventies
weeping. Susan [Sontag] was devastated."

Struggling to fend off depression, afraid of failure, Sontag was
terrified by her friend's death. "I don't want to fail," she wrote in
1975. "I want to be one of the survivors. I don't want to be Susan
Taubes. (Or Alfred. Or Diane Arbus.)"[21] In 1971, Alfred Chester
died in Israel, completely insane. Five days later, in New York,
Diane Arbus killed herself. Sontag's harsh reaction to Arbus's
work would give birth to *On Photography*. But the intensity of her
reaction to Arbus surely betokened identification—a fear that she
herself was a freak; that she, too, would eventually succumb.

———

Shortly before she met Carlotta, while Susan Taubes was still
alive, Sontag wrote the last of her sixties political pieces, "Some
Thoughts on the Right Way (for Us) to Love the Cuban Revolu-
tion." Sweden needed a revolution; Cuba was the future.

In December 1968, she flew with David and Bob Silvers to
Mexico City: Cuba was under an American embargo, and direct
flights were out of the question. Like Hanoi, Cuba was on the

international revolutionary itinerary, and the group traveled in an atmosphere of intrigue: "We were all photographed by the CIA as we got on the plane," Silvers said. In Havana, Susan was whisked off to a dramatic midnight meeting with "Redbeard," Manuel Piñeiro Losada. A former Columbia business student, Redbeard was now head of Cuban intelligence.[22]

A decade before, Bernard Donoughue said that politics, for Susan, meant "questioning all establishments and disliking all regimes." Now, she wrote that for the New Left, "the starting point is the view that psychic redemption and political redemption are one and the same thing."[23] But as at Oxford, it was aesthetics, rather than the "tedious things" of practical politics ("homes for people, pensions for people") that interested her.

Like Sweden and Vietnam—like Carlotta—Cuba was a projection of her own desire to be reinvented. "It is still common, as it has been throughout the ten years of the revolution, for people to go without sleep," she wrote. "It seems sometimes as if the whole country is high on some benevolent kind of speed." Sleeplessly, hyperactively, Cubans were creating the "New Man" of which Susan dreamed. This dream rarely elicited her finest prose. Its knotty patterns and jargon-laden phrasing show her effort to appropriate a language that was not quite her own:

> As Che stated in his famous "Man and Socialism in Cuba" and Fidel has reiterated many times, the Cuban leadership measures the revolution's success first of all by its progress in creating a new consciousness, and only secondly by the development of the country's economic productivity upon which the securing of its political viability depends.

A year before, in a preface to a book about Cuban poster art—which is to say, about revolutionary aesthetics—she praised its heroes: "Ever since my three month visit to Cuba in the summer

of 1960, the Cuban revolution has been dear to me, and Che, along with Fidel, have been heroes and cherished models."[24] Her descriptions were fuzzy, unsubstantiated. The United States was a "too white, death-ridden culture." Cubans had "become less erotic since the revolution." And she claimed that "almost all" Cubans "were illiterate when the revolution came to power." (In fact, in 1960, almost 80 percent could read.[25]) Death-ridden Americans ought to

> maintain some perspective when a country known mainly for dance music, prostitutes, cigars, abortions, resort life and pornographic movies gets a little up-tight about sexual morals and, in one bad moment two years ago, rounds up several thousand homosexuals in Havana and sends them to a farm to rehabilitate themselves. (They have long since been sent home.)

The puritanical tone is not the only thing that raises eyebrows. It is odder still that rounding up members of a despised minority and dispatching them to distant prisons did not resonate with a woman whose life had been split in two by images of the Holocaust. Reinaldo Arenas, a gay dissident novelist tortured under Castro, spelled it out. The sixties, he wrote, were "precisely when all the new laws against homosexuals came into being, when the persecution started and concentration camps were opened, when the sexual act became taboo while the 'new man' was being proclaimed and masculinity exalted."[26] The creation of the "New Man" meant destroying the "old," the "reactionary," the "effeminate"— exactly as the Nazi dream of purity meant destroying the impure.

———

In January 1970, less than two months after Susan Taubes's suicide, Sontag returned to Stockholm. There, she made the second

of her Swedish films, *Brother Carl*. This project would bear the mark of *Persona*, in the form of a mute character; and of Carlotta del Pezzo, from whom Sontag was separated, and after whom the film was named. It would also draw from Jacob Taubes's high-minded perversity and from Susan Taubes's novel and character. In the film, Susan sought a dramatic form for the ideas she had been exploring throughout the previous decade. And she sought a way of digesting her personal losses: Florence Malraux met Susan at this time, and Susan asked her for help with the script. As they discussed it, Malraux saw how weighted down Susan was by the loss of Carlotta.[27]

The film was shot over the summer. Two women, Karen and Lena—the Susan Taubes character—visit Lena's ex-husband, Martin, on an island. Martin was "a new version of the psychological fascist in *Duet for Cannibals*," Susan wrote—which is to say, of Jacob Taubes. (Perhaps Susan Taubes's description of their marriage in *Divorcing* made Sontag come to see him this way.)[28] Sontag adds other characters, too, including Martin's ward Carl, a dancer reminiscent of the mad Nijinsky, and Karen's young daughter, Anna, who, because she is mute, is the only character who can communicate with Carl. Like the Hester/Diddy pair in *Death Kit*, this last pair allows Susan to translate, now in visual form, the ideas she had discussed in "The Aesthetics of Silence."

The summer before the film was shot, when they were working on the script, Susan and Florence Malraux were walking through New York. Florence exclaimed over a Japanese platter in a shop window, only to have Susan denounce her frivolity: "Things like that weren't *serious*." The problem, for Florence, was that "Susan had no eye."

This practical problem joined the philosophical problems dramatized in the film. Without words—and above all without an

"eye"—*Brother Carl* shows the frustrations of the critical sensibility when attempting to venture into the visual arts, and becomes less a film to watch than a film to write an essay about. In 1974, Sontag did just that, noting that this film "takes a step beyond *Duet for Cannibals:* the spatial relations within the shots are subtler, the editing is more intelligent, the use of sound is more sophisticated, and the connections among the characters are more complex." Furthermore, she found that "the dialogue in *Brother Carl* is much more consistently 'de-naturalistic' than that of *Duet for Cannibals.*"[29]

"It is the work of a cinephile," said a new friend, the Argentine director Edgardo Cozarinsky.[30] Yet though *Brother Carl* is weighed down by theory, it is nonetheless a marked improvement over *Duet for Cannibals.* The story is less willfully bizarre, the characters more like people whose motives one might hope to fathom. Both films are constructed around themes of sadomasochistic power—eating the other, controlling the other, refusing the other's words—but in *Brother Carl* the characters strain to break out of these roles.

"Most of the critics said you have to feel something in order to understand," said Peter Hald, the production manager, of *Duet for Cannibals.* "And nobody of them felt anything."[31] One does feel something in *Brother Carl.* The film makes the viewer curious to know what is really going on, to get closer: the same feeling the people in the story experience. All fail to find the necessary words—all but one.

Like Susan Taubes, Lena drowns herself. Afterward, Carl coaxes the first words from Anna: "He's heavy," she says, her only line in the film. The effort to make her speak costs Carl his life.

———

If the film bore the traces of Sontag's personal and intellectual struggles, it also showed an evolution in her approach to the body

in which her mind had always been a "restive tenant." In her first film, *Duet for Cannibals,* the Jacob Taubes figure had repulsively wolfed down his food. Eva Kollisch had seen that this was a theme dear to Susan. In Sweden, Agneta Ekmanner saw that Susan "ate disgustingly."

A note from 1970 suggests a motive.

> I feel gratitude when I touch someone—as well as affection, etc. The person has allowed me proof that I have a body— and that there are bodies in the world.
>
> Being a big eater = desire to affirm that I have a body. Identifying refusal of food with refusal of the body. Irritation with people who don't eat—even anxiety (as initially with C.) and revulsion (as with Susan).[32]

When she was sixteen, she mentioned "my greatest unhappiness, the agonized dichotomy between the body and the mind." For years, she had fled the body into the safety of the mind—and, beyond the conscious mind, into the subconscious dream. As she grew older, she determined to come back into her body, including by emphasizing her physicality with gestures such as outspoken eating.

And *Brother Carl* includes a sign that "the obsessive theme of fake death" Sontag had identified in her work was ripening from a child's wish to an adult's understanding. She was looking, as she wrote in the introduction to *Brother Carl,* for a miracle, something to rouse her from the depression one senses everywhere in her work from this time. In the surprising form of Lena's corpse, that miracle was coming. Susan had earlier mocked the Christian belief that "every crucifixion must be topped by a resurrection." But her work betrayed an uncanny faith in resurrection, the fake deaths listed in her journals. These only began to change with this film: "Carl tries to make Lena's

death into a fake death (i.e. tries to resurrect her) but fails," she wrote.

As Lena's suicide allowed Anna to speak, Carl's failure offered Sontag an unexpected revival. Lena—which is to say Susan Taubes—would not be resurrected. Likewise, the theoretical, dreamlike vein of Sontag's early work was played out, too. In the Vietnam War, the loss of Carlotta, and the death of Susan Taubes, reality had intruded too aggressively. But these intrusions, however painful, would give her future work an anchor it had hitherto lacked. The "unlovable soldier" would reveal herself a bit more, and the writer's identity she had forged as a weapon against society, the metaphoric Susan Sontag, would broaden. The transition would not be smooth. But her next film would be littered with bodies.

China, Women, Freaks

The slightest gestures of Nicole Stéphane assumed the terrifying power of those of Electra," said Jean Cocteau, who cast her in *Les enfants terribles*. He had seen her in *Le silence de la mer*,[1] made in 1949, in which Stéphane played a Frenchwoman forced to quarter a Nazi lieutenant. As the idealistic young German expounded about French culture and the glorious union of Germany and France, the young woman and her uncle looked on in polite blankness, never addressing a single word to their compulsory guest. Without language, "slightest gestures," weaponized silence, were all the actress had.

The role of the steely *résistante* was one for which Stéphane was suited. Born Nicole-Mathilde-Stéphanie de Rothschild, a member of Europe's greatest Jewish banking family, she and her sister Monique escaped France over the Pyrenees in November 1942. They were clad in ski clothes and equipped with false papers giving a birthplace in a Norman village whose archives had been destroyed. Eighteen-year-old Nicole was so charming

that two young Wehrmacht soldiers helped carry her luggage; but weather and Nazis were not the only obstacles: refugees were regularly robbed and murdered by the men they paid to smuggle them across the Spanish border. Jean-Pierre Melville—director of *Les enfants terribles* and *Le silence de la mer*—lost a brother this way. But their guide, "Frère Jacques," saw them through to Catalonia, though their trials were not over: they were arrested upon arrival in Barcelona.[2] Once they were finally released, they made their way to Lisbon and from there to London, where they joined the Forces féminines de la France libre. Nicole was a driver for the air force, and debarked in Normandy just after D-Day.

After the war, life resumed in the Rothschild palaces. Nicole and Monique grew up at the Château de la Muette, whose backyard was the Bois de Boulogne. It had been built by her grandfather, the Baron Henri, an amateur playwright who created the Théâtre Pigalle for his mistress and financed the research of Pierre and Marie Curie. His son Baron James, Nicole's father, inherited his father's interest in women: his wife, the former Claude Dupont, the granddaughter of the Jewish engineer Paul Worms de Romilly, had the reputation of being the most beautiful woman in France. The couple lived in opposite wings of the house, their life together as carefully planned as their dinners. Nicole grew up literally without ever using a key: someone would open any door she might wish to enter.[3]

———

As a member of the selection committee for the New York Film Festival, Susan had been attending Cannes for several years. In 1971, she was there to show *Brother Carl*, but did not take much joy in the occasion. She was still miserable about the film's namesake, Carlotta, who had dumped her around six months before. "Solitude is endless," she wrote at the end of April. "A whole new world. The desert."[4]

Two weeks later, Nicole Stéphane walked into a meeting in a hotel room in Cannes. Nicole had not been able to follow up her early successes in *Les enfants terribles* and *Le silence de la mer* because she had been disabled by a car accident that forced her to learn to speak and walk again. She had to find a new career, and decided to produce films: "one of the two women producers in France."⁵ (There were few anywhere.) In 1969, she produced a picture based on Marguerite Duras's *Détruire, dit-elle;* her great dream was to film *À la recherche du temps perdu,* to which she had acquired the rights in 1962. It was this effort that brought her to Cannes. There, she and a friend, the Italian radiologist Mimma Quarti, had come to speak to an actress about the project.⁶

In the hotel room, they found a visibly despondent Susan Sontag. When the meeting was over, Nicole turned to Mimma and said: "We must save that woman."⁷ This missionary impulse was typical of Nicole. She and Susan soon became lovers, but if Carlotta was Susan's mother, Nicole—unlike Carlotta or Mildred—was genuinely maternal. She immediately surrounded Susan with a solicitude she had never before enjoyed. Nicole bathed, fed, clothed, and housed her, investing her considerable energies in saving Susan: her career, first, and then her life.

Their affair was not passionate in the way that Susan's affairs with Irene and Carlotta had been. That, in any case, was not Nicole's style. "For me, it lasts about one or two weeks," she said. "Then I want us to be friends and sisters forever but no more sex."⁸ This was similar to Susan's own pattern, in which the *coup de foudre* quickly became something else. Similar, too, was her conception of relationships as power. At first, Nicole was boldly dominant. She was ten years older, and she swept down on Susan, later explaining her technique: "Take her out, give her a couple of drinks, and *pounce!*" In words that recall Susan's appraisal of the Swedes, she said: "Susan is someone who needs to be raped."⁹

Yet the passivity Susan displayed with Nicole was different

from her total submission to Carlotta. Nicole found Susan on the ground. Having resolved to pick her up, she went at it with industry. Susan moved to Paris, temporarily, where she had been spending time, on and off, for years. Part of her desire to escape had to do with culture, but much of it had to do with Vietnam: "I don't want to live in the United States," she told an Italian reporter in 1973. "Staying in America means going crazy, being finished off, disappearing, disintegrating somehow. And if you're abroad, you understand what that country is, and how much harder it gets to go back and live there."[10] But she was never away from New York for more than a few months.

Perhaps afraid the relationship was moving too fast, Susan rented her own apartment in the rue Bonaparte, above the Café Bonaparte, the very same apartment where Sartre had produced *Les temps modernes*. She did not spend a single night there. Nicole immediately whisked her across the Seine—to 31, rue de la Faisanderie. She shared this house with Mimma, who occupied the ground floor. Nicole had the rest, arranged around a garden. She created an office for Susan on the top floor.

———

Susan would not quickly recover from the trials of the late sixties. At the beginning of 1973, a few days before her fortieth birthday, she noted in her diary

> the terrible, numbing loss of self-confidence I've experienced in the last three years: the attacks on *Death Kit*, feeling myself a fraud politically, the disastrous reception of *Brother Carl*—and, of course, the maelstrom of C.[11]

Reviews of *Death Kit* had, in fact, been mostly bad. The *Times* critic Eliot Fremont-Smith expressed particular disdain, in terms

guaranteed to wound: "An old saw has it that the critical and creative imaginations are in some sly way antithetical, that their sensibilities are mutually subversive, that one cannot successfully do the job to the other," he wrote. Then, as other critics would throughout her career, he wondered how "a critic of Susan Sontag's refined sensibilities can write fiction that is both tedious and demonstrably insensitive to the craft of fiction."[12]

The reception of *Brother Carl* was better than that of *Duet for Cannibals,* though that was not saying much. The Swedish reviews reflected a general mystification, and some of the American reviews would have hardly bolstered her self-confidence: "Susan Sontag will probably never find her way into artistic significance," she read in the *Harvard Crimson*. "Not many people will read her books, and not many will watch her movies. But she has her function nonetheless. She is thinking all the time and she rides the crest of every new fashion; she is worth keeping an eye on. When the cultural wind shifts, she rustles in the breeze."[13]

By taking her up and giving her a new home, Nicole helped her stem her growing sense of futility: a feeling always present, and one that would never entirely disappear. Only weeks after their meeting, the two women embarked on a project that allowed Susan to find a new direction for herself, as writer and filmmaker. Nicole had acquired the rights to Simone de Beauvoir's first novel, *L'invitée,* published in 1943. It was the story of a ménage à trois that included Beauvoir, Sartre, and a young protégée. The story would appeal to Susan for its unorthodox domestic arrangements, for its connection to the Paris intellectual world, for the possibility of directing a more mainstream feature after the failure of her Swedish ventures—and for its inclusion of a character that bore a striking resemblance to Carlotta. In June 1971, they were already working on a treatment with her old friend Noël Burch, a Californian long rooted in Paris. But then, apparently on Nicole's

advice, Susan unexpectedly dropped the project: the abrupt and unapologetic abandonment meant the end of her once-close friendship with Burch.[14]

Despite Nicole's grand name and connections, the life she offered Susan was austere: "the monastic cell." Susan's description of her apartment on the rue de la Faisanderie made it sound like the aesthetics of silence translated into interior design. In "small bare quarters," which "undoubtedly answers to some need to strip down, to close off for a while, to make a new start with as little as possible to fall back on," she wrote for months on end: "many blessed days and nights when I have no desire to leave the typewriter except to sleep."[15]

The occasion for these words was the death, in August 1972, of Paul Goodman. A radical bisexual polymath largely forgotten today, Goodman was one of the greatest influences on Susan's life, and on the New Left. His book *Growing Up Absurd,* published in 1960, listed many grievances that, until then, had been felt but not articulated. Goodman described the hopelessness behind the facade of American prosperity: how young people were trivialized, demoralized, and desexualized—shoved, after a bad education, into meaningless work, condemned to lives far more depressing than those a better society might have offered.

"For twenty years he has been to me quite simply the most important American writer," Susan wrote. "He was our Sartre, our Cocteau."[16] Her memorial essay was without precedent in her work. She had memorialized other people fictionally, but in this essay she takes a very different tone from the critical stance of her literary essays and political tracts. The tone, in fact, is that of the Susan friends recall—the enthusiast, the admirer. It is also the self-critical tone of her journals, which are saturated with a self-awareness that did not always find expression in her published work or public presentation. She recalls her nervousness in Goodman's company, her sense that he didn't really like her,

and how she, in turn, told people she didn't really like him: "How pathetic and merely formal that dislike was I always knew." She sympathized with his ambition: "There is a terrible, mean American resentment toward a writer who tries to do many things"—a resentment she herself was already feeling. And she sympathized with his sense of not being properly recognized while warning of a "media stardom" that had "little to do with actual influence and doesn't tell one anything about how much a writer is being read."

"On Paul Goodman" is short, but it marks a distance from the difficulty of her films and novels, as well as from the radicalism of her political writings. In her Paris apartment, where she was trying to live for a year without books, Susan nonetheless discovered a copy of his *New Reformation*, published in 1970. In it, Goodman warned that the absence of clearly defined, achievable goals was causing once-inspiring liberationist movements to degenerate into anarchy. It was a message Susan could not yet entirely embrace, just as she could not entirely abandon Olympus for a more personable style. But a fusion would be given a push by an unexpected journey to the kingdom of her childhood imagination.

———

In February 1972, President Nixon paid his historic visit to China, the first by an American president since the Communist revolution. The geopolitical realignment brought the possibility that other Americans might visit a country generally closed to them since the 1930s, when Mildred packed her trainload of Chinese bric-a-brac and plunged into Manchuria. On July 20, two weeks before Paul Goodman's death, Susan received an invitation. She would leave on August 25 for a three-week tour of China. On the very day the invitation arrived, she started jotting down ideas.

She sketched a film project, something she could produce with Nicole, a story of an American couple in China whose daughter—unlike Susan—went there as a child. The project did not advance,

and neither did "Notes Toward a Definition of Cultural Revolution," for which she took extensive notes. There, she named "trip to China" as one of the "two root metaphors of my life." (The other, "the desert," likewise referred to her childhood, as well as to her mood at that time.)[17] Another note listed "three themes I have been following all my life." They were "China, Women, Freaks."[18]

The trip was canceled, rescheduled, and then canceled again, but her note-taking gave her the material for one of her best stories, "Project for a Trip to China," which would appear in the April 1973 *Atlantic*. It had many of the outstanding features of her writing—her collagelike lists, her flair for marshaling quotes, her intimate voice, her humor—visible in her journals but mostly missing from her essays since "Notes on 'Camp.'"

She was conceived in China: "Conception, pre-conception," she writes.

> What conception of this trip can I have in advance?
> A trip in search of political understanding?[19]

As she described everything China meant to her, she emphasized that her China has nothing to do with real China. At school, "it seemed plausible that I'd made China up. . . . The important thing was to convince my classmates that China actually did exist." She listed possibilities for the book on China, but concluded: "Perhaps I will write the book about my trip to China before I go."

In her journal, she explained that

> I wrote a story that started "I am going to China" precisely because I then thought I wasn't. I decided to let the four-year old have her say, since the thirty-nine-year-old wasn't going to get to find out about Maoism and the Cultural Revolution. (Of course, when, in January, I did get to go—it

was the 39-year-old who went; the 4-year-old, to my surprise, didn't even deign to come along. Was it because she'd gotten the load off her chest? No—probably she would never have come—because the real China has nothing, never had anything, to do with her China.)[20]

This was a crucial insight. The inability to perceive the difference between fantasy and reality was a weakness of her earlier travel writing. This was the tension in "Trip to Hanoi"—between the reality of Vietnam and the Vietnam she knew from images: between Vietnam and its metaphors. It turned out that the China in her head was far more interesting than the China she actually saw when the rescheduled trip finally took place in January 1973, as she turned forty. There, she reverted to her old role of the earnest student, jotting down the less-than-riveting lectures of the guides—

> We have only a few state-run tractor factories, as in Shanghai, Peking, + Tientsin, Baulong
> More than 95% of all our counties have their own factories to make + repair their own machines[21]

—but these factories are mere distant cousins of the "lathes and pneumatic drills and welding machines" that captured her heart in North Vietnam. She was souring on her fellow travelers, noting their "condescending remarks" with a skepticism that never surfaced in Cuba or North Vietnam:

> "Oh, isn't that beautiful!" (of some calamitously poor village)
> Capa, at Peking Opera: "The audience is better than the opera. Look how drab they are. It's fantastic!"
> Of Forbidden City and Great Goose Pagoda: "Look. That's monumental."

Rather touching that people who enjoy liberty—
Americans—can't imagine a total dictatorship, a militarized
society. They can't recognize the signs. Of a soldier with
fixed bayonet at the gate of our hotel in Sian . . . "He's the
doorman." I demur, wearily. Chou explains that "there is a
guard because this is a government building . . ." Oh, of
course.[22]

These remarks often touch on aesthetic matters, and though
she never wrote about China—she once planned a book about
strictly supervised tours of Communist countries—she herself
had not entirely shaken her old habits. She praised the absence
of cars, which was "wonderful, ecologically. I was told that only
about one per cent of the population could afford cars, and there-
fore there are none." But when asked whether cars would be de-
sirable if everyone could have one, she exclaimed: "Oh yes!"[23]

"There are people interested in radical changes in society, in
some way in the line of the Marxist tradition. I am with them,"
she said. "China was an experience that shook me: it makes you
reexamine everything, including yourself." She does not say
how, though.[24] The closure of China's schools and universities,
the sacking of its libraries and museums, the desecration of its
temples and monasteries, the murder of hundreds of thousands of
people—the Cultural Revolution—is passed over in silence. As in
Vietnam, when she might not have known about the Americans
being tortured right down the street, the frame was everything.
It was not always easy to see; and in an age of "guided tours" and
strictly controlled news coverage, she may not have known the
extent of the disaster.

—————

After China, she paid a second visit to North Vietnam. There
had been talk of a Vietnamese publication of "Trip to Hanoi," for

which she wrote a brief preface, but the book did not materialize. Perhaps the overture—her confession that she found Vietnam incomprehensible and longed for her own more complex society—raised a censorial eyebrow.

At the airport in Hanoi, she got her period, an event for which she was utterly unprepared. When she told the story a few years later, she astonished her assistant, Karla Eoff, with this illustration of how surprised she was by this most predictable of events. She told Karla: "I couldn't believe it." Was she early? "Oh, no," Susan cheerfully answered. "It was time. I just couldn't believe I started it in the airport." Karla was amazed:

> Your period doesn't sort of creep on you every once in a while. You know this is coming. You are in North Vietnam, and you don't have a Kotex or a Tampax or whatever they had at that time? . . . It underscores a lot of this not living in reality, just not knowing basic survival things.[25]

She arrived back in Paris completely filthy, and Nicole bathed her with disinfectants.[26] Her difficulties with hygiene were nothing new: in high school, she had pretended to take a shower at the end of gym period.[27] And in her lists of exhortations to self-improvement she often had to remind herself to bathe: "Shower every other night," she wrote in 1957.[28] Five years later, the habit had still not taken: "Bathe *every* day (already big progress here in last 6 mos.)"[29]

All her life, her inattention to basic personal care—not brushing her teeth or bathing, not knowing that she was going to get her period or that childbirth was painful—baffled her friends: even as far back as Tucson, her sister was embarrassed by her lack of hygiene.[30] Such stories suggest more than carelessness—how many people, after all, need to exhort themselves to bathe?—offering example after example of an essential theme in Sontag's own

writings. This, as she wrote about Artaud, was "the unthinkable—about how body is mind and how mind is also a body." It was not a question of intelligence. These stories illustrate, in a strangely literal way, how even the most highly developed mind could find itself alienated from the body that circumscribes it. For Sontag, it would be no easy thing to unite the beastly body to the intellectual realm, the realm of language, metaphor, and art.

———

In October 1973, a few months after she returned to Paris from China, she was back in the United States. There, a brief encounter with a young academic would show just how many expectations were being heaped upon her. Camille Paglia had been obsessed with Sontag since she happened upon *Against Interpretation,* "among a dozen books that defined the cultural moment and seemed to herald a dawning age of revolutionary achievement."[31] In a culture that lacked models of intellectual women, Sontag became for Paglia something like what Madame Curie had become for Sontag: "I had fixed on Dorothy Parker and Mary McCarthy as the only available female role models in the literary life," she wrote. "With *Against Interpretation,* Sontag revived and modernized the woman of letters."[32]

Sontag, still young herself, was already a symbol for a whole generation of emerging female intellectuals. They were coming into a society with vastly more opportunities than their mothers had had, but without the role models they needed. Many of them looked to Susan Sontag; Paglia, fourteen years younger, was one of these. In April, Paglia drove from Bennington, where she was teaching, to Dartmouth, where Sontag was speaking. She invited her to Bennington, and Susan accepted, agreeing to half her usual fee. But this gesture could never have lived up to the expectations. At the end of September, Paglia was already nervously preening, as she wrote to the president of Bennington:

Naturally, I am tearing my hair out in my desire to set the right tone for myself. My new formal blue Forties/Mao jacket? Or my more casual slate-blue blousey turn-of-the-Fifties smock? Possibly my gamine French-boy's pullover? Alas, the burden of Chic![33]

And then Susan turned up, Paglia reported, "puffy, groggy, and disoriented." She was an hour late to an auditorium "tangibly simmering with hostility." A drunk Paglia introduced her ("Bacchus knows what I said") and then Susan began reading a "bleak and boring" story, disappointing an audience that had hoped to hear her on contemporary culture and politics. Afterward, they adjourned to a dinner at the house of Bernard Malamud, "Bennington's semi-resident star (and general pain in the ass)," who proceeded to say something rude to Susan "with his usual intolerable air of pious paternalism." Susan turned to Camille: "He invites me to his house to insult me!" Susan and Camille beat a retreat, at which point "'Sontag,' cool, detached, austere, and lofty," gave way to "'Susan,' warm, gossipy, and distinctly Jewish in speech and manner."[34]

Susan was late, tired, and boring, as she sometimes was when she spoke in public. Yet by Paglia's own admission, Susan was kind to her: taking a much lower fee, speaking to her privately and at length. "But our minds did not connect," she wrote. "Something was missing." There was a disconnect between Susan and Sontag.

Finally, [Susan] asked, half irritated, half amused, "What is it you *want* from me?" I stammered, "Just to talk to you." But that was wrong. I wanted to say, "I'm your successor, dammit, and you don't have the wit to realize it!" It was *All About Eve,* and Sontag was Margo Channing stalked by the new girl.[35]

After comparing herself to the upstart in *All About Eve,* Paglia did not go on to wonder whether Sontag wanted to be stalked, or whether she—barely forty—was already scanning the horizon for a successor. In the next two decades, Sontag would ripen into a much larger presence in Paglia's mind.

———

The day after Susan left Bennington, October 6, 1973, Egypt and Syria attacked Israel. It was Yom Kippur, the holiest day in the Jewish year. Despite repeated warnings, including from the Jordanian king, who secretly flew to Tel Aviv to alert the Israeli prime minister, the Israelis were not prepared. As Egyptians poured across the Suez Canal and Syrians flooded into the Golan Heights, many Israelis and their friends feared for the country's very existence.

One was Nicole Stéphane. From funding the first settlement in Palestine to securing the Balfour Declaration to building the Knesset in Jerusalem, her family had been instrumental in helping to create the State of Israel. In 1948, during the War of Independence, she had been a war correspondent. In 1957, she had been on a kibbutz, Ein Gev, on the Sea of Galilee: easy walking distance from the former Syrian border. These deep ties made her panic, and she called Susan.

"I can't bear being in France," she said. "The television reporting here is too terrible." Susan told her to come to New York, where "everybody is for Israel," and she did.[36] With Susan and David in tow, she almost instantly took off again, bound for Israel. "On a credit card,"[37] they made a film, *Promised Lands,* that would stand as the best Susan ever made. Even today, after all the shifts the Arab-Israeli conflict has undergone, the film remains an indispensable guide to that conflict. It brought Susan's analytical mind to a highly emotional situation and showed the

conflict's hideous toll on individual lives while avoiding clichés and propaganda.

It is a physical, visceral film. The camera lingers over textures: of the desert, of city streets, of the matériel with which the war—still raging during the filming—was conducted. The soundtrack constantly rumbles, as if someone is switching stations on a radio, skipping from Jewish funeral prayers to French pop songs to Italian arias and giving a good idea of the unlikely brew that came together to make modern Israel. But one sound remains in the mind. This is the sound, in the last few minutes of the film, of a doctor in a psychiatric hospital "treating" a sobbing, drugged veteran by re-creating the sounds of the war—clanging, whistling, shouting, shooting—that had driven him to the hospital in the first place. As the man buries his head in his pillow, crawls under the bed, whimpers, and begs, the horrible scene—orders shouted, sirens raging, furniture banging—goes on and on, an unendurable ten minutes: Jewish history embodied in a single faceless patient.

Like Nicole and Susan, *Promised Lands* is highly sympathetic to Jewish aspirations. "Why should I be anti-Israel?" Susan asked a reporter in Jerusalem. "I would find it very, very difficult to take a position against this country. I'm proud to be a Jew, I identify very much with other Jews, and by temperament I'm predisposed to Israel."[38] At the same time, it is also a portrait of the State of Israel as a mental hospital, haunted by pogroms and gas chambers, so perverted by its own suffering that it became unable to regard the pain of others.

The spokesman for this view is the novelist Yoram Kaniuk, who speaks throughout most of the film, tracking Zionism from "Tolstoy and the song and dance and the early beautiful socialist ideas" to the current stalemate. Until the 1967 war, he says, Israel had been a scrappy society whose main concern was

survival and whose highest values were equality and solidarity. But victory brought money—"People started building villas"— and the moral degeneration abetted by imperial fantasies: Israel "became very unconcerned about other people's suffering, other people's plights."

At this point, Susan takes stock of this society's paraphernalia, shifting from pictures of Bedouins herding sheep to sleek supermarkets and sleazy nightclubs. In an interview, she bemoaned the developments that had made Israel a modern materialistic society without making it modern in a positive, liberating way: "I didn't expect this conventionalism, this consumerism, and especially not the attitude that exists here toward women," she told the *Jerusalem Post*. Asked whether feminism might be considered a "fringe import from America," she retorted: "Considering all the things you have imported from America, this might have been one of the better ones." And asked whether it was "unusual for two women to be in charge of making a film," she answered: "Isn't it unusual for two women to be in charge of anything?"[39]

But feminism was not Israel's biggest challenge. (A woman, Golda Meir, was, in fact, prime minister.) The problem was that the Zionist dream, Kaniuk said, had caused the Jews to wander, totally unprepared, into a tragedy.

> The Jews know drama. They don't know tragedy. Tragedy is when right is opposed to another right. And here is two rights. The Palestinians have full rights to Palestine. And the Jews have full rights to Palestine. Don't ask me why. But they have. There is no solution to a tragedy, and this is a tragic situation here.[40]

The film expresses this ambivalence, and as a result was far more nuanced than Susan's earlier political writings. Too often,

they had been all drama, no tragedy. And the bodies that appeared in the film were not the dreamlike wraiths of *Death Kit* and *The Benefactor* but the charred faces and blackened legs of real people, rotting in the desert sun. As she put it in her journal, this is when "Death starts getting real."[41]

The Very Nature of Thinking

On October 18, 1973, five days before the ceasefire that brought an end to the Yom Kippur War, when Susan and Nicole were still camped out in the Sinai, an essay appeared in *The New York Review of Books*. Entitled simply "Photography," it announced one of the "revolutions of feelings and seeing" that Hippolyte called "the revolutions of my time."

One revolution was in Sontag's own work, of which it inaugurated the mature phase. Another was in the history of criticism and modern art. When *On Photography*—six essays, of which "Photography" was the first—appeared four years later, it almost immediately became that rare book of criticism that itself generated a whole school of criticism. It was not a perfect book, as Sontag herself later agreed. But it was a great book, its greatness residing not in its perfection but in its fecundity: its ability to provoke other thinkers, and to spur them to formulate new ideas of their own. It was the beginning of a conversation, not the end; and if we may never know whether it is possible to write about

photography without reference to Susan Sontag, that is because hardly anyone has bothered to try.

It was a powerful book: powerful enough to wreck Susan's friendships with photographers like Peter Hujar and Irving Penn;[1] powerful enough for a critic to make Susan sound like a highbrow counterpart of the Ku Klux Klan: "She doesn't see photographs as individual works of art in the same way that a bigot doesn't think of blacks or Italians or Jews as individual people."[2] For others, another reviewer wrote, "it became, almost instantly, a bible." Thirty years later, photographers still "ask themselves constantly why they are doing the work they do, and to whom they are doing it, and whether anyone cares whether they do it or not. If any one person provided the words for that self-questioning, it was Susan Sontag."[3]

———

The reception reflects the author's own ambivalence. Her longing to see correctly—the most insistent question in her work—struggled with her distrust of the inevitable distortions of metaphor and representation.

On the one hand, her suspicion of photographers rings so loudly that it is not surprising that many were aghast. The iconophobia of the American secular puritan joined the distrust of graven images that marked "Jewish moral seriousness." ("Yes, I am a Puritan," she wrote in 1976. "Twice over—American and Jew.")[4] She cast a supercilious eye over "mere images of the truth."[5] Photographs were consumerist kitsch and tools of totalitarian surveillance and did "at least as much to deaden conscience as to arouse it." Cameras were "predatory weapons"[6] and photographers were peeping toms, voyeurs, and psychopaths: "there is aggression implicit in every use of the camera."[7] This, just in the book's first chapter.

Twenty years before, in *The Mind of the Moralist*, she had noted

that "the sheer fact of *observing* atomic phenomena changed their velocities, and therefore the relations observed."[8] Quantum mechanics went still further, positing objects that only *began* to exist once they were observed. For this cabalistic mystery, the camera offered a ready simile: its lens altered reality and created it, too. This way of looking—one that transforms and falsifies matter—is the basis for Sontag's distrust of the camera, as for her distrust of metaphor. A photograph, after all, is a metaphor—one thing standing for another—and Susan had an instinctive aversion to metaphors.

> Somebody says: "The road is straight." Okay, then: "The road is straight as a string." There's such a profound part of me that feels that "the road is straight" is all you need to say and all you *should* say.[9]

But ("The very nature of thinking is *but*," she said) that was not the whole story. As when she wrote that she was "strongly drawn to Camp, and just as strongly offended by it," or that "I grew up trying both to see and not to see," her relationship to photography was never a simple matter of love or hate. It was love *and* hate, in extreme measure, an electric charge that explains why people loved or hated—loved *and* hated—*On Photography*.

That tension made the book exciting. If *Styles of Radical Will* is often impressive, it can hardly be called fun. *On Photography* is both. Sontag's learning no longer threatens to squash the middlebrow reader confronting it. She wears her knowledge lightly, making her range and wit all the more astounding. With hundreds of examples, she illustrates the complicated relationship between a metaphor and the thing that it represents, perverts, distorts, and creates.

For Susan, a degree of belief in the world's unreality had been psychologically necessary. Viewed through a sophistic lens, this

belief could even look convincing intellectually; but it was not satisfactory, because if the eye distorts, it nevertheless sees some actual thing. The dreamworld imagined in her novels and endorsed in her essays ("It's very tiny—very tiny, content") was the camp view, the Warhol view, that the world was made of surface and style. That was true, but only half true—drama, not tragedy. For if vision and metaphor and photography alter reality, they just as often reveal it.

But Susan could not have appreciated this "tragedy" until, in her words, death started getting real. She had been fascinated by Hujar's photographs of the bodies in Palermo; and in Israel, when she photographed bodies, she saw for herself the actual rotting flesh behind the images. It turned out that these bodies lurked behind the entire enterprise. "Photography is the inventory of mortality," she wrote.[10]

———

Inside *On Photography* is another of Sontag's disguised self-portraits. The book originated with her visit, at the end of 1972, to one of the great blockbuster exhibitions of the era, the posthumous retrospective of Diane Arbus. Arbus had slashed her wrists and taken an overdose of barbiturates a year before, aged forty-eight. In the short interval between her death and the show at the Museum of Modern Art, she had become so famous that when the show opened people lined up for blocks. It attracted more visitors than any previous photography exhibition, so popular that by the time it finished touring North America—seven years later!—no fewer than seven million people had seen it.[11]

Many were repeat visitors, and one was Susan Sontag.[12] In 1965, Arbus photographed her and David twice. The first portrait shows them on a park bench, their noses nearly touching, so close together that they almost look like two halves of the same face: no picture conveys their symbiosis as well as this one. Arbus also

produced another image with a very different mood, in which a depressed-looking Susan huddles against a nattily dressed David. He, too, looks uncomfortable, as if his mother's sadness had rubbed off on him. Susan did not take to Arbus, and perhaps it is this distaste one senses in the portrait: it certainly comes through in her comments on Arbus, on the evidence of which she seems to have loathed her.[13]

But Susan was also fascinated by her—and fascinated that people were fascinated by her. Part of the reason she kept going back, she said, was to see the audience, to eavesdrop on their comments.[14] The people these people were looking at were not just any people, since the Arbus exhibition was—to borrow the title of Susan's essay—a freak show. There was a "Jewish giant." There were people with Down's syndrome and people sporting facial tattoos. There was a boy playing with a toy hand grenade, men putting on makeup, and a woman swallowing a sword.

The audience devoured what Sontag called these "assorted monsters and borderline cases" because they were trendily appropriate to the times:[15]

> The Arbus photographs convey the anti-humanist message which people of good will in the 1970s are eager to be troubled by, just as they wished, in the 1950s, to be consoled and distracted by a sentimental humanism.[16]

———

As it happens, Susan had long been fascinated by freaks. They were one of the "three themes I have been following all my life." And they appear often in her notebooks. In 1965, she noted her fascination with

Disembowelment
Stripping down

Minimum conditions (from *Robinson Crusoe* to concen-
tration camps)
Silence, muteness
My voyeuristic attraction to:
Cripples (Trip to Lourdes—they arrive from Germany in
sealed trains)
Freaks
Mutants
. . .
Compare [X] who discovered he liked to play a sadistic
role in sex by noting that he liked the same things—looking
in medical books, at cripples, etc.
Or is there something more? Such as:
Identifying myself with the cripple?
Testing myself to see if I flinch? (reacting against my
mother's squeamishness, as with food)
A fascination with minimum conditions—obstacles,
handicaps—of which the mutilated person is a *metaphor*?[17]

In her essay on science fiction, she wrote that scientists were
"always liable to crack up or go off the deep end" because they
were a "species of intellectual." She, too, belonged to that spe-
cies, and part of her attraction to freaks was surely that she was
one: beaten because she was a Jew, belittled because she was a
woman, endangered because she was gay.

In November 1972, as she was repeatedly attending the Arbus
show, she wrote in her journals that her taste for freakishness was
also intertwined with her interest in camp, and that her essay on
that subject had nearly become something else entirely. That other
subject was morbidity, and it related to her discovery of homo-
sexual taste in Paris. Camp, she had written, was "not a lamp, but
a 'lamp'; not a woman, but a 'woman.'" And morbidity was not

death but "death"—the aesthetics of death—just as pornography was not sex but the depiction of sex. None were the real world. They were the world as will—and representation.

> My original choice was "morbidity." (From the neo-classical sculptures of Canova to the mummy art of the Capuchin catacombs of Palermo and Siracusa (Sicility) and Guanjuato (Mexico) [*both, sic*]. When that didn't work, I turned to "camp."
>
> To define the sensibility of Diane Arbus plunges me back into my original subject.
>
> Elliott Stein, eminence grise of many artists (me, Kenneth Anger)—underground cult founder of this taste: freaks, twins, Siamese twins, s-m, art nouveau, voodoo art, camp, baroque, Strauss operas, Damia & Frehel & Milly, Romaine Brooks, cancer exhibit in Medical Museum in London, Tod Browning movies, Zumbo effigies in Glore, "Symbolist" art (de Knopff) [*sic*], Times Square sex book shops, black magic, motorcycle cults, Justice weekly. Elliott's room at the Hôtel Verneuil in Paris was the 1960s. You could come into his room in the late 1950s and see the 1960s, see the future. Like the "magic box."[18]

———

"Photographing freaks 'had a terrific excitement for me,' Arbus explained. 'I just used to adore them.'"[19] The lines around the block testified that she was not alone. If Susan was also standing on that line, she also understood the obscenity of looking at what she saw as people displayed as freaks. And she was skeptical of the process that allowed viewers to see them—scrutinize them, study them, collect them, be shocked by them, mock them—without the slightest risk that they might return the favor. This voyeuristic

aspect of photography connected it to sexual perversion, made it "an extremely private obsession (like the thing Lewis Carroll had for little girls or Diane Arbus had for the Halloween crowd)."[20]

"You see someone on the street," Arbus wrote, "and essentially what you notice about them is the flaw."[21] This line, which Sontag quoted, makes Arbus seem mean. It also echoes what Susan's colleague at the University of Connecticut said about her: "You had the sense that she was perpetually judging and perpetually judging unfavorably." If Susan never enunciated this double identification—with the Halloween crowd as well as with the gawking culture-vultures—it lent *On Photography* the emotional color that hid behind Sontag's best polemics. She was Arbus and freak, photographer and subject, judge and accused, executioner and victim. Her ambivalence meant that these writings were addressed in the first instance to herself, toward purging a part of herself she distrusted. It also meant that those who accused Sontag of hating photography were as wrong as those who thought she loved it. She felt as ambiguously about photography as she did about herself: the division she had described in 1960 between "I'm no good" and "I'm great."

"The subject of Arbus's photographs is, to borrow the stately Hegelian label, 'the unhappy consciousness.'"[22] This is exactly the subject of Sontag's own work, though the subject of *On Photography* might equally be called the divided consciousness: between things and their representation, between a descriptive language and some "real" reality that consciousness fumbles around for but can never quite obtain. Sontag's longing to grasp it partly explains her fascination with "the ideal arm of consciousness in its acquisitive mood": the camera, which packages reality into an easily accessible consumer good. The desire to "acquire" reality should not be reduced to consumerism, since for Sontag it went far deeper. But it is true that the camera allows people's freakishness—their

suffering—to be sliced up, placed on the wall, sold: transformed into a product.

Yet showing the experiences of others is also a chance to understand them. "The ultimate wisdom of the photographic image is to say: 'There is the surface. Now think—or rather feel, intuit—what is beyond it, what the reality must be like if it looks that way.'"[23] Any child knows that appearances can be deceptive, and that not all realities can be understood through images. Susan had been so horror-struck by the Holocaust pictures she had seen as a girl in Santa Monica that she could say the experience broke her life in two. But what did she really know of that suffering? Images that were too shocking—images taken at the edges of experience—could overwhelm and deaden the consciousness as much as they could awaken it. Perhaps that very anesthesia, Sontag wrote, was the reason people sought photographs out.

> According to [Wilhelm] Reich, the masochist's taste for pain does not spring from a love of pain but from the hope of procuring, by means of pain, a strong sensation. . . . But there is another explanation of why people seek pain, diametrically opposed to Reich's, that also seems pertinent: that they seek it not to feel more but to feel less.[24]

Art, for her, had been a means of increasing sensation: "to *see* more, to *hear* more, to *feel* more." Behind her attack on Arbus was a fear that this art would make her feel less, glossing over reality, aestheticizing it, reifying it: "To the painful nightmarish reality out there," Sontag wrote, "Arbus applied such adjectives as 'terrific,' 'interesting,' 'incredible,' 'fantastic,' 'sensational'—the childlike wonder of the pop mentality."[25] By bringing Warhol's techniques to the carnival, Arbus was dulling the senses, Sontag thought. And because she saw Arbus's subject as the pain of others, she feared that Arbus was eroding the moral imperative—

itself ambiguous—to see the subject as more than its flaw. To see these pictures too often, to return to the freak show again and again, would make people feel less and less.

———

If the author's ingenuity in hiding herself gives *On Photography* an immediacy her earlier books lacked, not even the most prophetic writer could have suspected that her own future was announced within it, and would come to surround the book, decades after its publication, with another, eerier, aura. After she died, Susan's corpse became the locus of a sharp debate about what was appropriate, and what was obscene, in photography. The debate divided her friends and family. And it showed that the questions in *On Photography* were not only philosophical. They were ferociously emotional: matters, literally, of life and death.

When Susan Sontag was dying, her partner, Annie Leibovitz, took a series of photographs of her receiving chemotherapy, lying on hospital gurneys, twisting in agony, and then—bloated, scarred, completely unrecognizable—dead. The photographs were published two years after Susan's death in a book called *A Photographer's Life*. In that book, Leibovitz interspersed professional photographs, including images of politicians and celebrities, with photographs from her personal life. She documented her pregnancy and the birth of her first child; and then of two almost simultaneous deaths: Susan's, and then, a few weeks later, her father's.

For Leibovitz, it was a commemoration of life's extremes—births and deaths—alongside the days in between. For others, it was a freak show. David Rieff was outraged that his mother was "humiliated posthumously by being 'memorialized' that way in those carnival images of celebrity death."[26] The word "carnival" recalled Susan's own outrage at what she saw as Arbus's exploitation of people who were no longer in control of their own images

and could not give meaningful consent to their display and use. Leibovitz acknowledged the problem and its difficulties: "I think Susan would really be proud of those pictures—but she's dead," she said. "Now if she were alive, she would not want them published. It's really a difference. It's really strange."[27]

———

Despite her professions of love for the medium, Sontag's book became identified with a negative view of photography. "Many of her insights remain sharp and true," wrote a later critic, Susie Linfield. "But it is Sontag, more than anyone else, who was responsible for establishing a tone of suspicion and distrust in photography criticism, and for teaching us that to be smart about photographs means to disparage them."[28] One rarely wonders whether book critics love literature, or whether music critics love music, but when writing about photography, "critics view emotional responses—if they have any—not as something to be experienced and understood but, rather, as an enemy to be vigilantly guarded against. . . . They approach photography—not particular photographs, or particular photographers, or particular genres, but photography itself—with suspicion, mistrust, anger, and fear."[29]

Sontag often reacted coolly or dismissively in public to things that moved her a great deal in private; but it was the lack of a final conclusion that made the book so influential. Instead of a resounding, definitive-sounding statement ("Instead of a hermeneutics we need an erotics of art"), the book ends with an appendix of quotes. It is an appropriate conclusion for a book whose very quotability fueled controversy, since quotes, like photographs, can be extracted and assembled, doctored and framed and plucked from their proper context, to support almost any argument. Photographs are quotations of time, instants that stand for some greater whole; and any critical description—built around quotations—inevitably omits certain arguments: akin, in that

sense, to a book of photographs. A quotation, like a photograph, is a fragment that suggests reality without being equivalent to it, and that is why photography

> has not, finally, been any more immune than painting has to the most characteristic modern doubts about any straight-forward relation to reality—the inability to take for granted the world as observed.[30]

The relation of photography to the world is marked by the same doubts that surround every interaction between metaphor and reality. Image and thing were neither completely distinct nor completely identical. Instead, their relationship evolved with history, one thing in nineteenth-century France—

> "Our era" does not prefer images to real things out of per-versity but partly in response to the ways in which the no-tion of what is real has been progressively complicated and weakened, one of the early ways being the criticism of real-ity as a façade which arose among the enlightened middle classes in the last century.[31]

—and another thing in Maoist China:

> The Chinese don't want photographs to mean very much or to be very interesting. They do not want to see the world from an unusual angle, to discover new subjects. Photographs are supposed to display what has already been described. . . . For the Chinese authorities, there are only clichés—which they consider not to be clichés but "correct" views.[32]

By emphasizing how erratic these values are, and how strongly susceptible they are to culture and history, Sontag has moved far

from her interest in camp, "which blocks out content," and just as far from the views at the other extreme, which could be summed up as "against interpretation." No longer is content warring with interpretation, or metaphor with substance. Instead, they are enmeshed in ways that could be described as tragedy versus drama. Or—to put it in the personal terms in which both Sontag's and Leibovitz's books were received—as a relationship.

———

The relationship between photography and reality is as fraught as the relationship between any two people. As in any relationship, Sontag's own attitude toward photography was never constant. Her apprehension of the difficulties of looking and seeing had deepened since her early writings and, in coming years, would deepen further still. In no area would her understanding grow as richly complicated as in the question of looking at bodies, especially bodies in pain. She had been fascinated by Peter Hujar's pictures of dead bodies. She herself had photographed blackened corpses in Israel. To apply the same readings to these pictures that she applied to pictures of suffering, and that others applied to the pictures of her own body, would mean asking whether those people, too, had consented to allowing their bodies to be used to make a point, whether morbid ("Me today, you tomorrow") or moral (the human cost of war).

Leibovitz's pictures of the dead and wounded of Sarajevo, interspersed with pictures of rock stars and family outings, were taken at Sontag's direct insistence. "Photographing is essentially an act of non-intervention," she had written in *On Photography*. But by the time she brought Leibovitz to Bosnia, nearly twenty years later, she no longer believed that; no longer dismissed war photography as a combination of "voyeurism and danger"; no longer said that pictures of war were "the unbearable replay of a now familiar atrocity exhibition" deadening the senses of a jaded

bourgeoisie.[33] In Bosnia she saw that photography could be an act of love and self-sacrifice, a direct political intervention, a jolt, not an anesthetic.

At the same time—just as it is perfectly possible to love and hate the same person—it could also be obscene.

Quite Unseduced

In 1971, David Rieff was nineteen, finishing his first year at Amherst College. He had negotiated a difficult passage through adolescence between warring parents. Susan, often an absent and neglectful parent, herself acknowledged the observation of many close friends. She was too possessive, and saw David as an extension of herself. "I identify myself too much with him, him too much with myself,"[1] she wrote the year he left for college. This boundaryless relationship had gone on for a long time, since even before his birth. Philip, she wrote, had

> persuaded me of his idea of love—that one can *possess* another person, that I could be an extension of his personality and he of mine, as David would be of us both. Love that incorporates, that devours the other person, that cuts the tendons of the will.[2]

She criticized—even mocked—this possessive, cannibalistic "idea of love," but was unable to check her own neediness and fear of abandonment. She was more explicit on this subject, and less self-critical, in a letter to her sister, Judith, when David was still a toddler, writing that she had no intention of releasing "the divine little tyrant."

> I have already pledged him not to marry until he is forty and then to take an apartment in the same building with his parents, like a good Jewish son. I want none of this new-fangled emancipation from mamma that the psychiatrists are preaching to the heathens.[3]

In her journals, she was unsparing with herself—but the focus was always on herself. That, surely, is what a journal is for; but even the women who caused her agony appear as players in her personal drama rather than as personalities in their own right. And in the hundred volumes of these journals, one person is notable for his absence: her only child.

Her friends worried about her treatment of him. Susan had often left him to go to Europe, especially when she was involved with Carlotta and Nicole. Once Rose McNulty left, when David was quite young, she often confided him to the care of Roger Straus and Peggy Miller, who would check in on him in loco parentis. As he entered adolescence, Susan gave him unusual—and, to more conventionally minded people, alarming—freedom.

Susan left David to raise himself, though she liked to take credit for having created "a brilliant, funny, perfect gentleman," said Roger Deutsch. Deutsch was a "normal guy from Wisconsin" who became David's friend around this time and ended up spending more than two years, from 1975 to 1978, in the Riverside Drive apartment. He saw how Susan had groomed him as a companion.

"He had to be something that she could show off in public as her creation," said Deutsch.[4]

Susan was only nineteen when he was born, forty when he came of age. They were so close in age that their relationship evolved into a kind of companionship, and as he grew older, they came to resemble a couple more than a parent and child. "She was not a mother, and he was not a son," said Yoram Kaniuk, who met them in Israel in 1973.[5]

Their relationship often struck friends as odd. "She obviously did not love him in a motherly sense," said Deutsch. "She loved him in the sense of having created this character." Susan's constantly reiterated themes of his gorgeousness and brilliance seemed like something more than a mother's natural pride. In a letter from 1978, Paul Thek said what many others thought, but were unsure how to enunciate. "Your emotional situation regarding the establishment of the Sontag dynasty in Amer. Letters (with poor Davids cooperation) seemed desperate, ludicrous, even GREEDY."[6]

Despite his wide interests, David was not an ambitious scholar. His high school friends "were regular guys," Deutsch said. "They were not intellectually interesting, and they were boys, who did boy things." He dropped out of Amherst after a year, then moved to Paris, and then, the next year, went to Cuernavaca, Mexico. There, he studied at the "deschool" of the Austrian priest Ivan Illich, whose Center for Intercultural Documentation was "a free club for the search of surprise," Illich wrote, "a place where people go who want to have help in redefining their questions rather than completing the answers they have gotten."[7] During his time in Mexico, David learned Spanish, and then went back to New York, where he spent almost two years as a taxi driver. "I didn't know what the fuck I was doing," he said.[8]

It is impossible to imagine Susan dropping out of college and

becoming a cabdriver—and that was probably the point. David's rebellions took him places she could not follow, and he even announced that he wanted to join the marines. "That was a real challenge for her to outflank," said Stephen Koch.[9] But many young people try to escape overbearing parents, and the search for new ways of living under the guidance of charismatic gurus was typical of many members of his generation. Still, Susan did insist that he finish his education. He enrolled at Princeton in the fall of 1975, a decision that inadvertently sparked a grave crisis. Princeton required a physical, and David "was getting incredibly adolescent about the whole thing," he said. He refused to schedule an appointment, eventually telling Susan to make it for him. "Then she thought, 'Well, as long as he's getting one, I haven't had one in a long time. I might as well get one, too.'"[10]

———

The result was a shock. Sontag, at forty-two, had a tumor in her left breast: a metastasized cancer, stage 4. She went to the Cleveland Clinic, where the oncologist she consulted proposed a "milder" mastectomy. When she returned to New York for a second opinion, a doctor at Memorial Sloan Kettering hospital proposed a radical operation, and with that word her mind was made up: "Real commitment for her," David wrote, "was always radical."[11] But the meaning of the word was different in medicine than in politics; in oncology, it meant an extremely invasive surgery that turned out not to offer better results over the long term than more localized interventions.[12]

She alternated between optimism and despair. On one occasion, Roger Deutsch drove with her to Sloan Kettering. "We both got out of the car, and she took my hand in both of her hands, which she had never done before, and she looked me in the eye." She said, "Roger, I am dying." Whatever optimism she mustered

was fueled, in part, by medical dishonesty. "It was standard prac-
tice for doctors to lie to cancer patients," David wrote. Though
her doctor did not expect her to live, he did not communicate this
message; David later wondered whether, if she had known how
slim her chances were, "she would have had the strength of will
to go forward with treatment."[13] She knew that she had only a
10 percent chance of being alive in two years. "*Somebody's* got to
be that ten percent," she reasoned, trying to coax herself into
pressing on.[14]

Before the surgery, Stephen Koch talked to her about the
work of the seventeenth-century Anglican divine Jeremy Taylor,
Holy Living and Holy Dying. "She was very struck by it. She took
it in—as I recall—silently."[15] And in the hospital she composed
her short preface to Peter Hujar's book *Portraits in Life and Death:*
"In previous periods, people have made a discipline of studying
dying," she wrote. "But the body already knows. It's as if the body
is already familiar with death."[16]

On October 28, 1975, her left breast was "erased," she said, by
a skilled surgeon, who left no scar. Or no visible scar. Her "place
in her own body—never secure—had been irretrievably wrecked"
by the surgery, David said, and she came to think of herself as
"maimed."[17] It was the word she had used before—"maimed, in-
complete, pre-orgiastic"—to describe the conundrum she identi-
fied as a teenager. Then, she described her unhappiness as rooted
in "the agonized dichotomy between the body and the mind."
She had made strides toward overcoming that dichotomy, but ro-
mantic catastrophes forced her, time and again, to retreat into the
relative serenity of her mind.

So it was now. But the prognosis was not good, and the sur-
gery was only the beginning. The tumor was the most accessible
manifestation of a cancer that saturated her body. Four additional
operations followed, to remove other lesions; and then thirty long

months of chemotherapeutic bombardment. "I feel like the Vietnam War," she said. "They're using chemical weapons on me. I have to cheer."[18]

————

Shortly before her diagnosis, she had already been depressed. "I must change my life," she wrote. She was forcing herself to be cheerful. But she feared that, like Diane Arbus and Alfred Chester, she was being pulled under. She had been preserved only by "a system of safe harbors, of feudal relationships, to ward off terror—to resist, to survive." But this was no longer enough.

> I've constructed a life in which I can't be profoundly distressed or upset by anyone—except by D., of course. Nobody (except him) can "get" to me, get into my guts, topple me over the precipice. Everybody is certified "safe." The jewel and centerpiece of this system: Nicole.
>
> I'm safe, yes, but I'm getting even weaker. I have more and more difficulty being alone, even for a few hours.—My panic on Saturdays this winter in Paris, when N. leaves at 11 in the morning for the hunt and doesn't come back until after midnight. My inability to leave the rue de la Faisanderie and go around Paris alone. I just stay there, these Saturdays, unable to work, unable to move. . . .
>
> D. reminds me that the safe harbor isn't going to be so safe for much longer. (N.'s bankruptcy, the inevitability of selling the rue de la Faisanderie.) Then it will be even harder to change anything—My taste for custodial relationships. Propensity first developed in relation to my mother. (Weak, unhappy, confused, charming women.) Another argument against resuming any sort of connection with C., whom I found so pathetic, deteriorated in Rome this March.[19]

In this dark passage, it is easy to read a presentiment of the illness that, unbeknownst to her, was already infesting her body. Yet in sickness or in health, contentment—much less happiness— had never come naturally. She had grown up "literally never daring to expect happiness," and her relationship with Nicole was fading as quickly as all her other relationships did.

But when she fell sick, Nicole offered her shelter, physical and emotional. Healthy, Susan may have distrusted that cocoon; sick, she was in no position to decline. Her illness brought another blessing. She felt that David "had come back to her," said Minda Rae Amiran, "and that they were very close in that period. She was very happy about that."[20] Despite everything, these returns made her remember her brush with the abyss in a positive light.

> The only time in my life I knew I was loved—felt it, accepted it, welcomed it, humbly, gratefully—was in 1975–76—the first year I was sick, when I and everyone else thought I was going to die. And I was euphoric. Ted [Mooney] said I was filled with grace.[21]

Two decades later, she told a friend who had also suffered from cancer that "that was the first time in my life that I thought about how wonderful life is."[22]

———

After Susan's initial surgery in New York, Nicole located a Parisian oncologist, Lucien Israël, who recommended a course of immunotherapy then unavailable in the United States.[23] She would later credit Dr. Israël with having saved her, and credit herself for having chosen his ruthless treatment.

Like so many Americans who are self-employed, she had no health insurance when she fell sick, and no money to pay for the treatments she required. The cost was $150,000, which would be

nearly seven hundred thousand dollars today. It was a colossal sum for a writer whose books sold modestly and who had no private income.

Yet unlike so many Americans, she was lucky to have a network of affluent friends. Under the leadership of Bob Silvers, who sent out a fund-raising letter, they rallied to her side. Contributors included Martin Peretz, the owner of *The New Republic*, and the Houston collector Dominique de Menil. They also included fellow writers and artists, including Carlos Fuentes, Arthur Miller, and Jasper Johns.

Nicole made sure Susan had everything she needed, and despite her own financial difficulties made sure, for example, that Susan could fly back to New York on the Concorde: the long flights were too exhausting. And when she was fully recovered, her survival was greeted, in the cultural milieu, as a miracle. Stephen Donadio, a young intellectual, remembered as "one of the most important occasions of my life" the first public speech Sontag gave after her recovery, in Bobst Library at New York University.

When they saw Sontag approach the podium many people thought that it was as if they were seeing someone who'd come back from the dead. There was almost an audible gasp from the audience. But she did not appear frail or in the least hesitant, and she spoke on the subject of illness with a remarkable directness, and with the evident authority of experience. The sustained intensity of her presentation was something that I have very rarely witnessed, and the effect of what she had to say was electrifying. I can still remember her observing in a tone of absolute certainty that each of us is a citizen of two kingdoms—the kingdom of the well and the kingdom of those afflicted with illness—and that we are fated to spend time in each. During the time that she spoke, there was not the slightest sound in the audience.[24]

In 1978, she published a short essay, *Illness as Metaphor*, that examined how cancer was talked about—or, just as often, not talked about. In it, she made no reference to her own experience. This reticence placed the book at an emotional remove but also lent it, as so often in her work, an extra polemical charge. She had been struck by cancer in a world in which that was something to be ashamed of—something one most likely deserved—as she later wrote:

> Cancer is regarded as a disease to which the psychically defeated, the inexpressive, the repressed—especially those who have repressed anger or sexual feelings—are particularly prone, as tuberculosis was regarded throughout the nineteenth and early twentieth centuries (indeed, until it was discovered how to cure it) as a disease apt to strike the hypersensitive, the talented, the passionate.

In 1989, with the benefit of more perspective, Sontag reflected on her earlier essay. She described how her fury at the stigma surrounding cancer added to her fear of the disease itself: "What particularly enraged me—and distracted me from my own terror and despair at my doctors' gloomy prognosis—was seeing how much the very reputation of this illness added to the suffering of those who have it."[25] This reputation did what metaphors do: turned a thing into something it was not. In the case of cancer, a moralizing mythology turned a chemical or physiological condition into an occasion for judging those who suffered from it.

These judgments meant patients were often "shunned by relatives and friends and are the objects of practices of decontamination by members of their household," she wrote. "Getting cancer can be a scandal that jeopardizes one's love life, one's chance of

promotion, even one's job."[26] Patients were often not told what was wrong with them—because cancer suggested moral and psychological weakness. It was "a disease of insufficient passion, afflicting those who are sexually repressed, inhibited, unspontaneous, incapable of expressing anger." Sex—"What is called a liberated sexual life is believed by some people today to stave off cancer"—was as important as anger: "There are cancerophobes like Norman Mailer, who recently explained that had he not stabbed his wife (and acted out 'a murderous nest of feeling') he would have gotten cancer and 'been dead in a few years himself.'"[27]

These kinds of metaphors

> inhibit people from seeking treatment early enough, or from making a greater effort to get competent treatment. The metaphors and myths, I was convinced, kill. (For instance, they make people irrationally fearful of effective measures such as chemotherapy, and foster credence in thoroughly useless remedies such as diets and psychotherapy.) I wanted to offer other people who were ill and those who care for them an instrument to dissolve these metaphors, these inhibitions. I hoped to persuade terrified people who were ill to consult doctors, or to change their incompetent doctors for competent ones, who would give them proper care. To regard cancer as if it were just a disease—a very serious one, but just a disease. Without "meaning." And not necessarily a death sentence (one of the mystifications is that cancer = death).[28]

––––––

Cancer had been mythologized for millennia. The ancient Greek physician Galen believed that "'melancholy women' are more likely to get breast cancer than 'sanguine women,'" she wrote. And Sontag would never have written the book if descendants

of these ideas had not persisted in the contemporary world. In the popular mind, the "contemporary cancer personality" was a "forlorn, self-hating, emotionally inert creature."[29] As a result, she wrote, the patient was stuck with "not just a lethal disease but a shameful one."[30]

In its modern guise, this mythology derived not from Galen but from Freud. The science of the nineteenth century had progressively dispensed with the kinds of ideas Sontag attacked. Until Freud reversed the positivist formula that "the mental is based on the organic," disease had been "an alien which had somehow insinuated itself into the body of the patient." In the prescient words of the young Sontag, writing in *The Mind of the Moralist*, "Freud's general thesis—sickness conceived of as historical" was a dramatic reversal of the "anatomical, physical, and chemical factors" emphasized in Freud's own medical education.

Like so much of Freud's thought, these ideas, too, had been diluted, not least by Wilhelm Reich, a radical psychoanalyst who extended some of Freud's detective-story metaphors into regions Freud himself would never have ventured. He even turned them against the master himself. In Sontag's telling,

> Freud was "very beautiful . . . when he spoke," Wilhelm Reich reminisced. "Then it hit him just here, in the mouth. And that is where my interest in cancer began."

Susan had, at one point, been keenly interested in Reich. In *Illness as Metaphor,* she identified him as the source of the modern association of cancer with sexual and emotional repression.[31] "Nothing is more punitive than to give a disease a meaning," she insisted.[32] Cancer was simply a disease. It had no meaning.

Faced with this perverted symbolism, the writer acquired an unaccustomed role. "Not to confer meaning, which is the traditional purpose of literary endeavor, but to deprive something

of meaning: to apply that quixotic, highly polemical strategy, 'against interpretation,' to the real world this time."[33] So she wrote in *AIDS and Its Metaphors*, the pendant to *Illness as Metaphor* she published in 1989. There, she reflected on her two and a half years in cancer treatment. She had seen how metaphors demoralized and even killed her fellow patients, forcing them to evince "disgust at their disease and a kind of shame." They were "in the grip of fantasies about their illness by which I was quite unseduced."[34]

———

The image of her unshakable allegiance to science consoled fellow sufferers, and became a chapter of its own in medical history. The camera alters even as it records, and her observations began to alter the stereotypes about the disease and its sufferers. In part thanks to her, cancer became just another disease. One could not make it less ugly or painful, but by mitigating the metaphors, Sontag also mitigated some of the additional psychological suffering that cancer patients needlessly confronted. Yet of all the disguised self-portraits in Sontag's work, none is as poignant—or as revealing—as the one that emerges from the illness books.

She catalogs the superstitions that oppress the cancer patient. She quotes her adolescent heroes Thomas Mann ("Symptoms of disease are nothing but a disguised manifestation of the power of love; and all disease is only love transformed") and André Gide, whose hero comes down with tuberculosis "because he has repressed his true sexual nature."[35] She quotes a contemporary New York psychologist's outline of the "basic emotional pattern of the cancer patient." They share "a childhood or adolescence marked by feelings of isolation," and then lose, in adulthood, their "meaningful relationship," at which point they develop a "conviction that life holds no more hope."[36] She furthermore cites a nineteenth-century description of the cancer patient as one whose life consists of "deep and sedentary study and pursuits, the feverish and anx-

ious agitation of public life, the cares of ambition, frequent par-
oxysms of rage, violent grief." In Renaissance England, she wrote,
people believed that "the happy man would not get plague."[37]

This portrait of repression, inwardness, and sadness—the one
she denounces as punitive and medieval—coincides, however, ex-
actly with the self-portrait in her journals, the hidden self that
she almost never allowed to appear in public or in her writings: the
persona, or mask, that she had evolved as a means of survival.
"I'm responsible for my cancer," she wrote. "I lived as a coward,
repressing my desire, my rage."[38] Susan blamed herself bitterly.
"She came to New York [in the 1950s] where people were writing
about Eros and death and things like that," said Don Levine.
"She had bought into all of that, and that's when she starts think-
ing, Maybe I did give myself cancer."[39]

Her alienation from her body was so extreme that she had to
remind herself to bathe. She neglected her health in astonishing
ways. She never exercised. She barely slept. Sometimes she forgot
to eat, and sometimes she gorged. She was a heavy smoker—and
lied about her habit even to her oncologist.[40] But in *Illness as
Metaphor*—in her zeal to transform her story of guilt, shame, and
fear into something usable—she acknowledged none of this. In-
stead, she dismissed "crude statistics brandished for the general
public, such as that 90 percent of all cancers are 'environmentally
caused,' or that imprudent diet and tobacco smoking alone ac-
count for 75 percent of all cancer deaths."[41] She does not say what
is crude about these statistics, or display any interest in the science
behind them.

The pathogenesis of cancer is extremely complex; the disease
strikes for all sorts of reasons. But under the onslaught she lost
her ability, so recently acquired, to distinguish between tragedy
and drama. Her dismissal of personal responsibility—for some
cancers, for some people—made contracting cancer from chain-
smoking Marlboros sound as inexplicable as being dashed to

pieces by a meteor. She chose to dissociate her choices from any potential responsibility for her disease, and created, instead, a story about why she had been saved. She credited her survival to her own determination to be treated by the most radical methods, and to the doctor who had administered them. At the heart of this story was an impossible paradox. She was not responsible for her illness—but she was responsible for its cure.

———

In a peculiar homage to the power of metaphor, she could only destroy one mythology—the old ideas of the guilt-ridden victim of sexual repression and moral depression—by putting another in its place. Even when the body asserted itself as aggressively as it did in 1975, Sontag testified to the importance of metaphor by reshaping her story, replacing one mind-driven mystification— the Freudian-Reichian—with another, which she called "science."

"My mother loved science with a fierce, unwavering tenacity bordering on religiosity," David said.[42] But in later tellings her cure relied less on science and more on what might be called the power of positive thinking. She spoke of Leonard Bernstein's wife, Felicia Montealegre, once famed as the most beautiful woman in Chile, diagnosed with cancer at the same time. Montealegre and Susan spoke often about their shared ordeal. Felicia had a better medical outlook but died anyway—because, Susan came to believe, she had a defeatist mind-set.[43]

She believed that she had prevailed because she was determined to survive. That meant making up her mind not to die, and putting up with hideous amounts of pain. Toward the end of her life, she became intrigued by the cycling champion Lance Armstrong, who, like her, had been left for dead—only to triumph over cancer: "You have moments, for sure, moments of weakness where you think, I'm going to die or perhaps I'm going to die," he said. "I was totally committed, totally focused and I had complete faith

in my doctors, in the medicine, in the procedures." The words, David said, could have been Susan's.[44]

The story she told

> was not in fact the way that my mother had experienced her surgery and subsequent treatment for breast cancer as they were taking place. But it was the way that she came to remember it and it was this "rewriting" that informed the way she lived from that time forward.

What goes unsaid is that many patients display total commitment to fighting their disease, have complete faith in their doctors, and are willing to suffer insufferable pain—and die anyway. But willingness to suffer became the hallmark of her survival story. "She was proud of having dared to take this experimental and very painful treatment, much more painful than most people's treatment at the time," said David.[45] This pride was common among cancer survivors. "You want to concoct the particular romance of why you were spared, in which you are the hero of that romance," said the oncologist Siddhartha Mukherjee.[46] This mythopoetic conception had a long history in the writings of survivors, said Mukherjee, who seek explanations:

> "Oh, everyone else failed because they couldn't find this doctor in Paris." You don't need to be in oncology to know how often these things are circulating through our culture. People are going to Mexico to juice, and then saying to themselves when they survive: "It's because I had the guts and the smarts to go to Mexico to juice."

In Sontag's case, the paradox was the insistence that the mind could not make one sick—only that it could make one well. She could not escape the Freudian conception of the body "as a

symptom of mental demands." If this undermined her claims in
Illness as Metaphor, it nevertheless served to inspire others, who
otherwise might have silently accepted their disease as a moral
judgment. She could be justly proud, as she told an interviewer,
that "hundreds of people have written to me and have said that
[the book] saved their lives, that because of the book they went to
a doctor or changed their doctors."[47]

Thus was *Illness as Metaphor* accidentally transformed into the
very thing it deplored: a metaphor. It replaced one myth with an-
other, and in place of a terrified, guilty woman came the "quite
unseduced" Susan Sontag. As old theories about cancer were
swept away by therapeutic advances—a "revolution of seeing"—
this symbolic Sontag helped people: those who, as a result, got
better treatment and survived; and those who, though they
could not be saved, could at least die without being made to feel
ashamed of having wasted their lives.

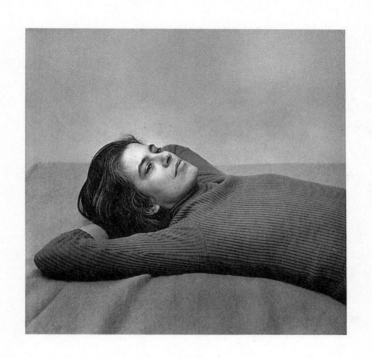

PART III

Toujours Fidèle

I n the fall of 1977, when Susan was in the final stages of cancer treatment, Don Levine came into Susan's apartment and found, lit by a single lamp over the kitchen table, the first copy of *On Photography*. The house was silent, and he discovered Susan lying on her bed. When he congratulated her on the book, she asked: "But it's not as good as Walter Benjamin, is it?"[1]

In her personal pantheon, Benjamin occupied pride of place; and in "Under the Sign of Saturn," the essay she dedicated to him the following year, she describes those of his loves—collecting and books, fragments and ruins—that were also hers, and what she saw as his outstanding characteristic: his tortured, melancholy personality. "Since the Saturnine temperament is slow, prone to indecisiveness, sometimes one has to cut one's way through with a knife," she wrote, as one who knew what she was talking about. "Sometimes one ends by turning the knife against oneself."[2]

It is a heartbreaking aperçu, one of many in the essay. It shows that, as an aphorist, Sontag was hardly inferior to Benjamin.

"The only pleasure a melancholic permits himself, and it is a pow-
erful one, is allegory," Benjamin wrote, and Sontag quoted him
approvingly.[3] Allegory, in fact, is one of the great pleasures of this
essay: Benjamin as a metaphor for Sontag, an exemplar of her
own saturnine temperament, with a "self-conscious and unforgiv-
ing relation to the self, which can never be taken for granted. The
self is a text—it has to be deciphered."[4] Because he sees the self
as an aesthetic phenomenon, the melancholic becomes an ideal
interpreter. He is uniquely positioned to see a world of which he
can never really be a part, because it exists wholly outside himself:
"Precisely because the melancholy character is haunted by death,
it is melancholics who best know how to read the world."[5] The
world, too, is a text, and through it the self travels, trying to deci-
pher the world, a travel-writer. "Benjamin, of course, was both a
wanderer, on the move, and a collector, weighed down by things;
that is, passions."[6]

 The character born under the sign of Saturn was a liar ("dissim-
ulation, secretiveness appear a necessity to the melancholic") who
needed his freedom ("Benjamin could also drop friends brutally")
and hid social unease with reading and writing ("the true impulse
when one is being looked at is to cast down one's eyes, look in a
corner. Better, one can lower one's head to one's notebook. Or put
one's head behind the wall of a book").[7] The Saturnine was "always
working, always trying to work more," always feeling he was com-
ing up short,[8] fearing that death would snatch him before he could
complete that work: "Something like the dread of being stopped
prematurely lies behind these sentences as saturated with ideas as
the surface of a baroque painting is jammed with movement."[9]

 The importance of work made relationships difficult:

 For the melancholic, the natural, in the form of family ties,
 introduces the falsely subjective, the sentimental; it is a
 drain on the will, on one's independence; on one's freedom

to concentrate on work. It also presents a challenge to one's humanity to which the melancholic knows, in advance, he will be inadequate.[10]

The melancholic endeavors to protect his work at all costs, because without it his self will dissolve. He needs armor: not a real self but a means of sheltering the self. This may resemble the "Being-as-Playing-a-Role" toward which Sontag confessed such ambiguous feelings in "Notes on 'Camp,'" but it is not a Warholian desire to be plastic; it is Being-*Through*-Playing-a-Role. As Susan was sometimes separate from Sontag, the being is sometimes separate from the role; but the role lets the being grasp a world in which he is irremediably alien. It allows him to shape a self he can only understand to the extent that it is like a book. He is a manic collector, made out of books and objects, and to lose those texts is to lose the self: the literal text, and the literal self. One reason for Benjamin's suicide was that he was unable to retrieve the library he had been forced to leave behind Nazi lines.

Keenly aware both of his brilliance and of his shortcomings, the fragile, authentic, hidden self creates a scrupulous mask, a persona:

> These feelings of superiority, of inadequacy, of baffled feeling, of not being able to get what one wants, or even name it properly (or consistently) to oneself—these can be, it is felt they ought to be, masked by friendliness, or the most scrupulous manipulation.

———

The standards to which Susan held herself were despotic, but they were also an inspiration to do more, to do better. "I try to imagine someone saying to Shakespeare, 'Relax!'"

The words were Elias Canetti's. She quoted them with warm

approval in "Mind as Passion," which closes *Under the Sign of Saturn,* the book she published in 1980, gathering essays previously published in *The New York Review of Books.*[11] Her essay on Canetti—a Bulgarian-born Jewish British resident of Switzerland whose native language was Spanish and who wrote in German—appeared almost exactly a year before he won the Nobel Prize. Even more than her essay on Benjamin, the Canetti essay is so autobiographical as almost not even to be about its purported subject.[12] In Canetti, she saw how a person with great talents and great limitations—a person like herself—had found a path forward. In Canetti, the fatherless Susan discovered not only a model but a genealogy.

The essay begins with Canetti's homage to the Austrian writer Hermann Broch, so eloquent that it "creates the terms of a succession." The great modern writer, Canetti said, "is original; he sums up his age; he opposes his age."[13] This writer would be "a noble admirer"; he would be "constantly prodding himself with the example of the great dead, checking his mental temperature, shuddering with terror as the calendar sheds its leaves." He would display a "heroic avidity." He would vow—like Canetti at sixteen, like Susan even earlier—"to learn everything."

"Mind as Passion" is an argument for the equality, and indeed the superiority, of mental passions to bodily ones: of preserving the body for the sake of the mind. "He is unperturbed by the possibility of the flagging of appetite, the satiation of desire, the devaluation of passion," she wrote. "Canetti gives no thought to the decomposition of the feelings any more than of the body, only to the persistence of mind. Rarely has anyone been so at home in the mind, with so little ambivalence."[14] It was a recipe for guiltless unconcern with the body, for accepting the self as Benjamin described. Postcancer, this idea was even more attractive to Susan. Canetti was "one of the great death-haters of literature." His habit of admiring worthy predecessors was a way "to do justice to each of his admirations, which

is a way of keeping someone alive." Literature gave life; and when life departed, literature preserved its memory.

Under the Sign of Saturn is shot through with this piety. The book includes two memorial essays, on Paul Goodman and on Roland Barthes. "Ah, Susan," Barthes said at their last meeting. *"Toujours fidèle."* She assented with a blush. "I was," she told him: "I am." Barthes's own "deepest impulse was celebratory," and so was hers. Much of what Susan Sontag came to represent to others was just what these models had represented to her: an ideal of high culture that held out the possibility of a better self.

—————

As she entered her forties, Sontag had been haltingly moving away from her earlier Communist enthusiasms through contacts with exiles from Communist countries—and especially through one, Joseph Brodsky. In contrast to the men she wrote about in *Under the Sign of Saturn*—dedicated to Brodsky—he was neither dead nor even very old: he was, in fact, seven years younger than Susan. But there was no doubt that he was a great man, and the Soviet authorities, in their perverse way, had recognized him as such when he was only twenty-three.

At that point, in 1963, he had published a handful of translations and a single poem in a children's magazine.[15] But in the wake of the apparent liberalization of 1962, which saw the publication of Solzhenitsyn's *One Day in the Life of Ivan Denisovich*, the government decided to send a message that, despite "de-Stalinization," the system had not changed. With attacks ginned up in the time-honored Soviet way, the completely unknown Brodsky was used to deliver that message. First, with a single article. In it, Brodsky was accused of being "a pygmy, smugly climbing up Parnassus," and one who moreover "doesn't care how he crawls up Parnassus," and who furthermore "cannot give up the idea of some Parnassus that he aims to climb by any and all

dirty means," and—if that was not bad enough—who wanted "to climb up Parnassus all on his own." The articles were followed by a trial straight out of Kafka. "Parasite Brodsky on Trial," read a placard at the entrance to the courtroom.[16]

If the same script had not destroyed millions, it would have been a farce. But Brodsky was different, and the kangaroo court, successful in silently annihilating so many others, became an international embarrassment. Brodsky was also different because he survived: sentenced to five years of hard labor in the Russian Arctic, he served eighteen months. The unknown poet became a cause célèbre and was released after international protests. In a letter to the chairman of the Presidium of the Supreme Soviet, Jean-Paul Sartre, sympathetic to Stalinism, regretted this "puzzling and regrettable aberration."[17]

And most of all, Brodsky was different because, unlike thousands of his comrades, who either lacked talent or never got the chance to develop it, he really did possess genius. It had been first confirmed by no one less than Anna Akhmatova, preeminent symbol of the suffering of Russian culture under Stalin. He was twenty-one when they met. "You have no idea what you've written!" she exclaimed, reading a poem of his.[18]

Following his release in 1965, he remained in Russia for seven more years. At last, with no warning, he was put on a plane to Vienna, and he never returned to the country of his birth—which he loathed. "Home was Russian," Susan wrote. "No longer Russia." His experiences had given him a Parnassian idea of culture: as a weapon against vulgarity and tyranny. Underlying this idea was a duty to cultivate the universal tradition that he announced on the first day of class at the American universities where he taught.

The list began with the Bhagavad Gita, the *Gilgamesh Epic*, the Old Testament, continued with roughly thirty works by ancient Greek and Roman writers, then moved on to Saint

Augustine, Saint Francis, Thomas Aquinas, Luther, Calvin, Dante, Petrarch, Boccaccio, Rabelais, Shakespeare, Cervantes, Benvenuto Cellini, Descartes, Spinoza, Hobbes, Pascal, Locke, Hume, Leibnitz, Schopenhauer, Kierkegaard (but neither Kant nor Hegel!), Tocqueville, Custine, Ortega y Gasset, Henry Adams, Hannah Arendt, Dostoevsky's *The Possessed,* Robert Musil's *The Man without Qualities, Young Törless,* and *Five Women,* Italo Calvino's *Invisible Cities,* Joseph Roth's *Radetzky March,* and finally wound up with a list of forty-four poets starting with Tsvetaeva, Akhmatova, Mandelstam, Pasternak, Khlebnikov, and Zabolotsky.[19]

Perhaps only Susan could have kept up. When they met—through Roger Straus, in January 1976, just after her mastectomy—she fell volubly in love. A number of acquaintances were skeptical about the erotic nature of their affair, but there is no question that she loved him: Brodsky and her mother were the two people she named in her last conscious moments.[20]

Brodsky, after all, was the friend she dreamed of in Tucson and Sherman Oaks; the teacher she hoped to find in Philip Rieff: the companion she had sought all her life, an intellectual and artistic equal, and even a superior. She never found another friend as congenial, and it was in these terms that she mourned his premature death, at fifty-five: "I'm all alone," she told a friend. "There's nobody with whom I can share my ideas, my thoughts."[21] This was the love his biographer found in Brodsky's own verse: "the dead end of carnality and the limitless space of Eros."[22]

"He made a stunning impression," Susan said. "He was so authoritative personally."[23] With his red hair and bright green eyes, he was very attractive to women, and much of his magnetism derived from the authority he claimed, unapologetically, as a

great poet's birthright. That status brought obligations, the first
of which was a dedication to the very highest artistic standards,
those his syllabus reflected: "One should write to please not one's
contemporaries but one's predecessors," he declared; Susan might
have written the same, and in his idea of culture, she found her
own.[24] "Man's greatest enemy is not Communism, not Socialism,
not Capitalism," Brodsky wrote, "but rather the vulgarity of the
human heart, of human imagination."[25]

These standards gave a way of living in the world, as Ben-
jamin had lived in and through books. These standards tamed
people, and were derived from literature: "For someone who has
read a lot of Dickens, to shoot his like in the name of some ideal
is more problematic than for someone who has read no Dickens."[26]
Reading sensitized, humanized; and in place of the socialist "new
man," Brodsky proposed a *Homo legens,* "reading man."[27] Though
not a fundamentally political writer, his aesthetics bore political
consequences. He hated communism with an energy Susan had
surely never encountered in such a powerful mind. Karen Ken-
nerly, who would become friends with Susan in the 1980s, had
a brief relationship with Brodsky shortly after he reached the
United States, and was stunned by his politics on a long weekend
they spent in Michigan:

> He was very difficult. He was very moody. He could hardly
> speak English. . . . Nixon was president and he sat in front
> of the television watching the news and the American flag
> and Nixon talking and he was clapping his hands. I thought,
> Get me out of here![28]

Susan Sontag surely had few friends who applauded the tele-
vised appearances of President Nixon. But Brodsky's personal and
artistic authority was such that he was difficult to ridicule. Part
of his hold on Susan was that he was a bully: "very arrogant," in

the words of a friend of both, the Polish writer Jarosław Anders.[29] "I didn't like the way he treated her," said Sigrid Nunez.[30] "There was something in his character that I didn't like," said Susan. "I didn't like how mean he was sometimes to people. He could be very cruel." Yet she admired his public persona:

> I was always impressed by how he enjoyed impressing people, enjoyed knowing more than they did, enjoyed having higher standards than they had. . . . I think the bond between us, whatever emotional bond there was, as he told me early on, was that I was the one American he knew who had standards like his.[31]

With these standards, with this attitude, he prepared her for the role she played in the last decades of her life: a voice of the liberal—no longer the radical—conscience. She had never fully absorbed the works of the anti-Communist writers she had read and, in many cases, known personally. Once, when she expressed skepticism about Solzhenitsyn, Brodsky interjected. "But Susan," he said, "what he writes about the Soviet Union is true." She was amazed—as if she had not fully understood that the oppression, the gulag, was real, or had believed it to be an exaggeration, said Stephen Koch.

> It was compartmentalized into inexistence. I really do believe that. And then at a certain moment it came out of its compartment and she became an intelligent person again.[32]

———

Susan, too, could deliver smackdowns, and this endeared her to Brodsky. In November 1977, the month that *On Photography* was published, she was in Venice for the "Biennale on Dissent," an event "entirely devoted to the problem of 'dissent' in the art and

culture of those European countries currently defined as social-
ist."[33] Brodsky was there, too, and received a call from Susan. She
had bumped into Olga Rudge, Ezra Pound's longtime mistress,
who invited her to visit. Susan dreaded going alone and asked
Brodsky to join her. They walked in: "The grip of boredom was
sudden but sure," Brodsky wrote.[34] Rudge began her litany of ex-
cuses for Pound's wartime collaboration, including the broadcasts
he made for the Italian Fascist government, before Susan inter-
rupted:

> "But surely, Olga, you don't think that the Americans got
> cross with Ezra over his broadcasts. Because if it were only
> his broadcasts, then Ezra would be just another Tokyo
> Rose." Now, that was one of the greatest returns I had ever
> heard. I looked at Olga. It must be said that she took it like
> a mensch. Or, better yet, a pro. Or else she didn't grasp what
> Susan had said, though I doubt it. "What was it, then?" she
> inquired. "It was Ezra's anti-Semitism," replied Susan.[35]

Anti-Semitism was precisely the kind of "vulgarity of the hu-
man heart, of human imagination" that Susan and Brodsky be-
lieved was the enemy of man, and in the seventies, Susan took
aim at that enemy. Like Brodsky, she believed that aesthetics was
the mother of ethics, and that traffic with beauty would produce
the ethically improved *Homo legens*. "The wisdom that becomes
available over a deep, lifelong engagement with the aesthetic,"
Susan wrote toward the end of her life, "cannot be duplicated by
any other kind of seriousness."[36]

This idea was put to the test by Leni Riefenstahl, whose
films married aesthetic refinement to ethical repulsiveness. Like
Pound's, Céline's, or Mishima's, her works were long hailed as
important even as she herself was considered to reside somewhere

outside the civilized pale. After the war, she made stabs at respectability, and by the mid-seventies was beginning to succeed in reinventing herself as an apolitical artist who, she always claimed, was loyal to beauty alone. Even her Nazi films—*Olympia,* about the Berlin Olympics of 1936; and *Triumph of the Will,* her celebration of the Nuremberg rallies—were beginning to be presented, to cinephilic audiences, as masterpieces. This reinvention was in part made possible by the idea that her films' beauty could be uncoupled from whatever "content" tedious groundlings purported to locate within them.

If prettiness were all that mattered, Leni Riefenstahl's was great art. Her Nazi films had been shown at the Telluride Film Festival in 1974, where Riefenstahl herself was a guest of honor, and in that same year, she published a book of photographs of the Nuba people of Sudan. Even Sontag admitted it was "certainly the most ravishing book of photographs published anywhere in recent years."[37] The strongest impetus toward Riefenstahl's rehabilitation, Sontag wrote, was "the new, ampler fortunes of the idea of the beautiful."[38]

Riefenstahl's work challenged those of Sontag's writings that might be classed as "against interpretation." In the sixties, she had briefly but notoriously defended Riefenstahl, writing, in "On Style," that certain improving qualities—"disinterestedness, contemplativeness, attentiveness, the awakening of the feelings"—might be stirred by a beautiful object, no matter how obnoxious:

> This is how we can, in good conscience, cherish works of art which, considered in terms of "content," are morally objectionable to us. (The difficulty is of the same order as that involved in appreciating works of art, such as *The Divine Comedy,* whose premises are intellectually alien.) To call Leni Riefenstahl's *The Triumph of the Will* and *The Olympiad*

masterpieces is not to gloss over Nazi propaganda with aesthetic lenience. The Nazi propaganda is there. But something else is there, too, which we reject at our loss.[39]

This paragraph became a notorious symbol of sixties leveling, Dante uttered in the same breath as Leni Riefenstahl. An anthology of her interviews mentioned "the frequency with which Sontag is asked to recapitulate her thoughts on the formal 'beauty' of Leni Riefenstahl's Nazi-era filmmaking."[40] To one interviewer, she explained that the paragraph "is correct—as far as it goes. It just doesn't go very far."[41]

But if her interest in Riefenstahl reflects the thorny relationship between ethics and aesthetics, it also reflects an almost sexual desire to be ravished, exalted, overwhelmed by art. This was what Riefenstahl's films provided: art that was a means of escaping the melancholy of selfhood. "You wanted to be kidnapped by the movie," she wrote of her obsessive filmgoing.[42] Happenings followed "Artaud's prescription for a spectacle which . . . 'will physically envelop the spectator.'" The description could serve for Riefenstahl's filming of the Nuremberg rallies, too: the individual swept away by the tsunami of an orgiastic Gesamtkunstwerk.

———

The power of Susan Sontag's enthusiasm was such that she became the world's most authoritative blurber. Her admiration for a book or a film—a dance, a painting—could usher an artist out of respectable obscurity and place him or her in the company of the great: discussed, exhibited, translated, celebrated. "When Elias Canetti won the Nobel Prize, Susan's was the only essay about him in English," said Edmund White, whose early work she likewise advocated. "She was the first one I knew to mention W. G. Sebald, Danilo Kiš, and Roberto Bolaño—all considered major literary figures now."[43] The same could be said for dozens of others.

In the last decades of her life, it became hard to remember that she had once been considered a leveler. She came to symbolize high culture and the rigorous standards that upheld it. But she almost never did so publicly by chastising works that fell short. "That's why I'm not a critic," she said, distancing herself from the label by which she was best known. "I really do think an important job of the critic is to savage this, to say this is garbage, this is terrible, this is pernicious. Although it is a lot of fun to do, the essay that was written most quickly was, of course, the Leni Riefenstahl because it's much easier to write when you feel angry, self-righteous and you know you are right."[44]

She distrusted that kind of writing, but her resorting to it reflected that much had changed in the decade between her brief defense of Riefenstahl, in 1965, and her publication, in 1975, of "Fascinating Fascism." The leveling of which an earlier generation of New York Intellectuals had warned—often using Sontag as an example—had shaken old standards. Part of this was a result of feminist and African American demands to expand the canon. In the sixties, that grip loosened, and for many younger intellectuals, Sontag herself stood for a broadened, modernized sensibility.

But it was one thing to open up to Virginia Woolf, and quite another to open up to Leni Riefenstahl. In "Fascinating Fascism," she wrote that "art that seemed eminently worth defending ten years ago, as a minority or adversary taste, no longer seems defensible today, because the ethical and cultural issues it raises have become serious, even dangerous, in a way they were not then."[45] The Nuba book was "full of disquieting lies," particularly regarding the artist's biography. "It takes a certain originality to describe the Nazi era as 'Germany's blighted and momentous 1930s,'" she wrote, and ridiculed the self-mythologizing in Riefenstahl's pre-Nazi films:

The role Riefenstahl devised for herself is that of a primitive creature who has a unique relation to a destructive power:

only Junta, the rag-clad outcast girl of the village, is able to reach the mysterious blue light radiating from the peak of Mount Cristallo, while other young villagers, lured by the light, try to climb the mountain and fall to their deaths.[46]

By tallying up the "inaccurate or invented" facts that Riefenstahl used to whitewash her past, Sontag leaves very little of her reputation standing—savaging, too, the critics who had let Riefenstahl travel so far down the road to respectability. By wielding biography to discredit a creator's art, Sontag was delivering an implicit rebuke to her hero, Roland Barthes, celebrated in the same book—*Under the Sign of Saturn*—in which the Riefenstahl essay appeared. His idea of "the death of the author," taken from an essay of 1967, popularized the idea that there was no connection, or at least none that mattered, between an artist and her work. In the circumstances Sontag documented, this sophistry crumbled.

Riefenstahl would sing the same *vissi d'arte* aria until she died, in 2003, at 101. But she understood very well that the author was not quite dead, that her history most certainly did matter to the way in which her films were seen, and that Sontag had landed a blow from which her reputation would not recover. Despite periodic attempts to revive it, they never really took, and she would forever be known as Hitler's filmmaker. The actor Kurt Krueger said: "I do not recall Leni to have been hateful towards anyone, even Hitler, except Susan Sontag."[47]

————

The excitement of seeing Susan take down Riefenstahl can blind the reader to certain problems in "Fascinating Fascism." The first has to do with feminism. In 1972, she published a long and eloquent piece, "The Double Standard of Aging." In 1973, she published another long essay, "The Third World of Women." In 1975, she published two shorter pieces, "A Woman's Beauty:

Put-Down or Power Source?" and "Beauty: How Will It Change Next?" These are among the best essays Sontag ever wrote, not least because they explicitly show connections between the image-world of "beauty" and the real world of actual human lives. By describing how ruthlessly women were judged for their failure to resemble representations of women, her essays on beauty and aging take their place alongside her very best writing, offering illustration after illustration of the theses of *On Photography*.

Their excellence makes it all the more noteworthy that she never republished them.[48] Except for the essay on Riefenstahl, all the essays in *Under the Sign of Saturn* were about men; and even if the feminist pieces do not quite fit alongside those essays, Sontag had plenty of opportunities to collect them in the later volumes that preserved far less worthy writings. Almost everything she wrote in a magazine eventually found its way into a book. But Sontag had a sense for which way the cultural winds were blowing; and by the end of the 1970s, as its earliest, most urgent goals were achieved, feminism had lost a certain momentum.

In 1960, the Food and Drug Administration approved the birth control pill. In 1965, the Supreme Court legalized contraception, and in 1973 abortion. These victories, and a profound shift in the culture over the course of the 1960s, made feminism seem unstoppable. This was the tone of a meeting at Town Hall, in Midtown Manhattan, on April 30, 1971, during which Norman Mailer faced a panel including Germaine Greer, Diana Trilling, and—demurely, from the audience—Susan Sontag. The commemorative film *Town Bloody Hall* casts Mailer as the dragon of patriarchal reaction, slain by an army of women warriors. In a famous example, Cynthia Ozick seized on Mailer's statement that "a good novelist can do without everything but the remnant of his balls" to ask a question she had long dreamed of posing. "Mr. Mailer, when you dip your balls in ink, what color ink is it?"[49]

Despite his macho posturing, Mailer was an odd bogeyman.

On the political substance, he hardly disagreed with any of the speakers. But the panel acknowledged no position to the right of Mailer's, and the film reveals the intramural nature of so many leftist debates, including over communism and the Vietnam War. (This—not incidentally—was still raging.) It reveals, too, how speakers focused on the sins of Norman Mailer would be blindsided by Phyllis Schlafly, who galvanized opposition to the Equal Rights Amendment; Anita Bryant, who became synonymous with opposition to gay rights; Jerry Falwell, who brought enraged evangelicals into politics; or Ronald Reagan, who would be elected partly by that outrage.

That night, at least, patriarchy was on the run. But the tide was already turning. It is astonishing to realize how quickly the bloom came off the rose of "second-wave feminism." Carolyn Heilbrun wrote that a girl seeking to read about female lives other than those "of prime devotion to male destiny" would have "few or no exemplars" before 1970. But almost as soon as this work had begun—of recovering the female past, and particularly the female artistic past—overtly feminist writers began to be shunned. A prominent example was Adrienne Rich, a poet who had, throughout the sixties, written essays in no way inferior to Sontag's; who had, like Sontag, appeared in the very first issue of *The New York Review of Books;* and who wrote a letter to the *Review* to protest a contention of "Fascinating Fascism": that Riefenstahl's revival could be attributed to a women's movement seeking, too uncritically, to revive forgotten female artists.

Without offering any evidence, Sontag had written that "part of the impetus behind Riefenstahl's recent promotion to the status of a cultural monument surely owes to the fact that she is a woman" and that "feminists would feel a pang at having to sacrifice the one woman who made films that everybody acknowledges to be first-rate."[50] Rich, in her letter, pointed out that it was cinephiles, not feminists, who resurrected Riefenstahl, and that femi-

nists had, in fact, protested the screenings.[51] "One is *not* looking for a 'line' of propaganda or a 'correct position,'" Rich wrote. "One is simply eager to see this woman's [i.e., Sontag's] mind working out of a deeper complexity, informed by emotional grounding; and this has not yet proven to be the case."

Sontag's furious response suggested that Rich had touched a nerve. She accused Rich of resorting to "the infantile leftism of the 1960s" that verged into "sheer demagogy" from "that wing of feminism that promotes the rancid and dangerous antithesis between mind ('intellectual exercise') and emotion ('felt reality')." This way of thinking was "one of the roots of fascism." Rich, an intellectual of the first rank, was subjected to the charge of illustrating "a persistent indiscretion of feminist rhetoric: anti-intellectualism."[52] Sontag's attack on Rich alienated many feminists, who would never consider her one of their own: a breach that may explain why Sontag's own feminist writings were mothballed.

———

Rich, who never turned from feminism, was banished along with it. In the thirty-seven years that remained of her life, she would publish only a single further essay in the *New York Review*. It appeared six months after her letter about Sontag: it was presumably already in the works. Her reputation in that world would be severely restricted by the word she never disavowed: never simply a writer, she was always, inevitably, a feminist writer, a "woman writer." In activism, in psychology, in universities, in the project of reclaiming of the female artistic legacy through biographies and criticism, feminism would go from strength to strength. But among the Family, it became more than unfashionable: it became liable to attract critical violence.

Sontag, too, was determined not to be held back by a description that she found limiting. In her aspiration to universality, her

example was Hannah Arendt, who would make her contribution to the cause of women by achieving equality—and, indeed, superiority—through talent alone.[53] But there was something else. Sue, age eleven, made her "great decision" to be popular: "I understood the difference between the outside and the inside." That instinct never soothed what David called her "profound, and in the end inconsolable, sense of being always the outsider." Rich had another label attached to her: besides being known as a woman writer and a feminist writer, she was also a lesbian writer. Sontag was well aware that to be known as a lesbian would mean walling herself into a ghetto.

"There was nothing to gain by coming out," said the gay writer Edmund White.[54] This did not mean keeping one's relationships secret, though many people did. Jill Johnston—who, at the Town Hall meeting, proclaimed that "all women are lesbians except those who don't know it yet"—only came out publicly in 1971, the year of the meeting. "In our world of the 60s," Johnston said, speaking of only a few years before, "Susan was the only other lesbian I knew of."[55] It is an astonishing statement: Johnston was gay, an art critic for the *Village Voice,* and thus a denizen of what were presumably the most progressive corners of New York. In the post-Stonewall era, the stigma surrounding homosexuality had lessened, but not by much. "Everyone" in the New York literary world might know about a prominent person's sexuality, said White, "but at that time 'everyone' equaled maybe four hundred people." With great courage, Rich, by coming out publicly, bought herself a ticket to Siberia—or at least away from the patriarchal world of New York culture.

In the pre-Internet age, said White, "you didn't know someone was gay unless you had met someone and they had confided in you personally. Ninety-nine percent of people in the outer circle didn't know" about Susan—and, as Johnston's testimony shows, lots of people knew about Susan. The only way the outer circle

could have known was if Susan—like Rich—began publishing explicitly gay works, or if, when invited to speak, she used phrases like "As a lesbian . . ."

"People would have been *really* shocked," said White, "and her readership would have been reduced by two-thirds." Susan's growing cultural power, the power of her admiration, depended on being unquestionably established as a universal arbiter. To be known as a feminist, much less as a lesbian, would have pushed her to the margins.

———

"Fascinating Fascism" was fun. Few object to seeing a Nazi propagandist debunked, and in this sense Riefenstahl was an easy target. And if the suggestion that feminists were responsible for her revival attracted Rich's attention, few seemed to notice another aspect of the essay, far more troubling.

The essay was divided into two "exhibits." Riefenstahl's Nuba photographs were the first. The second, a cheap paperback called *SS Regalia,* was unconnected to Riefenstahl except inasmuch as it concerned Nazism. Its appeal, Sontag wrote, "is not scholarly but sexual"[56]—because it shows photographs of uniforms rather than uniforms themselves. Despite what she calls "the banality of most of the photographs," this distinction mattered, she wrote, because photographs of uniforms "are erotic materials and photographs of erotic materials are the units of a particularly powerful and widespread sexual fantasy."[57]

It is unclear why she classifies this book as erotica, since she confesses that it contains no sexual references. "Precisely the innocuousness of practically all of the photographs testifies to the power of the image: one is handling the breviary of a sexual fantasy." As when she suggests that feminism is responsible for the revival of Riefenstahl, she does not offer any evidence for this statement: never quite says whose fantasy this is, or why this book

is different from any of the countless volumes of militaria published about the Second World War.

"In pornographic literature, films, and gadgetry throughout the world . . . the SS has become a referent of sexual adventurism."[58] Perhaps, but there was no shortage of real pornography available just up the street, in the bookshops of Times Square, that might have furnished better examples than this anonymous, unimportant, nonexplicit work. As we wonder who is producing this phenomenon, and who might be enjoying it, we get the answer. "It is among male homosexuals that the eroticizing of Nazism is most visible." (Visible where?) "S-m, not swinging, is the big sexual secret of the last few years."[59] (How did she learn about it?) "How could a regime which persecuted homosexuals become a gay turn-on?"[60] (It is a good question; it goes unanswered.) But the gay men turned on by Nazis, repeatedly mentioned, disappointingly fail to materialize.

In Sontag's strongest writings, example is piled upon example, quote upon quote, making it difficult for the reader to reach any conclusion other than hers. Her feminist writings, like her writings on photography, show, in mesmerizing detail, how apparently anonymous operations (camera, image, metaphor) distort and change, liberate and imprison. But "Fascinating Fascism" reveals a weakness of Sontag's writings about two subjects, sex and politics, whenever they appeared outside the pages of books. Both could be aestheticized, but were not aesthetic. Sexual play, after all, was hardly a secret. Pornography was widely available and did not need to resort to the kind of coding Sontag discovered in *SS Regalia*. Fantasies of domination and submission had not emerged "in the last few years," and they were neither gay nor straight. But even if they had been exclusively gay, there would still be a considerable distance between wearing leather at a Greenwich Village bar and getting off on images of Nazi brutality. (It is hard to know how else to interpret her repeated comparison of *SS Re-*

galia to "pornographic magazines.")[61] For one who conceived "all relationships as between a master and a slave," projecting her own conceptions onto others—unquoted, unseen—was a way of deflecting those anxieties.

"Fascinating Fascism" is an essay written by a person who derived her knowledge of sexuality from books—from a deranged genius like Mishima, or from a deranged mediocrity like the author of *The Solar Anus:*

> As the social contract seems tame in comparison to war, so fucking and sucking come to seem merely nice, and therefore unexciting. The end to which all sexual experience tends, as Bataille insisted in a lifetime of writing, is defilement, blasphemy.[62]

Bataille's assertion stands unchallenged. No wonder Rich's suggestion that the essay lacked "emotional grounding" struck a nerve. The allegory that was the only pleasure a melancholic permits himself could, after all, so easily shade into deflection, distancing: into the passive voice. Inauthenticity was the price Sontag paid for maintaining her cultural centrality; and the center of that culture was about to shift.

Who Does She Think She Is?

S usan's illness had many unintended consequences. One was to create a hairstyle that ranked alongside Elvis Presley's greasy pompadour and Andy Warhol's platinum fright wig as that rare coiffure that could, all by itself, identify the face over which it presided. It was simple: a single white streak rising from her forehead like a skunk's stripe, setting off the black hair around it. It eventually became so identifiable that *Saturday Night Live* had a Sontag wig in its wardrobe department—a comic synecdoche for the New York intellectual.[1]

Like many great ideas, its origins were simple. On August 20, 1966, Susan's sister, Judith, married Morrie Cohen in San Mateo, California. Susan was in Europe and did not attend, a slight that would estrange the sisters for twenty years. Not long after the wedding, Judith and Morrie moved to Honolulu, where Judith worked for a department store and where, in 1970, they were joined by Mildred and Nat: the elder Sontags had earlier moved to Northern California when Judith did, and now they followed

them to Hawaii. (Judith and Morrie later fled them again and moved to Maui, where Nat and Mildred did not follow.)

Susan first visited Honolulu in 1973, following her trip to China. In "Project for a Trip to China," she mentioned that "after three years I am exhausted by the nonexistent literature of unwritten letters and unmade telephone calls that passes between me and M."[2] The alternating enmity and closeness between Susan and Mildred set the pattern for many of her relationships, even if the enmity was mostly in Susan's head. But her visits to her family were always difficult. "She dreaded every minute," said a friend. "She couldn't wait to leave."[3] When Susan got sick, she did not tell her family, who only learned when a cousin happened to see her cancer written about in the *Hollywood Reporter*.[4]

Eventually, when Susan was better, she flew to Hawaii. There, she met Paul Brown, the hairstylist who had become close to Nat and Mildred. In the tropical sun, "I was afraid she was going to burn to a crisp because she was like a piece of paper, so white," said Brown. Mildred enlisted him in her perennial campaign to groom her daughter—"get Susan to dress better, wear makeup." A picture from the makeover survives: Susan in full makeup, wearing what looks to be a négligée. She had not lost her hair to the chemotherapy, but it had gone white. Paul cut it and dyed all but one swatch an inky black.[5]

———

"Standard accounts of epidemics," Sontag wrote in *Illness as Metaphor*, "are mainly of the devastating effect of disease upon character."[6] Pain can wreck even a saint. "It's like any one of the great emergencies that bring out the best and worst in people," she said, speaking of her cancer.[7] In health, wrote Virginia Woolf, "our intelligence domineers over our senses. . . . In health, a 'genial pretence must be kept up'; in illness that make-believe ceases." Illness, Woolf wrote, is when "the police [are] off duty."[8]

And so it was with Susan. Her police—her superego, her self-awareness—went off duty. Friends remarked that she was even more than usually insensitive to others, more prone to fabrication. Even when they were teenagers, Merrill thought she was dishonest. "Is she honest?" Harriet asked. Eva thought "there was something very wrong with Susan." Susan saw herself as "struggling to be honest, just, honorable." Don's description of the "blind area in Susan"—"she was not smart or intuitive emotionally"—was echoed by Irene, Alfred, and, not least, Susan herself, who concurred that she was not "very sharp about other people, about what they are thinking and feeling."

This awareness was rarely displayed in public. In "Trip to Hanoi," she mentioned her "empathic talents." That essay was an unusual instance of the first person that she had shunned, at least outside her journals, and she was, as she said, uneasy with its demands. When she channeled her psychological perception into portraits of others, as in her essays on Benjamin or Canetti, it was often acute. She had always had a tendency toward dishonesty and grandiosity—but she knew this, and reproached herself for it. Now, dismissing other people became an essential part of her self-image.

She had not accepted the advice of her doctors in New York; she had found a solution of her own. By going to Paris, she had not only taken charge of her therapy. She had actively ignored her New York doctors, and in her retelling, she came to believe that ignoring others was the key to survival. "Not listening to anyone and only trusting herself and having that save her life" became the center of her story, said Miranda Spieler, her assistant from 1994 to 1996. "It made her feel that her future and her safety were tied to listening to herself. Her stubbornness—some of the refusal to yield in relation to other people—all refers back to this moment where being willful and stubborn saved her life."[9]

Yet Sontag was not unique, as the cancer historian Siddhartha

Mukherjee observed. "The patient withdraws into herself, becomes aggressive, has no time for people—is fighting all alone."[10]

———

Susan, however, was not fighting all alone. Her relationship with Nicole had been strained before her illness; but cancer papered over their problems and brought friends rushing to her side. The French Brigade, as one friend called them, appeared: "three or four of the most exquisite women," he said. "Fantasy: beautiful, civilized, sophisticated, rich women."[11] These included Carlotta, whom Nicole "loathed,"[12] and whom she blamed for Susan's sickness. The loathing was partly attributable to jealousy, since Susan's love for Nicole never matched her mad passion for Carlotta. The rivals kept up appearances for the patient's sake, but, said Roger Deutsch, "everything was at an operatic pitch in [Susan's] house."[13]

Nicole had been instrumental in bringing Susan to Paris for the treatment that saved her life. And during Susan's treatment, Nicole was a mother figure, in more ways than one. Though she stopped drinking in the late 1970s, she was a "florid alcoholic,"[14] and even as she mothered Susan—fed her, bathed her, made sure she took her medicine—she also re-created the hostile dependency that, as in Susan's previous relations, allowed neither happy marriage nor clean break. When Susan was still in chemotherapy, they began the same agonizing process that marked her breakups with Harriet, Irene, and Carlotta. Now, though, there was an extra layer of desperation, since Susan feared that her very life depended on Nicole. In 1981, she mentioned "the old dependence felt since 1975, that I will get sick again if Nicole is not in my life."[15]

How to be alone, how not to be alone—the perennial problem.

I grieve, but dully. For it's not just that I love and miss N., but that I am so disappointed in her and in myself.

Perhaps the end of my life with N. is my last chance to be first-rate. (Intellectually, as an artist.) I've been wallowing in mediocrity and compromise—for that warmth, that warmth without which I thought I couldn't live.[16]

Four years later, she and Nicole were still enmeshed, and Susan was still trying to get away. Finally, Nicole herself put an end to it. Susan ran into Frederic Tuten in the street in Paris. "Nicole broke up with me," she told him sadly. "When this kind of thing happens, you're always sixteen years old."[17] If Susan needed "safe harbors" and "feudal relationships," she constantly rebelled against the helplessness that made her seek them, and against the people eager to provide them. "I feel myself a prisoner of revulsion," she wrote in 1981, "finding most everyone with whom I have contact ugly and shallow. And those feelings are, I feel at the same time, evidence of my failure: failure to love and to be loved by someone I can take pleasure in."[18] This was the limit of her will, and she knew it. She believed, David wrote, that "whatever she could will in her life she could probably accomplish as well (except in love: there she thought herself bereft of any gift and did not believe the will of any use at all)."[19]

———

"The perennial problem," her incapacity to be alone, grew more acute. Years before, she had expressed this brutally to Stephen Koch: "She once was in a Chinese restaurant with me, and we were talking about solitude and living with people. She said: I refuse to live alone. I won't live alone. Rather than live alone, I could live—and would live—with any person in this room chosen at random."[20]

Her house was packed. Lots of people—David; Nicole and Carlotta; assorted visitors and guests; Roger Deutsch; Don Levine; and then David's girlfriend Sigrid Nunez, a young writer—spent

longer or shorter periods in the house. Deutsch ended up spending more than two years on Riverside Drive, from 1975 to 1978, and noticed the perverse effects on both Susan and David of one apparent blessing: the money friends provided.

Susan had always been supported, more or less directly, in her feudal relationship with Roger Straus. Fame and reputation had never translated into the kind of sales that would allow her to live without financial worries. Straus helped by publishing unprofitable books (the screenplays of *Brother Carl* and *Duet for Cannibals*, for example) and by paying her advances for books she never wrote: in 1973, she wrote him about "at least four books for the next two years": a "China book," a book of stories, a novel, and a collection of essays, none of which materialized. (A book of stories, *I, etcetera*, was published five years later.) He championed her abroad and sold her foreign rights; he often paid her bills. According to his secretary and "office wife" Peggy Miller, Susan was the author he loved the best; and following her illness, Roger added her to the company's health insurance.[21]

But she was not insured when she got sick, and Bob Silvers, along with Peggy and Roger, helped raise funds for her treatment. They were almost too successful. "Their everyday life was English muffins and a Chinese chicken dinner and then once or twice a week being asked to Roger Straus's house for dinner or being given tickets to a concert," Deutsch said. "The change in lifestyle was immediate and it was unbelievable. She started getting driven around in limos and taking private planes and going on vacations, paid for, and her whole lifestyle changed—completely, completely changed."

Susan kept careful track of the contributors. If people who were in a position to help did not punch their weight, she grumbled, even when they were not close friends. "If somebody like Jackie Onassis put in $2,000," Deutsch remembered, "Susan

would say, 'That woman is so rich. Jackie Onassis. Who does she think she is?'"[22]

———

Susan's fear of being alone, and the length and agony of her treatment, made it hard for David to come into an independent life. His *Wanderjahre* over, he had decided to go back to school. At Princeton, it was hard for him to integrate into campus life, and not only because of Susan's illness: he was twenty-three, a sophomore who was older than most seniors; and his culture and experience gave him far more sophistication than most students of any age.

So David lived mainly at Susan's, attending classes only a few days a week. The people in his mother's entourage—the sort of society she herself had dreamed of frequenting in Tucson or Sherman Oaks—formed a natural milieu for him; and if, in the view of a doting single mother, David had "a great mind," that mind still lacked the training that Susan had undergone in thousands of nights at the library. "He had very few talents except for being brilliant and funny," said Roger Deutsch. He got a D on a paper for Carl Schorske, for example, a historian of Vienna who was one of the grandees of Princeton. Schorske, the kind of eminence his mother would have dazzled at Chicago or Harvard, could tell that David had not put in the time: "He did that Carl Schorske thing in one night on amphetamines," said Deutsch. Schorske ordered him to rewrite it.[23]

David was "basically just devastated." He would hardly have been the first college student to stay up all night and turn in a shoddy paper, but he was the son of a woman with tyrannical standards; and his reaction to even such a routine disappointment reflected a fear of falling short. "He felt like a failure," said Sigrid Nunez. "He was very easily humiliated."[24] David was "sweet

and not arrogant at all," said Deutsch—in visible contrast to his mother, always tremendously alive to being patronized. But now, his friend was shocked to see him don a new persona. "This man is deliberately trying to turn himself into an asshole," Deutsch realized. David agreed: "I've decided: No more Mr. Nice Guy."

> He'd say something rude that would never have come out of his mouth before. I said to him, "You're changing," and he said: "Yes, and it's a good thing. Don't expect me to be who I was before."[25]

The world around Susan was nasty. She had always been attracted to exceptional people, but her friends agree that she was never bitchy or particularly interested in gossip. Sigrid pointed out that Susan was an elitist—interested in people of high achievement—rather than a snob—interested in people of high birth or income. Still, every night's dinner provided an opportunity for new guests, along with Susan and David, to savage those who had sat at the same table the night before. "If they talked about another person, it was always in negative terms or gossip terms," Deutsch said. "Who he's fucking or he's such a jerk or he's really stupid. I never remembered a conversation that was 'Oh, how's Sally?' and we'd talk about how nice Sally is."[26]

They began to engage in ritual displays of superiority. "Who should we be snubbing?" David was once overheard saying to Susan at a theater intermission.[27] In the years following Susan's cancer, jokes circulated about their attempt to constitute themselves as a two-person aristocracy. Paul Thek mocked "the establishment of the Sontag dynasty in Amer. Letters." Nicole Stéphane called David *"le monstre"*; others called him *"le dauphin."* "David got this snobbery from Susan without much to back it up," said Susan's friend Gary Indiana. "He had not accomplished anything impressive in life, but he thought he was part of an aristocracy."[28]

Part of being an aristocrat was inheriting things. Susan suggested, even before he finished college, that David be considered "the heir apparent" to *The New York Review of Books,* and take it over from Bob Silvers, whom he and Susan idolized.[29] Later, Susan would express her desire to see David inherit FSG from Roger Straus. When he graduated from Princeton in 1978, the year after she finished her chemo and published *Illness as Metaphor,* Roger hired him as an editor at FSG. He had no prior editorial experience, but, as Peggy Miller put it, he was "mad" for the job, and he was also "smarter than everyone else."[30] His contacts in the literary world helped—he was on a first-name basis with many FSG authors, and his Spanish and French were an asset as well.

In a highly incestuous arrangement, Susan insisted that he become her editor. A troubled personal relationship became a troubled professional relationship. Even before he started at FSG, they were constantly fighting. David had not failed to observe that Susan tended to love people in inverse proportion to their love for her—"I always fell for the bullies—thinking, if they don't find me so hot they must be great"—and would withdraw, refusing to speak to her in not-quite-secret disputes whose exact nature was veiled in mystery. Edmund White wrote: "Exactly what was going on between them wasn't spelled out. Here again they seemed a bit like royalty—a dispute was registered throughout the court without anyone knowing the precise terms of estrangement."[31]

As she did with her lovers, "she could humiliate herself before David," said Minda Rae Amiran. "Susan apologizing, begging forgiveness."[32] She would grovel her way back: "She would do things like make Nicole buy David very expensive French suits, three or four at a time," said Don Levine.[33] Another favorite bribe was the luxurious cowboy boots that he accumulated and to which, in 1981, he dedicated his first book. The general impression of David was, to borrow Philip Rieff's self-description, of "a profoundly uncomfortable man." He seemed to be undergoing

a "deep fight within himself to control something," said Robert Silvers. "I don't want to know the inner life of David."[34]

———

Neither did his mother. The more David tried to distance himself, the more avidly Susan seemed to worship him. Her worship was detrimental to both, and he became, like Carlotta, a screen for her projections. These took precedence over any rational maternal consideration of what might be best for him. She reproduced with creepy exactitude—the word "creepy" is hers—the way her mother had treated her when she was a girl. In 1967, she had already seen this problem coming.

My own ageing: the fact that I look much younger than I am seems

1) like an imitation of my mother—part of the slavish thralldom to her. She sets the standards

2) like still keeping up the secret promise to protect her—that I would lie about her age, help her to look younger (What better way to establish that she's younger than that I'm younger than I am?)

3) like my mother's curse. (I hate anything in me—especially physical things—that's like her.) I felt my tumor and the possibility of a hysterectomy as her bequest, her legacy, her curse—part of the reason I was so depressed about that

4) like betraying my mother—for I look younger when it doesn't do her any good. Now she is getting old and looks it, but I'm not, I stay young—I increase the difference of age between us.

5) like a trap she's laid for me—so now people think David and I are sister and brother, and that pleases me immensely,

turns me on. And then I remember her—and I boast of my age, dragging the number into conversation when it's not really necessary, adding a year on to David's age[35]

In 1985, Edmund White wrote a novel, *Caracole,* which ended his friendship with David and Susan because two of its characters—a famous intellectual and her son—were so recognizable.

> More than once she'd assured him she knew what it was like to be stuck with a child in their nearly childless world of artists and intellectuals; after all she (with Mateo's distant if affectionate assistance) had raised a child, Daniel, who was now thirty and looked so nearly as though he were her brother that her maternity would have been suspect had not their celebrated, even infamous past together been so well documented. Nevertheless Mathilda was delighted when naive or provincial people mistook Daniel for her brother or lover, and to increase the confusion she often referred to him coyly as "the darling."

"Daniel," White also wrote, "liked to say Mathilda had less insight into herself than anyone else he knew."[36] But even where Susan did display that insight—privately, and in flashes—she had trouble translating it into action. This had often been the case, but in the years of her illness, the situation worsened. Her diaries— that repository of her authentic self—dried up, became less and less astute.

Her comments about David are notable for their absence, but her few remarks reveal moments of understanding that her presence, and her increasing neediness, was oppressive. "I must think about David," she reminded herself in 1971. A friend

said (rightly) that I don't describe him, I describe my rela-
tionship with him (us)—when she asked me to describe him,
I felt blocked—embarrassed—as if she were inviting me to
describe the best part of myself. That's the key to the prob-
lem: I identify myself too much with him, him too much
with myself. What a burden for him.[37]

And in 1975, shortly before she got cancer, she wrote:

D. told me he's noticed my anxiety this spring—each time
he leaves the house for a few hours, to go to the library at
Columbia, to spend an afternoon with Roger or Gary, etc.
What a dreadful burden for him![38]

In 1977, she left the Riverside apartment and moved down-
town, to an apartment at 207 East Seventeenth Street. From that
point on, Susan and David would not share a home, but that did
not mean David, now twenty-five, would be free to go: he ended
up next door. An appalled Paul Thek wrote:

In that weekend of The Move you changed your image in
my mind; a change from an image of a generous very hu-
man, tender person to an image of a manipulative harridan
frightened out of her own mind that her son (at long last)
wanted his own life, and it seemed you became willing to
use all manner of very unpleasant maneuvers to force people
into the positions required, with little respect or understand-
ing of their own private needs.[39]

She gave proof of this when David broke up with Sigrid, who
had lived in the apartment on Riverside Drive for more than a
year. David was "madly, madly in love, and dangerously in love,"
said Roger Deutsch. Later, Deutsch was astonished that their

breakup went unmentioned in Susan's journals. If she could justly write that she "was (felt) profoundly neglected, ignored, unperceived as a child," David could say the same. He began showing signs of depression: "He would go to sleep and then he would actually sleep for maybe thirty-six hours," Sigrid remembered.[40] For Deutsch, Susan's narcissism explained why David changed: "He's the nice guy, and he's got this mother who clearly does not love him for himself." Instead, she cared about him in relation to her. "Did he go out to dinner with her or not? That's all she cared about. It's about being a reflection of her. And he deals with it by humiliating other people, because then he's not humiliated."[41] One of the people he would humiliate would be Susan herself, whenever he got the chance. "He would know what would hurt her," said Nunez, "and he would do it."

The Slave of Seriousness

In public, the postcancer Sontag was invulnerable. From the end of the 1970s, she held court alongside other grandees (Brodsky, Derek Walcott, Donald Barthelme) at the New York Institute for the Humanities, whose members gathered to hear visiting speakers and discuss their own work. Sontag, with the white streak in her hair, was one of the Institute eminences, and visitors often marveled at the combative wit and intelligence on display. "At one point Susan took great offense at something I had said and turned on me in full force," said the Australian writer Dennis Altman, "a majestic if rather terrifying experience."[1] This was the Sontag, majestic and terrifying, whose raised eyebrow made and broke careers, who penned essays like "Fascinating Fascism," who knew everyone and everything.

But another Sontag was writing fiction whose main principle might be called narrative uncertainty. The uncertainty she introduced into her early novels and films was befuddling. Her insistence that nothing could be known—of her characters, of the

events that befell them—made those works impossible to engage emotionally. The reader resented being thwarted by theoretical gimmickry, and only the devout, one suspects, read or watched to the end.

Uncertainty was a frustrating principle around which to organize a story. But when shifted from the narrative to the narrator, it approached truth by the same means previously used to mask it. The actual woman behind the increasingly formidable Sontag persona was profoundly uncertain. When this Sontag—not the one who fell back on rude assertion or artsy "Marienbad" theorizing—allowed uncertainty to seep into her writings, those writings invariably gained in resonance and authority. The results resembled the lists that litter her journals, or the collages of the surrealists, or the boxes of Joseph Cornell: fragments, in their shattered—which is to say their authentic—form. Life is lived in a cloud of unknowing; experience, memory, and dreams are never more than shards.

The book she published in 1978, *I, etcetera*, collected eight such stories, all of which had been written before her illness: from a time when she could still allow herself uncertainty. Dedicated to her mother, to whom she remained intermittently close, it opened, quite literally, with Sue. Written when she thought she was not going to China, "Project for a Trip to China" gathered what she knew of her father: snippets of memories, clumps of sentences, ample blank space. This kaleidoscopic approach, facts and aphorisms heaped up without attempting to force them to any totalizing revelation, was a feature of her best essays. These did not attempt, as in the Riefenstahl essay, to assert or to damn. Instead, they expressed a desire to revive the dead (her father); to "think about the unthinkable" (Artaud); to define the indefinable (camp). These writings do not shut off discussion. They leave it open, stimulate it; and stimulating discussion is the function—the achievement—of the great critic.

—

I, etcetera is a story collection, but it is not really a collection of fictions, as the word is often understood: "Project for a Trip to China," for example, might be described as a poetic memoir. The next story, "Debriefing," is also a memoir, slightly more fictionalized, of Susan Taubes, who is called Julia.

> It's a pleasure to share one's memories. Everything remembered is dear, endearing, touching, precious. At least the past is safe—though we didn't know it at the time. We know it now. Because it's in the past, because we have survived.

Julia—who, we know, has not survived—has "actress hair" and "a weary, dainty body with wide wrists, shy chest, broadbladed shoulders, pelvic bones like gulls' wings; an absent body one might be reluctant to imagine undressed." Julia "doesn't bathe enough. Suffering smells." She and the narrator "know more than they can use." At the same time, they "don't know nearly enough."[2]

The story is stuffed with the material of sixties New York, which is not nearly enough to guide Julia safely through the world. "What People Are Trying to Do," a section of the story, includes observations of others: "All around us, as far as I can see, people are striving to be ordinary. This takes a great deal of effort."[3] "What Relieves, Soothes, Helps" offers some suggestions: "A sense of humor helps. . . . Sometimes it helps to be paranoid. . . . Flight is said to help. . . . It helps to feel guiltless about your sexual options, though it's not clear that many people actually manage this."

> Sometimes it helps to change your feelings altogether, like getting your blood pumped out and replaced. To become

another person. But without magic. There's no moral equiv-
alent to the operation that makes transsexuals happy.[4]

Nothing really helps Julia: unable to change her feelings, she
drowns herself. In the rest of the book, the desire to escape the
self recurs. In "The Dummy," a man creates a doppelgänger—an
alternative self, a persona—to carry out all the tasks he no longer
wishes to perform: "I want to keep for myself only what gives me
pleasure."[5] This would also mean a return to childhood, in which
even the most exotic possibilities had not yet been foreclosed by
the steady accumulation of self:

> I had grandiose plans for living the lives of others. I wanted
> to be an Arctic explorer, a concert pianist, a great courte-
> san, a world statesman. I tried being Alexander the Great,
> then Mozart, then Bismarck, then Greta Garbo, then Elvis
> Presley.[6]

None of these plans work out. Before long, the dummy him-
self spins off his more wearisome parts to yet another dummy: not
even a doll can escape the burden of self.

In "Old Complaints Revisited" and "Doctor Jekyll," Son-
tag examines another failure. Like *Duet for Cannibals* and *The
Benefactor*, both stories feature oppressive gurus who recall Jacob
Taubes but who might stand for any of the masculine superegos,
from Thomas Mann to Brodsky, that exercised imperium over
her. Characters aspire to freedom without hoping to attain it.
"The slave of seriousness" in "Old Complaints Revisited" is entan-
gled with an organization whose members can never get away. In
"Doctor Jekyll," disciples are bonded to their leader, literally, by
mystic ropes. The metaphor is blunt, the message clear: "You can't
become other than what you are," someone tells the character in

"Old Complaints Revisited."[7] "Don't speak to me about freedom,"
"Doctor Jekyll" concludes.[8]

———

One knows nothing, and cannot escape: if the diagnosis is at least
partly accurate, it is hardly encouraging; and into the early eight-
ies Susan's mood darkened further. She developed an obsession
with Wagner, writing in 1981 that "my passion—and that's not
too strong a word—for Wagner these last three years is also a sign
of my psychological collapse. I revel, I float: it's just as Nietzsche
described."[9]

She wanted to begin again, trying, and failing, to cast off her
ongoing entanglement with Nicole, trying to find a new way to
write, to find some moral equivalent to the operation that makes
transsexuals happy. She was still depressed, still feeling she was
doing less than she ought, still in a more or less permanent state
of panic:

> It must be possible to feel less anxious than I do. I feel—I
> don't know how exactly to put it—superfluous, unhinged,
> and (as I have for five years) posthumous. I'm playing at
> being alive, at being a writer. I don't know where to put my-
> self. I have neither energy nor hope. It must be possible to do
> better than this![10]

This was more than the usual writerly whinge. The uncer-
tainty in her stories and journals was real. The glorious produc-
tivity that marked the sixties and seventies would dry up in the
eighties, after she was fully recovered from her cancer. Her time
was increasingly taken up with ribbon-cutting duties.

But her renown would grow at the expense of her private and
artistic lives. Between 1980, when she published *Under the Sign*

of Saturn, and 1992, when she published *The Volcano Lover,* she would produce only a single short book, *AIDS and Its Metaphors.* She wrote short pieces, some outstanding; but the decade would become more notable for what she did not write than what she did. She started and abandoned book after book, distracted by unsatisfying projects, struggling, constantly, to begin again. For a woman famed for "reinvention," the eighties would show just how agonizing the struggle to move beyond outdated ideas and passé selves could be, how little it had to do with fashion: how intimately it related to an attempt to escape the bad parts of herself, the sad parts of herself. In *I, etcetera,* she observed, time and again, that flight was not an option. And as she realized its impossibility, she grew so depressed that she considered the ultimate escape: suicide.

But an uncertain mind is an open mind. And as Susan was better at admiring than attacking, she was better at doubt than assertion. It was just as well, since her attempts to think her way into a new self were occurring in a wildly fluctuating cultural context. A person who had so recently been "the tone of the times" and "the muse of the age" found herself stranded. Certain questions, urgent in the sixties and seventies, quickly became as outlandish as the quarrels among the Guelphs and the Ghibellines. Taken together, these sudden shifts—artistic, political, sexual—left her old world shattered.

———

The election of John Kennedy in 1960 symbolized a break between generations. Twenty years later, the election of Ronald Reagan became a watershed, too. Kennedy was the youngest president, following the oldest, Eisenhower. At sixty-nine, Reagan was seven years older than Eisenhower had been when he was inaugurated. He did not represent a new generation, but he did represent a new coalition. He married old Republican issues—antiunionism,

anticommunism, low taxes on the rich—with reaction to the progressive victories of the sixties. Appeals to "states' rights" won over southern racists, many of whom had been Democrats until Johnson's civil rights laws. He brought together those offended by the liberal Supreme Court decisions of the post-Kennedy era—banning prayer in schools, allowing abortion and contraception—and rallied antifeminist sentiment in the wake of the proposed Equal Rights Amendment.

His election, and then his resounding reelection, was a rebuff to the political world that Susan had inhabited for more than twenty years, the world that seemed victorious during the feminist meeting with Norman Mailer. In that world, said Norman Podhoretz, "the right wing did not exist. It wasn't even on the radar."[11] In those days, the enemy of radicalism was not conservatism but liberalism, and "the fights were all sectarian." The event of Reagan proved how much those battles had blinded the Left to a resurgent Right, and rendered them unprepared for people just as opposed to liberalism as they were, but from the opposite side. People like Sontag had not only failed to engage conservative ideas, Podhoretz said; they had not even acknowledged that such ideas existed. In 1950, Lionel Trilling, Podhoretz's teacher, wrote that "in the United States at this time Liberalism is not only the dominant but even the sole intellectual tradition." There were no conservative ideas, he said: only "irritable mental gestures which seek to resemble ideas."[12]

Even then, this was false. Reagan was a reinvigorated conservatism's rebuff to the sixties, but he was also a product of the sixties. In some ways, he represented the triumph of Andy Warhol: famously unable to distinguish between image and reality, metaphor and object, experience filmed and experience lived. He told, with apparent conviction, a story about his father "lying on the doorstep in a drunken stupor" that turned out to be lifted from a novel;[13] he claimed that during World War II he had

filmed Nazi death camps for the Signal Corps, whereas he spent the entire war in Culver City, making training films at the Hal Roach studio.[14]

This living exemplar of Warholian celebrity was a former middling actor whose sensibilities derived from Hollywood, and in whom a sense of irony was never detected: unable to distinguish between an atrocity and a photograph of an atrocity. His presidency was defined by this notion of politics as role-playing, as camp: "the farthest extension, in its sensibility, of the metaphor of life as theater." For Reagan, Joan Didion wrote, "rhetoric was soon understood to be interchangeable with action."[15]

———

The notion that rhetoric was equivalent to action was also—as it happened—a precept of that group of writings vaguely classified as postmodernist. The movement, which partly overlapped with French Theory, or just Theory, bore certain superficial similarities to some of Sontag's own earlier work, and set the tone for academic criticism for a generation.

The word "academic" is important. Theory, from the start, was an academic endeavor. Many of its American devotees specialized in—and boasted of—writing that was designed to be unreadable; and among its many effects was to sever the connections, fraught but essential, between specialized criticism and the educated public. The maintenance of this link had been a strength of Family writers such as Trilling, Edmund Wilson, and Hannah Arendt, as well as their third-generation successors, including Sontag and Robert Silvers. Theory isolated the academic humanities from the general reader, producing "texts" that reflected a retreat from the social debates in which scholars had once occupied a central role. The cleavage between the opaque writing of many postmodern academics and the increasingly lowbrow tone of magazines threatened to leave writers like Sontag stranded, with no place to publish.

The leading exponents of postmodernism—Jacques Derrida, Michel Foucault, Jean Baudrillard, Hélène Cixous, Gilles Deleuze—were French, members of a culture whose postwar productions Sontag had embraced and promoted at a time when those productions were mainly ignored in the United States. Like her, they were interested in film, photography, surrealism, and other forms of popular culture hitherto considered to lack the bon ton of high art. They were interested in sexuality and feminism; they were interested in and drew from writers that interested her, including Barthes, Benjamin, and Sartre.

But Sontag did not like these postmodern writers, and almost never referred to them by name. Instead, she expressed disapprobation of "what's called postmodernism," which she defined as "making everything equivalent."[16] She thereby addressed, obliquely, her own critics, particularly the neoconservatives who had always accused her of leveling. This was the accusation that Hilton Kramer, her long-ago *Commentary* colleague, brought when he said that "Notes on 'Camp'" created "the spiritual bankruptcy of the post-modern era" by severing "the link between high culture and high seriousness that had been a fundamental tenet of the modernist ethos."[17] This was Podhoretz's opinion, too: "Not only 'Camp' but 'Against Interpretation,' which is basically a relativistic—I don't know what you'd call it. It was certainly not on the side of what we, in those days, thought of as the right standards."[18]

It was one thing to expand standards to incorporate art excluded by historical injustice, as the feminist and black movements tried to do. It was something else to suggest that all works were equivalent. This was an implication of Sontag's sixties provocations: "It's very tiny—very tiny, content," she quoted De Kooning's saying in "Against Interpretation." These could seem designed to convince herself to experience art sensually, like Irene or Paul. She never actually believed that content did not exist:

like many modernists, including Wittgenstein, she was interested in the philosophical shift from examining *what* things mean—the classical task of criticism—to examining *how* they come to mean it. But this idea, popularized, risked suggesting that meaning was a mere construction, and that language, literature, and art were no more than the sum of the biases of a dominant group. Far more than Marxism or Freudianism, postmodernism was the "revenge of the intellect upon art" of which she had warned in "Against Interpretation."

In later years, she would often explain why democratizing "the right standards" was not the same thing as doing away with them.

> I am unquestioningly, without any ambiguity or irony, loyal to the canon of high culture in literature, music, and the visual and performing arts. But I've also enjoyed a lot of popular music, for example. It seemed we were trying to understand why that was perfectly possible and why that wasn't . . . and what diversity or plurality of standards might be. However, it didn't mean abolishing hierarchy, it didn't mean equating everything. In some sense I was as much a partisan or supporter of traditional cultural hierarchy as any cultural conservative, but I didn't draw the hierarchy in the same way. . . . Take an example: just because I love Dostoevsky didn't mean that I couldn't love Bruce Springsteen. Now, if somebody says you have to choose between Russian literature or rock 'n roll, of course I'd choose Russian literature. But I don't have to choose.[19]

In 2002, she made the connection between postmodernism and political vacuity: the cheesy, made-for-TV speechifying that had become standard in the wake of Reagan:

When the great Lincoln speeches are cited at the com-
memorative ceremonies of September 11th, they have—in
true postmodernist fashion—become completely emptied of
meaning. They are now gestures of nobility, of greatness of
spirit. What they were being great about is irrelevant.[20]

Sontag denounced a culture in which "Van Gogh and
Warhol"—Lincoln and Reagan—"are treated as equivalent." She
described "what's called postmodernism—that is, the making
everything equivalent" as "the perfect ideology for consumerist
capitalism. It is an idea of accumulation, of preparing people for
their shopping expeditions."[21]

This was a natural outgrowth of the idea that language and
metaphor refer only to themselves and not to any external reality.
By removing any connection to the real world (of bodies, of poli-
tics), postmodernism subverted critical authority, affirming Fer-
nando Pessoa's saying, half a century before, that "a great painting
means a thing which a rich American wants to buy."[22] The mea-
sure was money, the critic's opinion no more than that of one
consumer. The Age of Reagan was the Age of Warhol—minus
the irony.

———

During its long, wearisome reign over American academia,
Theory's refusal to engage an audience drove the humanities—
already besieged by a culture that found it ever harder to see
values other than financial—further to the margins. For the rest
of her life, Sontag defended works described, increasingly with a
sneer, as "the canon." This defense was seen as conservative. But
it had nothing to do with political conservatism. It was a great-
books, University of Chicago conservatism—the opposite of the
Sherman Oaks conservatism Reagan symbolized.

In the sixties, she became known as a symbol of novelty. But political radicalism in the age of Vietnam was not incompatible with respect for the authority of the past. In 1988, she admitted that some of her enthusiasm for certain fashionable art forms had been strained:

> I was not being entirely honest with myself in the 1960's about the accomplishment of *le nouveau roman*. What I really liked much more was the idea of it. When I wrote about Sarraute and Robbe-Grillet, I liked their essays and the ideas they had about fiction much better than the fiction that they themselves were writing.[23]

In those years, she often expressed disdain for "the novel." This reflected an insecurity, a suspicion of herself, that helped explain the more recherché devices in her own fiction. Privately, as the long lists of books in her journals show, she read thousands of novels, many if not most of which reflected the traditional culture found in Joseph Brodsky's syllabus. This was the culture she had venerated since the days of the Tucson stationery store.

With a lifetime of study behind her, she was now in a perfect position to defend that culture to a general readership: so well fitted that the very words "Susan Sontag" came to be synonymous with high culture. Admiration brought out the best side of her personality, where she rarely put a foot wrong; and in politics, too, she escaped another unconvincing part of her thought, moving from "the infantile leftism of the 1960s" to become, in Koch's phrase, an intelligent person again.

But rather than discreetly allowing her writing to express this evolution, Sontag jettisoned her leftist allegiances with a gesture whose flamboyance became notorious. It was a gesture that requires decipherment, because its language, once central to political debate, is almost lost today. On February 2, 1982, Susan Son-

tag denounced communism in an event that became known as
"Town Hall."

———

Shortly before the collapse of the Soviet Union, the rights and
wrongs of communism were still being debated in certain en-
claves in the United States. The days in which *Partisan Review*
congratulated a pregnant woman on producing "a future citizen
of Soviet America" were as distant as the days in which "Stalin-
ists, Trotskyites, Leninists, Marxist-Leninists, all debated their
positions endlessly in the pages of *Partisan Review*—or, as Ed-
mund Wilson called it, Partisansky Review."[24]

Over the decades, different Communist models had been in
fashion: often, like Vietnam and Cuba, as proxies for American
domestic battles. But interest in communism was never quite an
interest in real politics, since the constituency for a Communist
party in the United States was microscopic at most. For Ameri-
cans, interest in communism was above all a hope that an al-
ternative might be found to the consumer capitalism that was as
devastating—to the poor and the powerless, to culture, to the
environment—as it had come to seem invincible. Such interest ex-
pressed a hope that the valuable insights in Marxism might be
employed democratically, since even most radicals agreed that
communism was flawed wherever it really existed, despite vogues
for places like North Vietnam and, especially, Cuba. Many of
these debates were about aesthetics—about culture—and it was
in the cultural world of New York that they played out. This was
Susan's world, "the American Bloomsbury," in which she earned
the reputation of being "that most radical of radicals."[25]

From the mid-1970s, when she met Brodsky and the émigrés
around him, she had been close to writers who had suffered under
communism, though it took Brodsky's fulminant insistence on
the reality of their experience to make her "an intelligent person

again." But even before that, on her many visits to the Commu-
nist world, she had plenty of occasions to see what real commu-
nism meant. On their visit to Cuba in 1968, Robert Silvers met
a poet named Heberto Padilla, who described the worsening hu-
man rights situation and who, in March 1971, was detained and
tortured. Upon release, he issued an *Autocrítica* reminiscent of a
Stalinist show trial: "'I've been a CIA agent since I was five,' or
something like that," said Silvers. "And [the Cuban authorities]
were so stupid they actually published it."[26]

The persecution of Padilla took the shine off the Revolution
for many international supporters. Susan joined the flower of the
Latin American and European intelligentsia—Sartre, Beauvoir,
Moravia, Cortázar, Paz, Rulfo, Vargas Llosa, and many more—in
denouncing the proceedings. She signed two different letters, first
in *Le Monde,* then in the *New York Times.* Soon, however, she be-
gan to backpedal. At a meeting in which one speaker denounced
Padilla's "elitism and his willingness to cultivate a small literary
clique that held itself aloof from the people," she "strongly regret-
ted" signing them. She had only done so because "she had been
told it would be a private letter" to Fidel Castro, having "no idea
that such a missive would become front-page news in the *New
York Times.*"[27] This, though she signed the *Times* letter after the
first "private" letter had already appeared in *Le Monde.*

But like many of Susan's political missteps, this one would be
redeemed. Almost a decade later, Silvers got a call from Padilla's
wife, who had escaped Cuba in 1979. She begged for his help
in getting Heberto out, and in response Silvers invited Arthur
Schlesinger Jr., the Kennedy family consigliere, to lunch. Silvers
explained the situation, which Schlesinger correctly interpreted as
a request to appeal to Ted Kennedy. A week later, a call came from
the senator's office: Padilla would be arriving, through Canada, at
LaGuardia Airport. His arrival was a relief, but also a problem.
Press conference over, "the Kennedy guy gave him a thousand

bucks and he had proper visitor status," said Silvers. "But what could he do? Where could he live?"

The answer was with Susan Sontag. "Susan, without making any fuss about it, simply said, 'Come and stay here.'" Padilla ended up staying with her for six months, said Silvers. "I thought it was one of the most selfless and even noble acts on Susan's part."[28]

––––––

It was a gesture she would often repeat, as she did after a visit to Poland in 1980. She went with a group including Joyce Carol Oates and John Ashbery, and met a young Polish writer named Jarosław Anders. She dazzled him. "The way she expressed her views, opinions, with authority, with boldness, with recklessness sometimes, without any caveats. I found it very, very interesting and revealing, and liberating, personally. This was a free mind." He found her well prepared to understand the Polish situation. "She already knew Brodsky and Miłosz and they influenced her thinking," he remembered. "She was not the Susan from 'Trip to Hanoi.'"[29]

She arranged for Anders to visit the United States. At the end of 1981, he did, staying at Susan's apartment on Seventeenth Street. On the morning of December 13, she woke him up and showed him the headline in the *Times:* MARTIAL LAW DECLARED IN POLAND. This action, extreme even by the standards of the Soviet bloc, came in the wake of Karol Wojtyła's election, at the end of 1978, as Pope John Paul II. Susan visited in April 1980; in September, the trade union Solidarity emerged among workers in the Gdańsk shipyard. With the founding of Solidarity, the opposition of the church to which almost all Poles were loyal joined the opposition of the working class, in whose name the Communists claimed to rule.

Anders lost his job, and could not communicate with his wife and young daughter. Susan supported him throughout. "My

situation was paradoxical because it was not a very typical immigrant experience, when you are an intellectual and you have to drive a taxi," he said. With Susan's patronage, he became a fellow of the Institute for the Humanities, and "started writing in English, my acquired language, on the pages of *The New York Review of Books*." In February 1982, a meeting was called at Town Hall to express the support of left-wing intellectuals for Solidarity.

"In atmosphere," wrote Christopher Hitchens, "right down to the faulty film-projector, the overcrowded podium and the bearded chairman, it was clearly an evening of the Left."[30] In the age of Reagan, the Left was demoralized and defensive, though it kept to its old formalities, including a tendency to equate anything bad in the Communist with something bad in the capitalist world. This annoyed Brodsky, whom the peace activist Ralph Schoenman addressed:

> "You were invited to speak because we value your help to Polish writers, but no one has to answer to your misplaced self-righteousness. When we support Solidarity we are defending socialism from those who debase it. We have no intention of allowing the likes of Reagan to beat the drums for Polish workers."
>
> "Why not?" asked Brodsky. "What's wrong with US government support for the Polish people?"
>
> "Reagan and Haig's propaganda venture," [Schoenman replied], "included Bulend [*sic*] Ulusu, the prime minister of Turkey, who not only imposed martial law in his country—and at US behest—but has trade unionists under sentence of execution and thousands imprisoned without trial. If that's the company you wish to keep, we don't."[31]

Encouraged by Brodsky, Susan stood.

Imagine, if you will, someone who read only the *Reader's Digest* between 1950 and 1970, and someone in the same period who read only *The Nation* or *The New Statesman*. Which reader would have been better informed about the realities of Communism? The answer, I think, should give us pause. Can it be that our enemies were right?

After accusing an audience that included Gore Vidal, Allen Ginsberg, E. L. Doctorow, Pete Seeger, and Kurt Vonnegut (who sang a Polish song to the tune of "Are You from Dixie?") of being dumber than *Reader's Digest,* she twisted the knife.

Communism is Fascism—successful Fascism, if you will. What we have called Fascism is, rather, the form of tyranny that can be overthrown—that has, largely, failed.

I repeat: not only is Fascism (and overt military rule) the probable destiny of all Communist societies—especially when their populations are moved to revolt—but Communism is in itself a variant, the most successful variant, of Fascism. Fascism with a human face.[32]

There were catcalls and jeers; the weeks following elicited page after page of Family "responses": David responded to one, by Richard Grenier in *The New Republic,* by challenging the author to a duel.[33]

Her final salvo gave rise to quips: "I, for one, should hate to see Sontag, long one of the most valued assets of the American left, allow herself to become caricatured as Norman Podhoretz with a human face," wrote the editor Philip Pochoda.[34] (Podhoretz had abandoned the Left and become an outspoken supporter of Reagan.) Sir Isaiah Berlin weighed in with the iciest line of all: "I agree," he told Susan. "But I'm not so sure about the face."[35]

———

"She was attacked from both sides," said Anders. "I was with her. She was very, very upset about that. It hurt her, it hurt her personally." But the attacks had more to do with Susan's tone than anything else. The relationship of communism to fascism had, after all, been debated, often by the same people in the room, since the 1930s. People—again including many of the people in the room—had tried for years to make her understand the truth about communism, and how it was different from the democratic socialist aspirations they cherished. "She was sentimental about communism," said Eva Kollisch, a former Trotskyite, "at a time when communism was torturing, killing, starving people."[36] Bob Silvers said:

> She was not a person who had a consistent view of anything, but was constantly reinventing herself, and in relation to those different women [her lovers], and in relation to communism, and America, and Heberto [Padilla] . . . and then she did this book about an actress, you see, who impersonates [*In America*, published in 1999].[37]

And friends were annoyed by Susan's old tendency to project her own failings onto others. This was the characteristic Edmund White described in his roman à clef:

> Mathilda appeared to waste a lot of time pondering the moral aspects of other people's actions. Since her theoretical resourcefulness was joined to a powerful but naive egotism, her moral researches always ended with a conviction of her enemies, an exoneration of her friends and a sort of ethical perfect attendance pin for herself.[38]

She had always projected herself onto others. But in the wake of her cancer, the hesitations visible in the Padilla case or in "Trip to Hanoi" had disappeared. Belief in the image she had created—of the woman who listened to nobody, who was always right—was an increasingly vital lie. She would soon be denying Communist affinities with as much vim as she had used to announce that she was "quite unseduced" by the myths surrounding illness. It was the same pose that always got her in trouble: nobody, at least in her world, had forgotten her pro-Communist bluster. "In 1982, the sixties were yesterday," said Leon Wieseltier, a new friend, David's age, who was horrified by her performance at Town Hall.[39]

Yet by 1982, only four years before Gorbachev came to power in Moscow, the number of people interested in debates about communism had dwindled to almost zero; the entire dustup played out among "a small literary clique that held itself aloof from the people." Phillip Lopate noticed this when he saw her in Houston shortly thereafter. There, it had never occurred to anyone to be a Stalinist, Trotskyite, Leninist, or Marxist-Leninist.

> She expected to be heckled for her provocative political stance, and she even referred to that controversy in her opening remarks, but of course no one in Houston knew what she was talking about. . . . If anything, Houston high society— those who went to the opera, the ballet, museum openings, and our Reading Series—was obsessed with the British royals. A visit from Princess Margaret had generated far more excitement than any Left-sectarian debate ever could.[40]

Things That Go Right

The Town Hall mêlée involved categories and ideas that would soon be antiquated. But it had a salutary consequence. As in the cultural field—where changing times released Susan from an obligation to works that, she later admitted, she never liked anyway—her break with radicalism freed her from orthodoxies that were increasingly irrelevant to late-twentieth-century politics. She did not become a neoconservative, Norman Podhoretz with a human face. Instead, she became a liberal, that scourge of radicals, right and left. For the rest of her life, she championed causes that were not revolutionary but were nonetheless urgent. These included freedom of speech and opposition to racial, sexual, and religious bigotry—causes that needed the advocacy she could bring. In a world shifting sharply rightward, abandoning radicalism would not mean abandoning controversy.

As her writing gained authority when she avoided hidebound certainty, her political influence grew with her embrace

of liberalism, the political expression of uncertainty: the attempt
to accommodate multiple views rather than to impose a single
standpoint. Her radicalism became passé, but her liberal activism
formed one of her enduring legacies: an argument for culture as
a bulwark against barbarism, for the connection between art and
the political values that guaranteed individual dignity.

If she was writing less, her activism became a work of its own,
putting the lie to the idea that liberalism represented a moder-
ate center. Its traditions, artistic and political, were under siege:
at home, both Reaganite consumerism and the jargon of Theory
were, in different ways, undermining high culture. Abroad, they
were attacked by fanatics from Khomeini to Milošević. Sontag
argued for the centrality of culture with a conviction that ral-
lied people all around the world, and became genuinely counter-
cultural in a way she never was in the sixties.

———

This would be much of Susan's life in the eighties, though she
resisted dividing time into decades, or even centuries: a short-
hand, she wrote, that concealed a peculiarly modern histori-
cal discourse. This idea began around 1800, when people began
wondering what separated the nineteenth century from the eigh-
teenth. At a speech in 1981, she read from Balzac's *Beatrix* and
enumerated the characteristics of the nineteenth century:

> (a) a tendency to think in terms of travel, (b) a tendency to
> think in terms of observing rather than participating, (c) the
> past as an image, (d) the age produces products rather than
> works, (e) each age must be superseded, like parents by their
> children. There developed our peculiar modern ambivalence:
> progress is natural and desired, and yet it creates a pathos
> for the past, pathos for the notion that we have lost a more
> innocent age.[1]

This pathos characterizes one of Susan's most elegiac stories, "Unguided Tour," which closed *I, etcetera,* and which she had written in 1974, shortly before she fell ill. Sometimes its short paragraphs consist of a single word ("Right," "Pollution"); sometimes of quick touristy phrases ("Monsieur René says it closes at five"); sometimes of the lists that were a Sontag specialty:

> *I think it's safe to.* Pick up hitchhikers, drink unbottled water, try to score some hash in the piazza, eat the mussels, leave the camera in the car, hang out in waterfront bars, trust the hotel concierge to make the reservation, don't you?

But among the banality of these bourgeois tourists is a recognition of the pain of traveling among beautiful things that, like the self, are ever on the verge of disintegration and loss.

> They're still there.
> Ah, but they won't be there for long.
> I know. That's why I went. To say goodbye. Whenever I travel, it's always to say goodbye.

Knowledge of the world's beauty brings awareness of its fragility, awareness of how much we stand to lose: travel is "just one of the more disastrous forms of unrequited love." And to grow older amid objects from the past, to travel after years of having traveled, is to know that even the most beautiful places are no match for the restless self: "Prisons and hospitals are swollen with hope. But not charter flights and luxury hotels." Yet even in this world of ever-closing doors, "sometimes you were happy. Not just in spite of things."[2]

A few years after this story was published in *The New Yorker,* in 1977, it would bring her another form of happiness. Through Carlotta's friend Giovannella Zannoni, Susan was invited to

Venice to film "Unguided Tour" for Italian television. The production, with Zannoni's help, was cobbled together quickly, but Susan needed an actress who could play the part of a woman traveling to say good-bye: in this case, an American woman separating from an Italian lover. The solution came from the director Robert Wilson, in Paris at the time, who suggested Susan approach the dancer and choreographer Lucinda Childs.

Wilson had clearly seen how compatible, artistically speaking, Lucinda and Susan would prove. He also suspected that they would be compatible in other ways: Lucinda was beautiful, and as soon as she turned up in Venice, she and Susan fell in love, her most intense passion since her relationship with Carlotta ended more than a decade before. Their honeymoon, as in all of Susan's relationships, was short. But—as in all of Susan's relationships— they would be involved, in one way or another, for the rest of their lives.

Their love affair was disguised by the on-screen affair between Lucinda and the Italian actor Claudio Cassinelli. The film reproduces several themes in the story, including the bits of background inescapable in Venice: the polyglot chitchat, the oars splashing in canals, the pigeons strutting around San Marco. The film concentrates not on plot or character but on ritualized movement, and resembles a dance or a photographic essay more than a traditional narrative. It was boring in the way that Susan admired ("Maybe art *has* to be boring, now"): a single shot of the pigeons lasted three full minutes. This is perhaps a nod toward Joseph Cornell, whose shorts *Nymphlight,* made in 1957, and *The Aviary,* from 1955, share many characteristics of *Unguided Tour:* silence, repeated movement, monumental architecture—and a magnificent woman wandering through a landscape full of pigeons.

The film could have benefited from a less heavy-handed deployment of Venetian morbidity: the "capital of melancholy" is

gray, dripping, bursting with monuments to eminent cadavers. The couple walks past the palace where Wagner expired; Childs lays a wreath on the tomb of Diaghilev, a few feet from where Joseph Brodsky would soon be laid to rest. But the film springs to life when the camera lingers on "the woman of culture" who is the film's real subject: Lucinda. As she dances, admires churches, walks over and glides under bridges, the director's love for her lends the film a romantic élan that documents a moment in both women's lives: when they were happy, not just in spite of things.

———

Robert Wilson had created one of the seminal works of the 1970s, *Einstein on the Beach*. Five intermissionless hours long, the opera, with music by Philip Glass, was descended in part from earlier modernist works like Gertrude Stein and Virgil Thomson's *Four Saints in Three Acts*, in which the dramatic elements of classical opera, including narrative, would be replaced by sound, movement, and allusion: an idea related to the technique Susan had used in much of her fiction, in which experience would not be molded into clean forms but would be allowed to remain, as in the works of the surrealists or Joseph Cornell, fragmentary. *Einstein* was an "against interpretation" opera. Its ebb and flow attempted to suggest life as it is actually lived—the world coming into and then retreating from focus—undermining the modern idea of linear, progressive time that Susan had always resisted: the idea that Einstein did more than anyone to explode. Typical of the production was the freedom it left the audience to wander in and out of the theater.

One of the original cast members, also responsible for some of the choreography, was Childs. By 1976, when *Einstein* premiered, she was already a veteran of the avant-garde. She was a charter member of the Judson Dance Theater, the downtown art-and-dance collective that, though short-lived—it only existed from

1962 to 1964—was one of the most exciting moments of sixties culture. The downtown avant-garde was quite unlike the world in which she had grown up. The great-great-granddaughter of W. W. Corcoran, a banker who founded the Corcoran Gallery in Washington, Childs grew up on the Upper East Side: a conservative milieu of old Protestant money that, despite its geographical proximity, was in some ways as far culturally from the downtown art scene as it was from Tucson. After Sarah Lawrence, she began her dance apprenticeship with Merce Cunningham.

Her family's reaction was tepid: "They didn't care what I did as long as I wasn't late to dinner."[3] As Philip Glass would translate many of John Cage's ideas into the music of a new generation, so would Childs expand on many of Cunningham's ideas in dance. She would also break with them, including the Cage tradition of dissociating music from dancing. And Childs would find ways to bring small chamber pieces into giant theaters: *Einstein* had its American premiere on the stage of the Metropolitan Opera.[4]

"When I say something, multiply it by ten," Childs once said.[5] This was partly upper-class reserve. But it was also a principle that found a parallel in her choreography, in which a strictly limited vocabulary was repeated with tiny variations whose hypnotic effects were analogous to those of visual artists like Sol LeWitt, Donald Judd, or Dan Flavin. If her choreography seemed straightforward to the uninitiated, it was extremely difficult to perform, the product of what the director Peter Sellars called "the most rigorous mind in the history of dance."[6] Like the incantatory repetitions of Glass's music, Childs's work was as much spiritual as artistic: a perfect example of the mystical tendency Susan identified in "The Aesthetics of Silence." This was an art that "must tend toward anti-art, the elimination of the 'subject' (the 'object,' the 'image'), the substitution of chance for intention, and the pursuit of silence."[7] This was what Childs's teacher Merce Cunningham saw in dance: "It seems enough that dancing is a spiri-

tual exercise in physical form, and that what is seen is what it is. And I do not believe it is possible to be 'too simple.'"[8]

Childs was "austere but never cool," Susan wrote. In her work, she saw the incarnation of those ideas of Kleist's that had so attracted her to Cioran. These ideas, which, like the notion of progressive time, dated from the beginning of the nineteenth century, were a kind of spiritual ideal for Susan.

> Kleist exalts as the summit of grace and profundity in art a way of being without inwardness or psychology. Writing when the characteristic modern oppositions of the heart versus the head, the organic versus the mechanical, were invented, Kleist ignores the obloquy already attached to the metaphor of the mechanical, and identifies the mechanical movements of puppets with the sublimity of the impersonal. . . . In Childs's choreography, one is not a neutral but a transpersonal doer.[9]

In Lucinda's work, Susan would discover an iteration—now in movement and music—of themes that had interested her all her life, and that had run through her own work since at least *Against Interpretation*. She acknowledged as much when writing about Childs's work in "A Lexicon for *Available Light*," which appeared in 1983. In her journal, she noted "a major theme of my essays: art as a spiritual project. Gravity and grace. (And projects of disburdenment—a lower aim.)"[10]

———

But like the romance in the film, their happiness would not last. Lucinda's and Susan's mothers both struggled with the same problem. Lucinda's mother, also named Lucinda, was a society drinker who spent much of her time at the Cosmopolitan Club on East Sixty-Sixth Street. Like Mildred, she had had money and

lost it; like her, she was lonely; like her, she was alternately depen-
dent and distant, a woman who embarrassed her daughter, when
she was training with Merce Cunningham, by insisting that she
refer to herself, on her checks, as "Lucinda Childs, Junior." As
so much of Susan's personality was constructed around a need to
escape her parents' world, so was Lucinda determined to escape
hers. But they were unprepared for an enduring relationship. "In a
family situation like ours," Lucinda said, "we didn't learn a whole
lot about things that go right."[11]

Back in New York, things quickly fell into the pattern of
people from families where things never go right. Lucinda felt
excluded from Susan's literary world; Susan felt that she did not
get enough attention from Lucinda, an artist with a demanding
international touring schedule. In February 1984, they did man-
age to go to Japan, a country Susan first visited in 1979 and would
love for the rest of her life.[12] Lucinda remembered their conversa-
tions as one of the great legacies of their relationship, but Susan
complained—often loudly—of what David called Lucinda's "ab-
solutely immovable silences."[13]

Susan had been warned that Lucinda was not likely to re-
spond to the kind of drama that was always a part of her relation-
ships. Soon after their trip to Japan, Susan wrote in her journal:

> L is a recluse, you know, said Bob Wilson in August 1982. . . .
> Almost two years later I say: L. is a recluse. That means some-
> one who can't mate—or won't. Withdrawal from physical
> love, more and more infrequent; then banishing sexual ges-
> tures and caresses altogether; then the insomnia that requires
> sleeping separately sometimes; then the rule that we always
> sleep separately. Not to share sleep is not to share life.[14]

This was the same dynamic—one coming closer, the other
pulling back—that marked most of Susan's closest relationships,

and began remarkably soon after they met. Lucinda would always love Susan, but Susan was not the right mate for a person who avoided conflict by retreating from it. After their return from Japan, in one of many such letters, Susan told Lucinda:

> I can't go on in a situation that makes you into a sadist and deprives me of all dignity and self-respect. I feel so misperceived by you. By your steady misrepresentation of my behavior and intentions, you make me into someone petty, without value, and your enemy. You don't know how to recognize love, how to accept it, or how to give it.[15]

Susan's criticisms of others were, habitually, criticisms of herself. In 1986, she confessed that her "inability to write narrative fiction comes from an inability (perhaps, more accurately, a reluctance) to love."[16] She projected that failing onto Lucinda, turning her into a caricature, the "Ice Queen." This became a standard part of her repertoire: "You couldn't go thirty seconds of talking about Lucinda without saying 'ice queen,'" said Karla Eoff, who became Susan's assistant a few years later. "When I was out with Susan and saw Lucinda, the expression on her face when she saw Susan and looked at her did not compute with what Susan said about her."[17]

"Sometimes, because of Susan's fascinating psychology, she needed me to be the Ice Queen," said Lucinda. "I was not, I am not." Yet Childs understood where the impulse came from:

> She talked to me a lot about Mildred, but she would talk to me as if I was this person she could trust, this warm person. And then at other times she projected Mildred onto me in a way that was unfair and made me feel terrible. This was something she needed to do. I don't know that I fully understood it at the time. I think she imagined things sometimes.

You know, reasons why she could decide or declare that I didn't love her. She would cook up some things that had nothing to do with anything—because I would have said something to somebody at a party, or she'd pick up on some little thing and turn it into something that it wasn't.[18]

A woman who only said 10 percent of what she meant was confronted by one who said ten times more than she meant. Susan's attempts to attract Lucinda's attention sometimes veered into farce. Darryl Pinckney remembered a visit to Lincoln Center when Susan, knowing that Lucinda would be there, mounted an operetta of her own. "She took off her glasses so she couldn't see," he said. Since Susan was practically blind, she lurched and stumbled down the aisle. "She had to be helped, which created a big scene—so that Lucinda couldn't fail to see her arrive."[19]

Yet Susan painted these episodes as instances of Lucinda's coldness, her desire to hurt her, and saw herself as the injured party without the slightest desire "to make a scene." Four years after first mentioning that they were breaking up, Susan was still trying to get Lucinda's attention:

The reason I don't greet you when I see you—I've been to the [ballet] three times in the last week, and you've been in the audience all three times—is that it's nothing less than agony for me to see you. I still have the same feelings for you. So it seems insane to me to be sitting at the ballet in front of you, with someone else. When I see you I want to die. Or—otherwise stated—I want to put my arms around you. Or pass you my opera glasses. . . .

I honestly don't know what to do. It's ridiculous of me not to greet you; I certainly have no desire to make a scene or let anyone know what's going on. But for now it's more painful to me than, I think, you could possibly imagine.

I have been close to suicide in the last months and I'm not out of the dark place yet.[20]

These entreaties did not leave Lucinda unmoved—to the contrary—but she was stretched thin. "When Susan was talking about suicide, my mother was in the hospital because she had *actually* attempted suicide," said Lucinda. Lucinda Senior recovered, and mother and daughter reconciled after Lucinda's father's death. After never having attended her daughter's performances, she came to every one, for the rest of her life. And: "she picked me up and saved me when I was breaking up with Susan."[21]

Lucinda and Susan likewise reconciled, but neither separation nor reunion would ever be complete. Fifteen years after their meeting, Susan wrote again. "We're both fragile complicated people, who don't find anything easy," she said, "and neither of us like scenes."[22] She might not have liked them, but she had not learned to live without them.

———

Not learning a whole lot about things that go right: a striking number of Susan's lovers and friends were scarred by addiction. "Irene isn't my mommy," she had written twenty years before. She used the same word—"icy"—to describe Lucinda that she had used to describe Mildred.

"X, The Scourge," written around 1960, was ahead of its time. The first book about children of alcoholics was not published until 1978, the year of *Illness as Metaphor*.[23] As with cancer, a moralistic mythology surrounded alcoholism, and the idea that the children of addicts might share certain pathologies was only beginning to be discussed among specialists. As more studies were conducted, an intergenerational pattern emerged.

People who grew up in alcoholic homes are drawn to extremes, wavering between grandiosity and flagellating self-reproach;

between the hyperactivity of the perfect student and the leth-
argy of the depressive; between seeking attention and aggressively
repulsing those ready to give it to them. Because of their diffi-
culty in believing they are valued for who they are rather than
what they do, they are tormented by impossible ambition: "She
very early on assumed that she would deserve a Nobel Prize," her
sometime lover Jasper Johns remembered. This was not simply
ambition; it was a need for constant affirmation.[24]

In 1983, Janet G. Woititz published the first popularizing
work about the syndrome, *Adult Children of Alcoholics*. Published
in Deerfield Beach, Florida, this book was unlikely to have cap-
tured Susan's attention. Like its provincial place of publication,
its accessible language shows how far from highbrow psychology
this syndrome was when it was first being described. Books like
Woititz's owed little to high literary Freudianism, still dominant
in the therapeutic professions, and descended instead from the
grassroots therapies that originated with Alcoholics Anonymous.
In circles like Susan's, this literature was often belittled as "pop
psychology." But such works contained insights that would soon
earn general acceptance, and help the many people who struggled
with similar problems. Adult children of alcoholics, Woititz wrote,
were torn between "Always tell the truth" and "I don't want to
know." She called the conflict between demanding the truth and
not wanting to know it "the *greatest* paradox."[25]

————

As Mildred's behavior affected Susan, so did Susan's affect Da-
vid. Not long after he was installed as her editor at Farrar, Straus,
he began to fall short of her expectations. In public, she praised
him extravagantly: "I'm very pleased with the arrangement,"
she told the *New York Times* in 1982. "I have great confidence
in Mr. Rieff's judgment."[26] In private, though, she would berate
him mercilessly for any misstep. In the proofs of *Under the Sign*

of Saturn, she discovered that David had changed a reference to the "Black Stone of the Kaaba" to the "Black Stone of the Kabbalah." Rather than assuming an innocent mistake or gently explaining the distinction, she got him on the phone immediately, and started screaming.[27]

Acutely alive to anything that felt like being patronized, Susan did not see that David was the same. Like Lucinda, he reacted to Susan's increasingly desperate outbursts by shutting off. "It was like a love affair," said Roger Deutsch. "They would have blowups and they wouldn't speak to each other for days."[28] During these periods of estrangement, Susan resorted to the kinds of tactics that found her careening through the aisles of the Metropolitan Opera, using any pretext to get back in his good graces. When David's Malamute, Nunu, was dying, Susan bombarded him with requests to visit the dying dog; David understood that these requests had nothing to do with the dog.

"I always thought, One day David will rebel against this," said Steve Wasserman, a friend of both. "And when it happens, I don't want to be around because it's going to be very ugly." The explosion came in 1982, the year of Town Hall—and the year Susan met Lucinda. "Susan summoned me and said, 'David's having a nervous breakdown,'" Stephen Koch said. Wasserman remembered: "He basically woke up in the morning in a fetal position and crying and weeping uncontrollably."[29] David was thirty.

The immediate cause of his collapse was his breakup with his girlfriend Sara Matthiessen, daughter of the writer Peter Matthiessen.[30] On top of it all, his doctors discovered a growth on his spine which they feared was cancerous, and he had to be operated on at Sloan Kettering. This was the same hospital where Susan had had her mastectomy only a few years before. Then, David had upended his entire life to be with her, and "he thought that Susan would tend to him the way he had tended to her when she got cancer," said his friend the writer Jamaica Kincaid. But

Susan—whose own mother had notoriously evaporated as soon as a boyfriend came along—scampered off to Italy with Lucinda. "It was just unbelievable that she went," said Kincaid. "We couldn't believe she was really getting on the plane."[31]

As there was no mention of David's heartbreak over Sigrid in Susan's journals, in the late seventies, there is not a single mention a few years later of his breakup with Sara, nor of his brush with cancer. The lump was safely, swiftly removed, and turned out to be benign. Despite this welcome news, mentally, Kincaid said, "David got worse and worse." There was talk of putting him in Payne Whitney, a psychiatric hospital. Instead, he came to live with Kincaid and her husband, Allen Shawn. He spent six months there, alternatively laughing at their conventional life— "the regularity of Allen and me getting up and having breakfast, boiled eggs, you know"—and appreciating a predictability he had never known with Susan.

> Then Susan came back and became the adoring mother. But David was very wounded by this, and that was the first exposure I had to her. It's not ruthlessness. It's just Susan-ness. None of the words or the ways of characterizing her behavior really fit. Yes, she was cruel and so on, but it wasn't that, she was also very kind. She was just a great person. I don't think I ever wanted to be a great person after I knew Susan.

There were no words for this: it was "X." The incident, like so many others, seemed not to register with Susan. If she sought literary and moral models, she had none for relationships, for "things that go right." This was not a problem that could be addressed with will, Kincaid said:

> She really wanted to be a great mother, but it was sort of like wanting to be a great actress, or something. The mechanics

of being a mother were really beyond her. It's like if you put her on Mars and they spoke another language. She had no real instinct for it. I would say there was no real instinct for caring about another person unless they were in a book.

David was not in a book; and so Susan could not see him, or even know she should. "It's a turning point in the story of the two of them," said Kincaid. "Whatever themes of abandonment she had created before, this one had real reverberation."[32]

Faced with an accumulation of woes—the loss of a great love, his mother's rages, the tensions of editing her, a cancer scare—David broke down. His assistant at FSG, Helen Graves, daughter of the Texas writer John Graves, saw his decline. "He was mostly lovely to me when I worked for him," she said. "I have never had a nicer boss. I spent huge amounts of time giggling hysterically because he was very funny." But even before his health scare, he had started using cocaine. "He would always offer me a line," said Graves. "He gradually got angrier and angrier, more and more edgy and angry."[33]

His work began to suffer. Helen picked up his phone and constantly had to cover for him: "People would be yelling at me." His addiction made Susan "miserably unhappy," David said, but she responded with anger. "She was beside herself—beside herself—about David's habit," said her friend Robert Boyers. "She'd talk about it all the time." At a moment in his life when David needed the support a more empathic parent might have offered, he knew he could not rely on her. "Having failed to quit a couple of times," he finally got clean, once he accepted that doing so was a matter of life and death.[34]

———

Susan found her son's addiction "unforgivable," said Boyers. "She could tell it was ruinous to him personally and professionally and

that there was no possible way to forgive it." To speak of forgive-
ness is to speak of sin; Susan saw addiction in the same moralistic
terms that most people did. But in this area as in so many oth-
ers, she displayed an inability to conjugate "always tell the truth"
with "I don't want to know." To condemn drug use meant telling
the truth—about others. "People needed to be *told*," Sigrid Nunez
imagined her insisting. "But she told them unkindly, and often
when there were others present."[35] And she often took refuge in
dogmatism when hiding something from herself.

One astonishing case is an essay dating from the decline in
David's health, her relationship with Lucinda, and her break
with the Left. It was the kind of piece she specialized in, a career-
spanning evaluation of a major European writer: this time, of
Jean-Paul Sartre. Through several drafts, "Sartre's Abdication"
presents perhaps the most thinly camouflaged of all her self-
portraits, and one of which she seems unaware. It was, indeed,
a work of autofiction: using Sartre as a stand-in for Sontag, and
condemning him savagely for many of her own self-diagnosed
faults. Her reading of Sartre has all the ingredients of a novel: the
story of an outstanding mind who forfeited greatness because he
failed to be honest personally. It was a failure and "a tragedy—
for the misuse and devolution of his mind, one of the most fer-
tile, lavishly gifted of the century, was brought about not by an
intellectual but a flaw of character; a deficiency of the culture of
private life even more than of political culture."

The failure was twofold. First, he had embraced a public role.
Her insights on the pitfalls facing the public intellectual are bril-
liant. "No good writer speaks as well as he can write. (To write
means to revise.)" Sartre chitchatted his way through thousands
of interviews, accepting "an invitation to self-vulgarization, to the
adulteration of one's ideas, and the leveling of ideas into opinions,"
she insisted. The interview form was a leveling one, "an ideal arm
of the triumphant anti-elitist notion of literature."

This notion accorded with Sartre's communism. He was given to utterances that sounded suspiciously like Susan in Hanoi: "In a socialist society such as we envisage it there will no longer be any intellectuals," for example. He saw "vanguard literary works . . . as a luxury of bourgeois society. (Hence, the infamous judgment that in the Third World one could not read Robbe-Grillet.)" It was hard enough to read Robbe-Grillet in the First World, she admitted—but that, of course, was not what Sartre meant. His choice of party over nuance or truth, she wrote, resulted from a tendency to overgeneralize the aesthetic or metaphoric view of the world. "When it came to politics, Sartre treated it, too, as a moral fiction." She described "Sartre's basic strategy" as "the conflating of the real and the imaginary." The result was a career "shot through with philistinism—in the familiar guise of moralism."

There is much justice in the ideal life span Canetti sketched, which she quoted in "Mind as Passion."

> Fifty years to be a child and a pupil; fifty years to get to know the world and see all that exists in it; one hundred years to work for the benefit of all; and then, when he has achieved all human experience, another hundred years to live in wisdom, to rule, to teach, and to set an example. Oh, how valuable life would be if it lasted three hundred years.[36]

She turned fifty as she was writing this essay. She had been a child and a pupil. She had needed time to outgrow political errors; and if she was right that Sartre's had been reprehensible, she was in a better position than almost anyone to explain why he had made them. Instead, the finger points obstinately away from herself—at a man, she wrote, "always struggling against the experience of sluggishness, mental senescence; obsessed by the stupidity of the 'others.'"[37]

———

The thrust of "Sartre's Abdication" concerns how, exactly, Sartre had blown his mind.

> Perhaps the most inclusive pact with the devil, because it proceeds from a further stepping up of his ambition as a writer, as well as the most devastating, because it yoked physical ruin to mental, was the pact with speed.

This disaster caused Sartre's health to collapse, and fluency to degenerate into logorrhea. "*Saint Genet*," his long study of Jean Genet, "is not merely logorrheic but has the characteristic over-explicitness of writing done on speed," she wrote. Her description of Sartre's drug use, and the style that resulted from it, bears only the most cursory textual or medical reference. The unsupported assertions that had undermined much of her political writing, from Vietnam to Sweden to Leni Riefenstahl, proliferate, and a reader familiar with her own history will find it studded with elaborately disguised confessions:

> The speed was a response to the pre-existing character of Sartre's work, to the ambition and anxiety behind the work. Feelings of omnipotence, the attraction to schemes of total understanding, to the idea of totality itself—these were magnified by speed. . . . With speed came anxiety as well as euphoria.

His Faustian ambition, "which it never occurred to him to criticize,"

> far surpassed in grandiosity (and hubris) the dream harbored from childhood, so relentlessly scorned (with such rhetorical

overkill as out-of-date, bourgeois, idealistic, neurotic) in the last decades, of becoming a 19th-century-style Great Writer.

Amphetamines, he said,

> are all right for philosophy, where they "induce facility," though not for literature, because to work on a novel one must be "absolutely normal." Wrong. . . . To use amphetamines was, essentially, to give up on literature; set the seal on his abandonment of literature.[38]

———

"I've been working about sixteen hours a day, seven days a week," Susan wrote Roger Straus from Paris in 1973. "I wish to hell I could write faster. I might seem to write fast, or at least faster than some writers, but it isn't true. I just stay longer hours at the typewriter than anyone else."[39] She was a person of extraordinary energy. "She would stay up so long," said Sigrid Nunez. "The little lamp was on for so many hours that it burnt the shade."[40]

But much of that energy was provided by speed. Its first commercial production occurred in 1933, the year of Susan's birth, and it would be decades before the effects of amphetamine were fully understood. It was given to pilots in World War II to keep them awake on long bombing runs; and after the war, pop stars started using speed to stay perky for show after show after show; it was then pushed to the American housewife as a weight-loss tool, the guise in which it entered the mainstream. Around the same time, writers discovered it, too. Allen Ginsberg's *Howl* and Jack Kerouac's *On the Road* were composed on speed. In both, a jumpy euphoria alternated with histrionics and depression: the amphetamine style.

It was this personality that Sontag began to develop in the sixties. She would use amphetamines, often heavily, for at least a

quarter of a century.[41] They helped her concentrate. But if all they had done was deprive her of sleep, that would have been enough: every torturer knows that keeping a prisoner from sleeping is the best way to drive her mad. Amphetamines did more than that, though. Speed worsened the personality disorders grouped together in "Cluster B." These fall short of physically dangerous psychosis, but nonetheless make life extremely unpleasant for both patients and those around them. Symptoms include fears of abandonment and feelings of inconsolable loneliness, which trigger frantic neediness; antisocial behaviors such as rudeness (it is hard for such people to feel empathy) and volatility: mood swings that doom relationships. Cluster B sufferers tend toward drama and—to compensate their sense of low self-worth—are prone toward attention-seeking and grandiosity. Their desperate need to be admired leads them to issue cruel judgments of others.

When Susan started taking speed, the effects of amphetamine use, like those of parental alcoholism, were only dimly understood. But the upshot of both was that, as Virginia Woolf wrote, the police went off duty. Added to the consequences of her cancer treatment and her string of failed relationships, she would have increasing difficulty keeping herself in line. Even people who loved her most—especially people who loved her most—were dumbfounded. If, in her early years, she could be insensitive and self-involved—even, as she had noted, "extraordinarily tactless"— her treatment of others would reach such proportions that outré stories about Susan Sontag eventually became part of American literary folklore.

This behavior was chalked up to the eccentricities of a legendary diva. But to hear too many of these stories is to realize that something darker was at play. For those who have studied amphetamine use, this behavior was typical of Cluster B. The B, therapists grimly joke, stands for "bastard."

———

When she asked for his help in editing the Sartre essay, Gary Indiana was shocked. "She'd been attracted to the subject. She was a speed freak, obviously," he said. For years, he had bought speed for her. Other people raised an eyebrow, too. As she was describing Sartre's addiction, David sardonically commented to Helen Graves: "Meanwhile she's got these caches of the stuff all over the apartment."

Gary was baffled by the attitude, and by the writing itself: the manuscript is repetitive, insistent, impossible to follow. "She had generated bales and bales, and she got very angry with me about this because reading through it I realized that Susan wrote in a way that no one I've ever known wrote or writes."

Bob Silvers, who she hoped would publish it, found it "odd." In a letter, he said that her excessive use of superlatives ("extraordinary," "stupendous," "dazzling") without concrete examples undermined her case, and objected to the unfootnoted assertion that Sartre had been addicted to speed:

> It will come as a surprise to many. A central question seems at first passed over and then touched on in passing: how we know about this, and how much we know about it. . . . Are his talks with de Beauvoir the only source we have? When did he first disclose it and in what way? As it is, you very strongly broach the thesis of his pact with amphetamines on page 4 and it is not until page 7 that we learn that de Beauvoir talked to him about it reproachfully in 1974. You say on page 5 that his early work acquired the traits of the amphetamine style. Did he acknowledge that this was the time that he began to take speed? Did he say that *Saint Genet* was written while taking it (p. 6)? These questions naturally arise

because the reader has no idea of the status of the connection being made: the reader will not know if it is something you knew from him personally; if it is a speculation based on rumor and on a diagnostic reading of the work; or if it is something declared by Sartre himself.[42]

Silvers never published the essay. To read it in draft form is to see something sadder than confused writing or undocumented assertions. It is to see a loss of self-awareness, which is to say: a loss of self. "I won't let 'them' take it away from me," she once vowed. "I won't be annihilated."

As a philosophical matter, giving "no idea of the status of the connection being made" between an artist and her subject reverses the traditional objection to metaphor, which is that it distorts the very thing it attempts to portray. Such distortion may be an inevitable consequence of language. But to deploy Sartre as a metaphor for Sontag without acknowledging that he is, in fact, a metaphor—is strange. This is the acknowledgment that separates fiction from lying. It was also a refusal of the revolution of feminism and the gay rights movement, whose truths would soon be demonstrated by the catastrophe of AIDS.

The Word Won't Go Away

The disease that succeeded tuberculosis and cancer as the most feared scourge of the modern age began to appear in the United States at the end of 1980, two years after the publication of *Illness as Metaphor*. Sontag could not have conceived of a better illustration of her theses about the deadly workings of metaphor. Neither could the feminist and gay thinkers of the sixties and seventies have imagined how soon their assertion of the relation of the physical body to the apparent abstractions of politics would be clad, in the eighties, with flesh—as often as not, their own.

AIDS pushed questions of language to the forefront of politics. The disease bumped up against a host of linguistic difficulties. Writers groped for military metaphors to describe the apparently unstoppable "invasion." Some of these difficulties were the same Sontag had earlier adumbrated with reference to tuberculosis and cancer. Others were new. The first and most intractable was that to speak of AIDS was to speak of sex—gay sex. The

need to speak clearly—without religious sanctimony or political posturing, without blaming victims or feeding panic—was a matter of life and death.

Sontag was far from the only person—far from the only gay person—who struggled to find an appropriate language. To read the literature from the gay movement in the eighties is to discover phrases that sound far more dated than the language of the civil rights movement or feminism from twenty years earlier. Even the most radical African American and feminist activists stood in a venerable tradition. In the age of AIDS, gay activists had to invent a grammar to allow them to speak about their lives. AIDS sparked a revolution, and so would the language discovered by the activism it unleashed. But it would be a revolution that Sontag would largely sit out: unable to speak certain words.

———

Rumors of a "gay cancer" started spreading at the beginning of the eighties. The first notice in the *New York Times* came on July 3, 1981: RARE CANCER SEEN IN 41 HOMOSEXUALS. The cancer, "rapidly fatal," was called Kaposi's sarcoma. Little was known of its cause, which is partly why the linguistic confusion that characterized the disease's career appeared in that first article. But that article, and that language, also relied heavily on stereotypes about gay men. It suggested a link to promiscuity that would be durable: the victims were "homosexual men who have had multiple and frequent sexual encounters with different partners, as many as 10 sexual encounters each night up to four times a week."

The phrase made the disease seem restricted to sexual athletes, which it was not: a single encounter could mean infection. The sentence suggested that anyone with a more prosaic sex life was safe; also immune, a doctor affirmed, were women and heterosexuals. Male homosexuality—rather than certain behaviors—was a pathogen: "There was no apparent danger to nonhomosexuals

from contagion. 'The best evidence against contagion,' Dr. Curran said, 'is that no cases have been reported to date outside the homosexual community or in women.'"[1] This was an embarrassingly unscientific statement: homosexuals are not physiologically different from heterosexuals.

If the words in a single article, published long before the epidemic was understood, had not been repeated and amplified in the following years, they would not be worth parsing now. But that language contributed to the shame surrounding the disease and complicated the attempt to understand it. The truth was that nobody, at first, knew what was causing these strange cancers. Joseph Sonnabend, a doctor in the heart of the gay community of Greenwich Village, only a few blocks from Susan's house, had an idea. He had been a laboratory microbiologist before going into private practice, where his experience led him toward sexually transmitted diseases. "There were almost no specialists in sexually transmitted diseases," he said. "As a field, it was not regarded as respectable. Doctors would giggle at words like 'gonorrhea.' They couldn't utter the words 'anal intercourse.'"[2]

Cancer patients had been thwarted by medical prudery—in the early 1950s, the *New York Times* refused an advertisement for a group supporting breast cancer patients with the explanation that "The *Times* cannot publish the word *breast* or the word *cancer* in its pages."[3] And gay men, even before AIDS, had trouble being taken seriously by doctors. "There was squeamishness about homosexuality," said Dr. Sonnabend. "The things I used to hear from colleagues were just so horrible. They made jokes about gay men, absolutely." Yet researchers faced a difficulty as the epidemic spread. To describe this as a "gay disease" meant letting it be trivialized as a problem for a marginal population toward which there was significant hostility. It became important to find words to disassociate the disease from homosexuality. Almost a year after the *New York Times* first mentioned it, a name was proposed. No

longer GRID—gay-related immune deficiency—the disease be-
came AIDS: acquired immune deficiency syndrome.

This terminology brought problems of its own. AIDS *was,*
at least at first, a gay disease, and Sonnabend, like many others,
suspected it was sexually transmitted. "What became apparent
to me was that people who were getting this disease weren't just
anywhere. They were placed in geographical locations where the
prevalence of microorganisms was very high," venues for gay sex
in New York, San Francisco, and, to a lesser extent, Los Angeles.
But to emphasize that would feed a stereotype and invite the
opprobrium of the right wing, which had mounted populist at-
tacks on homosexuals in the seventies and was now, in the eight-
ies, in power in Washington. "You don't want to point out that
substantial numbers of gay men were having multiple anonymous
sexual exchanges," Sonnabend saw. "You don't want to say any-
thing like that because that's somehow judgmental."

And so activists went out of their way to universalize the lan-
guage of AIDS. "They would go to great lengths to say this is not
a gay disease. It's everybody's disease," Sonnabend said. In 1983,
Sonnabend helped found the American Foundation for AIDS
Research. "Without my knowledge, they were putting out press
releases that nobody's safe from AIDS, everybody's going to get
it. They did it for fund-raising purposes." This was understandable
but deceptive: some groups were indeed at much higher risk.
But if it was not everyone's disease, it soon would be. In 1983,
worldwide only a few hundred people had died. The toll eventu-
ally reached nearly forty million: one of the greatest pandemics in
history.

———

In 1983, two long years after the first patients began trickling
into Sonnabend's office, the disease's cause was isolated. In 1984,
the American government announced that that cause was a virus,

and in 1986 that virus received a name, the Human Immunodeficiency Virus, known as HIV. With research came understanding about how it spread, calming the rumors unleashed by misunderstanding and panic: Could you get it by kissing? shaking hands? touching contaminated sweat? drinking out of the same glass?

No one was sure. And no one could be sure if they had it, since there was no commercially available test until 1985. Until then, every cough, every cold, every bruise could be the harbinger of a horrible death. And the spread of reliable information was rendered more difficult by politics. Both main causes were taboo, linguistically speaking. The first cause was contaminated syringes used by intravenous drug users. But to warn against sharing needles ran up against the rhetoric of the "War on Drugs" that the Reagan administration was vigorously prosecuting. Needle exchanges to curb the spread of HIV were, in most cases, illegal.

The second cause was unprotected sex. With the country governed by the religious Right—a disparate group bonded primarily by hostility to feminism and homosexuals—"you couldn't say certain things," Dr. Sonnabend remembered. "You couldn't even talk about condoms." Meanwhile, in the gay neighborhoods of major cities, men walked the streets with fear in their eyes. In 1990, Michael Musto, a writer for the *Village Voice,* described the terror of the words one had, and the terror of those one didn't:

> You remember when it was called "gay cancer" and might have been caused by poppers. You remember when they said 10 percent of those with the virus came down with the disease. You remember thinking you were in the clear if you hadn't had sex in three years. You remember when Rock Hudson was the first famous person to die of AIDS. . . . They avoid the word—on death certificates, in conversations, in the media—but the word won't go away. You're bored with it, mad at it, terrified of it—but it *won't go away.*[4]

In *Illness as Metaphor*, Susan had written that "a surprisingly large number of people with cancer find themselves being shunned by relatives and friends and are the object of practices of decontamination by members of their household."[5] Many gay people were shunned, told that their sexuality was dirty, even before AIDS; and AIDS, like cancer and tuberculosis, was strongly linked to sexuality. Cancer was "considered to be de-sexualizing." Tuberculosis "was imagined to be an aphrodisiac, and to confer extraordinary powers of seduction."[6] But if cancer and tuberculosis were linked to heterosexuality, AIDS was linked to homosexuality—and homosexuality, Michelangelo Signorile would shout a few years later in one of the all-caps columns that made him notorious, was "SOME SCANDALOUS SECRET, THE NAME OF WHICH WE CAN'T INVOKE."[7]

———

This tissue—of things without names, of scandalous secrets whose names could not be invoked—made up "The Way We Live Now," which Susan published in *The New Yorker* in November 1986. The story is a chain of people talking about an unnamed patient who has come down with some unnamed disease, none of whom can quite say what is going on: "Ursula said, and the bad news seemed to come almost as a relief, according to Ira, as a truly unexpected blow, according to Quentin . . ."[8] Things can only be known according to so-and-so, according to someone else, and the characters go through the motions of their lives, oppressed by an all-pervading fear: "Well, everybody is worried about everybody now, said Betsy, that seems to be the way we live, the way we live now."[9]

Susan had opened *Illness as Metaphor* by dividing the sick from the well:

Illness is the night-side of life, a more onerous citizenship. Everyone who is born holds dual citizenship, in the king-

dom of the well and in the kingdom of the sick. Although we all prefer to use only the good passport, sooner or later each of us is obliged, at least for a spell, to identify ourselves as citizens of that other place.[10]

But in "The Way We Live Now," the nature of the disease blurs the boundaries between the two citizenships. Anyone could slip, without warning, to the night-side.

> My gynecologist says that everyone is at risk, everyone who has a sexual life, because sexuality is a chain that links each of us to many others, unknown others, and now the great chain of being has become a chain of death as well.[11]

Twenty-six characters—one for each letter of the alphabet—define themselves in relation to the disease, and to the patient: whether he likes seeing them, whether they are visiting him, what they know about his condition, and what they do not. They all know where he is headed, and they all try to push that knowledge aside:

> There must be a way to get something positive out of this situation, he's reported to have said to Kate. How American of him, said Paolo. Well, said Betsy, you know the old American adage: When you've got a lemon, make lemonade.[12]

Platitudes, gossip—meaningless words—follow these people, persecute them, all the way to the grave: "The thing I can't bear to think about, Tanya said to Lewis, is someone dying with the TV on."[13] In the absence of real knowledge or effective treatment, the afflicted cling to their worn-out language, to their metaphors. Without hope, even the dullest words offer some comfort—however temporary, however ineffective.

———

Over the thousands of pages of the nearly hundred volumes of Susan Sontag's journals, a few leap out as particularly bloodcurdling. This is her list of AIDS deaths: page after page, name after name after name, offered without comment, as on the Vietnam Veterans Memorial, inaugurated in 1982, just as the crisis began. There are the artists Susan knew—Peter Hujar, Robert Mapplethorpe, Keith Haring, Jack Smith, Michel Foucault, Bruce Chatwin—and the others whose deaths brought the disease to broader attention: Rock Hudson, Halston, Liberace, Perry Ellis.

Only one name appears twice: Paul Thek. This was the man to whom she twice dedicated a book: *Against Interpretation,* and then, in 1989, *AIDS and Its Metaphors.* She had been out of touch with him since 1978, since the letter in which he accused her, following her cancer, of being a "manipulative harridan" and trying to make him heterosexual:

> I deeply resent, DEEPLY, that effort on your and Davids part to mold ME in HIS image, as it were, all that bit about those damn cowboy boots, etc., etc. . . . trying to "update" me, etc., very boring. Very tacky. You both seem cornily determined to "make a man out of me" (shall I "make a lady out of you"!?) That is, YOUR version of what a "man" is. How would you know? . . .
>
> And I didn't FEEL good when you and David went thru your lets-wake-Paul-up-teach-him-to-be-a-"man" routine. He actually even used those words to me![14]

Susan had been attracted to Paul's unforced, unintellectual brilliance, and to the spontaneous warmth that she had missed as a child. When she was comfortable enough to let her guard down, Susan could be girlish; Paul, all his life, was boyish. "If he

wanted to tell you something that might surprise you, he would put on big expressions of surprise himself," said Stephen Koch. "Paul was one of the few people with whom I saw Susan be physically playful. It was not unlike the way she would be physically playful with David. Lots of hugs, kidlike voices, giggling. When Paul came by, which in those days he did often, Susan anticipated fun."

Yet—rather like Alfred Chester—Paul grew increasingly unbalanced. He once came to visit her "with one ear, Van Goghish, painted blood red."[15] Susan was upset by his drug use. One day, in a restaurant, he began looking around: "You see, Susan, all these people are dead." She said: "No, they're not, Paul. They're not dead."[16] He became convinced that any woman who expressed even the mildest interest was sexually obsessed with him and would take revenge if he failed to reciprocate. And he pursued Susan, Koch remembered.

> Paul would call up, ask if he could come by, and be given some (probably transparently false) excuse. He would then try again, pester her, and struggle to negotiate time with her. Though she remained nominally loyal to their friendship, she plainly saw him as a burden. Not a bore, but crazy. She was rather interested in his later almost fanatic Roman Catholicism. I remember him telling me that he often heard the devil chattering in his head.

In the letter in 1978 in which he accused Susan and David of trying to "make a man out of him," he had—with unquestionably awkward timing—implored her for a loan. Soon, beautiful, brilliant Paul was so poverty-stricken that he was bagging groceries. Exhausted, depressed, and mentally disturbed, he could no longer work on art.[17] Susan never responded to his request for money. Then, on January 15, 1987, weeks after she published "The Way

We Live Now," he sent news. He had been calling FSG, trying to get in touch with her, but she had never returned the calls.

> I've been told by my doctor that I have, of course, AIDS. I'd felt psychically that SOMETHING was drastically different, my disillusion, my total boredom with the "art" world, etc., was all really too extreme . . . and now I know I was right. They say the illness brings on newly deep awarenesses, and that is surely true! Word has it that you see a good deal of Robt Mapplethorpe these days, and word also has it that HE too has been "very ill." I don't know at all how much truth there is in these bits of news . . . but, if it is true . . . then you already have more than enough problems of this sort.

In the letter, he said that he wanted to ask her to take care of a storeroom full of art that he would be leaving. "Without a widow . . . chances are all these things would just be THROWN AWAY! All that work." He mentioned her failure to help him when he needed her, but added at the end: "I hope you'll forgive me . . . as you know I have forgiven you."[18] They eventually reconciled, and before long Paul lay dying. A hastily sketched log of his final days survives, written by a friend, the artist Ann Wilson:

> August 5: "Susan (Sontag) came—and Paul asked us to leave them alone together. Susan said Paul requested her to read him Rilke (Dueno Elegies) she went and got a copy and read to us all from about 3–6 . . .
>
> August 6 . . . 2pm Susan brought priest writer IVAN ILLYCH to meet Paul and they had a discussion, he had a big round lump in his cheek
>
> August 7 4PM returned to find Shala [Sheyla Baykal] and ED very upset because Susan Sontag wanted to move

Paul into the care of Barbara Starett at St. Vincents hospital and had apparently been setting up this move

August 8 I called Priest for last Rites at residents suggestion—

August 9 . . . DR. Brown "Paul is sick with HIV disease. He has colitus. Paul is living. Paul has been sick for one month with severe intractable diarrea. Last week Shala and Paul called. I was informed that he had dirreha for three weeks. He was so week he could not get out of bed and feed self. Admitted to hospital. We found him severely dehydrated. He was very weak. . . . it was my understanding it was irreversable-His arm had swollen up-it was causing it great distress-he would have died in two days if he had not gone to the hospital-its irrelevant-Theres no bringing him back-nothing except to keep him comfortable-

. . . Susan Sontag called Dr. Sterrett-Paul was near death and getting morphine-What your evaluation?

Dr Brown "She doesnt have time."

. . . 10pm Susan (Sontag) reads-all night vigil-all of us reading-Susan and Ed left around midnight. Susan asked me to call her if Paul died.

AUGUST 10 . . . Paul stopped breathing at 1:45 AM

The wonderful Jamacan practicle nurse had wrapped Paul in white guaze and placed the flowers which Bob Money had brought from Pauls roof garden down the center with his rosary-Shala called me back in to see this—he was his own image.[19]

———

To read "The Way We Live Now" alongside the chronicle of Thek's death is to see how Sontag transformed the powerlessness of words—the friends whispering in the corridors, the doctors hopelessly mumbling, the priests and poets fumbling with pretty

phrases, the patient deprived of any voice at all—into an indelible portrait of terror.

This makes it all the more bizarre that Susan was adamant that the story, which is obviously about AIDS, was not about AIDS. In 1991, she collaborated with the British artist Howard Hodgkin on a book version, to which Hodgkin contributed six paintings. The copyright page announced that the proceeds were "given to AIDS charities in the United Kingdom and the United States." But Susan "didn't want it to be an AIDS story," Hodgkin said. "She was very firm about that and would deny that it was about AIDS. She wanted it to be bigger than that."[20]

The insistence on being "bigger than" something that was killing her friends by the dozen, on refusing labels, on being universal—on giving, in Bob Silvers's phrase, "no idea of the status of the connection" between artist and subject—had the ironic effect of distancing her from her subject, of undermining her story, by turning something real into something abstract. This was the very thing for which she had indicted the metaphors of illness in two impassioned polemics.

In 1984, six weeks before Silvers sent Susan the letter about her Sartre essay that contained the above phrase, Adrienne Rich delivered a speech called "Notes Toward a Politics of Location." Rich had come to believe that a writer ought to "begin with the material. Pick up again the long struggle against lofty and privileged abstraction," speak from specific experience:

Perhaps we need a moratorium on saying "the body." . . . To say "the body" lifts me away from what has given me a primary perspective. To say "my body" reduces the temptation to grandiose assertions.[21]

This essay dates from the beginning of the age of AIDS, when denial of that most personal experience, of sickness and death,

was reaching farcical proportions. The obituaries attributing deaths to "a sudden illness," people falling "very ill," the funerals at which it was forbidden to mention the cause of death, are far too numerous to recount: eerily reminiscent of the silence around cancer that Sontag had earlier denounced. A refusal of names—"the body" rather than "my body"—provided false comfort, and added to the gauzy atmosphere of silence and shame.

Michael Shnayerson, a journalist at *Vanity Fair*, was assigned to cover the epidemic toward the end of 1986, in the weeks surrounding the publication of "The Way We Live Now." "It was like covering a war that was going on all around you, right in New York City, invisibly." Shnayerson, who was heterosexual, lived on Bedford Street, in the heart of the gay community of Greenwich Village. "Even in that neighborhood, I didn't have much awareness of AIDS," he said. "It was invisible to the broad readership of *Vanity Fair*, and it was probably invisible to a lot of New Yorkers."[22]

His piece, for which he interviewed Susan, focused on the devastation in the art world. This was controversial: "a political risk," he said, "because it was based on the premise that people in the arts were dying disproportionately, and was it somehow politically incorrect to suggest that there were more gay people in the art world, and that gay people were getting AIDS far more than straight people." Six long years after the "gay cancer" had first started spreading fear, it was not being written about in the mainstream press. "It was one of the first pieces in a venue that prominent that was talking about the epidemic in those terms": in the terms of naming names.

The silence around AIDS meant that people who suffered from it were invisible. The editors borrowed a concept from one of the great pieces of Vietnam-era photojournalism, a *Life* cover story from 1969 entitled "The Faces of the American Dead in Vietnam." This showed page after page of boys next door, 242, killed

in a single week. This simple tactic—showing the victims' faces—had a powerful impact on the war debate. "We must pause to look into the faces. More than we must know how many, we must know who."[23]

Because of the shame surrounding AIDS, its victims were not being seen. "The culture was in the closet," said Michelangelo Signorile. This was the culture in which people were surprised to learn about the homosexuality of Allen Ginsberg or Gertrude Stein. "Gay sexuality was so unspoken. There were old ladies who were shocked that Liberace was gay."[24] Many people had not acknowledged that they had AIDS, many people had not acknowledged that they were gay—and so, said Shnayerson, "it was actually much harder than the words, getting the pictures."

> Many people had not acknowledged they had AIDS, many people had not acknowledged they were gay. What did you do? Did you just put them in that spread anyway? Did you talk to their lovers and families, and see what their sentiments were? As I recalled, each case was its own issue. There were many pictures, probably fifty or more. . . . We were essentially outing all those people. Some were out, but many weren't. I think the debate just turned on what was more important, and it was more important to get the story out, make people aware of the devastation, and draw the government's attention, and do something.

This was the conclusion Adrienne Rich had reached. As in the age of Vietnam, a political response to AIDS would have to be forced. The anti-gay Reagan ignored the epidemic for years. He shielded his brutality behind Warholian "sound bites"—a term invented for Reagan, who depended, like so many politicians, on the most cynical function of metaphor: to sever the connection between language and reality. Sontag was certainly right that

abuse of metaphor could keep citizens from making the connection between clichés and bodies. That is why—as *Life* did in the sixties and *Vanity Fair* did in the eighties—activists realized that "we must know who" was speaking, who was dying. "The Way We Live Now" was published into a context in which it was essential to name names—particularly the name of AIDS.

Why Don't You
Go Back to the Hotel?

T he Way We Live Now" appeared in *The New Yorker* on
November 24, 1986. Six days later, the Hawaii Interna-
tional Film Festival opened in Honolulu. Susan was on
hand as a jury member, participating, as she had for several years,
in order to visit her family. Despite the palmy location and the
opportunity to see movies from around Asia and the Pacific, Su-
san could not stand the visits. "There were these beautiful trips,"
said Steve Wasserman, "but it was like a horror show."[1]

Money was always a problem for Mildred and Nat, but their
Hawaiian retirement had been otherwise pleasant. They managed
to go on the occasional cruise, and they had their friends, in-
cluding Mildred's hairdresser Paul Brown and Nat's nephew Jeff
Kissel. Jeff came to Hawaii for college and, in his early years in
Honolulu, saw the couple at least five days a week. They were ac-
tive until the early eighties, when Mildred, in her seventies, was

crippled by arthritis, forcing Nat into the caregiver role. It was only then that her drinking became more visible.

"She was never in any way impaired by alcohol," said Kissel. "She was never aggressive. She would just retreat to the bedroom. The evening would need to end after an hour and a half." Brown agreed: "She wasn't the kind of alcoholic that gets sloppy, or drunk, or stupid. Never."[2] But the retreat to the bedroom was one of the most painful memories of Susan's childhood: the departure of the dependable presence a child needs to feel secure. "The queen of denial" always melted away when things got unpleasant; that is why Susan could say that her "profoundest experience is of indifference."

Mildred had her admirers, but her daughters were not among them. "From the reaction after my mother died," said Judith, "her friends were totally bereft, and thought she was the most wonderful person who ever lived, and so beautiful."

> She was really charming to just about everyone except us. She was like Susan in that she could put on a different face in different relationships. She pigeonholed us. I was the average, conventional daughter. She didn't know shit about my life. Neither did Susan, really.[3]

Mildred—who didn't like details, who didn't want to be disturbed—spent a lifetime cultivating appearances. She got her hair done every week, and displayed considerable stoicism when the end was nearing. "I noticed I had to help her out of a chair a couple of times," said Paul Brown. "She'd put her hand on her back. I'd say: Oh, you're having back pain? She said yes, she was having some pain."

But her back pain was not arthritic. Like so many others, she did not, when she learned she was sick, utter the name of cancer. "She never said the word," Judith remembered. She expressed her

love to Susan with a final gesture. She waited for her to arrive and then, with only days left to live, met her at the airport. With Susan settled into the Hyatt Regency in Waikiki, she said: "Now it's time to go to the hospital."

"I think the reason Mother decided to go to the hospital and die was because we were both here," said Judith. "Even when she was in the hospital—dying—her hands were so beautifully manicured."

———

All week, the sisters slept, side by side, on the hospital floor. They had not been close since Susan skipped Judith's wedding twenty years before. Now Susan rediscovered her sister, and for the rest of her life had a friend in the woman she once dismissed as a humdrum housewife. "I realize all Mother left me was you," Judith told her.

"She wept," Susan added. "I wept."[4]

"What are you doing here?" Mildred said. "Why don't you go back to the hotel?"

These were her final words to Susan. "Oh, oh, oh . . . what am I going to do?" were her last words, "addressed to no one." The sisters made the decision to take her off life support, and on December 1, 1986, aged eighty, Mildred died. She was cremated, her ashes scattered in the waters off Oahu.

With her went the figure that defined Susan more than any other. So many of her relationships—to herself, to her son, to her lovers—had been shaped by Mildred. The ardent, almost romantic love that she had felt for Mildred as a girl gave way, as she aged, to resentment at the void Mildred had left—a hollowness Susan internalized. Passion sometimes matures into dispassion. But in Susan's case it did not, and she could not pity a woman whose life was stunted first by her own mother's early death, then by early widowhood, and then by drinking and the isolation it

entailed. She became dependent, too, on her looks for a sense of value, and on the men those looks attracted.

Shortly after Mildred's death, Susan confided to her journal that she had "always felt guilty for leaving home/M. So she had the right to treat me so coldly, so ungenerously. (My phone call from Madison when I realized I was pregnant—etc. etc.)"[5] Yet Susan often turned guilt against the person toward whom she felt it, and so it was with her mother. "I had no mother," she would say a few years later.

When Susan returned to New York, she recounted her mother's death to Lucinda Childs. "My mother didn't try to kiss me or hug me or anything like that." Lucinda disputed this telling.

> "Don't you understand? She waited for you. She did this un-believable physical feat to meet you. This is a woman on her deathbed who actually physically went to the airport." . . . She showed so much in her way—but not in the way that Susan wanted. She didn't die until Susan got there, which was sort of a miracle.[6]

A dream Susan once confided to a friend may illuminate the nature of Mildred's grip on her, the damage she did to her, and the enduring sense of being haunted by a ghost whose features she would, at times, discern in the women she loved. While in Hawaii, she fell asleep on the couch, "feeling a closeness with another human presence—and looked up and it was her mother, leaning over, about to strangle her."[7] Nobody haunted her like Mildred.

————

With her mother gone, Susan began writing more personally, more accessibly, mixing revelation and obfuscation as she had in "The Way We Live Now." This was a kind of resumption of her

movement, a decade before, toward a more personal manner. The best example was her Thomas Mann story, "Pilgrimage," which appeared at the end of 1987.

She had sketched this piece for decades, but only published it after Mildred's death. It portrayed her family as intellectually primitive, mentioning her "morose, bony" mother and her feeling that living with Mildred and Nat amounted to "slumming in her own life." This surely would have wounded her mother—as it wounded her stepfather. "He was one of the most honest people I've ever met," said her cousin Jeff Kissel.

> He lived in the belief that Mildred and Susan actually had a close relationship. They were in touch frequently by phone. I think that it came as a real shock that Susan decided to say what she said publicly. The fact that she was critical of her mother, he was really hurt by that. A couple of years after Mildred died, I was talking to him and I said, "Have you heard from Susan lately?" He just looked at me and said, "I have no relationship with Susan anymore." Literally that was the last time he mentioned her.[8]

If Mildred's death freed Susan to write more personally, it also further eroded the tact and empathy that had been diluted by her struggle with cancer more than a decade before. The "tall lonely walker" of her journals—the keenly self-aware persona that accurately diagnosed her shortcomings and harshly castigated her missteps—threatened to walk away for good. As she had trouble seeing Lucinda or Mildred other than as extensions of her, she could only see her son in those same terms. He was thirty-five, and his attempts to assert his own identity, to erect and enforce boundaries between them, wounded her. On March 25, 1987, her mother's eighty-first birthday, "her first non-birthday," she wrote:

For decades, being D.'s mother made my identity bigger—I
was an adult, I was strong, I was good, and I was loved
 entirely positive . . .

now it's negative:
I feel stripped of my identity when I'm with him.
 Not a writer—
 Just his mother
 And his rival
 And I'm not loved[9]

Her friend's observation, in 1975, that "I don't describe him, I
describe my relationship with him" was valid as ever. Then, how-
ever, she had written: "What a dreadful burden for him." Now
she expressed no such sympathy. In her relationship with her son,
as with her mother and girlfriends, she was never appreciated,
"not loved."

Yet she was. "I loved Susan," said Leon Wieseltier, speaking
for many others. "But I didn't like her." She grew more and more
insulting toward the people who did love her, and as a result her
isolation often astonished people who knew her only as a famous
public figure. Many formerly close friends abandoned her. "It
was like Marilyn Monroe, who couldn't get a date on a Saturday
night," Wieseltier said. "She had absolutely no understanding of
herself."[10] And so she suffered genuinely from the cruelty and in-
difference she perceived in others. But she could not perceive her
effect on those she hurt in turn, and friends and acquaintances
were constantly befuddled by her behavior, which they would still
be analyzing years after her death.

Jeff Seroy, head of publicity at FSG, once mentioned her to
his psychiatrist, only to hear the shrink burst out laughing. Seroy
asked what was so funny. The doctor answered: "You can't imag-

ine how many people have sat on that couch over the years and talked about Susan Sontag."[11]

————

But if she could drive other people crazy, no one struggled more than she to keep up with the "great person" Jamaica Kincaid identified, that shadow-self that her striving had created. Her reputation as the smartest person in the room, the person who set the pace, gave her a responsibility to know everything, said Wieseltier, who saw what that reputation cost her.

> She had this terrible sense of inadequacy, and it was not easy being her. The level of nervousness was just spectacular. I thought it was amazing that she could breathe. What if you felt that you yourself were not enough and you had this insane fame always preceding you? What if deep down you feared that you might be empty?[12]

Around the time of Mildred's death, she redoubled her efforts to present an admirable facade. In 1964, she had confessed this tendency to her journal, and revealed how far back in childhood it was rooted.

> I valued professional competence + force, think (since age four?) that that was, at least, more attainable than being lovable "just as a person."[13]

One who despairs of being loved will drive off, or deprecate, those who try to love her, and this increasingly became the story of Sontag's relationships. A moment of intense closeness would quickly burn out. Her former friends were legion. "I began to notice that almost everyone I ran into had once been a close friend

of Susan's," said Wieseltier. "Everybody started as fascinating and a secret sharer and there were only the two of you. But with a lot of people it wasn't just that Susan gave up on them: they gave up on Susan, too."

Susan—human—drove people away. But the symbolic Sontag was tremendously attractive. She was so recognizable as a public intellectual that Woody Allen could include her as a commentator in his fake documentary *Zelig*, which came out in 1983. He filmed Susan on a Venetian canal, offering profound commentary on Leonard Zelig, the "human chameleon" who miraculously turned up everywhere and could morph into anything: a celebrity with no stable identity, a mirror upon whom anything could be projected.

In that film, Susan could view her position as the face of American intellectuals with irony. But that position was ratified on June 3, 1987, when she was elected president of the PEN American Center. Her ascent symbolized a makeover of the venerable organization. PEN was one of the earliest international human rights organizations, founded in 1921 along the same principles as the League of Nations. A large part of its work had always been to help writers targeted by oppressive regimes, but because it was international and thus, like the United Nations, dependent on harmony among its members, it could not always be effective. In Communist countries, where writers like Brodsky were targeted and "official writers" were apparatchiks, its reach was limited. But it had often proven invaluable: its intervention had saved the lives of Arthur Koestler, for example, when he was imprisoned in Fascist Spain, and of the Nobel Prize winner Wole Soyinka, sentenced to death in Nigeria. Until the mid-eighties, the PEN American Center "was a fairly small, not particularly prosperous" group, according to the feminist writer Meredith Tax. Its transformation began under a new president, Norman Mailer, elected in 1984. Much of the literary world loved to hate Mailer's

bluster and machismo, but he could, and did, raise the profile of PEN as few writers could. "Mailer came in," said Tax, "and all of a sudden it was like Rockefeller Center."[14]

———

He showcased this transformation in an International PEN Congress hosted in New York in January 1986. The "Mailer Congress" made a dazzling impression on an Indian writer who would himself soon need the organization's advocacy. Salman Rushdie was "more than a little awestruck" by the roster. "Brodsky, Grass, Oz, Soyinka, Vargas Llosa, Bellow, Carver, Doctorow, Morrison, Said, Styron, Updike, Vonnegut, Barthelme, and Mailer himself" were there, and when a photographer put Rushdie into a horse-drawn carriage in Central Park, he found himself squeezing in alongside Czesław Miłosz and Susan Sontag.[15]

Mailer, a publicist of genius, could create an event that placed literature at the center of politics and culture: the place it occupied in certain European countries, the place that—to Sontag's regret—it never occupied in the United States. "The PEN congress was on the front page of the *Times* every single day," said Meredith Tax. "That doesn't happen with literary events in New York." Rushdie wrote: "In those days in New York literature felt important, and the arguments between the writers were widely reported and seemed still to matter outside the narrow confines of the world of books."[16]

There were two major controversies. The first was Mailer's invitation of George Shultz, Reagan's secretary of state. This elicited protests: from writers who were critical of American policies toward apartheid or Nicaragua; from those who recalled that the State Department had denied visas to writers deemed subversive, including Farley Mowat and Gabriel García Márquez. Sontag and E. L. Doctorow led the movement and handed Mailer a letter as Shultz was getting up to speak. Mailer showed it to Shultz,

but refused to read it aloud. When Grace Paley protested, he said: "I didn't bring the Secretary of State here to be pussywhipped by you."[17] The protesters would have surely been more receptive to his subsequent explanation: since PEN aimed to reduce the oppression of writers, "the more clout we have with the State Department, the more effective we are."[18]

But Mailer specialized in zingers, sometimes jokingly, sometimes resorting to misogynistic rhetoric. This—not to mention having stabbed his wife—undermined his position in the other dispute. That concerned the underrepresentation of women, a mere sixteen out of the 120 invitees. "He announced it as the best writers in the world," said Tax. "After sitting there for the first day, it became painfully clear that the best writers in the world were white men." Karen Kennerly, the executive director of PEN, disputed this characterization. "Susan and Donald Barthelme and I were the ones who decided who should be invited," she said, and many prominent women they invited—Joan Didion, Eudora Welty, Doris Lessing, Mary McCarthy—were unable to attend.[19]

Rather than acknowledging or trying to address the problem, Mailer added fuel to the fire, telling a reporter that "there are not that many women, like Susan Sontag, who are intellectuals first, poets and novelists second." This further enraged the protesters. It did not, however, enrage Susan. To Nadine Gordimer, she said that "literature is not an equal-opportunity employer."[20] This was repeated as an assertion of meritocracy. It was, in fact, the opposite. Tax remembered that "she didn't say—which would have been the perfectly obvious thing for anyone to say—'Oh, come on, Norman. There are lots of women intellectuals, it's just so-and-so is busy and so-and-so is dead.' She took it as her due."[21]

Her quip assumed some equal playing field, and hinted that women were demanding inclusion based on their sex rather than on their achievement. As Sontag surely knew, the feminist critique was that the playing field was not equal, and that any woman

who arrived at the position she had was not only exceptionally talented but—more to the point—exceptionally lucky. In feminist terminology, she was an "exceptional woman": like the one black or Jewish family allowed in an otherwise all-white neighborhood. Waiving the rules for an odd exception did not undermine those rules; a show of flexibility only strengthened them.

Ironically, it was Mailer himself who came closest to identifying the problem: "There are countries in the world where there are no good woman writers." Phrased, as ever, in the most provocative form, this line earned hisses. But what he meant, he explained, was that "women had been exploited and kept down in those countries." Lack of access—to education, birth control, economic opportunity—meant that any woman who overcame these structures would always be exceptional.

———

After this fiasco, PEN America needed a woman president. Mailer's term ended in June 1986, and the choice fell on the novelist Hortense Calisher. Calisher immediately clashed with Kennerly, who ran the day-to-day operations, and resigned after a year, when Susan found a way to allow all parties to preserve their dignity. The American Academy of Arts and Letters, to which she had been elected in 1979, was looking for a new president, and she suggested that they might choose Calisher, and then suggested to Kennerly that she herself could step in as president of PEN, a position that she had often been invited to occupy in the past. "God bless Susan," said Kennerly, for finding such an elegant solution. "How can you not love her forever and ever for that?"[22]

The presidency was largely symbolic. Meetings would be attended; Washington visited; letters drafted, signed, dispatched to newspapers. Yet the role of constitutional monarch fit Susan perfectly. She made an important start at the next International PEN Congress, which opened in Seoul on August 28, 1988, a

little more than two weeks after Paul Thek's death. American
PEN and its allies—Australia, Canada, Denmark, the Nether-
lands, Sweden, and West Germany—protested the selection of
South Korea, which, though it had been steadily democratizing,
still had writers in prison. But when they lost the battle, Kennerly
went, and for two weeks before the congress laid the groundwork
for their protest. This was to be a simple cocktail party in honor
of the dissident writers, and it was to be in sharp contrast to the
"quiet diplomacy" other countries sought, "a moderate noncon-
frontational approach."[23]

Susan had never been one for moderate nonconfrontational
approaches. And the apparently modest cocktail party, described
by one Korean paper as "an illegal gathering," attracted 150
people, including friends and relatives of imprisoned writers.
The attendees read from the prisoners' work and described their
plights. When told that the party was regarded as an insult to the
Korean government, Susan riposted: "We are writers here to help
other writers. It is not our job to be silently polite house guests.
The job of writers is to speak out." The event was offensive enough
to the regime that President Roh Tae-woo canceled his scheduled
address.[24]

The protests were noted. One writer, San-Ha Lee, had been
arrested in 1987 for a poem about American brutality toward ci-
vilians during the Korean War. In prison, his lawyer informed
him that Sontag wanted to make him an honorary member of
American PEN.

> During the long legal process, Sontag, in New York, de-
> manded that the South Korean government release me sev-
> eral times. . . . So the government started to be embarrassed
> because the Olympic Games would be held in South Korea
> that year and the government had to be cautious about inter-
> national public opinion. So the government gave some sort

of commitment to her regarding my release, that's what I've heard about it. Susan Sontag requested an interview while I was in prison several times, but the office rejected all her requests.[25]

As soon as the government could bury this incident, it did: one publisher was released in October, three more in December, and San-Ha Lee in 1990.[26] But he was forbidden to leave the country.

I was only able to travel, finally, to Japan ten years later, in 2000. And in the end, Susan Sontag passed away due to cancer at age 71 in 2004, so I was not able to meet her. Periodically Susan Sontag appears on my television screen, or I come across *Regarding the Pain of Others,* and her name functions as a reminder: to consider how my thinking has developed, if I have walked a proper path, and how deep the tracks are that I've left behind.[27]

———

The Seoul Congress was a dress rehearsal for the far more important role Sontag would soon be called to play. Her fearsome reputation, long record of activism, and position as president of PEN America would combine to put her at the center of one of the most notorious sagas in modern literary history. On Valentine's Day 1989, the Ayatollah Khomeini, Supreme Leader of Iran, issued a death sentence against Salman Rushdie for *The Satanic Verses,* a novel published in London a month after Susan returned from Seoul. The ayatollah and his government had not read the novel in question, whose title alluded to an incident in the life of Muhammad in which Satan tempted the prophet to utter the names of three pagan goddesses.

The author was accused of blasphemy; and the fatwa—the

word would soon need no italics—set off a wave of terror in which
at least sixty people ultimately died. Bookstores in Britain and
America were bombed. Rushdie's Norwegian publisher and Turk-
ish and Italian translators were shot and wounded. His Japanese
translator was murdered. For Rushdie himself, it was the begin-
ning of many years of safe houses and fruitless and humiliating
"apologies" to the Iranian authorities. It was also the beginning
of what Rushdie saw as abandonment by fellow writers who fa-
vored a "moderate nonconfrontational approach" that, in practice,
meant blaming Rushdie for deliberately provoking the calamity.
"I don't think it is given to any of us to be impertinent to great
religions with impunity," said man-of-the-world John le Carré;
and anti-Semite Roald Dahl called Rushdie "a dangerous oppor-
tunist" who "knew exactly what he was doing and cannot plead
otherwise. This kind of sensationalism does indeed get an indif-
ferent book on to the top of the best-seller list,—but to my mind
it is a cheap way of doing it."[28]

In 1989, the fatwa, like the word itself, was a new phenom-
enon, and the fear that it provoked was real. "It was the first
taste we had of the theocratic sensibility," said E. L. Doctorow.
"It was our first taste of the relationship between faith and vi-
olence in that part of the world."[29] The book had not yet been
published in the United States—it was scheduled for February 22,
little more than a week after Khomeini's pronouncement. At
first, many thought that there had been some misunderstanding;
and when the fatwa was issued, prominent American writers—
including some of those who had spoken out against censorship
in Korea—made themselves scarce. "I'm saying this now only be-
cause they're dead," said Karen Kennerly. "But Arthur Miller said
he didn't want to have anything to do with it. Vonnegut said the
same thing. Until they died I always pretended this wasn't true."[30]

The danger was real: the PEN office received repeated hang-
up calls; Penguin had to hire bodyguards; major chain book-

stores, fearing the violence that had erupted in other parts of the world, refused to sell the book. Rushdie had the protection of the British security services, but others involved with the book did not. "I know American journalists who were phoning around trying to get comments, who said that they were surprised by how many leading American writers were suddenly unavailable," said Rushdie.[31] Even Mailer—normally so combative—hesitated; but he had not reckoned with one American writer more combative than he.

Within days, something changed. "Whipped into line by Susan, almost all of them found their better selves," Rushdie wrote.[32] The idea was to place the emphasis on the book, which almost nobody had seen, rather than on the controversy. PEN lined up leading writers to read excerpts. Mailer turned up, and so did Joan Didion, Don DeLillo, E. L. Doctorow, Diana Trilling, Larry McMurtry, Edward Said, Robert Caro, and Leon Wieseltier. "I'm glad it was Susan who was president rather than somebody a little more timid," said Rushdie.

This solidarity gave Rushdie, dispirited by "non-Islamic hostility," an important source of support. "The cardinal of New York, the British chief rabbi, the pope were all on the other side. All perfectly willing to condemn the novel they hadn't read." The day after the reading, the chains B. Dalton and Barnes & Noble announced that they would, after all, carry *The Satanic Verses*. "It was very important for me," he said, after hearing recordings of the reading. "To have allies is very strengthening." First among them was the woman he called "Good Susan."

Casual Intimacy

W hen she met Susan, Annie Leibovitz was famous even by the standards of Susan's world. Not yet forty, she had been prominent since the time most people her age—she was born in 1949—were in college. Her father was an air force officer, which meant that Anna-Lou, like Susan, had a nomadic childhood. This reinforced the centrality of her family: "My sisters and brothers"—she was one of six children—"have always been and still are my best friends."[1] Constantly pulling up stakes made relationships outside the family difficult to maintain. But for a photographer, the ability to pop up anywhere, read the room, and get what she needed proved an essential gift.

Like Susan, she had an alcoholic mother; like Susan, she displayed the characteristics of the adult child of the alcoholic: insecure and anxious to prove herself, tormenting herself and others with impossible perfectionism; lurching from crisis to crisis, veering from opulent generosity to impetuous violence. Like so many children of alcoholic homes, she had a propensity to

substance abuse,[2] though in contrast to Susan she described her childhood as "extremely happy" and remembered "a strong feeling of being loved."[3]

During the Vietnam War, her father was posted to Clark Air Base, the giant military city in the Philippines from which much of the war was staged: he himself was often in Vietnam. In 1967, at the height of the antiwar movement, Annie started art school in San Francisco, the center of that movement. After a year studying painting, she visited her parents, and she and her mother took a trip to Japan. There, she bought her first serious camera and took it up Mount Fuji. She loved the immediacy of photography and its promise of a path out of the isolation of the painter's studio. "There were a lot of angry abstract expressionists in the painting studios," she said. "I wasn't ready for abstraction. I wanted reality."[4] Later, as a photographer, she retained a painterly sensibility that would become ever more refined as her means, financial and technical, increased.

In 1969, torn between loyalty to her father and agony about the war, she sought a third option, heading to a kibbutz. But "becoming an expatriate wasn't going to solve anything," she realized, and returned to America with a pile of photographs of Israel. A year after "Trip to Hanoi," Annie began to respond to the war with pictures of the antiwar protests roiling San Francisco and Berkeley. With the encouragement of a boyfriend, she took these, along with her work from the kibbutz, to the art director of a new magazine. "In the younger generation," said Roger Black, who would become art director a few years later, "*Rolling Stone* was probably more important a magazine than any magazine since."[5]

Annie Leibovitz gave a face to that generation's heroes, and in the process became one herself. She made a spectacular debut when, still only twenty, she prevailed upon Jann Wenner to let her

photograph John Lennon. Only three years older, Wenner was notoriously cheap; Annie snagged the assignment by mentioning that she could fly to New York on a youth fare, and her expense report for the two weeks was twenty-five dollars.[6] "Yoko said later that she and John were impressed that Jann let someone like me photograph people who were so famous."[7] Her close-up portrait was on the cover of *Rolling Stone*'s January 21, 1971, issue. The cover put Annie on her way to becoming what Kathy Ryan, the renowned photo editor of *The New York Times Magazine,* called "the court painter to some of the most famous people of our era."[8]

Less than two years later, Shel Silverstein wrote a song that became a hit for the group Dr. Hook and the Medicine Show:

> We take all kinds of pills that give us all kind of thrills
> But the thrill we've never known
> Is the thrill that'll getcha when you get your picture
> On the cover of the Rolling Stone.[9]

"That was an endorsement," said Andrew Eccles, who became her assistant a few years later. "To say I want to be on the cover of the *Rolling Stone* was to say: I want to be photographed by Annie Leibovitz."[10]

———

Leibovitz was lucky to be in the right place at the right time—San Francisco at the peak of the counterculture. She was lucky to happen upon a fledgling magazine that became the symbol of a generation. But to reach the summit of her profession and stay there for a career spanning nearly five decades took more than luck, and part of her secret was her ability to get places other people could not.

She got in people's faces, said Timothy Crouse, who wrote for *Rolling Stone* in the early years:

She had this thing that I never saw in any other photographer, which was that she was able, literally, to get in people's faces. The lens was in their face and it could be a person that she had worked with and had time to establish some rapport with or that she knew a little bit, or it could be a person that she had met one second before in the street. It wasn't only that she was fearless. It wasn't like she was just in their face in a brazen way. In one second, she was able to establish some kind of rapport.[11]

She got in people's homes, said Andrew Eccles:

The subject would say, "Well, you can't come to my house." That became the thing that she would have to do, is go to their house. "How am I going to get to their house?" We're going to keep asking. We're going to maybe stake out the house. Whatever it was. There was a relentless drive.[12]

She got people naked. The number of people who appeared in *Rolling Stone* partially or entirely undressed became a running joke, and part of the magazine's appeal.

It's really a lot of fun taking pictures with me. And then I slap them in the mud! And then I hang them from the ceiling! And they say, "I heard you were hard, Leibovitz. I heard it wasn't easy."[13]

She got into people's beds. "Sexuality plays a huge part in her work," said Karen Mullarkey, who became *Rolling Stone*'s photo editor in 1974. "All really excellent photographers are seductive— because they deal in casual intimacy." A childhood spent on the move, negotiating new towns, new schools, new people, had given her a talent for casual intimacy.

They make you think they're your friend, they're your what-
ever, and then they get what they need, and they're fucking
out of there. You're photographing a celebrity. You do what-
ever it takes to suck up to them, make them feel safe. Then
they're vulnerable—then you go in for the kill—and then
it's over.[14]

Getting in people's faces, getting into their houses, getting
them naked, getting them—literally—into the mud: this was the
photographer's game of dominance, said another *Rolling Stone*
veteran, Max Aguilera-Hellweg:

Annie knew from the beginning the photographer's psychol-
ogy of dealing with people. You are controlling your subject
from the minute you call them. Everything you say is a con-
stant, evolving equation, to get more time with them, to get
more intimacy, to get them to open up more—and to stay
dominant. To get them on film. For them to reveal them-
selves. Sometimes it's exposing yourself, becoming more in-
timate yourself. Sometimes it's saying the wrong thing on
purpose to get them to challenge you. But if you don't do it
from the very first second, you've lost.[15]

——

In the early years, before she herself became a celebrity, Annie
had to find a connection to her subjects. On the one hand, she
approached them as Susan approached her portraits of Canetti
or Artaud: "with really tremendous thought and respect, and
admiration for who the person is. She celebrated them," said
Eccles.

She really loved her subjects. Sometimes *really* loved her sub-
jects, but she just would flatter everything that the person

did. Sometimes photographers don't have those people skills. Someone will be in front of the camera, and they'll say "Oh, don't do that, you look fat" or "Don't sit that way." The only things to come out of Annie's mouth were how wonderful what you were doing was—but maybe try this instead. She made people feel great about themselves. That allowed people to relax and feel safe, and maybe take their clothes off or maybe be gently coaxed into an idea that they were a little on the fence about.[16]

Annie's subjects made love to more than just the camera. The number of subjects she reportedly slept with, from Mick Jagger to Bruce Springsteen, was also fabled.[17] "There's a whole series of pictures of Jerry Garcia, and he's clearly waking up in the morning and climbing out of bed," said one employee, who started working at *Rolling Stone* in 1971. Karen Mullarkey recalled how Annie shot Linda Ronstadt in medias res, spread out in bed, ass in the air, clad in a slinky red negligee.

You just don't get pictures like that. "Hey, why don't you get on the bed? Hey, why don't you hike your skirt up?" That didn't happen that way. It was much more personal.[18]

Ronstadt was thirty when Annie took those pictures. She had been constantly portrayed as a girl half her age, so Annie decided to show her grown-up side. Ronstadt later "bitterly regretted" the pictures, claiming that Annie tricked her, and that they were taken on a "break."[19] Despite her protestations of love toward her subjects, Annie prided herself on being a vulture:

I like to work with these people where they're going to have the time, and they're going to be bored shitless and have

nothing else to do. You know, get them when they're vulnerable.[20]

This was the camera-as-vampire that Susan had denounced. The photographs of Ronstadt put the viewer above her. Her face is invisible, removed along with her clothes; her nearly exposed genitals invite penetration. To get the pictures, Annie had used the techniques of Diane Arbus: "I always thought of photography as a naughty thing to do—that was one of my favorite things about it," Arbus wrote, "and when I first did it I felt very perverse."[21] Susan quoted the phrase in *On Photography;* Leibovitz admired Arbus, and Annie's flattering of her subjects in order to dominate them echoes Susan's description of Arbus's methods: "Far from spying on freaks and pariahs, catching them unawares, the photographer has gotten to know them, reassured them."[22] This was another way of asserting the dominance Susan saw behind every use of the camera.

> To photograph is to appropriate the thing photographed. It means putting oneself into a certain relation to the world that feels like knowledge—and, therefore, like power.[23]

Seduction was part of the trick. Another was on the mirror on the nightstand that Ronstadt was reaching for, just out of view. "She was lying on her stomach with her legs spread in the teddy and she's reaching over," Mullarkey said. "That's because there's cocaine on the mirror."[24]

At the time, neither sex nor drugs caused alarm. "Everybody was sleeping with everybody," said a colleague. "It wasn't like it is now, verboten and illegal." It was the same with drugs: "It's hard to explain that drugs in that period was everywhere and normal,"

said Mullarkey. "We hadn't known anybody yet who died," said Black.[25]

Rolling Stone began in 1967, the year of the "Summer of Love," when a song invited people to San Francisco with flowers in their hair. Thousands flocked to "love-ins," and marijuana smoke wafted over concerts, meditation gatherings, and sexual celebrations made possible by the birth control pill and advances in treating venereal disease.

Besides weed, the emblematic drug of the Summer of Love was LSD; but in the seventies, more, harder, drugs became widely available. Though two early *Rolling Stone* icons, Jimi Hendrix and Janis Joplin, overdosed within days of each other in the fall of 1970, the dangers of cocaine and heroin had not yet sunk in. *Rolling Stone* even had in-house drug dealers, who worked from a room known as the Capri Lounge. "You could buy your reefer there," said Mullarkey. "You could get your cocaine there. It was a company store." The two hippies who ran the Capri Lounge photographed all their customers to make sure they would never be turned in, and—like all smart drug dealers—refrained from indulging in their own merchandise. Both retired in style: "One has a giant farm in the Catskills with a view of the Hudson," said Roger Black. "The other lives on an Alabama horse farm with two thousand acres, and giant stables, and Range Rovers."[26]

Not everyone was so lucky. For Annie, the turning point came in the summer of 1975, when she accompanied the Rolling Stones on their Tour of the Americas.

> The band was rehearsing at Andy Warhol's place in Montauk, at the end of Long Island, and I went out there for a month or so, and then there was a break, and then the tour started in June. I was very naïve. . . . At the time, I thought that the way to get the best work was to become a chameleon. . . . I did everything you're supposed to do when you go on tour

with the Rolling Stones. It was the first time in my life that something took me over.[27]

She came back a different person. If everybody did drugs, everybody agreed that there was something different about the Stones, said a friend:

> The Grateful Dead did tons of drugs, so many drugs they couldn't tour Europe. But the Stones, there's something more evil—I mean really evil—about that whole scene. People died. Hanging out with those people for an extended period of time just fucked her up. It wasn't just the drugs, it was sex, and drugs, and deviltry, and evilness, and horribleness. I don't know what she was subjected to, but when she came back she was a different person. She just got weirder and weirder the more drugs she did, and by that first year in New York, '77, '78, she was completely fucked up.[28]

In seduction mode, she did what she needed to please. "In the beginning," said Karen, "she would do fucking *anything* to get the picture. Sometimes it was very demeaning. She'd take whatever shit they wanted to deal out." This was the Faustian bargain that made Annie successful. "The problem," Karen told her, "is that you deal in casual intimacy, and you're brilliant at it. But there's a price, because what you've seen is so horrible."

———

Like Susan, Annie was publicly unflappable. Those who knew her were not fooled.

"Annie was extremely fragile," said Black, "and she was always afraid that she wouldn't be able to put herself together again. Hysterical fits in the office, throwing things, not being aware of what was going on." These were years of feverish work. "I don't

know how much more frenzied it can get," she said in 1973. "But the speed at which I operate, I put on myself."[29] She had the same need to prove herself that Susan did, "wanting to take the next great picture," said Eccles.

> She felt an intense responsibility to take the greatest picture of this person that can be taken. Certain doctors probably work that way. Like if there were a saving-someone's-life version of a photograph.[30]

Her relentless drive was exploited by her boss, Jann Wenner, whom Black called "a very shrewd and evil judge of character." Annie, Jann, and his wife, Jane, formed a triangle. "It was very, very intense and impregnable," said Black. "There was no way you could enter that triangle." Annie became their child: "It was a family in which she was the only child," said Mullarkey. "That was part of it, plus the drugs. They were so available. You could do anything you want. There was no judgment call." In later years, Annie never referred to Jann and Jane by name: she called them "them."[31]

Jann saw Annie's insecurity as a key to controlling her. "He'd play on the fact that 'Without me you wouldn't have gone anywhere,'" said Mullarkey. "'Without me you wouldn't have happened.'" The manipulation was all the more effective because it came with encouragement and opportunity. "You're going to be the greatest photographer in the world," he would say. And it came with a stunning amount of space. On the cover of the tenth anniversary issue, only two names appeared: Hunter S. Thompson and Annie Leibovitz. She was given fifty full pages, a retrospective of a decade of work. "No writer has appeared in *Rolling Stone* as often," Black wrote.[32] By then, she had shot an astounding fifty-eight covers.

———

In 1977, the year of the tenth anniversary, *Rolling Stone* moved to New York, and Bea Feitler came in to design Annie's fifty-page portfolio. Born in Rio de Janeiro in 1938, only two years after her Jewish parents arrived as refugees from Frankfurt, Bea came to New York to study at Parsons. She returned to Brazil after her studies, where she made a name at the epochal magazine *Senhor*, including designing covers for the issues that first published Clarice Lispector's stories.[33] But she returned to New York in 1961, eventually becoming art director of *Harper's Bazaar*. A decade later, she became one of the founders of the feminist magazine *Ms.*

"Annie was always looking for a strong female person in her life who would be her work mother," said Mullarkey. Like Jann before and Susan later, Bea offered the possibility of self-improvement:

> Bea was gorgeous, and very exotic, and blond hair, and was full of life, and had a great design sense, and could give her constructive criticism, and help mold her eye, how she saw what things would look like. She had a wonderful apartment on Central Park South, a fabulous apartment, scads of art books. She would take stuff out to show you, things she designed, books she had done, great photographers she'd worked with. Here was an opportunity.

She had worked closely with Diane Arbus, and was a natural teacher. The Brazilian photographer Otto Stupakoff said that "she was the only art director I've known—and I've worked with hundreds—who felt a pedagogical responsibility toward her photographers."[34] Bea could speak to Annie with calm authority, Mullarkey said.

She was firm and smart. That was something that gave comfort to Annie because she would yell at people to try to browbeat them. Bea didn't need to yell. Annie was drawn to that because it was safety. It was a good reliable mother.[35]

Their amorous relationship was brief, but it meant the end of Annie's involvement with Jane, and a certain stability. Her drug use, however, continued, her behavior becoming increasingly notorious, even as she continued to produce work of the highest order. If, as a young person, she had claimed to want reality, she, like Susan, preferred the world seen at a remove, through her camera. "The substance of this business is what seems rather than what is," she said. It was a phrase Susan might have quoted, with a cocked eyebrow, in *On Photography*. "I encourage people to take my vision for reality."[36]

As with Susan, the confusion of image with reality led her places from which more sensible people would have recoiled. Black remembered a shoot in 1978:

Patti Smith had been doing a show in New Orleans. So Annie rented a warehouse. She wanted the wall of fire. She had read that the way they did it in movies was to weave a net of rope, heavy rope, and soak it in kerosene, and light it. It would be a solid wall of fire. She gets this built, and she puts Patti Smith in front of it, and then she lights it. Evidently Hollywood people have a much tighter weave on these ropes than she understood, and it all burned up in this enormous fire and Patti Smith was, like, first-degree burns on her backside—really, really hot, and she started sweating badly, and Annie was screaming: "Perfect! Perfect!"[37]

———

One of her great pictures, taken in 1981, shows a friend, the comedian John Belushi, standing beside a road. The image is formally perfect, its blues and greens as rich as on a Limoges enamel; but it is the expression on the bloated actor's face, his defeated posture, and the lights of onrushing traffic that make it so grimly prophetic: he would overdose a few months later.

Belushi was killed by a speedball, a mixture of cocaine and heroin; and by the time he died, Annie had been using that same combination for several years. The two often did drugs together. Twice, she nearly died; both times, her dealers dropped her off in front of a hospital. The first time, the doctors saved her; the second time, the same doctor managed to save her again, but warned her: "If they drop you off a third time, I'm not going to bring you back."[38]

In Annie's apartment in the Dakota, the building on Central Park West where she photographed John Lennon and Yoko Ono hours before his murder, Mullarkey happened upon a horrifying tableau: "blood on the wall, an arc of blood on the wall." She sat in the living room for fifteen minutes trying to muster the courage to go into the other room and see if Annie was dead; when, at last, she did, and found Annie still alive, Mullarkey called her father. "I don't totally bust her, but I tell Sam: 'She's got this terrible cold. I am afraid it's pneumonia. She just won't go see the doctor. Could you come up? It's really important.'"

At last, Annie checked into rehab. When the first twenty-eight days were up, she signed up for another twenty-eight.

———

Annie needed her health for a new job. *Vanity Fair* had ceased publication in 1936, though had never entirely been left for dead:

the masthead of *Vogue,* also published by Condé Nast, still read "Incorporating *Vanity Fair.*" Condé Nast's owner, Si Newhouse, decided to revive *Vanity Fair* as a new kind of magazine: literary and political but with the glossy production values and the attention to fashion and society that might be at home in *Vogue.*

Bea was brought in as art director, and she, in turn, brought in Annie. But Bea had been diagnosed with a rare cancer in 1979. Though rapid intervention seemed to save her, the cancer metastasized. In September 1981, a month after her second operation, she began working on *Vanity Fair,* to be launched in March 1983. She finished the prototype and then returned to Rio, where, on April 8, 1982, she died in her mother's bed. For Annie, it was a terrible loss, and when her book *Photographs* was published in 1983, it was dedicated to Bea.

Bea was also a loss for *Vanity Fair,* which, despite all the publicity that accompanied its rebirth, struggled under its first two editors, Richard Locke and Leo Lerman. Without Bea's leadership, the graphic design was muddled, stories stopping and starting with no sense of order. "There was too much time to overdesign it, and redesign it, and tear it up and redesign it again," said Annie's friend Lloyd Ziff; and its concept was criticized for being too highbrow for its intended readership: "sort of like *The New York Review of Books* becoming a magazine," said Michael Shnayerson.[39] Its eighth cover, in October 1983, featured Susan Sontag.

That issue came out precisely as Tina Brown was being brought in from London as the new editor. Not yet thirty, Brown had earned her reputation by saving the dying *Tatler,* and was tasked with doing the same for *Vanity Fair.* "The upside was that she brought this British sense of class," said Sid Holt, who joined *Rolling Stone* the year Brown came to *Vanity Fair.* "The downside was that she brought this British sense of class."[40]

"Tina had a phrase," said Shnayerson. "'We want to be hot,

hot, hot'—not just one hot but three. She was an equal opportunity celebrator of power and money and glamour"—the very
Warholian ideal that made her magazine a symbol, if only in retrospect, of the Reagan years. Her first lieutenant, Annie Leibovitz, portrayed the most famous people in the world, but she did
not simply show the already famous. She created celebrities. The
Leibovitz portrait—far more than the Sontag blurb—conferred a
status no other photograph could.

This "Susan Sontag" Thing

I n March 1987, a little more than a year before she met Annie, a fire ravaged Susan's apartment. In the summer of 1985, she had left Seventeenth Street and moved to an upper duplex at 36 King Street, in SoHo, where her fireplace shared a chimney with the next-door neighbors. The ancient fireplaces were intended to be simply ornamental—until new tenants pressed them into service, filling Susan's bedroom with black smoke in the middle of the night: "Thank God I woke up," she said. "Another five minutes . . ."[1]

Susan's library was safe, but the firefighters had to chop through the ceiling; and after the immediate danger had passed, she found herself roofless, sheltered by little more than a tarp, horrified to realize that she didn't have enough money for a decent hotel. "I realized how unprotected I was," she said. "Maybe I shouldn't be so carefree about these things," she thought. "You don't discover you're undefended until a brick falls on your head."[2]

The roof was repaired and the smoke damage scrubbed away.

But the fire had other consequences, including ushering several people into—and out of—Susan's life. Her friend Sharon De-Lano, an editor at *Vanity Fair* who had long helped Susan with all sorts of practical matters, enlisted a young man named Peter Perrone to catalog her library so that it could be properly insured.

"It was love at first sight," he said, "and you're suddenly in the tribe." Peter would remain close to Susan until the end of her life. At the same time, Richmond Burton, a young painter from Alabama, joined the tribe, too, unpacking the books that had been saved from the fire. The first day he came to her house was the day of Andy Warhol's funeral, and he found a memorial issue of *Art in America* on her kitchen counter. "What a horrible person he was," she said as she looked at the cover. "Of course I'm not going to the funeral."

"I agree," Burton said. "I've never liked his work. What do people see in it?"

"Well . . . most people are stupid," we practically said simultaneously.

We were off and running.[3]

But tribal membership was conditional even for stalwarts. The fire damage included her relationship with Roger Straus, one that had outlasted all her other close friendships. The break was not immediate and it was not complete, but anxiety about money led her to a literary agent for the first time. Andrew Wylie was highbrow enough for Susan: someone who could contend intellectually, and was compatible in other ways, too. Robert Silvers saw Susan as a series of poses; Annie Leibovitz described herself as a chameleon; Wylie described himself in the same way:

I don't have a very stable character of my own. I have a series of sort of borrowed personalities. So I think the reason why I can frequently represent someone successfully is, I am

literally able not only to see the world from their perspective but actually to become them. So I know pretty accurately what they want because I have abandoned my former personality and climbed inside theirs. So if I spend a day and a half with Susan Sontag and you catch me at the end of the day, you'll swear it's Susan Sontag.[4]

Wylie had a reputation for turning unprofitable but respectable literary writers into frontlist moneymakers. David had introduced them: at Wylie's urging, David had left FSG. "It is because of his belief in me—stronger than my own at the time—that I became a writer," David said.[5] Belief in her son's brilliance was always a sure way to earn Susan's affection, but becoming a writer brought him even deeper onto Susan's own terrain, and they both felt the rivalry, she wrote a friend in 1990:

> David is well, finally reconciled to being a writer, too, after all. He feels a little sorry for himself, very proud of himself, and more than a little competitive with me. Our relationship is, inevitably, a difficult one, and he will always be the love of my life.[6]

In the year of the fire, he published *Going to Miami: Tourists, Exiles, and Refugees in the New America*. "Miami suffered from an inferiority complex," said the bookseller Mitchell Kaplan, who met David at this time. "It was never really taken seriously. David got it right in so many different ways that the book is still in print."[7] He followed it with a series of books that had in common his interest in war.

———

When Susan met Wylie, she explicitly asked for help with Sontag-as-metaphor: "You have to help me stop being Susan Sontag," she

said. She needed, in other words, to delegate the demands of her public role in order to concentrate on her writing. She was "bursting" to work on a novel, "but I can't because of this 'Susan Sontag' thing."[8]

Wylie would shield her from the ceaseless solicitations, and help her gain the financial security to ensure that she would never again sleep beneath a plastic tarp. In principle, there was no reason that her relationship with an agent needed to bring conflict with Roger. Roger, after all, loved Susan: more, according to Peggy Miller, than any other author. He had himself suggested that she get an agent, since the Farrar, Straus offices were not equipped to handle the volume of requests she received and made.[9] Roger understood that the interests of publishers and authors were not always in perfect harmony: there was nothing novel about an author's wanting to be paid more, and a publisher's wanting to pay less.

"By virtue of the way the relationship is structured," said Wylie, "every writer has that feeling of gratitude declining into resentment." The "paternalistic-publisher model" did indeed involve an imbalance of power.[10] But in her comments about her relationship with Straus, it is hard not to conclude that it was not paternalism but its perceived lack that led to the conflict. "I've found a system of safe harbors, of feudal relationships, to ward off terror—to resist, to survive," she had earlier written; and their relationship had been feudal in the extreme. For decades, he had supported her, directly or indirectly. He had published all her books. He had repeatedly given her advances for books that did not materialize. He had kept her books in print at home, and sold them widely abroad. He had paid her gas and light bills; he and Peggy had taken care of David when she was traveling; he gave David a prestigious job, and employed him for more than a decade.

Yet in Susan and David's telling, they were being exploited.

After the fire, David said, "Roger was simply unresponsive. He could have given her some money. He never gave her a dime, and he underpaid her for her work."[11] But it is not clear what work she was being underpaid for. Eight long years had elapsed between *Under the Sign of Saturn* and *AIDS and Its Metaphors*, a book less than a hundred pages long. Despite her prestigious name, her books had never sold more than respectably. But Susan's own expectations were revealing. "I'd had more than thirty years of work," she told the *Washington Post* a few years later. "It's not so much to own an apartment and have all your books out of storage and have time to write. These are not unreasonable demands; they're not corrupt."[12]

These demands do, at first glance, sound reasonable. But who was supposed to provide that apartment, that space for her thousands and thousands of books, that freedom from the teaching or editing or translating or lecturing or journalism to which most writers—those who have neither private incomes nor steadily selling backlists—are forced to resort? In 1962, she mentioned, among the ways she resembled her mother, "money—my idea (from M.) that it's vulgar. The money comes from 'somewhere.'"[13]

"You're a rich man," she wrote Roger. "I'm not a rich woman. I don't have any money. I don't think you quite get it."[14] The attitude behind this statement helps explain why, though she would stay at FSG for the rest of her life, the rift was not fully healed by Roger's offer of a then-sensational eight hundred thousand dollars for four books.

———

AIDS and Its Metaphors was not one of those four. It was published in early 1989, shortly before she signed the contract. The austere jacket had no author photo, but she needed new photos for publicity. Knowing that her friend Sharon DeLano was working with Annie Leibovitz at *Vanity Fair*, Susan asked Sharon if

Annie might be willing to create the pictures she needed.[15] Annie agreed, and the resulting image showed Susan at her desk, her hair swept back dramatically, gazing expectantly into the distance.

As so often with Annie, "casual intimacy" led to another kind. She had unwittingly found a surefire way to seduce Susan: expressing enthusiasm for her little-loved *Benefactor*. For one who saw photographically, its succession of fantastic images appealed in a way that they did not always for literary people. Annie was dazzled by Susan. "I remember going out to dinner with her and just sweating through my clothes because I thought I couldn't talk to her," she said. "Some of it must have been I was just so flattered she was even interested in me at all."[16]

The dynamic was set on that first date. Only a couple of weeks after they met, Susan acquired her first assistant, a no-nonsense woman from West Texas named Karla Eoff, who would work for Susan for the next several years.

> One of the first calls I got was from Annie. Susan was supposed to be leaving for her book tour, and Annie said, "Have you got her itinerary? Will you send it over to the studio and let me put you in touch with my people who run the studio? How's she traveling? Who's handling that? I want to upgrade her to first class."

Karla found Susan characteristically coy. "She was really nice to Annie," she said, "not in a terribly affectionate way, in the first few months. And then I had a come-to-Jesus moment with her." Karla thought Susan was hiding the relationship because she was unsure whether she could trust her. "This is just my friend Annie," Susan would say. "My friend Annie was over last night for a minute." Karla ignored the remarks, but worried that Susan suspected Karla of homophobia. Finally, she mustered the courage to tell

her new boss that there was no need to hide her relationship. At that, Susan exclaimed that Annie was just a friend.

> I said, "No, she's not. The way she comes by, brings you flowers, touches you. She's courting you." "Do you really think so?" "Oh, come on." She said, "I don't know if you know, but I've been with women."

Karla said she always assumed Susan was a lesbian, but Susan said, "I don't like that label. I've been with men, too." After the conversation, Susan allowed herself to show more affection toward Annie when Karla was around—but only briefly, and only privately. In public, in fact, she would show Karla far more affection than she ever showed Annie: Karla was not gay, so a hug or a gushing introduction ("This is my assistant, I just love her to death") raised no suspicions. "She wouldn't be labeled that way with me."[17]

In 1989, "being labeled"—which was to say being out of the closet—meant something quite different than it had a decade before. Before AIDS, Edmund White could say that if Susan had been publicly identified as gay, she would have lost two-thirds of her readership. But AIDS forced a revolution in the way "labels" were perceived. Every year of the epidemic—in which first dozens, then hundreds, then thousands, then millions died—brought new ideas about how to contend with it, and with the labels it imposed on those who, for whatever reason, would not have voluntarily embraced them.

By 1989, the radicals had the upper hand. The Reagan administration, whose spokesmen guffawed at mentions of the "gay cancer," was replaced by the Bush administration, whose campaign ginned up attacks on gay people in the name of "family

values." These attacks were not merely rhetorical. Gay people had been dying of a disease that would surely have been combated far more aggressively if it had not been associated with homosexuals. (As indeed it was, when it became apparent that it was not restricted to gays.) Gay people were dying as a result of the words of Reagan and Bush: 30 percent of the teen suicides in America were gay kids, according to the same United States government whose leaders were fomenting hatred of them.[18] It was a desperate situation, and desperate people fought back. The AIDS Coalition to Unleash Power, ACT UP, was founded in 1987. It took gay anger to the streets and choreographed high-profile demonstrations against the organs of repression, from the Catholic Church to the Food and Drug Administration. In *Illness as Metaphor,* Susan had denounced the idea that "cancer = death." Now, the activists carried signs reading "Silence = Death."

The most enduring legacy of the late eighties in AIDS activism proved to be its critique of silence, which is to say: of the closet. That critique departed from the proposition that homosexuality was a natural orientation, exactly like heterosexuality. The simplicity of this statement gave it sweeping implications that were only beginning to emerge under the pressure of the crisis. The gay activists stated that sexuality—in sharp contrast to sex— was no more "private" than being black or female or Catholic. They demanded that gay lives be discussed in the same way that straight lives were. This was radical because the media went to bizarre lengths to pretend that gay people were straight. "The American media didn't report about the lives of famous queers because they saw homosexuality as the most disgusting thing imaginable," wrote Michelangelo Signorile in 1993, "worse than extramarital affairs, abortions, boozing, divorces, or out-of-wedlock babies, all of which are fodder for the press."[19]

With his column in the short-lived *OutWeek* magazine, Signorile became notorious for revealing the homosexuality of famous

people. It is hard to imagine, at this distance, the controversy these revelations unleashed, if only because they touched upon people "everyone knew" were gay. It was not, for example, stunning to learn that the flamboyant socialite and prominent Fabergé collector Malcolm Forbes was gay. But this was not something one could say in print—though he was dead when Signorile wrote about him in 1990. The *New York Times* gingerly referred to the controversy as involving a "recently deceased businessman."[20] As if accused of some dreadful misdeed, he could not be named.

The tactic became known as "outing," after a piece in *Time* about the Forbes dustup. This was not the activists' preferred word: "I think the action should simply have been called 'reporting,'" said Signorile.[21] Reporting on public figures' homosexuality was so outrageous that journalists like Signorile were likened to McCarthyite ayatollahs. But they forced the media to debate its own role in enforcing the closet. "So much of the media at that time was clearly biased," Signorile wrote. "The lives of lesbians and gay men were grossly distorted."[22] Gay people had gained a sympathetic space in the media in the seventies, but they had been caught by the broader cultural backlash of the Reagan era. This was racial: Reagan and Bush exploited resistance to the civil rights movement. It was economic: Reagan and Bush rolled back the social-democratic vision of the Great Society. And it was sexual. In the eighties, Signorile wrote, lesbians were repeatedly being defamed on-screen: "This was directly due to the backlash against the women's movement; independent, assertive women were presented as villainous, man-hating dykes. Negative portrayals of gay men also escalated dramatically amid the AIDS crisis."[23]

Thirty years after Susan first read it, the situation was not far from Patricia Highsmith's *The Price of Salt*, in which a lesbian's losing her child—but not being killed—was considered an upbeat ending. It was imperative for gays and lesbians to resist those

portrayals by showing their real faces, defining themselves rather than allowing their enemies to define them. The "outers" insisted that people who did not come out perpetuated the idea that gayness was something to be ashamed of, and the coming of AIDS made the situation so urgent that everyone, especially prominent people, had to take a position.

Despite the fiery controversy, the outers' analysis triumphed so completely that dishonesty about sexuality came to be seen as pathetic at best, pathological at worst. This had not been the case, even among gays themselves. But they would soon view closet cases with the contempt African Americans reserved for light-skinned blacks who tried to "pass," or Jews reserved for coreligionists who changed their names and joined clubs from which other Jews were barred. This was a revolution, and Signorile marveled at how much had changed, and how fast:

> Even five years ago, many in the mainstream considered it an "embarrassment" to be out of the closet, "flaunting" one's sexuality. People who were doing that were said to be "indiscreet" and were even considered "unfashionable." But outing focused attention on the closet and what a horrible, pitiful place the closet is. Outing demands that everyone come out, and defines the closeted—especially those in power—as cowards who are stalling progress. With outing, the tables have turned completely: It is now an embarrassment to be *in* the closet.[24]

"Even five years ago": these words were written in 1993. Those years spanned the publication of *AIDS and Its Metaphors* and the beginning of Susan's relationship with Annie; and the problems in both book and relationship bear the unmistakable mark of the closet. Gays had always associated bitchiness and vindictiveness

with the closet, even when the closet was the only option. Self-loathing translated into contempt and cruelty; lying about who one was bled into lying *tout court*. It made people mean.

Like the moral opprobrium attached to illnesses like cancer or addiction, the opprobrium surrounding homosexuality was eroding with remarkable speed. But Sontag's refusal to say "my body" perversely made *AIDS and Its Metaphors* more interesting than it would have been otherwise. This is not to say that the book would not have qualities without the illustrations her own life offered of the problems she denounced. As so often in her work, its basic theme is the distance between thing and metaphor, and it examines particularly metaphors of the body—"the body as temple," "the body as factory," "the body as a fortress"—in order to dismantle them.[25] She traces these ideas in her own work, all the way back to "Against Interpretation." And she announces that her purpose in *Illness as Metaphor* was

> not to confer meaning, which is the traditional purpose of literary endeavor, but to deprive something of meaning: to apply that quixotic, highly polemical strategy, "against interpretation," to the real world this time. To the body. My purpose was, above all, practical. For it was my doleful observation, repeated again and again, that the metaphoric trappings that deform the experience of having cancer have very real consequences.[26]

The link she establishes between interpretation (language, metaphor) and the real world (body, medicine, politics) adds a rich new layer to her previous works. Her insistence on seeing the disaster in scientific rather than moral terms is salutary. And her reading of AIDS as the end of something—exuberant sexual customs—is interesting, too: however inevitable and necessary, the insistence on "safe sex" was a downer, a disappointment, part

of the end of the attempts to find newer, freer ways of living that characterized the sixties.

These attempts were marginalized in the eighties,

> part of a larger grateful return to what is perceived as "conventions," like the return to figure and landscape, tonality and melody, plot and character, and other much vaunted repudiations of difficult modernism in the arts. . . . The new sexual realism goes with the rediscovery of the joys of tonal music, Bouguereau, a career in investment banking, and church weddings.[27]

Despite its grim subject, the book is fun to read. It displays the humor Sontag was often accused of lacking, particularly when making striking connections with apposite quotations. She links the new fear of the HIV virus to the new fear of computer viruses—like AIDS, the personal computer was among the revolutions of the 1980s—comparing the insistence on condom use with a line from an advertisement: "Never put a disk in your computer without verifying its source."[28] The light touch makes the book far more accessible than many of her others.

Yet something in Sontag still felt that a choice needed to be made between substance and style, body and mind, thing and image, reality and dream. In *The Benefactor,* her character embraced the dream to the complete exclusion of reality. Over the years, she had moved, sometimes haltingly, sometimes with furious insistence, in the other direction. Reality, in her mind, could best be perceived once metaphor had been exiled. With the iconoclastic fervor of a disappointed believer, she had hacked away at metaphor, and now attacked the war metaphors associated with AIDS: "We are not being invaded," she concluded. "The body is not a battlefield. The ill are neither unavoidable casualties nor the enemy."[29]

But one need not abuse metaphor to think that the body was, in fact, a battlefield (between healthy cells and infected ones); or that the virus was in fact invading people's bodies; and that if the ill were not the enemy, they were, at least up to that point, unavoidable casualties. In 1989, AIDS was still a death sentence.

———

Sontag's early novels had plenty of detractors. But if those books were failures, they were brave, noble failures—unforgettable. And her books on related subjects, from *Against Interpretation* to *On Photography* to *Illness as Metaphor,* were undergirded by a passion all the more palpable for being unstated.

They changed the way you saw the world.

You never forgot them.

The problems with *AIDS and Its Metaphors* become clear when read alongside other works of the age: Tony Kushner's *Angels in America,* Edmund White's *The Farewell Symphony,* Andrew Holleran's *The Beauty of Men,* Paul Monette's *Borrowed Time,* Alan Hollinghurst's *The Line of Beauty,* Randy Shilts's *And the Band Played On.* These diverse books—plays, novels, memoirs, histories—are united by sheer heartbreak. Beside them, and even beside "The Way We Live Now," Sontag's contribution seems thin, dainty, detached: forgettable because lacking the sense of what AIDS meant to *my* friends, *my* lovers, *my* body. Her metalinguistic critique is important, but those books contain it, too; and the critics who had made it before her go unmentioned. This is noteworthy because the gay critique—the outers' critique—was the same as hers.

Banish metaphor: "the body."

Embrace reality: "my body."

And so the importance of Sontag's book is how it inadvertently illustrates the very thing it denounces. Its pages reveal how quickly metaphor can slide into obfuscation, abstraction, lying.

"I try abstractly," she had written years before; and on any given subject, abstraction and distance are always good measures of her passion. Here, wrote the critic Craig Seligman, her leaden prose has "a muting effect, like wall-to-wall carpeting." He tallied, in a single paragraph, the following examples of the passive voice:

> considered by . . . is judged . . . is understood as . . . are currently being told that . . . regarded as . . . is named as . . . is thought to be . . . are seen as . . . fostered by . . . could be viewed as . . . who cannot by any stretch of the blaming faculty be considered . . . may be as ruthlessly ostracized by . . .[30]

The passive voice allows the writer, quite literally, to avoid the "I." In a puzzled review in the *Times,* Christopher Lehmann-Haupt wrote that "she never quite defines whatever it is that ultimately concerns her." This echoes Silvers's criticism of her Sartre essay: "the reader has no idea of the status of the connection being made."[31] The passive voice—the voice of bureaucracy, of wall-to-wall carpeting—was not appropriate at a time when so many were screaming.

Not everyone—not every writer—needed to scream. But Sontag had always been willing to put her body on the line, and scorned those who did not: those who failed to make the trip to Hanoi or Havana; those who refused to risk death for Salman Rushdie or, soon, Sarajevo. The new AIDS activism was *her* kind of activism. She would not have needed to storm the Pentagon or ambush the cardinal-archbishop of New York. But there was much she could have done, and gay activists implored her to do the most basic, most courageous, most principled thing of all. They asked her to say "I," to say "my body": to come out of the closet. Signorile called Leibovitz's studio day after day, asking her

and Susan to comment on their relationship. Neither returned his calls.

"My purpose was, above all, practical," she wrote, in *AIDS and Its Metaphors,* about her reasons for writing *Illness as Metaphor.* AIDS activists thought she could have had a great practical impact on the demoralized and dying gay community by saying that she was one of them. What would it have meant—practically— for one of the most famous writers in the country, a writer whose cultural authority was unparalleled, to say that she was in a relationship with another famous woman? Signorile described the effect she could have had:

> Imagine if she were at the FDA. . . . The other thing that is less obvious if Susan Sontag came out was the effect on editors and writers and newspaper editorialists. There were so many problems just with the *New York Times.* First was getting them to simply cover the epidemic. Second was getting their medical editors to do the kind of independent investigations at the FDA and the NIH that needed to be done. Getting the political editors focused on the Reagan-Bush years. . . . All of it becomes about people getting the courage to speak out. When one person speaks out, it gives somebody else a little bit more courage to speak out. It just has that effect.[32]

And so, for a movement that had moved far beyond polite critique, the book was most remarkable for its irrelevance. This in itself was a first in Susan's work. But "there is no evidence," one scholar wrote, "to suggest that *AIDS and Its Metaphors* was used in the AIDS- or gay-activist movements, in spite of this being the closest to a gay-rights book Sontag would produce."[33] The general reaction was a shrug.

Taking Hostages

Susan spent the fall of 1989 in Berlin, where she began writing *The Volcano Lover*, the novel she had long dreamed of, the first she would complete since *Death Kit*. But work was overwhelmed by world events. On November 9, she and Karla were at her friend Alf Bold's cinema; Susan, Karla, and Alf walked out to find their eyes stinging from tear gas. While they were watching the film, the East German authorities had announced that the Berlin Wall would be opened. After twenty-eight years of enforcing the border with land mines and machine guns, the East German police were still confused. "Some people were looking a little too happy, so they lobbed some tear gas," said Karla. "Susan thought it was loads of fun."[1] For those who dreamed of a wall-less world, that night seemed like a triumph.

Susan would soon enjoy a triumph of her own in an area where she had never been successful before: money. Her windfall had three sources. The first was the eight-hundred-thousand-dollar contract with FSG. The second was a MacArthur Fellowship, a

quarter of a million dollars as well as health insurance, dispensed over five years, starting in 1990. These fellowships had "no strings attached," since their recipients were not required to do anything in exchange for the money. The same could not be said of the third and most opulent source of all: Annie Leibovitz.

———

Money allowed Susan, for the first time in her life, to buy an apartment. This had been a priority since the fire, and even before the MacArthur she had made up her mind to buy something. She had long hoped to be selected for the fellowship, and often talked about it—especially because she heard on several occasions that she had been considered, and passed over. Later, she learned why: she had been blackballed by a member of the board, Saul Bellow, who loathed Sontag personally and had a long record of opposing grants to women and "militant blacks."[2]

After visiting several apartments with Peter Perrone, Susan grew bored. "It's like shopping for sour milk," she told Karla. Peter continued the search without her and helped her narrow the choice to two. One was a gigantic loft in SoHo, the neighborhood where she had been living, five thousand square feet that would have given her ample space for her library. The other was a penthouse in London Terrace, a building that spanned an entire block in Chelsea, with broad views of the Hudson and the Empire State Building and marble fireplaces in tall rooms. The choice these two apartments offered was less between houses than between sensibilities, lives, as Susan instantly understood.

"I don't know which one to choose," she told Perrone, "because the loft in SoHo is literally choosing the life of a monk or a scholar and the place in London Terrace is quite different." The loft was not especially stylish. "It just had a ton of space," Perrone said. "It was going to be about her books and her work and inner life and dedication. London Terrace was really quite glamorous,

and conjured up a different persona."[3] The choice of masks, of selves, was never easy, but there was no doubt as to which she would elect.

She would spend the rest of her life at London Terrace. A few months later, another penthouse in the same complex became available, and Annie moved in. London Terrace was not all glamour. Chelsea was still gentrifying, and the buildings were located near some rough public housing projects. The buildings were old, with weeds on the terraces and cracks in the paving tiles.[4] But the arrival of Sontag and Leibovitz signaled the direction the neighborhood was headed, and the direction their relationship was headed. "I'm reading *Against Interpretation*—and I find myself smiling inside—that I can carry you with me—I can read you and feel you—you are so very special," Annie wrote from a plane in June 1989. "How can I love you more. How can I love you better—"[5]

———————

"I was never a child!" Susan had exclaimed in her journals, decades before. Now, with Annie, she seemed to be reverting to a childhood she never had. In so many of her "feudal" relationships, she had been looking for a parent more than for a lover. "She was just this charming, beautiful child inside," said Annie. "She had such delight with life and everything."[6] The word "child" appears in many descriptions of Susan at this time. When Karla Eoff left on a weekend when Susan had stayed home working, she would be astonished, when she returned on Monday, by how unable Susan was to take basic care of herself. "She would have on the same clothes, and would not have bathed, brushed her teeth, anything, like a child."[7]

Annie seemed to be the perfect mother. By the end of the eighties, flush with millions from *Vanity Fair* and a series of high-profile advertising campaigns, she could offer a life unthinkable

only a few years before, when Susan had been cowering beneath
a plastic tarp on King Street. Annie was not only rich: she was
lavishly, overwhelmingly generous. And she wanted to take care
of Susan. "I wanted to make everything possible for her, what-
ever she needed. I felt like a person who is taking care of a great
monument."[8]

She wanted to buy her time to work. "I loved Susan," she said.
"I thought she was a great artist, and it made me really happy
to do those things for her."[9] Annie offered comforts Susan could
never have possibly afforded. As what began with flowers blos-
somed into a subsidy of every aspect of Susan's life, Annie's lar-
gesse became the subject of amazed comment. There were the car
services, and the first-class tickets, and the private chef Annie
sent to Susan's apartment, and the maid she paid to clean it—and
the apartment itself, for which she was soon paying: first "just"
the maintenance, thirty-five hundred dollars a month, and eventu-
ally the mortgage, too, and the studio she rented for Susan in
the grand Police Building on Centre Street, an apartment with
its own entrance and elevator, where Susan could work on her
novel—"She did start to work on her fiction when she had some
help and support," said Annie, "and that was exciting"[10]—and
then the office in the building on Vandam Street where Annie
had her studio. These outposts would expand, over the years, to
places that Annie owned but that were available to Susan: a house
in the Hudson Valley and a dream of Susan's, a splendid apart-
ment on the banks of the Seine. There were magnificent vaca-
tions, an entirely new wardrobe, endless gifts.[11]

And Annie was not only supporting Susan. Directly but more
often indirectly, she was supporting everyone around Susan. She
paid all of Susan's assistants. And through Susan, quite a lot of
Annie's money found its way to David, "down to buying Susan's
Christmas present to him of Navajo bracelets every year."[12] Annie

supported Nicole, impoverished following the death of her spend-thrift father in 1984: "I would just call Annie and say, 'Nicole needs some money,' and she would send it," Karla said.[13] One duty of Susan's next assistant, Greg Chandler, was depositing Annie's checks. After the MacArthur ran out, these amounted to fifteen thousand dollars per week. Their accountant estimated that over the course of their relationship Annie gave Susan at least eight million dollars.[14]

———

If it is easy to understand the appeal of such generosity, their love affair—the longest of Susan's life—would be expressed in a language that many watching from the outside found hard to decipher. From early on, Susan gave the impression of wanting to get away from the relationship, and her discomfort burst into full public view. She began to fire a rat-a-tat of invective at Annie, said Richmond Burton, "like a little machine gun."[15]

"It was this hectoring, condescending, mildly outraged superior voice," said Stephen Koch. Richard Howard remembered a constant litany of attacks on Annie—"You're so dumb, you're so dumb"—that caused him to all but end a friendship of decades. The first time Karla heard Susan use the word "stupid"—Susan's central accusation—"tears just started flowing almost immediately. It was like a child and an abusive mother."[16] Joan Acocella, who wrote a profile of Susan for *The New Yorker* in 2000, had never seen anything like it.

> People couldn't bear to be at dinner when she was with Annie because she was so sadistic, so insulting, so cruel. Of course, the person who came off looking bad was not Annie. Susan would say something about Artaud then she'd say to Annie, "Well, you wouldn't understand who that is." It

was just unbelievable. It was just an absolutely unbelievable performance and it replayed itself every single time you saw them together.[17]

"They were the worst couple I've ever seen in terms of unkindness, inability to be nice, held resentments," said David, who was no friend of Annie's. "I said to [Susan] more than once, 'Look, either be nicer to her or leave her.'"[18] He said to Michael Silverblatt, a close friend of Susan's in the nineties: "This woman that you admire so highly and you love and adore—you countenance her behavior with Annie. She becomes vicious and loud and violent and vulgar."[19]

On the day Silverblatt met Annie, Susan told him that "she felt obliged to explain that Annie would be the stupidest person I'd ever met." Just as often, she would trash her to her face. Annie was sitting right next to her when Susan said to Marilù Eustachio: "This one"—signaling Annie with a dismissive wave—"doesn't understand a thing."[20] As Annie stood by, she would gush to another photographer: "You're the only interesting photographer in America."[21]

"It might have been Susan's birthday at L'Ami Louis," Burton said, referring to a famously overpriced restaurant in Paris. "Susan's abuse would really cast a pall. It was hard not to have the experience ruined."[22] The first Christmas in London Terrace, Annie threw a lavish dinner at the new apartment. Roger and Dorothea Straus came, and Peter Perrone, and David and his girlfriend, and Karla Eoff, and perhaps a half-dozen others. When the servers brought around the appetizer, Susan saw that it had shrimp in it, stood up, threw her napkin down, and shouted at Annie: "How stupid could you be? David is allergic to shellfish! How could you be so stupid?"

Annie ran out. Karla found her sobbing on Susan's bed.

"What do I have to do?" she asked. "How am I supposed to read people's minds? I didn't know David was allergic to shellfish." After a few minutes, she pulled herself together: "I'm going to call some other restaurant, and I'm going to go out myself and get David a fucking appetizer that won't kill him." She ordered her car and returned with a takeout box she set down in front of David. "I'm so terribly sorry that I almost made you ill," she said. "It was not my intention."[23]

———

When she was in charge, Annie herself could be tyrannical. As her prominence grew, so did her staff, and with it her notoriety. "She had a bad reputation among assistants, throwing magazines at them, screaming, embarrassing them in public, on the shoots," said one assistant, Christian Witkin. "The intimidation, the signals she sent out: she'll go for the throat."[24] Still, her employees were well paid, their roles defined, and they were free to leave.

By all accounts Annie was kind to friends and family—and she was kind to Susan. Susan was the opposite. She was at her best with "casual intimacy," whispering a confession to a star-struck young writer, visiting a museum with a friend she saw once a year. But when new friends crossed the line from acquaintance-ship into intimacy, they often found themselves susceptible to bullying. Annie herself loved Susan enough to endure the sniping. "I would have done anything," she said.[25]

Annie behaved toward Susan exactly as Susan behaved toward any woman—Harriet, Irene, Carlotta—who loved her less than she did. The distinction between kindness and groveling, between generosity and appeasement, between letting bygones be bygones and masochism, was one Susan herself had always had trouble respecting. One friend, Vincent Virga, whose partner was a re-covering alcoholic, saw Annie's response as typical:

She had this almost childish behavior—not childlike, childish—which addicts have. And Annie was Susan's hostage. It reminded me of a line in Al-Anon: "We don't have lovers. We take hostages."[26]

Soon after Greg Chandler started working for Susan, he was in a car, returning from an opening of Richmond Burton's paintings. When, in the middle of an innocuous conversation about the evening, Annie made a tiny grammatical mistake, Susan exploded: "You know, maybe if you'd gone to college, you would know that that makes you sound like an utter fool!"

A few days later, I went to Annie's studio and saw how Annie was at work: just like Susan, very bossy, very in control, very demanding, very grumpy. All these people at her beck and call—and yet, with Susan, a child.[27]

———

"You're good but you could be better," Susan told Annie when they met. The appeal fell on attentive ears: "I wanted to do better things, take photographs that matter."[28] Like Susan's, her success came from insecurity transfigured into perfectionism. Both were tyrannical toward others, and more so toward themselves. Much of their success had been in finding the right teachers—masters—to help them improve. When Annie came to *Vanity Fair,* having outgrown the sex, drugs, and rock 'n' roll of *Rolling Stone,* she vowed to "shake this reputation as the girl who gets people to undress."[29] And when she met Susan, she hoped to take the next step, and—with the help of the great photography critic—move from the newsstand to the museum wall.

She wanted Susan's help in learning to take "photographs that matter." Susan offered that help, as she did to many others who

entered her life in those years. For many, she was a guru: the pro-
fessor who insisted you read more, the older sister who dragged
you to foreign films, the sophisticated restaurant-goer who intro-
duced you to exotic dishes. Her enthusiasm for culture, and her
eagerness to share it, was genuine; but she was not always able to
distinguish the relationship between teacher and student from the
relationship between master and slave.

When they first met, Annie expressed her eagerness to take
the inferior position. She told Susan she was the smartest woman
she knew, and that she was intimidated by her intellectual prow-
ess.[30] At first, as Susan had spurred Mildred to read Henry James,
Susan insisted that Annie read. "She wanted her to read all these
books," said Virga. "She was trying to educate her." Soon, she
grew frustrated with the pace of Annie's evolution, and began to
condescend to this otherwise formidable woman: her ignorance
of Balzac was often mentioned, loudly and in public. If Susan ad-
mired the unschooled intelligence of Irene Fornés and Paul Thek,
she could not find the same admiration for Annie's.

She was still trying to shape the ideal companion for whom
she had longed since childhood, and behaved toward Annie as she
had toward her sister: "She thought I didn't meet my potential,"
Judith remembered, "and let me know it in spades." She let Annie
know it, too. Though their friends were sometimes appalled by
Susan's behavior, the one person who mattered—Annie herself—
was not. "I needed to be more serious, period," she said.[31]

Susan thought she was being helpful, including in the area
of feelings and emotions. Michael Silverblatt once asked Susan
why she stayed with a person she constantly badmouthed. "You
have to understand," Susan told him. "Annie has slept with Mick
Jagger. Annie has slept with just about every man she's ever pho-
tographed when she was working for *Rolling Stone*." She asked
Silverblatt if he had heard the term "fuck buddies," which she had

learned from Annie. He was surprised she had never heard such a common term.

> "I had to teach Annie what emotions are. We're not fuck buddies, and that's something that Annie as far as I know stopped, but I couldn't be with someone who has fuck buddies." Susan saw her job as to teach Annie what Susan believed were the emotions, the human emotions.[32]

Jamaica Kincaid had said that Susan wanted to be a good mother in the way one might want to be a great actress; Susan herself confessed that she had no talent for love; Steve Wasserman sensed "a little war among the many little wars that were going on simultaneously within her," a war between two concepts of love. There was one she believed intellectually, and another she believed emotionally:

> One was a desire to be a loving person and to be generous, and the other was a person who had a very self-suffocating and constraining view of love, the opposite of the John Lennon view. The John Lennon view is the love you give is the love you get. Love is the expanding art. It's not like you have only a finite amount of love and you give a little bit away and you have less for everybody else. That's not the way it works. I think she thought it does work that way. That if I give you love, I have less for myself.[33]

In *The Mind of the Moralist,* Susan described the sexuality that Freudian therapy strove to overcome. "Power is the father of love" in a connection that includes "the parental fact of domination." For children, parental authority is essential. But if not purged in adulthood, this form of love can descend into sadomasochism. The mature person will therefore evolve beyond "the sadistic conception of

coitus" to achieve "an ideal love purged of parental influences, an exchange of equals." As a young woman, she clearly enunciated this goal. But as she entered the last phase of her life it eluded her still.

———

Susan was so wise in so many respects that her inability to understand her effect on others baffled those around her. At least since college, bewildered friends had argued about whether she was intentionally malicious, and many concluded that she was simply unable to see her effect on others. "It was not because she wanted to hurt people," said her old friend Martie Edelheit, who had wondered at the phenomenon ever since Chicago. "It was that she simply was oblivious."[34]

Thirty years before, Alfred Chester said she was "extraordinarily tactless." She countered that she was "dumb, insensitive"— though she also recorded Irene's disagreement: "She thinks I know what I'm doing, but that I'm cruel." But her writings about "X" showed a self-awareness—a desire to understand her flaws and purge them—that faded. Fame shielded her from some of the consequences of this behavior. She never lacked for sycophants. And there were always people around—assistants, publishers, agents, friends—to clean up after her. Increasingly, when she spoke of uncertainties or vulnerabilities, these were always in the past, blamed on youth or inexperience; and if Annie was a hostage, so was Susan—of an irrational force that doomed her to act out, again and again, the same script, to fight, again and again, the same "little wars." Despite the distance she placed between herself and Freud, her actions affirmed his central contention: the inequality of consciousness to unconsciousness.

———

In her later years, she constantly shed friends. But some of the same people who felt they had no choice but to step away loved

her for the same reason they resented her. As a child is exempt from adult rules, so, too, was Susan.

Her cluelessness about so many things, from brushing her teeth to paying her bills, was touching. Like Mildred, she did not ever quite know where the light switch was, and the disequilibrium between her talent for ideas and her incapacity for daily living was excruciating, for herself and for others. People saw her trouble better than she could and wanted to protect her. "To watch her, to be around her brains and her knowledge and to listen to her opinions, was always a delightful feast," said Kasia Gorska, a young Polish student who worked first for Susan and then for Annie. "In a way she was like a child."[35]

Unfortunately, she hated the child others loved. Decades before, Harriet Sohmers saw Susan's butch pose as a carapace protecting a vulnerable nature: "Everything that came later is a killing of that child that she was." It was a necessary murder. The metaphoric self—"Susan Sontag"—helped the child—"Call her Sue"—survive, but the determination to be other than she was demanded a steep price. Those who tried to love or protect the child were often mauled by the metaphor. "Underneath all of this monstrous personality there's this really frightened, sweet person," said Karla Eoff. "When you could be with that person, it was really wonderful."[36]

CHAPTER 33

The Collectible Woman

Every writer—after a certain point, when one's labors have resulted in a body of work—experiences himself or herself as both Dr. Frankenstein and the monster," Sontag wrote in a short essay, "Singleness," published in 1995. In it, she examined the division between the public writer and the private self. There was "Sontag," she wrote, and there was "I":

> In my "Sontag and I" game, the disavowals were real. Oppressed by as well as reluctantly proud of this lengthening mini-shelf of work signed by Susan Sontag, pained to distinguish myself (I was a seeker) from her (she had merely found), I flinched at everything written about her, the praise as much as the pans.[1]

She had turned to Andrew Wylie for relief from the burden of "the Susan Sontag thing," and in 1983 had written that "to have two selves is the definition of a pathetic fate."[2] Now, she claimed,

she had avoided that fate by writing a book of which both "Sontag and I" could be proud, the book she was writing during the first years of her relationship with Annie Leibovitz.

She had

at last come to feel that the writer is me: not my double, or familiar, or shadow playmate, or creation. (It's because I got to that point—it took almost thirty years—that I was finally able to write a book I really like: *The Volcano Lover*.)

With *The Volcano Lover*, Sontag wrote the kind of book that Sue had dreamed of. In "Singleness," she implies that the novel is the product of a harmonious resolution of the tension between the gnostic dualisms, between mind and body, "Sontag" and Sontag: between monster and Frankenstein.

But as the book and Sontag's reaction to it would show, she did not achieve unity by combining the two sides of her personality. She did so by choosing one over the other. Rather than venerating Thomas Mann or Walter Benjamin or Joseph Brodsky, she became them, leaving the modernist experiments of her earlier novels behind her. This was the very thing for which she had criticized Sartre: trying to make herself into "a 19th-century-style Great Writer."

This was the role she was born to play. And she played it without ambivalence, inhabiting the dreamworld of celebrity and money, of high culture and "opera." If grandiosity and posturing were held against normal people, they were not held against a great diva, from whom they were expected, and whose colorful legend they enhanced. Susan Sontag's last two novels were about actresses.

————

At the center of *The Volcano Lover* is a famous triangle: of Sir William Hamilton, British ambassador at Naples; Lord Nelson,

hero of the age; and the most alluring woman in Europe, Emma Hamilton—wife to the former, mistress to the latter.

The story upon which it was based had already been made into a movie, *That Hamilton Woman,* starring Vivien Leigh. It appeared in 1941, before Sue moved to Tucson. Whether she saw it then or later, the foul-mouthed courtesan intrigued her. "What did this concealed woman have that these great men loved her?" she wondered in 1960.[3] In the eighties, in London, she found a series of prints. "Erupting Vesuvius, somnolent Vesuvius, close-ups and cross sections of volcanic rock—she bought five prints, five more the next day, and then another seven," a journalist wrote.[4]

The city of Vesuvius was the city of Carlotta. And like Carlotta, her protagonist was a tabula rasa, a beautiful blank. Unlike Carlotta, who made no effort to be more than surface, Emma works eagerly to adapt to the fantasies of others. In this sense, she is more Annie than Carlotta, keen to be shaped, molded, carved, "taking his impress as clay does a sculptor's thumb." And though he loved her, Sir William—whom Susan calls the Cavaliere—sees Emma as Susan saw Annie: "Her perfections and his happiness did not mean he did not want to improve her." The Cavaliere notes Emma's grammatical slips as Susan noted Annie's: "Oh lordy how vulgar they was," she says. As a result, "the Cavaliere's mansion was stocked with tutors from morning to night."[5]

"He tells me I am a grate work of art," she writes.[6] Emma's sumptuous beauty—"A truly great beauty always has beauty enough for two"[7]—demands a means of display. "The Cavaliere had first asked her to pose inside a tall velvet-lined box open on one side, then within a huge gilt frame." As Annie's models posed, so does Emma, and adapts to any gaze: Emma's poses—"Attitudes"—were gazed upon by the whole Neapolitan court. "I could not help it if I had an actress's talent." Emma shrugged. "If I liked to please . . . It is really very easy to please. It is no different from learning."[8]

As a work of art, Emma is susceptible to collection. She eagerly endeavors to be acquired by a series of powerful men until finally snagged by one of the supreme collectors of the day. Sontag understands that, for one eager to rise, being turned into an object has its uses. And the mentality of collector and collected, hunter and hunted, allows Sontag's talent for aphorism to flourish:

> A collection is always more than necessary.
> Every collector is potentially (if not actually) a thief.
> You can't have everything. . . . Actually, you can have quite a lot.[9]

The collector par excellence, the aging Cavaliere, is a melancholic for whom beauty and art are medicine. "His is the hyperactivity of the heroic depressive," Sontag writes, about herself as much as about him. "He ferried himself past one vortex of melancholy after another by means of an astonishing spread of enthusiasms."[10] These enthusiasms make him an admirer: "Even more than wanting to be admired, he liked admiring." And what he wants to collect—besides Emma, besides his stunning antiquities—is his great obsession, the volcano: "The Cavaliere had discovered in himself a taste for the mildly plutonian."[11]

———

"Nothing can match the elation of the chronically melancholy when joy arrives."[12] Emma's arrival brings joy to great men, but great women take a dimmer view. The first is Madame Vigée Le Brun, painter to the deposed queen of France. She has sought refuge in Naples, and sizes Emma up with a glance:

> Never, in all the portraits made of her, was she depicted so patently as a courtesan. Unpleasant depiction by one inde-

pendent woman surviving out in the great world by her wits and talents, of another woman at the same perilous game. But impudent as the portrait was, it was a success. The artist knew her patrons. She must have wagered that the Cavaliere (infatuated) and the young woman (innocently vain) would not see the portrait as others might see it, would see only one more tribute to her all-conquering beauty.

Among the large number of roles and personae that she deemed herself suited to play, there was a special pleasure in portraying women whose destiny was so unlike her own happy one, such as Ariadne and Medea, princesses who sacrificed all—past, family, social position—for a foreign lover and then were betrayed. She saw them not as victims but as persons who were inordinately expressive: persons affecting and heroic in the intensity of their feeling, in the recklessness and wholeheartedness with which they gave themselves to a single emotion.

She elaborated her Attitudes, improved the stagecraft and the dramaturgy.[13]

Eleonora de Fonseca Pimentel, a revolutionary writer who emerges as the real heroine of the book, sees Emma as "not merely exuberant and vulgar, but cunning, cruel, bloodthirsty." Her judgment might be said to reflect another female character's, one who, after an appearance at the beginning, pops up in the very last paragraph:

I [Eleonora] would lie to myself about how complicated it is to be a woman. Thus do all women, including the author of this book. But I cannot forgive those who did not care about more than their own glory or well-being. They thought they were civilized. They were despicable. Damn them all.[14]

The glories of power—the delights of wealth and acquisition, of conquests military and sexual—are lavishly described by a person who knows their joys are real. Yet the book's true heroine has refused them, and it was this refusal that Sontag saw as the mark of the truly noble. "I did know about power," Eleonora says. "I did see how this world was ruled, but I did not accept it."

In her essay on Canetti, Sontag wrote that

> the teacher at his boarding school to whom he now "bows" won his fealty by being brutal during a class visit to a slaughterhouse. Forced by him to confront a particularly gruesome sight, Canetti learned that the murder of animals was something "I wasn't meant to get over."

She quoted his observation that "the *loudest* passage in Kafka's work tells of this guilt with respect to the animals."[15] And when Sontag denounces the vanity and cruelty of Emma, Nelson, the Cavaliere, and the world over which they preside, she does so most effectively when showing that world's cruelty toward enslaved animals. The court celebrations feature an artificial mountain laden with food, including living food, delivered to the mercies of the brutalized citizenry, who are unleashed with knives in hand:

> One's nose [was assaulted] by the smell of blood and the excrement of the terrified animals; one's ears, by the cries of the animals being slaughtered and the screams of people falling or being pushed from some part of the mountain.[16]

The cruelty is not always this spectacular. The Cavaliere has a monkey, Jack, housed with the rest of the collection, "tied up, made comfortable." The Cavaliere behaves toward Jack as Su-

san did toward anyone who loved her more than vice versa. "He wanted a mock protégé, a jester," she writes, "and poor Jack loved him abjectly enough to oblige." And so "he began adding a tiny bit of teasing to his treatment of the monkey, a little bit of cruelty, a touch of deprivation."[17] No courts will punish these crimes. But their savagery is visited on those who commit them; the "despicable" trio receives their merited comeuppance.

———

"Damn them all" are the last words of *The Volcano Lover*. They are not, however, Sontag's last word. Her protagonists are genuinely despicable. They are also genuinely lovable. They push against internal limits, as she did. They push against external limits—those imposed by politics and society, love and passion—as she did. And in that struggle, they, like her, reveal themselves as monsters and heroes both.

In *The Volcano Lover*, she resisted the temptation to choose sides, or to choose them conclusively. This was the pitfall that reduced many of her political writings to propaganda. Instead, she patiently dissected the conflicting motives inside every person— the little wars—to make a book that united the rigor of her best essays to the ambivalence of her best stories. This was the difference between having no firmly held opinions and acknowledging the complexities and conflicts that animate people's lives—the view that distinguishes the novelist from the pamphleteer.

She brought this view to that most difficult of questions, metaphor. She hated saying "the road is straight as a string." Now, the "profound part of me that feels that 'the road is straight' is all you need to say and all you *should* say" ceded, seismically, to this:

Like a wind, like a storm, like a fire, like an earthquake, like
a mud slide, like a deluge, like a tree falling, a torrent roaring,
an ice floe breaking, like a tidal wave, like a shipwreck, like

an explosion, like a lid blown off, like a consuming fire, like spreading blight, like a sky darkening, a bridge collapsing, a hole opening. Like a volcano erupting.[18]

But—the very nature of thinking was still *but*—this did not mean an unambiguous embrace of metaphor: of changing one thing, through an aesthetic operation, into another. Much of the novel shows people pushing against the limits of this aesthetic view, one that, no matter how earnestly cultivated, is unable to compete with the more brutish realities of nature: including one's own nature.

> The Cavaliere thought of himself as—no, was—an envoy of decorum and reason. (Isn't that what the study of ancient art teaches us?) Besides a most profitable investment and the exercise of his collecting lust, there was a moral in these stones, these shards, these dimmed objects of marble and silver and glass: models of perfection and harmony. The antiquity that was uncouth, alert to the demonic, was largely hidden from these early patrons of antiquity. What he overlooked in antiquity, what he was not prepared to see, he cherished in the volcano: the uncouth holes and hollows, dark grottoes, clefts and precipices and cataracts, pits within pits, rocks under rocks—the rubbish and the violence, the danger, the imperfection.[19]

In *The Volcano Lover*, we see the sad demise of Brodsky's *Homo legens*. Uncouth holes lurk beneath the most polished surfaces. Art is not only futile as a means of teaching goodness or morality: it is a product of the same demonic forces that underlie the eruptions of passion and politics.

The aesthetic or metaphoric view is not only beautifying. It is also remorseless—and to no one more than a beautiful woman.

Emma's beauty rocketed her from scummy origins and placed her among the great; but the loss of self is the price of ascent: "She does not know who she is anymore," Sontag writes, "but she knows herself to be ascending."[20] The tension between persona and person becomes untenable when reality resurges, and avenges itself upon the dream.

"Without my beauty, my shield, everyone could mock me," Emma says.[21] She descends into alcoholism. The beauty is damned by the drunk old tart; the no-longer-collectible woman is discarded. Perhaps, for her cruelties, she deserves to be discarded. But it is not for these that she is condemned:

> For nothing was she judged more harshly than her failure at what is deemed a woman's greatest, most feminine accomplishment: the maintenance and proper care of a no longer youthful body.[22]

———

The Volcano Lover was a huge success. Susan had never before had a bestseller. Now she did—and in the genre, fiction, in which she had always dreamed of excelling. "I think I'm a slow developer," she said. "I ask myself this all the time—why did it take me so long?" She decided that it was because she "didn't have access to this kind of expressiveness, of inner freedom. . . . One blushes to use such well-worn phrases as 'maturity,' but I think it is. . . . I think I will do, now, my best work."[23]

With the exception of the eighty-something pages of *AIDS and Its Metaphors*, *The Volcano Lover* was the first book she had published since *Under the Sign of Saturn*, twelve years before. She had changed in those years, and so had the broader culture. The novel garnered admiring reviews and widespread media attention, and Susan reveled in her success. She was elated when friends expressed their pleasure in the book. To several, she gave a version

of the same reply: "Good, now read it again" or "It's even better the second time." Terry Castle saw her childlike pleasure:

> A waiter came up and said, "I know you're famous, but who are you?" And she was delighted by the question, first of all. She said: "Well, I am Susan Sontag. I'm a writer, and my most recent book was a novel you may have heard of, called *The Volcano Lover*." Then she said, "Here, I'll write it on a napkin." So she wrote her name, like she was signing somebody's high school yearbook, with *The Volcano Lover* written on the napkin, too.[24]

Zoë Heller saw it, too, when a newsagent recognized Susan. She beamed, and spent several minutes talking to him:

> She tells me she has been "moved in a very feminine and almost maternal way" by the encounter. "I just think of him standing there selling papers," she says, "and probably it's not the thing he wanted to do most in the world. If he knows who I am, that means he reads and he probably went to college and then . . . Well, this is my over-empathetic sensibility at work. I just feel he's probably not doing what he wants to and he is struggling for self-esteem."
>
> In spite of this warm reaction, Sontag claims that she would much rather go unnoticed in public. "People find this hard to believe," she says, "but despite all the attention that has been paid to my person, I'm not at all interested in being famous."[25]

———

In 1996, when Farrar, Straus celebrated its fiftieth anniversary, the Israeli writer David Grossman introduced himself. "Oh, Ms. Sontag, it is such a pleasure to meet you. I'm a great fan of

your essays," he said. "My *essays*?" she spat. "Juvenilia! Have you read *Volcano*?"[26] Graciousness had never been her forte. Now, she began to speak disparagingly of her essayistic work, enthusiastically claiming the title of novelist.

"She began to speak of her own work as a critic and a woman of letters as entirely subordinate to her fiction," her old friend Robert Boyers said.[27] And as she had allowed her conflict with Annie to be visible to people far outside her immediate circle, she began attacking even friends in full public view, oblivious to the impression this made. At Skidmore College, where Boyers taught, she came to speak, an occasion for which he had prepared an extensive introduction.

When he finished, Susan stepped onto the podium: "Robert Boyers still doesn't get it," she sneered. "He still doesn't get that I'm a novelist and that all this other writing he talked about is writing I did to keep writing and have something to do while I was developing myself as a fiction writer." The attack was so blunt, so unmerited, that a chill went through an auditorium packed with three hundred appalled guests. Afterward, Peg Boyers marched up to Susan and said: "You must apologize to Bob *immediately*." Susan did, "profusely," like a chastened child—and like a child unsure what she had done wrong.

And in Amsterdam, where she came for the novel's publication, she was onstage with the Dutch writer Abram de Swaan. A comment he made about Pirandello rubbed her the wrong way. "She went into a tirade that seemed endless," said Annie Wright, a translator who was in the audience. "It did not stop. It went on and on and on and on—so extreme that it was discussed in the Dutch press, which was generally unflappable at the time."[28]

———

The Volcano Lover found her cast in someone else's psychodrama. In 1990, Camille Paglia resurfaced. In the twenty years since

their brief encounter at Bennington, Paglia, flush with a success of her own, exploded with a "Homeric boast" directed at Susan: "I've been chasing that bitch for twenty-five years and at last I've passed her!"[29] Paglia's surprise bestseller, *Sexual Personae*, was published in 1990, two years before *The Volcano Lover*. Its subtitle, *Art and Decadence from Nefertiti to Emily Dickinson*, gives an idea of its range and ambition; and Paglia's boast shows that Sontag remained a central figure for many women intellectuals, and especially for younger lesbians. If Sontag had not had a lineage when she was a young woman, she had come to represent a lineage for the younger generation, who aspired to emulate her. "It should have been perfectly obvious in the nineties that I was indeed her successor in terms of media profile and flash for an American woman intellectual," Paglia said.[30]

The tone of Paglia's public taunting of Sontag was deliberate. Gaily comparing herself to Eve Harrington in *All About Eve*, Paglia hurled barbs that soon hit the tabloids. Proclaiming herself a "believer in pagan public spectacle" and in "trashy literary feuds,"[31] she modeled her attack on Sontag on famous rivalries of the past.

> I loved those feuds that had been going on with William F. Buckley versus Gore Vidal, threatening to punch him. Gore Vidal and Norman Mailer, and Mary McCarthy versus Lillian Hellman. I thought that was fabulous. I love the tabloids and I thought it was fabulous to be attacking Sontag from a gossip column.[32]

This high camp did indeed hit the tabloids. MORE FROM SONTAG'S "NIGHTMARE,"[33] the headline of Page Six, the gossip column of the *New York Post*, blared in August, when Camille called Susan "the ultimate symbol of bourgeois taste" and "an

intellectual duchess" who was "defunct as an intellectual presence."

Susan proclaimed that she had never so much as heard of Camille Paglia. An interviewer asked if she really had said "Who is Camille Paglia?"

"Excuse me," she answered. "Are we not speaking English?"[34]

The same interviewer showed Paglia the clip, and Paglia tossed her head:

> It's as in *The Turning Point* with Anne Bancroft, I mean she is literally being passed, okay, by a younger rival. . . . She doesn't watch TV, she's not into rock, and she has been passed. . . . So she did me a tremendous favor. Nineteen ninety-two was a wonderful year for me because she came out of hiding and Germaine Greer came out of hiding and suddenly people realized just how interesting *I* am.

Later, Paglia regretted that Sontag had not participated in this campy performance. "It's very entertaining to readers," she said. It was: the Paglia-versus-Sontag feud was written about all over the world. "I think it's good for women to have open combat the way men have always had open combat. I could have written Sontag's lines! Against me. But she wasn't playing the game—at all."[35]

———

"Andy Warhol was my hero, I was a Warholite in college," Paglia said. And in a Warholian way, not playing along was Susan's way of playing along, her role enriching Paglia's own. Who better to play "Miss Mandarin," the "intellectual duchess," than Susan Sontag? Susan's snubs only encouraged Paglia, kept the story in the tabloids, and the ruckus strengthened Sontag's reputation as a formidable diva.

She told Zoë Heller she was pretending she had never heard of Camille Paglia. "And the reason is I went to this party and I heard this guy say, 'Gertrude Stein, who is that?' and I loved that. So I'm using the same thing on Paglia."[36] But if Susan played along, this was, ultimately, Camille Paglia's show. Only a few months later, Susan traveled to Sarajevo, and mounted a far more consequential performance of her own.

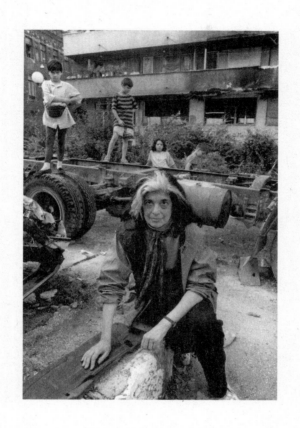

PART IV

A Serious Person

W hen the Berlin Wall fell, even the flintiest cynic might have seen the arc of the moral universe bending toward justice. The thrilling televised scenes of crowds tearing down walls and chasing off tyrants seemed to corroborate the old American belief—naïve or hopeful or both—that freedom was the destiny of all peoples, and that history could be conflated with progress. Communism collapsed, leading to the emergence of liberal governments across a huge swathe of the planet; in those years, too, most of the Latin American dictatorships crumbled; the Oslo Accords of 1993 promised peace between Israelis and Palestinians; and the release of Nelson Mandela announced the expiration of South African apartheid.

These changes were so dramatic that peace and democracy began to seem foreordained. It was easy to ridicule this notion, and Sontag often had. In "Project for a Trip to China," she quoted a United States senator at the turn of the century who announced that "with God's help, we shall raise Shanghai up and up and up

until it reaches the level of Kansas City."[1] But for a few brief years, progress was real enough that even the most horrifying setbacks, such as the massacre in Tiananmen Square, seemed like temporary glitches. In 1992, Francis Fukuyama published a book whose title became famous, so perfectly did it sum up the age: *The End of History and the Last Man*. History, which had rarely given much reason for optimism, had found its better self.

———

Sunny Yugoslavia topped the list of places that stood to gain from these revolutions. This land of islands, mountains, and forests had suffered less from communism than anywhere else in Communist Europe. In sharp contrast to other Communist citizens, who could only travel abroad with difficulty, Yugoslavs could freely come and go. The country was a dictatorship, but Tito never approached the full-fledged megalomania of Stalin or Ceaușescu; and though the economy was dysfunctional, it never approached the full-scale collapse of countries like Russia or Romania. With the end of communism, Yugoslavia, with its promising industries and highly educated people, its good infrastructure and its good wine, seemed ready to be seamlessly integrated into the West.

For the outside world, Yugoslavia was a nation and Yugoslavs were a people. That outside world, which had paid this place only the most occasional and absentminded heed, was little prepared for the complexities, "racial," religious, and cultural, that characterized it. The largest ethnic group was the Serbs, for example, who were often coextensive with—but nonetheless distinct from—the Serbians, who are the citizens of Serbia, not all of whom are Serbs: they could be Albanians, Hungarians, Jews, or even Chinese. Serbs, in contrast, are an ethnic group of Eastern Orthodox Christians who may be found anywhere from Moscow to Miami; and there were furthermore Bosnian Serbs, Kosovo

Serbs, and Croatian Serbs—by no means to be confused with the Serbian Croats—all of whom had their own histories, though all spoke the same language, which was generally known as Serbo-Croatian but which was also, depending on the place, called Serbian, Croatian, Bosnian, Montenegrin, or simply, with a shrug, "our language."

When the country began falling apart, this complexity made it easy to describe Yugoslavia as a medieval mystery, brewing with unfathomable hatreds; and this description was useful to foreign politicians seeking excuses for sitting on their hands. But there were other ways to describe Yugoslavia, the most obvious of which was as a modern European nation. It was true that it had a multiethnic populace, which also happened to be true of every nation based on citizenship rather than ethnicity. The Yugoslavs were people "for whom," wrote David Rieff, "the ownership of seaside cottages, second cars, and university educations had become commonplace."[2] They were "as dependent on elevators, gas pipelines, supermarkets, and electricity as any other population of a modern, developed country."

Perhaps, its dictatorship vanquished, Yugoslavia could have become a federation on the Swiss or Belgian model. Or perhaps, on the Czechoslovak model, its constituents might have peacefully gone their separate ways. That it did neither—that its name became a byword for horror—was largely thanks to one man, Slobodan Milošević, an apparatchik who rose to prominence in the 1980s by denouncing the abuses to which Serbs, the majority, were supposedly being subjected. Serbs were being oppressed by the Kosovar Albanians, the Croats, the Bosnian Muslims, he declared—and moved, as president of Serbia, to centralize power in Belgrade. This provoked a reaction. Slovenia and Croatia seceded in early 1991. Slovenia's independence was quickly assured; but fighting was fierce in Croatia, which bordered Serbia and was

home to many Serbs. The Yugoslav army's bombardment of Du-
brovnik, the jewel of the Croatian Riviera, gave a taste of things
to come.

These came the next year in Bosnia and Herzegovina, the
most mixed of the republics. Its population, "divided" among
Serbs, Croats, and Muslims, was in practice so intermingled that
many Bosnians believed that the kind of violence that had erupted
so brutally in Croatia was impossible in Bosnia: to divide people
by ethnic or religious background would mean destroying cities,
neighborhoods, families. And that was exactly what happened af-
ter a referendum on Bosnian independence was boycotted by the
Bosnian Serbs. War broke out on April 6, the day Bosnia received
international recognition. On May 2, the rump of the Yugoslav
army sealed off the Bosnian capital.

———

The word "capital" is a bit exalted for Sarajevo, which, in the ex-
aggerated words of one Bosnian, is just one street. That street,
parallel to the Miljacka River, is bisected by others, which, within
a few blocks of the river, rise steeply into green hills, offering
views of the gardens and minarets that gave the city a reputa-
tion for Islamic romance. It was also a place of European mo-
dernity: roughly equidistant from Milan and Istanbul, Vienna
and Athens, Sarajevo had a cosmopolitan culture that lent it a
far more sophisticated ambience than its size seemed to allow.
With mosques and synagogues cheek by jowl, and Catholic and
Orthodox churches side by side, Sarajevo represented the plural-
istic ideal of which cities like New York were the heirs. There had
been many of these cities in Central Europe; but most had been
destroyed in the twentieth century by the irredentism that now
threatened Sarajevo.

Like two hands cupped together, the valley that holds Sara-
jevo is deep, and narrows at both ends. Where the wrists touch,

the valley squeezes into a thin pass; where the fingers meet, at the top of the valley, the terrain is just flat and wide enough to allow room for the strip of the airport runway. The city's terrain had been a blessing for the tourism that Bosnia, like Croatia, hoped to attract. With ski lifts only a few minutes from downtown, Sarajevo hosted the Winter Olympics in 1984. Then, few dreamed of the meaner uses to which this geography might be put.

Eight years later, Sarajevo was encircled. It would be choked off for 1,425 days, the longest siege in modern history. It lasted nearly twice as long as even the previous record holder, the Nazi siege of Leningrad. Those who could have ended it—the United States Navy determined this would have required at most forty-eight hours[3]—took refuge in clichés about the unplumbed intricacies and irreparable grievances of the Yugoslav tribes. The historical complexities were real, but once Sarajevo was surrounded the moral obligation became straightforward.

Milošević and his lieutenants placed the formerly mixed Yugoslav army at the service of a project to establish an ethnocracy in areas either heavily populated by Serbs or bearing some historical significance, no matter how fanciful, to them. The army and its countless spinoffs murdered, raped, and expelled Muslims and Croats from community after community in full view of a world that agreed on little but the one principle that, after Hitler, separated civilization from barbarism. This was a rejection of "ethnic cleansing," a phrase the Yugoslav slaughter contributed to the world's lexicon. Everyone agreed that the phenomenon of racial terror ought to be in the past; but without outside intervention such agreement was empty. Supposedly civilized nations kept calm and carried on as concentration camps were established and civilians were bombed and starved less than an hour from Venice.

"It was amazing," said Atka Kafedzić Reid, a young Bosnian woman, "how you could go, in one day, from watching MTV to a completely medieval existence."[4] The Olympic city became a place

where the gift of an onion was an extravagant token of altruism; where birds, frightened by the constant shelling, had fled the city; where people carried their own feces in paper bags in search of somewhere to dispose of them; and where citizens no longer noticed the dead bodies they stepped over in the street. "A European city was being reduced to nothing," wrote David Rieff. "Carthage in slow motion, but this time with an audience and a videotaped record."[5]

———

David went to Bosnia in September 1992, at the end of the first summer of siege. As for so many of the journalists who stayed in Sarajevo, the journey became a continental divide. "In a previous life, the life before Bosnia, I used to flatter myself that indignation was an emotion to which I was virtually immune," he wrote.[6] Like so many of the journalists who made the journey to Sarajevo, he did so because he believed, however implicitly, in the existence of a civilized world, and in the duty to inform it. "If the news about Bosnia could just be brought home to people," he thought, "the slaughter would not be allowed to continue."[7]

At the end of that first visit, he spoke to Miro Purivatra, who later founded the Sarajevo Film Festival, and asked if there was anything, or anyone, he could bring back. "One of the persons who could be perfect to come here to understand what's going on would definitely be Susan Sontag," he said. Without mentioning the connection—"for sure," Miro said, "I did not know that he was her son"—David said he would do what he could. He appeared at Miro's door a few weeks later. "We hugged each other and he told me, 'Okay, you asked me something and I brought your guest here.' Just behind the door, it was her. Susan Sontag. I was frozen." It would be at least a month before he figured out their relationship: "They never told me."[8] This was in April 1993, the first of what would turn out to be Susan's eleven visits to a

place that became so important to her life that a prominent down-town square is named for her—so important that David would consider burying her there.

As Sarajevo was situated at the intersection between Islam and Christianity, and between Catholicism and Orthodoxy, it was the place where the interests that Sontag had pursued throughout her life coincided. The political role, and the social duty, of the art-ist; the attempt to unite the aesthetic with the political, and her understanding that the aesthetic *was* political; the link between mind and body; the experience of power and powerlessness; the ways pain is inflicted, regarded, and represented; the ways im-ages, language, and metaphor create—and distort—whatever people call reality: these questions were refracted, and then liter-ally dramatized, during the nearly three years she spent coming and going from the worst place in the world.

———

"I didn't not come before because I was afraid, I didn't not come because I wasn't interested," Susan said on that first visit. "I didn't come before because I didn't know what's the use of it."[9] But once she left, she could not get the city out of her mind. The contrast between what she had seen and the cool indifference of the world outside was too jarring.

> To leave Sarajevo and be, an hour later, in a "normal" city (Zagreb). To get into a taxi (a taxi!) at the airport . . . to ride in traffic regulated by traffic signals, along streets lined with buildings that have intact roofs, unshelled walls, glass in the windows . . . to flip on the light switch in your hotel room . . . to use a toilet and flush it afterward . . . to run the bath (you haven't had a bath in several weeks) and have water, hot water, come out of the tap . . . to take a stroll and see shops, and people walking, like you, at a normal pace . . .

to buy something in a small grocery store with fully stocked shelves . . . to enter a restaurant and be given a menu . . .[10]

Safely in Berlin, she found herself "totally obsessed," writing a German friend that "to go to Sarajevo now is a bit like what it must have been to visit the Warsaw Ghetto in late 1942."[11] The comparison to the Holocaust was not made flippantly—and, when the massacres, concentration camps, and "ethnic cleansing" came to light, would become commonplace. But Susan was the first to make it, after that first visit, in an interview with German television. "She was the first international person who said publicly that what is happening in Bosnia in 1993 was a genocide," said Haris Pašović, a young theater director. "The first. She deeply understood this. She was absolutely one hundred percent dedicated to this because she thought it was important for Bosnia but it was also important for the world."[12]

What was at stake in Sarajevo was not only the fate of a people and a country. Sarajevo was a European city—and European, David wrote, "had become a moral category as well as a geographical one."[13] This category was the liberal idea of the free society: of civilization itself. The Bosnians knew this, and were bewildered that their appeals were met with such indifference.

> We are part of Europe. We are the people in the former Yugoslavia who stand for European values—secularism, religious tolerance, and multi-ethnicity. How can the rest of Europe let this happen to us? When I replied that Europe is and always has been as much a place of barbarism as a place of civilization, they didn't want to hear. Now no one would dispute such a statement.[14]

This idea of Europe emerged from the Holocaust, after which the basic measure of civilization became the willingness to re-

sist the kinds of horrors unfolding in Bosnia. After Auschwitz, the civilized government was one defined by its resistance to these crimes; but governments were not the only ones called: the free citizen, too, had an obligation to resist. But how could a single person stand in the path of a genocidal army? The question of how to oppose injustice had occupied Susan since childhood: since she read *Les Misérables,* since she saw the first pictures of the Holocaust in the bookstore in Santa Monica.

"I'm very attached to the idea of noble conduct," she said in 1979. "Words like *nobility* sound very strange to us now, and they sound snobbish, to say the least."[15] But nobility was the heart of what she described, even earlier, as "seriousness." "Being serious," she wrote in notes for "The Aesthetics of Silence,"

> means being "there." Feeling the "weight" of things. Of one's own statements or acts. . . . When [Kierkegaard] said there are no Christians today, he meant there are no serious Christians, no Christians who take Christianity seriously.

> don't mean it "seriously"—
> i.e. aren't prepared to act on it
> put your body on the line, put your money where your mouth is[16]

Sarajevo offered a chance to put her body on the line for the ideas that had given dignity to her life. This was what she had not been able to do with AIDS—but she did now, and Pašović saw how far she was willing to go.

> Susan did understand, very, very deeply, that this was a defining moment in European and perhaps world history. She knew that. And she was ready to die for it. Because she was

saying . . . I'm trying not to cry. I didn't talk about Susan
this way for a long time. It was that she didn't say that, but
I dare to say that she didn't want to live in the world where
those things are possible.[17]

––––––

Susan Sontag was an individual, but her career had made her
something more. She was a symbol of the cosmopolitan, "Euro-
pean" culture under attack. And she took her obligation to that
culture seriously enough to place both these existences—Susan
the person, Sontag the metaphor—in the line of fire.

She had often pondered the public duty of the writer. She
admired those of her predecessors who, in similarly perilous situ-
ations, risked their own lives. And she was shocked that more
people in her position were not risking their own. "The striking
thing about Susan, before you got to know her, was that she was
there at all," said John Burns, Balkan correspondent for the *New
York Times*. "Sarajevo was famous for the people who didn't show
up. Faced with evident cases of genocide, where was the intelli-
gentsia of the time?"[18]

Upon returning, after her first visit, to an unruffled Ger-
many, she was "dismayed to find that every German intellectual
and writer I spoke to—Günter Grass, [Hans] Magnus [Enzens-
berger], etc.—seemed completely indifferent to the genocide, or
worse. For the first time I heard Magnus talking as a German,
not as a European." In Sarajevo, she was asked about the absence
of many noted American writers:

There is an enormous depoliticization of the Western intelli-
gentsia, the Western writers, the writers of Western Europe
and North America. You mention Kurt Vonnegut. . . . All
of these people are just sitting in their huge, rich apartments

and going out to the country on the weekends and living their private lives.[19]

The contrast with another conflict was often mentioned, as in an interview Sontag gave Burns in August:

Sarajevo is the Spanish Civil War of our time, but the difference in response is amazing. In 1937, people like Ernest Hemingway and André Malraux and George Orwell and Simone Weil rushed to Spain, although it was incredibly dangerous. Simone Weil got terrible burns and George Orwell got shot, but they didn't see the danger as a reason not to go. They went as an act of solidarity, and from that act grew some of the finest literature of their time.[20]

But what did this courting of death accomplish? To stimulate the literary impulse once back in London or Paris? In *Against Interpretation*, Sontag had written about Michel Leiris's *Manhood*, a memoir whose unforgettable preface, "On Literature Considered as a Bullfight," suggested that modern literature was bloodless, safe, harmless. "To be a writer, a man of letters, is not enough. It is boring, pallid. It lacks danger." The bourgeois resident of a pacified nation had to seek his thrills in some duskier abroad, whether artistic or geographic.

Leiris must feel, as he writes, the equivalent of the bullfighter's knowledge that he risks being gored. Only then is writing worthwhile. But how can the writer achieve this invigorating sense of mortal danger? Leiris' answer is: through self-exposure, through *not* defending himself; not through fabricating works of art, objectifications of himself, but through laying himself—his own person—on the line

of fire. But we, the readers, the spectators of this bloody act, know that when it is performed well (think of how the bullfight is discussed as a preeminently aesthetic, ceremonial act) it becomes, whatever the disavowals of literature—literature.[21]

Leiris's demand was the same as Adrienne Rich's, the same as the gay activists': to lay oneself on the line of fire. This imperative could be interpreted, as Sontag had, as an aesthetic or as a political requirement; but it could also be interpreted in the other sense Leiris suggested: a simple demand to risk one's life. This demand was frighteningly easy to achieve by setting foot in Sarajevo. During the siege, an average of ten people were killed every day, 11,541 in all.

———

Was there not something grotesque about using other people's suffering to "achieve this invigorating sense of mortal danger"? Did the duty—social, political, moral, aesthetic—mean nothing more than risking terrible burns, or getting shot in the neck, or being gored? And would it be enough to volunteer for the risk—or was dying the only way of proving one's commitment?

Even those who did brave the journey to Sarajevo discovered how difficult it was to answer these questions. Some, whose intentions were beyond reproach, offended the Sarajevans. Amid widespread starvation, Joan Baez warned Atka Kafedzić that she was "too skinny"; Bernard-Henri Lévy, known in France as BHL, became known in Bosnia as DHS: "Deux Heures à Sarajevo," Two Hours in Sarajevo.

The locals had ample opportunities to size up their visitors. "We were very cynical about the whole circus element of these war safaris," said Una Sekerez, who issued passes on behalf of the United Nations, and issued one to Susan:

There were other people like that, like: What are they doing here? I just assumed she was in for a quick look at how these people on the reservation lived—and she would go. Then she stayed. That was very, very unusual.[22]

On that first visit, the poet Ferida Duraković translated questions from a journalist.

His first question was: How do you feel coming to Sarajevo for safari? I translated it and Susan said: I understood the question. Please be careful when you translate this. She looked at me and then said, "Young man, don't put stupid questions. I am a serious person."[23]

———

"Witnessing requires the creation of star witnesses," Sontag wrote in *Regarding the Pain of Others*, the last book published in her lifetime.[24] Like so many of her works, the book was a meditation on ways of seeing and representing; but if her reference to stars sounded sardonic, it was not—or not only. Like all forms of seeing and representing, witnessing was often pathetically ineffective. How was watching something happen, even risking one's life to write about it or take pictures of it, going to change the world of armies and politics?

Yet John Burns saw the importance of witnesses. Shortly after the siege began, three journalists were killed; and the remaining reporters, led by the BBC, decided that they should *all* leave: "It was an intense, shameful debate." They evacuated to the suburb of Ilidža, safely beyond the airport, to the same hotel where Archduke Franz Ferdinand slept before his own apocalyptic visit. There, Burns made up his mind to go back to Sarajevo. "As soon as we left, the Serbs started letting loose on the city," he

explained. "Ten thousand shells that day. They felt free because the journalists were gone."

Eyes made a difference, even if only a limited one. In *On Photography*, Susan discussed the limits of representing calamity. "A photograph that brings news of some unsuspected zone of misery cannot make a dent in public opinion unless there is an appropriate context of feeling and attitude."[25] This allowed a witness—a writer, a journalist, a photographer—to create that context; but that process could be agonizingly slow, and it was not easy to know if one was making any difference. "No longer can a writer consider that the imperative task is to bring the news to the outside world," she wrote. "The news is out."[26]

This was what David discovered. Everyone everywhere knew what was happening in Bosnia, yet few went beyond rhetorical expressions of solidarity. The politicians relied on compassion fatigue, exactly as Susan had warned in *On Photography*—photographs of war would become nothing more than "the unbearable replay of a now familiar atrocity exhibition."[27] And the victims, enraged by the world's apparent indifference, mocked the powerless newsbringers, whether celebrities or journalists.

> In Sarajevo in the years of the siege, it was not uncommon to hear, in the middle of a bombardment or a burst of sniper fire, a Sarajevan yelling at the photojournalists, who were easily recognizable by the equipment hanging round their necks, "Are you waiting for a shell to go off so you can photograph some corpses?"[28]

The reporters who were risking their lives for the sake of Sarajevo were judged. And they, likewise, judged those they suspected of tourism. But both Sarajevans and journalists respected Susan Sontag. One, the American Janine di Giovanni, was amazed by her sheer stamina.

It was unbelievably tough for me, a twenty-something-year-old girl. And she was a woman in her sixties. It really struck me. For a New York intellectual it was an odd place to be. Lots of celebrities came, and the reporters were cynical. I remember hearing she was coming and not being that impressed. But she didn't complain. She sat with everyone else, she ate the crap food, she lived in the bombed-out rooms we lived in.[29]

The actor Izudin Bajrović said:

She represented for us the *part* of the world that understood what was going on and was ready to do something about it. *Not* the world. But it meant more to us that she came than some prime minister. We didn't really believe in any prime ministers. We never doubted her goodwill. We doubted everyone else's.[30]

———

If praise and prosperity brought out the worst in her, oppression and destitution brought out the best. If she could be haughty in New York, she was kind in Sarajevo. There, she put her body on the line, and bore witness, and earned universal respect; but none of that answered the difficult question she posed: of what she, either as an individual or as a symbol, could actually do to help. "I didn't want to be a tourist here," she said, "to watch while everybody suffered. . . . I wanted to give something, to contribute."[31] Perhaps, she later wrote, the most appropriate response would have been silence:

The best thing is not to speak at all, which was my original intention. To speak at all of what one is doing seems—perhaps, whatever one's intentions—a form of self-promotion.[32]

This was the response—silence—offered by many modern artists. It was the response that Elisabet, in Bergman's *Persona,* elected when confronted with other exemplary horrors: a Vietnamese monk burning himself alive; a terrified child in the Warsaw Ghetto. Elisabet, Susan wrote nearly thirty years before, "wants to be sincere, not to play a role, not to lie; to make the inner and the outer come together, [and] having rejected suicide as a solution, [has] decided to be mute." But this was a spiritual response, not a political one. The Bosnians had real needs, and Susan hoped to be of some real assistance.

> I'd have been happy simply to help some patients get into a wheelchair. I made a commitment at the risk of my life, under a situation of extreme discomfort and mortal danger. Bombs went off, bullets flew past my head. . . . There was no food, no electricity, no running water, no mail, no telephone day after day, week after week, month after month. This is not "symbolic." This is real.[33]

On her first visit, she asked Ferida Duraković to organize a meeting with intellectuals. Duraković invited some people who brought predictable requests for material assistance—which, in time, Susan would provide. "But what do you want me to do," she asked, "besides bringing food, or money, or water, or cigarettes? What do you want from me?"

Eventually, with Pašović, head of the International Theater Festival, she discussed putting on a play. This would by no means liberate the city. But it did have some practical use. It would offer employment to actors, provide cultural activity, and show the world that the supposedly barbarous clans of Yugoslavia were every bit as modern as the people who might read of the production in their newspapers. She considered *Ubu Roi,* the play by Alfred Jarry that is often considered the grandfather of modernist the-

ater.[34] And she mentioned *Happy Days,* Beckett's play about a woman chattering with her husband, remembering happier days, while being buried alive. The dirt reaches her neck by the end of the play.

"She came with Beckett," Pašović remembered. "And I said: But Susan, here—in Sarajevo—we are waiting."[35]

CHAPTER 35

A Cultural Event

B eing! Being is nothing! Being is becoming!" a character
exclaimed in Susan's first theatrical venture.[1] This was Pi-
randello's *Come tu mi vuoi*, which she directed in Turin
in 1979 at the behest of Adriana Asti, an actress who starred in
Duet for Cannibals.[2] Pirandello had long been a favorite: already
in 1958, she wrote that "Pirandello's schmaltzy reflections on il-
lusion & reality have always appealed to me."[3] She also came, a
friend said, to be closer to Carlotta.[4] And the play had a connec-
tion to another of Susan's heroes, who had starred in a film ver-
sion from 1932, *As You Desire Me:*

> What fascinates me about this Pirandello play is the theme
> of psychological cannibalism. So I moved the character
> played by Greta Garbo in the film version to the center of
> my production as a sort of queen bee who entraps the other
> characters; but ultimately she is their victim.[5]

During this production, another play was born: *Alice in Bed*, first performed in Bonn in September 1991.

> One day Adriana Asti, who played the lead, said to me—
> dare I say it?—playfully, Please write a play for me. And
> remember, I have to be onstage all the time. And then Alice
> James, thwarted writer and professional invalid, fell into my
> head, and I made up the play on the spot and told it to Adri-
> ana. But I didn't write it for another ten years.[6]

Alice James was, almost like Susan Taubes, an admonish-
ment, a symbol of female failure, and one in whom Susan Sontag
had an old interest. Sontag got cancer at forty-two; Alice James
died of the same at forty-three. The talented sister of two great
writers, William and Henry, Alice had not mustered "the egocen-
tricity and aggressiveness and the indifference to self that a large
creative gift requires in order to flourish," Sontag wrote—that
same egocentricity that she, following Virginia Woolf, believed
came more naturally to men.[7]

Instead, Alice took to bed. In the play, Sontag shows sev-
eral renowned women, real and mythological—Kundry and
Myrtha, Emily Dickinson and Margaret Fuller—who must be
sedated, calmed, or left to "sleep it off"; and who, in their differ-
ent ways, struggle with the question of action, of how to respond.
They have, Sontag says, "the bourgeois luxury of psychological
invalidism,"[8] a subject that was much on her mind while directing
Pirandello: "another play about a woman in despair who is, or is
pretending to be, helpless."[9]

Were these women really helpless, or just "pretending"? "Al-
ice is shamed by the knowledge that her threats of suicide were
mere self-dramatizations," one critic wrote, "as if they were merely
the empty words of an actor."[10] These threats recall Susan's threats

of suicide, as her relationship with Lucinda was ending; and allow her to ponder, again, the question of duty.

Duty to self—

ALICE: Life is not just a question of courage.
MARGARET: But it is.[11]

—and duty to others:

KUNDRY: It is hard to save anyone. But that is all we desire.

———

In 1985, Frank Rich, theater critic of the *New York Times,* wrote that

> If ever there was a Cultural Event, it is "Jacques and His Master," the Milan Kundera play now at Harvard's American Repertory Theater. Not only is this production the American premiere of the Czechoslovak writer's sole stage work, but it also marks the American debut of Susan Sontag as a theater director. Leafing through the program, one half expects to discover Irving Howe and Philip Roth in the cast list.[12]

In the postideological age, this was a Cultural Event: famous names entertaining the lawyers and professors and bankers who could be expected to show up for a play directed by Susan Sontag at Harvard. There was nothing wrong with this kind of culture. But it was a poor cousin of culture as Sontag always understood the word. Great art lent such meaning and dignity to life that it was literally worth dying for—as she had been willing to give her life for Stravinsky as an adolescent, as she had always, as an adult, admired most those artists who understood art as a bullfight.

To this culture she had pledged her life. For decades, Sontag was forced to see its centrality questioned, its values eroded. "The undermining of standards of seriousness is almost complete," she wrote in 1996, "with the ascendancy of a culture whose most intelligible, persuasive values are drawn from the entertainment industries."[13] Around that time, she mentioned to Miranda Spieler, her assistant, that during the Columbia University uprising of 1968, one of the leaders published a letter that ended with the phrase "Up against the wall, motherfuckers." Susan wryly remarked: "I hadn't realized that we were going in this direction."[14]

And the direction was less toward revolt than toward money. It was one thing to offer one's life for Shakespeare and Rembrandt and Mozart, and something else to offer it for Andy Warhol. The consumerist vision demanded nothing, and certainly not sacrifice. This may have been the difference between culture and Cultural Event: at a Cultural Event, there was not the slightest risk of being gored.

Modernism had called art's social function into question. But this was not in order to see it replaced with price tags. So much modern art—from the silent compositions of John Cage to the installations of Paul Thek to the happenings of Allan Kaprow—manifested a desire to place itself beyond buying and selling. These artists sought another justification: Sontag cited Artaud's demand "that art justify itself by the standards of moral seriousness."[15] But the question of what those standards ought to be was maddeningly hard, and Artaud himself had not found a use for art: his view, she wrote in that essay, "makes a work of art literally useless in itself."[16] Ditto for the writer's social and political role:

The modern authors can be recognized by their effort to disestablish themselves, by their will not to be morally useful to the community, by their inclination to present themselves

not as social critics but as seers, spiritual adventurers, and social pariahs.[17]

Yet Sontag found a different, less obvious usefulness in Artaud's postulation of "a psychological materialism: the absolute mind is also absolutely carnal."[18] His "writings on the theater may be read as a psychological manual on the reunification of mind and body. Theater became his supreme metaphor for the self-correcting, spontaneous, carnal, intelligent life of the mind."[19] This reunification would not be fun. "His theater would have nothing to do with the aim of providing 'pointless, artificial diversion,'" she wrote. "Only the most passionate of moralists would have wanted people to attend the theater as they visit the surgeon or the dentist."[20] This was "art as an ordeal." And while it might hasten "a swift, wholly unified consciousness"[21] and even "heal the split between language and flesh,"[22] it could also get you killed.

———

Susan returned to Sarajevo on July 19, 1993, to direct *Waiting for Godot*. This performance was produced without so much as electricity, and without costumes worthy of the name, and with a set made of nothing more than the plastic sheets the United Nations distributed to cover windows shot out by sniper fire.[23] Yet this production became a cultural event in the highest sense of the term, an event that showed what modernist culture had been—and what, in extraordinary circumstances, it might yet be.

"Nowhere had the risk been so great, for what is involved this time, without ambiguity, is what is essential," Alain Robbe-Grillet wrote in February 1953, less than a month after the debut of *Godot*. "Nowhere, moreover, have the means employed been so *poor*."[24] He was referring to Beckett's own means: a set that consisted of a scrawny tree and a trash can; a strictly minimal language; a threadbare cast of beggars—one deprived of sight,

another of speech—waiting for a salvation, a climax, that never comes.

In Paris, in 1953, these were artistic choices: metaphors. In Sarajevo, forty years later, they were daily reality. "They saw people being happy and suffering," wrote the play's first reviewer, "and did not understand that they were watching their own lives."[25] This misunderstanding did not burden the Sarajevans. At the casting, Susan asked the actors whether there was a connection between their lives and Beckett's piece. Admir Glamočak, who would be cast as the ironically named Lucky, answered:

I would act Lucky in such a way to portray Sarajevo, portray this city. Lucky is a victim. And Sarajevo was a victim. I was maybe ten kilos less than now, so I didn't need any makeup and I just had to reveal a little bit of my body so you could see the bones and something that was supposed to be muscle. And everything that Lucky says that makes no sense was actually the voice of any person in Sarajevo.[26]

Izudin Bajrović thought the choice of the play was obvious:

We really were waiting for someone to come and to free us from this evil. We thought that would be a humane act. A decent act. To free us from this suffering. But nobody came to help us. We waited in vain. We waited for someone to say: this doesn't make sense, for these innocent people to be killed like this. We were waiting. We actually lived *Waiting for Godot*.[27]

———

Susan stayed at the Holiday Inn, a cheerful yellow building whose name associated it with middle-class vacations in unperturbed

destinations. Now, a scant decade after being built for the 1984 Olympics, it found itself stranded at the end of a wide avenue officially called Zmaja od Bosne but notorious all over the world as Sniper Alley. This was the main road from the airport into the city center, and its many high-rise buildings stared straight out at the Serb positions in the nearby hills.

From the airport, one reached the Holiday Inn in a United Nations armored vehicle or, failing that, by car: to avoid getting shot, the trick was reclining the driver's seat as flat as it would go, lying nearly supine, and speeding down the avenue as fast as possible. On the short distance between the airport and the Holiday Inn, people could be killed, and often were.

The hotel itself was a large rectangle surrounding a tall covered courtyard. The side facing the Serb positions had been shelled, but the far side was still largely safe. There, most foreign reporters were lodged. "One of the hotel staff said the place hadn't been this full since the 1984 Winter Olympics," Susan wrote.[28] The staff went to great lengths to keep up appearances, but their smart uniforms became increasingly ragged, and they cooked whatever food they had on an open fire on the kitchen floor.

By siege standards, the Holiday Inn was a place of luxury: there was food, in the form of the starchy rolls served at breakfast. In the blockaded city, even these were something of a miracle, and nobody was quite sure how the staff managed to find them. One actor, Izudin Bajrović, remembered what this food meant to Susan's starving cast.

> For some reason, from somewhere, she would bring us rolls that she would gather at the breakfast table. And we ate those rolls and it was wonderful. Now, when you eat a sandwich at work, it's not a big event. But at the time, when she brought those rolls, it was a very significant thing.[29]

Ferida Duraković recalled Susan's oblique ways of showing affection. "She was not a soft person," she said. "You had to be very careful talking with her and being in her company." Instead, she showed a more discreet solidarity:

> At that time, she was smoking a lot and she was very ner-
> vous and she smoked like half a cigarette and then put it
> out in the ashtray. Suddenly, on the third or fourth day, I
> saw the actors waiting for her to put the butt out because
> it was half of a cigarette. After a break of fifteen minutes,
> they would go back to the ashtray. One morning she real-
> ized what she was doing and never did it again. She either
> smoked it to the end or she left a box of cigarettes just next
> to the ashtray, like she forgot her cigarettes. That was the
> way not to humiliate the actors.[30]

Senada Kreso, an Information Ministry official responsible for helping foreign visitors, remembered another gesture, unforgettable because it meant being seen not as a wretched victim but as a normal woman. Whereas many foreign visitors would come with food, Susan appeared with "a huge bottle of Chanel No. 5" as a gift for Senada. "That marked the beginning of my utmost admiration for the woman, not just the author."[31]

And Bajrović never forgot her kindness.

> On August 18, my daughter's first birthday, Susan came to
> the rehearsal with a watermelon. For us—I can't describe. It
> was incredible. I couldn't believe it. And when she found out
> that it's my daughter's birthday she gave me half of the entire
> watermelon. It was beyond the lottery. As if someone would
> give you now a brand-new Mercedes. Even more! When I
> came home with half a watermelon, nobody believed they
> were seeing right.[32]

One of the most touching items in Sontag's archives is a drawing of a green-and-white striped watermelon. Above it, in a childish hand: "Susan is our big water-melon!"[33]

———

"I'm looking for my dignity. Don't laugh," Susan had written in her journal in 1971. The line would have rung true in Sarajevo, too, for people who, she said, had "to spend a good part of each day seeing to it that their toilets flush, so that their bathrooms don't become cesspools."[34] For Sarajevo as for Susan Sontag, culture was the best way to overcome humiliation and fear. "I do go to fetch water," said Ines Fančović, an older star of the Sarajevo stage, who played Pozzo.

> But it would be horrible if I were to think of myself as a water-fetcher. When I am working in the theater I forget about all else. I forget I need to carry up to thirty or fifty liters of water daily, forget I'm afraid of shells, that I'm so very afraid of shells.[35]

Throughout the hot, hungry summer of 1993, Sontag and her actors worked ten hours a day. The original Paris production—directed, not coincidentally, by a friend of Artaud's, Roger Blin—had basic scenography, and so did the Sarajevo production: not because of an artistic choice, but because there was no alternative.

> We played by candlelight [said Glamočak]. We had two little spotlights that were hooked to a generator. Sometimes we wouldn't have fuel for the generator. So then we would bring more candles, but then we would run out of candles. Then we made our own oil lamps. So that Beckett's world was perfectly placed in the here and now.

That here and now revealed difficulties that Beckett could not
have anticipated. Some obstacles were technical: "Lacking the
normal peripheral vision that anybody has in daylight or when
there is electric light," she wrote, "they could not do something as
simple as put on or take off their bowler hats in unison."[36] Some
were nutritional: despite her efforts to keep the troupe fed, the
actors were so undernourished that they would instantly lie down
as soon as there was a break. "Another symptom of fatigue: they
were slower to memorize their lines than any actors I have ever
worked with."

"Distraction, and fear" also made them forget their lines,[37]
and their fear was not abstract. The degree of danger varied, but
could never be put out of mind. One day, Sarajevo was hit by
nearly four thousand shells; another day, July 30, only one fell:
enough to kill Vlajko Šparavalo, a well-known Shakespearean ac-
tor. When the news reached the rehearsal room, Bajrović said,

> Susan came and asked if we're up to working today. I was
> the only one who said I don't think we should do it today.
> Everyone else said yes we should. And Susan agreed. Now,
> maybe I was pathetic that day. Maybe they were right. Every
> day someone was dying here.[38]

The actors were filled with the import of their work. In no
place but Sarajevo was such Artaudian drama possible, if "Artau-
dian" is taken to mean "the world of plague victims which Ar-
taud invokes as the true subject of modern dramaturgy."[39] Velibor
Topić, who played Estragon, gave an idea of what, in that context,
acting now meant.

> You couldn't fool the audience. You don't know if you're go-
> ing to be alive in five minutes or ten or the next day. So you

can't fool them. You have to give them your honest acting abilities because you just don't know if you can do another play the next day. I've played in front of wounded people, I've played in front of blind children, in the hospital, on the second floor, while people were having their legs cut off on the ground floor, people who were literally losing their lives, screaming, while I was playing.[40]

———

Against this background, the play took shape. Susan made significant changes to the text. The tramps, Vladimir and Estragon, became three different couples: a man and a man, a woman and a woman, and a man and a woman. This created another obstacle, making the play excessively long; and so Susan decided, seven days before the premiere, to cut the second act. "The second act would remain in the heads of the audience, as well as in the heads of all of us," Glamočak remembered her explaining. "Perhaps in the second act we could have simply sat down with the audience and waited with them, who's going to do what, what's going to happen now."

There were practical reasons for the abridgment: "How could I ask the audience, which would have no lobby, bathroom, or water, to sit so uncomfortably, without moving, for two and a half hours?"[41] And there were symbolic ones:

Perhaps I felt that the despair of Act I was enough for the Sarajevo audience, and I wanted to spare them a second time when Godot does not arrive. . . . For, precisely as *Waiting for Godot* was so apt an illustration of the feelings of Sarajevans now—bereft, hungry, dejected, waiting for an arbitrary, alien power to save them or take them under its protection—it seemed apt, too, to be staging *Waiting for Godot, Act I.*[42]

The production was acclaimed in Sarajevo, said Glamočak.

> She made a fantastic performance. Because she managed to
> create a performance that is happening here and now with
> somebody else's text, written so many years before we actu-
> ally played it.[43]

The symbolism was important, received, Senada Kreso said,
"as the story of our lives." Those who saw it never forgot it, said
Ademir Kenović, a producer who, miraculously, continued mak-
ing films throughout the war, including of *Godot*.

> It was giving hope, and when something is strong, in war it
> is a hundred times stronger. When something is good, it's
> a hundred times good. The psychological importance was
> HUGE. Susan Sontag is telling the world about what is
> happening here! So it's much bigger than you can imagine.[44]

———

If the play made a powerful impact on those who saw it, it was
also important for those who did not: for those for whom Bosnia
was a distant, inscrutable conflict. With what may have sounded
like false modesty, Susan wrote that she was "surprised by the
amount of attention from the international press that *Godot* was
getting."[45] She had often been accused of publicity-hounding, and
so it was in Bosnia: the Irish journalist Kevin Myers wrote, in
one especially cretinous example, that his "real mistake was not
radioing her co-ordinates to the Serb artillery, reporting that they
marked the location of Bosnian heavy armour."[46]

Yet she was right to be surprised. Only a few years before
Internet use became universal, getting news out of the besieged
city presented an almost insurmountable challenge. Any means
of communication that depended on electricity—radio, tele-

phones, telegraphs, television—had almost entirely ceased to exist. To file reports for the *New York Times*, John Burns resorted to a special military radio in the Presidency Building, where he dictated stories to a policeman in a town outside Sarajevo—a policeman who barely spoke English—who would then dispatch the stories to Split, in Croatia, and thence, by computer, to New York.[47]

The Bosnians were perfectly aware of the difficulties, and were not naïve about what would happen even if word did get out. But they were still hopeful, Izudin Bajrović said:

> We were hoping that this project would open the eyes of the world. And they will see what is happening to us and they will react. And we were hoping that Susan Sontag was powerful enough to move things. Our expectations were high, obviously. But we didn't even have the feedback whether the world has heard of this.[48]

When they learned how much publicity the production garnered, the besieged Sarajevans were thrilled. "The front page of the *Washington Post:* 'Waiting for Clinton,' 'Waiting for Intervention,'" said Pašović. "For us this was a very big victory—the *New York Times* and everybody wrote about it."[49] This was a recognition of the dignity that culture conferred. "We hoped that people in the outside world would learn about us," said the poet Goran Simić. "People in the West had the impression that we were quite uncivilized people."[50]

Susan was frustrated by the indifference of her powerful friends, but two did show up, and generated publicity of their own. In France, Nicole Stéphane had been making the rounds. Pierre Bergé, Yves Saint-Laurent's partner, was on holiday when the phone rang: "Susan is in Sarajevo and she wants to put on *Waiting for Godot*," Nicole said, "but she needs money. Can

something be done?"[51] Bergé immediately agreed, and soon enough, Susan wrote,

> Nicole surprised me by turning up in the besieged city (not an easy thing to do!) to direct herself, with only a cinematographer and a sound-man, a documentary centring on the production I was rehearsing with local actors in a bombed-out theatre of *En attendant Godot*. . . . Nicole was, as usual, fearless and enthusiastic—just as she must have been as the adolescent volunteer in the Free French Forces in London who participated in the Liberation of Paris.[52]

Miro Purivatra, who had asked David to bring Susan Sontag without suspecting that she was his mother, was in for yet another surprise. At the end of her first visit, Susan wondered if there was anything or anyone she could bring back, and he mentioned—without the foggiest notion of their connection—a famous photographer. "Maybe she could do some pictures here," he said.

> Then maybe five months later Susan Sontag is knocking on the door. "Hi, Miro. I have the guest you asked me to bring." She brought Annie Leibovitz.[53]

As soon as she arrived, Annie began making expressive photographs, including of the maternity ward at Koševo Hospital, where mothers were giving birth without anesthesia; and of the heroic journalists of the *Oslobođenje* newspaper, working to bring the news a stone's throw from the front line. Perhaps her most famous image was of a child's toppled bicycle beside a stain—a half circle, as in a Zen *ensō* painting—of blood. There was nothing airbrushed or removed about this kind of photography, as she remembered:

We chanced upon it as we were driving along. A mortar went off and three people were killed, including the boy on the bicycle. He was put in the back of our car and died on the way to hospital.[54]

"Photographing is essentially an act of non-intervention," Sontag had written in *On Photography*.[55] Now, she saw how essential images were to the Bosnian cause. Published in *Vanity Fair*, they brought the war to the attention of millions who would not have read David Rieff in *The Nation* or John Burns in the *Times*. In the pages of the magazine, Annie's work produced some odd conjunctions—"Here was suddenly Sarajevo next to Brad Pitt"— and in her own life. After photographing the murdered boy, she headed home: "I had to remember which side to shoot Barbra Streisand's face from."[56]

———

Sontag's *Godot* answered many of the essential questions about the usefulness of modern art. It did not save the boy on the bike, or usher in military intervention, or summon the great quaquaquaqua. But she found a way to offer everything she had, following Vladimir's exhortation in act 2:

Let us do something, while we have the chance! It is not every day that we are needed. Not indeed that we personally are needed. Others would meet the case equally well, if not better. To all mankind they were addressed, those cries for help still ringing in our ears! But at this place, at this moment of time, all mankind is us, whether we like it or not. Let us make the most of it, before it is too late! Let us represent worthily for once the foul brood to which a cruel fate consigned us![57]

If a condition of the modern artist—of the modern *person*—is awareness that Godot will not be turning up, that does not mean that that person is not needed, cannot make some difference. Sontag's determination to make that difference made her exceptional. "She was not *seen as* unique," said Kenović. "She *was* unique."[58] After her death, the plaza in front of Bosnia's National Theater was named Susan Sontag Square. It was an appropriate homage, Admir Glamočak said:

> Susan Sontag was made an honorary citizen of Sarajevo, the highest award the city gives: I don't have that award. I don't have my own square in front of the theater. Not only me, but none of the actors. Old actors get some little street in the suburbs once they're dead. But I always think: if it's Susan Sontag, she *deserves* that damn square.[59]

The Susan Story

Sontag produced *Waiting for Godot* in 1993, on her second visit to Sarajevo. She would return to Bosnia seven more times before the end of 1995, when the Dayton Accords were signed at an air force base in Ohio. The agreement ended the siege, but it partitioned Bosnia into the enclaves produced by "ethnic cleansing," and rendered the country economically stagnant and politically impotent. During the years of the siege, Susan's life would be inextricable from Bosnia's, and her heroic actions would continue entirely without the publicity *Godot* had brought.

On each trip, she brought rolls and rolls of deutsche marks, Bosnia's unofficial currency, hidden inside her clothes, and distributed them to writers, actors, and humanitarian associations. She brought letters to a place that was cut off from the world and had no functioning post, and took them out when she left. She won the Montblanc de la Culture Arts Patronage Award in 1994 and dedicated the proceeds to Sarajevo. She tried to begin

an elementary school for children unable to attend classes because
of the war; she spoke ceaselessly for the Bosnian cause in Europe
and the United States; she badgered friends in high places to help
people escape Sarajevo.

When Atka Kafedzić was refused a visa at the American
embassy in Zagreb, she picked up the phone. "Give me half an
hour and then go back to the embassy," Susan ordered. The visa,
needless to say, was granted, and eventually helped Atka's en-
tire family, fourteen people, begin new lives in New Zealand.[1]
Through Canadian PEN, she helped the poet Goran Simić, his
wife Amela, and their two children reach Canada. "Susan even
organized the housewarming party," said Ferida Duraković—and
for Ferida, who became pregnant during the war, Susan brought
mountains of vitamins and prenatal medicines. And she helped
Hasan Gluhić escape to the United States, since his work driving
her during the *Godot* visit endangered him: "The [Islamic] Fun-
damentalists were against her and against the play," he wrote in
an affidavit requesting asylum in the United States.

> On January 3, 1994, I came home from work to find my wife
> in tears and my children trembling with fear. The door of my
> house was painted over with the words "traitor" and "her-
> etic." At work the following day I found a note on my desk
> that read, "Gluhić: Remember what happened to Salman
> Rushdie. An Islamic Bosnia has no place for people like
> you."[2]

Sontag's archives bear evidence of her more than two years of
vigorous efforts on Gluhić's behalf. She wrote to everyone from
Senator Daniel Patrick Moynihan, who arranged a public interest
parole, to the Little Red School House, a private school in New
York, to beg them to admit Gluhić's children. And she found him
a job working for Annie Leibovitz.

"I wouldn't have believed it if I hadn't seen it," said John Burns. "Susan became tremendously popular. There was a tremendous ease about her manner, and not a trace of superiority."[3] Pašović knew her outside Bosnia and understood that, in places like New York, she needed to keep a certain distance. "She wasn't approachable, but that was her way to filter," he said. "Here that attitude vanished. She was just normal, and people related to her."[4] One symbol of her normality was her refusal to wear a flak jacket. The gesture was remembered by dozens of Bosnians, for whom it was a discreet way of emphasizing her equality, her willingness to brave the same risks—of being killed, of being maimed—that they faced every day. To Miranda Spieler, who was working for her around this time in New York, "she described liking the fact that she could be shot. She was talking about how in a sense it was exciting for her, the fact of being able to die."[5]

Duraković recalled the intense camaraderie and the many positive feelings the war evoked:

> She would bring liquor and we had wonderful talks and one of the main questions she asked was "What is your feeling about life under the siege? Are you disappointed, are you depressed?" I said: Never in my life—I was thirty-six then— never in my life I was so alive. I feel so wonderful. I want to live, I want to write, I want to see dawn, I want to meet people. I have a hunger for it. And she said: "That's so interesting, because when I got cancer that was for the first time in my life that I thought how wonderful is life."[6]

Kasia Gorska saw the change that Sarajevo brought her. "When she came back, she was just so loaded with energy. She was emanating this power from being right there in the center

of those events."[7] In 1994, in the middle of the war, she began a novel called *In America*, which, when published in 2000, would be dedicated "To my friends in Sarajevo"—and "all that book was full of Sarajevo, full of energy from Sarajevo," said Duraković. "She was alive here."[8]

But as love and success and money made her unhappy and unkind, her newfound purpose soured. Her indictment of the intellectuals who failed to rally to the side of Bosnia alienated the same people she was trying to recruit. If her activism was an inspiration, she wielded it as an admonishing finger, which was unfortunate, because there was no arguing with the analysis she offered in 1995:

> Individualism, and the cultivation of the self and private well-being—featuring, above all, the ideal of "health"—are the values to which intellectuals are most likely to subscribe. ("How can you spend so much time in a place where people smoke all the time?" someone here in New York asked my son, the writer David Rieff, of his frequent trips to Bosnia.) It's too much to expect that the triumph of consumer capitalism would have left the intellectual class unmarked. In the era of shopping, it has to be harder for intellectuals, who are anything but marginal and impoverished, to identify with less fortunate others.[9]

Like many who had witnessed terrible things, she found it hard to put her experiences out of mind. She found it hard, too, to be around people "who don't want to know what you know, don't want you to talk about the sufferings, bewilderment, terror, and humiliations of the inhabitants of the city you've just left," she wrote in 1995. "You find that the only people you feel comfortable with are those who have been to Bosnia, too. Or to some other slaughter."[10]

This was all perfectly understandable. But it became less so

when, two years later, this same analysis led her to tell other intel-
lectuals, in no uncertain terms, to shut up.

> You have no right to a public opinion unless you've been
> there, experienced firsthand and on the ground and for some
> considerable time the country, war, injustice, whatever, you
> are talking about.
> In the absence of such firsthand knowledge and experi-
> ence: silence.[11]

But did one have no right to deplore the siege of Sarajevo
without personally experiencing the "whatever" being inflicted?
Was there nothing to be learned about the world from literature
or film or photography—from art?

———

The police went off duty. "Everything she said about Bosnia was
admirable," said Stephen Koch. "Her behavior about it was insuf-
ferable. Because if you had not gone to Sarajevo yourself, you were
obviously just a morally inferior being. And she let that be known
very clearly, with almost sneering condescension."[12] The need for
moral invulnerability that had led to dalliances with questionable
political causes in the past now unleashed behavior that offended
people who were otherwise sympathetic and admiring.

Her attitude could verge into the comical, wrote Terry Castle,
who encountered her on "Palo Alto's twee, boutique-crammed
main drag."[13]

> Sontag was wearing her trademark intellectual-diva outfit:
> voluminous black top and black silky slacks, accessorised
> with a number of exotic, billowy scarves. These she con-
> stantly adjusted or flung back imperiously over one shoulder,
> stopping now and then to puff on a cigarette or expel a series

of phlegmy coughs. (The famous Sontag "look" always put me in mind of the stage direction in *Blithe Spirit:* "Enter Madame Arcati, wearing barbaric jewellery.") . . .

She'd been telling me about the siege and how a Yugoslav woman she had taken shelter with had asked her for her autograph, even as bombs fell around them. She relished the woman's obvious intelligence ("Of course, Terry, she'd read *The Volcano Lover,* and like all Europeans, admired it tremendously") and her own sangfroid. Then she stopped abruptly and asked, grim-faced, if I'd ever had to evade sniper fire. I said, no, unfortunately not. Lickety-split she was off—dashing in a feverish crouch from one boutique doorway to the next, white tennis shoes a blur, all the way down the street to Restoration Hardware and the Baskin-Robbins store. Five or six perplexed Palo Altans stopped to watch as she bobbed zanily in and out, ducking her head, pointing at imaginary gunmen on rooftops and gesticulating wildly at me to follow.

But she went beyond unintentional comedy. At a party in New York, her behavior caused Salman Rushdie to remark the fault lines in her personality.

She was really two Susans, Good Susan and Bad Susan, and while Good Susan was brilliant and funny and loyal and rather grand, Bad Susan could be a bullying monster. A junior Wylie agency employee said something about the Bosnian conflict that was not to Susan's liking and Bad Susan came roaring out of her and the junior Wylie agent was in danger of being devoured.[14]

Richmond Burton saw behavior once reserved for Annie leaking into all her interactions, "a martyr complex" linked to an

abusiveness toward people. "Her patience had just worn down," he said, "and it was somehow linked with Sarajevo. It kind of took over. Everything was another occasion for a tantrum. You'd think: Don't go there, Susan. And yet she did."[15]

She began speaking of herself in grandiose terms:

> Whatever I would do, whatever vocation I would assume, I know that I would not assume it in this selfish spirit. If I had become a doctor, I would have worked in a big hospital—I would not have had a private practice, sit in an office and see people coming with their silly problems and make a lot of money. No, I would have worked in a big hospital with poor people . . .[16]

"Something happened in which she was really seeing herself as this almost sacrificial heroic figure, in terms of her involvement in Sarajevo," said Burton. "I even heard her describe herself on the phone—comparing herself to Joan of Arc."[17]

———

The years during and after her involvement with Sarajevo became the golden age of the "Susan Story," whose protagonist was unable to perceive how she was perceived.

The woman who thought of herself as Joan of Arc was the same woman who ate so much caviar at Petrossian on Fifty-Eighth Street that, Larry McMurtry said, she "decimated the species." A series of movies and bestsellers had made him rich, and Susan took full advantage of his good fortune. One evening, his flight from Washington was delayed, and when he got to the restaurant, the maître d' told him that Ms. Sontag had departed, leaving him a piece of paper: a bill for the sumptuous, multicourse caviar dinner to which Susan had helped herself.[18]

Greg Chandler, a new assistant, witnessed many tantrums.

One took place in the summer of 1995, when she had to go to Madrid for the Spanish publication of *The Volcano Lover*. She hated having to go. Before the trip, she handed him a giant box with coins from all over the world that she had been collecting for decades, and instructed him to pluck out the pesetas. When he was finally finished, Susan examined his triage and spotted a franc. She brandished it reproachfully: "This is a franc!" she screamed. "This is a franc! What the fuck am I going to do with a *franc* in *Spain*?" She flew into a rage, then took the coins and flung them all around the room.

"I dutifully cleaned up the mess," said Chandler, "feeling like Christina Crawford."[19]

———

"I have preferred to write as little as possible of my relations with my mother in the last decade of her life, but suffice it to say that they were often strained," David acknowledged.[20]

Even the people in Susan's entourage who disliked or resented David agreed that he was in an impossible position, as his engagement with Bosnia showed. In 1995, he published *Slaughterhouse: Bosnia and the Failure of the West,* an indictment of the "international community": the people Bosnians meant when they joked about "waiting for Clinton." The book addressed many of the linguistic questions that Susan had posed in Vietnam. "The French *were* 'the French colonialists'; the Americans *are* 'imperialist aggressors,'" she wrote then.[21] Now, David wrote that "The Chetniks *were* fascist aggressors in the strictest sense of the term, and the defense of Sarajevo *was* heroic."[22] They shared some interests, but David's was the work of a journalist rather than an aesthete, far more rooted in real politics than anything Susan could write.

From David's perspective, Susan's involvement in Bosnia was awkward. This was in part because he had brought her there him-

self, and in part because she had not been unambiguously supportive of his writing. In January 1993, Annie organized a Nile cruise for Susan's sixtieth birthday. Among the guests were Howard Hodgkin, who contributed his paintings to "The Way We Live Now," and his partner, Antony Peattie. "She was scathing about [David's] writing, his affairs, his life," said Peattie.[23] And Hodgkin saw "the verbal equivalent of sawing him off at the ankles whenever the opportunity arose. She was really very nasty."[24]

In Bosnia, David had discovered a mission. After meeting Bosnian refugees in Germany, he felt "the strongest sense of compulsion I have ever known as a writer . . . and boarded a flight to Zagreb."[25] Faced with the horror and injustice of the Bosnian war, he could hardly speak of anything else. Back in New York, he tried to convince others to come to Sarajevo: "I invited dozens of people, but the only person I persuaded was my own mother!"[26]

She was aware of the conundrum her presence created for David. In public, she would defer to him. "I'm not going to write a book because I think in this family business there must be a division of labor—he writes the book," she declared on her first visit to Sarajevo.[27] Two decades before, Paul Thek had denounced "the establishment of the Sontag dynasty in Amer. Letters." Now, she still thought of writing as a "family business." At first, she tried to keep to the side, "because she thought this was David's story," said Haris Pašović, "but later it was inevitable that she would also write about it."[28] David simply said: "It was not a promise she was able to keep."

Even before she came, he knew that if she got involved, "her role would inevitably eclipse mine."

I was proud of what I had done in Bosnia. I had worked mainly in the north, in Serb-occupied Banja Luka and around the camps—a terrifying part of the world in the day. I had taken enormous physical risks and paid dearly for

my willingness to do so (I was badly hurt, and by all rights should have died, in the fall of '92 near Zenica in Central Bosnia). And Bosnia was my cause—perhaps the only one I have ever fully believed in.[29]

But he had a clear choice to make. "Which was more important, the attention Sarajevo would derive from my mother taking up the Bosnian cause and working there, or my own ego and ambition? Bosnia was infinitely more important than my wish not to be eclipsed by my mother." David was careful to give Susan credit for what she accomplished in Sarajevo, but what was good for Bosnia was not necessarily good for their relationship.

We were estranged, but there was no break. We still saw each other, and there are moments in the diaries where she talks, before Bosnia, about my not being available, to my being less there for her. It wasn't like Thor's hammerbolt: Bosnia happened and everything changed between us. But it didn't help.

She knew this—"she felt like she was stealing David's thunder," she confided to her sister—but proved, as so often, unable to make something emotionally useful out of something she might have known intellectually.[30] Even seven years after the end of the siege, when she was preparing her last book, *Regarding the Pain of Others,* she wrote her friend Paolo Dilonardo:

David does mind, very much, my doing this book. For him, it's a continuation of the betrayal of "Waiting for Godot in Sarajevo," which he asked me, in 1993, not to write, after I had promised it to the NYRB. Last night at Honmura An: "Couldn't you leave me this one corner of the world as my subject?" That is, war. When I said, but it's a sequel to

On Photography, he replied, it's about history, and about war, and you know nothing about history. You got all that from me, etc. You're poaching on my territory.

I'm heartsick. But there's nothing I can do.[31]

———

Nothing I can do: the phrase remits to the same questions about the usefulness of art that Sarajevo posed. What was the point? "Art was there to make you a more sensitive and a more humane human being," said her Bosnian friend Senada Kreso. "Art can make you cry, it can make you happy, it can make you sad, but not *help.*"[32] Art, by itself, could not summon the armies Sarajevo demanded. But as many of Susan's relationships—with herself, with others—showed, it could not even always make a human more humane.

"How should one live?" she asked her diary at the height of the siege. "The great question of 19th century Russian literature . . . I live under the aegis of 19th century Russian literature."[33] Sontag had always turned to literature, to art, to help her answer this question. Art offered a model of solidarity. But to aestheticize is to distort, she argued throughout her life. And her own life illustrates this thesis as eloquently as anything in her writing. Does metaphor deepen one's relation to reality—or, to the contrary, pervert and pollute it? Put another way: Can Dostoevsky help you get along with your son?

This was what she argued in 2002, describing "the role of literature itself" as a means "to extend our sympathies; to educate the heart and mind; to create inwardness; to secure and deepen the awareness (with all its consequences) that other people, people different from us, really do exist."[34] Yet to learn about her life in its last years is to see that such awareness cannot be secured through art. Absent native empathy, no amount of metaphor can help, and no amount of literary knowledge—who had more than

she?—can substitute for an ability to see others. Years after she confided that she was "not very sharp about other people, about what they are thinking and feeling," after she said "I'm sure I have it in me to be empathetic and intuitive," she had still not learned empathy.

If stories about Susan, in these years, told of obliviousness, they also, increasingly, told of cruelty. She could not bear even the most delicate intervention, and she evaded intimacy when friends tried to evoke it, as her assistant Karla Eoff did one day, when she was helping Susan pack for a trip. They were playing around as they had done in earlier days, and Karla, hoping to spark a serious conversation, said: "Susan, it's so nice to have you back with me." Susan answered:

> "I'm only going away for a couple of days." I said, "That's not what I'm talking about. Some part of you has gone away, and I see the real Susan—not often enough, and I am really, really missing it. It's just painful to be around the other Susan." She said, "I don't know what you're talking about!" and got up and took off.[35]

"She didn't have regular friends" in the mid-nineties, said Miranda Spieler. "She was pretty isolated."[36] On January 27, 1996, a volume of the Loeb *Greek Anthology* open on his desk, Brodsky had died in New York. It was a hard loss. "I am all alone," Susan told Marilù Eustachio. "I don't have anyone to talk to, anyone with whom I can exchange my ideas, my thoughts."[37] Brodsky was one of the few people she admitted as a superior. Now he was gone.

———

In *On Photography*, she had written of "how plausible it has become, in situations where the photographer has the choice be-

tween a photograph and a life, to choose the photograph."[38] Now, she, too, chose the Warholized personality, the opposite of what she had seen as the goal of Cioran's work, "to keep one's life from being turned into an object, a thing." Increasingly, she interacted with similarly aestheticized others. Leon Wieseltier was astonished, one evening, to hear that she had just been hanging out with Debbie Harry, the lead singer of Blondie. "She entered this universe where you knew Mick Jagger but you didn't know the Stones. It's A-List land. Everyone is great friends, and nobody knows anybody."[39]

There, if one was famous enough, the rules that bound the layman no longer applied. But in exchange for that freedom, one had to choose the photograph—the image—over the life; and this, the young Sontag had written in *The Benefactor*, was a kind of death.

> He is gone: aged, transfixed by the great stare of the public eye, frozen. Now he is utterly famous. Everyone laughs at his mockery, he can offend no one. His acts have been transformed into postures.[40]

Sontag's next book, which she began in 1994, was about a woman who occupied the public eye without pain or ambivalence, "utterly famous."

CHAPTER 37

The Callas Way

In America opens with a flash of memoir. In Tucson and Los
Angeles, Sue discovers the wobbly stirrings of vocation:
"Steadfastness and caring more than the others about what
was important would take me wherever I wanted to go." She re-
calls her marriage to Philip Rieff: "I married Mr. Casaubon after
knowing him for ten days."[1] And she describes her first encounter
with a diva:

> I remember the first time I ever saw a diva up close: it was
> more than thirty years ago, I was new in New York and se-
> riously poor and a rich suitor took me to lunch at Lutèce,
> where, shortly after the first delicacies had materialized on
> my plate, my attention was galvanized by the (come to think
> of it) familiar-looking woman with high cheekbones, raven-
> black hair, and full, red-painted mouth eating at the next
> table with an elderly man to whom she said loudly: "Mr.

Bing. [Pause.] Either we do things the Callas way or we do
not do them at all."[2]

She could not have foreseen how many people would later
tell of their first sightings of Susan Sontag in similarly starstruck
tones. And it is the figure of the diva that connects *In America* to
her earlier fiction. This character dramatized the contrast be-
tween the person and the aestheticized person, between reality
and dream: Sontag's great theme. The diva is the dream of others.
They fantasize about her, long to possess her, idealize her beauty,
worship her genius, envy her wealth and fame. She is the product
of a collective will—a product, like literary or political fictions,
with a reality of its own.

From the time Susan was a child and started calling her
mother "Darling," she had been obsessed with this dream-figure.
"I wanted to *be* Garbo," she wrote in 1965, explicitly connecting
this desire to her homosexuality. In a later journal, beneath the
word "DIVA," she wrote "Detest . . . adore" and then offered the
following list.

> I detest paying visits, writing letters, signing photographs. I
> adore having people come to see me, and I detest going to
> see them. I adore receiving letters, reading them, comment-
> ing on them, but I detest writing them. I adore giving advice
> and I detest receiving it, and I never follow at once any wise
> advice that is given me.[3]

Her writings were peopled with divas: Garbo, Callas, Bern-
hardt, Medea, Lady Hamilton—and, now, Helena Modjeska, the
Polish actress who, in *In America*, became Maryna Zalewska.
Sontag descended from two generations of movie "fans-fatales,"
as she described her mother. And her childhood in the shadow of
Hollywood had taught her, like the masses of the unfamous, to

use the movies as an escape—not simply from a tedious, worka-day life, but from consciousness itself. What she craved from art was annihilation, *la petite mort:* "It is this longing to have one's normal consciousness ravished by the singer's art that is preserved in an irrepressible phenomenon usually dismissed as an oddity or aberration of the opera world: diva worship."[4]

This was a darker idea of the diva. Stardom was not the same as happiness. Instead, for one who had renounced happiness, it was perhaps the best one could hope for.

Maryna sat down and looked into the mirror. Surely she was weeping because she was so happy—unless a happy life is impossible, and the highest a human being can attain is a heroic life. Happiness comes in many forms; to have lived for art is a privilege, a blessing.[5]

"I identify entirely with those words,"[6] she assented, when an interviewer asked whether this was a self-portrait. She had grown up without the expectation of happiness; and her friend Michael Silverblatt agreed: "For Susan, happiness was a trivial subject. I don't think she would have been interested in happiness. That was not Susan."[7] A kind of contentment, instead, was generated through the most intense forms of art: the theater of Artaud, the operas of Wagner.

She was a tragedian. She wanted absolute passion. The heightened quality, that's Susan. Maybe sometimes a mon-ster, and many of my friends told me that they would never be anywhere with Susan, ever again, not to even think of it, not to ask them. She really was very, very rough on people. I have no illusions about that. I am saying that for Susan, it was always an occasion—first for a bravura scene, and then for an aria.[8]

"I do have this fantasy of tearing everything up and starting all over again under a pseudonym which no one would know was Susan Sontag," she told an interviewer in 1978. "But I just want to say that my notion is very much that of going further and further, of new beginning, and of *not* going back to origins."[9]

With *In America* she would find a way to go further—into her preferred identity as a novelist—while at the same time going back to origins. The novel was based on the true story of Poland's greatest actress, who, in 1876, at the height of her fame, uprooted a troupe of friends and traveled halfway around the world in order to create a utopian colony in Anaheim, California. To no one's astonishment, the colony did not flourish; but Modjeska did, returning triumphantly to the stage and acquiring all the signs of gaudy American success. These included her own train, complete with "a large watercolor painting of your pet pug adorning a panel of the parlor of your private car."[10]

For so many reasons, the story was irresistible to Sontag. There was the theme of starting over, this time in a dreamlike utopia. (In the sixties, alongside her writing on Vietnam and Cuba, she worked for a time on a novel, *Joseph Dover*, about the founding of a utopian colony.) And there was the theme, as in her memoir on Thomas Mann, of European sophisticates stranded in materialistic California.

It requires little imagination to hear Sontag's voice in Maryna's. "We're always talking about ourselves when we talk of anything else,"[11] she avows in the novel, and her reflections on what motivates a person to become famous, and what fame demands of the famous person, are the best part of the book. "It was partly so as not to feel like a child, ever, that she had become an actress," she writes.[12] As an actress, Maryna was also freed from the restraints imposed on women: "A woman could not say much," she

wrote. "A diva could say too much. As a diva, with a diva's permissions, she could have tantrums, she could ask for the impossible, she could lie."[13]

In America, a diva's permissions were granted more generously than in Europe.

> In America, you were expected to exhibit the confusions of inner vehemence, to express opinions no one need take seriously, and have eccentric foibles and extravagant needs, which exhibited the force of your will, the spread of your self-regard—all excellent things.[14]

And America was itself founded on a requirement of the acting profession: to keep moving, to the next city, the next costume, the next role. An actor could discard a former existence like last night's costume: "To change one's life: it's as easy as taking off a glove."[15] Not even a new life was enough: "It wasn't a new life M. wanted, it was a new self."[16] This self was there for the making:

> Giving interviews entailed rewriting the past, starting with her age (she lopped off six years), her antecedents (the secondary-school Latin teacher became a professor at the Jagiellonian University), her beginnings as an actor (Heinrich became the director of an important private theatre in Warsaw where she made her debut at seventeen), her reasons for coming to America (to visit the Centennial Exposition) and then to California (to restore her health). By the end of the week Maryna had begun to believe some of the stories herself.[17]

The illusion of intimacy was the permission America gave the diva: "You go somewhere, you please people, and then you never have to see them again."[18] Emotions were useful when they

could be performed, and even Maryna's famed lack of fakeness is fake: "There was nothing natural about this naturalness, which was concocted for each role out of a thousand tiny judgments and decisions."[19] Eventually, "it became harder—does this always happen to great actors?—to remember the difference between what she said and what she thought"[20]—between being and pretending to be.

———

"I believe I can give a faultless imitation of the emotions that may elude me in real life," says Maryna. And Susan often gave the impression of offering, in place of true feelings, a faultless imitation, as Gary Indiana said:

> She worked up to her exaltations with an eye to impress those around her with a depth of feeling that seemed a bit dramatized and artificial. It took formidable willfulness for her to cry at the end of Vigo's *L'Atalante*, I thought, when she had already seen it thirty times. . . . Susan heaved from one enthusiasm to the next, a storm-tossed vessel calling in at every Port of Epiphany.[21]

"I am myself an actress," Sontag told a Polish journalist in 1998, "a closet actress. I always wanted to write a novel about an actress. I understand what acting is all about."[22] And on the evidence of this novel, she also understood that a danger of faking emotions is that one ends up confusing performance for reality. Sontag was almost ideally equipped to analyze these themes; yet in order to plumb them, she needed a sense of irony, of distance, that she had so far failed to attain, and her infatuation with Maryna undermined a book that might otherwise have been a masterpiece.

> An actor doesn't need to have an essence. Perhaps it would
> be a hindrance for an actor to have an essence. An actor
> needs only a mask.[23]

Sontag had earlier written of the longing for a doppelgänger, a body double, a literal or metaphoric clone; she had offered "Being-as-Playing-a-Role" as a definition of camp: "the farthest extension, in its sensibility, of the metaphor of life as theater." But here, the effects of life as performance pass largely unexamined, and she describes Maryna in ways that, for one acquainted with her life, become uncomfortable. "I too am not a good mother (how could I be? I am an actress)," Maryna sighs. "Actresses make willful mothers," she later reiterates, "smothering and neglectful."[24] There is no examination of what this might mean for the child, and Sontag grants a similar leniency to Maryna's treatment of her lovers, who are reduced to foils for her ambition: "I loved him with that part of me that wanted to be someone, someone who would do great things in the world."[25]

Love, in this book, is something received from frenzied fans, a state of constant throbbing excitement, "passion," the "quasi-amorous approval of innumerable, never to be known or barely known, others."

> The *à deux* thing isn't, can never be that important to me.
> I understand that now. *Déformation professionelle*, if you
> will.[26]

Once she achieves stardom, the diva floats, in her private train, from place to fabulous place, delighting crowd after adoring crowd, heaping up laurels and lovers. The greater her success, the more fantastic Sontag's descriptions become. Fantastic, as in "fantasy."

The woman she created—both Maryna and "Susan Sontag"—
could combine Joan Crawford's outrageousness with Greta Gar-
bo's blankness. She could compare herself to Joan of Arc, and be
famous for being famous, and live in A-List land, and do things
the Callas way. The only requirement was that she be "not a
woman, but a 'woman.'"

In Sontag's best writings, she chastens her own enthusiasms.
She is "strongly drawn to Camp, and just as strongly offended by
it." Her relationship to the aestheticized woman in *In America*
was an embrace of the "larger than life"; yet to the astonishment
of her friends, she refused to admit that the category of the diva,
which had fascinated her since childhood, applied to her. "She
would get very angry" when Silverblatt suggested it. "She hated
the categorization, of being 'the diva.' She just couldn't stand it.
She couldn't accept it."[27] The self-analytical Sontag—the one
dedicated to self-improvement, the one who wrote that "I've al-
ways identified with the Lady Bitch Who Destroys Herself"—
had vanished.

After decades of censoring her desires, repressing them, she
was, in a sense, liberated. Silverblatt saw her larger-than-life per-
sona as a key to her enduring appeal to ambitious women.

> Susan had decided to be that kind of woman—the woman
> who gets what she wants. We never use these words any-
> more, but we called such women "hellcats." We don't even
> call them femmes fatales anymore. All of that diction for
> the woman strong enough to go after what she believed was
> hers. The role of Regina in Lillian Hellman's *Little Foxes*
> is the role of the little sister strong enough to take over her
> brothers and murder her husband in order to gain control of

the family fortune. She sometimes had to play a villainess—
and when I say villainess, [I mean] an old-fashioned movie
villainess. That was one of her facets. She didn't care what
you wanted or expected her to be. That was a self-conscious,
morose, self-absorbed person who thought first about conse-
quences. For Susan, consequences be damned.[28]

———

The title of *In America* alludes to a place where an individual need
have no fixed identity. This notion partly reflects Sontag's experi-
ence in Bosnia, to which she refers in the preface. In Bosnia, and
by extension in Europe, identities were immutable—even those
identities that people, like the Yugoslavs, were hardly aware they
possessed.

"The past is not really important here," she wrote. "Here the
present does not affirm the past but supersedes and cancels it."[29]
Critics frequently mentioned this characterization. "Europe is
about the past, about roots and tradition; America is about the
present, about freedom and newness and change," wrote Michiko
Kakutani in the *New York Times*.

> America, we're told, is "where the poor can become rich and
> everyone stands equal before the law, where streets are paved
> with gold." America is "where the future is being born."
> America is where "everything is supposed to be possible."
> "The American," Ryszard declares in a letter, "is someone
> who is always leaving everything behind."[30]

Though hackneyed, this depiction never seems indignant
or malicious, as Sontag's Vietnam-era writings sometimes had.
Instead, it adds up to a place where identities are switched and
shed at will: "a whole country of people who believe in the will."[31]

In Vietnam, she condemned "the principle of 'will'" as "what's most ugly in America." In 1960, she noted in her journals a "project: to destroy the will." Now, unambiguously, she praised the American will, and Maryna's journeys amount to a "geographical cure"—an escape. "Happiness depended on not being trapped in your individual existence, a container with your name on it,"[32] she wrote. Her success strengthens Maryna's belief in the will: "I have proved to myself once and for all that with a strong enough will one can surmount any obstacle."[33]

But not even the greatest actresses can avoid certain "traps," especially the cruelest trap of all. Fake death was a theme in Sontag's youthful fiction, and it returns in this novel in a stupendously literal form.

> It was generally acknowledged that her greatest success in dying was in *Camille,* during one performance of which, reported the town's leading newspaper, *The Territorial Enterprise,* two members of the audience, in different parts of the thousand-seat theatre, were so transfixed with horror at seeing Marguerite spring from her couch and fall with a terrifying crash, dead, upon the floor, that both were struck with a rigidifying paralysis and remained unable to rise from their seats for a full hour after the performance had ended.[34]

For her willfulness, for her determination to overcome death, her minions praise her.

> "She just doesn't know how to die," said Ryszard.
> "An inspiration to us all," said Mrs. Withington.[35]

———

In June 1998, as she was writing these words, Susan was staying with Paolo Dilonardo in Bari, finishing the book. She had met

him when he translated *The Volcano Lover*. "He looked strange and interesting," said Annie. "And she loved Italy, and she'd had so many great romances, such a great life there, and she liked hearing that Italian accent."[36] Where David challenged and often fought with her, Paolo never disagreed with her, and Susan felt confident with this good son nearby.

Now, the heroine of the will was beginning to bump up against real life. "Perhaps, Maryna wondered gloomily, she had used up the allotted number of impossible feats her will could make possible."[37] This wondering happens toward the end of the book. "Nothing can stop me now," Susan thought as she was writing it. A few days later, she started urinating blood.[38]

CHAPTER 38

The Sea Creature

For nearly twenty-five years, Sontag had been dreading the recurrence of cancer. In July 1998, back in New York, the diagnosis arrived: uterine sarcoma. The tumor was the size of a grapefruit, she told a friend, spiked "like a sea creature."[1] This creature was eating her from the inside, and the treatment was a hysterectomy followed by radiation and chemotherapy. It involved doses of cisplatin, a platinum-based drug. This might be effective in combating her sarcoma, she was warned, but it filled her body with heavy metals, which could later provoke different diseases.

Susan was now sixty-five and had a good idea of what treatment would involve. "She was sure she was going to die," said Michael Silverblatt. "She felt she could face the cancer, but I'm not sure she felt she could face the chemo and all the subsequent weakening that the treatment would involve." She said these things "very simply." But if she was daunted by the ordeal, she was also bravely determined to get through it. She once said to

a friend whose partner had cancer: "Remember: this is not a de-
tour in her life. This *is* her life."[2] And now, said Silverblatt, "her
life became facing the disease. She made her home into a field of
battle. She kept records of all her blood work. Anything a doctor
had, she had, too. She had her X-rays on her computer."[3]

She focused on the physical aspects of the disease in order to
allay her suffering and fear. This focus was what she had offered
others in the same situation. "My purpose was, above all, practi-
cal," she said of writing *Illness as Metaphor,* which had appeared
twenty-one years before. During her first cancer, when she asked
other patients what drugs they were receiving, they would inevi-
tably answer "chemo." Now, she marveled that when she asked
the same question, "polysyllables would come tripping off their
tongues."[4] The responsibility was not hers alone, but her insistence
that patients ought not submit unquestioningly to medical au-
thority meant that many people were, like her, hitting the books.
And not only the books: "The Internet is the new Ground Zero of
21st century illness."[5]

She saw negative changes, too. Like everything else, sickness
and health were products to be marketed and consumed. "The
pharmaceutical industry plays a huge, if not actually controlling,
role, its paraphernalia and propaganda reaching directly into the
waiting room, the examination room, and the hospital room.
New capitalist medicine—which is ruled by the bureaucracies of
insurance companies—has undermined in a far more radical way
the authority of doctors to make independent decisions on behalf
of patients." As always, she was attentive to the language in which
this change was cloaked. The doctor is "a purveyor of medical ser-
vices," she wrote; the patient, "a consumer of medical services."[6]

Her sickness brought up another fear: that she would not live
to complete *In America.* She thought that finishing the book was
more important than survival itself, and Silverblatt agreed. Even
if she died, he said, it would be a great final triumph: "I thought

that finishing the book was at least as important as dealing with her cancer." She pressed on, and the book bears the shadow of her struggle. "You feel it's been born with pain," said Kasia Gorska.[7]

Indeed, something unspeakable, something that cannot be named, lurks beneath the novel's swaggering surface. "And could Maryna herself be——? Was it now her turn to come down with——?"[8] *In America*'s final scene is a single paragraph, twenty-seven pages long; and if it occasionally reads like a rant, that is because it was produced "in a cloud of painkillers," said Joan Acocella, who interviewed her in 2000.[9] For at least two years, Sontag would be in severe pain, and she would never be entirely well again: she developed neuropathy in her feet, which made it difficult for her to walk, and forced her into physiotherapy.

But the cancer had a consolation. In the mid-nineties, as her relationship with Annie degenerated, she and Lucinda rekindled their affair. Susan had never stopped loving Lucinda, and brushed off Annie's protests. Carried on principally in Europe, the relationship wounded Annie; but the need to take care of Susan inspired the women to join forces to care for her.[10]

———

"God knew how weak she was," she wrote of Maryna, "but forgave her because she tried so hard."[11] Sontag, forever "trying a little too hard," was less forgiving of herself. Behind Maryna's sentiment is an idea—the idea of the American secular puritan—that salvation is a reward for a pitiless work ethic. Once Susan vanquished the cancer, she was even more than usually determined to wring the most out of life. "There are just 24 hours in a day," she said, "though I try to treat it as though there were 48."[12]

This determination seemed admirable—inspiring, even. But she pushed herself mercilessly. If, when she was sick, she displayed a single-minded devotion to science and treatment, she seemed to forget this devotion as soon as she was healthy again, neglecting

her body and rejecting "the ideal of 'health'" as a bourgeois ego-
tism. Despite loving science, as David wrote, "with a fierce, un-
wavering tenacity bordering on religiosity,"[13] her disregard for the
most basic scientific guidelines shocked those close to her.

Ever since she read *Martin Eden*, she had equated sleep and
death. Greg Chandler noted her "bizarre obsession with sleep,"
and said that she "often took naps and would deny it even to me
after I'd gone into the bedroom and seen her—and heard the
powerful snoring." This was Terry Castle's experience, too, when
she arrived in London Terrace and found a Sontag who had obvi-
ously just been roused. She apologized for waking her.

> It was as if I had accused her of never having read Proust, or
> of watching soap operas all day. Her face instantly darkened
> and she snapped at me violently. Why on earth did I think
> she'd been having a nap? Didn't I know she never had naps?
> Of course she wasn't having a nap! She would never have
> a nap! Never in a million years! What a stupid remark to
> make! How had I gotten so stupid? A *nap*—for God's sake![14]

Susan had long stunned others with her appetite: for food,
for culture, for experience. She referred to it as her "legendary
energy"—her ability to march from one event to the next, never
displaying the slightest sign of fatigue, professing dismay with
anyone unable to keep up.[15]

———

In Sarajevo, she spent many a candlelit night with John Burns,
the *New York Times* correspondent: "I can see that badger hair
now." Burns was recovering from near-fatal cancer, and they dis-
cussed the suffering engendered by stereotypes around illness. He
recalled a "mind-over-matter" doctor who gave him crayons and
encouraged him to "make cancer your friend." They laughed. But

Burns confessed that when he became ill he had, in fact, imagined that he had "mocked God." And "Susan understood what I felt about cancer being a punishment."[16]

Cancer was not a punishment for mocking God. But it could be a punishment for mocking science, and even Susan, so dismissive of "health," was aware that smoking was a bad idea. In 1993, a Brazilian reporter called her back to ask what brand of cigarettes she was smoking during their interview. "Susan was furious," he remembered. "She said it would be shameful for her to give out that information, since she'd had cancer and didn't want people to know she still smoked."[17] She was still smoking at least two packs a day, and sometimes, when she was out with Karla and a photographer approached, "she would shove the cigarette into my hand, even if I already had one."[18]

In 1995, three years before her second cancer, she attended a program called Smokenders. Her course book is filled with the kind of "pop psychology" jargon she found hilarious. Much of it was related to "Freud's general thesis—sickness conceived of as historical." She noted, "Your attitude is the only difference between success and failure." She chirped, "Avoid self-pity—laugh at yourself—pick yourself up." And she encouraged herself: "Self-pity is a negative thought—replace it with a positive thought. Eliminating self-pity allows self-respect to return."[19] There was practical advice: "Don't wash ashtray until next week," the great student noted. "No smoking in any trigger situation."

This was all standard for smoking cessation programs, but it appears, in Sontag's handwriting, like Duchampian ready-mades.

 observe smokers
 do they look glamorous
 do they look as if they're
 enjoying themselves

The key to self-improvement was "advertising to yourself."

Say it to yourself out loud
 when you wake up,
 when you go to bed
 "good strong
 positive thought"

There are "Reasons why I want to quit smoking (specific)":

So I won't get lung cancer
 So I can avoid emphysema
 To please David
 To stop coughing

And "Dreams (things you would still like to accomplish, do . . .)":

Go up/down the Amazon
 Have great sex

A phrase of William James's makes a surprising appearance amid the "Smokendertalk." He had said that "the greatest discovery of my generation is that people can alter their lives by altering their attitudes." Not always: Susan failed to quit smoking. But Smokenders and organizations like it popularized the writings of James and Freud's generation, their contention that mental attitudes—the will—could, when consciously steered, improve lives. If their ideas in part derived from religion, these ideas were reinvented without the moralism—the concept of sin, of mocking God—that underpinned earlier approaches to self-improvement. A Christian imagined the passion of Christ. A psychotherapeutic patient used her imagination, too.

A belief in the reality of dreams had created Sontag and kept her going through a difficult life. So many of her difficulties came from her refusal to see what most people thought of as reality. But there was a usefulness to the dreamworld. "Create 'dream picture,'" the Smokenders instructor said. "Something pleasing, relaxing . . . use for distraction." As it happened, she had lived her life in the "dream picture." In certain respects, this was a strength, and an anesthetic. She refused to accept limitations—to her talent, to her achievements, to her possibilities for reinvention—that would have stymied more clear-eyed people.

On October 19, 1998, when *The New York Review of Books* celebrated its thirty-fifth anniversary, a gaunt Sontag attended in a long black wig. And in the spring of 1999, she was strong enough to return to Bari. She needed Paolo's unconditional support in order to finish the book. But she was distracted by the disaster still unfolding across the Adriatic: the last act in Slobodan Milošević's wars.

———

In 1995, the Dayton Accords put an end to the Bosnian war. But Milošević was determined to teach a lesson to yet another former Yugoslav people, the Albanians of Kosovo. In Communist Yugoslavia, this Serbian province had enjoyed a large degree of autonomy, but that autonomy was curtailed during the breakup of Yugoslavia, and vigorous repression of the Kosovo Albanians—90 percent of the population—began. Amid the general calamity, this repression had not received the attention that it deserved; but to anyone watching, it seemed only a matter of time before it degenerated into open warfare. When Milošević's army began an ethnic cleansing operation that resulted in the expulsion of around a million people, the "international community" that had sat on its hands in Bosnia had finally had enough.

The Kosovars would not be waiting for Clinton as long as the

Bosnians had. On March 24, 1999, NATO began bombing Serbia. Over the seventy-eight days of the campaign, President Clinton was criticized by many of the same people who had criticized botched American interventions in the past, from Vietnam and Cuba in the sixties to Nicaragua, Lebanon, and Panama in the eighties. But if readers of "Trip to Hanoi" expected to find Susan Sontag among them, they were disappointed by a long essay published in the *New York Times* on May 2.

"Why Are We in Kosovo?" was written in Bari. This was not far from an Italian air base from which NATO planes left for sorties over Serbia. Many Italians opposed the bombing. "The right is against immigrants," Sontag wrote. "The left is against America." Much of the piece criticizes Europeans for abandoning the ideals of postwar Europe: "The Europe that let Bosnia die." It was the same disappointment in Europe that appears in *In America*. That book portrayed a vulgar and materialistic America; but as she nevertheless embraced her country in that book, now she argued that Clinton was right to intervene.[20] "Not all violence is equally reprehensible," she insisted. "Not all wars are equally unjust."

The essay, like so much of her work, is an argument about how to see. It opens with a friend's call from New York, asking her whether Sontag, in Italy, could hear bombs exploding in Serbia. Her "geographyless American friend's vision of European countries being only slightly larger than postage stamps" is easy to mock. But geography was the least of it. Anyone paying attention could see what was happening in Kosovo. It was not a question of where one was—but where, and whether, one was willing to look.

Of course, it is easy to turn your eyes from what is happening if it is not happening to you. Or if you have not put yourself where it is happening. I remember in Sarajevo in

the summer of 1993 a Bosnian friend telling me ruefully that in 1991, when she saw on her TV set the footage of Vukovar utterly leveled by the Serbs, she thought to herself, How terrible, but that's in Croatia, that can never happen here in Bosnia . . . and switched the channel.[21]

This support did not go unnoticed in Washington. And a few days later, Susan was invited to a state dinner at the White House. The guest of honor was the president of Hungary, Árpád Göncz. He had been sentenced to death under the Communist regime, taught himself English in prison, and became a writer and translator once he was freed. Among his publications was an anthology, *A pusztulás képei (The Imagination of Disaster)*, which collected many of Susan's essays, including "The Aesthetics of Silence" and "Notes on 'Camp.'"[22]

The Kosovo campaign was ongoing; and in his toast, President Clinton saluted President Göncz's commitment to the "European" principles Susan had seen abandoned in Sarajevo.

Your vision of people living together and nations living together, resolving differences peacefully, drawing strength from their diversity, treating all people with equal dignity, this will form the basis of a better future for Europe and the world.[23]

Susan reflected on how certain politicians could make an interlocutor feel like the center of the world. She was especially impressed by a quality in Bill Clinton—an aspect of his smile, his gaze, his intensity—that many of her friends thought she herself possessed. In thirty seconds, she told Michael Silverblatt, he focused an attention on you that gave you the illusion of a treasured intimacy. This dinner took place on June 8, 1999. Two days later,

the NATO bombing campaign ended, and Yugoslav troops withdrew from Kosovo.

————

Susan would be back at the White House five months later, on October 26, when Hillary Clinton invited her for the launch of *Women*, a book of Annie Leibovitz's images of women from all walks of life. The book was Susan's idea, and her introduction recasts her obsessions with looking and being looked at. "A man is, first of all, seen," she wrote. "Women are looked at." She discusses how women are praised, and condemned, for their beauty: "A primary interest in having photographs of well-known beauties to look at over the years is seeing just how well or badly they negotiate the shame of aging."[24] And she mentions the final shot of *Queen Christina*, and how the diva's very emptiness is the source of her power:

> Garbo asked the director, Rouben Mamoulian, what she should be thinking during the take. Nothing, he famously replied. Don't think of anything. Go blank. His instruction produced one of the most emotion-charged images in movie history: as the camera moves in and holds on a long close-up, the spectator has no choice but to read mounting despair on that incomparably beautiful, dry-eyed, vacant face. The face that is a mask on which one can project whatever is desired is the consummate perfection of the looked-at-ness of women.[25]

The book concludes with a portrait of her with the short white hair that grew back following her cancer treatment, and the huge letters on the cover give Leibovitz and Sontag equal billing. The names, and the essay, revealed Annie's success in two campaigns. The first was to "shake this reputation as the girl who gets

people to undress." The second was to establish herself as a serious artist—with Susan Sontag's imprimatur. Susan had never shied from advising Annie. Sometimes her advice was superfluous, if not mildly insulting—as when she insistently nudged Annie, on their Nile cruise, to look at the pyramids. ("That was slightly embarrassing," said Howard Hodgkin.) And sometimes she expressed amazement at Annie's visual talents, as when she first visited her apartment. "She really has an eye!" she exclaimed.[26]

> What a tyrant I am, Maryna did sometimes think. But he doesn't seem to mind. He's so kind, so patient, so husbandly. That was the true liberty, the true satisfaction of marriage, wasn't it? That you could ask someone, legitimately demand of someone, to see what you saw. Exactly what you saw.[27]

Like Maryna's husband, Annie did her best to see exactly what Susan saw.

> You would go into a museum with her and she would see something she liked and she'd make you stand exactly where she stood when she looked at it, so that you could see what she was seeing. You couldn't stand a little to the left or a little to the right. You had to stand exactly where she had stood.[28]

"She told me I was good, but I could be better," Annie said. "Because of her, I diversified and broadened my goals. Because of her, I went to Rwanda, to Sarajevo, and started taking things much more seriously."[29]

> She was very, very tough. She was very hard to please. Ever since I met her, I tried to please her, but it didn't always

work. She was always raising the bar. . . . She was a very
tough critic, but also a great admirer, my biggest fan.[30]

Susan delighted in intervening on Annie's behalf, and one of
her interventions resulted in one of the most unforgettable maga-
zine covers of the decade. Annie was commissioned to photograph
the actress Demi Moore for the August 1991 issue of *Vanity Fair*.
Moore was seven months pregnant, and Leibovitz posed her in
profile, perfectly made up, clad in chunky diamonds—and noth-
ing else. "The girl who gets people to undress" was up to her old
tricks. But Tina Brown was leery of the image at a time when
pregnant women—particularly when naked, particularly when so
heavily eroticized—did not appear on the covers of magazines.
Susan picked up the phone and convinced Brown to run it, and an
estimated one hundred million people saw the cover, the bestsell-
ing issue in the history of *Vanity Fair*.[31]

———

In the wake of Susan's second cancer, their relationship improved.
Annie could take care of Susan in her illness; Susan could nudge
Annie toward the museum. Each could mother the other. "She
always tried to do something really spectacular for Susan on her
birthday," said Peter Perrone. "Susan became a little girl: someone
was really remembering her birthday, and taking care of her on
her birthday."[32] Annie's friend Lloyd Ziff remembered romantic
evenings by the fireplace in Annie's country house in Rhinebeck,
as Susan read Virginia Woolf out loud to the guests.
 Susan could lend Annie a high-culture respectability, but An-
nie could make Susan cool. Her magazine covers were seen by a
hundred million people, most of whom had never heard of, much
less read, Susan Sontag. If Susan despised much about the mod-
ern celebrity culture, she was not blind to the benefits of such a

large potential audience. She told a friend that she had learned from Nicole Stéphane, who let herself disappear following her car accident, that "if you separate from the public eye, you vanish to it."[33]

And Annie's response to Susan was trying to prove—and improve—herself. "She tried so hard with Susan, and when she was told to do things, it was like watching Eliza Doolittle," said Oliver Strand, one of Susan's last assistants. Where some saw cruelty, Annie saw encouragement. On Susan's sixtieth birthday, when Annie took her on a cruise down the Nile, they snuck up the Great Pyramid. In order to catch the sunrise, they started at two in the morning, clambering over the huge stone blocks. "It was windy, and you felt like you were going to be blown right off," said Annie. Halfway up, she had enough. I don't really have to do the whole thing, she thought. "I really felt very comfortable not going anywhere." But then Susan came whizzing past: "See you at the top!" Annie dutifully followed. "That was it in a nutshell. If Susan's going to do it, I've got to get up there."

Inspiration remained Annie's overwhelming memory of their relationship. "She was tough, but it all balanced out," she said. "The good things far outweigh the bad things. We had so many great experiences together."[34]

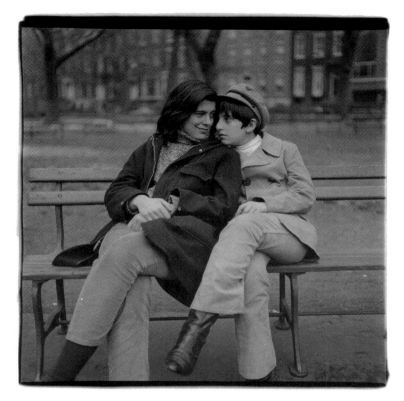

In 1965, Diane Arbus photographed Susan and David; perhaps no picture conveyed their symbiosis as well as this one. Following Arbus's suicide in 1971, her retrospective at the Museum of Modern Art become the most visited photography exhibition in history. Among the seven million visitors was Sontag, who was fascinated and repulsed by what she saw as people displayed as freaks. Her highly ambivalent reactions to Arbus extended to Arbus's medium itself and resulted, in 1977, in her great collection *On Photography*.

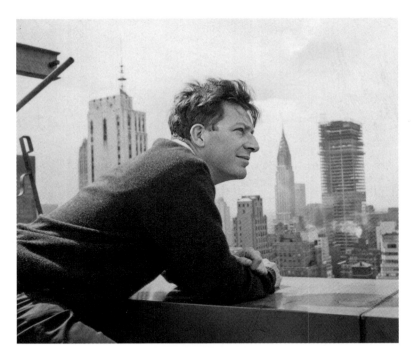

When Paul Goodman died in 1972, Sontag called him "quite simply the most important American writer." She sympathized with his ambition: "There is a terrible, mean American resentment toward a writer who tries to do many things." When he died, she was recovering from her breakup with the indolent Neapolitan duchess Carlotta del Pezzo, one of the "four hundred lesbians" of European high society (*shown here with Susan a decade later*).

Depressed about the loss of Carlotta, Susan traveled to Cannes, where she attended the festival and met another member of the "four hundred," the Rothschild heiress and Resistance heroine Nicole Stéphane (*top*). At Cannes, the former "Miss Librarian" found herself hobnobbing with (*bottom, from left*) Louis Malle, John Lennon, Yoko Ono, and Jeanne Moreau.

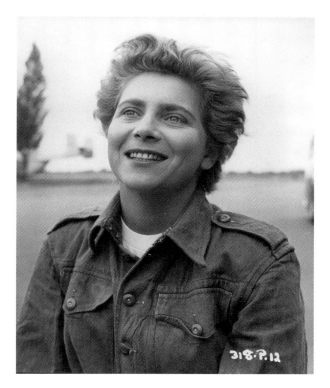

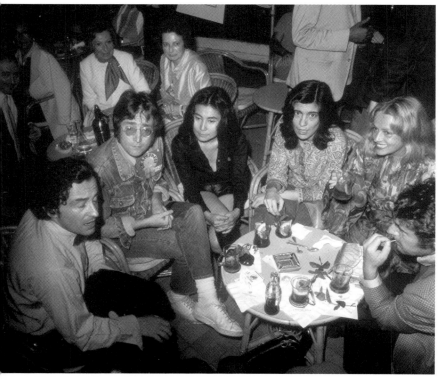

Sontag identified "the obsessive theme of fake death" in her work. Through her friendship with Peter Hujar (*left*), one of the great photographers of the era, she began to move away from it. In Palermo, Hujar photographed his boyfriend, Paul Thek, in a crypt full of desiccated bodies: "Bodies could be used to decorate a room, like flowers," Thek marveled. Susan and Nicole went to Israel during the Yom Kippur War; her third film, *Promised Lands,* was full of the bodies, the physical evidence of suffering, that she had skirted in her previous work.

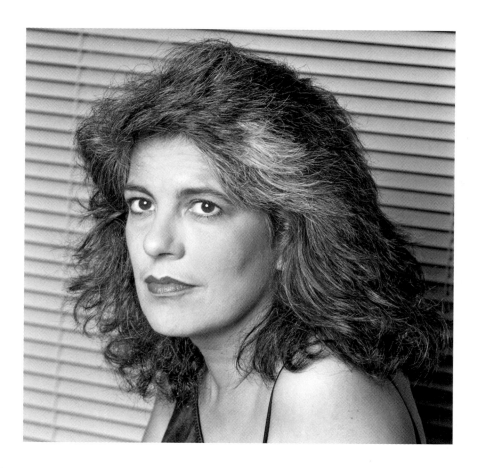

In 1975, just forty-two years old, Susan was diagnosed with stage 4 breast cancer; she was not expected to survive. After the grueling treatment, she flew to her mother in Honolulu. Her hair had gone completely white, and her mother sent her to a hairdresser, who gave her a makeover. The resulting hairstyle—all black but for a streak of white—became one of the most iconic of the age. Back home in 1978, she wrote *Illness as Metaphor*, a reflection on cancer; when it was published, she was photographed in FSG's offices.

In an unpublished essay, Sontag criticized Jean-Paul Sartre (*top left*), whose mind she called "one of the most fertile, lavishly gifted of the century," for destroying that mind with amphetamines; she never mentioned her own decades-long use of the same drug. She also attacked Hitler's filmmaker, Leni Riefenstahl (*bottom, center*); in turn, Sontag, like one of her heroines, Hannah Arendt (*top right*), would be criticized by feminists as an "exceptional woman," exempted from the social and economic barriers that held other women back.

Joseph Brodsky, Russian poet and Nobel laureate: "I was always impressed by how he enjoyed impressing people, enjoyed knowing more than they did, enjoyed having higher standards than they had," Susan said. In his favorite city, Venice, Susan met the dancer and choreographer Lucinda Childs, who starred in her last film, *Unguided Tour.* She would love Lucinda (*here photographed by Robert Mapplethorpe),* for the rest of her life, and would speak of Brodsky on her deathbed.

As a public intellectual, Sontag participated in countless panel discussions, including this one (*middle*), in 1982, when she said that "Communism is Fascism with a human face." The next year, in Woody Allen's fake documentary *Zelig*, Susan Sontag played the role of the ubiquitous commentator "Susan Sontag" (*bottom*). Later, as president of PEN, Sontag was involved in supporting Salman Rushdie, under attack from Islamic fundamentalists, by organizing readings like this one, alongside (*top, left to right*) Gay Talese, E. L. Doctorow, and Norman Mailer.

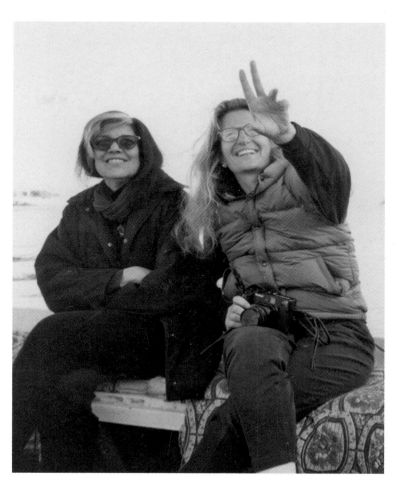

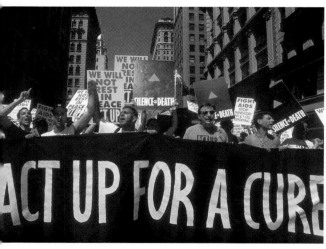

She largely abdicated that role during the revolution sparked by AIDS, which demanded that gay public figures eschew metaphor, and speak about themselves more directly (*bottom*). She never acknowledged her enduring—and enduringly fraught—relationship with Annie Leibovitz (*top, right*). "You're good, but you could be better," Susan told her. "I would have done anything," Annie said, to please Susan.

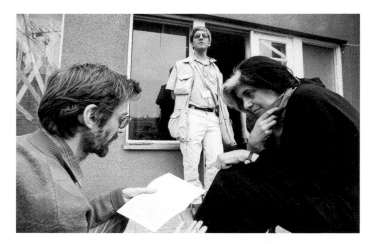

The siege of Sarajevo, the longest in modern history, began in 1992. At great personal risk, Susan (with David [top, center] and the director Haris Pašović [top, left]) traveled there and put on a play, Waiting for Godot, without electricity and lit only by candles (middle), and with starving actors to whom she smuggled precious rolls of bread (bottom). It was art-as-bullfight, played in "the world of plague victims which Artaud invokes as the true subject of modern dramaturgy."

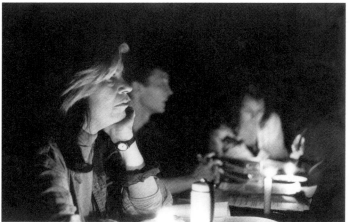

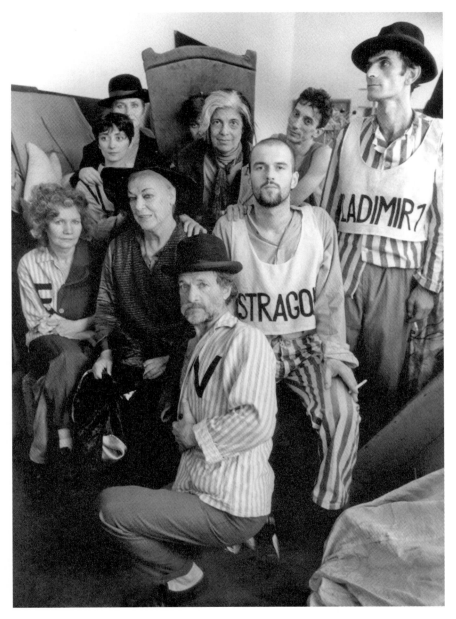

Susan with the cast of *Godot*. (*Top row, left to right:*) Milijana Zirojević, Nada Đurevska, Susan, Admir Glamočak, Izudin Bajrović. (*Second row:*) Irena Mulamuhić, Ines Fančović, Velibor Topić. (*Foreground:*) Sead Bejtović. "You couldn't fool the audience," said Topić. "You don't know if you're going to be alive in five minutes or ten or the next day. So you can't fool them. I've played in front of wounded people, I've played in front of blind children, in the hospital, on the second floor, while people were having their legs cut off on the ground floor, people who were literally losing their lives, screaming, while I was playing."

In 1998, after twenty-five years of being free of cancer, Susan relapsed; by 1999, when this photograph was taken, she had recovered, but would never be entirely well again. In 2000, she published her final novel, *In America*, and on September 11, 2001, she was in Berlin, transfixed by images of horror on CNN. She wrote a short piece for *The New Yorker* that violated her own principle: "You have no right to a public opinion unless you've been there." The three paragraphs about 9/11 became the most controversial she ever wrote.

BREAKING NEWS
CAPITOL, TREASURY, WHITE HOUSE EVACUATED

On her final trip abroad, in March 2004, Susan visited South Africa with Nadine Gordimer, who said, "Wherever Susan was, the walls seemed to expand." Weeks later, she would be diagnosed with the cancer that would kill her. After her death, the square in front of the theater in Sarajevo was renamed in her honor.

Sontag wrote searchingly of the history of fake or staged photographs, including these images of war—taken at Antietam, Berlin, and Iwo Jima—and how knowledge that they are staged obliterates their authority, and the authority of all photography.

In her last book, *Regarding the Pain of Others,* Sontag explored themes she had pursued all her life, about the obscenity, and the necessity, of looking. She traced the history of images of suffering from Goya through the modern day and showed how authentic pictures of horror, like a Vietnamese girl fleeing a napalmed village or a Cambodian woman and her infant child about to be murdered, could create a moral context for putting a stop to those horrors.

In 2004, already undergoing treatment for her terminal cancer, Sontag wrote her final essay, "Regarding the Torture of Others," in response to images emerging from Abu Ghraib of Americans torturing Iraqi prisoners—and photographing themselves doing it. Like all her writing on photography, the essay showed how a subject that might have seemed intellectual or abstract—the separation of the person from the image of the person, of the thing from its metaphors—could break people's bodies, and make them scream.

The Most Natural Thing
in the World

We have just signed a contract with W. W. Norton to write a biography of you," Susan read in March 1996, in a letter sent by a married couple, Carl Rollyson and Lisa Paddock. They had briefly crossed paths with Sontag during her trip to Poland in 1980. "Since then," they wrote, "Carl has published biographies of Marilyn Monroe, Lillian Hellman, Martha Gellhorn, Norman Mailer, Pablo Picasso (for young adults), and Rebecca West."[1]

Susan was shocked, but waited to sound the alarm. In August, Rollyson and Paddock contacted Roger Straus. "I spoke to her yesterday," Straus wrote Norton's publisher, Starling Lawrence, about "this project which she abhors."[2] A few weeks later, an interview with Rollyson and Paddock appeared in the *New York Times*: IT'S A LONELY WAY TO PAY THE BILLS: FOR UNAUTHORIZED

BIOGRAPHERS, THE WORLD IS VERY HOSTILE. Rollyson seemed to
have a hard time imagining himself in Susan's position. "'I've left
instructions to everybody: Talk, talk, talk,' he said, laughing. 'I
want it to be a good book, colorful stories. Everybody talk. I want
to be famous.'" Paddock, on the other hand, seemed to have a
better idea of why Susan—or anyone else—would not welcome
such an unsolicited intrusion. "I wouldn't like it at all," she said.
"It would make me very angry and upset."[3]

Susan had many acquaintances—not to mention enemies—
from her forty years as a public figure, and by early 1997, she
decided to make clear that those who collaborated were doing so
against her will. "I wanted to let you know that you may be hear-
ing from them," she wrote as many people as she could think of.
"I have had no contact with them, of course."

> While any biography of me written during my lifetime
> strikes me as a futile or unserious enterprise, one whose au-
> thors saw no need to inform me of their intentions, or seek
> my approval or cooperation, before getting a contract for
> their book, promises something even less palatable.[4]

The book was composed quickly, and at the end of 1999, the
writers' agent sent a letter to fifteen periodicals inviting them to
publish an early extract. One reached the desk of the book edi-
tor of the *Los Angeles Times*. This was none other than Susan's old
friend Steve Wasserman, who faxed it to Susan.[5]

———

The letter contained a reference to the subject's "open love of
women." Incredibly, that "open love" had only once before spoken
its name in a mainstream publication—seven years before, when
Zoë Heller interviewed Susan in Berlin for the *Independent*. Her
piece included the following half paragraph:

As far as any of her friends can make out, all her roman-
tic relationships since the break-up of her marriage to Rieff
have been with women, but Sontag refuses to be categorised
as a lesbian, or to confirm the status of her relationship with
her long-term companion, the photographer Annie Leibo-
vitz. "Of course I think it's wonderful that a woman of 59 is
assumed to have an active emotional life—which I have—
but I don't talk about my erotic life any more than I talk
about my spiritual life. It is . . . too complex and it always
ends up sounding so banal."[6]

When Susan read Heller's interview, she panicked and called
her own agent, Andrew Wylie, to deal with the "crisis." Shortly
thereafter, said Heller,

David Rieff, whom I'd never met, rang me, absolutely out
of the blue, and it was a very strange thing, and I never re-
ally understood what was going on. We met at the *Indepen-
dent* offices, and we went for lunch, and I don't remember
much of what he said, except the phrase "You made her
cry."[7]

The meeting baffled Heller, who never had the slightest inten-
tion of "outing" Susan: she thought she was referring to something
everyone knew. She had, in fact, recently written in opposition to
outing: "I interviewed Barry Manilow (!) around the same time
and made no mention of his being gay." The lunch was all the
more bizarre because David did not explicitly say what had so
upset his mother.

Karla Eoff saw the toll this hiding took. "There came a point
when Annie got frustrated and upset, because she was proud of
the relationship," she said. "She was in love with her, and they
were public people. She didn't want to take out an ad, but she

didn't feel like they had to pretend like it was something other than it was." Susan's reaction hurt Annie: "I'm getting more and more the feeling that you're ashamed of me," she told her, tear-fully.[8]

Karla asked Susan: "Why can't you just be with who you're with and not care who knows?" The answer stunned her:

> "Well, it's not like you, Karla. You can be married to a man, but it's not the same. We can't be devoted. Two people of the same sex cannot be in the same relationship that people of the opposite sex are. And besides, I still like men."
>
> I said, "So you're bisexual. Own up to that. What does it hurt?" "What does it help? It's no one's business but mine." I kept pushing her, and finally she just said, "I don't think same-sex relationships are valid." She came up with all of these things that you hear from these awful people who call themselves Christian: "The parts don't fit."

"Love in the sexual mode must be across the sexes in order to be true," Philip Rieff wrote in one of his later works.[9] And in *The Benefactor*, Sontag described homosexuality as "a playfulness with masks." All these years later, she had not managed to take off that mask. She had covered it with another, the identity of the famous writer, a mask she once had explicitly described as intended to hide her sexuality: "I need the identity as a weapon, to match the weapon that society has against me," she wrote. "Being queer makes me feel more vulnerable. It increases my wish to hide, to be invisible."

If the culture had changed, Sontag had not. Until the very end of her life, homosexuality was, in Signorile's words, "some scandalous secret." In public and even in private, she vehemently repudiated any relationship with Leibovitz. "Contrary to what

everyone assumes, we were not lovers," she told the Argentine writer Luisa Valenzuela in 2002.[10] The next year, the Italian journalist Alessandra Farkas walked into a buzz saw when she printed a mention of the relationship in the *Corriere della Sera*.

"I was shocked and am indeed very angry that you chose, without any justification or relevance, to repeat as fact a longstanding rumor about my private life," she thundered in an e-mail. "You know nothing about my private life. You did not ask me anything about my private life."

> As it happens, this rumor is untrue. But even if it were true, it seems to me uncivilized and vulgar for you to repeat gossip in an interview devoted, I thought, to serious subjects.[11]

Farkas's polite response ("The mention of your friendship seemed like a natural, and truthful, inclusion. . . . For us and our readers, sexuality is not an issue") only inflamed Susan further. "She was obsessed with 'this Farkas woman,'" said a friend,[12] and fired back an e-mail bristling with mocking quotation marks:

> There is nothing "natural" about your mentioning, in the context of a discussion of my work, that Annie Leibovitz is indeed a friend of mine. And it was not my impression that you were referring to a friendship. As it happens, I have quite a few friends. Several of them are photographers.
>
> And it is not "information." The "research" to which you refer amounts to other references to this longstanding piece of gossip, gossip which—though of course it does me no "harm"—happens not to be true.[13]

She would not always respond so aggressively. In 2003, a fact-checker from the *New York Times* inquired whether she was

"Ms. Leibovitz' former companion," and received a reply. "I am of course aware of these rumors. No, the information is not correct."[14] She even lied to her sister.

> I would visit her in New York. . . . And then, after we'd gone out, gone somewhere, seen something, visited with someone, she'd say, "I have to go over to Annie's. She's having a lot of problems with her family." She'd make up some big bullshit story, and then I would see her the next morning, and then it would be something else and then something else, and I just got used to it.

As she learned of her cancer from the *Hollywood Reporter*, Judith only learned of the relationship from a friend in San Francisco, who mentioned it casually—as a fact everyone knew. Judith was stunned.[15]

———

At the same time that Susan got wind of the Rollysons' determination to out her, she was being interviewed by Joan Acocella for *The New Yorker*. The profile was timed to appear with the publication of *In America*. "That series of interviews that I did with Susan was the most difficult interviewing job I ever did in my life," Acocella said. "And that includes Nijinsky's daughter, who was schizophrenic."[16]

The abuse she showered upon Acocella was odd, if only for reasons of self-interest. But interspersed with the bullying grandiosity was a person who struck Acocella as almost miraculously un-self-aware.

> She *truly* wanted me to say nice things about her. She *truly* wanted me as her friend quote-unquote: to be part of her

circle, and to be one of "her people." She was immensely proud and self-deceiving about who *were* her friends. She would say: Well, so and so is my very close friend. And I would have been on the phone with him the day before, and he's saying: That fucking bitch.[17]

Acocella quickly discovered the main lie. Susan confided that the first woman she slept with was Irene Fornés, for example, and only because Irene brought her a thousand white roses. But Acocella knew the Rollyson book was coming, and told Sontag she ought to act "before they come out and point a gun at you." She offered to print something innocuous.

> "Head them off at the pass and use me for it. Use this article for it. Say you're bisexual and that's that." Well, she was terrified. She was absolutely terrified, and she said to me, "I don't know the words to use. I don't know what words to use." I said, "I'll write them down on a piece of paper and you can look at them, and either you can say something else, or you can say these words. I'm going to sit in front of you and it's going to be on the record and that tape recorder will be on."

The New Yorker's rigorous fact-checkers would demand support for every quote, so Acocella needed it on tape.

> I came the next time. You wouldn't believe: she sat in this huge high chair in the middle of the living room. I said, "Susan, I'm going to ask to come over there or you have to come here." I was on a couch on the side. It was psychotic. She finally came over to the couch. I did sit, sort of, at her feet. I had the tape recorder on, but I was going to

be damned if there would be any tape recorder problems. Anyway, with incredible halting difficulty, she said what is quoted in my piece.

The line seems tossed off with the sophistication one expected of the author of "Notes on 'Camp.'" "That I have had girlfriends as well as boyfriends is what? Is something I guess I never thought I was supposed to have to say, since it seems to me the most natural thing in the world."[18]

But if that sounded harmless on the page, it sounded very different when spoken.

> My transcriber, the guy who types the interviews, and who is gay, and a New York gay guy—in other words, a completely out gay guy—is typing along, and he has to type this. He hears not just the words, but the strangulated tone. And the transcriber said that he burst into tears. And I said, "So did I." As she delivered it, I cried.[19]

———

The closet is not a place. It is a metaphor. Together with its associated metaphor, "coming out," it reveals the imperfections of metaphor in general. However culturally or socially fraught "coming out of the closet" may be, the phrase makes it sound, practically or linguistically, like a simple, onetime operation—a decision to step out of one room and enter another.

The metaphor did not appear before the 1960s in the gay movement, or in the language gay men and lesbians used about themselves.

> Like much of campy gay terminology, "coming out" was an arch play on the language of women's culture—in this case the expression used to refer to the ritual of a debutante's be-

ing formally introduced to, or "coming out" into, the society of her cultural peers. . . . Gay people in the prewar years, then, did not speak of *coming out of* what we call the "gay closet" but rather of *coming out into* what they called "homosexual society" or the "gay world."[20]

Once it acquired a name, the phenomenon now known as "the closet" could be studied and understood. If homosexuals in the age of the black and women's liberation movements were beginning to see that they, too, were an oppressed minority, they also understood that there were significant differences between the ways girls or members of minority communities grow up and the way gay children grow up.

Girls—most of them—learn about being a woman from a mother. A black child can learn how to cope with racism from parents and community. But most gay children are born into heterosexual families, and into communities that often hold strongly antihomosexual attitudes. The incentive this creates to lie about who they are is so strong that those behaviors—reprehensible in other contexts—are a matter of survival.

This is the context in which the young Susan could write that "being queer . . . increases my wish to hide." When she was growing up, this skill was not limited to children. It remained vital for adults, too. Like her, many gay people married. Until the sixties, any attempt to socialize with other gay people brought terrifying risks. Discovery could mean, as it almost did for Susan, losing one's children, and in any licensed profession, including medicine, law, or psychiatry, exposure meant that one's license could be revoked on grounds of "moral turpitude." The police frequently harassed homosexuals. Journalists entered gay bars and published the names and addresses of the people they found there; many committed suicide as a result.

This pressure translated into low self-esteem and depression.

"The theory of the day was if you really wanted to change, you could," said Dr. Charles Silverstein, one of the first psychologists to treat gay people. "Therefore, if a person kept having homosexual fantasies, it had to be their own fault. They became a failure in life, a failure in the family, failure with spouses, failure to change. It just led to greater depression." This sense of failure meant it was "impossible for some people to establish a love relationship," Silverstein said. "There were such couples, but most of them lived in rural areas. I never found couples who had been together a long time in big cities, although I know that they existed."[21]

Even once the gay liberation movement began in earnest—following one of those police raids, on a bar called the Stonewall Inn in 1969—the closet was not a matter of being "in" or "out." One could be open over the weekend but, come Monday morning, dissemble at the office. One might live freely in the city, only to revert to subterfuge when visiting a conservative hometown. And so "the closet" was never a place, nor something left behind once and for all. In places where homosexuals were not in physical danger, "coming out involves choices about how to handle moments of ordinary, daily conversation."[22] It is, another scholar has written, "a process that potentially never ends. . . . [Gay] people must decide on a daily basis whether to reveal and to whom they will reveal—an experience that may have no exact parallel for those with heterosexual identities."[23]

This was the world in which Sontag came of age. Despite the revolutionary change in the view of homosexuality, her behavior at the end of her life revealed that she had never been able to shed the attitudes that prevailed when she was young. Being openly gay no longer placed her in legal or social jeopardy. (If anything, honesty would have burnished her reputation as a fighter for radical causes.) But the habit persisted, with results that, in an age that no longer countenanced scientific condemnations of homosexuality, were increasingly understood by psychologists. "Hiding

and passing as heterosexual becomes a lifelong moral hatred of the self," wrote two researchers in 1993, "a maze of corruptions, petty lies, and half truths that spoil social relations in family and friendship."[24]

Hiding took another toll. Over the years, closeted people developed "difficulties in accurately assessing other people's perceptions of [them], as well as recognizing [their] own strengths," another gay psychiatrist found.[25] This can explain why Susan could agonize over publicly revealing something everyone had known, at least in private, for forty years. Hiding made it hard for such people to feel "actual accomplishments as reflections of one's own abilities"—since these, like themselves, could hardly be genuine. This made them exceptionally dependent on the opinions of others.

"Transparency, invisibility, losing one's voice, and being stuck behind walls or other barriers are some of the terms used to describe the subjective experience" of being in the closet. These, too, were metaphors. But "the closet" did mean secrecy, hiding, and shame. It meant losing one's voice, and being unable to see.

———

Spending time with Susan was "like being in a cave with a dragon," Acocella said.

> Susan was just very, very difficult, and she lied. She lied a lot. Although we were not friends, we were acquaintances and we were a part of the same social circle. She lied to me in a way that she shouldn't have.

Acocella's profile, "The Hunger Artist," was published on March 6, 2000, and is warm and admiring. She showered *In America* with far more praise than she thought it deserved, and

said nothing of Susan's behavior toward her. It is "the least can-
did profile I have ever written," she said. "If I had told the truth
about what it was like to be with Susan, the piece would have
been very different." Like a child who, seeing her outwardly mon-
strous mother's struggles, refuses to expose her to public humili-
ation, Acocella was touched by Susan's "immense neediness," and
was willing to cover up for her. Susan dismissed the essay as "ex-
tremely laudatory but vulgar."[26]

———

Two months later, a less laudatory notice appeared in the *New
York Times*. Ellen Lee, an eighty-one-year-old amateur historian
in California, had discovered at least twelve passages in *In Amer-
ica* that seemed to have been plagiarized from works by and about
Helena Modjeska, the actress who inspired the figure of Maryna
Zalewska. Lee, a specialist on Modjeska, was astonished: "Why
would a writer of Susan Sontag's stature and prestige use sources
without quotation marks and without documentation?"[27]

Sontag deflected the controversy. "There's a larger argument
to be made that all of literature is a series of references and allu-
sions," she told the *Times* reporter. "I distinguish between writers
and sources," she continued. "The sources themselves are work-
ing from sources and they are using quotations of actual words."
Though the amount of borrowed material only added up to around
three pages, one would have to take an extremely liberal view in
order to consider Sontag's use of "sources" anything other than
plagiarism. She was able to judge herself—and absolve herself—by
the standards she had set for Maryna:

"Most rules for behaving properly on a stage," she told
them, "also apply to real life." ("Except," she said, smiling
blithely, cryptically, "when they don't.") One such rule is:
Never acknowledge a mishap.[28]

But plagiarism was a subject that interested Sontag. Her fiction is full of characters who alternate between fear of being discovered and tempting fate with reckless behavior. Hippolyte, in *The Benefactor*, tries to kill Frau Anders, apparently for no better reason than to get caught. In *Death Kit*, Diddy confesses to a murder that he did not commit. In her journal, she pondered the different kinds of plagiarism:

> Brecht to be dismissed as a plagiarist? In a conversation with Eckermann, Goethe suggested a robust response to any writer so accused: "What is there is mine, and whether I got it from a book or from life is of no consequence; the only point is, whether I have made a right use of it." OK for Brecht, whose method of operation was collective. But what about D. M. Thomas? No, doesn't exonerate him.[29]

Merrill Rodin, who stole books with her in high school, suspected that her deceitfulness went beyond shoplifting. And later, Susan told Edmund White that he should stop citing references and "claim thoughts as your own."[30]

Ellen Lee was willing, albeit warily, to accept Sontag's explanations: "Maybe the rules have changed and there are different rules for fiction now," she said in the *Times* article. But she was shocked to read what Sontag said in the article. "I actually thought that they would be quite thrilled," Sontag said. "Modjeska was quite forgotten. She was a great figure. I made her into a marvelous person. The real Modjeska was a horrible racist." For Lee and the mainly Polish American women dedicated to preserving Modjeska's memory, this was slander. Those same condescended-to "sources" revealed, after all, that Sontag's accusation was untrue: Modjeska had, in fact, been a vigorous fighter against racism.[31]

Susan was unchastened by the episode. The very last speech she ever gave, in Johannesburg in 2004, was full of lines lifted

from the critic Laura Miller. "The irony is that it was in a lecture on morality and literature," Miller said.[32]

———

"Though I can hardly complain of the treatment I have received from critics, I have never liked them," Maryna says. "They always start out thinking you are going to fail."[33] But despite a tepid critical reception, *In America* was honored with the National Book Award. Some speculated that Acocella's description of Sontag's cancer and heavy-metal poisoning had moved the jury. Others, despite reservations, found it an appropriate prize for Sontag's lifetime of achievement.

James Miller, a professor at the New School, recalled that David was sick, and there was some question about whether he could come. This made Susan nervous, and her nervousness about both David and the prize revealed a side of Susan he had never seen.

> Nobody—but nobody—expected Susan Sontag to win a National Book Award for *that* novel. . . . David had materialized at the eleventh hour and Susan—she was still in tears. In tears. And completely unguarded and overwhelmed. . . . The insecurity was at such a great level that when a kind of recognition like this came she was completely disarmed. She needed it insatiably, and then when the moment arrived, it was *stunning*—and the fact that David had shown up at the last moment: it was very unexpected and moving.[34]

She called Brenda Shaughnessy, a young poet she had recently befriended. "It was the softest I have ever heard her talk on the phone," said Shaughnessy. "It wasn't the typical bark." Susan invited her to join the party at the Russian Samovar, the Midtown bar where she had often hung out with Brodsky. Roger Straus was

there, and all her friends. Whatever doubts her entourage may have harbored about *In America,* they were thrilled.

Roger said something so great to her: "You know what really matters about this, Susan? You know why this is so great? Because it means that *In America* will last forever. It will be immortal. It will always, always exist because of this." That's what she wanted to hear. That's what she wanted to happen. We all knew that was her greatest dream. There were opera singers at the piano. They were singing songs for her. It was just an incredible triumph. I was so lucky to be there. It was so beautiful.[35]

CHAPTER 40

It's What a Writer Is

In her last years, Susan had a series of friendships that took a remarkably similar pattern. These friends were younger, sometimes much younger. They were usually gay or bisexual. They were usually from boring provincial backgrounds, like Susan, and like her were highly talented, usually as writers or visual artists. And they were often unsure about how to use their talents—until the *dea ex machina* swept into their lives.

She would shower them with elaborate praise that was irresistibly flattering, and desperately necessary. She would dispense wonderful advice that they would never forget. She would encourage their work and praise them, often in front of very famous people, as "gorgeous" or "brilliant." She would offer personal confessions that put them on a first-name basis with the great. They would eat foods they had never eaten and see plays they had never seen. They would read books they had never heard of, and dine with people they had. They might be invited to some exotic destination they could never have afforded to visit by themselves. During

this honeymoon, they would see themselves becoming the person they had dreamed of being in their no-name hometown. For all of this, they would be—the phrase recurs—"eternally grateful."

But then the recriminations began. At first, the mentor delighted in recommending books. Now she professed herself frankly demoralized by her friend's dreadful ignorance. The younger person would scurry to prove herself, improve herself; but what started as encouragement would devolve into bullying. In many cases, Susan would begin ignoring or snubbing her protégée at the very opera or ballet to which she had brought her. These new friends would be shocked by Susan's treatment of the woman who, it became obvious, was paying all the bills—a woman who fit into this category as well as anyone. The self-esteem that came from being fulsomely praised by Sontag was a devastating thing to lose, and if these people had a problem with drugs or alcohol, this often worsened. But they could not quickly loose themselves from Susan's spell. Those who had glimpsed sweet, girly, nervous Sue would feel the need to help Susan, to guide her back to that charismatic person they were—the phrase recurs—"in love with." For many, she would remain, even long after her death, the most important relationship, the most dominant influence, in their lives.

———

Brenda Shaughnessy was one such friend. In 1999, FSG published her first poetry collection, *Interior with Sudden Joy*. The book came to Susan's attention, and the twenty-nine-year-old was alerted to her interest by Richard Howard, her teacher at Columbia. He told her to call Sontag: "She didn't call people. She had a mutual friend call." Susan was excited to meet the woman behind the book. "She really expected me to talk in this incredibly rarified erotic-poetry kind of way. I totally did not. I have a Valley Girl accent. I grew up in Southern California. She was visibly disappointed."[1]

But Susan was sweet. She peppered Brenda with questions about poetry. She encouraged her writing and took her to bookstores, where she berated her for not being better read. At first, this was inspiring. "It's hard to explain her magnetism and her sexual charm and just how dazzling she was in person," Brenda said. "She never seemed old to me." Like so many others, Brenda fell for Susan. "I loved hearing her talk. I loved the way she laughed."

And as she got to know her, she saw Susan's vulnerabilities. "She would say things like, 'I don't drink because my mom was a drunk,'" Brenda remembered. "She'd have a margarita in her hand." Brenda found this moving.

> I started noticing how if the conversation ever turned to something she didn't know anything about she would quickly steer it back to something she knew about. I started understanding that she would do that repeatedly. She's got this understanding of herself that she's got to know everything. That has got to be huge pressure; that's got to be so scary.[2]

Like so many others, Shaughnessy saw her isolation. "I eventually got put in this heavy rotation where I was on call to take her to doctor's appointments. I was like, 'Oh, my gosh, I'm so lucky. This amazing person is hanging out with me.' It didn't really cross my mind that—why would someone who is so amazing want to hang out with me five times a week? Why is she so available?"

Susan's loneliness had aggravated as she got older.[3] In the early sixties, in Paris, she wrote that "I still don't know how to be alone—even sitting in a café for an hour."[4] Solitude turned her into a child: "I hate to be alone because when alone I feel about ten years old," she wrote in 1963, around the same time that

she told Stephen Koch that she would rather live with any person plucked at random from a Chinese restaurant than live alone. "How to be alone, how not to be alone—the perennial problem," she noted in 1977 in her journal.

"To write, as Kafka said, you can never be alone enough," she had written in "Singleness" in 1995.[5] At the same time, "she was afraid of silence," said Jamaica Kincaid. "And I have always thought that the kind of thinking she admired comes out of silence." She wrote with people: she sat next to Don Levine, chomping on amphetamines, gulping down coffee, puffing on Marlboros. She carried on writing with the younger writer Ted Mooney in the room, too, which amazed him. "Come to my room," she would tell Michael Silverblatt. "Bring a book. I'm going to be writing. We can babble." This need for constant attendance suffocated people, and as Susan's praise turned to abuse, Shaughnessy started to wonder whether Susan merely wanted a lady-in-waiting. "Why was she calling this person who's thirty years younger than she is—and then berating that person?"

Susan's need for praise, like her need for company, sometimes led to compromises that her most steadfast friends deplored. In May 2000, a few months before Susan won the National Book Award for *In America*, she traveled to Israel to accept the Jerusalem Prize for the Freedom of the Individual in Society. Even then, when there was more hope than there later would be for a peaceful resolution to the Israeli-Palestinian conflict, this honor was controversial. Several prominent writers urged her to refuse it. One of Susan's closest friends, Nadine Gordimer, the South African Nobel laureate, wrote her an insistent letter.

> I write to you instead of calling because I feel that my dismay and distress will confuse me, on the phone, and I want

to be clear in what I have to convey to you. My dear and much-loved friend, the writer whom I hold among a five-finger handcount as one of the best living—I am convinced beyond question that you should not allow yourself to be the recipient of the Jerusalem Prize this year.[6]

Gordimer—Jewish like Susan—had been offered the prize and had turned it down. She did not, she said, "wish to travel from one apartheid society to another." And she had seen how effective the boycott of South Africa had been in forcing the apartheid regime to stand down. Israel had been a prime ally of that regime, and its apartheid in Palestine was clear to anyone who wanted to see, including Israelis themselves.

Another friend, the Palestinian American writer Edward Said, also begged Susan to refuse.

Israel is in its 33rd year of a brutal military occupation, the longest (except for Japan's 35 year occupation of Korea) in the 20th and 21st centuries. . . . This is not a war between two states, but a colonial military action by one state against a stateless, dispossessed, poorly led people.

Thus, your charismatic presence for the Prize and your acceptance of it is, for the Israeli government, a badly needed boost to its poor international standing, a symbol that the greatest talents in the end subscribe to what Israel is doing.[7]

Susan never responded to Gordimer. To Said, she wrote: "Wouldn't refusing the Prize—and how do I make that known? hold a press conference? write an Op-Ed piece for the *Times*?—be a lot less serious as a gesture than my going there and speaking out."[8] It was an odd comment: she found the op-ed page of the *Times* a serious enough place to denounce ethnic cleansing in

Kosovo, the persecution of writers in China, and, soon enough, American torture in Iraq.

"She really went off" when Shaughnessy passed on a message from a Jewish lawyer who believed that what Sontag called "the Nobel Prize for Israel" was inappropriate. She was angry that Brenda agreed: "I think she was worried about her legacy. She was worried that people would forget about her."

Susan's acceptance speech offered bromides—"the writers and readers in Israel and Palestine struggling to create literature made of singular voices and the multiplicity of truth"—and included an attack on writers who lacked her moral gallantry.

> Have all the writers who have won the prize really championed the Freedom of the Individual in Society? Is *that* what they—now I must say "we"—have in common?
>
> I think not.
>
> Not only do they represent a large spectrum of political opinion. Some of them have barely touched the Big Words: freedom, individual, society . . .
>
> But it isn't what a writer says that matters, it's what a writer *is*.[9]

Edward Said found the speech "staggeringly bad,"[10] and her ruminations on "righteous action" made no mention that there were no Arabs or Muslims at the Jerusalem Book Fair, where the prize was given.[11]

———

Shaughnessy loved Susan's advice. "It was never very sweetly presented," she said. "It was always sort of cruel. But it was brilliant advice." Much of it had to do with claiming the prizes on offer. Susan demanded to know whether Brenda had applied for a Guggenheim Fellowship, and when Brenda protested that she was far

too young for such an honor, Susan exploded. "It is not your job to reject yourself. It is their job. You put your name in the hat. If they reject you, that is their job. It has nothing to do with you! Why are you making it all about yourself? You are so egotistical!" Brenda dutifully applied—and applied, and applied, and applied, and applied. Finally, on her eleventh attempt, she got it.

Others received advice from her: similarly brusque, similarly vital. She granted Richmond Burton permission to have thoughts he was previously too timid to express at galleries and museums.

> She would be very quick to make pronouncements that I usually agreed with but that everyone else was afraid to say. She would say, "Listen, Richmond, most people are just afraid of their feelings." That was such a gift to have that understanding, and to have it spelled out, especially by her.[12]

She told Michael Silverblatt to grow up. As a boy, he was found to be allergic to dust and dirt, and his parents incinerated his stuffed animals. As an adult, he began to collect toys. "You will throw them out," she ordained. "Every one of them. You are not a child anymore. You have been doing that crazy child thing for too long. I'm not angry at you, but you will stop. Simply stop. Turn your back on childhood." He obeyed, and was forever glad. And he saw the advice she gave others:

> She told Jimmy McCourt, "Jimmy, I don't know how you did it, but you've got a lover who's worth your time, and he's worth yours; and if you continue to drink the way you drink you will lose him. You will lose him, and you think that you're someone. You're a writer of a barely known specialty novel. Who knows if you'll write another?" And Jimmy, instead of taking offense, became a member of Alcoholics Anonymous, and he and his boyfriend are still together

today largely because of Susan. So for all the people who may have been destroyed or distraught by things Susan said, there are an equal number of people whose lives she saved—my own among them.[13]

Klaus Biesenbach, a young German curator who was close to her in her final years, remembered Susan's screaming at him at four in the morning while they were buying French fries in Berlin: he had misused a word. The incident changed his whole approach to his work: "She made you aware that everything you do, every word you use, has an impact. Everything has a meaning. You have to be incredibly precise and focused." He understood why she emphasized the meaning of words. "Klaus," she said, "as a curator, as a critic, the only thing we have is our opinion. Never sell that, never give that away. That's the only thing you have."[14]

"It's as if she sat on my head," said Burton. "She remains an idealized authority figure." But in some cases, authority slipped into authoritarianism. After Susan's death, said Shaughnessy, "I was really shocked when those women [including Terry Castle and Sigrid Nunez] mentioned that she'd say they were stupid. None of them are stupid." She began to consult a therapist to understand her attraction to someone who treated her so badly. As in any abusive relationship, cruelty makes the occasional kindness all the more narcotic. "When she would shine this love on me—when she didn't think I was an idiot, for that moment—it was just spectacular."

———

Infatuation came easily to Sontag, and she was therefore more susceptible to disappointment than a woman more reticent in her enthusiasms, clearer in her judgment of people, and ironic about

her own shortcomings. But there was one friend who had never disappointed her, and that, for lack of a better word, was Art. In 2001, she published *Where the Stress Falls,* which pays reverence to that friend, and shows the charisma of her admiration.

Admiration was directed at others when one could not quite admire oneself, she wrote in *The Volcano Lover:* "He wanted to admire himself, but he was even quicker to admire anyone he loved." Lady Hamilton's "passion is admiration,"[15] and so was hers. To admire was to participate in something greater, purer, more beautiful than oneself; and admiration suited her personality—a crush, a passion—not the long steady work of loving but the quick flush of falling in love.

Where the Stress Falls gathers twenty years of exercises in admiration. It is full of aspirations to the ideal, whether the ideal work of art or the ideal "serious" life—moral, artistic, political. It contains writings on books, films, and dance; on people she loved as a child, like Richard Halliburton, and as an adult, like Lucinda Childs and Joseph Brodsky. It includes the places that marked her, particularly Sarajevo. And it illustrates one of the most important services she lent to the arts. Since *Against Interpretation,* she had been renowned for bringing the news of artistic developments in a way that only one with her extensive travels and broad reading could have. There are essays on Danilo Kiš and Juan Rulfo and Machado de Assis; on Rainer Werner Fassbinder and Howard Hodgkin.

Over the years, "Susan Sontag" had become synonymous with high culture, and *Where the Stress Falls* helps explain why. She was the one intellectual recognized by people who knew nothing about intellectuals. She was the guru in Woody Allen's *Zelig,* the genius on the cover of *Vanity Fair*—as well as the woman who, in 2000, allowed herself to be photographed by Annie Leibovitz for an Absolut Vodka advertisement. These popularizations might have

been tacky, but in the age of shopping, culture needed defenders who could venture into the demotic. Sontag was a hopeful figure for those who felt that culture was worth defending.

The idea of the woman who went to every opening and saw every opera and read every book and resisted the siege of Sarajevo through dramaturgy alone was essential. For Susan, the person, it meant a degree of pressure that was beginning to madden her. In Israel, she claimed that the importance of a writer lay in what she *was*. But Sontag's real importance increasingly lay in what she *represented*. The metaphor of "Susan Sontag" was a great original creation. It rose far above her individual life, and outlived her, and helps explain why discriminating critics like Joan Acocella were merciful to Susan—graded her on a moral curve.

———

Where the Stress Falls contains an essay, "Borland's Babies," about the Australian photographer Polly Borland's images of adult men who dress as infants. Borland shows "an intimate, private space whose banal activities—yowling, drooling, eating, sleeping, bathing, masturbating—here acquire the character of weird rituals, because they're done by adult men dressed as, and carrying on like, babies." The magic of Borland's photographs, Sontag writes, is that these apparently freakish people are not depicted as such. They have none of the "ingenuous stare of a Diane Arbus picture."

> The pictures register a truth about human nature which seems almost too obvious to spell out—the temptation of regression? the pleasures of regression?—but which has never received so keen, so direct a depiction. They invite our identification ("nothing human is alien to me")—daring us to admit that we, too, can imagine such feelings, even if we are astonished that some people actually go to the trouble, and assume the shame, of acting them out.[16]

This was a fantasy of Susan's, too, despite the revulsion she often professed for childhood. ("It was partly so as not to feel like a child, ever, that she had become an actress."[17]) Childishness in her friends evoked stern reproaches. "You have to turn your back on childhood," she told Silverblatt.

Ironically, though, she turned her lovers, including Irene, Carlotta, Nicole, and Lucinda, into avatars of her own mother. So when, in 2000, Annie decided to have a baby on her own, her age—fifty-one—was the least of her difficulties. Susan had long mocked her for the very notion. "She made fun of her wanting to have a child," said Karla Eoff.[18] Shaughnessy saw how upset she was that Annie was embarking on the pregnancy "without her permission." One day, at lunch, she broke down. "I'm falling apart," she confessed. "Annie's leaving me. She's having a baby without me."[19]

"I had a lot I wanted to give," said Annie. "And I was giving a lot to Susan, but I wanted to give more. I wanted to give more love. I come from a big family, and I wanted to have children. I mean, I really was moving on. And eventually we were going our own ways." She wanted to help Susan do something she had always dreamed of: "I am so happy to have Sarah. What is it for you?" She bought an apartment for Susan to use on the rue Seguier, in the Hôtel Feydeau de Montholon, on the banks of the Seine, with spectacular views of Notre-Dame. "The Paris apartment was a place for her to write," Annie said.[20]

Susan came to love Sarah. Annie took a picture of the two on a Long Island beach: one approaching the end of her life, another still at the beginning. "I look at those pictures," Annie said, laughing, "and I think: Which one is the child?"[21]

———

After two or three years, Shaughnessy, with Susan's help, got a fellowship to Japan, her mother's country. She was living in

Tokyo, where Susan was coming to judge an art contest. Brenda
was excited to see her, but when Susan arrived, "very agitated,"
she began battering Brenda with questions. "She was talking a
mile a minute in a manic way, talking too much. 'How do you
like it here? How do you like it here? How do you like Tokyo?' I
said, 'I love it.' She goes, 'What do you like about it? Tell me what
you like about it! Why do you love it so much?'"

Brenda had often had the experience of answering Susan—
only to have Susan dismiss her as dumb or ridiculous. Now, forti-
fied by the distance of her months in Japan, she made up her mind
to give an honest answer: she was fascinated by the conjunction of
an ancient culture with the most futuristic novelty.

She just gestures around with her arms wide open and goes,
"How can you love this? It's the end of reading!"

I said, "What do you mean, it's the end of reading?" "It's
the end of reading! Everything you love! Books! Everything
you love! This is the end of it! This is the end of reading!" She
was freaking out. I'm like, "Why are you always so negative?
Why do you want to fight with me? I don't want to fight
with you." Now I'm crying and I'm yelling. I don't even no-
tice how funny this is. Because in retrospect it's really funny
that she said that Tokyo is the end of reading.

I'm crying, and I've never done this before, but I finally
say to her, "You know what? I can't do this. I'm not going to
lunch with you. I'm walking away."

I turned away and she grabbed my arm, physically
grabbed my arm, and says, "Don't leave me. Don't leave me
here." I'm like, "Okay, okay." I suddenly realized that she
felt helpless, that she actually couldn't get around in Tokyo
by herself.

She always acted like, "Oh, I've been to Japan a hundred

times, and I know everything." The truth is she was terrified of being left on that street corner by herself. She says, "I can't get back to the hotel. I don't know how to get back to the hotel." She was staying at a major hotel. It wasn't going to be that hard. But she seemed really, really upset. She still had a grip on my arm. I said, "Okay, fine. Let's just forget it. Let's just forget it. Let's go to lunch."[22]

CHAPTER 41

A Spectator of Calamities

I n early 2001, Susan returned with David to Sarajevo, where she had also rung in the millennium. It was the ideal place to celebrate it, she said. The twentieth century had started in Sarajevo, with the assassination of Franz Ferdinand in 1914, and ended there, too, with the siege of 1992. She was always happier there, said her friend Senada Kreso, who had been a Bosnian government spokeswoman. Kreso found her "in a fantastic mood . . . full of energy." They went to "one of the rare good restaurants in Sarajevo."

> We laughed like mad, we laughed our heads off, we ate, we got completely drunk. . . . It was the first time David and I got her involved with small talk, like astrology. I read those books, and David also read those books, like Linda Goodman's *Star Signs* and *Love Signs*. And it was for her a revelation. A discovery of a completely new realm.[1]

Soon, she learned about Annie's pregnancy. In February, she gave a lecture in Oxford that became *Regarding the Pain of Others*, the last book published in her lifetime. The lecture, and then the book, continued the arguments of almost all her works—about the writer and politics, language and war, image and cruelty. "Being a spectator of calamities taking place in another country is a quintessential modern experience," she wrote in that book.

On the afternoon of September 11, she was that spectator—and the country was her own. That morning, teams of terrorists boarded airplanes, overpowered their pilots, and aimed the planes at the heart of the American empire. One, heading toward Washington, was retaken by its passengers and crashed in a field in Pennsylvania. Another destroyed a large part of the Pentagon. Two others hit the World Trade Center in Manhattan, causing the buildings, once the tallest in the world, to crash to the ground. On live television, people trapped on the upper floors jumped a hundred stories to their deaths. Among the millions of spectators was Susan Sontag, who was staying at the Hotel Adlon, in central Berlin.

Sixty years before, Pearl Harbor united the nation against a mortal threat. So, for a time, did the attacks of September 11. But it soon became clear that the attacks would be used for the narrow partisan advantage of an unpopular president, George W. Bush, the first to take office without winning a popular majority since 1888. He understood that, in the face of such apocalyptic attacks, most Americans would see rallying behind their government as a patriotic duty. The man who ended his term as the least-popular president since scientific polling began briefly enjoyed a stunning 92 percent approval.

For weeks, Manhattan was blanketed with missing-persons posters, and with the gruesome stench of the smoldering ruins. A week later, military-grade anthrax began appearing in the mailboxes of senators and journalists, eventually killing five people.

These attacks, never convincingly solved, added to the apocalyptic mood. Everyone agreed that something had to be done. No one was thinking about metaphor.

———

Almost no one. Two days after the attacks, as Susan sat glued to the television in her suite at the Adlon, her old friend Sharon DeLano at *The New Yorker* asked her to write something short for the magazine. She contributed three paragraphs.

> The disconnect between last Tuesday's monstrous dose of reality and the self-righteous drivel and outright deceptions being peddled by public figures and TV commentators is startling, depressing. The voices licensed to follow the event seem to have joined together in a campaign to infantilize the public. Where is the acknowledgment that this was not a "cowardly" attack on "civilization" or "liberty" or "humanity" or "the free world" but an attack on the world's self-proclaimed superpower, undertaken as a consequence of specific American alliances and actions? How many citizens are aware of the ongoing American bombing of Iraq? And if the word "cowardly" is to be used, it might be more aptly applied to those who kill from beyond the range of retaliation, high in the sky, than to those willing to die themselves in order to kill others. In the matter of courage (a morally neutral virtue): whatever may be said of the perpetrators of Tuesday's slaughter, they were not cowards.
>
> Our leaders are bent on convincing us that everything is O.K. America is not afraid. Our spirit is unbroken, although this was a day that will live in infamy and America is now at war. But everything is not O.K. And this was not Pearl Harbor. We have a robotic President who assures us that America still stands tall. A wide spectrum of public figures,

in and out of office, who are strongly opposed to the poli-
cies being pursued abroad by this Administration apparently
feel free to say nothing more than that they stand united
behind President Bush. A lot of thinking needs to be done,
and perhaps is being done in Washington and elsewhere,
about the ineptitude of American intelligence and counter-
intelligence, about options available to American foreign
policy, particularly in the Middle East, and about what con-
stitutes a smart program of military defense. But the public
is not being asked to bear much of the burden of reality. The
unanimously applauded, self-congratulatory bromides of a
Soviet Party Congress seemed contemptible. The unanimity
of the sanctimonious, reality-concealing rhetoric spouted by
American officials and media commentators in recent days
seems, well, unworthy of a mature democracy.

Those in public office have let us know that they consider
their task to be a manipulative one: confidence-building and
grief management. Politics, the politics of a democracy—
which entails disagreement, which promotes candor—has
been replaced by psychotherapy. Let's by all means grieve
together. But let's not be stupid together. A few shreds of
historical awareness might help us understand what has just
happened, and what may continue to happen. "Our country
is strong," we are told again and again. I for one don't find
this entirely consoling. Who doubts that America is strong?
But that's not all America has to be.[2]

These paragraphs were more incendiary than anything she
had ever published. The words may have been just—even, as
time would show, prophetic. And the opening sentence—"To
this appalled, sad American, and New Yorker, America has never
seemed farther from an acknowledgment of reality than it's been

in the face of last Tuesday's monstrous dose of reality"—was cut, an edit that she felt distorted her intentions.

With or without that sentence, the tone struck many as wrong, even before it was published. The first reactions were shocked. She had planned to read from *In America* at a previously scheduled event at the American Academy in Berlin, but a hundred people wanted to hear her speak about the inescapable subject of the day. She accordingly read a text that lacked, as she herself admitted beforehand, "any specially high level as far as the writing is concerned, is moralistic, may go too far, and is exaggerated."

A German journalist who heard her was astounded. "The criticism is devastating, polemical, and aimed at America. No paper has printed this kind of belligerent rage. Only the next weeks will say whether it will appear in *The New Yorker*."[3] At the end of her reading, she looked up. The audience was sitting in dumbfounded silence.

The piece violated her own principle, articulated four years before, about Sarajevo: "You have no right to a public opinion unless you've been there." The images CNN was pouring into her hotel room were no substitute for being in New York, and the negative reactions demonstrated her old adage. No matter how sensational, photographs are a poor substitute for reality.

At home, where many remembered her political interventions in seasons past, the right wing pounced. "What do Osama bin Laden, Saddam Hussein, and Susan Sontag have in common?" one piece in *The New Republic* opened. "Susan Sontag should not be permitted to speak in honorable intellectual circles ever again," said a spokesman for the Reaganite Heritage Foundation.[4] A columnist for the *New York Post* said: "I wanted to walk barefoot on broken glass across the Brooklyn Bridge, up to that despicable woman's apartment, grab her by the neck,

drag her down to ground zero and force her to say that to the firefighters."[5]

———

Fiercer was the friendly fire. David Rieff was indignant. "I've come rather to dislike the piece I dashed off for the *New Yorker*," she wrote, trying to appease him, a week after it was published. "Even while writing it, I thought it primitive. Now I think it's more seriously defective. I was right to denounce the retro smarminess and bluster of American rhetoric. But I should also have said something about terrorism—what you have emphasized in your several letters to me. . . ." He kept at her. "I continue to mull over the issues you raise. Was my piece hateful? I prefer to think it wasn't very smart. I'm beginning to think that the main thing driving people—which I see includes me—to take positions you hate and despise is rage against Bush: that America should be led by this team."[6]

David would not let it go. She grew annoyed by his insistence, but defended herself.

> Once again about my piece. It was written last Thursday. I was in Berlin. It was about the rhetoric I heard on CNN. Sharon asked me to write something, and I agreed. You speak of "the view Sharon was pressing on me." Please. . . . My mistakes are mine.[7]

"Never acknowledge a mishap," she wrote in *In America*. Except with David, she hardly ever did. Now, with him, she kept backtracking, trying to regain the approval of the only person who could berate her: the words "my mistakes" were rare in her interactions with anyone else.

But as to the substance of the critique, she was not in the least a fool. The campaign against her was directed toward anyone who

questioned the reigning jingoism. On September 26, the White House press secretary, Ari Fleischer, warned people to "watch what they say, watch what they do." The comedian Bill Maher was condemned for saying something Sontag also said: that the terrorists were not cowards. "Staying in the airplane when it hits the building, say what you want about it, it's not cowardly," he said. Following these comments, his advertisers made themselves scarce, and at the end of the season his show was canceled.

Glenn Greenwald, one of the most unyielding critics of the Bush administration, believed that the time to react was before emotional reactions hardened into orthodoxy. It was important to say that "the reason we should stop droning people and killing everybody is so that we don't keep getting attacked by people who want to take revenge on us. So if you're Sontag and you see all these people using 9/11 to justify all the militarism and demand greater militarism and imperial domination, that's the time that you push back."

Sontag was right to point out the connection between American actions and terrorism, Greenwald believed.

> Most Americans had this idea that America was just minding its own business in the world and out of the blue, for no discernible reason, these fucking extreme religious fanatics decided to attack us, right? Just because they're hateful and fucked up and crazy. And I think if you're someone like Susan Sontag, who had spent decades saying the United States is the source of extreme violence and aggression in the world, it makes total sense to make that connection.[8]

Another president might have proven Sontag wrong. That president was not George W. Bush, who soon plunged America into the greatest foreign policy catastrophe since Vietnam. But if her analysis was proven right, David and others who criticized

SONTAG

662

her had a point. Behind her analysis was the lack of empathy that wrecked her relationships and trivialized many of her political observations. Brenda Shaughnessy was thunderstruck.

> When 9/11 happened she said the most amazing thing that I still can't get out of my head. She said, "The restaurant workers! The restaurant workers! I don't care about the bankers. I don't care about the CEOs. I don't care about the finance guys. The restaurant workers." I was like, "Wait, you don't care about the other people?" It seemed like such a weird political thing to say about 9/11.[9]

On 9/11, Annie Leibovitz, eight months pregnant, was at her doctor's office, listening to her baby's heartbeat. "When I got back to my apartment and looked out the window, the towers were gone," she said. "There was just smoke. I could not believe that I was not grabbing my camera and running down to the site, but I had to think about the baby."[10] A few days later, Susan returned to New York and they went down to the site now known as Ground Zero, Annie masking her advanced pregnancy with an oversized coat.

To express her solidarity with the city where she had lived "ten stupendous years," the Argentine writer Luisa Valenzuela came at the end of September. Just before Annie's birthday, on October 2, Susan invited her to Annie's country house in Rhinebeck. "Annie had gathered friends, colleagues, and assistants to honor life and invite them to believe in a world still worth bringing children into," Valenzuela said. Wearing a cap with the logo of the New York Fire Department, Susan offered to read a story, "Rip van Winkle," set near Rhinebeck. "It was a magical reading that evening, and later Susan invited me to the small house where she lived on Annie's estate. There, looking out at a pond,

she spoke to me of her happiness, of how good she felt about the baby's arrival. 'I'll be like her grandmother,' she told me."[11] Susan cut Sarah Cameron Leibovitz's umbilical cord on October 16, 2001. "When they wheeled Sarah into my hospital room and left me alone with her, I was scared out of my mind," Annie said.[12]

Susan was, too. It did not take long for her fears of abandonment to surface. Anna Wintour, the editor of *Vogue* and Annie's titular boss at Condé Nast, came to the party to welcome Sarah, and arrived in the same elevator as Susan. Michael Silverblatt said that Annie greeted Wintour a bit too enthusiastically.

> Susan said, "What am I, chopped liver?" I couldn't believe that Susan was using that kind of Barbra Streisand line. But she wanted to be at Annie's side and not neglected or shunted aside, certainly not for Anna Wintour. Now, you don't ignore Anna Wintour, but I think Susan immediately thought, Well, you don't ignore me, either. She was experiencing it as a scene in an opera where the lover welcomes the prince regent and ignores the sordid object of affection.[13]

"I think she wanted me to herself," Leibovitz wryly said.

———

In early 2002, Annie left London Terrace. She bought two adjacent town houses in the West Village, and began remodeling them as a home for her family. "For reasons I don't entirely fathom," Susan wrote Luisa Valenzuela in May, "Annie has really no place for me in her new life, or rather all she has to offer is the possibility of visiting her in her apartment now and then, at which there are invariably many others there." The resentment at the others competing for Annie's attention was palpable; but Susan remained stoical: "I tell myself I shouldn't want to be close to the rather brutal, imperial person she has become."[14]

In 1962, Susan wrote: "The cult of love in the West is an as-
pect of the cult of suffering—suffering as the supreme token of
seriousness (the paradigm of the Cross)."[15] This was her experi-
ence, and it was no different now: she had always suffered in love.
"I am going through hell," she wrote a friend.

> Ever hopeful, or gullible, or masochistic, I get flushed out,
> enter into a conversation (on the phone) and within a minute
> I'm listening to a vulgar, vicious, truly stupid, screaming de-
> nunciation; and then she hangs up on me. It would be funny
> if it weren't so painful. In a word, I've been fired, although
> that's not the way Annie sees it. (The only relationships
> Annie understands are those with employees and relatives.)[16]

The next month, Susan wrote Peter Perrone about Jane,
"nanny from hell," a British woman with whom Susan errone-
ously believed that Annie was having an affair.

> As for Annie, well, she's gone . . . psychologically, humanly,
> whatever. Her only thought is to get Jane back. . . . In the
> meantime, Jane is spending her summer with the Niar-
> chos family on their island in Greece—Annie's never heard
> of Niarchos—and will return in September. The move is
> scheduled for November. And then? Then Jane will take
> care of Annie and nose her around and make her feel secure.

Still, Annie made another gesture: "I've been told I could
have a floor in one of the houses if I want to move there."[17]

———

Annie's spending had always inspired awe, and some in her en-
tourage believed that her approach to money reflected a more
general refusal of reality. Her assistant Christian Witkin saw it

on her shoots: "She was clueless," he said. "And she had all these ludicrous demands of us while we were—say—up to our knees in water in the Atlantic. She wanted to have lights in the water, but we weren't going to risk our lives. She didn't seem to have much common sense."[18]

But cluelessness had its uses. Like Susan, she disregarded rules as a way to flex her muscles. "She was an intimidating woman," said Witkin. "She would make a fool of you. She had no clue what it took to get the lighting right, but psychologically she was very clever. Mean clever." And like Susan, she could surprise with showy generosity. "Suddenly she was the nicest person in the world" at an opening. "Or at the employee Christmas dinners. She'd hand people Rolexes and gifts, and you'd love her. It's like an on-off switch."

She knew these lavish outlays impressed, and was even more careless with other people's money. According to Susan's assistant Oliver Strand, when Sarah was born and Annie had to be in Europe for a shoot, she would take the Concorde, and then pay for her nanny and daughter to come back on the Concorde: "Then, of course, change the tickets."

> Just for the kid to come on the plane might be, on the low end, ten thousand dollars. On the high end, thirty-five or forty thousand dollars. This would happen a few times a year.[19]

But there were limits even for Annie, whose financial situation had been weakened by a combination of extravagance and bad financial advice. On October 11, 2002, Dan Kellum was busy setting up Sarah Leibovitz's first birthday party. This would include "a petting zoo and performances by hipster kiddie singer Dan Zanes and country singer Rosanne Cash, who was being flown in to sing Sarah's favorite lullaby." As he was preparing the

festivities, Kellum received a panicked call. The two nineteenth-century town houses had a sub-basement that was only five feet tall; Annie decided to dig past the foundations to create a full floor. During the excavation, the wall she shared with the house next door groaned, and sank several inches. "The wall separated from the floors, leaving a gaping hole," *New York* magazine reported. Much of the damage was covered by insurance, but the neighbors' home was condemned. They sued, and, under a settlement reached in 2003, she purchased their home for $1.87 million.[20] The two-house complex became even grander when the third house was added, with its attendant restoration and remodeling costs.

To help with Annie's deteriorating finances, Susan took out a second mortgage on her apartment—which Annie had mostly paid for—and loaned her the money: around three hundred thousand dollars, according to Susan's accountant.[21]

———

In January 2002, UCLA announced the acquisition of Sontag's archive. "I am delighted that my archive is going to UCLA, thereby renewing an old connection with Southern California," she said.[22] The sale also included her library, estimated at twenty thousand books. The price, $1.1 million, was enough to allow Sontag to help set David up in a large floor-through apartment in Tribeca. But the delight she expressed in the press release was not quite the way she felt privately, and the sight of her papers being prepared for shipment overwhelmed her. "Psychologically that's a very difficult thing to do, and she did it to help David get that apartment," said Sharon DeLano.[23] "She was really upset," said Karen Mulligan, who worked in Annie's studio and helped prepare the archive. "She didn't want to do it."[24]

Once she had bought the apartment, "she spent a tremendous amount of her money," said Minda Rae Amiran, "and money is

nothing compared to time, outfitting it. He made sure she bought the kind of handle he wanted on the door." Susan struck Oliver Strand as unusually determined to please David: "That's the only time when she'd be not rational and a little aggressive and a little huffy and puffy." She was intimidated by him. "She called him a bully, many times," said Annie Leibovitz. Once, before Sarah's birth, she turned to Annie after David walked out. "Just wait till you have children," she said.[25]

Can't Understand, Can't Imagine

In March 2003, the United States invaded Iraq. It would be some time before the full breadth of this folly became universally clear, at which point far more people would claim to have been against the invasion than had been at the time. Many prominent liberals voted for the Senate resolution authorizing the invasion; in 2008, Hillary Clinton's support was a principal reason she lost the Democratic presidential nomination to Barack Obama, who had opposed the war.

By then, such opposition required little courage. But if anything proved the prescience of Sontag's warnings against the language of overheated patriotism, it was the run-up to the war, when bad metaphors showered, like missiles, upon the frightened populace. "We don't want the smoking gun to be a mushroom cloud," said Condoleezza Rice, Bush's national security adviser, making her fraudulent case that Iraq possessed weapons of mass destruction. In England, a "dodgy dossier" showing that Iraq was hiding prohibited weapons was, in the words of a British official,

"sexed up." Iraq had no connection to the September 11 attacks, and so a connection had to be pitched—as a consumer item. Asked why the administration waited until September 2002 to press its case, Bush's chief of staff candidly admitted: "From a marketing point of view, you don't introduce new products in August."[1]

This language sustained the frenzy September 11 unleashed. George W. Bush, who dodged service in Vietnam, was marketed as martial, macho, the only barrier between America and Armageddon. His opponents were jeered as members of the "Blame America First Club." This phrase was slapped onto figures as various as the country band the Dixie Chicks, the government of France, and Susan Sontag. A rhetorical low was attained with the resolution to change the wording of the menus in the House of Representatives cafeteria from "French fries" to "freedom fries." If, two days after the fall of the World Trade Center, it seemed inappropriate for Sontag to denounce the climate of chauvinism, her opposition would seem farsighted after hundreds of thousands of people—by some estimates more than a million—were killed in the Iraqi inferno.

———

A month before the invasion, Sontag published her final reflection on the ways of seeing and denouncing war. *Regarding the Pain of Others* appeared in February 2003, a month after her seventieth birthday and a month before the invasion of Iraq.

It opens with a citation from Virginia Woolf's "brave, unwelcomed reflections" on war, published shortly before the outbreak of World War II. In the age of the "War on Terrorism," which in practice meant permanent war, the vision of a world without war seemed quaint. But that had not been the case following World War I. Sontag recalled that the Kellogg-Briand Pact of 1928 bound fifteen leading nations, including the United States, France, Great Britain, Germany, Italy, and Japan, to renounce

"war as an instrument of national policy."[2] That renunciation was quickly forgotten. The death of the idea of a world without war meant that it was all the more urgent to know how to read violent images. Citizens were duty-bound to know how they were being manipulated—by whom, and to what end.

Many journalists, occasionally through gullibility but often by design, helped sell the Iraq War. If individuals did not seek to understand the images they diffused, politicians and their flacks would provide the captions, she wrote: "All photographs wait to be explained or falsified by their captions. During the fighting between Serbs and Croats at the beginning of the recent Balkan wars, the same photographs of children killed in the shelling of a village were passed around at both Serb and Croat propaganda briefings."[3]

The merger of war with the marketing mechanisms of late-stage capitalism made it harder than ever to know how to interpret images. And images of war had gradually taken over war itself, which was now, as Bush's chief of staff said, a consumer product. The Vietnam War, "the first to be witnessed day after day by television cameras," had "introduced the home front to a new tele-intimacy with death and destruction." Now, in the era of twenty-four-hour cable news, the televised war was arranged for maximum entertainment. It provided an incentive to start wars, and to keep them going; the image had so conquered reality that people could increasingly see only in terms of the metaphor: the representation of actual events. That is why "the attack on the World Trade Center on September 11, 2001, was described as 'unreal,' 'surreal,' 'like a movie,' in many of the first accounts of those who escaped from the towers or watched from nearby."[4]

Felice Beato, in the nineteenth century, "was the first photographer to attend a number of wars."[5] Larry Burrows, in Vietnam, was "the first important photographer to do a whole war in color."[6] The verbs are borrowed from the realm of spectacle, of

entertainment; and Sontag assembles a fascinating list of faked war pictures. The photograph of the marines raising the flag on Iwo Jima was a "reconstruction" created "by an Associated Press photographer." The picture of Russian soldiers hoisting the Soviet flag atop the smoldering Reichstag "was staged for the camera."[7] The knowledge that these photographs are faked obliterated their authority. "Only starting with the Vietnam War is it virtually certain that none of the best-known photographs were set-ups. And this is essential to the moral authority of these images."[8]

In this historical evolution, the photograph had moved closer to the thing it showed; artists had nudged their metaphors closer to the things and events those representations symbolize, and re-asserted the moral authority of the image. Sontag traces this genealogy from Goya's *Desastres de la guerra* through Dostoevsky to the journalists and photographers who, in her own time, wielded truthful images against fake ones, risking their lives to convey images that might translate into action.

This increasing fidelity to reality makes *Regarding the Pain of Others* more optimistic than *On Photography*. In Bosnia, she had seen the lengths to which witnesses went to bring back images. "Most of the many experienced journalists who reported from Sarajevo were not neutral," she wrote.[9] The making of images was not only voyeuristic or propagandistic. This discovery led her to quarrel with two ideas that, she admitted, she herself had popularized.

> The first is that public attention is steered by the attentions of the media, which means, most decisively, images. . . . The second—it might be described as the converse of what's just been described—is that in a world saturated, no, hypersaturated with images, those that should matter have a diminishing effect: we become callous. . . . In the first of the six essays in *On Photography* (1977), I argued that while an

event known through photographs certainly becomes more real than it would have been had one never seen the photographs, after repeated exposure it also becomes less real. As much as they create sympathy, I wrote, photographs shrivel sympathy. Is this true? I thought it was when I wrote it. I'm not so sure now.[10]

And she quarreled with her previous idea that the proliferation of images could undermine their moral authority.

Since *On Photography*, many critics have suggested that the excruciations of war—thanks to television—have devolved into a nightly banality. . . . But what is really being asked for here? That images of carnage be cut back to, say, once a week? More generally, that we work toward what I called for in *On Photography*: an "ecology of images"? There isn't going to be an ecology of images. No Committee of Guardians is going to ration horror, to keep fresh its ability to shock. And the horrors themselves are not going to abate.[11]

Bosnia and Iraq proved that the need to see was a matter of life and death. But how? Could metaphor—the image, the photograph, the thing-once-removed—help "recover our senses"? Could it teach us "to *see* more, to *hear* more, to *feel* more"?

———

More than any others, these were the questions that had occupied Sontag throughout her life. Perhaps only a person to whom empathy did not come naturally could have addressed them as well; a person who hears normally rarely thinks about hearing as a deaf person must. Her handicap, and her desire to overcome it, led her to reflect upon phenomena others took for granted, and her arguments with herself enrich her reflections.

An ironic consequence of this handicap, however, was that she could not see that others *could* see. That inability made the conclusion of *Regarding the Pain of Others* akin to a deaf person's refusing to admit the existence of the music he cannot hear himself.

> [Other people] can't understand, can't imagine. That's what every soldier, and every journalist and aid worker and independent observer who has put in time under fire, and had the luck to elude the death that struck down others nearby, stubbornly feels. And they are right.[12]

These are the last sentences in the book, and they seem reasonable enough. But one must read them a few times before their implications sink in. If nothing can be understood or imagined without firsthand experience, why represent experience at all? Do those who strive to bear witness torture themselves in vain? The paragraph echoes the conception of marriage in *In America:* to "ask someone, legitimately demand of someone, to see what you saw. Exactly what you saw." It echoes her demands of Annie: "You couldn't stand a little to the left or a little to the right. You had to stand exactly where she had stood."

This is the opposite of the conception of metaphor that emerges from the novels of Dostoevsky or the etchings of Goya. If such artists had departed from Sontag's precept, their works would never have come to exist. If no representation could bridge the gap between the person in Sarajevo and the person reading about Sarajevo, why write about Sarajevo? The point of artistic representation is not to make the reader's experience identical to the artist's. The point of representation is to allow the reader or the viewer to enter another person's experience. We *can*, in fact, imagine. We *can* understand.

To say otherwise is to say that a black person can never understand a white person, or a man a woman, or a Chinese a Bosnian: to say that no person can ever understand another. One need not become another person, or to have had exactly the same experiences, in order to imagine that person's life—which is why the foundation of metaphor is empathy. Art and metaphor do not make other people's experiences identical. They make other people's experiences *imaginable*.

———

Throughout 2003, Susan gathered honors and prizes. In April, she went to the book fair in Bogotá. "A few people told her that it was a really bad idea, including Andrew Wylie," her agent, said her assistant Oliver Strand. Colombia, after all, was still dangerous. "I think we should go," she said. Her Spanish editor, Juan Cruz, came along.

But soon after they arrived, Strand, born in Chile, realized there had been a misunderstanding. Reading *"conferencia"* as "conference," Susan had not prepared a speech, which is the meaning of the word in Spanish. She expected, instead, to be interviewed. "I realized that in the middle of the press conference and I told her, and it's like ten o'clock at night." Knowing how she agonized over her writing, he expected her to be upset, but she rose to the occasion. In the morning, she told Strand: "I'm going to go and denounce García Márquez for supporting Castro in the execution of the intellectuals."[13]

This was no small provocation. A Colombian icon and winner of the Nobel Prize, Gabriel García Márquez was one of the most famous writers in the world—and a notorious apologist for Fidel Castro. If, in the sixties, many Latin American writers had been hopeful about the Cuban Revolution, half a century of political repression and enforced poverty had left Castro few friends

among intellectuals. This exception, however, was an essential one, and allowed the dictator to present a cultivated face.

In March, just before Susan went to Bogotá, the Cuban regime put on one of its periodic show trials, in which seventy-eight dissidents were sentenced to prison terms from twelve to twenty-seven years, including for crimes such as "possessing a Sony tape recorder." Soon after, Castro had three men executed for trying to flee to the United States in a small boat.[14] These actions were denounced all over the world. At her speech, attended by a thousand people (three hundred more waited outside), Sontag said:

> I know that Gabriel García Márquez is very respected, and his books widely read. He is the great writer of this country and I have great admiration for him, but it is unforgivable that he has not spoken out against the latest measures of the Cuban regime.[15]

Rather than taking offense, the Colombian audience, embarrassed by the great man's prevarications, greeted this attack with a standing ovation. The reactions forced García Márquez to respond. "I myself cannot calculate the number of prisoners, dissidents, and conspirators that I have helped, in absolute silence, get out of jail or emigrate from Cuba over no less than twenty years," he told the Colombian paper *El Tiempo*. "That's a regime that deserves to be defended?" Susan riposted. "A regime you have to help people escape?"[16]

Following the book fair, Susan, Strand, and Cruz headed to Cartagena de Indias. Invigorated by the controversy, she maintained her punishing schedule even in that laid-back beachside city. In the hotel pool, she "swam, swam, swam to oblivion," wrote Cruz. And despite the oppressive Caribbean heat, she went looking for culture, music, art, unable to sit still, "sweating her human marathon."

In the less than two years since Sarah's birth, Annie Leibovitz had pressed ahead with her determination to have more children. Despite her age—she turned fifty-four in 2003—she had managed to get pregnant twice following Sarah's birth. Both pregnancies ended in miscarriages. Forced to accept that she would not be able to have another child, she turned to surrogacy, and with Susan's help wrote a letter to women she hoped would help her. In it, she explained her decision to delay childbearing: "I've had a big fantastic wonderful career, and consider now that I've been incredibly lucky to make a good living doing something I love doing," Susan wrote, in her voice.

> People say—well, here goes the part that seems like praising myself—that I'm the kind of person who would give the shirt off my back to someone in need. I guess I can say, without too much embarrassment, that generosity is one of my outstanding characteristics. I love helping people.
>
> What else? I'm sentimental, I suppose. I love people, especially children. I cry pretty easily. But I'm strong, too. I'm a good person in an emergency.
>
> Family means everything to me. It is a specially wonderful time when we all get together to celebrate the Jewish holidays. I believe in a strong sense of tradition and of religious values. From the beginning, I have trusted in the values of religion to guide me in bringing up Sarah.[17]

Despite the description of Annie's generosity and strength, and despite Susan's apparent support, revealed in the letter, for Annie's desire to have more children, the relationship had not improved. Susan was still fretting to Sharon DeLano, who, at the end of September, urged her to cut the cord.

You are SUSAN SONTAG, for chrissake. . . . Now, I know
that you are not without sin in terms of the relationship-
with-Annie department. Your impatience and censorious-
ness have been noted. Nevertheless, would a guy have moved
on? Yes, he would. WHAT ARE YOU DOING?[18]

———

Five days after Sharon's e-mail, on October 3, the Nobel Prize was
awarded to J. M. Coetzee. The award depressed Susan, according
to her French publisher, Dominique Bourgois.[19] It made it highly
unlikely that another English-language writer would receive it in
the coming years, and Susan, at seventy, realized she was unlikely
to achieve the goal she had set as a child. But a few days later, she
was in Frankfurt to receive another prestigious award, the Peace
Prize of the German Book Trade. There, she was snubbed by the
United States ambassador, Dan Coats, an undistinguished former
senator from Indiana, who did not attend as a protest against her
supposed anti-Americanism. And, in fact, it did seem that she
was given the award, at least in part, for her objections to the Iraq
War, which the German government had opposed.

Sontag represented an alternative to the America of "freedom
fries," and she recognized as much in her speech.

Irate, dismissive statements about Europe, certain European
countries, are now the common coin of American politi-
cal rhetoric; and here, at least in the rich countries on the
western side of the continent, anti-American sentiments are
more common, more audible, more intemperate than ever.[20]

She analyzed this antagonism, particularly the misunder-
standings it engendered about America: "a profoundly conser-
vative country in ways that Europeans find difficult to fathom"
but also "radical, even revolutionary, in ways that Europeans find

equally difficult to fathom."[21] And if continent-as-metaphor engendered dangerous misunderstandings, it also spurred dreams: Europeans dreamed of America; Americans, of Europe.

One of those Americans was a girl growing up in the "cultural desert" of southern Arizona, who discovered German literature through a teacher named Mr. Starkie. "And a few years later, when I was a high school student in Los Angeles, I found all of Europe in a German novel. No book has been more important in my life than *The Magic Mountain*. . . ."

She then told of the man who later became her German editor, Fritz Arnold, who spent the war as a prisoner just up the road from the Sontags, in northern Arizona.

> Fritz told me that what got him through his nearly three years in the prison camp in Arizona was that he was allowed access to books: he had spent those years reading and re-reading the English and American classics. And I told him that what saved me as a schoolchild in Arizona, waiting to grow up, waiting to escape into a larger reality, was reading books, books in translation as well as those written in English.
>
> To have access to literature, world literature, was to escape the prison of national vanity, of philistinism, of compulsory provincialism, of inane schooling, of imperfect destinies and bad luck. Literature was the passport to enter a larger life; that is, the zone of freedom.
>
> Literature was freedom. Especially in a time in which the values of reading and inwardness are so strenuously challenged, literature *is* freedom.[22]

This was a moving valedictory—though Sontag could not have known it at the time—to the cosmopolitan tradition to which she had pledged herself as a girl.

———

A few months later, in March 2004, she traveled to South Africa at the invitation of Nadine Gordimer. Their dispute over Israel had healed. And in *Regarding the Pain of Others*, Susan even used that most radioactive of South African words—one she had not used in Jerusalem—to describe Israel: "an apartheid state maintaining a brutal dominion over the lands captured in 1967."[23]

When the University of the Witwatersrand inaugurated a yearly lecture in Gordimer's name, she suggested that Susan be the first honoree. "I'd always wanted Susan to come to South Africa," she said. "Wherever Susan was, the walls seemed to expand." Susan ran her escorts ragged with sightseeing, Gordimer said: "She wasn't very well, but she didn't spare herself at all, or anybody else!"

Gordimer wanted to take her to a game reserve, but Susan proclaimed that she was not interested in nature. "I'm interested in people." But Gordimer insisted: "You've met so many people, and I absolutely will not allow you to be in Africa and see only the human animal." Because Susan loved Nadine, she accepted.

> I took her to a very lovely game reserve, and I was so upset because it was drizzly. It was March and it was raining half the time. She didn't give a damn. This wild hair was all sprinkled with raindrops, and she—first of all, she fell in love with the countryside, with the thorn trees and the whole look of the space. . . . And then when we came to the animals, especially giraffes, elephants—the smaller animals you couldn't see, it was drizzling so much—she was tremendously impressed by their majesty, by their poise, by everything about them. . . . And then she said something that I so much wished it could have happened. She said, "Yes, well, I want to come back. I want to come and sit here," because

it was the hotel part of it—you could go—you were fed, you were looked after. And she said, "This is what I need to get away from New York, from Paris, from everywhere, and I want to come and finish my book here." . . . Wouldn't it have been wonderful—and it would have been such, to me, such a paradox and irony, I would have teased her with it. I don't want to see anything but the human animal, and then—she falls in love with this place and the animals.[24]

———

The idea of returning to finish her book was all the more poignant because by the time she went to South Africa she already knew—or at least strongly suspected—that she was sick. A couple of weeks before the trip, she went to Santa Fe for a speaking engagement. Michael Silverblatt was there to introduce and interview her. In the twelve years since they met, Sontag and Silverblatt had become passionate friends. "She was very tactile," he said. "There was a great emotional need to be held and touched and felt."[25]

Silverblatt was one of the rare people she trusted to touch her. When he took her to an acupuncturist to help her quit smoking, Peter Perrone saw just how hard this was for her. He had been after her for years to try acupuncture to help her quit, and finally wore her down. The elderly Chinese therapist explained the process to Susan, saying that a patient should not so much as feel properly applied acupuncture needles. But she started writhing and screaming before he even touched her. "Are you all right?" he asked. "Go ahead, go ahead," she answered. He tried again, and then again, with the same results. Exasperated, he finally told her it was no use. "Let's go get dim sum," she said to Peter.[26]

In Santa Fe, Susan and Michael visited a massage center called Ten Thousand Waves. Susan claimed that she had never had a massage in all her life. Her mother was "a pig of pleasure,"

she told him. "She wanted to be as unlike her mother as possible."
They booked a double room. Silverblatt knew it was a consequen-
tial moment, a level of intimacy she rarely attained. "I knew that
she wanted to see if she could show me her mastectomy wounds,
her scars," he said. "It was something that she had enormous fear
about, to be naked with people. Of course, I was extraordinarily
moved and touched and frightened."

A more frightening sequel was to come. The pressure from
the massage left black-and-blue marks on her body—and that,
said Silverblatt, "was when she realized she had this very difficult
kind of leukemia."

CHAPTER 43

The Only Thing That's Real

On March 28, on his way back from a reporting trip in Palestine, David called from Heathrow. After listening to his stories about the West Bank, Susan said: "There *may* be something wrong." She downplayed the danger, though she asked him to come with her to the doctor the next day. Back in New York, he went to her apartment. "She kept talking about the Middle East, and, unable to say anything that mattered, let alone touch her, I kept on telling stories about Yasser Arafat and his compound in Ramallah." The tests left no doubt. Susan had myelodysplastic syndrome, a blood cancer. The doctor explained with brutal clarity what that meant. "So what you're telling me is that in fact there is nothing to be done," she said. "Nothing I can do." The doctor did not answer. He suggested that, rather than pursue futile treatments, she take the time she still had—around six months—to live.[1] On the drive back downtown, she stared out the window. "Wow," she said. "Wow."[2]

———

At first, Susan understood. "Three strikes and you're out," she told several friends.[3] "I don't feel lucky about this one," she said to Peter Perrone. "This time, for the first time in my life, I don't feel special," she would say in particularly black moods.[4] She had never been able to be alone, but now she needed someone with her around the clock. Her housekeeper, Sookhee Chinkhan, took to sleeping in the living room. One night, when she woke up screaming, Chinkhan prayed: "Please Lord, give Susan peace."[5]

"My mother came to being ill imbued with a profound sense of being the exception to every rule," David wrote.[6] Beyond the threat to her body, the loss of that sense of specialness, of self, added to the terror of the cancer. This was not grandiosity chafing against a monstrous dose of reality. To renounce her exceptionalism would mean renouncing the foundation of her identity, the fiction that had transformed Sue Rosenblatt into Susan Sontag. Giving it up would mean death, though clinging to it in the face of this diagnosis meant madness. Soon, David said, her choice became clear: "To say that we were all worried about her immediate mental state does not begin to describe the anxieties."[7]

"Lie to me," Susan had imagined Mildred's saying. Once Susan's mind reasserted itself over her body, this was exactly what she demanded of those around her. David "gave the answers that I believed she wanted to hear." He felt he had no choice. "Never for a moment, during the course of my mother's illness, did I think she could have 'heard' that she was dying."[8]

This was the woman who "always liked to pretend my body isn't there," who had always been willing to subject her body to extreme ordeals. "They're using chemical weapons on me. I have to cheer," she wrote during her first cancer. Convinced that a steely mind was the key to survival, she would cheer again: a perverse last tribute to Freud.

———

She went back to work. A month after her diagnosis, another horrible event proved the ongoing relevance of her thought. Photographs emerged at the end of April that showed Americans torturing inmates at the Abu Ghraib prison in Iraq. The revelation that George W. Bush had instituted torture did much to undermine support for a war he packaged as a liberation, and stirred Sontag to write one last time on the subject that had occupied her throughout her life. "Regarding the Torture of Others" appeared in *The New York Times Magazine* at the end of May.

Her final published essay showed how a subject that might have seemed intellectual or abstract could break people's bodies. Among the many things the separation of thing from metaphor could effect was a separation of crime from criminal. When the Abu Ghraib pictures surfaced, "the president was shocked and disgusted by the photographs—as if the fault or horror lay in the images, not in what they depict."

And so it was with language: "There was also the avoidance of the word 'torture,'" which Bush skirted with legalese. Metaphor meant so many things; and among its sinister powers was its ability to disguise evil by dressing it in other names. Thousands of years ago, Confucius wrote that the abuse of metaphor led to the destruction of society, because tyranny began with language. The warning could never be repeated enough. In every generation, it needed to be relearned, often at hideous cost.

> Those held in the extralegal American penal empire are "detainees"; "prisoners," a newly obsolete word, might suggest that they have the rights accorded by international law and the laws of all civilized countries. This endless "global war on terrorism"—into which both the quite justified invasion of Afghanistan and the unwinnable folly in Iraq

have been folded by Pentagon decree—inevitably leads to the demonizing and dehumanizing of anyone declared by the Bush administration to be a possible terrorist: a definition that is not up for debate and is, in fact, usually made in secret.

Into these mangled meanings entered the predatory weapon, the camera. The Abu Ghraib pictures were made by people who saw nothing wrong with what they were doing and recorded torture exactly as they recorded everything else. Torture was simply another occasion for photography.

Andy Warhol's ideal of filming real events in real time—life isn't edited, why should its record be edited?—has become a norm. . . . Here I am—waking and yawning and stretching, brushing my teeth, making breakfast, getting the kids off to school.

The camera made all events equal. "The distinction between photograph and reality—as between spin and policy—can easily evaporate." And, as Warhol had predicted, it had made people equal to their images: "The photographs are us," she wrote.

Was this distinction overstated? There would be no "ecology of images," no way to check their proliferation. And so the identity of object and image had to be made a positive weapon. Because they retained a power that words had lost, pictures needed to be wielded against other pictures, as artists since Goya had endeavored to do.

The pictures will not go away. That is the nature of the digital world in which we live. . . . Up to then, there had been only words, which are easier to cover up in our age of infi-

nite digital self-reproduction and self-dissemination, and so much easier to forget.[9]

––––––

On May 25, two days after this essay was published, Roger Straus, the most enduring parental figure in Susan's life, died at eighty-seven. Their relationship had lasted forty-two years. "I never thought I would die the same year that Roger did," Susan told Karla Eoff.[10]

In *Illness as Metaphor,* she had denounced the practice of lying to patients. "All this lying to and by cancer patients is a measure of how much harder it has become in advanced industrial societies to come to terms with death," she wrote then. "Yet the modern denial of death does not explain the extent of the lying."[11] Her experience would suggest another explanation: the sufferer wanted to be lied to—insisted on it. But the lying deprived her of an opportunity to come to terms with what was happening to her. Sharon DeLano saw that if she was sometimes far more optimistic than she had reason to be, that was because her doctors frequently gave her false encouragement. "She was not allowed the chance to reconcile herself with death." DeLano believed that she would have made other choices if the options had been more soberly explained to her, as the doctor who gave her the initial diagnosis had attempted to do. But his banishment resulted in a gruesome "treatment" that was almost certainly bound to fail. Echoing many of those who accompanied Sontag's last months, DeLano said: "Torture is not too strong a word."[12]

Thirty years before, as she was preparing for her first cancer surgery, Susan had written that

We no longer study the art of dying, a regular discipline and hygiene in older cultures; but all eyes, at rest, contain

that knowledge. The body knows. And the camera shows, inexorably . . .[13]

The body knew. But the mind needed to be brought to that knowledge. With talk of "miracle drugs" constantly dangled before her, she held out hope far longer than she had any rational reason to. But she had beaten cancer twice. The first victory maimed her, and the second poisoned her: the third was the result of the chemotherapy she had received for her uterine sarcoma.[14] Still, that therapy had bought her six more years. Encouraged by her new doctors, she was determined to do whatever it took to buy herself a bit more time.

And so, as she was writing "Regarding the Torture of Others," she was undergoing torture herself, in a desperate bid to prove the initial diagnosis wrong. Her battle plan had two prongs. First, a determination to outwit the disease through careful study. "Above all," David wrote, "information needed to be collected."[15] Second, the willingness to undergo suffering.

———

She elected a bone-marrow transplant. Most cancer treatments aim to produce remission: to buy some time. A successful bone-marrow transplant effects a total cure. Stem cells are injected into the vein, and these—beautifully, mysteriously—fight their way into the marrow. There, if all goes well, they establish themselves and begin to make new blood. The patient's cancerous blood is banished, replaced by a new blood system, borrowed from the donor.

It is no small thing to destroy a person's entire blood system. For all its theoretical elegance, the transplant presented so many obstacles that her doctors in New York did not want to risk it. For a person of her age and with her medical history, its chances of success were slight. It was shockingly expensive; Annie paid.[16]

And it entailed grotesque suffering. Nevertheless, there was a chance it could work. She found a matching donor: one in three patients never do. And she found a hospital in Seattle willing to offer the therapy, the Fred Hutchinson Cancer Research Center at the University of Washington. Before she went, she began conditioning chemotherapy at Sloan Kettering. Then, on June 9, Annie arranged for her to be flown to Seattle in a private plane.

Annie also arranged a whole system of caretakers to ensure that Susan would not need to be alone. With them, the first days of summer in Seattle were not unpleasant, considering the circumstances. With Sharon DeLano, she visited the new public library, designed by Rem Koolhaas. With Peter Perrone, she saw *Spider-Man 2*. With Peter, Annie set up two apartments at a Residence Inn: one to house Susan as she awaited her operation, and the other to house visiting friends and relatives.

"It is not a procedure for which anyone can be prepared," wrote her friend Jerome Groopman, the physician and writer.[17]

> It is a treatment of last resort. Even when all goes well, it represents an experience beyond our ordinary imaginings— the ordeal of chemotherapy taken to a near-lethal extreme.[18]

In July, Susan was isolated in a radiation chamber and brought as close to death as is clinically sustainable. On August 21, she received the transplant. It was not clear whether the cells would root; and throughout the days of doubt, from time to time, Annie took pictures. If words can be inadequate to describe the pain of others, photographs showed the torment. Susan's skin turned black. Her face swelled beyond recognition. For all the controversy these photographs created when they were published, the most remarkable thing about them may be that they did not show this instantly identifiable woman in any identifiable form. Susan Sontag was no longer herself.

———

Peter was relieved by Paolo Dilonardo, who was relieved by Karla, who stayed from the end of August until early October, when Sharon came. Though her father was dying in Florida, Annie came whenever she could. Judith came in from Hawaii.

Those who came faced arduous work. Throughout September, Karla began circulating a daily e-mail to a few of the people entrusted with Susan's care. They discuss the monitoring of Susan's blood counts, as the doctors waited to see if the transplant had worked. They show the frantic concern of Nicole Stéphane, in Paris, trying to get Dr. Israël to pull off another miracle. In a moment of despair, Susan called Nicole, herself elderly and ill, and said: "I'm not going to make it this time."[19] They show the efforts of Anne Jump, Susan's assistant. And they show the team Annie had assembled and paid to arrange practical matters from her office in New York, and her efforts to give Susan emotional support, too: "Annie was overachieving, giving Susan all of her attention (which was loving and sweet) but something that Annie couldn't possibly keep up at that level if she was here all the time."[20]

They show the efforts made to distract Susan: "Annie had put *Parsifal* on (5 hours, oy) and so Susan was completely engrossed."[21] And they show how difficult the most basic activities had become. It took her hours to eat a simple meal, and her inability to control her bodily functions created a horror. She was incontinent, but often too dazed to realize that she had soiled herself, Karla wrote: "You can barely hear her when she talks, she won't talk on the phone, her hands shake, she doesn't look at you when you talk to her (or only rarely)."

As they were striving to keep Susan alive long enough to give the transplant a chance, Susan had one overwhelming wish: to see David. He had not one but two dying parents: Philip Rieff was

sick in Philadelphia, and David himself had to undergo a minor operation in New York. But many felt his presence was grudging. "It was hard to get David out there," said Annie.[22] He had not been since Karla arrived in August, and had promised to come on his birthday, September 28. As the hours passed and he had still not arrived, Susan began to panic. "Can you call David? Can we find David? David's not here. I hope nothing's happened to him. Where's David? Where's David? Where's David?"

Around five, Karla finally got him on the phone. "I'm not coming," he said. Karla reminded him that it was the last time she would be alive for his birthday. "It means more to her than anything." But he was in New York, and declined to call; it was left to Karla to break the news. "She freaked out. She was like, 'Oh my God, is he sick? Is he in the hospital?'"

To get her mind off David, Karla brought some sushi, since she hated the hospital food, and suggested they talk about his birth. "I certainly couldn't get her to talk about dying, but I could celebrate David's birthday with her. I could give her that." That night, she wrote David.

> We turned off the lights and watched the moon rise, and I asked Susan to tell me the story of your birth.
>
> She said that at four o'clock in the morning, the day before you were born, she was in bed next to Philip and realized that she was lying in a puddle of water. Philip asked what they should do, and she said, "I guess we should call a taxi." She was in a maternity ward at the hospital, so she could hear other women in labor. "The strange thing is that they didn't call out for their husbands, they called out for their mothers."
>
> Every few hours she would ask for painkillers, and they would say, "Soon, but you have to push some more first." It was a long period of labor, difficult, but when it was over she

had a ten-pound boy. "I always knew it would be David. I never even thought I'd have a girl."

You looked like an Inuit baby. You had a Mongolian spot at the base of your spine, and a tiny tail. Your hair was black and fuzzy and came all the way down to your eyebrows.

I don't think Susan has ever done anything that made her happier than having you. She's always said that you were the love of her life. You must realize how proud of you she is, but multiply that by a thousand.[23]

———

Friends sent the kinds of weighty foreign films that Susan had enjoyed all her life, but to their surprise she was not interested. "It was not Dreyer or Bergman but Cary Grant and Fred Astaire," said Sharon. "The American musical." They watched *Kiss Me, Kate; Singin' in the Rain; It Happened One Night; The Philadelphia Story; Some Like It Hot; To Have and Have Not.*[24] "We really liked *Funny Face,* for instance," Sharon said. "We thought how great that holds up." When Susan was watching a movie, she would not be interrupted. Once, a doctor tried to interrupt, and Susan waved him away. "You've got to go and come back when this is over." The doctor insisted, but Susan told him to come back later: she was watching *Aida.* "She wouldn't let him talk because she was watching an opera," Karla said.

As so often in her life, art kept her sane. In the hopes that it would give her energy to do her physical therapy, she was put on increasingly high doses of Ritalin, but the drug did not work. The only things that distracted her were talking about the past, watching movies, and being read to.

"I can't emphasize enough that she really loves being read to," Karla wrote the inner circle on September 22. "I think her mind is hungry, and it needs to be fed. My main job (besides being

an extra hand for the staff when needed) is giving some mental stimulation." Three days later, she wrote:

> She seemed to feel particularly humiliated by everything today. I'm telling her how much I admire the way she's handling this, and that I know it must be unspeakably difficult. Don't know how much that helps. This is a very despondent person. She only seems happy when she's being read to, and keeps saying that the only thing that's real is the book.[25]

When Karla left to return home to New Mexico, she tried to bid Susan farewell; but Susan did not want to acknowledge that this leave-taking was final. "Oh, darling," she said, "the next time you're in New York, we must go out for dim sum."

———

There was reason to believe that, despite the pain, humiliation, and boredom, she might recover. On September 26, just before she left, Karla wrote that "it appears that the cancer is in remission and that the graft is being accepted. The body's response to the graft seems almost too perfect." By the time Peter Perrone returned, there was more hope: she was moved to a floor of the hospital reserved for patients whose recovery was advancing, and was delighted by this sign of progress.[26]

That hope was soon extinguished. She was developing graft-versus-host disease, a feared consequence of transplants: the body's own cells begin attacking the transplanted cells, which it sees as invaders. On November 9, she was moved back downstairs. "It's an incredibly intricate story," David wrote Sharon, "not great, the bottom line is the GVHD is serious, it's enough."[27] They had to await another bone-marrow biopsy—another hideously painful procedure.

Her friends in New York, including Sharon and Annie,

scrambled to make arrangements in case the transplant failed. On November 9, David wrote Dr. Stephen Nimer, her oncologist in New York.

> My mother's situation may, I emphasize may, be coming to a point where it might be better for her to come home. [Her Seattle doctors] tell me that much depends on the bone marrow biopsy they are going to perform in the next few days. If it's bad, they seem to be suggesting she might be better off in New York, but I am starting to wonder even if it does not show that she has converted to full-blown AML [acute myeloid leukemia], if that's the right term, whether she might not be better off at Sloan Kettering.[28]

The results were as feared. On Saturday, November 13, David, Peter Perrone, and her team of six doctors delivered the dreadful news. "But this means I am dying!" she screamed.

"Susan collapsed on herself," said Peter. A doctor's assistant tried to comfort her.

> "You might want to take this time to concentrate on your spiritual values."
>
> "I have no spiritual values!"
>
> "You might want to take this time to be with your friends."
>
> "I have no friends!"[29]

Annie rushed to Seattle. When she arrived, Peter said, she knew exactly what to do.

> It was really beautiful, because Susan was basically inconsolable at that point. Because she knew what it meant. Annie came in and immediately crawled onto her bed and held her. It was just so . . . I don't know, it was just really the right

thing to do, that no one else could have done. It really did comfort Susan for the moment, and calm her down.[30]

—————

Two days later, on November 15, Annie brought her back to New York on a medevac plane, and she was admitted to Sloan Kettering. The heroic depressive had always managed to pull herself out of despondency, and people who came to visit were sometimes staggered by her vigor. The next morning, she was sitting in bed, reading *The New Republic* and complaining about one of the articles.[31] And she continued to tinker with the last piece of writing she would complete, an introduction to the Icelandic novelist Halldór Laxness's *Under the Glacier*. In it, she quoted one of his characters, who seemed to offer a witty gloss on her own writing:

> "Don't be personal. Be dry! . . . Write in the third person as much as possible . . . No verifying! . . . Don't forget that few people are likely to tell more than a small part of the truth: no one tells much of the truth, let alone the whole truth . . . When people talk they reveal themselves, whether they're lying or telling the truth . . . Remember, any lie you are told, even deliberately, is often a more significant fact than a truth told in all sincerity. Don't correct them, and don't try to interpret them either."[32]

David read *Don Juan*. Peter Perrone read *The Death of Ivan Ilyich*, hoping to spark a conversation about death. He could not, though there were moments when she spoke of the end. At Sloan Kettering, she summoned David to her bedside. "The most important thing I'm leaving you is my journals," she said. "There are a few things that should be taken out"—she meant the names of some of her lovers—"but they should be published."[33] And she chose the music for her funeral: Beethoven's last piano sonata,

no. 32; and one of his final string quartets, no. 15. Of this work, T. S. Eliot had written to Stephen Spender: "I find it quite inexhaustible to study. There is a sort of heavenly or at least more than human gaiety about some of his later things which one imagines might come to oneself as the fruit of reconciliation and relief after immense suffering."[34]

That reconciliation—that relief—would not come. Spurred by Dr. Nimer's mention of an experimental drug, she rallied, again and again, a willfulness that amazed Marcel van den Brink, a physician who met her at this time. He saw how she vacillated between "I don't want this anymore. I realize that it's hopeless" and, within a matter of seconds, "I don't want to give up. Give me another drug." Dr. Van den Brink wondered whether it was wise to encourage her. "One could debate if that was giving her false hope." She was too far gone for a new therapy to make a difference.

> Normally people at that stage would be tired of the long battle that they have fought. They might do this once or twice, maybe, might still say, "No, no, no, please still try to give me another drug and see if you can save me." She died still going like a pendulum, going back and forth in a few seconds from "I can't stand this anymore, I want to give up" to "No, actually, still please give me the drug." That is somewhat unusual. I have not seen that often, that people would do that until the last moment.[35]

She needed to stay alive; she had work to do. The standards of perfection she had internalized as a child were impossible to let go. She "spoke, when she could speak, of what she could do when she got out of the hospital," David wrote. "She would write in a different way, get to know new people, do some of the things she had been meaning to do."[36] When Andrew Wylie found her

asleep one day, she insisted, flustered, that he had it wrong. She had not been asleep. She was working.[37]

Asleep, she dreamed of persecution. One night in December, she dreamed that Hitler was chasing her. On December 18, Sharon was surprised to find her making painstaking efforts to be nice to a nurse she had never liked. This was because of a paranoid delusion. She thought the nurses had held a secret night meeting. They decided she was mean and arrogant and were all against her. She was determined to win them back.[38]

———

As a young woman, Sontag noted some last words in her journal. Gertrude Stein emerged from her coma to demand of her companion: "Alice, Alice, what is the answer?"

"There is no answer," Alice Toklas replied.

"Well, then," Stein said, "what is the question?"

Of Henry James, she wrote:

A Remington was the only typewriter whose rhythms he could bear, + on his deathbed—at his last moments—he called for his Remington. And she [his secretary] typed for him. James died to the tune of his typewriter. Flaubert would have appreciated this—pathos of the artist's vocation.[39]

"Get me out of here," she begged Annie on Christmas Day, grabbing her sleeve. Annie had to leave to visit her father in Florida; he died six weeks later.[40] "I kissed her goodbye," said Annie, "and I said I love you, and she said I love you."[41] On December 26, she gasped for breath, speaking of only two people: her mother and Joseph Brodsky.[42] On December 27, she asked: "Is David here?" He answered that he was, and she said: "I want to tell you . . .";[43] and then nothing more.

The Body and Its Metaphors

After Sontag died, at 7:10 in the morning of December 28, David opened her gown and gazed upon her body: a mass of bruises, black and blue.[1] As the group of her friends looked on, he kissed her mastectomy scars.[2] The other person closest to her needed her own evidence that this larger-than-life woman was dead. At the funeral chapel, Annie clothed her in a Fortuny dress they had bought together in Milan. The images she made showed a beautifully dressed corpse—nothing more. The most recognizable writer of her generation was gone.

David decided to bury her in Paris, at Montparnasse. The funeral, on January 17, 2005, was a homecoming of sorts. She would keep eternal company with Sartre, Cioran, Barthes, Beckett—the ideal family of which she had dreamed in Tucson. Annie paid for many friends to attend. But for many who came, it was a dismal farewell. Kasia Gorska, who had flown in from Warsaw, said tactfully: "It was the most unusual funeral I've ever been to."[3] Marina Abramović was similarly depressed: "She had this amazing

charisma and so much energy, but she had a sad little funeral. . . . It was rainy. It was all wrong."[4] Sharon DeLano was disappointed by the size of the crowd, by invitation only: "If it had been up to Susan, people would have been throwing flowers in the streets."[5]

————

On March 30, a memorial was held in Zankel Hall, in the basement of Carnegie Hall. Though many friends were present and Mitsuko Uchida played Schoenberg and Beethoven, this occasion, too, left hard feelings.

For the guests, Annie and Sharon had produced a beautiful book. It showed Susan and Judith in Arizona, and then an elegant tour of her life in pictures by some of the great photographers of the twentieth century. There was Susan by Andy Warhol and Joseph Cornell and Richard Avedon and Peter Hujar and Robert Mapplethorpe and Henri Cartier-Bresson and Irving Penn and, finally, Annie Leibovitz herself.

But David refused to allow the book to be distributed with the program, inside the auditorium. Annie and Sharon had to hand it out to guests as they arrived, in the street-level foyer. After the ceremony, friends were divided between "David people" and "Annie people." Annie and David each hosted a reception, but not everyone understood that a choice had to be made. "If you're going to her thing, you can't come to ours," Paolo Dilonardo told several mourners.[6]

Judith, who had come from Hawaii to New York in midwinter, borrowed one of her sister's coats; as she got into the taxi for the airport, David asked for it back. "Good-bye, David," Judith said, refusing to take the coat off. Annie took a coat, too, a cherished memento she had bought Susan on one of their Christmas trips to Venice. Paolo accused her of stealing, and the next time she came to the apartment, she found the locks changed to keep her out.[7]

Eventually, two books that dealt with her death would appear, two competing narratives: David's *Swimming in a Sea of Death* and Annie's *A Photographer's Life*. Many of those who had accompanied Susan in her last months found David's account dissembling, and many of those who distrusted Annie found her images of Susan's suffering obscene.

Leibovitz's book elicited phrases even fiercer than those *On Photography* had provoked thirty years before. "Really, it's a matter of when you find yourself throwing up,"[8] wrote the critic David Thomson. Others found the book moving. It is the only occasion on which Annie published her assignment work with personal photographs—her family at play, her father's death, the births of her children. But the book does raise uncomfortable questions— the same raised in *On Photography*. In that book, Sontag wrote that photographs allowed reality, including the reality of other people's suffering, to be packaged as a consumer item. She cited an advertisement:

> "Prague . . . Woodstock . . . Vietnam . . . Sapporo . . . Londonderry . . . LEICA." Crushed hopes, youth antics, colonial wars, and winter sports are alike—are equalized by the camera. Taking photographs has set up a chronic voyeuristic relation to the world which levels the meaning of all events.[9]

As if to illustrate how the camera's mechanical eye flattens all experience, Leibovitz shows spreads of Bill Clinton and Bill Gates and then, a couple of pages later, the bloody handprints of massacred Rwandan schoolchildren. She shows beautiful bodies—Leonardo DiCaprio with a swan around his neck; Cindy Crawford, nude, with a snake around hers—alongside Bosnian war victims, juxtapositions that recall *On Photography*.

That book's most troubling questions are those about the depiction of bodies. The metaphor of the photograph, the image, had triumphed over reality, Susan wrote: "One of the perennial successes of photography has been its strategy of turning living beings into things, things into living beings."[10] And these things were more often than not living beings in pain, "the world of plague victims which Artaud invokes as the true subject of modern dramaturgy."[11]

> Whatever the moral claims made on behalf of photography, its main effect is to convert the world into a department store or museum-without-walls in which every subject is depreciated into an article of consumption, promoted into an item for aesthetic appreciation. Through the camera people become customers or tourists of reality . . . for reality is understood as plural, fascinating, and up for grabs.[12]

Yet omitting the suffering would have betrayed the book's title. "*A Photographer's Life* tells a love story," Leibovitz said. "That's what it is."[13] It shows their relationship: the happiness of their early days, their many travels together, and how the story ended. The births of her children, the deaths of her father and her partner, made it intensely personal. "When I was making the book, in a driven, obsessive way, I somehow hadn't imagined that other people would be looking at it," she later said.[14] The debates the pictures ignited—debates about the ethics of photography, about how to regard the pain of others—were an homage to Sontag's thought.

———

Meanwhile, at Montparnasse, the grave site was attracting pilgrims. The black slab covering her remains grew into one of the

most visited destinations in a cemetery packed with the illustrious dead, and was often heaped with flowers or stones.

Yet in an ironic tribute to her life, it was not Susan Sontag's body these visitors honored. It was what she had stood for. After her death, it no longer mattered, exactly, that she had written bad books as well as great ones, or said dumb things as well as brilliant ones, or been wrong as well as right. The same could be said of any writer.

What mattered about Susan Sontag was what she symbolized. To those inspired by the image of Sontag calmly fighting cancer, it was not so important that the real Susan had, like anyone else, been terrified. To those carrying posters of Sontag at protest marches, it hardly mattered that her own fights against injustice had been marred by hesitations.

She showed how to remain anchored in the achievements of the past while embracing her own century. She demonstrated endless admiration for art and beauty—and endless contempt for intellectual and spiritual vulgarity. She impressed generations of women as a thinker unafraid of men, and unaware she ought to be. She stood for self-improvement—for making oneself into something greater than what one was expected to be. She symbolized the writer who ranged widely without falling into either overspecialization or dilettantism. She represented the hope for a tolerant and diverse America that would engage with other nations without chauvinism. She stood for the social role of the artist, and showed how the artist might resist political tyranny. And she held out hope for the permanence of culture in a world besieged by the indifferent and the cruel.

The great modern writer, Canetti wrote, "is original; he sums up his age; he opposes his age."

After Sontag's death, when new phenomena arose that demanded interpretation, people often wondered what she would have made of them, and said they missed her. This was not because her answers had always been right. It was because for almost fifty years, she, more than any other prominent public thinker, had set the terms of the cultural debate in a way that no intellectual had done before, or has done since. One could argue with her; whether one agreed or disagreed with her conclusions—whether she herself agreed or disagreed with her conclusions—she had both summed up and opposed her age.

The relation of language to reality was her theme. Neither language nor reality is stable, and in a notoriously turbulent century, no writer reflected their instability as well as Sontag. The meaning of culture changed over her lifetime, and so did the understanding of its relationship to society. These changes amounted to a change in how, in the modern age, a person was to live—including how a woman was to live, and how a gay person was to live. And she traced changing attitudes toward how a person was to die.

In politics, Sontag's life showed how unstable even the biggest words—"socialism," "art," "democracy"—could be. She showed the wild fluctuations, the clashing connotations, of the term "America." She was there when the Cuban Revolution began; she was there when the Berlin Wall came down; she was in Hanoi under bombardment; she was in Israel for the Yom Kippur War. She was in New York when artists tried to resist the pull and tug of money and celebrity, and she was there when many gave in. She witnessed great changes in science and medicine, from the shifting fortunes of Sigmund Freud to the new understandings of drug and alcohol use to the emergence of a new psychology.

To a divided world, she brought a divided self. But if she herself was one with her age, her greatest theme stood apart from it. Aristotle had written that "metaphor consists in giving the thing

a name that belongs to something else"; and Sontag showed how metaphor formed, and then deformed, the self; how language could console, and how it could destroy; how representation could comfort while also being obscene; why even a great interpreter ought to be against interpretation. And she warned against the mystifications of photographs and portraits: including those of biographers.

ACKNOWLEDGMENTS

Robert Ackerman

Joan Acocella

Max Aguilera-Hellweg

Vince Aletti

David Alexander

Jeff Alexander

Clifford Allen

Minda Rae Amiran

Benjamin Anastas

Jarosław Anders

Laurie Anderson

David Archer

Birgitta Ashoff

Helene Atwan

Paul Auster

Lila Azam Zanganeh

Blake Bailey

Izudin Bajrović

Eric Banks

Jeannette Montgomery Barron

Sabine Baumann

Maria Bedford

Pierre Bergé

Matthew Berry

Klaus Biesenbach

Kristal Bivona

Roger Black

Phillip Blumberg

Christopher Bollen

Ted Bonin

Dominique Bourgois

Robert Boyers

Marie Brenner

Paul Brown

Lauren Buisson

Noël Burch

Edward Burns

John Burns

Richmond Burton

Ian Buruma

Sarah Funke Butler

Carol Devine Carson

Bernardo Carvalho

Terry Castle

Patrizia Cavalli

Dale Cendali

Aida Cerkez

Evans Chan

Greg Chandler

Lucinda Childs

Suet Y. Chong

Bill Clegg

Jennifer Cohen
Judith Sontag Cohen
Jonas Cornell
Jonathan Cott
Edgardo Cozarinsky
Timothy Crouse
Samira Davet
Lynn Davis
Raffaella de Angelis
Sharon DeLano
Roger Deutsch
Janine di Giovanni
Paolo Dilonardo
Katrina Dodson
Rachel Donadio
Stephen Donadio
Bernard Donoughue
Jack Drescher
Pamela Druckerman
Marie-Christine Dunham Pratt
Ferida Duraković
Marion Duvert
Andrew Eccles
Martha Edelheit
Gösta Ekman
Agneta Ekmanner
Karla Eoff
Barbara Epler
Marilù Eustachio
Alicia Glekas Everett
Joyce Farber
Brenda Feigen
Bruno Feitler
Bob Fernandes
Edward Field
Walter Flegenheimer
Ben Fountain
Sharon Fountain
Edwin Frank
Hardy Frank

John Freeman
Jonathan Galassi
Oberto Gili
Todd Gitlin
Admir Glamočak
Misha Glenny
Allen Glicksman
Walter Goldfrank
Andrew Goldman
Bill Goldstein
Melissa Goldstein
Gloria Gonzalez
Kasia Gorska
Helen Graves
Glenn Greenwald
Kimble James Greenwood
Maxine Groffsky
Judith Spink Grossman
Genie Guerard
Judith Gurewich
David Guterson
Molly Haigh
Peter Hald
Daniel Halpern
Matthew Hamilton
Tayt Harlin
Erin Harris
Andrew Hay
Zoë Heller
Roger Hodge
Howard Hodgkin
Sid Holt
Glenn Horowitz
Richard Howard
Evan Hughes
Larry Husten
Tom Hyry
Gary Indiana
Tanja Jacobs
Jasper McNally Jackson

Tracey Jackson
Emma Janaskie
Lex Jansen
Arthur Japin
Jasper Johns
Una Jones
Bo Jonsson
Bill Josephson
Boris Kachka
David Kambhu
Rick Kantor
Mitchell Kaplan
Nancy Kates
Daniel Kellum
Karen Kennerly
Ademir Kenović
Eitan Kensky
Jamaica Kincaid
Alexis Kirschbaum
Jeffrey Kissel
Ann Kjellberg
Samuel Klausner
Gary Knight
Stephen Koch
Eva Kollisch
Senada Kreso
Michael Krüger
Maria José de Lancastre
Nicholas Latimer
Claudio Leal
Dominique Lear
Fran Lebowitz
Hyosun Lee
Carol LeFlufy
Annie Leibovitz
Ivan Lett
Don Eric Levine
Phillip Lopate
Iris Love
Paul Lowe

Lisa Lucas
Tom Luddy
Carri Lyon
John R. MacArthur
Cassiano Elek Machado
Koukla MacLehose
Florence Malraux
Snežana Marić
Gene Marum
Lawrence Mass
Erroll McDonald
Larry McDonnel
Larry McMurtry
Sarah McNally
Lauren Mechling
Michelle Memran
Uwe Michel
Annette Michelson
Chrissy Milanese
Laura Miller
Peggy Miller
Vicente Molina Foix
Antonio Monda
Bob Monk
Ted Mooney
Honor Moore
Stephen Moran
Bertrand Moser
Blair Moser
Charles Moser
Jane Moser
Laura Moser
Siddhartha Mukherjee
Karen Mullarkey
Karen Mulligan
Michael Musto
Aryeh Neier
Cindy Nguyen
Minka Nijhuis
Ethel Nishiyama

Ann Northrop
Amy Novogratz
Sigrid Nunez
Geoffrey O'Brien
Lynda Rosen Obst
Lawrence Orenstein
Sheila O'Shea
Diana Ossana
Denise Oswald
Anita Oxburgh
Camille Paglia
Zoë Pagnamenta
Christina Pareigis
Haris Pašović
Antony Peattie
Gilles Peress
Russell Perreault
Peter Perrone
Julie Phillips
Darryl Pinckney
Linda Plochocki
Paulina Pobocha
Norman Podhoretz
Katha Pollitt
Miranda Popkey
Lucie Prinz
Miro Purivatra
James Purnell
Danny Rafinejad
David Randall
Atka Kafedzić Reid
Jessica Reifer
Mariel Reinoso Ingliso
Roger Richards
David Rieff
Joanna Robertson
Merrill Rodin
Gordon Rogoff
Michael Roloff
Carlin Romano

Corina Romonti
Jeff Roth
Philip Roth
Eric de Rothschild
Monique de Rothschild
Isabella Rozendaal
Tilla Rudel
Salman Rushdie
Kathy Ryan
Allison Saltzman
Josyane Savigneau
Daniel Schreiber
Oliver Schultz
Luiz Schwarcz
Maya Sela
Peter Sellars
Jeff Seroy
Mary Shanahan
Brenda Shaughnessy
Elizabeth Sheinkman
Michael Shnayerson
Elaine Showalter
Choire Sicha
Michelangelo Signorile
Michael Silverblatt
Robert Silvers
Charles Silverstein
Goran Simić
Sidney Sisk
Mats Skärstrand
Joseph Sonnabend
Miranda Spieler
Stephanie Steiker
Michael Stout
Oliver Strand
Luca Sueri
Béla Tarr
Ethan Taubes
Tanaquil Taubes
Meredith Tax

Adam Taylor
Benjamin Taylor
Mark Thompson
David Thomson
David Thorstad
Judith Thurman
Robert Toles
Melissa Tomjanovich
Simon Toop
Velibor Topić
Frederic Tuten
Raymond van den Boogaard
Marcel van den Brink
Janine van den Ende
Joop van den Ende
Ivo van Hove
Greg Villepique
Vincent Virga
Lauren Miller Walsh

Robert Walsh
Shelley Wanger
Steve Wasserman
Simon Watney
Paulo Werneck
Edmund White
Leon Wieseltier
Oceana Wilson
Robert Wilson
Christian Witkin
Annie Wright
Andrew Wylie
Mia You
Pjer Žalica
Giovannella Zannoni
Lloyd Ziff
Peter Zinoman
Terri Zucker
Harriet Sohmers Zwerling

To the New York Institute for the Humanities and the University of California, Los Angeles,

and to those who wished to remain anonymous

NOTES

INTRODUCTION: AUCTION OF SOULS

1. A. H. Giebler, "News of Los Angeles and Vicinity: 8,000 Armenians in Selig Spectacle," *The Moving Picture World* 39, no. 4 (1919).
2. Sontag, *I, etcetera* (New York: Farrar, Straus and Giroux, 1978), 23.
3. Sontag, *On Photography* (New York: Farrar, Straus and Giroux, 1977), 70.
4. Ibid., 20.
5. Cynthia Ozick, "On Discord and Desire," in *The Din in the Head* (Boston: Houghton Mifflin, 2006), 3.
6. Author's interview with Michael Roloff.
7. Author's interview with Honor Moore.
8. Sontag, *On Photography*, 21.
9. Author's interview with Vincent Virga.
10. Sontag, *On Photography*, 7.
11. Ibid., 11.
12. Conor Skelding, "Fearing 'Embarrassment,' the FBI Advised Agents Against Interviewing Susan Sontag," *Muckrock*, June 13, 2014, https://www.muckrock.com/news/archives/2014/jun/13/susan-sontag-security-matter/.
13. Sontag, *On Photography*, 165.
14. Sontag, *The Benefactor: A Novel* (New York: Farrar, Straus, 1963), 1.
15. Ibid., 246.
16. Ibid., 70.
17. Sontag, *Against Interpretation and Other Essays* (New York: Farrar, Straus and Giroux, 1966), 277.
18. "The World as India," in Sontag, *At the Same Time: Essays and Speeches,*

eds. Paolo Dilonardo and Anne Jump (New York: Farrar, Straus and Giroux, 2007).

19. Susan Sontag Papers (Collection 612). UCLA Library Special Collections, Charles E. Young Research Library, UCLA.

20. Sontag Papers, August 13, [1960].

21. David Rieff, *Swimming in a Sea of Death: A Son's Memoir* (New York: Simon & Schuster, 2008), 62.

22. Sontag Papers, December 12, 1957.

23. Sontag, *On Photography*, 164.

24. "Notes on 'Camp,'" in Sontag, *Against Interpretation*, 281.

25. Sontag Papers, December 9, 1961.

26. Sontag Papers, April 11, 1971.

27. Sontag to Peter Schneider, June 18, 1993, Sontag Papers.

28. Author's interview with Admir Glamočak.

29. Author's interview with Senada Kreso.

CHAPTER 1: THE QUEEN OF DENIAL

1. After her death, they were digitized by UCLA. They may be seen at http://digital2.library.ucla.edu/viewItem.do?ark=21198/zz00151t9g. The shipboard film is cataloged as dating from 1926 on the SS *Paris* to Beijing, but it more likely dates to 1931, when the couple took that ship from Le Havre to New York. (See U.S. Customs records, listed in note 15.) The sign on the train reads: Stolpce-Warszawa-Poznan-[Zbąszyń?]-Berlin-Hannover-Köln-Liege-Paris.

2. Author's interview with Judith Cohen.

3. Sontag Papers, "week of Feb. 12, 1962."

4. Author's interview with Judith Cohen.

5. Author's interview with Paul Brown.

6. Nora Ephron, "Not Even a Critic Can Choose Her Audience," *New York Post*, September 23, 1967.

7. Sontag Papers.

8. Author's interview with Judith Cohen.

9. Sontag Papers.

10. Sontag, *Illness as Metaphor* and *AIDS and Its Metaphors* (New York: Doubleday, 1990), 100.

11. Author's interview with Judith Cohen.

12. Sontag Papers, early 1970s.

13. Author's interview with Paul Brown.

14. Judith Cohen to Sontag, late 1970s, Sontag Papers.

15. A sample of the records on Ancestry.com includes the following outline

of the couple's travels. There is no record of Mildred's travel to or arrival from Asia, and the only record of her arrival from Europe was in 1931.

Jack Rosenblatt applied for his first passport on November 17, 1923, declaring his intention to travel to China via Vancouver on the *Empress of Asia* on November 29, 1923. His occupation was "buyer of furs," and he was employed by Julius Klugman's Sons, Inc., 42 West Thirty-Eighth Street, New York City.

He applied for an extension of his passport at Tientsin, as a representative of the Mei Hwa Fur Trading Corporation. This application is not dated. He departed Shanghai on May 19, 1924, arriving in Seattle on June 4, 1924, on the SS *President Madison*. His address was 950 Noe Avenue, New York. He departed Yokohama for Manila and Vancouver on the SS *Empress of Canada* on July 9, 1927. He was living at 330 Wadsworth Avenue, New York. He sailed from Kobe to Seattle on July 17, 1928, on the SS *President McKinley*, arriving on July 30, 1928. His address was the Continental Fur Corporation, 251 West Thirtieth Street, New York. Jack and Mildred departed Le Havre on June 3, 1931, on the SS *Paris*, and arrived in New York on June 9, 1931. They listed their address as 251 West Thirtieth Street. Jack departed Shanghai on the SS *President Coolidge* on October 14, 1933, arriving in Honolulu on October 24, 1933. The address given was still 251 West Thirtieth Street. He met Mildred in Honolulu. She had departed Los Angeles on October 18, 1933, on the SS *Monterey* and reached Honolulu on October 23, 1933. They departed together on November 4, 1933, on the SS *Lurline*, and reached San Francisco on November 9, 1933. They departed Hamilton, Bermuda, on February 14, 1934, arriving at New York on February 15, on the SS *Monarch of Bermuda*. The address they gave was the business address, 251 West Thirtieth Street. Judith was born in New York on June 20, 1936. They departed Havana on January 3, 1937, on the SS *Oriente*, and arrived at New York on January 5, 1937. They now listed their address as 21 Wensley Drive, Great Neck, Long Island. On March 11, 1938, they departed Havana again, on the SS *California*, and arrived at New York on March 14, 1938. Jack died at Tientsin on October 19, 1938. There are no online records of Mildred's return to the United States.

16. "China" screenplay, Sontag Papers.
17. Judith Cohen to Sontag, late 1970s, Sontag Papers.
18. Sontag, *I, etcetera*, 18.
19. Author's interview with Judith Cohen.
20. "China" screenplay, Sontag Papers; ibid.
21. Author's interview with Judith Cohen.

22. Sontag Papers, August 10, 1967.
23. Sontag to Mildred Sontag, July 4, 1956, Sontag Papers.
24. Author's interview with Harriet Sohmers Zwerling.
25. Author's interview with Judith Cohen.
26. Sontag Papers, March 25, 1986.
27. Sontag Papers, March 25, 1987.
28. Sontag Papers, January 11, 1960.
29. Author's interview with Judith Cohen.
30. Sontag Papers, n.d.
31. "Project for a Trip to China," in Sontag, *I, etcetera*, 23.
32. Sontag Papers, n.d. Among the thousands of pages in the Sontag Papers, no more than these two are in Mildred's voice.
33. "Project for a Trip to China," in Sontag, *I, etcetera*, 24.
34. Sontag, *Illness*, 7.
35. Suzie Mackenzie, "Finding Fact from Fiction," *Guardian*, May 27, 2000.
36. "Project for a Trip to China," in Sontag, *I, etcetera*, 17.
37. Sontag Papers, n.d. He had been born, the fourth of five children of a poor immigrant family on the Lower East Side in New York City, on March 6, 1906.
38. "Project for a Trip to China," in Sontag, *I, etcetera*, 5.
39. Ibid., 7.
40. Ibid.
41. "China" screenplay, Sontag Papers.
42. "Project for a Trip to China," in Sontag, *I, etcetera*, 24.
43. Sontag Papers, n.d.
44. Sontag Papers, n.d.
45. Rieff, *Swimming*, 174.

CHAPTER 2: THE MASTER LIE

1. Author's interview with Vincent Virga.
2. Author's interview with Martie Edelheit.
3. Author's interview with Judith Cohen.
4. Author's interviews with Terri Zucker and David Rieff.
5. Sontag, *As Consciousness Is Harnessed to Flesh: Journals and Notebooks, 1964–1980*, ed. David Rieff (New York: Farrar, Straus and Giroux, 2013), 72, January 16, 1965.
6. Judith Cohen in Nancy Kates, dir., *Regarding Susan Sontag*, HBO, 2014.
7. Author's interview with Judith Cohen.
8. Author's interview with Don Levine.
9. Sontag, *Consciousness*, 25, August 29, 1964.

10. Author's interviews with Don Levine and Judith Cohen.

11. Sontag Papers.

12. Author's interview with Don Levine.

13. Sontag Papers.

14. Sontag Papers.

15. Sontag, *Consciousness*, 213, August 9, 1967.

16. Sontag Papers, n.d.

17. Sontag, *Consciousness*, 226, August 9, 1967.

18. Sontag, *Reborn: Journals and Notebooks, 1947–1963*, ed. David Rieff (New York: Farrar, Straus and Giroux, 2008), 302, March 3, 1962.

19. Janet Geringer Woititz, *Adult Children of Alcoholics* (Deerfield Beach, FL: Health Communications, 1983), 3.

20. Sontag Papers.

21. This discussion relies on Woititz, *Adult Children of Alcoholics*.

22. Ibid.

23. Sontag, "Pilgrimage," *The New Yorker*, December 21, 1987.

24. "Project for a Trip to China," in Sontag, *I, etcetera*, 7.

25. Ibid., 22.

26. Author's interview with Paul Brown.

27. Sontag Papers.

28. Author's interview with Judith Cohen.

29. Author's interview with Lucinda Childs.

30. Sontag, *Consciousness*, 222, August 10, 1967.

31. Ibid., 213, August 9, 1967.

32. Ibid., 223, August 10, 1967.

33. Author's interview with Ferida Duraković.

34. Author's interview with Vincent Virga.

35. Eva Kollisch in Kates, *Regarding Susan Sontag*.

36. Sontag, *Consciousness*, 222, August 10, 1967.

37. Ibid., 223.

38. Sontag, *Reborn*, 258, February 29, 1960. The person quoted is María Irene Fornés.

CHAPTER 3: FROM ANOTHER PLANET

1. Sontag, *Reborn*, 106ff.

2. Ibid., 115, January 1957.

3. Sontag, *The Volcano Lover: A Romance* (New York: Farrar, Straus and Giroux, 1992), 105.

4. Sontag Papers, dated 1948. Mary is the name Sontag used in fictional accounts of Rosie.

5. Sontag, *Reborn*, 106, January 1957.

6. David Rieff quoted in Daniel Schreiber, *Susan Sontag: Geist und Glamour: Biographie* (Berlin: Aufbau Verlag, 2010), 18.

7. Sontag Papers.

8. Author's interview with Walter Flegenheimer.

9. Carolyn G. Heilbrun, *Writing a Woman's Life* (New York: W. W. Norton, 1988), 21. On page 12, she explains: "In 1984, I rather arbitrarily identified 1970 as the beginning of a new period in women's biography because *Zelda* by Nancy Milford had been published in that year. Its significance lay above all in the way it revealed F. Scott Fitzgerald's assumption that he had a right to the life of his wife, Zelda, as an artistic property."

10. Carl E. Rollyson and Lisa Olson Paddock, *Susan Sontag: The Making of an Icon* (New York: W. W. Norton, 2000), 152.

11. Michael Norman, "Diana Trilling, a Cultural Critic and Member of a Select Intellectual Circle, Dies at 91," *New York Times,* October 25, 1996.

12. Wendy Perron, "Susan Sontag on Writing, Art, Feminism, Life and Death," *Soho Weekly News,* December 1, 1977.

13. Sontag, *In America* (New York: Farrar, Straus and Giroux, 2000), 11.

14. Author's interview with Jarosław Anders.

15. Sontag, *In America*, 26.

16. Sontag, *Reborn*, 113, January 1957.

17. Quoted in Craig Seligman, *Sontag & Kael: Opposites Attract Me* (New York: Counterpoint, 2004), 16.

18. Rollyson and Paddock, *Making of an Icon*, 161.

19. Author's interview with Don Levine.

20. Author's interview with Paolo Dilonardo. She told him that the first synagogue she visited was in Florence. Her sister tells of the founding of the synagogue in the Valley.

21. Sontag to Jonathan Safran Foer, May 27, 2003, Sontag Papers.

22. Author's interview with Judith Cohen; Sontag, *Reborn*, 107, 116, September 1957.

23. "Literature Is Freedom," in Sontag, *At the Same Time*, 207.

24. Author's interview with Judith Cohen.

25. Sontag Papers.

26. Ibid.

27. "The Desert Sanatorium and Institute of Research: Tucson, Arizona," http://www.library.arizona.edu/exhibits/pams/pdfs/institute1.pdf.

28. Sontag, *In America*, 154.
29. Author's interview with Judith Cohen.
30. Author's interview with Larry McMurtry.
31. Sontag, *Reborn*, 108, September 1957.
32. Sontag Papers, March 25, 1987.
33. Sontag, *Consciousness*, 114–15, September 6, 1965, Tangier.
34. Rieff, *Swimming*, 74.
35. Sontag, *Death Kit* (New York: Farrar, Straus and Giroux, 1967), 260–63.
36. Sontag, "Pilgrimage."
37. Sontag, *Consciousness*, 114–15, September 6, 1965, Tangier.
38. Author's interview with Judith Cohen.
39. Sontag Papers, not included in the published journals.
40. Author's interview with Stephen Koch.
41. "Literature Is Freedom," in Sontag, *At the Same Time*, 207.
42. Ibid.
43. Greg Daugherty, "The Last Adventure of Richard Halliburton, the Forgotten Hero of 1930s America," *Smithsonian*, March 25, 2014.
44. "Homage to Halliburton," in Sontag, *Where the Stress Falls: Essays* (New York: Farrar, Straus and Giroux, 2001), 255; Annie Leibovitz, *A Photographer's Life: 1990–2005* (New York: Random House, 2006).
45. "Homage to Halliburton," in Sontag, *Where the Stress Falls*, 255.
46. Judith Cohen to Sontag, Sontag Papers.
47. *Cactus Press*, vol. I, no. VIII, May 6, 1945, Sontag Papers.
48. Sontag Papers, 1948.
49. Author's interview with Judith Cohen.
50. Ibid.; Sontag, *Reborn*, 127, September 1957.
51. Susan Rieff, "Decisions," Sontag Papers.
52. Sontag, *In America*, 195.
53. Author's interview with Larry McMurtry.

CHAPTER 4: LOWER SLOBBOVIA

1. Ephron, "Not Even a Critic Can Choose Her Audience."
2. Sontag, *In America*, 120.
3. Rieff, *Swimming*, 88.
4. Sontag, "Pilgrimage."
5. Author's interview with Greg Chandler.
6. Sontag, "Pilgrimage."
7. Author's interview with Uwe Michel.
8. Sontag, "Pilgrimage."

9. Sontag Papers, August 24, 1987.

10. Sontag, *Reborn*, 70, January 12, 1950.

11. Author's interview with Florence Malraux.

12. Sontag, "Pilgrimage."

13. Rieff, *Swimming*, 142.

14. "The Imagination of Disaster," in Sontag, *Against Interpretation*, 211.

15. Ibid., 225.

16. Ibid., 224.

17. Ibid., 217.

18. Sontag, "Pilgrimage."

19. Ibid.

20. Ibid.

21. Author's interview with Merrill Rodin.

22. Jack London, *Martin Eden* (New York: Macmillan, 1909).

23. "Time to Get Up," May 17, 1948, Sontag Papers.

24. Rollyson and Paddock, *Making of an Icon*, 17.

25. Author's interview with Merrill Rodin.

26. "Viva la Slobbovia," *The Arcade*, April 16, 1948, Sontag Papers.

27. Perron, "Susan Sontag on Writing." The presence of several encouraging English teachers in her journals makes one wonder if this rather theatrical description is not a piece of the mythmaking to which Sontag was prone.

28. Sontag Papers, March 7, 1947.

29. Sontag Papers, Notebook #5, March 7, 1947–May 6, 1947; Notebook #11, May 28, 1948–May 29, 1948.

30. Sontag Papers, October 18, 1948.

31. Sontag Papers, August 24, 1987.

32. Steve Wasserman quoted in Schreiber, *Geist*, 33.

33. Margalit Fox, "Susan Sontag, Social Critic with Verve, Dies at 71," *New York Times*, December 28, 2004.

34. Norman Birnbaum quoted in James Atlas, "The Changing World of New York Intellectuals," *The New York Times Magazine*, August 25, 1985.

35. Zoë Heller, "The Life of a Head Girl," *Independent*, September 20, 1992.

CHAPTER 5: THE COLOR OF SHAME

1. Sontag, "Pilgrimage."

2. Sontag Papers, December 28, 1949.

3. Thomas Mann, *Tagebücher 1949–1950*, ed. Inge Jens (Frankfurt am Main: S. Fischer Verlag, 1991), 143.

4. From an early draft of "Pilgrimage," Sontag Papers.

5. Ibid.

6. Sontag, *Reborn*, 113, January 1957.

7. Sontag Papers, June 9, 1948.

8. Sontag Papers, May 26, 1948.

9. Michael Miner, "War Comes to Rockford/Cartoonist Kerfuffle/Cartoon Recount," *Chicago Reader*, June 5, 2003, http://www.chicagoreader.com /chicago/war-comes-to-rockfordcartoonist-kerfufflecartoon-recount /Content?oid=912271.

10. Sontag Papers, May 26, 1948.

11. Sontag Papers, February 10, 1947–April 20, 1947.

12. Sontag Papers, May 6, 1948.

13. Judith Cohen to author, e-mail.

14. Sontag Papers, Notebook #12, n.d., around 1948.

15. Sontag, *Reborn*, 11, December 25, 1948.

16. Ibid., 34, May 31, 1949.

17. Ibid., 223, December 24, 1959.

18. Ibid., 220, November 19, 1959.

19. Sontag Papers, August 24, 1987.

CHAPTER 6: THE BI'S PROGRESS

1. Sontag, *Consciousness*, 315, April 11, 1971.

2. Sontag, *Reborn*, 14, February 19, 1949.

3. Gene Hunter, "Susan Sontag, a Very Special Daughter," *Honolulu Advertiser*, July 12, 1971.

4. David Bernstein, "Sontag's U. of C.," *Chicago Magazine*, June 2005.

5. Sontag Papers, June 18, 1948.

6. Hunter, "Susan Sontag, a Very Special Daughter."

7. Author's interview with Terri Zucker.

8. Sontag Papers, Notebook #11, May 28, 1948–May 29, 1948.

9. Sontag, *Reborn*, 8, September 2, 1948.

10. Sontag Papers, Notebook #11, May 28, 1948–May 29, 1948.

11. Sontag, *Reborn*, 5, August 19, 1948.

12. Ibid., 13, February 11, 1949.

13. Sontag Papers, Chicago.

14. Sontag to Judith Cohen, June 6, [1960], Sontag Papers.

15. Sontag Papers, December 30, 1986, Paris.

16. Sontag, *Reborn*, 14, February 19, 1949.

17. Ibid., 20, May 17, 1949.

18. Ibid., 15, April 6, 1949.

19. Author's interview with Don Levine; Djuna Barnes, *Nightwood,* preface by T. S. Eliot (New York: New Directions, 1937).
20. Barnes, *Nightwood,* 35.
21. Ibid., 90.
22. Ibid., 118.
23. Ibid., 95.
24. Ibid., 100.
25. Author's interview with Harriet Sohmers Zwerling.
26. Sontag, *Reborn,* 18; Sontag Papers, written on the cover of the notebook dated 5/7/49–5/31/49.
27. Sontag, *Reborn,* 20, May 23, 1949.
28. Ibid., 36, June 6, 1949.
29. Ibid., 42, August 3, 1949.
30. Ibid., 33, May 31, 1949. This woman's name was Irene Lyons.
31. Ibid., 34, May 30, 1949.
32. Ibid., 33, May 31, 1949.
33. Author's interview with Harriet Sohmers Zwerling.
34. Author's interview with Merrill Rodin.
35. Author's interviews with Gene Marum and Merrill Rodin.
36. Sontag Papers.
37. Sontag, *Reborn,* 40, June 29, 1949.

CHAPTER 7: THE BENEVOLENT DICTATORSHIP

1. *Barron's Profiles of American Colleges* (New York: Barron's, 1986), 253.
2. Deva Woodly, "How UChicago Became a Hub for Black Intellectuals," January 19, 2009, https://www.uchicago.edu/features/20090119_mlk/.
3. Author's interview with Martie Edelheit.
4. Author's interview with Robert Silvers.
5. Molly McQuade, "A Gluttonous Reader: Susan Sontag," in Sontag, *Conversations with Susan Sontag,* ed. Leland Poague (Jackson: University Press of Mississippi, 1995), 277.
6. "Robert Maynard Hutchings," Office of the President, University of Chicago, https://president.uchicago.edu/directory/robert-maynard-hutchins.
7. Sontag, *Reborn,* 30–31, May 26, 1949.
8. Joel Snyder quoted in Bernstein, "Sontag's U. of C."
9. Author's interview with Minda Rae Amiran.
10. Author's interview with Sidney Sisk.
11. Author's interview with Martie Edelheit.
12. Quoted in Rollyson and Paddock, *Making of an Icon,* 29.

13. James Miller in Philoctetes Center, "Susan Sontag: Public Intellectual, Polymath, Provocatrice," https://www.youtube.com/watch?v=zXJe3EcPo1g.

14. Author's interview with Joyce Farber.

15. Robert Boyers in Philoctetes Center, "Susan Sontag: Public Intellectual, Polymath, Provocatrice."

16. Author's interview with Robert Silvers.

17. Sontag, *Conversations*, 278.

18. Ibid., 275.

19. Rollyson and Paddock, *Making of an Icon*, 32.

20. Sontag Papers.

21. Author's interview with Sidney Sisk.

22. Author's interview with Joyce Farber.

23. Sontag to Mildred Sontag, October 29, 1950, Sontag Papers.

24. Author's interview with Joyce Farber.

25. Sontag, *Conversations*, 274.

26. Author's interview with Lucie Prinz.

27. Author's interview with Martie Edelheit.

28. Sontag, *Reborn*, 67–68, early September 1950.

29. Ibid.

30. Sontag to Mildred Sontag, Chicago, [November?] 1950, Sontag Papers.

CHAPTER 8: MR. CASAUBON

1. Author's interview with David Rieff.

2. Jonathan Imber, "Philip Rieff: A Personal Remembrance," *Society*, November/December 2006, 74.

3. Author's interview with Allen Glicksman.

4. Gerald Howard, "Reasons to Believe," *Bookforum*, February/March 2007.

5. Author's interview with David Rieff.

6. Philip Rieff, *My Life Among the Deathworks: Illustrations of the Aesthetics of Authority*, Vol. 1: *Sacred Order/Social Order* (Charlottesville: University of Virginia Press, 2006), 185–87.

7. Author's interview with David Rieff.

8. Maxine Bernstein and Robert Boyers, "Women, the Arts, & the Politics of Culture: An Interview with Susan Sontag," in Sontag, *Conversations*, 75.

9. Sontag to Judith Sontag, November 25, 1950, Sontag Papers.

10. Sontag to Mildred Sontag, December 2, 1950, Sontag Papers.

11. Rollyson and Paddock, *Making of an Icon*, 35.

12. Author's interview with Minda Rae Amiran.

13. Sontag Papers.

14. Ibid.
15. Sontag Papers, July 27, [1958], Ydra.
16. Alice Kaplan, *Dreaming in French: The Paris Years of Jacqueline Bouvier Kennedy, Susan Sontag, and Angela Davis* (Chicago: University of Chicago Press, 2012), 93.
17. Author's interview with Joyce Farber.
18. Author's interview with Judith Cohen; Sontag Papers.
19. Sontag, *Reborn*, 64, February 13, 1951.
20. Fictionalized memoir of her marriage, Sontag Papers.
21. Arthur J. Vidich, *With a Critical Eye: An Intellectual and His Times*, ed. and intro. Robert Jackall (Knoxville: Newfound Press, 2009).
22. James Miller in Philoctetes Center, "Susan Sontag: Public Intellectual, Polymath, Provocatrice."
23. Author's interview with Joyce Farber.
24. Unpublished memoir, Sontag Papers.
25. Author's interview with Joyce Farber.
26. Michael D'Antonio, "Little David, Happy at Last," *Esquire*, March 1990.
27. Sontag Papers, September 10, 1948.
28. Author's interview with Stephen Koch.
29. Author's interview with Allen Glicksman.
30. Author's interview with Samuel Klausner.
31. Unpublished memoir, Sontag Papers.
32. Susan Rieff, "Decisions," Sontag Papers.
33. Sontag Papers.
34. Sontag, *In America*, 24.
35. Sontag, *Consciousness*, 362, August 14, 1973; author's interview with David Rieff.
36. Rieff, *Swimming*, 40–41.
37. Author's interview with Karla Eoff.
38. Joan Acocella, "The Hunger Artist," *The New Yorker*, March 6, 2000.
39. Heller, "The Life of a Head Girl."

CHAPTER 9: THE MORALIST

1. Philip Rieff, *Freud: The Mind of the Moralist* (Chicago: University of Chicago Press, 1959), 6.
2. Sontag to Judith Sontag, Sontag Papers. One ghostwritten manuscript survives in a private collection. Dating from 1951, it is an extensive examination of a thesis, "Jacob Burckhardt, Philosopher and Historian," presented at Yale in 1941. The author was James Hastings Nichols, who was teaching at Chicago in Sontag's time. On the backs of several pages,

both typewritten and in Sontag's handwriting, are drafts of letters from Philip Rieff, submitting the work as his own. It does not seem to have been published, perhaps because Sontag's work so far exceeds what would have been necessary or expected of a book review. It is almost unbelievable that this could be the work of an eighteen-year-old girl—so learned, so conversant with Renaissance history and philosophy, that it suggests that Sontag's mind, even then, was fully fledged. It requires no effort whatsoever to imagine this author producing *The Mind of the Moralist* a few years later. Already we see the author of the essays that made her reputation.

3. Author's interview with Minda Rae Amiran.
4. Sontag to Mildred Sontag, July 4, 1956, Sontag Papers.
5. Jacob Taubes to Sontag, October 22, 1958, Sontag Papers.
6. Author's interview with Don Levine.
7. Jacob Taubes to Sontag, November 19, 1959, Sontag Papers.
8. Collection of David Rieff, dated "29th Sept. 98."
9. Rollyson and Paddock, *Making of an Icon*, 46.
10. Philip Rieff, *Freud: The Mind of the Moralist* (New York: Anchor Books, 1961), viii.
11. Ibid., 38.
12. Ibid., 40.
13. Ibid., 67.
14. Ibid., 75.
15. Ibid., 145.
16. Ibid., 128.
17. Ibid., 134.
18. Ibid., 176.
19. Ibid., 148.
20. Ibid., 153.
21. Ibid., 174.
22. Ibid., 175.
23. Ibid., 182.
24. Ibid., 149.
25. Author's interview with Sigrid Nunez.
26. Daniel Horowitz, *Consuming Pleasures: Intellectuals and Popular Culture in the Postwar World* (Philadelphia: University of Pennsylvania Press, 2012), 315.
27. Author's interview with Samuel Klausner.
28. Rieff, *My Life Among the Deathworks*.
29. Author's interview with Allen Glicksman.

30. Rieff, *My Life Among the Deathworks,* 126.
31. Author's interview with Joyce Farber.
32. Rieff, *Moralist,* 155, 167.
33. Sontag, *Consciousness,* 47, November 17, 1964.

CHAPTER 10: THE HARVARD GNOSTICS

1. Author's interview with Hardy Frank.
2. Sontag to Mildred Sontag, University of Connecticut press release, Sontag Papers.
3. Sontag to Mildred Sontag, "Tuesday" [Fall 1955], Sontag Papers.
4. Mackenzie, "Finding Fact from Fiction."
5. Sontag to Mildred Sontag, Sontag Papers.
6. Author's interview with Minda Rae Amiran.
7. Sontag, *Essays of the 1960s & 70s,* ed. David Rieff (New York: Library of America, 2013), 816.
8. Sontag to Mildred Sontag, Sontag Papers; Morton White, *A Philosopher's Story* (University Park: Pennsylvania State University Press, 1999), 147–48.
9. Sontag Papers. Around this time (1958), Sontag was already writing short memoirs, nominally fictionalized, about her marriage. It was a theme to which she often returned, in conversation and occasionally in her writing, for the rest of her life.
10. Author's interview with Hardy Frank.
11. Hans Jonas, *Memoirs: The Tauber Institute Series for the Study of European Jewry* (Hanover, NH: Brandeis University Press/University Press of New England, 2008), 168.
12. Sontag, *Consciousness,* 336, July 21, 1972.
13. Susan Taubes, *Divorcing* (New York: Random House, 1969), 225.
14. Christina Pareigis, "Susan Taubes—Bilder aus dem Archiv," *Aus Berliner Archiven* (Beiträge zum Berliner Wissenschaftsjahr, 2010), 22.
15. Sontag, *Reborn,* 288, September 14–September 15, 1961.
16. Taubes, *Divorcing,* 56.
17. Author's interview with Christina Pareigis.
18. "Debriefing," in Sontag, *I, etcetera,* 52.
19. "'Thinking Against Oneself': Reflections on Cioran," in Sontag, *Styles of Radical Will* (New York: Farrar, Straus and Giroux, 1969), 75.
20. Hans Jonas, *The Gnostic Religion: The Message of the Alien God and the Beginnings of Christianity,* 2nd ed. (Boston: Beacon Press, 1963), 31.
21. Ibid., 38.
22. Ibid., 31.

23. Antonin Artaud, *Selected Writings,* ed. and intro. Sontag (New York: Farrar, Straus and Giroux, 1976), xxxiii, xxiii.
24. Ibid., xxxv.
25. Ibid., xxv.
26. Ibid., xlv–xlvi.
27. Rollyson and Paddock, *Making of an Icon,* 38.
28. "Report—7th Meeting," minutes of a class taught at Columbia University by Jacob Taubes and Sontag, March 7, 1961, Sontag Papers.
29. Author's interview with Michael Krüger.
30. Sontag, *Reborn,* 83, September 4, 1956.
31. Ibid., 140, March 27, 1957.
32. Ibid., 98–99, March 3, 1957.
33. Ibid., 180–81, January 6, 1958. The friend was Annette Michelson.
34. Kaplan, *Dreaming in French,* 92.
35. Sontag, *Reborn,* 170, early 1958.
36. White, *A Philosopher's Story,* 148; Sontag Papers, July 1, 1958.
37. Sontag Papers.
38. Author's interview with Minda Rae Amiran.
39. Author's interview with Michael Silverblatt.
40. Sontag, *Reborn,* 103, 133, 135, January 14, 1957; January 19, 1957; February 18, 1957.
41. Author's interview with David Rieff.
42. Sontag, *Reborn,* 152, September 5, 1957.

CHAPTER 11: WHAT DO YOU MEAN BY MEAN?

1. Unpublished fictionalized memoir, Sontag Papers.
2. Sontag Papers.
3. Author's interview with Judith Spink Grossman.
4. Author's interview with Bernard Donoughue.
5. Judith Grossman, *Her Own Terms* (New York: Soho Press, 1988), 217.
6. Jonathan Miller and John Cleese, "Oxbridge Philosophy," https://www.youtube.com/watch?v=qUvf3fOmTTk.
7. Sontag, *Reborn,* 193, February 25, 1958.
8. Author's interview with Bernard Donoughue.
9. Sontag, "The Letter Scene," *The New Yorker,* August 18, 1986.
10. "Late in Rieff's life, his son, David, once said to me that his father was a hypochondriac his entire life, but now he was actually ill," wrote Jonathan Imber, a former student of Rieff's. Imber, "Philip Rieff: A Personal Remembrance."
11. Author's interview with Joyce Farber.

12. H. L. A. Hart to Morton White, December 18, 1957, quoted in White, *A Philosopher's Story*, 149.
13. Harriet Sohmers Zwerling, *Abroad: An Expatriate's Diaries: 1950–1959* (New York: Spuyten Duyvil, 2014), 26, February 21, 1951.
14. Ibid., 32, July 15, 1951.
15. Ibid., 121–22, December 2, 1954.
16. Ibid., 129–30, May 1, 1955.
17. Sontag, *Reborn*, 183, January 2, 1958.
18. Zwerling, *Abroad*, 264–65, December 7–22, 1957.
19. Sontag, *Reborn*, 167, December 31, 1957.
20. Ibid., 165, December 29, 1957.
21. Sontag, *Consciousness*, 133, December 10, 1965.
22. Schreiber, *Geist*, 61.
23. Author's interview with Stephen Koch.
24. Author's interview with Noël Burch.
25. Ted Mooney, a writer who, for a period in the eighties, was friendly with both Susan and David, remembered that she was "visually unable to see painting." They visited a Mondrian retrospective: "She appreciated it but she didn't see it. I remember trying to teach her how not to make a judgment or have a verbally couched thought for five minutes in front of a painting . . . it was impossible. She didn't see the point of it. She didn't believe it was possible or desirable. I found it very frustrating because I know she checked off some things in her mind about perspective and the course of abstraction without really seeing it once." Leon Wieseltier, who had become close to Susan around 1976, tells a similar story. "Susan would go to the opera every night, but if you asked me was Susan genuinely musical, I would have to say no. It was programmatic. She couldn't dance. She never tapped her feet to the rhythm." Florence Malraux had said that Susan had no eye; Stephen Koch said that "she wasn't a good reader, in the sense that she would get how a style works. I remember one thing that is almost insulting to bring up. She was known for promoting the works of Jean Genet. And I had been in a discussion with her about metaphor. And she says she doesn't see metaphor, she sees two things. And I said, oh now come on, you must, and gave her certain examples of metaphors that seemed quite obvious. And later she came to me, the next time we met, with a copy of Genet in French, she said, You know, you're right! I've just been going through Genet! And there are five or six metaphors per page! Look, I've underlined them. And handed it to me, a proud student. And I thought, this woman is one of the best-known

critics in English. And it didn't make me despise her, by the way. It's sort of touching."

26. Zwerling, *Abroad*, 270–71, April 3, 1958, Seville.
27. Author's interview with Joanna Robertson.
28. Author's interview with Stephen Koch.
29. Edmund White, *City Boy: My Life in New York During the 1960s and '70s* (New York: Bloomsbury, 2009), 271.
30. Author's interview with Noël Burch.
31. Sontag, *Reborn*, 182, January 12, 1958.
32. Ibid., 184, February 5, 1958.
33. Ibid., 193, July 14, 1958.
34. Zwerling, *Abroad*, 266, January 13, 1958.
35. Author's interview with Edward Field.
36. Author's interview with Bernard Donoughue.
37. Sontag, *Reborn*, 202, May 31, 1958.
38. Kaplan, *Dreaming in French*, 110ff.
39. Quoted in ibid., 97.
40. Sontag, *Reborn*, 166, December 31, 1957.
41. Ibid., 164, December 31, 1957.
42. Sontag Papers, December 29, 1958.
43. "A Poet's Prose," in Sontag, *Where the Stress Falls*, 8.
44. David Rieff, preface to Sontag, *Reborn*, xiii.

CHAPTER 12: THE PRICE OF SALT

1. Sontag to Mildred Sontag, Athens, n.d. ("Monday night"), Sontag Papers.
2. Quoted in Kaplan, *Dreaming in French*, 111.
3. Author's interview with David Rieff.
4. Philip Rieff to Joyce Farber, March 27, 1959, Sontag Papers.
5. Draft dated February 26, 1958, Paris, Sontag Papers.
6. Entry undated, in notebook labeled September 1, 1958–January 2, 1959, Sontag Papers.
7. Author's interview with Sigrid Nunez.
8. Author's interview with David Rieff.
9. Author's interview with Judith Cohen.
10. Entry undated, in notebook labeled September 1, 1958–January 2, 1959, Sontag Papers.
11. This novel is the basis for Todd Haynes's film *Carol* (2015).
12. Sontag, *Reborn*, 181, January 16, 1958.

13. Author's interview with Darryl Pinckney.

14. Jacob Taubes to Sontag, November 10, 1958, Sontag Papers.

15. Author's interview with David Rieff.

16. Author's interview with Judith Cohen.

17. Author's interview with Sigrid Nunez.

18. Charles Ruas, "Susan Sontag: Me, Etcetera," in Sontag, *Conversations*, 181.

19. Author's interview with David Rieff.

20. Jacob Taubes to Sontag, October 22, 1958, Sontag Papers.

21. Author's interview with Norman Podhoretz.

22. Ibid.

23. Author's interview with Stephen Koch.

24. Author's interview with Robert Silvers.

25. Author's interview with Harriet Sohmers Zwerling.

26. Michelle Memran, dir., *The Rest I Make Up*, 2018.

27. Author's interview with Stephen Koch.

28. Mary V. Dearborn, *Mailer: A Biography* (New York: Houghton Mifflin Harcourt, 2001), 83.

29. Author's interview with Robert Silvers.

30. Stephanie Harrington, "Irene Fornes, Playwright: Alice and the Red Queen," *Village Voice*, April 21, 1966, 1, 33–34, quoted in Scott T. Cummings, *Maria Irene Fornes: Routledge Modern and Contemporary Dramatists* (London: Routledge, 2013).

31. Sontag Papers, March 4, [1959].

32. Sontag Papers, February 22, 1959.

33. Rollyson and Paddock, *Making of an Icon*, 53.

34. Sontag Papers.

35. Sontag Papers, March 2, [1959].

36. Sontag Papers, March 8, [1959].

37. Sontag, *Reborn*, November 11, 1959. As published, the passage is heavily redacted from the original in the Sontag Papers: the references to rape, to fucking oneself, and to Freud (!) are omitted, for example.

38. Author's interview with Harriet Sohmers Zwerling.

39. Author's interview with Stephen Koch.

40. Sontag, *Consciousness*, 169, January 4, 1966.

41. Suzy Hansen, "Rieff Encounter," *New York Observer*, May 2, 2005.

42. Sontag, *Reborn*, 219–20, September 1959.

43. Hansen, "Rieff Encounter."

44. Sontag Papers, February 22, 1959.

45. Sontag Papers, March 4, 1959.

46. Author's interview with David Rieff.

47. Ibid.

48. Hansen, "Rieff Encounter."

49. Sontag to Mildred Sontag, [1960], Sontag Papers.

50. Author's interview with Don Levine.

CHAPTER 13: THE COMEDY OF ROLES

1. "Happenings: An Art of Radical Juxtaposition," in Sontag, *Against Interpretation*, 271.

2. Sontag Papers, Notebook #4, April 20, 1947.

3. Sontag to Judith Sontag, on *Commentary* stationery, n.d. [probably summer 1959], Sontag Papers.

4. Author's interview with Judith Cohen.

5. Sontag, *Consciousness*, August 7, 1968, Stockholm.

6. Sontag Papers, 1947.

7. "Simone Weil," in Sontag, *Against Interpretation*, 50.

8. "Nathalie Sarraute and the Novel," in Sontag, *Against Interpretation*, 111.

9. Sontag, *Benefactor*, 4–5.

10. Author's interview with Evans Chan.

11. Sontag, *Benefactor*, 19.

12. Ibid., 97.

13. Ibid., 80, 83. Like Artaud, Hippolyte dabbles in film acting.

14. Ibid., 155.

15. "Happenings: An Art of Radical Juxtaposition," in Sontag, *Against Interpretation*, 269.

16. Sontag, *Benefactor*, 261.

17. Rieff, *Moralist*, 136, 76, 119.

18. Sontag, *Benefactor*, 40, 18.

19. Ibid., 41.

20. Ibid., 109.

21. Ibid., 258.

22. Ibid., 261.

23. Sontag, *Reborn*, 229, January 21, 1960.

24. Author's interview with Don Levine.

25. Sontag, *Reborn*, 274, June 12, 1961.

26. Ibid., 246, n.d. [February 1960, possibly 1961].

27. Sontag, *Reborn*, 255, February 19, [1960, possibly 1961]; February 29, [1960 or 1961].

28. Sontag, *Benefactor*, 223.

29. Ibid., 52, 55.

30. Ibid., 57–58. "When I began to accompany my friend the writer, I had no

opinions about his activities, and even if I had felt licensed to urge him to a less perverse and promiscuous life, I would have held my tongue. Jean-Jacques, however, would not allow my silence. Though I did not attack him, he was resolute and ingenious in his own defense, or rather the defense of the pleasure of disguises, secrecy, entrapments, and being-what-one-is-not.

"Several times that summer, he tried to overturn my unspoken objections. 'Don't be so solemn, Hippolyte. You are worse than a moralist.' While I could not help regarding this world of illicit lust as a dream, skillful but also weighty and dangerous, he saw it simply as theatre. 'Why should we all not exchange our masks—once a night, once a month, once a year?' he said. 'The masks of one's job, one's class, one's citizenship, one's opinions. The masks of husband and wife, parent and child, master and slave. Even the masks of the body—male and female, ugly and beautiful, old and young. Most men, without resisting, put them on and wear them all their lives. But the men around you in this café do not. Homosexuality, you see, is a kind of playfulness with masks. Try it and you will see how it induces a welcome detachment from yourself.'

"But I did not want to be detached from myself, but rather in myself.

"'What is a revolutionary act in our time?' he asked me, rhetorically, at another meeting. 'To overturn a convention is like answering a question. He who asks a question already excludes so much that he may be said to give the answer at the same time. At least he marks off a zone, the zone of legitimate answers to his question. You understand?'

"'Yes, I understand. But not what bearing it has—'

"'Look, Hippolyte. You know how little audacity is required today to be unconventional. The sexual and social conventions of our time prescribe the homosexual parody.'"

31. Mark Greif, *The Age of the Crisis of Man: Thought and Fiction in America: 1933–1973* (Princeton, NJ: Princeton University Press, 2015), 104.

CHAPTER 14: ALL JOY OR ALL RAGE

1. Sontag Papers.
2. Author's interview with Stephen Koch.
3. "Report—7th Meeting," March 7, 1961, Sontag Papers.
4. Author's interview with Frederic Tuten.
5. Author's interview with Stephen Koch.
6. Author's interview with Norman Podhoretz.
7. Ira S. Youdovin, "Recent Resignations Reveal Decentralization Problems,"

Columbia Daily Spectator CV, no. 81 (March 9, 1961), http://spectatorarchive
.library.columbia.edu/cgi-bin/columbia?a=d&d=cs19610309-01.2.4.

8. Quoted in Ilana Abramovitch and Seán Galvin, eds., *Jews of Brooklyn: Brandeis Series in American Jewish History, Culture, and Life* (Hanover, NH: Brandeis University Press, 2001), 303.

9. Author's interview with Edward Field.

10. Norman Podhoretz, *Making It* (New York: Random House, 1967), 309.

11. Ibid., 40.

12. Ibid., 110. The term was originally Murray Kempton's.

13. Mark Greif, "What's Wrong with Public Intellectuals?" *The Chronicle of Higher Education*, February 13, 2015, http://chronicle.com/article /Whats-Wrong-With-Public/189921/.

14. Quoted in Greif, *Age of the Crisis of Man*, 17.

15. Greif, "What's Wrong with Public Intellectuals?"

16. Author's interview with Don Levine.

17. Sontag, *Reborn*, 160, November 4, 1957.

18. Ibid., 163, December 29, 1958.

19. Podhoretz, *Making It*, 161.

20. Ibid., 268.

21. Alfred Albelli, "Prof: Gotta Be Sneak to See My Son," New York *Daily News*, December 15, 1961, Sontag Papers.

22. Sontag, *Reborn*, 223, December 24, 1959.

23. Albelli, "Prof: Gotta Be Sneak."

24. "Prof Wins 1st Round on Son," undated clipping, Sontag Papers.

25. Sontag to Zoë Pagnamenta, e-mail, July 20, 2001, Sontag Papers.

26. Author's interview with Allen Glicksman. Jonathan Imber tells a similar story: "On a visit he made to Boston . . . he insisted I drive him to Cambridge, in particular along those streets he had walked while living there with Sontag and their young son. We drove around a specific block five or six times, slowing down again and again as we passed the house in which they had lived together. Here was an occasion, literally driving in circles, of heartfelt regret that explains best of all to me why he dedicated the last book published in his lifetime to 'Susan Sontag in remembrance.'" (Imber, "Philip Rieff: A Personal Remembrance.")

27. Boris Kachka, *Hothouse: The Art of Survival and the Survival of Art at America's Most Celebrated Publishing House, Farrar, Straus & Giroux* (New York: Simon & Schuster, 2013), 48, 51.

28. Author's interview with Jonathan Galassi.

29. Kachka, *Hothouse*, 147.

30. Author's interview with Peggy Miller.

31. Author's interview with Greg Chandler.
32. Christopher Lehmann-Haupt, "Roger W. Straus Jr., Book Publisher from the Age of the Independents, Dies at 87," *New York Times*, May 27, 2004.
33. Author's interview with Jonathan Galassi.
34. Kachka, *Hothouse*, 130.
35. Ibid.
36. Author's interview with Jonathan Galassi.
37. Kachka, *Hothouse*, 147.
38. Rollyson and Paddock, *Making of an Icon*, 66.
39. Sontag, "Demons and Dreams," *Partisan Review*, Summer 1962, 460–63.
40. Podhoretz, *Making It*, 170.
41. Sontag, *Reborn*, 223, December 28, 1959.
42. Ibid., 232, January 1960.
43. Ibid., 258, February 29, 1960.
44. Sontag, *Consciousness*, 98–99, n.d. [1962].
45. Ibid., 214, n.d. [1967].
46. Sontag, *Reborn*, 241, February 18, 1960.
47. Michelle Memran, a young filmmaker, befriended Irene toward the end of her life, as she was sliding toward dementia, and conducted extensive interviews with her over a period of several years. The resulting film, *The Rest I Make Up*, features many of these interviews.
48. Cummings, *Maria Irene Fornes*, 8.
49. Fornés won a total of eleven times, from 1965 to 2000. http://www.obieawards.com/?s=fornes.
50. Ross Wetzsteon, "Irene Fornes: The Elements of Style," *Village Voice*, April 29, 1986, 42–45.
51. Author's interview with Don Levine.
52. Memran, *The Rest I Make Up*.

CHAPTER 15: FUNSVILLE

1. John Wain, "Song of Myself, 1963," *The New Republic*, September 21, 1963.
2. "Identifiable as Prose," *Time*, September 14, 1963.
3. Hannah Arendt to Roger Straus, August 20, 1963, Sontag Papers.
4. Sontag, *Benefactor*, 6.
5. Stephen Koch, *Stargazer: Andy Warhol's World and His Films* (New York: Praeger, 1973), 140.
6. Ibid., xi.
7. Ibid., 5.
8. Ibid., 6, 7.

9. Dana Heller, "Absolute Seriousness: Susan Sontag in American Popular Culture," in Barbara Ching and Jennifer A. Wagner-Lawlor, *The Scandal of Susan Sontag* (New York: Columbia University Press, 2009), 32ff.

10. Koch, *Stargazer*, 22–23.

11. Author's interview with Norman Podhoretz.

12. "Not Good Taste, Not Bad Taste—It's 'Camp,'" *New York Times*, March 31, 1965.

13. Atlas, "The Changing World of New York Intellectuals."

14. "On Roland Barthes," in Sontag, *Where the Stress Falls*, 80.

15. Sontag Papers, July 19–July 24, 1958, Ydra.

16. Quoted in Seligman, *Sontag & Kael*, 116.

17. Robert Trumbull, "Homosexuals Proud of Deviancy, Medical Academy Study Finds," *New York Times*, May 19, 1964.

18. Donn Teal (as "Ronald Forsythe"), "Why Can't 'We' Live Happily Ever After, Too?" *New York Times*, February 23, 1969, quoted in David W. Dunlap, "Looking Back: 1964 | 'Homosexuals Proud of Deviancy,'" *New York Times*, June 9, 2015.

19. Heilbrun, *Writing a Woman's Life*, 79.

20. Author's interview with Stephen Koch.

21. "Jack Smith's *Flaming Creatures*," in Sontag, *Against Interpretation*, 226.

22. "Pornography Is Undefined at Film-Critic Mekas' Trial," *Village Voice*, June 18, 1964. The conviction was later reversed by an appeals court.

23. Terry Castle, "Some Notes on 'Notes on Camp,'" in Ching and Wagner-Lawlor, *Scandal*, 21–31.

24. "Notes on 'Camp,'" in Sontag, *Against Interpretation*, 276.

25. Koch, *Stargazer*, 22, 15.

26. Author's interview with Stephen Koch.

27. Author's interview with Don Levine.

28. Ibid.

29. Ephron, "Not Even a Critic Can Choose Her Audience."

30. "Not Good Taste, Not Bad Taste—It's 'Camp.'"

31. Larry McMurtry, *In a Narrow Grave: Essays on Texas* (New York: Simon & Schuster, 1968), xxiv.

32. Eliot Fremont-Smith, "After the Ticker Tape Parade," *New York Times*, January 31, 1966.

33. Author's interview with Stephen Koch.

34. Author's interview with Don Levine.

35. Author's interview with Stephen Koch.

36. Author's interview with David Rieff.

37. Author's interview with Martie Edelheit.

38. Koch, *Stargazer,* 13.
39. Author's interview with Greg Chandler.
40. Author's interview with Don Levine.
41. Author's interview with Gary Indiana.
42. Author's interview with Camille Paglia.

CHAPTER 16: WHERE YOU LEAVE OFF AND THE CAMERA BEGINS

1. Sontag, *Reborn,* 262, December 18, 1960.
2. Ibid., 266, April 14, 1961; April 23, 1961.
3. Sontag, *Consciousness,* 72, January 16, 1965.
4. Sontag, *Reborn,* 312, March 26, 1963.
5. Sontag quotes on Cornell from transcript of interview with Robert McNab, broadcast on BBC, December 9, 1991, Sontag Papers.
6. Koch, *Stargazer,* 6.
7. Rollyson and Paddock, *Making of an Icon,* 111.
8. Diana Athill, *Stet: A Memoir* (London: Granta Books, 2000), 202.
9. Rollyson and Paddock, *Making of an Icon,* 107.
10. Athill, *Stet,* 185.
11. Sontag in *The New York Times Book Review,* May 31, 1964.
12. Sontag, *Consciousness,* 108, August 29, 1965.
13. Ibid., 110, August 28, 1965.
14. Edward Field, *The Man Who Would Marry Susan Sontag: And Other Intimate Literary Portraits of the Bohemian Era* (Madison: University of Wisconsin Press, 2005).
15. Rollyson and Paddock, *Making of an Icon,* 107.
16. Blake Bailey, "Beloved Monster," Vice, March 1, 2008.
17. Rollyson and Paddock, *Making of an Icon,* 106.
18. Sontag, *Consciousness,* 117, September 6, 1965.
19. Ibid., 108, August 29, 1965, Tangier.
20. Ibid., 107, August 29, 1965.
21. Author's interview with Michael Krüger.
22. Yoram Kaniuk quoted in Rollyson and Paddock, *Making of an Icon,* 163.
23. Sontag, *Consciousness,* 134, October 17, 1965.
24. Author's interview with Eva Kollisch.
25. Sontag to Rogers Albritton, May 14, 1966, Sontag Papers.
26. Author's interview with Don Levine.
27. Author's interview with Eva Kollisch.
28. Sontag, *Consciousness,* 115, September 6, 1965.
29. Author's interview with Don Levine.

30. Author's interview with David Rieff.

31. Sontag, *Consciousness*, 105, September 3, 1964.

32. Ibid., 104, August 28, 1965.

33. Ibid., 69, January 5, 1965.

34. Sontag, *Reborn*, 300, March 3, 1962.

35. Author's interview with Don Levine.

36. Sontag, *Consciousness*, 97, August 24, 1965.

37. Author's interview with Leon Wieseltier.

38. D'Antonio, "Little David, Happy at Last," 128.

39. Rollyson and Paddock, *Making of an Icon*, 89.

40. Author's interview with Frederic Tuten.

41. Author's interview with Roger Deutsch.

42. Author's interview with Ethan Taubes.

43. Author's interview with Don Levine.

44. Sontag Papers.

45. Author's interview with David Rieff.

46. Author's interview with Peggy Miller.

47. Sontag to Judith Sontag Cohen, May 27, 1968, Sontag Papers.

48. Author's interview with Stephen Koch.

49. Sontag, *Reborn*, 223, December 28, 1959.

50. Jill Johnston, *Jasper Johns: Privileged Information* (New York: Thames and Hudson, 1996), 50.

51. Ibid., 64.

52. Ibid., 55.

53. Sontag, *Consciousness*, 144, November 20, 1965.

54. Johnston, *Privileged Information*, 134.

55. Author's interview with Jasper Johns.

56. Sontag, *Consciousness*, 78, March 26, 1965.

57. Sontag, *Against Interpretation*, 303.

58. Benjamin DeMott, "Lady on the Scene," *The New York Times Book Review*, January 23, 1966.

59. Larry McMurtry, *Times Literary Supplement*, June 7, 1992.

60. Author's interview with Stephen Koch.

61. Author's interview with Don Levine.

62. Ibid.

CHAPTER 17: GOD BLESS AMERICA

1. Sontag, *Conversations*, 258.

2. Annie De Clerck, "Susan Sontag" (interview), http://cobra.canvas.be/cm/cobra/videozone/rubriek/boek-videozone/1.676237.

3. Paul Thek, notebook dated November 30, 1978–12.11.78, Alexander and Bonin, New York.

4. Irving Howe, "The New York Intellectuals," *Dissent,* October 1, 1969.

5. Peter Brooks, "Parti pris," *Partisan Review,* Summer 1966.

6. Quoted in Seligman, *Sontag & Kael,* 23.

7. "Media Man's Mascot," *Guardian,* September 28, 1967.

8. Sontag, *Against Interpretation,* 301.

9. Ibid., 298.

10. Ibid., 297.

11. Ibid., 295.

12. Ibid.

13. "Thirty Years Later," in Sontag, *Against Interpretation and Other Essays* (New York: Picador U.S.A., 2001), 311.

14. Ibid., 309.

15. Quoted in Robert R. Tomes, *Apocalypse Then: American Intellectuals and the Vietnam War, 1954–1975* (New York: New York University Press, 1998).

16. Ibid., 70.

17. Paul L. Montgomery, "Detective Interrupts Vietnam Read-In," *New York Times,* February 21, 1966.

18. "Robert Mayer in New York: Dr. Spock's Breakfast Club," *Newsday,* December 6, 1967.

19. "Susan Sontag's Statement to the Press, Wednesday, March 16, 1966," Sontag Papers.

20. "What's Happening in America" was originally published in *Partisan Review,* Winter 1967.

21. Allen Ginsberg, *Howl and Other Poems* (San Francisco: City Lights Pocket Bookshop, 1956).

22. Author's interview with Stephen Koch.

23. Paul Thek et al., *"Please Write!": Paul Thek and Franz Deckwitz: An Artists' Friendship, Boijmans Studies* (Rotterdam, Netherlands: Museum Boijmans van Beuningen, 2015), 13.

24. Sontag, *Death Kit,* 311.

25. Sontag, *Consciousness,* 335–36, July 21, 1972.

26. Sontag, *Death Kit,* 157.

27. Ibid., 177, 179.

28. Sontag, *On Photography,* 168.

29. Sontag, *Death Kit,* 209.

30. Ibid., 272.

CHAPTER 18: CONTINENT OF NEUROSIS

1. Author's interview with Richard Howard.
2. Author's interview with Stephen Koch.
3. Ibid.
4. Schreiber, *Geist*, 119.
5. Author's interview with Don Levine.
6. Author's interview with Judith Cohen.
7. Author's interview with David Rieff.
8. Sontag, *Reborn*, 261, March 20, 1960.
9. Sontag, *Consciousness*, 137, November 7, 1965.
10. "Thinking Against Oneself," in Sontag, *Styles*, 80.
11. Ibid., 74.
12. Ibid.
13. Ibid., 77.
14. Ibid., 78.
15. Ibid., 87.
16. Ibid., 80.
17. Ilinca Zarifopol-Johnston, *Searching for Cioran*, ed. Kenneth R. Johnston, foreword Matei Calinescu (Bloomington: Indiana University Press, 2019), 10.
18. Ibid., 13.
19. Ibid., 102, 93.
20. "Thinking Against Oneself," in Sontag, *Styles*, 90.
21. Ibid., 93.
22. Ibid., 94.
23. Quoted in Kay Larson, *Where the Heart Beats: John Cage, Zen Buddhism, and the Inner Life of Artists* (New York: Penguin Press, 2012), 237.
24. "The Aesthetics of Silence," in Sontag, *Styles*, 5.
25. Ibid., 6.
26. Ibid., 14, 12.
27. "Bergman's *Persona*," in Sontag, *Styles*, 124.
28. Ibid., 131.
29. Ibid., 144.
30. "The Pornographic Imagination," in Sontag, *Styles*, 37.
31. Ibid., 36.
32. Sontag Papers, December 31, 1948.
33. "The Pornographic Imagination," in Sontag, *Styles*, 46.
34. Ibid., 50.
35. Ibid., 47.

36. Ibid., 57.
37. Ibid., 45.
38. Ibid., 55.
39. Ibid., 57.
40. Ibid., 58.
41. Sontag, *On Photography,* 70.

CHAPTER 19: XU-DAN XÔN-TĂC

1. Lyndon Baines Johnson, "Remarks in Memorial Hall, Akron University," October 21, 1964, http://www.presidency.ucsb.edu/documents/remarks -memorial-hall-akron-university.
2. "Trip to Hanoi," in Sontag, *Styles,* 208, 206.
3. Ibid., 209.
4. James Toback, "Whatever You'd Like Susan Sontag to Think, She Doesn't," *Esquire,* July 1968.
5. Jonathan Cott, *Susan Sontag: The Complete* Rolling Stone *Interview* (New Haven, CT: Yale University Press, 2013), 96.
6. Sontag, *Styles,* 211.
7. Ibid., 212, 214.
8. Ibid., 213.
9. Ibid., 215.
10. Ibid.
11. Ibid., 216.
12. Ibid., 224.
13. Ibid., 229.
14. Ibid., 224.
15. Ibid., 226.
16. Ibid.
17. Ibid., 234.
18. Ibid., 253.
19. Ibid., 251, 252, 256, 262.
20. Nguyễn Đức Nam, "Con Người Việt-Nam Hiện đại Trong Nhận Thức Của Nhà Văn Mỹ Xu-Dan Xôn-Tắc," trans. Cindy A. Nguyen, Sontag Papers.
21. *Evening Standard,* July 18, 1967.
22. "What's Happening in America," in Sontag, *Styles,* 195.
23. Author's interview with Robert Silvers.
24. Author's interview with Minda Rae Amiran.
25. Rieff, preface to Sontag, *Consciousness,* xi.
26. Sontag, "A Letter from Sweden," *Ramparts,* July 1969.
27. Author's interview with Agneta Ekmanner.

28. Author's interview with Bo Jonsson.
29. Author's interview with Peter Hald.
30. Author's interview with Gösta Ekman.
31. Unpublished screenplay, Sontag Papers.
32. Author's interview with Gösta Ekman.
33. Sontag Papers, 1984.
34. Author's interview with Phillip Lopate.
35. "A Century of Cinema," in Sontag, *Where the Stress Falls.*
36. "Godard," in Sontag, *Styles,* 148, 150.
37. Ibid., 151.
38. Ibid., 154.
39. Ibid., 155.
40. Sontag, *Duet for Cannibals: A Screenplay* (New York: Farrar, Straus and Giroux, 1970), 16.
41. Koch, *Stargazer,* 63.
42. Klas Gustafson, *Gösta Ekman: Farbrorn som inte vill va' stor* (Stockholm: Leopard Förlag, 2010), 202.
43. Sontag, "Letter from Sweden," 32.
44. Ibid., 28.
45. Ibid., 29.
46. Ibid., 31.
47. Ibid.
48. Ibid., 32.
49. Ibid., 35.
50. Ibid., 27.
51. Ibid., 38.
52. "Trip to Hanoi," in Sontag, *Styles,* 249.
53. Sontag, "Letters from Sweden," 38.

CHAPTER 20: FOUR HUNDRED LESBIANS

1. Author's interview with Don Levine.
2. Author's interview with Marilù Eustachio.
3. Author's interview with David Rieff.
4. Author's interview with Patrizia Cavalli.
5. Giovannella Zannoni to Sontag, March 7, 1970, Sontag Papers.
6. Author's interview with Don Levine.
7. Author's interviews with David Rieff and Don Levine.
8. Bernstein and Boyers, "Women, the Arts, & the Politics of Culture, in Sontag, *Conversations,* 60.
9. Author's interview with David Rieff.

10. Sontag, *Consciousness*, 386, May 25, 1975.
11. Sontag, *Reborn*, 193, February 25, 1958.
12. Sontag, *Consciousness*, 313, January 1971.
13. Sontag Papers, July 27, [1958], Ydra.
14. Sontag, *Consciousness*, 138, November 8, 1965.
15. "Notes on 'Camp,'" in Sontag, *Against Interpretation*, 279, 286.
16. "Greta Garbo, 84, Screen Icon Who Fled Her Stardom, Dies," *New York Times*, April 16, 1990.
17. "Novelist Drowns Herself," *East Hampton Star*, November 13, 1969.
18. Hugh Kenner, "Divorcing," *The New York Times Book Review*, November 2, 1969.
19. Author's interview with Stephen Koch.
20. Author's interview with Ethan Taubes.
21. Sontag, *Consciousness*, 384–85, May 25, 1975.
22. Author's interview with Robert Silvers.
23. Sontag, "Some Thoughts on the Right Way (for Us) to Love the Cuban Revolution," *Ramparts*, April 1969, 6.
24. Sontag and Dugald Stermer, *The Art of Revolution: Ninety-Six Posters from Cuba* (London: Pall Mall Press, 1970).
25. Max Roser and Esteban Ortiz-Ospina, "Literacy," Our World in Data, September 20, 2018, https://ourworldindata.org/literacy/.
26. Jonathan Lerner, "Whorehouse of the Caribbean," Salon, January 4, 2001, http://www.salon.com/2001/01/04/havana/.
27. Author's interview with Florence Malraux.
28. Sontag, *Brother Carl* (New York: Farrar, Straus and Giroux, 1974), x.
29. Ibid., xv, xi.
30. Author's interview with Edgardo Cozarinsky.
31. Author's interview with Peter Hald.
32. Sontag, *Consciousness*, 261, February 4, 1970.

CHAPTER 21: CHINA, WOMEN, FREAKS
1. Jean-Luc Douin, "Nicole Stéphane," *Le Monde*, March 17, 2003; Gérard Leford, "Nicole Stéphane, la mort d'une enfant terrible," *Libération*, March 15, 2007.
2. Monique de Rothschild, *Si j'ai bonne mémoire . . .* (Saint-Rémy-en-l'Eau: Éditions Monelle Hayot, 2001).
3. Author's interview with Don Levine.
4. Sontag, *Consciousness*, 318, April 27, 1971.
5. Victoria Schultz, "Susan Sontag on Film," from *Changes* (May 1, 1972), in Sontag, *Conversations*, 33.

6. One part of Proust was eventually made, *Swann in Love,* directed by Volker Schlöndorff, in 1984.
7. Author's interview with Don Levine.
8. Ibid.
9. Ibid.
10. Maria Adele Teodori, "Un'americana a Parigi," *Il Messaggero,* May 26, 1973. "Perché non voglio vivere negli Stati Uniti. Non potevo pensare a un luogo più logico come scelta, non ha bisogno di ragioni e l'amo molto. . . . Restare in America oggi significa diventare pazzo, finire, sparire, disintegrarsi, in un qualsiasi modo. E se stai fuori, capisci cos'è quel paese e anche come è difficile tornarci a vivere."
11. Sontag, *Consciousness,* 351, January 7, 1973.
12. Eliot Fremont-Smith, "Diddy Did It—Or Did He?" *New York Times,* August 18, 1967.
13. H. Michael Levenson, "The Avant-Garde and the Avant-Guardian: Brother Carl New England Premiere at the Brattle," *Harvard Crimson,* July 27, 1973.
14. Author's interview with Noël Burch.
15. "On Paul Goodman," in Sontag, *Under the Sign of Saturn* (New York: Farrar, Straus and Giroux, 1980), 3.
16. Ibid., 8–9.
17. Sontag, *Consciousness,* 342, October 21, 1972.
18. Ibid., 348, November 6, 1972.
19. "Project for a Trip to China," in Sontag, *I, etcetera,* 18–19.
20. Sontag, *Consciousness,* 361, July 31, 1973.
21. Sontag Papers.
22. Ibid.
23. Helga Dudman, "From Camp to Campfire," *Jerusalem Post Weekly,* November 27, 1973.
24. Teodori, "Un'americana a Parigi."
25. Author's interview with Karla Eoff.
26. Author's interview with Don Levine.
27. Sontag, *Reborn,* 115, January 1957.
28. Ibid., 139, late February or early March 1957.
29. Ibid., 299, "Week of Feb. 12, 1962."
30. Author's interview with Judith Cohen.
31. Camille Paglia, "Sontag, Bloody Sontag," in *Vamps & Tramps: New Essays* (New York: Vintage, 1994), 344.
32. Ibid., 347.
33. Camille Paglia, letter to Gail Thain Parker, September 27, 1973,

Administrative Records, 1972–1975, Bennington College Archive, Bennington, VT, http://hdl.handle.net/11209/8827.

34. Paglia, "Sontag, Bloody Sontag," 350, 351.

35. Ibid., 352.

36. Dudman, "From Camp to Campfire."

37. Author's interview with David Rieff.

38. Dudman, "From Camp to Campfire."

39. Ibid.

40. Yoram Kaniuk in Sontag, dir., *Promised Lands*, New Yorker Films, 1974.

41. An undated document in the Sontag Papers includes this "'structural' analysis of my own work

> The theme of death (fake) in my fiction, films:
> Death of Frau Anders in *The Benefactor*
> Death of Incardona in *Death Kit*
> Deaths of Bauer's wife and Bauer in *Duet for Cannibals*
> In each of these cases someone who was thought to be dead wasn't—and came back
> Death starts getting real, since 1973
> Death of Julia in 'Debriefing'
> Deaths, deaths, deaths in *Promised Lands*."

CHAPTER 22: THE VERY NATURE OF THINKING

1. Schreiber, *Geist*, 175. According to Stephen Koch, Hujar was offended that he was not mentioned in the book, believing that Susan did not find him famous enough to include; and that Susan was arguing that photography was not a real art. "This opinion was fatal in Peter's eyes. And he told me, probably in a discussion about the book, that Richard Avedon once said to him, 'You know, Peter—sometimes I think that Susan may be the enemy.'" Koch added that "Peter's idol, Lisette Model, ('one of the greats') said of *On Photography:* 'This is a book by a woman who knows everything and understands nothing.'" Author's interview with Stephen Koch.

2. Colin L. Westerbeck Jr., "On Sontag," *Artforum*, April 1978, 58, quoted in Seligman, *Sontag & Kael*, 130.

3. Neal Ascherson, "How Images Fail to Convey War's Horror," *Los Angeles Times*, March 16, 2003.

4. Sontag, *Consciousness*, 401, February 1976.

5. Sontag, *On Photography*, 3.

6. Ibid., 21, 15.

7. Ibid., 7.

8. Rieff, *Moralist*, 115.

9. Jonathan Cott, "Susan Sontag: The *Rolling Stone* Interview," in Sontag, *Conversations*, 121.

10. Sontag, *On Photography*, 70.

11. Robin Muir, "Women's Studies," *Independent*, October 18, 1997.

12. Rollyson and Paddock, *Making of an Icon*, 176.

13. Later, she admitted to her French publisher that she had been too hard on Arbus. Author's interview with Dominique Bourgois.

14. Rollyson and Paddock, *Making of an Icon*, 176.

15. Sontag, *On Photography*, 29.

16. Ibid., 32.

17. Sontag, *Consciousness*, 104, August 28, 1965.

18. Sontag Papers, November 1972.

19. Sontag, *On Photography*, 38.

20. Ibid., 58.

21. Ibid., 34. The full quotation reads, "Everybody has that thing where they need to look one way but they come out looking another way and that's what people observe. You see someone on the street and essentially what you notice about them is the flaw. It's just extraordinary that we should have been given these peculiarities. And, not content with what we were given, we create a whole other set. Our whole guise is like giving a sign to the world to think of us in a certain way but there's a point between what you want people to know about you and what you can't help people knowing about you. And that has to do with what I've always called the gap between intention and effect. I mean if you scrutinize reality closely enough, if in some way you really, really get into it, it becomes fantastic. You know it really is totally fantastic that we look like this and you sometimes see that very clearly in a photograph. Something is ironic in the world and it has to do with the fact that what you intend never comes out like you intend it." From *Diane Arbus: An Aperture Monograph* (Millerton, NY: Aperture, 1972).

22. Sontag, *On Photography*, 36.

23. Ibid., 23.

24. Ibid., 40.

25. Ibid., 41.

26. Rieff, *Swimming*, 150.

27. Cathleen McGuigan, "An Exclusive Look at Annie Leibovitz's Compelling—and Surprisingly Personal—New Book," *Newsweek*, October 2, 2006, 56.

28. Susie Linfield, *The Cruel Radiance: Photography and Political Violence* (Chicago: University of Chicago Press, 2010), xiv.

29. Ibid., 4.
30. Ibid., 120.
31. Ibid., 160.
32. Ibid., 172–73.
33. Ibid., 39, 19.

CHAPTER 23: QUITE UNSEDUCED

1. Sontag, *Consciousness,* 400, n.d. [early 1970s].
2. Sontag, *Reborn,* 207, July 14, 1958.
3. Sontag to Judith Sontag, July 27, 1954, Sontag Papers.
4. Author's interview with Roger Deutsch.
5. Rollyson and Paddock, *Making of an Icon,* 161.
6. Paul Thek to Sontag, May 29, 1978, Sontag Papers.
7. http://infed.org/mobi/ivan-illich-deschooling-conviviality-and-lifelong
 -learning/.
8. Author's interview with David Rieff.
9. Author's interviews with Tom Luddy and Stephen Koch.
10. Author's interview with David Rieff.
11. Rieff, *Swimming,* 38.
12. Siddhartha Mukherjee, *The Emperor of All Maladies: A Biography of Cancer*
 (London: Fourth Estate, 2011), 60ff.
13. Rieff, *Swimming,* 25, 40–41.
14. Rollyson and Paddock, *Making of an Icon,* 172.
15. Author's interview with Stephen Koch.
16. Peter Hujar, *Portraits in Life and Death,* preface by Susan Sontag (New
 York: Da Capo Press, 1976).
17. Rieff, *Swimming,* 36, 73.
18. Ibid., 35.
19. Sontag, *Consciousness,* 386, May 25, 1975.
20. Author's interview with Minda Rae Amiran.
21. Sontag Papers, April 8, [1984].
22. Author's interview with John Burns.
23. Author's interview with Robert Silvers. Silvers's partner, Grace, Countess
 of Dudley, helped Nicole locate Dr. Israël.
24. Author's interview with Stephen Donadio.
25. Sontag, *Illness,* 100.
26. Ibid., 6, 8.
27. Ibid., 21, 22.
28. Ibid., 102.
29. Ibid., 53.

30. Ibid., 57.
31. Ibid., 40, 23.
32. Ibid., 59.
33. Ibid., 102.
34. Ibid., 100.
35. Ibid., 21.
36. Ibid., 51.
37. Ibid., 52, 55.
38. Rieff, *Swimming,* 36.
39. Author's interview with Don Levine.
40. Author's interview with Stephen Koch.
41. Sontag, *Illness,* 70.
42. Rieff, *Swimming,* 31, 41.
43. Author's interview with Roger Deutsch.
44. Rieff, *Swimming,* 91.
45. Author's interview with David Rieff.
46. Author's interview with Siddhartha Mukherjee.
47. Marithelma Costa and Adelaida López, "Susan Sontag: The Passion for Words," in Sontag, *Conversations,* 230.

CHAPTER 24: *TOUJOURS FIDÈLE*

1. Author's interview with Don Levine.
2. "Under the Sign of Saturn," in Sontag, *Saturn,* 117.
3. Ibid., 124.
4. Ibid., 121.
5. Ibid., 119.
6. Ibid., 124.
7. Ibid., 126.
8. Ibid., 127.
9. Ibid., 129.
10. Ibid., 128.
11. The essay on Artaud had been published in *The New Yorker.*
12. In *Swimming,* David wrote that this was "an essay about him that I found to be as much disguised autobiography as it was one writer describing another's work."
13. "Mind as Passion," in Sontag, *Saturn,* 181.
14. Ibid., 203.
15. Lev Loseff, *Joseph Brodsky: A Literary Life,* trans. Jane Ann Miller (New Haven, CT: Yale University Press, 2011), 69.
16. Ibid., 72, 82.

17. Ibid., 116.
18. Ibid., 58.
19. Ibid., 189.
20. Author's interviews with David Rieff and Judith Cohen.
21. Author's interview with Marilù Eustachio.
22. Loseff, *Brodsky*, 219.
23. Valentina Polukhina, "Thirteen Ways of Looking at Joseph Brodsky," *Words Without Borders*, June 2008, http://www.wordswithoutborders.org /article/thirteen-ways-of-looking-at-joseph-brodsky.
24. "Joseph Brodsky," in Sontag, *Where the Stress Falls*, 331.
25. Loseff, *Brodsky*, 163.
26. Ibid., 235.
27. Ibid., 234.
28. Author's interview with Karen Kennerly.
29. Author's interview with Jarosław Anders.
30. Author's interview with Sigrid Nunez.
31. Polukhina, "Thirteen Ways of Looking at Joseph Brodsky."
32. Author's interview with Stephen Koch.
33. Carlo Ripa di Meana, "News from the Biennale," *The New York Review of Books*, September 15, 1977.
34. Joseph Brodsky, *Watermark* (New York: Farrar, Straus and Giroux, 1992), 71.
35. Ibid., 72–73.
36. "An Argument About Beauty," in Sontag, *At the Same Time*, 12.
37. Ibid., 73.
38. Ibid., 84.
39. "On Style," in Sontag, *Against Interpretation*, 25.
40. Sontag, *Conversations*, xv.
41. Bernstein and Boyers, "Women, the Arts, & the Politics of Culture," in ibid., 59.
42. "A Century of Cinema," in Sontag, *Where the Stress Falls*, 118.
43. Author's interview with Edmund White.
44. Ruas, "Susan Sontag: Me, Etcetera," in Sontag, *Conversations*, 176.
45. "Fascinating Fascism," in Sontag, *Saturn*, 98.
46. Ibid., 77.
47. Steven Bach, *Leni: The Life and Work of Leni Riefenstahl* (New York: Alfred A. Knopf, 2007), 271.
48. Sontag's feminist essays were posthumously collected in *Susan Sontag: Essays of the 1960s & 70s*, published by the Library of America in 2013.
49. Chris Hegedus and D. A. Pennebaker, dirs., *Town Bloody Hall*, 1979.

50. "Fascinating Fascism," in Sontag, *Saturn*, 84.

51. Adrienne Rich and Sontag, "Feminism and Fascism: An Exchange," *The New York Review of Books*, March 20, 1975. Tom Luddy, Susan's friend and the director of the Telluride Film Festival that invited Riefenstahl, confirms Rich's observation. Author's interview with Tom Luddy.

52. Rich and Sontag, "Feminism and Fascism: An Exchange."

53. Author's interview with Don Levine.

54. Author's interview with Edmund White.

55. Rollyson and Paddock, *Making of an Icon*, 92.

56. "Fascinating Fascism," in Sontag, *Saturn*, 98.

57. Ibid., 100, 99.

58. Ibid., 101.

59. Ibid., 103.

60. Ibid., 102.

61. Ibid., 98.

62. Ibid., 103.

CHAPTER 25: WHO DOES SHE THINK SHE IS?

1. Acocella, "The Hunger Artist."

2. "Project for a Trip to China," in Sontag, *I, etcetera*, 28.

3. Author's interview with Steve Wasserman.

4. Author's interview with Judith Cohen.

5. Author's interview with Paul Brown. The photograph is by Gil Gilbert.

6. Sontag, *Illness*, 40.

7. Charles Ruas, "Susan Sontag: Past, Present and Future," *New York Times*, October 24, 1982.

8. Virginia Woolf, "On Being Ill," in *The Moment and Other Essays* (London: Hogarth Press, 1947).

9. Author's interview with Miranda Spieler.

10. Mukherjee, *Emperor*, 169.

11. Author's interview with Vincent Virga.

12. Author's interview with Don Levine.

13. Author's interview with Roger Deutsch.

14. Author's interviews with David Rieff and Sigrid Nunez.

15. Sontag Papers, June 2, 1981.

16. Sontag Papers, January 27, 1977.

17. Author's interview with Frederic Tuten.

18. Sontag Papers, May 31, 1981.

19. Rieff, *Swimming*, 140.

20. Author's interview with Stephen Koch.

21. Author's interview with Peggy Miller.

22. Author's interview with Roger Deutsch.

23. Ibid.

24. Author's interview with Sigrid Nunez.

25. Author's interview with Roger Deutsch.

26. Ibid.

27. Author's interview with Stephen Koch.

28. Author's interview with Gary Indiana.

29. Author's interviews with Roger Deutsch and Sigrid Nunez.

30. Author's interview with Peggy Miller.

31. White, *City Boy*, 279.

32. Author's interview with Minda Rae Amiran.

33. Author's interview with Don Levine.

34. Author's interview with Robert Silvers.

35. Sontag, *Consciousness*, 223, August 10, 1967.

36. Edmund White, *Caracole* (New York: Dutton, 1985), 93.

37. Sontag, *Consciousness*, 400, n.d. [early 1970s].

38. Sontag Papers, May 25, 1975.

39. Paul Thek to Sontag, May 29, 1978, Sontag Papers.

40. Author's interview with Sigrid Nunez.

41. Author's interview with Roger Deutsch.

CHAPTER 26: THE SLAVE OF SERIOUSNESS

1. Rollyson and Paddock, *Making of an Icon*, 190.

2. "Debriefing," in Sontag, *I, etcetera*, 33, 37.

3. Ibid., 38.

4. Ibid., 44–45.

5. "The Dummy," in ibid., 88.

6. Ibid., 93.

7. "Old Complaints Revisited," in ibid., 129.

8. "Doctor Jekyll," in ibid., 230.

9. Sontag Papers, May 31, 1981. In *Nietzsche contra Wagner*, Nietzsche had written: "Richard Wagner wanted a different kind of movement; he overthrew the physiological presuppositions of previous music. Swimming, floating—no longer walking and dancing" (III, 1).

10. Sontag Papers, May 31, 1981.

11. Author's interview with Norman Podhoretz.

12. Ibid.; Lionel Trilling, *The Liberal Imagination* (New York: Viking Press, 1950), preface.

13. Steven R. Weisman, "The Hollow Man," *New York Times,* October 10, 1999, https://www.nytimes.com/books/99/10/10/reviews/991010.10weismat .html.

14. Joan Didion, *Political Fictions* (New York: Alfred A. Knopf, 2001), 112.

15. Ibid., 99.

16. Evans Chan, "Against Postmodernism, etcetera—A Conversation with Susan Sontag," *Postmodern Culture* 12, no. 1 (Johns Hopkins University Press, September 2001).

17. Seligman, *Sontag & Kael,* 116.

18. Author's interview with Norman Podhoretz.

19. Chan, "Against Postmodernism."

20. "One Year After," 120.

21. Chan, "Against Postmodernism."

22. Fernando Pessoa, *Heróstrato e a busca da imortalidade,* trans. Manuela Rocha, ed. Richard Zenith, *Obras de Fernando Pessoa,* Vol. 14 (Lisbon: Assírio & Alvim, 2000).

23. Stefan Jonsson, "One Must Defend Seriousness: A Talk with Susan Sontag," *Bonniers Litterära Magasin* 58, no. 2 (April 1989): 84–93; in Sontag, *Conversations,* 244.

24. Atlas, "The Changing World of New York Intellectuals."

25. Ibid.

26. Author's interview with Robert Silvers.

27. Mary Breasted, "Discipline for a Wayward Writer," *Village Voice,* November 5–11, 1971.

28. Author's interview with Robert Silvers.

29. Author's interview with Jarosław Anders.

30. Christopher Hitchens, "Party Talk," *Observer,* June 20, 1982.

31. Ralph Schoenman, "Susan Sontag and the Left," *Village Voice,* March 2, 1982.

32. "Susan Sontag Provokes Debate on Communism," *New York Times,* February 27, 1982.

33. James Brady, "Town Hall," Page Six, *New York Post,* April 17, 1982; author's interview with Helen Graves.

34. "Tempest on the Left," *Across the Board: The Conference Board Magazine* XIX, no. 5 (May 1982).

35. Sontag to Octavio Paz, March 2, 1982, Sontag Papers.

36. Author's interview with Eva Kollisch.

37. Author's interview with Robert Silvers.

38. White, *Caracole,* 265.

39. Author's interview with Leon Wieseltier.

40. Phillip Lopate, *Notes on Sontag* (Princeton, NJ: Princeton University Press, 2009), 171–72.

CHAPTER 27: THINGS THAT GO RIGHT

1. From the journals of Kimble James Greenwood, December 8, 1981, Seattle, Washington. Provided to author.

2. Sontag, "Unguided Tour."

3. Author's interview with Lucinda Childs.

4. Around the time of its premiere, said Roger Deutsch, there was much discussion among Susan and her friends "about whether *Einstein on the Beach* was actually something that was great or something that was just a folly." Author's interview with Roger Deutsch.

5. Author's interview with David Rieff.

6. Author's interview with Peter Sellars.

7. "The Aesthetics of Silence," in Sontag, *Styles*, 4.

8. "A Lexicon for *Available Light*," in Sontag, *Where the Stress Falls*, 162–63.

9. Ibid., 168–69.

10. Sontag Papers, August 20, 1983.

11. Author's interview with Lucinda Childs.

12. Ibid. Sontag planned a book about Japan, and even signed a contract for it. But this became one of the many projects that she never completed in these years.

13. Author's interview with David Rieff.

14. Sontag Papers, March 24, 1984.

15. Sontag to Lucinda Childs, November 9, [1984?], Sontag Papers.

16. Sontag Papers, December 30, 1986, Paris.

17. Author's interview with Karla Eoff.

18. Author's interview with Lucinda Childs.

19. Author's interview with Darryl Pinckney.

20. Sontag to Lucinda Childs, June 7, 1987, Sontag Papers.

21. Author's interview with Lucinda Childs.

22. Sontag to Lucinda Childs, August 12, 1997, Sontag Papers.

23. This was Robert J. Ackerman's *Children of Alcoholics* (Holmes Beach, FL: Learning Publications, 1978).

24. Author's interview with Jasper Johns. Her French publisher, Dominique Bourgois, remembered her bitter disappointment when, a little more than a year before her death, J. M. Coetzee won the prize. The award to a fellow English-language writer, she knew, almost surely meant she would never get it. But the need to prove herself never left her: when her bone-

marrow transplant—her last hope for surviving her final cancer—failed, her agent came to the hospital and found her curled up, asleep. When she realized who it was, she sprang to life: "I'm working!" the dying woman insisted. "I'm working!" Author's interviews with Andrew Wylie and Dominique Bourgois.

25. Woititz, *Adult Children of Alcoholics,* 27. She added that adult children of alcoholics "carry with them the experience of come close, go away—the inconsistency of a loving parent-child relationship. They feel loved one day and rejected the next. The fear of being abandoned is a terrible fear. . . . As a result of the fear of abandonment, you don't feel confident about yourself. You don't feel good about yourself or believe you are lovable. So you look to others for what it is that you cannot give yourself in order to feel okay" (68). This is a perfect description of most of Susan's relationships.
26. Ruas, "Susan Sontag: Past, Present and Future."
27. Author's interview with Don Levine.
28. Author's interview with Roger Deutsch.
29. Author's interviews with Steve Wasserman and Stephen Koch.
30. Author's interviews with Jamaica Kincaid, Todd Gitlin, Lucinda Childs, and David Rieff.
31. Author's interview with Jamaica Kincaid.
32. Ibid.
33. Author's interview with Helen Graves.
34. Author's interviews with Robert Boyers and David Rieff.
35. Sigrid Nunez, *Sempre Susan: A Memoir of Susan Sontag* (New York: Atlas, 2011), 117.
36. "Mind as Passion," in Sontag, *Saturn,* 201.
37. "Sartre's Abdication," unpublished essay, Sontag Papers.
38. Ibid.
39. Sontag to Roger Straus, Paris, May 13, 1973, Sontag Papers.
40. Nunez, *Sempre Susan.*
41. The first mention of speed in the diaries is on March 12, 1960. According to David Rieff and Helen Graves, she would still be using it at least until the mid-eighties. Sontag Papers; author's interviews with David Rieff and Helen Graves.
42. Robert Silvers to Sontag, August 24, 1984, Sontag Papers.

CHAPTER 28: THE WORD WON'T GO AWAY
1. Lawrence K. Altman, "Rare Cancer Seen in 41 Homosexuals," *New York Times,* July 3, 1981.
2. Author's interview with Joseph Sonnabend.

3. Mukherjee, *Emperor*, 27.

4. "The AIDS Era: Life During Wartime," July 31, 1990, in Michael Musto, *La Dolce Musto* (New York: Carroll & Graf, 2007), 246–47.

5. Sontag, *Illness*, 6.

6. Ibid., 13.

7. Michelangelo Signorile, *Queer in America: Sex, the Media, and the Closets of Power* (New York: Random House, 1993), 68.

8. Sontag, "The Way We Live Now," *The New Yorker*, November 24, 1986.

9. Ibid.

10. Sontag, *Illness*, 3.

11. Sontag, "The Way We Live Now."

12. Ibid.

13. Ibid.

14. Paul Thek to Sontag, May 29, 1978, Sontag Papers.

15. Author's interview with Stephen Koch.

16. Author's interview with Frederic Tuten.

17. Rachel Pastan, "Remembering Paul Thek: A Conversation with Ann Wilson and Peter Harvey," Institute of Contemporary Art, University of Pennsylvania, http://icaphila.org/miranda/6114/remembering-paul-thek -a-conversation-with-ann-wilson-and-peter-harvey.

18. Paul Thek to Sontag, January 15, 1987, Sontag Papers.

19. These notes are preserved in the Sontag Papers.

20. Author's interview with Howard Hodgkin.

21. Adrienne Rich, "Notes Toward a Politics of Location," in *Blood, Bread, and Poetry: Selected Prose: 1979–1985* (New York: W. W. Norton, 1986), 215.

22. Author's interview with Michael Shnayerson.

23. Ben Cosgrove, "Faces of the American Dead in Vietnam: One Week's Toll," *Life*, June 27, 1969, http://time.com/3485726/faces-of-the-american -dead-in-vietnam-one-weeks-toll-june-1969/.

24. Author's interview with Michelangelo Signorile.

CHAPTER 29: WHY DON'T YOU GO BACK TO THE HOTEL?

1. Author's interview with Steve Wasserman.

2. According to Judith Cohen, Susan "did not know until very late in life" that her mother was an alcoholic. David Rieff contested this: "It was impossible not to know." But Susan often did not know things that were obvious to everyone else. In her journals, there is but a single mention, ambiguous, of alcoholism: "My mother lay in bed until four every afternoon in an alcoholic stupor, the blinds on the bedroom window firmly closed," she wrote on August 14, 1973 (Sontag, *Reborn*, 362). Hawaiian

friends say that, until the last few years, when her health had badly deteriorated, it would have been easy not to know. "She was an alcoholic, as Susan found out many years later, from Judith," Joan Acocella wrote in a profile published in 2000 in *The New Yorker*. Her source was Susan. Yet Don Levine remembered, when Mildred went on a cruise, Susan's remark that it was interesting that there were AA groups even on cruise ships, implying that she had learned this from Mildred. David Rieff also recalls that Susan attended AA meetings with her mother in Honolulu. Perhaps it is another case of her knowing something intellectually that she had not fully absorbed emotionally.

3. Author's interview with Judith Cohen.

4. Sontag Papers, December 30, 1986, Paris.

5. Ibid.

6. Author's interview with Lucinda Childs.

7. Author's interview with Steve Wasserman.

8. Author's interview with Jeff Kissel.

9. Sontag Papers, March 25, 1987.

10. Author's interview with Leon Wieseltier.

11. Author's interview with Jeff Seroy.

12. Author's interview with Leon Wieseltier.

13. Sontag, *Consciousness*, 7, August 6, 1964.

14. Author's interview with Meredith Tax.

15. Salman Rushdie, *Joseph Anton: A Memoir* (New York: Random House, 2012), 75–76.

16. Ibid., 76.

17. Rhoda Koenig, "At Play in the Fields of the Word," *New York*, February 3, 1986, 40–47.

18. Walter Goodman, "Norman Mailer Offers a PEN Post-Mortem," *New York Times*, January 27, 1986.

19. Author's interview with Karen Kennerly.

20. Koenig, "At Play in the Fields of the Word."

21. Author's interview with Meredith Tax.

22. Author's interview with Karen Kennerly.

23. Ibid.

24. Digby Diehl, "PEN and Sword in Seoul," *Los Angeles Times*, September 11, 1988.

25. "Park Sang-mi's Empathetic Storytelling: The Drum Sounds That Beat the Consciousness of the Silent," trans. Hyosun Lee, *Kyunghyang Shinmun*, October 13, 2015.

26. Yongbeon Kim, "'The Poetry I Risked My Life to Write Has Finally Been

"Restored" 16 Years Later': Poet Lee San-ha," trans. Mia You, *Mun-hwa Ilbo*, June 16, 2003, published online by Naver News, http://news .naver.com/main/read.nhn?mode=LSD&mid=sec&sid1=103&oid=021 &aid=0000033892.

27. "Park Sang-mi's Empathetic Storytelling."

28. Rachel Donadio, "Fighting Words on Sir Salman," *New York Times*, July 15, 2007.

29. Paul Elie, "A Fundamental Fight," *Vanity Fair*, May 2014.

30. Author's interview with Karen Kennerly.

31. Author's interview with Salman Rushdie.

32. Rushdie, *Joseph Anton*, 150. For an alternative view, see John R. Mac-Arthur, "The Friends Rushdie Forgot," https://www.spectator.co.uk/2012 /09/the-friends-rushdie-forgot/.

CHAPTER 30: CASUAL INTIMACY

1. Letter to a potential surrogate mother, Sontag Papers.

2. Author's interview with Karen Mullarkey.

3. Annie Leibovitz, *At Work* (New York: Random House, 2008).

4. Ibid., 13.

5. Author's interview with Roger Black.

6. *Rolling Stone*, no. 254, Tenth Anniversary Issue, December 15, 1977, 62.

7. Leibovitz, *At Work*, 44.

8. Author's interview with Kathy Ryan.

9. https://www.youtube.com/watch?v=vqpK9lUTVXs.

10. Author's interview with Andrew Eccles.

11. Author's interview with Timothy Crouse.

12. Author's interview with Andrew Eccles.

13. Annie Leibovitz, *Photographs* (New York: Pantheon/Rolling Stone Press, 1983).

14. Author's interview with Karen Mullarkey.

15. Author's interview with Max Aguilera-Hellweg.

16. Author's interview with Andrew Eccles.

17. Author's interview with Roger Black.

18. Ibid.

19. Ronstadt's attitude toward Leibovitz pictures: http://www.ronstadt-linda .com/gold03.htm, http://www.ronstadt-linda.com/artnt77.htm.

20. Leibovitz, *Photographs*.

21. Sontag, *On Photography*, 12–13.

22. Ibid., 35.

23. Ibid., 4.

24. Author's interview with Karen Mullarkey.

25. Author's interviews with Karen Mullarkey and Roger Black.

26. Ibid.

27. Leibovitz, *At Work,* 34.

28. Author's interview with an anonymous source.

29. Annie Leibovitz, ed., *Shooting Stars: The* Rolling Stone *Book of Portraits* (San Francisco: Straight Arrow Books, 1973), 70.

30. Author's interview with Andrew Eccles.

31. Author's interview with Karen Mullarkey.

32. *Rolling Stone,* no. 254, Tenth Anniversary Issue, December 15, 1977, 62.

33. See, for example, *Senhor,* July 1960.

34. Bruno Feitler, *O design de Bea Feitler* (São Paulo: Cosac Naify, 2012).

35. Author's interview with Karen Mullarkey.

36. Leibovitz, *Shooting Stars,* 70.

37. Author's interview with Roger Black.

38. Author's interview with Karen Mullarkey. See also Joe Hagan, *Sticky Fingers: The Life and Times of Jann Wenner and* Rolling Stone *Magazine* (New York: Alfred A. Knopf, 2017).

39. Author's interview with Michael Shnayerson.

40. Author's interview with Sid Holt.

CHAPTER 31: THIS "SUSAN SONTAG" THING

1. Paula Span, "Susan Sontag, Hot at Last," *Washington Post,* September 17, 1992.

2. Ibid.

3. Richmond Burton, "Notes on Life with Susan," unpublished manuscript.

4. Rebecca Mead, "Mister Pitch," *New York,* August 5, 1996.

5. Kachka, *Hothouse,* 257.

6. Sontag to Judith Wechsler, June 13, 1990, Sontag Papers.

7. Author's interview with Mitchell Kaplan.

8. Kachka, *Hothouse,* 257.

9. Author's interview with Peggy Miller.

10. Kachka, *Hothouse,* 257.

11. Ibid., 256.

12. Span, "Susan Sontag, Hot at Last."

13. Sontag, *Reborn,* 298, "Week of Feb. 12, 1962."

14. Kachka, *Hothouse,* 258.

15. Author's interview with Sharon DeLano.
16. Janny Scott, "From Annie Leibovitz: Life, and Death, Examined," *New York Times*, October 6, 2006.
17. Author's interview with Karla Eoff.
18. Signorile, *Queer*, 81.
19. Ibid., 75.
20. http://www.msignorile.com/bio.htm.
21. Signorile, *Queer*, 77.
22. Ibid., 67.
23. Ibid., 232.
24. Ibid., 84.
25. Sontag, *Illness*, 96.
26. Ibid., 102.
27. Ibid., 165.
28. Ibid., 167.
29. Ibid., 183.
30. Seligman, *Sontag & Kael*, 36.
31. Christopher Lehmann-Haupt, "Shaping the Reality of AIDS Through Language," *New York Times*, January 16, 1989.
32. Author's interview with Michelangelo Signorile.
33. Jay Prosser, "Metaphors Kill," in Ching and Wagner-Lawlor, *Scandal*, 200.

CHAPTER 32: TAKING HOSTAGES

1. Author's interview with Karla Eoff.
2. Gloria L. Cronin et al., *A Political Companion to Saul Bellow* (Lexington: University Press of Kentucky, 2013). Richmond Burton tells the same story.
3. Author's interview with Peter Perrone.
4. Author's interview with Jeff Seroy.
5. Annie Leibovitz to Sontag, June 1989, Sontag Papers.
6. Scott, "From Annie Leibovitz."
7. Author's interview with Karla Eoff.
8. Scott, "From Annie Leibovitz."
9. Author's interview with Annie Leibovitz.
10. Ibid.
11. This portrait is derived from many sources, including the author's interviews with Karla Eoff, Greg Chandler, Sharon DeLano, Rick Kantor, Christian Witkin, and Annie Leibovitz.
12. Author's interview with Annie Leibovitz.

13. Author's interview with Karla Eoff.

14. Author's interview with Rick Kantor.

15. Author's interview with Richmond Burton.

16. Author's interview with Karla Eoff.

17. Author's interview with Joan Acocella.

18. Author's interview with David Rieff.

19. Author's interview with Michael Silverblatt.

20. Author's interview with Marilù Eustachio.

21. Author's interview with Gary Indiana.

22. Author's interview with Richmond Burton.

23. Author's interview with Karla Eoff.

24. Author's interview with Christian Witkin.

25. Author's interview with Annie Leibovitz.

26. Author's interview with Vincent Virga.

27. Author's interview with Greg Chandler.

28. Scott, "From Annie Leibovitz."

29. Andrew Goldman, "How Could This Happen to Annie Leibovitz?" *New York,* August 16, 2009.

30. Author's interview with Karla Eoff.

31. Author's interview with Annie Leibovitz.

32. Author's interview with Michael Silverblatt.

33. Author's interview with Steve Wasserman.

34. Author's interview with Martie Edelheit.

35. Author's interview with Kasia Gorska.

36. Author's interview with Karla Eoff.

CHAPTER 33: THE COLLECTIBLE WOMAN

1. "Singleness," in Sontag, *Where the Stress Falls,* 260.

2. "A Poet's Prose," in ibid., 8.

3. Sontag Papers.

4. Span, "Susan Sontag, Hot at Last."

5. Sontag, *Volcano Lover,* 133, 163.

6. Ibid., 128.

7. Ibid., 135.

8. Ibid., 406.

9. Ibid., 72, 73.

10. Ibid., 23.

11. Ibid., 25.

12. Ibid., 119.

13. Ibid., 166.
14. Ibid., 419, 299.
15. "Mind as Passion," in Sontag, *Saturn*, 195–96.
16. Sontag, *Volcano*, 41–43.
17. Ibid., 77–80.
18. Ibid., 160.
19. Ibid., 56.
20. Ibid., 134.
21. Ibid., 407.
22. Ibid., 242.
23. Span, "Susan Sontag, Hot at Last."
24. Terry Castle, "Desperately Seeking Susan," *London Review of Books* 27, no. 6 (March 17, 2005).
25. Heller, "The Life of a Head Girl."
26. Author's interview with Jamaica Kincaid.
27. Author's interview with Robert Boyers.
28. Author's interview with Annie Wright. The American biographer Julie Phillips, who lived in Amsterdam, reported hearing from a friend that Sontag, full of her experiences in Sarajevo, also declared that "people don't really understand what a city at war is like." "You could feel a ripple of shock and anger spread through the crowd, not only because De Swaan is Jewish [born 1942], but because many in the crowd had lived through the war." Author's interview with Julie Phillips.
29. Paglia, *Vamps*, 355.
30. Author's interview with Camille Paglia.
31. Paglia, *Vamps*, 357.
32. Author's interview with Camille Paglia.
33. "More from Sontag's 'Nightmare,'" Page Six, *New York Post*, August 14, 1992.
34. Camille Paglia interview with Christopher Lydon, 1993, https://www.youtube.com/watch?v=kFgYcVbAaNs.
35. Author's interview with Camille Paglia.
36. Rollyson and Paddock, *Making of an Icon*, 274.

CHAPTER 34: A SERIOUS PERSON

1. "Project for a Trip to China," in Sontag, *I, etcetera*, 14.
2. David Rieff, *Slaughterhouse: Bosnia and the Failure of the West* (New York: Simon & Schuster, 1995), 31, 123.
3. Author's interview with John Burns.
4. Author's interview with Atka Reid.

5. Rieff, *Slaughterhouse*, 216; Dževad Karahasan, *Sarajevo, Exodus of a City* (New York: Kodansha America, 1994), 78–79.
6. Rieff, *Slaughterhouse*, 25.
7. Ibid., 9–10.
8. Author's interview with Miro Purivatra.
9. Omer Hadžiselimović and Zvonimir Radeljković, "Literature Is What You Should Re-Read: An Interview with Susan Sontag," *Spirit of Bosnia* 2, no. 2 (April 2007), http://www.spiritofbosnia.org/volume-2-no-2-2007 -april/literature-is-what-you-should-re-read-an-interview-with-susan -sontag/.
10. "'There' and 'Here,'" in Sontag, *Where the Stress Falls*, 323.
11. Sontag to Peter Schneider, June 18, 1993, Sontag Papers.
12. Author's interview with Haris Pašović.
13. Rieff, *Slaughterhouse*, 34.
14. "Waiting for Godot in Sarajevo," in Sontag, *Where the Stress Falls*, 304.
15. Cott, *Susan Sontag*, 97.
16. Sontag Papers, n.d. [mid-1960s]. This is taken from early notes on "The Aesthetics of Silence," which reveal that she was originally considering an "essay on boredom."
17. Author's interview with Haris Pašović.
18. Author's interview with John Burns.
19. Hadžiselimović and Radeljković, "Literature Is What You Should Re-Read."
20. John Burns, "To Sarajevo, Writer Brings Good Will and 'Godot,'" *New York Times*, August 19, 1993.
21. "Michel Leiris' *Manhood*," in Sontag, *Against Interpretation*, 64.
22. Author's interview with Una Sekerez Jones.
23. Author's interview with Ferida Duraković.
24. Sontag, *Regarding the Pain of Others* (New York: Farrar, Straus and Giroux, 2002), 33.
25. Sontag, *On Photography*, 17.
26. "Waiting for Godot in Sarajevo," in Sontag, *Where the Stress Falls*, 299.
27. Sontag, *On Photography*, 19.
28. Sontag, *Regarding*, 12.
29. Author's interview with Janine di Giovanni.
30. Author's interview with Izudin Bajrović.
31. John Pomfret, "'Godot' amid the Gunfire: In Bosnia, Sontag's Take on Beckett," *Washington Post*, August 19, 1993.
32. "Waiting for Godot in Sarajevo," in Sontag, *Where the Stress Falls*, 319.
33. Chan, "Against Postmodernism."

34. "On Being Translated," in Sontag, *Where the Stress Falls*, 336.
35. Author's interview with Haris Pašović.

CHAPTER 35: A CULTURAL EVENT

1. Julia A. Walker, "Sontag on Theater," in Ching and Wagner-Lawlor, *Scandal*, 133.
2. For Sontag's reflections on this collaboration (at the Teatro Stabile) see an unpublished interview with the British Pirandello Society, March 20, 1981, in the Sontag Papers. In it, Sontag expresses herself in uncharacteristically harsh terms about Asti. If Sontag, in private, could say cutting things about people, she very rarely did so in public. This almost surely explains why the interview was never published.
3. Sontag, *Reborn*, 180, January 6, 1958.
4. Author's interview with Marilù Eustachio.
5. Roger Copeland, "The Habits of Consciousness," in Sontag, *Conversations*, 191.
6. Edward Hirsch, "Susan Sontag, The Art of Fiction No. 143," *Paris Review*, no. 137 (Winter 1995).
7. Sontag, *Alice in Bed* (New York: Farrar, Straus and Giroux, 1993), 113.
8. Ibid., 116.
9. Ibid.
10. Walker, "Sontag on Theater," in Ching and Wagner-Lawlor, *Scandal*, 142.
11. Sontag, *Alice*, 63, 68.
12. Frank Rich, "Stage: Milan Kundera's 'Jacques and His Master,'" *New York Times*, January 24, 1985.
13. "Thirty Years Later," in Sontag, *Against Interpretation*.
14. Author's interview with Miranda Spieler.
15. "Approaching Artaud," in Sontag, *Saturn*, 28.
16. Ibid., 29.
17. Ibid., 16, 15.
18. Ibid., 22.
19. Ibid., 39.
20. Ibid., 36.
21. Artaud, *Selected Writings*, xxxiii, xxiii.
22. Ibid., xxxv.
23. Author's interview with Izudin Bajrović.
24. Ruby Cohn, ed., *Casebook on* Waiting for Godot: *The Impact of Beckett's Modern Classic: Reviews, Reflections & Interpretations* (New York: Grove Press, 1967), 17. This book also offers another suggestion for why Beckett

might have appealed to Susan. In *Murphy*, we read: "Murphy felt himself split in two, a body and a mind. They had intercourse apparently, otherwise he could not have known that they had anything in common. But he felt his mind to be bodytight and did not understand through what channel the intercourse was effected nor how the two experiences came to overlap. He was satisfied that neither followed from the other. He neither thought a kick because he felt one nor felt a kick because he thought one."

25. Ibid., 11.
26. Author's interview with Admir Glamočak.
27. Author's interview with Izudin Bajrović.
28. "Waiting for Godot in Sarajevo," in Sontag, *Where the Stress Falls*, 315.
29. Author's interview with Izudin Bajrović.
30. Author's interview with Ferida Duraković.
31. Author's interview with Senada Kreso.
32. Author's interview with Izudin Bajrović.
33. Sontag Papers.
34. "Waiting for Godot in Sarajevo," in Sontag, *Where the Stress Falls*, 303.
35. Pjer Žalica, dir., *Sarajevo—Godot*, SaGA Production Sarajevo, 1993.
36. "Waiting for Godot in Sarajevo," in Sontag, *Where the Stress Falls*, 309.
37. Ibid., 310.
38. Author's interview with Izudin Bajrović.
39. Sontag, *On Photography*, 105.
40. Author's interview with Velibor Topić.
41. "Waiting for Godot in Sarajevo," in Sontag, *Where the Stress Falls*, 312.
42. Ibid., 313.
43. Author's interview with Admir Glamočak.
44. Author's interview with Ademir Kenović.
45. "Waiting for Godot in Sarajevo," in Sontag, *Where the Stress Falls*, 318.
46. Kevin Myers, "I Wish I Had Kicked Susan Sontag," *Telegraph*, January 2, 2005.
47. Author's interview with John Burns.
48. Author's interview with Izudin Bajrović.
49. Author's interview with Haris Pašović.
50. Author's interview with Goran Simić.
51. Author's interview with Pierre Bergé.
52. Sontag Papers.
53. Author's interview with Miro Purivatra.
54. Angela Lambert, "Taking Pictures with Annie Leibovitz: From Jagger to

Trump, She Summed Up the Seventies and Eighties. Her Latest Subject Is Sarajevo," *Independent*, March 3, 1994.

55. Sontag, *On Photography*, 11.

56. Bob Thompson, "A Complete Picture: Annie Leibovitz Is Ready for an Intimate View of Her Life," *Washington Post*, October 19, 2006.

57. Samuel Beckett, *Waiting for Godot: A Tragicomedy in Two Acts*, translated from the original French by the author (New York: Grove Press, 1954), 51.

58. Author's interview with Ademir Kenović.

59. Author's interview with Admir Glamočak.

CHAPTER 36: THE SUSAN STORY

1. This story is recounted in Atka Reid and Hana Schofield, *Goodbye Sarajevo: A True Story of Courage, Love and Survival* (London: Bloomsbury, 2011).

2. Affidavit of Hasan Gluhić, Sontag Papers.

3. Author's interview with John Burns.

4. Author's interview with Haris Pašović.

5. Author's interview with Miranda Spieler.

6. Author's interview with Ferida Duraković.

7. Author's interview with Kasia Gorska.

8. Author's interview with Ferida Duraković.

9. "'There' and 'Here,'" in Sontag, *Where the Stress Falls*, 328.

10. Ibid., 324.

11. "Answers to a Questionnaire," in ibid., 298.

12. Author's interview with Stephen Koch.

13. Castle, "Desperately Seeking Susan."

14. Rushdie, *Joseph Anton*, 363.

15. Author's interview with Richmond Burton.

16. Hadžiselimović and Radeljković, "Literature Is What You Should Re-Read."

17. Author's interview with Richmond Burton. Judith Cohen heard her make the same comparison.

18. Author's interview with Larry McMurtry.

19. Author's interview with Greg Chandler.

20. Rieff, *Swimming*, 160.

21. "Trip to Hanoi," in Sontag, *Styles*, 216.

22. Rieff, *Slaughterhouse*, 123.

23. Author's interview with Antony Peattie.

24. Author's interview with Howard Hodgkin.

25. Rieff, *Slaughterhouse*, 52.

26. Author's interview with David Rieff.

27. Hadžiselimović and Radeljković, "Literature Is What You Should Re-Read."
28. Author's interview with Haris Pašović.
29. Author's interview with David Rieff.
30. Author's interview with Judith Cohen.
31. Sontag to Paolo Dilonardo, e-mail, August 28, 2002, Sontag Papers.
32. Author's interview with Senada Kreso.
33. Sontag Papers, 1994.
34. "The World as India," in Sontag, *At the Same Time*, 177.
35. Author's interview with Karla Eoff.
36. Author's interview with Miranda Spieler.
37. Author's interview with Marilù Eustachio.
38. Sontag, *On Photography*, 12.
39. Author's interview with Leon Wieseltier.
40. Sontag, *Benefactor*, 260.

CHAPTER 37: THE CALLAS WAY

1. Sontag, *In America*, 24.
2. Ibid., 15.
3. Sontag Papers, n.d. [1980s].
4. "Wagner's Fluids," in Sontag, *Where the Stress Falls*, 205.
5. Sontag, *In America*, 369.
6. Chan, "Against Postmodernism."
7. Author's interview with Michael Silverblatt.
8. Ibid.
9. Cott, *Susan Sontag*, 137.
10. Sontag, *In America*, 346.
11. Ibid., 363.
12. Ibid., 85.
13. Ibid., 41.
14. Ibid., 347.
15. Ibid., 159.
16. Ibid., 228.
17. Ibid., 268.
18. Ibid., 44.
19. Ibid., 304.
20. Ibid., 355.
21. Gary Indiana, *I Can Give You Anything but Love* (New York: Rizzoli, 2015), 118–19.

22. Elżbieta Sawicka quoted in Carl Rollyson, *Reading Susan Sontag: A Critical Introduction to Her Work* (Chicago: Ivan R. Dee, 2001), 176.

23. Sontag, *In America*, 206.

24. Ibid., 39, 208.

25. Ibid., 127.

26. Ibid., 290.

27. Author's interview with Michael Silverblatt.

28. Ibid.

29. Sontag, *In America*, 196.

30. Michiko Kakutani, "'In America': Love as a Distraction That Gets in the Way of Art," *New York Times*, February 29, 2000.

31. Sontag, *In America*, 342.

32. Ibid., 216.

33. Ibid., 303.

34. Ibid., 278.

35. Ibid., 183.

36. Author's interview with Annie Leibovitz.

37. Sontag, *In America*, 342.

38. Rieff, *Swimming*, 75, 77.

CHAPTER 38: THE SEA CREATURE

1. Author's interview with Karla Eoff.

2. Author's interview with Todd Gitlin.

3. Author's interview with Michael Silverblatt.

4. Liam Lacey, "Waiting for Sontag," *Globe and Mail*, November 23, 2002.

5. In Sontag's proposal for an unwritten book to be entitled *Being Ill*, March 15, 2001, Sontag Papers.

6. Ibid.

7. Author's interview with Kasia Gorska.

8. Sontag, *In America*, 62.

9. Joan Acocella in Philoctetes Center, "Susan Sontag: Public Intellectual, Polymath, Provocatrice."

10. Author's interview with Lucinda Childs.

11. Sontag, *In America*, 41.

12. Lacey, "Waiting for Sontag."

13. Rieff, *Swimming*, 31.

14. Castle, "Desperately Seeking Susan."

15. Lacey, "Waiting for Sontag."

16. Author's interview with John Burns.

17. Bob Fernandes, "Suburbana América," *Isto É,* June 23, 1993.

18. Author's interview with Karla Eoff.

19. Smokenders notebooks, Sontag Papers.

20. Sontag, "Why Are We in Kosovo?" *The New York Times Magazine,* May 2, 1999.

21. Ibid.

22. Leland Poague and Kathy A. Parsons, *Susan Sontag: An Annotated Bibliography: 1948–1992* (New York: Garland Publishing, 2000), 47.

23. William J. Clinton, "Remarks at the State Dinner Honoring President Arpad Goncz of Hungary," June 8, 1999, http://www.presidency.ucsb.edu/ws/?pid=57698.

24. "A Photograph Is Not an Opinion. Or Is It?" in Sontag, *Where the Stress Falls,* 241; Annie Leibovitz, *Women* (New York: Random House, 1999).

25. "A Photograph Is Not an Opinion. Or Is It?" in Sontag, *Where the Stress Falls,* 247.

26. Author's interview with Peter Perrone.

27. Sontag, *In America,* 74.

28. Leibovitz, *A Photographer's Life.*

29. Jesús Ruiz Mantilla, "Sin Susan Sontag, no habría ganado el Príncipe de Asturias," *El País,* November 11, 2013.

30. Natividad Pulido, "Desde que conocí a Susan Sontag traté de complacerla, pero no siempre funcionaba," *ABC* (Madrid), June 19, 2009.

31. Maxine Mesinger, "VF Dresses Demi in Paint," *Houston Chronicle,* July 7, 1992; Tina Brown's memoir, *Vanity Fair Diaries,* tells the story differently.

32. Author's interview with Peter Perrone.

33. Author's interview with Miranda Spieler.

34. Author's interview with Annie Leibovitz.

CHAPTER 39: THE MOST NATURAL THING IN THE WORLD

1. Carl Rollyson and Lisa Paddock to Sontag, March 7, 1996, Sontag Papers.

2. Roger Straus to Starling Lawrence, August 28, 1996, Sontag Papers.

3. Janny Scott, "It's a Lonely Way to Pay the Bills: For Unauthorized Biographers, the World Is Very Hostile," *New York Times,* October 6, 1996.

4. Sontag to Jeannette Paulson Hereniko, February 20, 1997, Sontag Papers.

5. Elizabeth Manus, "Susan Sontag Gets Jumpy; Pat Conroy Gets Left Out," *New York Observer,* January 17, 2000.

6. Heller, "The Life of a Head Girl."

7. Author's interview with Zoë Heller.

8. Author's interview with Karla Eoff.

9. Rieff, *My Life Among the Deathworks,* 126.

10. Sontag to Luisa Valenzuela, e-mail, May 24, 2002, Sontag Papers.

11. Sontag to Alessandra Farkas, e-mail, February 3, 2003, Sontag Papers.

12. Author's interview with Antonio Monda.

13. Sontag to Alessandra Farkas, e-mail, February 4, 2003, Sontag Papers.

14. Sontag to Joyce Wadler, October 8, 2003, Sontag Papers.

15. Author's interview with Judith Cohen.

16. Author's interview with Joan Acocella.

17. Joan Acocella in Philoctetes Center, "Susan Sontag: Public Intellectual, Polymath, Provocatrice."

18. Acocella, "The Hunger Artist."

19. Author's interview with Joan Acocella.

20. George Chauncey, *Gay New York: Gender, Urban Culture, and the Making of the Gay Male World, 1890–1940* (New York: Basic Books, 1994), 6–7, quoted in Jack Drescher, "What's in Your Closet?" in *The LGBT Casebook,* eds. P. Levounis, J. Drescher, and M. E. Barber (Washington, D.C.: American Psychiatric Press, 2012), 3–16. Italics in original.

21. Author's interview with Dr. Charles Silverstein.

22. Jack Drescher, "The Closet: Psychological Issues of Being In and Coming Out," *Psychiatric Times,* October 1, 2004.

23. Drescher, "What's in Your Closet?"

24. Drescher, "The Closet."

25. Ibid.

26. Sontag to Lee Poague, March 9, 2001, Sontag Papers.

27. Doreen Carvajal, "So Whose Words Are They, Anyway? A New Sontag Novel Creates a Stir by Not Crediting Quotes from Other Books," *New York Times,* May 27, 2000.

28. Sontag, *In America,* 349.

29. Sontag Papers, March 17, 1996.

30. Author's interview with Edmund White.

31. Author's interview with Linda Plochocki, Helena Modjeska Foundation.

32. Author's interview with Laura Miller. For further examples, see Michael Calderone, "Regarding the Writing of Others," *New York Observer,* May 9, 2007.

Sontag: "Ever since word-processing programs became commonplace tools for most writers—including me—there have been those who assert that there is now a brave new future for fiction." Miller: "Shortly after personal computers and word-processing programs became commonplace tools for writers, a brave new future for fiction was trumpeted." Sontag: "Hyperfiction is sometimes said to mimic real life, with its myriad op-

portunities and surprising outcomes. . . ." Miller: "Hypertext is sometimes said to mimic real life, with its myriad opportunities and surprising outcomes. . . ." Sontag: "People who read for nothing else will read for plot. Yet hyperfiction's advocates maintain that we find plot 'confining' and chafe against its limitations." Miller: "People who read for nothing else will read for plot, yet hyperfiction's advocates maintain that we find it 'confining' and chafe against its 'limitations.'"

There were also accusations of plagiarism around *Alice in Bed*. The tea party scene "shows strong parallels with an imaginary scene of a group of famous women in Caryl Churchill's drama 'Top Girls'" (Schreiber, *Geist*, 237). And Dana Heller asked Sontag about a similarity to another work, provoking the kind of outburst that was typical of Sontag when caught in a lie. "I have always wondered if Sontag had ever read the novel of the same name by Cathleen Schine—published in 1983, ten years earlier than Sontag's play—which tells the darkly comic story of a literate young woman named Alice who is stricken with an undiagnosed malady that renders her immobile and bodily confined to bed, while her mind remains wickedly alive. And so I asked. It was the wrong question. And Susan Sontag exploded. 'No, I have never read anything by the Schine person, but more to the point, the question is an absurd one since there is no relationship whatsoever between my play and any novel, which you would know if you were familiar with my play! Do you know my play? Have you seen my play?' 'I've read but not seen your play,' I stammered. 'Yes, and it isn't likely that you will see my play in this . . . town . . . but if you'd read the play correctly you know that there is no connection between it and any novel except for the title—unless you think that Joan Didion's *Democracy* was influenced by Henry Adams, who also happened to write a book called *Democracy*. Would you ask Joan Didion if her *Democracy* is a reference to Henry Adams' *Democracy*?' I felt as though my hair were on fire. I considered her question for a long, agonizing beat, a 'creative moment' in the evolution of modern stress. 'I probably would,' I was forced to admit. Here, Sontag visibly surrendered all hope for me and looked away. My students were dumbstruck. Yet they were also fully alert, captivated by the operatic quality of her blowup and the sorry spectacle of my feckless effort to stem the tide of her outrage. Was this a fight? Or was their teacher in flight? As Sontag composed herself for the next question, it appeared for a moment that I had successfully fled. But then suddenly she was on me again, newly committed to my upbraiding, only evenly and dispassionately this time. 'I am stunned, utterly stunned that you would ask such a stupid question that no one who knew even the

least bit about the life of Alice James would ask.' There was something else on Sontag's mind. Urgently, she asked me, 'Do you know who Alice James is?' 'Yes.' I said. The cross-examination continued. 'Do you know why she was in bed?' 'Cancer,' I said." (Dana Heller, "Desperately Seeking Susan," *The Common Review*, Winter 2006.)

33. Sontag, *In America*, 250.
34. James Miller in Philoctetes Center, "Susan Sontag: Public Intellectual, Polymath, Provocatrice."
35. Author's interview with Brenda Shaughnessy.

CHAPTER 40: IT'S WHAT A WRITER *IS*

1. Author's interview with Brenda Shaughnessy.
2. Ibid.
3. Rieff, *Swimming*, 65.
4. Sontag, *Reborn*, 275, June 12, 1961.
5. "Singleness," in Sontag, *Where the Stress Falls*, 261.
6. Ronald Suresh Roberts, *No Cold Kitchen: A Biography of Nadine Gordimer* (Johannesburg: STE Publishers, 2005), 573.
7. Edward Said to Sontag, April 27, 2001, Sontag Papers.
8. Sontag to Edward Said, May 5, 2001, Sontag Papers.
9. "The Conscience of Words," in Sontag, *At the Same Time*, 155.
10. Quoted in Roberts, *No Cold Kitchen*, 576.
11. Ibid., 575.
12. Author's interview with Richmond Burton.
13. Author's interview with Michael Silverblatt.
14. Author's interview with Klaus Biesenbach.
15. Sontag, *Volcano Lover*, 235, 126.
16. "Borland's Babies," in Sontag, *Where the Stress Falls*, 229–30.
17. Sontag, *In America*, 85.
18. Author's interview with Karla Eoff.
19. Author's interview with Brenda Shaughnessy.
20. Author's interview with Annie Leibovitz.
21. Ibid.
22. Author's interview with Brenda Shaughnessy.

CHAPTER 41: A SPECTATOR OF CALAMITIES

1. Author's interview with Senada Kreso.
2. Sontag et al., "Tuesday, and After," *The New Yorker*, September 24, 2001.
3. Harald Fricke, "Meinung und nichts als die Meinung," Taz.de, September 15, 2001, http://www.taz.de/Archiv-Suche/!1151172&s=&SuchRahmen=Print/.

4. David Talbot, "The 'Traitor' Fires Back," Salon, October 16, 2001, http://www.salon.com/2001/10/16/susans/.

5. Rod Dreher quoted in Seligman, *Sontag & Kael*, 97.

6. Sontag to David Rieff, e-mail, September 20, 2001, Sontag Papers.

7. Ibid.

8. Author's interview with Glenn Greenwald.

9. Author's interview with Brenda Shaughnessy.

10. Leibovitz, *A Photographer's Life*.

11. Luisa Valenzuela, "Susan Sontag, amiga," *La Nación*, January 14, 2008.

12. Leibovitz, *A Photographer's Life*.

13. Author's interview with Michael Silverblatt.

14. Sontag to Luisa Valenzuela, e-mail, May 24, 2002, Sontag Papers.

15. Sontag, *Against Interpretation*, 47.

16. Sontag to Joan Macintosh, e-mail, May 24, 2002, Sontag Papers.

17. Sontag to Peter Perrone, e-mail, June 22, 2002, Sontag Papers.

18. Author's interview with Christian Witkin.

19. Author's interview with Oliver Strand.

20. Goldman, "How Could This Happen to Annie Leibovitz?"

21. Author's interviews with Rick Kantor and Annie Leibovitz.

22. Dawn Setzer, "Library Buys Sontag Papers," UCLA Newsroom, February 12, 2002, http://newsroom.ucla.edu/stories/020212sontag.

23. Author's interview with Sharon DeLano.

24. Author's interview with Karen Mulligan.

25. Author's interview with Annie Leibovitz.

CHAPTER 42: CAN'T UNDERSTAND, CAN'T IMAGINE

1. "Quotation of the Day," *New York Times*, September 7, 2002, http://www.nytimes.com/2002/09/07/nyregion/quotation-of-the-day-766518.html.

2. Sontag, *Regarding*, 3, 5.

3. Ibid., 10.

4. Ibid., 21.

5. Ibid., 51.

6. Ibid., 38.

7. Ibid., 56.

8. Ibid., 57.

9. Ibid., 112.

10. Ibid., 104–5.

11. Ibid., 108.

12. Ibid., 126.

13. Author's interview with Oliver Strand.

14. Enrique Krauze, "García Márquez's Blind Spot," *New York Times*, May 28, 2014.
15. "Gabo responde a Susan Sontag," *El Tiempo*, April 29, 2003, http://www.eltiempo.com/archivo/documento/MAM-1033192.
16. "Susan Sontag contra Gabo," *La Nación*, April 4, 2010, http://www.lanacion.com.ar/1249538-susan-sontag-contra-gabo.
17. Letter to potential surrogate mothers, Sontag Papers.
18. Sharon DeLano to Sontag, e-mail, September 29, 2003.
19. Author's interview with Dominique Bourgois.
20. "Literature Is Freedom," in Sontag, *At the Same Time*, 193.
21. Ibid., 200.
22. Ibid., 207.
23. Sontag, *Regarding*, 36.
24. Nancy Kates, unpublished interview with Nadine Gordimer.
25. Author's interview with Michael Silverblatt.
26. Author's interview with Karla Eoff.

CHAPTER 43: THE ONLY THING THAT'S REAL

1. Author's interview with Sharon DeLano.
2. Rieff, *Swimming*, 1–11.
3. Author's interviews with Karla Eoff and Michael Silverblatt.
4. Rieff, *Swimming*, 85.
5. Katie Roiphe, *The Violet Hour: Great Writers at the End* (New York: Dial Press, 2016), 32.
6. Rieff, *Swimming*, 144.
7. Ibid., 81.
8. Ibid., 98, 104.
9. Sontag, "Regarding the Torture of Others," *The New York Times Magazine*, May 23, 2004.
10. Author's interview with Karla Eoff.
11. Sontag, *Illness*, 8, 9.
12. Author's interview with Sharon DeLano.
13. Hujar, *Portraits in Life and Death*, preface by Sontag.
14. Rieff, *Swimming*, 71.
15. Ibid., 45.
16. Author's interviews with Annie Leibovitz, Rick Kantor, and Sharon DeLano.
17. Roiphe, *Violet Hour*, 39.
18. Ibid., 43.
19. Author's interview with Don Levine.

20. Karla Eoff to Sontag's care group, e-mail, mid-September 2004.
21. Karla Eoff to Sontag's care group, e-mail.
22. Author's interview with Annie Leibovitz.
23. Karla Eoff to David Rieff, e-mail, September 28, 2004.
24. Roiphe, *Violet Hour,* 44.
25. Karla Eoff to Sontag's care group, e-mail, September 22 and September 25, 2004.
26. Roiphe, *Violet Hour,* 54.
27. David Rieff to Sharon DeLano, e-mail, November 9, 2004.
28. David Rieff to Stephen Nimer, e-mail, November 9, 2004.
29. Roiphe, *Violet Hour,* 56.
30. Author's interview with Peter Perrone.
31. Roiphe, *Violet Hour,* 58.
32. "Outlandish: On Halldór Laxness's *Under the Glacier,*" in Sontag, *At the Same Time,* 101.
33. Author's interview with Sharon DeLano.
34. Katie Mitchell, "A Meeting of Minds," *Guardian,* November 18, 2005, https://www.theguardian.com/music/2005/nov/18/classicalmusicand opera.thomasstearnseliot.
35. Author's interview with Marcel van den Brink.
36. Rieff, *Swimming,* 104–5.
37. Author's interview with Andrew Wylie.
38. Author's interview with Sharon DeLano.
39. Sontag, *Reborn,* 88, November 4, 1956; November 16, 1956.
40. Roiphe, *Violet Hour,* 75.
41. Emma Brockes, "Annie Leibovitz: My Time with Susan," *Guardian,* October 7, 2006.
42. Rieff, preface to Sontag, *Consciousness,* xii.
43. Rieff, *Swimming,* 137.

EPILOGUE: THE BODY AND ITS METAPHORS

1. Author's interview with Don Levine.
2. Author's interview with Joanna Robertson.
3. Author's interview with Kasia Gorska.
4. Andrew Goldman, "The Devil in Marina Abramovic," *The New York Times Magazine,* June 13, 2012.
5. Author's interview with Sharon DeLano.
6. Author's interview with Karla Eoff.
7. Author's interviews with Annie Leibovitz and Judith Cohen.

8. David Thomson, "Death Kit," *The New Republic*, February 12, 2007, 26–27.

9. Sontag, *On Photography*, 11.

10. Ibid., 98.

11. Ibid., 105.

12. Ibid., 110.

13. Author's interview with Annie Leibovitz.

14. Annie Leibovitz, *Portraits, 2005–2016* (New York: Phaidon Press, 2017), afterword.

BIBLIOGRAPHY

Abramovitch, Ilana, and Seán Galvin, eds. *Jews of Brooklyn: Brandeis Series in American Jewish History, Culture, and Life.* Hanover, NH: Brandeis University Press, 2001.

Ackerman, Robert J. *Children of Alcoholics.* Holmes Beach, FL: Learning Publications, 1978.

Acocella, Joan. "The Hunger Artist." *The New Yorker,* March 6, 2000.

Albelli, Alfred. "Prof: Gotta Be Sneak to See My Son." New York *Daily News,* December 15, 1961.

Altman, Lawrence K. "Rare Cancer Seen in 41 Homosexuals." *New York Times,* July 3, 1981.

Arbus, Diane. *Diane Arbus: An Aperture Monograph.* Millerton, NY: Aperture, 1972.

Artaud, Antonin. *Selected Writings.* Edited and introduced by Susan Sontag. New York: Farrar, Straus and Giroux, 1976.

Ascherson, Neal. "How Images Fail to Convey War's Horror." *Los Angeles Times,* March 16, 2003.

Athill, Diana. *Stet: A Memoir.* London: Granta Books, 2000.

Atlas, James. "The Changing World of New York Intellectuals." *The New York Times Magazine,* August 25, 1985.

Bach, Steven. *Leni: The Life and Work of Leni Riefenstahl.* New York: Alfred A. Knopf, 2007.

Bailey, Blake. "Beloved Monster." Vice, March 1, 2008.

Barnes, Djuna. *Nightwood.* Preface by T. S. Eliot. New York: New Directions, 1937.

Barron's Profiles of American Colleges. New York: Barron's, 1986.

Beckett, Samuel. *Waiting for Godot: A Tragicomedy in Two Acts.* Translated from the original French by the author. New York: Grove Press, 1954.

Bernstein, David. "Sontag's U. of C." *Chicago Magazine,* June 2005.

Brady, James. "Town Hall." Page Six. *New York Post,* April 17, 1982.

Breasted, Mary. "Discipline for a Wayward Writer." *Village Voice,* November 5–11, 1971.

Brockes, Emma. "Annie Leibovitz: My Time with Susan." *Guardian,* October 7, 2006.

Brodsky, Joseph. *Watermark.* New York: Farrar, Straus and Giroux, 1992.

Brooks, Peter. "Parti pris." *Partisan Review,* Summer 1966.

Burns, John. "To Sarajevo, Writer Brings Good Will and 'Godot.'" *New York Times,* August 19, 1993.

Burton, Richmond. "Notes on Life with Susan." Unpublished manuscript.

Calderone, Michael. "Regarding the Writing of Others." *New York Observer,* May 9, 2007.

Carvajal, Doreen. "So Whose Words Are They, Anyway? A New Sontag Novel Creates a Stir by Not Crediting Quotes from Other Books." *New York Times,* May 27, 2000.

Castle, Terry. "Desperately Seeking Susan." *London Review of Books* 27, no. 6 (March 17, 2005).

Chan, Evans. "Against Postmodernism, etcetera: A Conversation with Susan Sontag." *Postmodern Culture* 12, no. 1 (September 2001).

Chauncey, George. *Gay New York: Gender, Urban Culture, and the Making of the Gay Male World, 1890–1940.* New York: Basic Books, 1994.

Ching, Barbara, and Jennifer A. Wagner-Lawlor. *The Scandal of Susan Sontag.* New York: Columbia University Press, 2009.

Clinton, William J. "Remarks at the State Dinner Honoring President Arpad Goncz of Hungary." June 8, 1999. http://www.presidency.ucsb.edu /ws/?pid=57698.

Cohn, Ruby, ed. *Casebook on* Waiting for Godot: *The Impact of Beckett's Modern Classic: Reviews, Reflections & Interpretations.* New York: Grove Press, 1967.

Cosgrove, Ben. "Faces of the American Dead in Vietnam: One Week's Toll, June 1969." *Life,* May 15, 2014. http://time.com/3485726/faces-of-the -american-dead-in-vietnam-one-weeks-toll-june-1969/.

Cott, Jonathan. *Susan Sontag: The Complete* Rolling Stone *Interview.* New Haven, CT: Yale University Press, 2013.

Cronin, Gloria L., et al. *A Political Companion to Saul Bellow.* Lexington: University Press of Kentucky, 2013.

Cummings, Scott T. *Maria Irene Fornes: Routledge Modern and Contemporary Dramatists.* London: Routledge, 2013.

D'Antonio, Michael. "Little David, Happy at Last." *Esquire,* March 1990.

Daugherty, Greg. "The Last Adventure of Richard Halliburton, the Forgotten Hero of 1930s America." *Smithsonian,* March 25, 2014.

Dearborn, Mary V. *Mailer: A Biography.* New York: Houghton Mifflin Harcourt, 2001.

De Clerck, Annie. "Susan Sontag" (interview). http://cobra.canvas.be/cm/cobra/videozone/rubriek/boek-videozone/1.676237.

DeMott, Benjamin. "Lady on the Scene." *The New York Times Book Review,* January 23, 1966.

"The Desert Sanatorium and Institute of Research: Tucson, Arizona." http://www.library.arizona.edu/exhibits/pams/pdfs/institute1.pdf.

Didion, Joan. *Political Fictions.* New York: Alfred A. Knopf, 2001.

Diehl, Digby. "PEN and Sword in Seoul." *Los Angeles Times,* September 11, 1988.

Donadio, Rachel. "Fighting Words on Sir Salman." *New York Times,* July 15, 2007.

Douin, Jean-Luc. "Nicole Stéphane." *Le Monde,* March 17, 2003.

Drescher, Jack. "The Closet: Psychological Issues of Being In and Coming Out." *Psychiatric Times,* October 1, 2004.

Dudman, Helga. "From Camp to Campfire." *Jerusalem Post Weekly,* November 27, 1973.

Dunlap, David W. "Looking Back: 1964 | 'Homosexuals Proud of Deviancy.'" *New York Times,* June 9, 2015.

Elie, Paul. "A Fundamental Fight." *Vanity Fair,* May 2014.

Ephron, Nora. "Not Even a Critic Can Choose Her Audience." *New York Post,* September 23, 1967.

Feitler, Bruno. *O design de Bea Feitler.* São Paulo: Cosac Naify, 2012.

Fernandes, Bob. "Suburbana América." *Isto É,* June 23, 1993.

Field, Edward. *The Man Who Would Marry Susan Sontag: And Other Intimate Literary Portraits of the Bohemian Era.* Madison: University of Wisconsin Press, 2005.

Fox, Margalit. "Susan Sontag, Social Critic with Verve, Dies at 71." *New York Times,* December 28, 2004.

Fremont-Smith, Eliot. "After the Ticker Tape Parade." *New York Times,* January 31, 1966.

Fremont-Smith, Eliot. "Diddy Did It—Or Did He?" *New York Times,* August 18, 1967.

Fricke, Harald. "Meinung und nichts als die Meinung." Taz.de, September 15, 2001. http://www.taz.de/Archiv-Suche/!1151172&s=&SuchRahmen=Print/.

"Gabo responde a Susan Sontag." *El Tiempo,* April 29, 2003. http://www
.eltiempo.com/archivo/documento/MAM-1033192.

Giebler, A. H. "News of Los Angeles and Vicinity: 8,000 Armenians in Selig
Spectacle." *The Moving Picture World* 39, no. 4 (1919).

Ginsberg, Allen. *Howl and Other Poems.* San Francisco: City Lights Pocket
Bookshop, 1956.

Goldman, Andrew. "The Devil in Marina Abramovic." *The New York Times
Magazine,* June 13, 2012.

Goldman, Andrew. "How Could This Happen to Annie Leibovitz?" *New
York,* August 16, 2009.

Goodman, Walter. "Norman Mailer Offers a PEN Post-Mortem." *New York
Times,* January 27, 1986.

Greif, Mark. *The Age of the Crisis of Man: Thought and Fiction in America:
1933–1973.* Princeton, NJ: Princeton University Press, 2015.

Greif, Mark. "What's Wrong with Public Intellectuals?" *The Chronicle of
Higher Education,* February 13, 2015. http://chronicle.com/article/Whats
-Wrong-With-Public/189921/.

"Greta Garbo, 84, Screen Icon Who Fled Her Stardom, Dies." *New York
Times,* April 16, 1990.

Grossman, Judith. *Her Own Terms.* New York: Soho Press, 1988.

Gustafson, Klas. *Gösta Ekman: Farbrorn som inte vill va' stor.* Stockholm:
Leopard Förlag, 2010.

Hadžiselimović, Omer, and Zvonimir Radeljković. "Literature Is What You
Should Re-Read: An Interview with Susan Sontag." *Spirit of Bosnia* 2, no.
2 (April 2007). http://www.spiritofbosnia.org/volume-2-no-2-2007-april
/literature-is-what-you-should-re-read-an-interview-with-susan-sontag/.

Hagan, Joe. *Sticky Fingers: The Life and Times of Jann Wenner and* Rolling
Stone *Magazine.* New York: Alfred A. Knopf, 2017.

Hansen, Suzy. "Rieff Encounter." *New York Observer,* May 2, 2005.

Hegedus, Chris, and D. A. Pennebaker, dirs. *Town Bloody Hall.* 1979.

Heilbrun, Carolyn G. *Writing a Woman's Life.* New York: W. W. Norton, 1988.

Heller, Dana. "Desperately Seeking Susan." *The Common Review,* Winter
2006.

Heller, Zoë. "The Life of a Head Girl." *Independent,* September 20, 1992.

Hirsch, Edward. "Susan Sontag, The Art of Fiction No. 143." *Paris Review*
no. 137 (Winter 1995).

Hitchens, Christopher. "Party Talk." *Observer,* June 20, 1982.

Horowitz, Daniel. *Consuming Pleasures: Intellectuals and Popular Culture in the
Postwar World.* Philadelphia: University of Pennsylvania Press, 2012.

Howard, Gerald. "Reasons to Believe." *Bookforum,* February/March 2007.

Howe, Irving. "The New York Intellectuals." *Dissent,* October 1, 1969.

Hujar, Peter. *Portraits in Life and Death.* Preface by Susan Sontag. New York: Da Capo Press, 1976.

Hunter, Gene. "Susan Sontag, a Very Special Daughter." *Honolulu Advertiser,* July 12, 1971.

"Identifiable as Prose." *Time,* September 14, 1963.

Imber, Jonathan. "Philip Rieff: A Personal Remembrance." *Society,* November/ December 2006.

Indiana, Gary. *I Can Give You Anything but Love.* New York: Rizzoli, 2015.

Johnson, Lyndon Baines. "Remarks in Memorial Hall, Akron University." October 21, 1964. http://www.presidency.ucsb.edu/documents/remarks -memorial-hall-akron-university.

Johnston, Jill. *Jasper Johns: Privileged Information.* New York: Thames and Hudson, 1996.

Jonas, Hans. *The Gnostic Religion: The Message of the Alien God and the Beginnings of Christianity.* Second edition. Boston: Beacon Press, 1963.

Jonas, Hans. *Memoirs: The Tauber Institute Series for the Study of European Jewry.* Hanover, NH: Brandeis University Press/University Press of New England, 2008.

Kachka, Boris. *Hothouse: The Art of Survival and the Survival of Art at America's Most Celebrated Publishing House, Farrar, Straus & Giroux.* New York: Simon & Schuster, 2013.

Kakutani, Michiko. "'In America': Love as a Distraction That Gets in the Way of Art." *New York Times,* February 29, 2000.

Kaplan, Alice. *Dreaming in French: The Paris Years of Jacqueline Bouvier Kennedy, Susan Sontag, and Angela Davis.* Chicago: University of Chicago Press, 2012.

Karahasan, Dževad. *Sarajevo, Exodus of a City.* New York: Kodansha America, 1994.

Kates, Nancy, dir. *Regarding Susan Sontag.* HBO, 2014.

Kenner, Hugh. "Divorcing." *The New York Times Book Review,* November 2, 1969.

Kim, Yongbeon. "'The Poetry I Risked My Life to Write Has Finally Been "Restored" 16 Years Later': Poet Lee San-ha." Translated by Mia You. *Munhwa Ilbo,* June 16, 2003. Published online by Naver News. http://news .naver.com/main/read.nhn?mode=LSD&mid=sec&sid1=103&oid=021& aid=0000033892.

Koch, Stephen. *Stargazer: Andy Warhol's World and His Films.* New York: Praeger, 1973.

Koenig, Rhoda. "At Play in the Fields of the Word." *New York,* February 3, 1986.

Krauze, Enrique. "García Márquez's Blind Spot." *New York Times,* May 28, 2014.

Lacey, Liam. "Waiting for Sontag." *Globe and Mail,* November 23, 2002.

Lambert, Angela. "Taking Pictures with Annie Leibovitz: From Jagger to Trump, She Summed Up the Seventies and Eighties. Her Latest Subject Is Sarajevo." *Independent,* March 3, 1994.

Larson, Kay. *Where the Heart Beats: John Cage, Zen Buddhism, and the Inner Life of Artists.* New York: Penguin Press, 2012.

Leford, Gérard. "Nicole Stéphane, la mort d'une enfant terrible." *Libération,* March 15, 2007.

Lehmann-Haupt, Christopher. "Shaping the Reality of AIDS Through Language." *New York Times,* January 16, 1989.

Leibovitz, Annie. *At Work.* New York: Random House, 2008.

Leibovitz, Annie. *A Photographer's Life: 1990–2005.* New York: Random House, 2006.

Leibovitz, Annie. *Photographs.* New York: Pantheon/Rolling Stone Press, 1983.

Leibovitz, Annie. *Portraits, 2005–2016.* New York: Phaidon Press, 2017.

Leibovitz, Annie, ed. *Shooting Stars: The* Rolling Stone *Book of Portraits.* San Francisco: Straight Arrow Books, 1973.

Leibovitz, Annie. *Women.* Preface by Susan Sontag. New York: Random House, 1999.

Lerner, Jonathan. "Whorehouse of the Caribbean." Salon, January 4, 2001. http://www.salon.com/2001/01/04/havana/.

"Let Us Now Praise Famous Women." Slate, December 9, 1999. http://www.slate.com/articles/news_and_politics/culturebox/1999/12/let_us_now_praise_famous_women.html.

Levenson, H. Michael. "The Avant-Garde and the Avant-Guardian: Brother Carl New England Premiere at the Brattle." *Harvard Crimson,* July 27, 1973.

Levounis, P., J. Drescher, and M. E. Barber, eds. *The LGBT Casebook.* Washington, D.C.: American Psychiatric Press, 2012.

Linfield, Susie. *The Cruel Radiance: Photography and Political Violence.* Chicago: University of Chicago Press, 2010.

London, Jack. *Martin Eden.* New York: Macmillan, 1909.

Lopate, Phillip. *Notes on Sontag.* Princeton, NJ: Princeton University Press, 2009.

Loseff, Lev. *Joseph Brodsky: A Literary Life.* Translated by Jane Ann Miller. New Haven, CT: Yale University Press, 2011.

MacArthur, John R. "The Friends Rushdie Forgot." *Spectator,* September 29, 2012. https://www.spectator.co.uk/2012/09/the-friends-rushdie-forgot/.

Mackenzie, Suzie. "Finding Fact from Fiction." *Guardian,* May 27, 2000.

Mann, Thomas. *Tagebücher 1949–1950.* Edited by Inge Jens. Frankfurt am Main: S. Fischer Verlag, 1991.

Manus, Elizabeth. "Susan Sontag Gets Jumpy; Pat Conroy Gets Left Out." *New York Observer,* January 17, 2000.

McGuigan, Cathleen. "An Exclusive Look at Annie Leibovitz's Compelling—and Surprisingly Personal—New Book." *Newsweek,* October 2, 2006.

McMurtry, Larry. *In a Narrow Grave: Essays on Texas.* New York: Simon & Schuster, 1968.

McMurtry, Larry. [Letter to the Editor.] *Times Literary Supplement,* June 7, 1992.

Mead, Rebecca. "Mister Pitch." *New York,* August 5, 1996.

"Media Man's Mascot." *Guardian,* September 28, 1967.

Memran, Michelle, dir. *The Rest I Make Up.* 2018.

Mesinger, Maxine. "VF Dresses Demi in Paint." *Houston Chronicle,* July 7, 1992.

Miller, Jonathan, and John Cleese. "Oxbridge Philosophy." https://www.youtube.com/watch?v=qUvf3fOmTTk.

Miner, Michael. "War Comes to Rockford/Cartoonist Kerfuffle/Cartoon Recount." *Chicago Reader,* June 5, 2003. http://www.chicagoreader.com/chicago/war-comes-to-rockfordcartoonist-kerfufflecartoon-recount/Content?oid=912271.

Mitchell, Katie. "A Meeting of Minds." *Guardian,* November 18, 2005. https://www.theguardian.com/music/2005/nov/18/classicalmusicandopera.thomasstearnseliot.

Montgomery, Paul L. "Detective Interrupts Vietnam Read-In." *New York Times,* February 21, 1966.

"More from Sontag's 'Nightmare.'" Page Six. *New York Post,* August 14, 1992.

Muir, Robin. "Women's Studies." *Independent,* October 18, 1997.

Mukherjee, Siddhartha. *The Emperor of All Maladies: A Biography of Cancer.* London: Fourth Estate, 2011.

Musto, Michael. *La Dolce Musto.* New York: Carroll & Graf, 2007.

Myers, Kevin. "I Wish I Had Kicked Susan Sontag." *Telegraph,* January 2, 2005.

Nguyễn Đức Nam, "Con Người Việt-Nam Hiện đại Trong Nhận Thức Của Nhà Văn Mỹ Xu-Dan Xôn-Tăc." Translated by Cindy A. Nguyen. Sontag Papers, UCLA Archives.

Norman, Michael. "Diana Trilling, a Cultural Critic and Member of a Select Intellectual Circle, Dies at 91." *New York Times,* October 25, 1996.

"Not Good Taste, Not Bad Taste—It's 'Camp.'" *New York Times,* March 31, 1965.

"Novelist Drowns Herself." *East Hampton Star,* November 13, 1969.

Nunez, Sigrid. *Sempre Susan: A Memoir of Susan Sontag.* New York: Atlas, 2011.

Ozick, Cynthia. "On Discord and Desire." In *The Din in the Head.* Boston: Houghton Mifflin, 2006.

Paglia, Camille. Interview with Christopher Lydon, 1993. https://www .youtube.com/watch?v=kFgYcVbAaNs.

Paglia, Camille. *Vamps & Tramps: New Essays.* New York: Vintage, 1994.

Pareigis, Christina. "Susan Taubes—Bilder aus dem Archiv." *Aus Berliner Archiven.* Beiträge zum Berliner Wissenschaftsjahr, 2010.

"Park Sang-mi's Empathetic Storytelling: The Drum Sounds That Beat the Consciousness of the Silent." Translated by Hyosun Lee. *Kyunghyang Shinmun,* October 13, 2015. http://news.naver.com/main/read.nhn?mode =LSD&mid=sec&sid1=103&oid=021&aid=0000033892.

Pastan, Rachel. "Remembering Paul Thek: A Conversation with Ann Wilson and Peter Harvey." Institute of Contemporary Art, University of Pennsylvania. http://icaphila.org/miranda/6114/remembering-paul-thek-a -conversation-with-ann-wilson-and-peter-harvey.

Perron, Wendy. "Susan Sontag on Writing, Art, Feminism, Life and Death." *Soho Weekly News,* December 1, 1977.

Pessoa, Fernando. *Heróstrato e a busca da imortalidade.* Translated by Manuela Rocha. Edited by Richard Zenith. Vol. 14 of *Obras de Fernando Pessoa.* Lisbon: Assírio & Alvim, 2000.

Philoctetes Center, "Susan Sontag: Public Intellectual, Polymath, Provocatrice." https://www.youtube.com/watch?v=zXJe3EcPo1g.

Poague, Leland, ed. *Conversations with Susan Sontag.* Jackson: University Press of Mississippi, 1995.

Poague, Leland, and Kathy A. Parsons. *Susan Sontag: An Annotated Bibliography: 1948–1992.* New York: Garland Publishing, 2000.

Podhoretz, Norman. *Making It.* New York: Random House, 1967.

Polukhina, Valentina. "Thirteen Ways of Looking at Joseph Brodsky." *Words Without Borders,* June 2008. http://www.wordswithoutborders.org/article /thirteen-ways-of-looking-at-joseph-brodsky.

Pomfret, John. "'Godot' amid the Gunfire: In Bosnia, Sontag's Take on Beckett." *Washington Post,* August 19, 1993.

"Pornography Is Undefined at Film-Critic Mekas' Trial." *Village Voice,* June 18, 1964.

Pulido, Natividad. "Desde que conocí a Susan Sontag traté de complacerla, pero no siempre funcionaba." *ABC* (Madrid), June 19, 2009.

"Quotation of the Day." *New York Times,* September 7, 2002. http://www .nytimes.com/2002/09/07/nyregion/quotation-of-the-day-766518.html.

Reid, Atka, and Hana Schofield. *Goodbye Sarajevo: A True Story of Courage, Love and Survival.* London: Bloomsbury, 2011.

Rich, Adrienne. *Blood, Bread, and Poetry: Selected Prose: 1979–1985.* New York: W. W. Norton, 1986.

Rich, Adrienne, and Susan Sontag. "Feminism and Fascism: An Exchange." *The New York Review of Books,* March 20, 1975.

Rich, Frank. "Stage: Milan Kundera's 'Jacques and His Master.'" *New York Times,* January 24, 1985.

Rieff, David. *Slaughterhouse: Bosnia and the Failure of the West.* New York: Simon & Schuster, 1995.

Rieff, David. *Swimming in a Sea of Death: A Son's Memoir.* New York: Simon & Schuster, 2008.

Rieff, Philip. *Freud: The Mind of the Moralist.* Chicago: University of Chicago Press, 1959.

Rieff, Philip. *My Life Among the Deathworks: Illustrations of the Aesthetics of Authority.* Vol. 1: *Sacred Order/Social Order.* Charlottesville: University of Virginia Press, 2006.

Ripa di Meana, Carlo. "News from the Biennale." *The New York Review of Books,* September 15, 1977.

"Robert Mayer in New York: Dr. Spock's Breakfast Club." *Newsday,* December 6, 1967.

Roberts, Ronald Suresh. *No Cold Kitchen: A Biography of Nadine Gordimer.* Johannesburg: STE Publishers, 2005.

Roiphe, Katie. *The Violet Hour: Great Writers at the End.* New York: Dial Press, 2016.

Rolling Stone, no. 254. Tenth Anniversary Issue. December 15, 1977.

Rollyson, Carl. *Reading Susan Sontag: A Critical Introduction to Her Work.* Chicago: Ivan R. Dee, 2001.

Rollyson, Carl E., and Lisa Olson Paddock, *Susan Sontag: The Making of an Icon.* New York: W. W. Norton, 2000.

Roser, Max, and Esteban Ortiz-Ospina. "Literacy." One World Data, September 20, 2018. https://ourworldindata.org/literacy/.

Rothschild, Monique de. *Si j'ai bonne mémoire . . .* Saint-Rémy-en-l'Eau: Éditions Monelle Hayot, 2001.

Ruas, Charles. "Susan Sontag: Past, Present and Future." *New York Times,* October 24, 1982.

Ruiz Mantilla, Jesús. "Sin Susan Sontag, no habría ganado el Príncipe de Asturias." *El País,* November 11, 2013.

Rushdie, Salman. *Joseph Anton: A Memoir.* New York: Random House, 2012.

Schoenman, Ralph. "Susan Sontag and the Left." *Village Voice,* March 2, 1982.

Schreiber, Daniel. *Susan Sontag: Geist und Glamour: Biographie.* Berlin: Aufbau Verlag, 2010.

Scott, Janny. "From Annie Leibovitz: Life, and Death, Examined." *New York Times,* October 6, 2006.

Scott, Janny. "It's a Lonely Way to Pay the Bills: For Unauthorized Biographers, the World Is Very Hostile." *New York Times,* October 6, 1996.

Seligman, Craig. *Sontag & Kael: Opposites Attract Me.* New York: Counterpoint, 2004.

Setzer, Dawn. "Library Buys Sontag Papers." UCLA Newsroom, February 12, 2002. http://newsroom.ucla.edu/stories/020212sontag.

Signorile, Michelangelo. *Queer in America: Sex, the Media, and the Closets of Power.* New York: Random House, 1993.

Skelding, Conor. "Fearing 'Embarrassment,' the FBI Advised Agents Against Interviewing Susan Sontag." *Muckrock,* June 13, 2014. https://www.muckrock.com/news/archives/2014/jun/13/susan-sontag-security-matter/.

Sontag, Susan. *Against Interpretation and Other Essays.* New York: Farrar, Straus and Giroux, 1966.

Sontag, Susan. *Alice in Bed.* New York: Farrar, Straus and Giroux, 1993.

Sontag, Susan. *As Consciousness Is Harnessed to Flesh: Journals and Notebooks, 1964–1980.* Edited by David Rieff. New York: Farrar, Straus and Giroux, 2013.

Sontag, Susan. *At the Same Time: Essays and Speeches.* Edited by Paolo Dilonardo and Anne Jump. New York: Farrar, Straus and Giroux, 2007.

Sontag, Susan. *The Benefactor: A Novel.* New York: Farrar, Straus, 1963.

Sontag, Susan. *Brother Carl.* New York: Farrar, Straus and Giroux, 1974.

Sontag, Susan. *Death Kit.* New York: Farrar, Straus and Giroux, 1967.

Sontag, Susan. *Duet for Cannibals: A Screenplay.* New York: Farrar, Straus and Giroux, 1970.

Sontag, Susan. *Essays of the 1960s & 70s.* Edited by David Rieff. New York: Library of America, 2013.

Sontag, Susan. *I, etcetera.* New York: Farrar, Straus and Giroux, 1978.

Sontag, Susan. *Illness as Metaphor* and *AIDS and Its Metaphors.* New York: Doubleday, 1990.

Sontag, Susan. *In America.* New York: Farrar, Straus and Giroux, 2000.

Sontag, Susan. "A Letter from Sweden." *Ramparts,* July 1969.

Sontag, Susan. "The Letter Scene." *The New Yorker,* August 18, 1986.

Sontag, Susan. *On Photography*. New York: Farrar, Straus and Giroux, 1977.

Sontag, Susan. "Pilgrimage." *The New Yorker,* December 21, 1987.

Sontag, Susan, dir. *Promised Lands*. New Yorker Films, 1974.

Sontag, Susan. *Reborn: Journals and Notebooks, 1947–1963*. Edited by David Rieff. New York: Farrar, Straus and Giroux, 2008.

Sontag, Susan. *Regarding the Pain of Others*. New York: Farrar, Straus and Giroux, 2002.

Sontag, Susan. "Regarding the Torture of Others." *The New York Times Magazine,* May 23, 2004.

Sontag, Susan. "Some Thoughts on the Right Way (for Us) to Love the Cuban Revolution." *Ramparts,* April 1969.

Sontag, Susan. *Styles of Radical Will*. New York: Farrar, Straus and Giroux, 1969.

Sontag, Susan. *The Volcano Lover: A Romance*. New York: Farrar, Straus and Giroux, 1992.

Sontag, Susan. "The Way We Live Now." *The New Yorker,* November 24, 1986.

Sontag, Susan. *Where the Stress Falls: Essays*. New York: Farrar, Straus and Giroux, 2001.

Sontag, Susan. "Why Are We in Kosovo?" *The New York Times Magazine,* May 2, 1999.

Sontag, Susan, and Dugald Stermer. *The Art of Revolution: Ninety-Six Posters from Cuba*. London: Pall Mall Press, 1970.

Span, Paula. "Susan Sontag, Hot at Last." *Washington Post,* September 17, 1992.

Stevenson, Peter M. "Leibovitz Sees Glitz and Grit, Sontag Broods on the Big Idea." *New York Observer,* November 8, 1999. http://observer.com/1999/11/leibovitz-sees-glitz-and-grit-sontag-broods-on-the-big-idea/.

"Susan Sontag contra Gabo." *La Nación,* April 4, 2010. http://www.lanacion.com.ar/1249538-susan-sontag-contra-gabo.

Susan Sontag Papers (Collection 612). UCLA Library Special Collections, Charles E. Young Research Library, UCLA.

"Susan Sontag Provokes Debate on Communism." *New York Times,* February 27, 1982.

Talbot, David. "The 'Traitor' Fires Back." Salon, October 16, 2001. http://www.salon.com/2001/10/16/susans/.

Taubes, Susan. *Divorcing*. New York: Random House, 1969.

Teal, Donn (as "Ronald Forsythe"). "Why Can't 'We' Live Happily Ever After, Too?" *New York Times,* February 23, 1969.

"Tempest on the Left." *Across the Board: The Conference Board Magazine* XIX, no. 5. (May 1982).

Teodori, Maria Adele. "Un'americana a Parigi." *Il Messaggero,* May 26, 1973.

Thek, Paul. *Journals.* Archive of Alexander & Bonin, New York.

Thek, Paul, et al. *"Please Write!": Paul Thek and Franz Deckwitz: An Artists' Friendship, Boijmans Studies.* Rotterdam, Netherlands: Museum Boijmans van Beuningen, 2015.

Thompson, Bob. "A Complete Picture: Annie Leibovitz Is Ready for an Intimate View of Her Life." *Washington Post,* October 19, 2006.

Thomson, David. "Death Kit." *The New Republic,* February 12, 2007.

Toback, James. "Whatever You'd Like Susan Sontag to Think, She Doesn't." *Esquire,* July 1968.

Tomes, Robert R. *Apocalypse Then: American Intellectuals and the Vietnam War, 1954–1975.* New York: New York University Press, 1998.

Trilling, Lionel. *The Liberal Imagination.* New York: Viking Press, 1950.

Truitt, Eliza. "Exorcising Arnold." Slate, December 1, 1999. http://www .slate.com/articles/news_and_politics/summary_judgment/1999/12 /exorcising_arnold.html.

Trumbull, Robert. "Homosexuals Proud of Deviancy, Medical Academy Study Finds." *New York Times,* May 19, 1964.

Valenzuela, Luisa. "Susan Sontag, amiga." *La Nación.* January 14, 2008.

Vidich, Arthur J. *With a Critical Eye: An Intellectual and His Times.* Edited and introduced by Robert Jackall. Knoxville, TN: Newfound Press, 2009.

Wain, John. "Song of Myself, 1963." *The New Republic,* September 21, 1963.

Weeks, Linton. "Susan Sontag Wins National Book Award for Fiction." *Washington Post,* November 16, 2000.

Weisman, Steven R. "The Hollow Man." *New York Times,* October 10, 1999.

Westerbeck, Colin L., Jr. "On Sontag." *Artforum,* April 1978.

Wetzsteon, Ross. "Irene Fornes: The Elements of Style." *Village Voice,* April 29, 1986.

White, Edmund. *Caracole.* New York: Dutton, 1985.

White, Edmund. *City Boy: My Life in New York During the 1960s and '70s.* New York: Bloomsbury, 2009.

White, Morton. *A Philosopher's Story.* University Park: Pennsylvania State University Press, 1999.

Woititz, Janet Geringer. *Adult Children of Alcoholics.* Deerfield Beach, FL: Health Communications, 1983.

Woodly, Deva. "How UChicago Became a Hub for Black Intellectuals." University of Chicago, January 19, 2009. https://www.uchicago.edu/features /20090119_mlk/.

Woolf, Virginia. *The Moment and Other Essays.* London: Hogarth Press, 1947.

Youdovin, Ira S. "Recent Resignations Reveal Decentralization Problems."

Columbia Daily Spectator CV, no. 81 (March 9, 1961). http://spectatorarchive
.library.columbia.edu/cgi-bin/columbia?a=d&d=cs19610309-01.2.4.

Žalica, Pjer, dir. *Sarajevo—Godot*. SaGA Production Sarajevo, 1993.

Zarifopol-Johnston, Ilinca. *Searching for Cioran*. Edited by Kenneth R. John-
ston. Foreword by Matei Calinescu. Bloomington: Indiana University
Press, 2019.

Zwerling, Harriet Sohmers. *Abroad: An Expatriate's Diaries: 1950–1959*. New
York: Spuyten Duyvil, 2014.

CREDITS

Page 1, bottom right: Jack Rosenblatt and Susan. Susan Sontag Papers (Collection 612). Library Special Collections, Charles E. Young Research Library, UCLA.

Page 2, top: Susan and Mildred Jacobson. Susan Sontag Papers (Collection 612). Library Special Collections, Charles E. Young Research Library, UCLA.

Page 2, bottom: Judith, Nat Sontag, and Susan. Susan Sontag Papers (Collection 612). Library Special Collections, Charles E. Young Research Library, UCLA.

Page 3, top: Thomas Mann. Photograph from ullstein bild—Thomas-Mann-Archiv.

Page 3, center: Marie Curie. Photograph from the Library of Congress.

Page 4, bottom left: Gene Marum and Merrill Rodin. Photograph courtesy of Merrill Rodin.

Page 5, top left: Djuna Barnes. Djuna Barnes Papers, Special Collections and University Archives, University of Maryland Libraries.

Page 5, top right: Kenneth Anger. Photograph from Prod DB © Puck Film Productions/DR SCORPIO RISING de Kenneth Anger 1964 USA. TCD/Prod DB/Alamy Stock Photo.

Page 5, center: Maya Deren. Photograph from Archive PL/Alamy Stock Photo.

Page 6: Harriet Sohmers. Photograph courtesy of Harriet Sohmers Zwerling.

Page 7, top left: Susan and Philip Rieff. Susan Sontag Papers (Collection 612). Library Special Collections, Charles E. Young Research Library, UCLA.

Page 7, top right: *Mind of the Moralist*. Photograph by and courtesy of Melissa Goldstein.

Page 7, bottom: Susan and David Rieff. Susan Sontag Papers (Collection 612). Library Special Collections, Charles E. Young Research Library, UCLA.

Page 8, top: Sketch. Susan Sontag Papers (Collection 612). Library Special Collections, Charles E. Young Research Library, UCLA.

Page 8, bottom: Mildred, Susan, and David. Susan Sontag Papers (Collection 612). Library Special Collections, Charles E. Young Research Library, UCLA.

Page 9, top: Jacob and Susan Taubes. Photograph courtesy of Ethan and Tanaquil Taubes.

Page 9, bottom left: Harriet Sohmers in Greece. Photograph courtesy of Harriet Sohmers Zwerling.

Page 9, bottom right: Susan in Spain. Photograph courtesy of Harriet Sohmers Zwerling.

Page 10, top left: Article from the New York *Daily News.*

Page 10, top right: Cartoon. Susan Sontag Papers (Collection 612). Library Special Collections, Charles E. Young Research Library, UCLA.

Page 10, bottom right: Irene Fornés. Photograph courtesy of Harriet Sohmers Zwerling.

Page 11, bottom: "Happening." Photograph © Julian Wasser.

Page 12, top left: Alfred Chester and his boyfriend. Photograph courtesy of Edward Field.

Page 12, bottom: Roger Straus. Photograph © Estate of David Gahr.

Page 13, top left: Robert Silvers and Barbara Epstein. Photograph © Gert Berliner.

Page 13, top right: Susan and Jasper Johns. Photograph © Bob Adelman Estate.

Page 14, top: Handwritten letter. Susan Sontag Papers (Collection 612). Library Special Collections, Charles E. Young Research Library, UCLA.

Page 14, bottom: Joseph Cornell gifts. Photograph by Benjamin Moser.

Page 15, top left: Mark Rothko. Photograph by Kate Rothko/Apic/Getty Images.

Page 15, top right: *Silence: Lectures and Writings.* Photograph by and courtesy of Lauren Miller Walsh.

Page 16, top: Susan arrested in New York. Photograph by Fred W. McDarrah/Getty Images.

Page 16, bottom: Susan in Sweden. Photograph courtesy of Florence Malraux.

SECOND INSERT

Page 1, top: *Susan Sontag and her son on bench, N.Y.C. 1965* © The Estate of Diane Arbus.

Page 1, bottom: Diane Arbus show at MoMA. Digital Image © The Museum of Modern Art/Licensed by SCALA/Art Resource, NY.

Page 2, top: Paul Goodman. Photograph by Sam Falk/The New York Times/Redux.

Page 2, bottom: Susan and Carlotta del Pezzo. Photograph courtesy of Patrizia Cavalli.

Page 3, top: Nicole Stéphane. Photograph from ITV/Shutterstock.

Page 3, bottom: Susan at Cannes. Photograph from Leemage/Bridgeman Images.

Page 4, left: Photo-booth strip. Susan Sontag Papers (Collection 612). Library Special Collections, Charles E. Young Research Library, UCLA.

Page 4, top right: *Thek in the Palermo Catacombs (II),* 1963. Reproduced from

INDEX